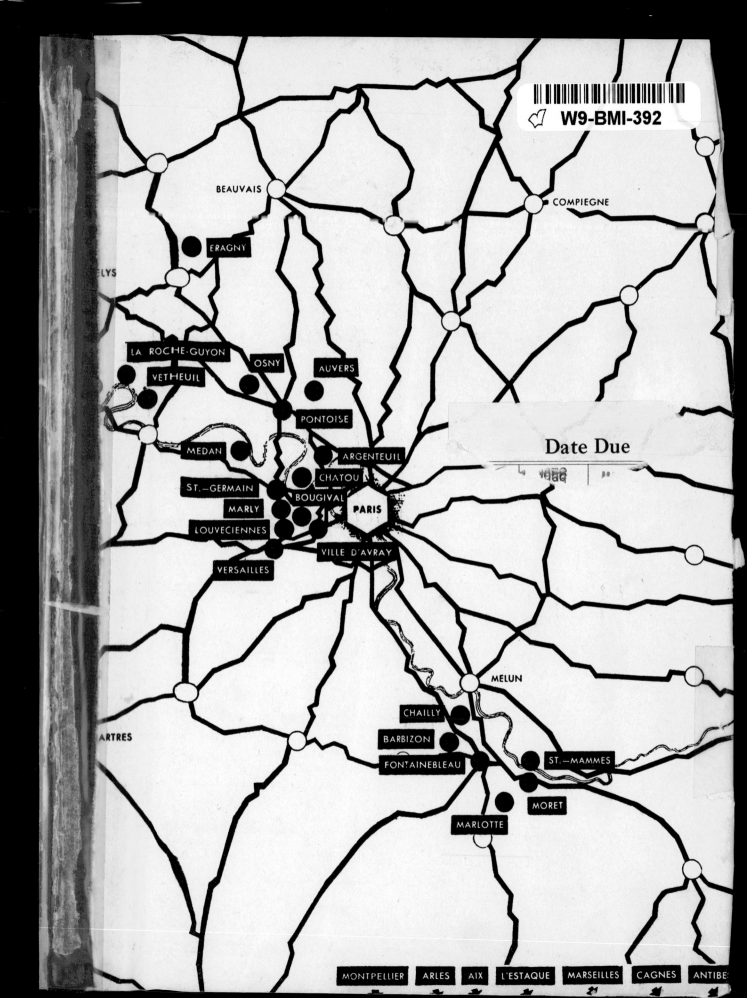

BOOKS BY JOHN REWALD

CEZANNE, SA VIE, SON OEUVRE, SON AMITIÉ POUR ZOLA, Paris, 1939, *English edition in preparation*
GAUGUIN, New York, 1938
MAILLOL, New York, 1939
GEORGES SEURAT, New York, 1943

EDITED BY THE SAME AUTHOR

PAUL CEZANNE, LETTERS, London 1941
PAUL GAUGUIN, LETTERS TO A. VOLLARD AND A. FONTAINAS, San Francisco, 1943
CAMILLE PISSARRO, LETTERS TO HIS SON LUCIEN, New York, 1943
THE WOODCUTS OF ARISTIDE MAILLOL (A Complete Catalogue) New York, 1943
THE SCULPTURES OF EDGAR DEGAS (A Complete Catalogue) New York, 1944
RENOIR DRAWINGS (*in preparation*)

THE HISTORY OF
IMPRESSIONISM

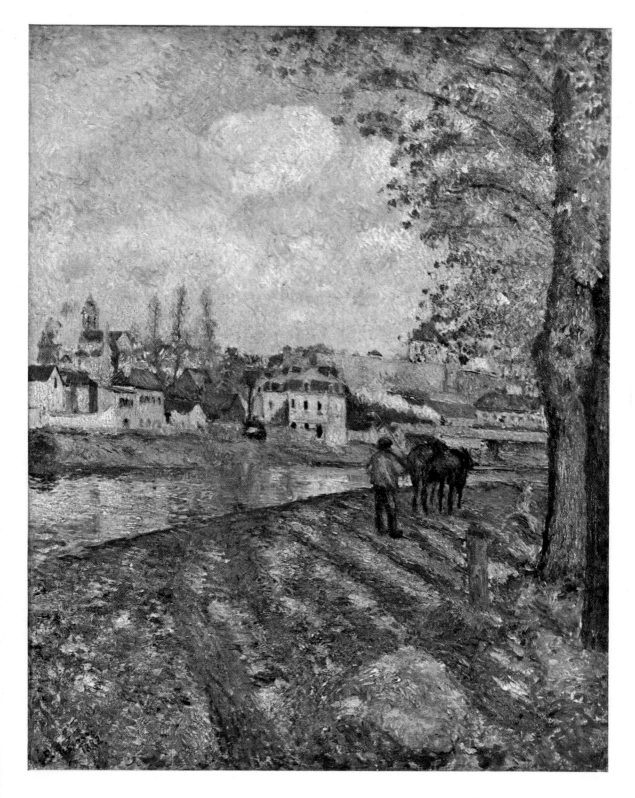

PISSARRO: Tow-Path at Pontoise, d. 1882. 22 x 26″. Durand-Ruel Galleries, New York.

THE

HISTORY

OF

IMPRESSIONISM

JOHN REWALD

THE MUSEUM OF MODERN ART, NEW YORK

DISTRIBUTED BY SIMON AND SCHUSTER, ROCKEFELLER CENTER, NEW YORK

CONTENTS

INTRODUCTION

In the spring of 1874 a group of young painters defied the official Salon in Paris and organized an exhibition of its own. While this action was in itself revolutionary and broke with century-old customs, the paintings which these men showed seemed at first glance even more opposed to tradition. The reaction of visitors and critics was by no means friendly to this innovation. They accused the artists of painting differently from the accepted masters simply to catch the public's eye. The most indulgent saw in their efforts merely a joke, an attempt to pull the legs of honest folk. It took years of bitter struggle before the members of the little group were able to convince the public of their sincerity, not to mention their talent.

This group included Monet, Renoir, Pissarro, Sisley, Degas, Cézanne and Berthe Morisot. Its members were not only of diverse character and gifts, but also, to a certain extent, of differing conceptions and tendencies. But born more or less within the same decade, they all went through similar experiences and fought against an identical opposition. Thrown together by chance, they accepted their fate in common, just as they accepted their designation as "impressionists," a term thought up in derision by some satirical journalist.

When the impressionists organized their first group exhibition, they were no longer awkward beginners; they were men over thirty and had been working ardently for fifteen years and more. They had studied at the *Ecole des Beaux-Arts,* gone to the older generation for advice, discussed and absorbed the various currents in the arts of their time: classicism, romanticism, realism. Yet they had declined to follow blindly the methods of the acclaimed masters and pseudo-masters of the day. Instead, they had derived new concepts from the lessons of the past and the present, developing an art entirely of their own. Although their efforts shocked their contemporaries as being brazen, they were in fact the true continuation of the works and theories of their predecessors. Thus the new phase in the history of art inaugurated by the impressionist exhibition of 1874 did not come as a sudden outbreak of revolutionary tendencies; it was the culmination of a slow and consistent development.

The impressionist movement does not begin, therefore, with the year 1874. While all the great masters of the past contributed their share to the development of impressionist principles, the immediate roots of the movement can be most clearly discovered in the twenty years preceding the historic exhibition of 1874. Those were the years of formation, the years during which the impressionists met and brought forward their views and their talent toward a new approach to the visual world. Any attempt to retrace

the history of the impressionist movement will thus have to begin with the period in which the essential ideas took shape; that is, well before they found their complete expression. Whereas that period was dominated by older men, Ingres, Delacroix, Corot and Courbet, as well as by ill-understood traditions, despotically purveyed by the official art schools, it was the background against which the young generation promoted its new concepts. This explains the importance of those early years when Manet, Monet, Renoir and Pissarro refused to follow their teachers and set out to seek a road of their own, the road which lead to impressionism.

The present survey follows the evolution of the impressionist painters from their beginnings to the culmination of their efforts in 1874 and throughout the eight group exhibitions organized by them. It ends virtually with the year 1886 in which the last group show marks the definite disbandment of the companions and their more or less complete abandonment of impressionism. In due time it is planned to cover the story of the twenty years after 1886—until the death of Cézanne—in an equally detailed *History of Post-Impressionism.*

"It would be impossible now, I'm afraid," states the author of a recent study on impressionism, "for anyone to piece together a full and in the minutest degree accurate report of developments that led up to the first impressionist exhibition. . . . An inclusive record such as that would cover the germinating decade, and to it we should want added, of course, as full and minute and accurate a report covering the decade that followed, with its triumphs and its setbacks, its slow and often painful success in breaking down barriers of critical and popular disesteem."[*] Nothing could describe better the program of the present book, for it is exactly its ambition to offer such an "accurate report of developments."

There exists already a score of books on impressionism, but most of them are divided into chapters devoted to the different artists connected with the movement, without telling the story of the movement itself. The first attempt to consider simultaneously the evolution of the individual impressionists was made by Wilenski,[†] whose brilliantly conceived book suffers, however, from numerous inaccuracies as well as from an abundance of not always related details. As to the many books devoted to the various members of the impressionist group, they have naturally a tendency to isolate their specific subject and therefore to present only truncated evidence. Yet, to appreciate fully the individual stature of each impressionist, it seems essential first to study his position in the movement, his personal contribution to it and also the contribution of the others to his own development.

"Perfection is a collective work," Boudin once wrote; "without that person, this one would never have achieved the perfection he did achieve." If this is true of any artist, it is easy to understand how much more true it is of a group of painters who learned, worked, fought, suffered and exhibited together. But not all of those who participated in their exhibitions were real impressionists, while others, who did not openly join the group, could be considered as such. For this reason the scope of the present survey has been extended to all those who, from near or far, were connected with the movement and collaborated in giving it shape. Even if they sometimes acted contrary to each other's interests

[*] E. A. Jewell, French Impressionists, New York, 1944, p. 9.
[†] R. H. Wilenski, Modern French Painters, London, New York, 1940.

and were, as a group, occasionally divided by internal struggles, their works tell, almost better than their actions, how they pursued—both individually and together—their conquest of a new vision.

The story of this conquest may be told in many ways, but most effectively by presenting it through the works themselves. To do this, every work should be carefully assigned a date, and all illustrations arranged chronologically. By placing the works of the different painters back into historical "context," by showing together works conceived and executed in the same period by the various members of the group, by following the progress of each artist simultaneously with that of his colleagues, it seems possible to obtain a true image of the impressionist movement. Such a procedure may not always do justice to individual works, since it considers them merely as parts of a whole, but once these works have been given their place in that whole, it will become easier for others to explore them more completely.

The evidence on which this study is based can be divided roughly into the following elements: the artist's *works* (and here, in many instances, little-known works have been reproduced in preference to more famous ones); next to these, the *writings* and utterances *of the artists themselves;* furthermore, the numerous *accounts of witnesses,* who offer substantial information about these artists, their work, their surroundings etc.; finally, *contemporary criticisms,* which are essential insofar as they are not only of anecdotal interest but are facts in every artist's life, implying a wide range of psychological and financial consequences. By quoting extensively contemporary sources in preference to rewriting the information derived from them, the author hopes to reconstitute to a certain extent the atmosphere of the period, placing the reader in direct contact with the original texts. In this way he provides students with actual documents that could otherwise be obtained only through long research. Most of these documents, moreover, have not been made available in English before.

Although the author was able to gather some material for this book in France (the descendants of Pissarro, Zola, Cézanne and Berthe Morisot were most helpful in this connection), he naturally had to depend chiefly on previous publications. A list of these, together with a discussion of their respective value for the student, will be found in the bibliography, but it should be stated here that even the most authoritative sources have not been used without checking.

It is obvious that the historian who explores a period through which he himself has not lived must rely exclusively upon sources and upon deductions derived from them. The extreme of scholarly procedure would be therefore to accompany every single sentence by a footnote explaining its origin. Although this can be done, such a method is hardly advisable in a book destined for a wide public. With notes reduced to simple references at the end of each chapter, it appears not unimportant to acquaint the reader more closely with the manner in which the author's material has been handled, so as to convince him that every fact has been investigated and every word carefully weighed. Wherever the author has not resorted to actual quotations, he gives the reader (a) information derived directly from documents, though these remain unquoted; (b) deductions arrived at by consideration of facts often in themselves not worth mentioning; (c) guesses, indicated as such by the use of qualifying adverbs—"probably," "apparently" etc. Deductions are more difficult to obtain when various sources contradict each other. Even the most scrupulous investigation does not always yield definite results, and the author—unwilling to discuss such contradictions within his narrative—may have to resort to guessing unless he feels authorized to draw conclusions.

In doing so, the author of the present *History of Impressionism* has been inspired by the principles

of the great French historian Fustel de Coulanges, who wrote: "History is not an art, it is a pure science. It does not consist in telling a pleasant story or in profound philosophizing. Like all science, it consists in stating the facts, in analyzing them, in drawing them together and in bringing out their connections. The historian's only skill should consist in deducing from the documents all that is in them and in adding nothing they do not contain. The best historian is he who remains closest to his texts, who interprets them most fairly, who writes and even thinks only at their direction."

Nowhere outside of France can so many milestones in the history of impressionism be found as in the public and private collections of America. It has, therefore, seemed desirable, in a volume published in the United States, to reproduce works owned in this country whenever a choice could be made without prejudice as to the particular significance or quality of the example.

The author wishes to record his deep appreciation of the generous assistance he has received in the preparation of this book from the many scholars in the field of nineteenth-century French art, from the collectors who have permitted him to examine and reproduce their pictures, from the staffs of museums and libraries, and from art dealers. In one instance only has help been denied. The Frick Art Reference Library has refused him admission because he was born in Germany and has not yet acquired his final American papers.

Special thanks are due to the Durand-Ruel Galleries of New York and Paris, whose important role in the history of impressionism will appear in these pages, for permitting the use of their valuable files of photographs, catalogs and other records; and to Mr. Herbert Elfers of that firm for his gracious personal assistance.

The author is also indebted to Lionello Venturi, who has given him access to much material not otherwise available; to Alfred H. Barr, Jr., Miss Agnes Rindge, Meyer Schapiro and James Johnson Sweeney for their constructive criticism of the manuscript; to Monroe Wheeler for his sympathetic encouragement of this publication and to Miss Isabell Athey for perfecting the translations.

<div align="right">J. R.</div>

NOTE CONCERNING THE ILLUSTRATIONS

There are no references in the text to illustrations if reproductions of works mentioned appear in the same chapter. Such references are given only if reproductions occur in other chapters.

As far as possible, the illustrations are arranged chronologically. For dated works, the date is given in the caption preceded by the letter d. (for *dated*); for undated works which can be dated within a definite year, this date is given; for works which can be dated only by deduction, the date is either preceded by c. (for *circa*), or two different years are indicated, connected by a hyphen. In cases of doubt, the date is followed by a question mark in brackets.

Unless otherwise mentioned, the medium is *oil on canvas*. In all dimensions height precedes width. A list of sources of illustrations may be found on p. 434.

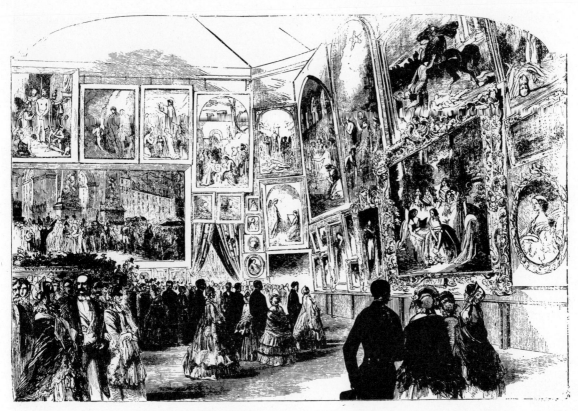

View of the Central Hall of the Palais des Beaux-Arts *at the Paris World's Fair, 1855.—From a wood-engraving published in* The Illustrated London News, *Sept. 1, 1855.*

1855-1859

THE PARIS WORLD'S FAIR, 1855

A PANORAMA OF FRENCH ART

When Camille Pissarro came to France in 1855 he arrived in time to see the great *Exposition Universelle* in Paris, the first of its kind to include a large international section devoted to the arts. Eager to show its liberalism toward industry, commerce and art, the newly established second Empire had spared no efforts to make this a truly representative manifestation of its strength as well as its progressive ideas. While their soldiers fought side by side in the Crimean peninsula, Queen Victoria and the French Emperor visited together the imposing exhibition, and Prince Napoléon proclaimed that this international fair was helping to produce "serious links for making Europe one large family."[1] Proud of her achieve-

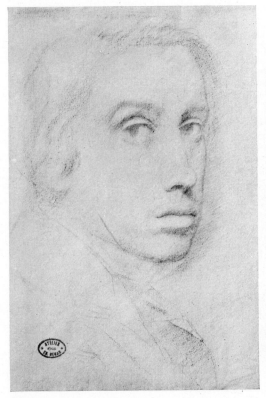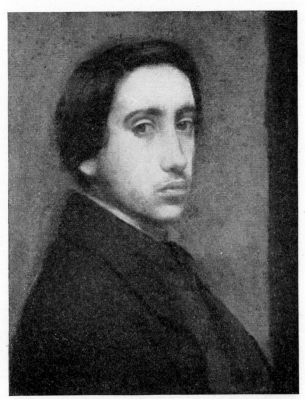

DEGAS: *Self Portrait, 1854-55. Drawing in red crayon, 11½ x 8¼". Collection John Nicholas Brown, Providence, R. I.*

DEGAS: *Self Portrait, c. 1855. 16¼ x 13". Collection A. Conger Goodyear, New York.*

ments and confident of her destiny, France seemed to inaugurate a new era in a spirit of enterprise on a scale unknown in the defunct kingdom of Louis-Philippe, the man against whom Daumier had published his wittiest cartoons.

The young Pissarro certainly did not fail to note this difference, for he had spent several school years in Paris before he was called back in 1847 to his native St. Thomas in the Danish West Indies, a small and rocky island near Puerto Rico. There he worked as a clerk in his father's general store, devoting all his spare time to drawing. Whenever he was sent to the port to supervise the arrival of shipments, he took a sketchbook with him and, while entering the merchandise that was being unloaded, made drawings of the animated life of the harbor surrounded with verdure-covered rocks and hills capped by citadels. For five years he struggled between his daily chores and his vocation. Since he could not obtain permission to devote himself to painting, one day he ran away, leaving a note for his parents on a table. He went to Caracas in Venezuela in the company of a painter from Copenhagen, Fritz Melbye, whom he had met while sketching in the port. Pissarro's parents then reconciled themselves. However, his father argued that if he really wanted to be an artist, he would do better to go to France and work in the studio of one of the well-known masters. And so, at the age of twenty-five, Camille Pissarro had returned to Paris at the very moment when the most representative works of all living painters were

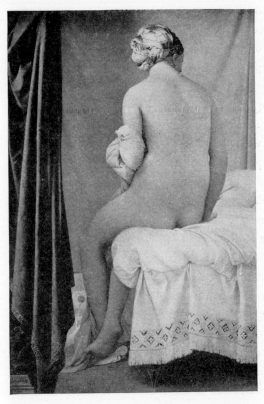

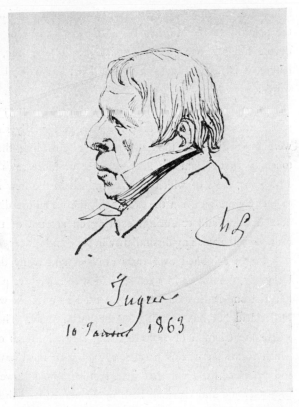

INGRES: *Bather (so-called* Baigneuse Valpin-çon*), 1808. 56¾ x 38¼". Louvre, Paris.*

LEHMANN: *Portrait of Ingres, d. 1863. Drawing, 7½ x 5½". Collection Mr. and Mrs. Walter S. Brewster, Chicago.*

assembled in a huge exhibition, including those of artists from twenty-eight nations, constituting "the most remarkable collection of paintings and sculpture ever brought within the walls of one building."[2] In this collection France's share was incomparably the most brilliant one.

The artists invited to participate in the exhibition had selected their works with the greatest care, since, for the first time in history, they were being given a chance to measure themselves, not only with their countrymen, but with artists from all parts of the world. Delacroix had chosen a series of paintings representing the various phases of his development, an arrangement such as had never been seen before, one-man shows being still unknown at that period. Ingres, who for twenty years had not deigned to send pictures to the Salon because the public and the critics had not given him the praise which he thought he deserved, had agreed to break this rule. Perhaps he was encouraged to do so by the government's promise of special honors.

Ingres had almost failed to obtain one of his most important works, a Turkish *Bather,* belonging to a M. Edouard Valpinçon, who refused to part with his treasure. But the son of M. Valpinçon's banker friend Auguste De Gas was so aroused by the idea that anybody should ignore a request of the master that he managed to prevail upon the collector. Thereupon M. Valpinçon took twenty-year-old Edgar De Gas—then about to abandon his law studies in order to become a painter—directly to Ingres'

studio and informed the artist that, owing to the insistence of this young admirer, he was willing to lend the painting to the World's Fair. Ingres was very pleased; when he learned that his visitor intended to devote himself to art, he advised him: "Draw lines, young man, many lines; from memory or from nature, it is in this way that you will become a good artist."[3] Edgar De Gas was never to forget these words.

It seems doubtful whether, among all the pictures that solicited his admiration, Camille Pissarro gave special notice to Ingres' Turkish *Bather,* particularly since he was mainly interested in landscapes. There were more than five thousand paintings crowding the walls, without any space between them, frame touching frame from the floor in three or more rows up to the ceiling—not to speak of all the other attractions, most of which were assembled in the new *Palais de l'Industrie.* For Pissarro, who had spent so many years far from the art world, the grandiose display at the *Palais des Beaux-Arts* must have been both exciting and confusing: exciting on account of the large number of works shown, and confusing because of the amazing dissimilarity in style and conception of these works.

Ingres exhibited over forty canvases and many drawings in a special gallery, while his opponent, Delacroix, dominated in a central hall with thirty-five paintings; yet Corot, for whom Pissarro immediately felt a strong inclination, was represented by only six works, Daubigny and Jongkind by even fewer, and Millet had but one painting in the entire show. Though Charles Baudelaire proclaimed in a vibrant article the triumph of Delacroix and accused Ingres of being "stripped of that energetic temperament which forms the destiny of genius,"[4] Pissarro must have observed with some surprise that all the medals and prizes of the exhibition went to men who followed more or less closely Ingres' lead. Among them were Gérôme and Cabanel, both of whom received the red ribbon of the Legion of Honor; Meissonier, whose precious little genre scenes were rewarded with a *Grande Médaille d'Honneur;* Lehmann, a pupil of Ingres, and Couture, both teachers at the *Ecole des Beaux-Arts,* to whom went first-class medals (Couture refused his, having expected a higher reward); and Bouguereau, who for the time being had to content himself with a second-class medal. Daubigny's medal was third-class; Jongkind and Millet did not receive any, nor did Courbet, who, because the jury had refused two of his most important canvases, had defiantly constructed at his own expense his *Pavillon du Réalisme* close to the official building. There he exhibited fifty of his paintings, among them the rejected ones. This courageous gesture met with little success, however. When Delacroix went to see the two controversial canvases, which he discovered to be masterpieces, he remained for almost an hour absolutely alone in Courbet's *Pavillon,* although the entrance fee had been greatly reduced.[5]

One of the two rejected canvases was Courbet's huge composition representing his studio and bearing the paradoxical title: *L'Atelier du peintre, allégorie réelle, déterminant une phase de sept années de ma vie artistique. (The painter's studio, a true allegory, defining a seven-year phase of my artistic life.)* The artist's intention had been to recapitulate and to group the various principles and personalities which had influenced his life, assembling within one large frame all the social types and all the ideas that had been part of his life since 1848, even introducing portraits of some of his friends, like Baudelaire, Champfleury and the collector Bruyas from Montpellier. A woman posing in the nude occupies the center of the canvas, while, amidst the crowd of people in his studio, the artist himself, strangely enough, works on a landscape affixed to his easel. This contradiction in the composition may have startled Pissarro, but even more striking, no doubt, were the vigorous brushstrokes and the bold treatment with which the artist

had rendered his subject. In rejecting this picture the members of the jury had declared, as Courbet put it, that "at all costs a stop had to be put to my painting tendencies, which were disastrous for French art."[6] And the general public tacitly approved of the jury's decision by shunning Courbet's exhibition. The public favored the classicism of Ingres and his numerous followers, it admired the eclectic taste of Couture, who cleverly blended the Venetians with elements of classicism, romanticism and even realism; it was no longer completely hostile to pure landscapes and bought works of Rousseau and Troyon, but it seemed only reluctantly aware of Delacroix's greatness. Confused by the diversity of currents in the arts, the public was neither ready nor willing to face a new issue and to approve of Courbet's revolutionary program to "interpret the manners, the ideas, the aspect of my time, in terms of my own evaluation, in a word, to produce living art."[7]

Confronted with these different problems, Pissarro avoided taking a position for or against Ingres, Delacroix or Courbet. He apparently did not even try to approach Chassériau, for a time one of Ingres' most promising pupils, who had left his master and "gone over" to Delacroix; (Pissarro could very well have introduced himself, for Chassériau's father had been French consul at St. Thomas and had done business with his own father). Instead, Pissarro turned to Corot, whose soft harmonies and poetic sentiment seemed closest to his own aspirations. After having met Antoine Melbye, the brother of his friend Fritz and a well established painter of seascapes, who promised help and counsel, Pissarro paid a short visit to Corot himself, who, as was his habit, received the beginner with great friendliness. Corot had never accepted regular pupils but was always ready to give advice and to propagate his belief that "the first two things to study are form and values. These two things are for me the serious bases of art. Color and execution give charm to the work."[8] However, if Pissarro wanted to profit from Corot's experience, he would have had to show some of his own work for criticism, but he had not yet produced anything of importance. He therefore heeded his father's wishes and entered one of the many studios in Paris where artists found models and occasional instruction.

Although it may seem to have been natural for Pissarro to address himself to Corot for guidance, it required a certain courage to do so, for Corot's works were far from being accepted, and many still saw in them mere sketches of an amateur who did not even know how to paint a tree and whose figures were "the most miserable in the world." As one critic stated: "Among his followers range themselves all who, having neither talent for drawing nor gift for coloring, hope to find glory at the least effort under his banner."[9]

The path of "least effort" was considered to be the simple study of nature as the painters of the Barbizon group had already practiced it for twenty-five years in the small village on the borders of Fontainebleau forest. Their devotion to nature and their disregard for historical or anecdotal subjects had deprived the public of what it most liked in a painting, the story told by the artist; for the public was by no means inclined to content itself with beauty of color, freshness of execution, the natural poetry of the trees and rocks, the huts and lanes, which made rustic Barbizon so attractive to the eyes of its painters. Had Pissarro bought a book on Fontainebleau which appeared that very year of 1855, he would have found in it, from the pen of Paul de Saint-Victor, one of the best known writers of the day, the unequivocal declaration: "We prefer the sacred grove where fauns make their way, to the forest in which woodcutters are working; the Greek spring in which nymphs are bathing, to the Flemish pond in which ducks are paddling; and the half-naked shepherd who, with his Vergilian crook, drives his rams and

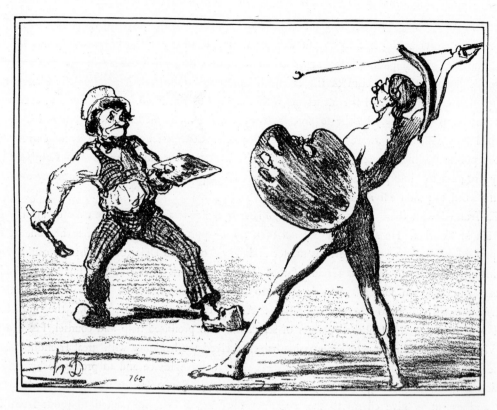

DAUMIER: *Battle of the Schools: Classic Idealism versus Realism. Caricature published in* Le Charivari, *1855.*

she-goats along the Georgic paths of Poussin, to the peasant, pipe in mouth, who climbs Ruysdael's side-road."[10] Such comment might have helped Pissarro understand why Millet was represented only by a single painting in the World's Fair exhibition, for, romantic as his subjects would seem, compared to those of Courbet, they showed a sentimental interest in rural life that was intolerable to so-called people of taste and refinement. "This," declared Count Nieuwerkerke, the Imperial Director of Fine Arts, "is the painting of democrats, of those who don't change their linen, who want to put themselves over on men of the world; this art displeases me and disgusts me."[11]

Since Pissarro was not disgusted by the works of Millet or Corot, it seems obvious that he could not have been much attracted by the *Ecole des Beaux-Arts,* supervised by the same Nieuwerkerke. He apparently worked in different studios, including that of Ingres' pupil Lehmann, but he did not stay long in any of them. Because he was in touch with various masters and their students, he probably soon became acquainted with all the written and unwritten laws of French art life, compliance with which was a decisive factor in the career he had chosen. For art was a career like any other, comparable especially to a military one, so strictly was it governed by rules which provided a step-by-step advancement, offering as ultimate rewards fame and wealth, social standing and influence. Murger's touching tales of Bohemian life describe only one aspect of the artist's existence in Paris, and although young Whistler, who had arrived in the city at about the same time as Pissarro, devoted himself with ardor to a kind of life

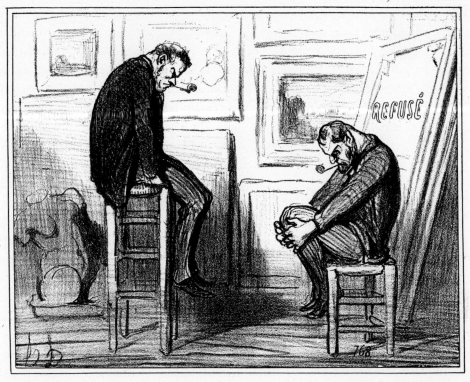

DAUMIER: *Caricature of artists whose works have been rejected by the jury of the World's Fair. Published in* Le Charivari, *1855.*

worthy of his favorite author, the so-called serious students knew that the path to glory led not so much through romantic garrets as through the bare studios of the *Ecole des Beaux-Arts.* There pupils were prepared in somewhat dry lectures and uninspiring courses to climb the ladder of perfection which leads from honorable mentions to medals, from the *Prix de Rome* to purchases by the state and finally from government commissions to election to the Academy of Fine Arts.

It was this Academy of Fine Arts, one of the sections of the *Institut de France,* which despotically governed the arts in France. From its members were chosen the teachers at the *Ecole des Beaux-Arts* and the directors of the French Academy in Rome, that is, those entrusted with the education of new generations. At the same time the Academy controlled the jury of admission and of reward at the biennial Salons and was thus given the power to exclude from these exhibitions every artist who did not comply with its requirements. Through its influence with the Director of Fine Arts, the Academy also took part in decisions upon the purchases of pictures for museums or for the Emperor's personal collection, as well as upon the award of commissions for mural decorations. In all these decisions the Academy naturally favored its most docile pupils, who in turn were favored by that public which sees in medals and prizes the proof of an artist's talent.

The artistic conceptions which guided the Academy in its policy were those put forward in David's teaching half a century before and transformed though not relaxed by his most famous pupil, Ingres. In

the year 1855, when Pissarro arrived in Paris, Ingres had been for thirty years a member of the Academy, and this strange and haughty man, who himself had suffered at the outset of his career from the rigidity of his master's principles, had now adopted an attitude in no way more tolerant. Unwilling to give a thought to the natural laws of development, unwilling to see in the past anything but the artists he admired, despising Rubens and hence Delacroix, Ingres had clung to his classic ideals without any consideration for or interest in the efforts of those who had chosen other roads, never asking himself whether his conceptions were still in accordance with the times. In a final discussion with his former master, Chassériau had been surprised to find that Ingres "has no comprehension of the ideas and the changes which have taken place in the arts in our day. He is completely ignorant of all the poets of recent times."[12]

DEGAS: *Ingres in the Attire of an Academician, from a sketchbook. Original size. Collection Marcel Guérin, Paris.*

Although his convictions in art matters were so strong as to give him the power of tyrannical leadership, Ingres had been a very inadequate teacher himself. His genius was able to find expression only in affirmations that excluded any reply, and his impatience and narrow-mindedness never admitted discussion.[13] His pupils, therefore, had been more anxious to imitate than to understand him. Even his followers admitted the shortcomings of his instruction; those who were not blinded by admiration openly accused him of utter failure. "It may be said," wrote Baudelaire, "that his teaching was despotic and that he has left an unfortunate mark upon French painting. A man full of stubbornness, endowed with highly special capacities, but determined to deny the utility of those capacities which he does not possess, has attached to himself the extraordinary, exceptional glory of extinguishing the sun."[14]

Rearing his pupils in what he thought to be the tradition of Raphael, Ingres had advised them to copy their models *stupidly* and not to forget that an object well drawn is always well enough painted. He never tired of proclaiming the superiority of line over color, a statement which led his followers to regard paintings merely as colored drawings, and to consider as "badly drawn" the landscapes of Corot or the compositions of Delacroix because in these every object was not carefully delineated by a minute contour. To Ingres' pupils correct drawing finally became an end in itself, and a "noble contour" was a sufficient excuse for lack of inspiration, dry execution and dull coloring. In the absence of any personal link with the classical ideals admired by their master, they simply blended the classical tradition with a cheap genre style. It was this mixture of empty craftsmanship with anecdotal platitude that, at the Salons, caused the delight of the picture-reading public. No response to nature, no observations of life guided these artists in their works. Only *after* the choice of subject had been made would they have models pose for the figures and indulge in scholarly research so as to be meticulously clear and "true" in

every detail. Yet, as Delacroix put it, their works did not contain that "dash of truth, the truth which comes from the soul."[15]

Ingres himself deplored this state of affairs and frankly admitted that "the Salon stifles and corrupts the feeling for the great, the beautiful; artists are driven to exhibit there by the attractions of profit, the desire to get themselves noticed at any price, by the supposed good fortune of an eccentric subject that is capable of producing an effect and leading to an advantageous sale. Thus the Salon is literally no more than a picture shop, a bazaar in which the tremendous number of objects is overwhelming and business rules instead of art."[16] In protest Ingres had not only abstained from exhibiting at the Salon but had also refused to participate in the duties of the jury. Yet he had failed to recognize that it was the exclusiveness of his own convictions and the rigid suppression of any individual tendencies that had equipped the new generation of painters with conceptions and means of such a uniformity that through their subjects alone could they hope to find a personal note. Since all the paintings at the Salons were conceived and executed according to the same rules, it was in fact the subject that distinguished a work from its neighbors; hence it was upon their subjects that the artists concentrated most. Nevertheless Courbet's friend Champfleury could speak of "the mediocre art of our exhibitions in which a universal cleverness of hand makes two thousand pictures look as if they have come from the same mould."[17]

Ingres' statement that the Salon was a "picture shop" was absolutely correct, so much so that many well-known artists did not bother to exhibit, because they no longer had to look for customers. But this fact in itself did not offend the dignity of art, because artists have to live from their works and because, as a natural consequence of the political and economic situation, the Salon had become the normal place for their trade. Since the beginning of the century France had known at least five different forms of government and as many monarchs. The inevitable rise and fall of favorites, which accompanied every change, had brought fortune and misfortune not only to artists, it had particularly affected the nobility, among whom art patrons were normally recruited. To make up for this loss, the artists had turned toward the rising bourgeoisie and had found it perfectly willing to take an interest in art and to buy paintings, all the more as the short existence of the various regimes and the uncertainties of the times were favorable to investment in small objects of assured value. It was precisely at the Salons that the artists could present themselves, achieve a reputation through the help of the press and reach this large public of new buyers. These buyers, however, lacked any art education and were satisfied with whatever flattered their eyes and hearts: pretty nudes, sentimental stories, religious subjects, heroic deeds, flowers which one could almost "smell," patriotic scenes and touching tales. It was natural that pure landscape was considered of an inferior category and that painters of historic events concentrated on their figures, leaving the landscape background to some professional master of hill and cloud. The critics themselves, in their reviews, put particular emphasis on the subject, describing pictures rather than judging them. Had not Théophile Gautier, one of the most influential critics of the day, once reproached an artist for having painted a swineherd with his pigs, whereas he could have given "much more importance to his composition" by portraying instead the *Prodigal Son Driving Swine?*[18]

It might have been perfectly within Ingres' power to fight against such misconceptions with regard to subject matter. But Ingres had not merely been sterile as a teacher, he was not a leader. Instead of allying himself with the healthy and progressive forces of romanticism against the rising pettiness, he had seen no other danger than that of romanticism itself. He could not forgive Delacroix for

abandoning the "perfect type of the human figure," for rejecting the systematic use of the nude, for denying the superiority of antique draperies, for distrusting academic recipes and for favoring individualism and liberty, not only of conception, but also of execution. He was horrified to see sentiment take the lead over reason and to witness Delacroix's participation in the political struggle, glorifying the barricade and the Greeks' fight for independence, while he, Ingres, kept his art pure by painting scenes from the past, portraits of the various monarchs and meticulous likenesses of his wealthy sitters. No wonder, then, that he failed to realize that his rival could have supplied at the *Ecole des Beaux-Arts* all the elements he himself lacked: imagination and vitality, passion for action and color, and a keen interest in all manifestations of life. Quite the contrary, Ingres and his followers concentrated their forces in an effort to eliminate Delacroix from any position in which he could exert some influence. There had even been a time when Delacroix was summoned by the Minister of Fine Arts, who gave him to understand that he would have to change his style or renounce the prospect of seeing his works acquired by the State.

Six times already Delacroix had presented his candidacy at the Academy, only to see the vacancy filled by some nonentity. If Ingres cannot be held responsible for the ostracism Delacroix had to suffer, he nevertheless had something to do with the policy of intolerance increasingly manifested by the Academy. Only once had he threatened to resign from this body, upon the occasion when a work by his favorite pupil, Jules Flandrin, had been rejected by the Salon jury; but never had he voiced any disapproval when Delacroix was barred. Relentlessly Ingres pursued the fight of classicism against romanticism, of line against color, which was to be for many years the chief topic wherever artists met. When Paul de Saint-Victor introduced his newly arrived cousin, John La Farge, at Chassériau's, the American student was startled at being questioned immediately, as if it were of first importance, about the position he held with regard to Ingres and Delacroix.[19] And those away from Paris were informed through newspaper caricatures and articles of "how hot the disputes of the Ingrists and Delacroix fanatics are."[20] Artists, collectors and critics were openly divided into two hostile camps, which the followers of both painters did their best to antagonize. "Ingres" and "Delacroix," wrote the Goncourt brothers, were the two *battle-cries of art.*[21]

Delacroix meanwhile confined himself to his work and left the propaganda for his ideals entirely to his friends and admirers among the writers and artists of the new generation with whom he had indeed little personal contact. John La Farge remarked with some surprise that the solitary master "was known to the younger men at a great distance. His studio was open to anyone who wished to call, if they were students. . . . Notwithstanding, we all felt a veil of something between us and him, and few of us had the courage to do more than occasionally present our respects."[22] Pissarro apparently did not have even this courage, although he was certainly not indifferent to Delacroix's art and must have felt, like so many others, its fertile forces as compared to the cold skill of his own teachers at the *Ecole des Beaux-Arts,* Lehmann, Picot and Dagnan. In the different studios in which Pissarro worked Ingres' spirit governed uncontested, in spite of the fact that his system began to be attacked more and more violently.

"How does one proceed when teaching drawing according to the classical method?" asked one of the antagonists of the *Ecole:* "One begins by showing the pupils silhouettes that are called outline drawings, and having them copy these mechanically. The eye . . . first of all begins by acquiring a bad habit, which is that of not taking account of planes, and of seeing in the object to be interpreted nothing but a flat surface surrounded by a contour. . . . Then, in what consists the teaching at the *Ecole des Beaux-Arts?* It confines itself to having the young people copy what are vulgarly called *academies,* that is, a male

20

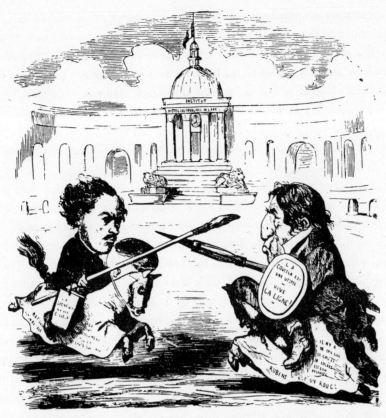

Caricature of Delacroix and Ingres dueling in front of the Institut de France. *Delacroix: "Line is Color!"—Ingres: "Color is Utopia. Long live Line!"*

nude, illuminated by ever the same light, in the same spot, and subject to a pose which may generally be considered torture at hourly rates."[23] Only after several years of such studies were students permitted to paint, and the historical subjects which they then had to deal with had nothing whatsoever to do with their own visual experiences, with real life. "They are taught the beautiful as one teaches algebra," said Delacroix with disdain.

Without any consideration for the natural inclinations of the individual pupil, the academic system was applied in an atmosphere of pressure that has been best analyzed by the architect Viollet-Le-Duc in an acid criticism of the instruction in the fine arts. Studying the problems of the artist-to-be, he thus described such a student's situation:

"A young man shows inclination for painting or sculpture. . . . This young man has usually to overcome first the distaste of his parents, who would rather see him enter the school for engineers or make a merchant's clerk of him. His powers are doubted, proofs of his abilities are desired. If his first efforts are not crowned by some sort of success, he is considered mistaken, or to be lazy; no more allowance. Thus it is necessary to pursue that kind of success. The young artist enters the *Ecole,* he gets medals . . . but at what price? Upon condition of keeping precisely and without any deviation within the limits

imposed by the corporation of professors, of following the beaten track submissively, of having only exactly the ideas permitted by the corporation and above all of not indicating the presumption of having any of his own. . . . We observe besides that the student body naturally includes more mediocrities than talented people, that the majority always aligns itself on the side of routine; there is no ridicule sufficient for the person who shows some inclination toward originality. How is it possible for a poor fellow, despised by his teachers, chaffed by his companions, threatened by his parents, if he does not follow the middle of the marked-out highway, to have enough strength, enough confidence in himself, enough courage to withstand this yoke—commonly adorned with the title 'classical teaching'—and to walk freely?"[24]

There were actually very few who had this courage. Some of them toiled for many years at the *Ecole* before they could free themselves, some avoided entering it, some stayed only a short while, as Pissarro himself did; but each of them had been confronted, at one moment or the other, with the alternative of heeding his parents' wishes or of going his own way without their help. It is true that there was, outside the *Ecole des Beaux-Arts,* a teacher who tried new methods. Lecoq de Boisbaudran's system was based on the development of pictorial memory, and his pupils were trained so to permeate themselves with what they saw that they would be able to reproduce it entirely from memory.[25] Their master even went so far as to have them observe dressed or undressed models moving freely in a forest or a field, in order to study natural attitudes. But not more than ten or twelve pupils followed his classes, among them Henri Fantin-Latour. The bulk of those who wanted an art career preferred for obvious reasons the *Ecole des Beaux-Arts,* where the studio of Thomas Couture was particularly popular, among Americans too, of whom there were quite a number.[26]

Couture, a rather self-satisfied and arrogant man, was jealous of his independence and allied himself neither with Delacroix nor with Ingres, being "very sure that he was the greatest painter living and that all others were mere daubers. . . ."[27] Yet his teachings were not far from Ingres' principles since they were based on a careful and, if possible, stylish or elegant outline drawing of the subject to which colors were added, each one in its exact place. His motto was *Ideal and Impersonality.* "He used to say," as one of his pupils remembered, "that he preferred a thin to a stout model, because you could study the structure, and could *add* as much as you liked; whereas, in the other case, the flesh hid everything from view, and you did not know how much to *take off.*"[27] To paint the models as they were would have been, in his eyes, to copy nature servilely. Couture's constant preoccupation with idealization did not prevent his admirers from admitting, in the words of the American painter, Ernest W. Longfellow, that "his faults were a certain dryness of execution . . . and a want of unity in his larger compositions, arising in part from his habit of studying each figure separately and in part from a lack of feeling for the just relation of values."[27]

John La Farge, who was for a short while among Couture's pupils, was annoyed not only by his theories but even more by his "constant running-down of other artists greater than himself. Delacroix and Rousseau were special objects of insult or depreciation."[28] Of Millet, too, Couture made all possible sport, ridiculing his pictures and drawing caricatures of his subjects, until one of his favorite students, the American, William Morris Hunt, left him for the peasant painter.[29] Subsequently Couture became even more satirical and bitter but ceased to refer to Millet. Soon, however, he found another object for attack in Courbet's realism and drew for the benefit of his pupils caricatures of a *realist* in whose studio

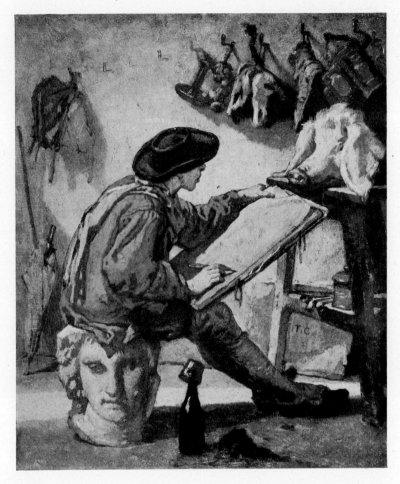

COUTURE: *The Realist, 1865. 18 x 14¾". Formerly Vanderbilt Collection, New York.*

Laocoön is replaced by a cabbage, a plaster cast of the Gladiator's feet by a candlestick base covered with tallow or by a shoe, and who copies a pig's head while sitting on the head of Olympian Jupiter. But, for Couture's students, romanticism and realism were far too serious to be dismissed in this way.

In spite of Couture's mockeries one of his pupils, Edouard Manet, went, accompanied by his friend Antonin Proust, to ask Delacroix for permission to copy his *Dante and Virgil* in the Luxembourg Museum, a permission which Delacroix granted, although he received the young man with such a polite coldness that Manet decided not to repeat his visit. Fantin-Latour, who had abandoned Lecoq de Boisbaudran for the *Ecole des Beaux-Arts,* decided to leave his classes after only a year, preferring to work in the Louvre. He had been deeply impressed with Courbet's exhibition and shared his enthusiasm with another student of the *Ecole,* James McNeill Whistler, a pupil of Gleyre, the least aggressive and most lenient among the teachers. In the *Pavillon du Réalisme* Fantin had also met, it seems, Edgar De Gas, who in spite of his admiration for Ingres had been greatly excited by the works of Courbet, as well as Delacroix. After obtaining his father's permission to abandon law and devote himself to art (signing his pictures *De Gas*

23

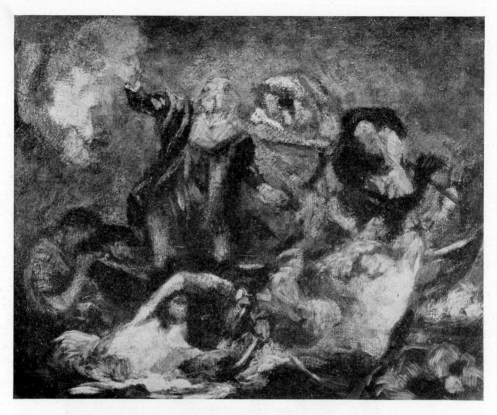

MANET: *Dante and Virgil, copy after Delacroix, c. 1854. 13 x 16⅛". Metropolitan Museum of Art, New York (H. O. Havemeyer Collection).*

until about 1870 when he changed to *Degas*), he had made fast friends with one of Delacroix's pupils, Evariste de Valernes, fourteen years older than himself. Although he entered the *Ecole des Beaux-Arts*— he did so in the very year of the World's Fair—Degas in fact worked there hardly at all, preferring the private studio of Louis Lamothe, one of Ingres' ablest pupils. Soon, however, he decided to go to Italy, the only place where he could really get acquainted with classic art as well as with the primitives who attracted him particularly. But before he left he had many long discussions with a friend of his parents, Prince Grégoire Soutzo, who not only taught him the technique of etching but also helped him to understand and interpret nature in a fashion not unlike Corot's.[30]

Although Degas had participated very little in Parisian art life, he was so disgusted with it that he put down in one of his Italian notebooks: "It seems to me that today, if one wants to engage seriously in art and make an original little niche for oneself, or at least to preserve for oneself the most unblemished of personalities, it is necessary to steep oneself again in solitude. There is too much going on; one might say that pictures are produced like stock exchange prices by the friction of people eager to gain; there is as much need, so to speak, of the mind and ideas of one's neighbor, in order to produce whatever it may be, as business men have need of other people's capital in order to profit in speculation. All this trading puts the spirit on edge and falsifies the judgment."[30]

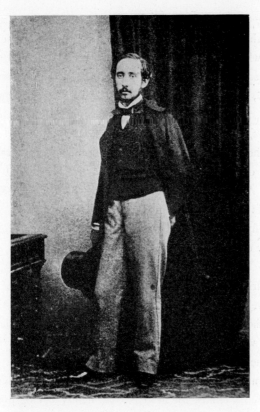

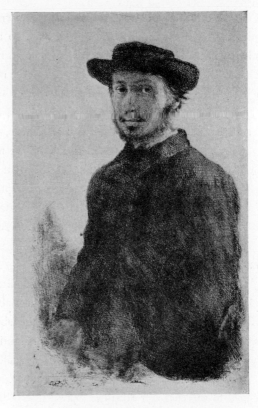

Photograph of Edgar Degas, c. 1857. From Manet's album of photographs.

DEGAS: *Self Portrait, 1855. Etching, 9 x 5⅝". National Gallery of Art, Washington, D. C. (L. Rosenwald Collection).*

After three years in Paris, Pissarro, too, was to feel the desire to steep himself again in solitude, but not before he had exhausted all that Paris could offer him. Indeed, there were, besides the *Ecole des Beaux-Arts,* many places where a student could teach himself. Although there did not then exist any art galleries with regularly changing exhibitions, there were a few shops in which pictures could be seen, among others that of Durand-Ruel, who handled the works of many of the Barbizon painters and who had established himself shortly after the World's Fair in new quarters in the rue de la Paix. There were the Louvre, of course, and the Luxembourg Museum, where contemporary art was sheltered, or at least what the Academy considered contemporary art. But almost more interesting to a young student eager to become acquainted with the burning art questions of the day were the cafés in which the different groups of artists met. The Café Taranne, for instance, where Fantin and his friends came together and where Flaubert occasionally appeared; the Café Fleurus, with panels decorated by Corot and others, which was favored by the pupils of Gleyre; the Café Tortoni on the boulevards, where the more fashionable painters held forth, and, more popular among the Bohemians, the Brasserie des Martyrs and the Andler Keller, where Courbet appeared frequently. The two smoke-filled rooms of the Andler Keller were always crowded with writers, poets, journalists as well as painters from all the different schools, the "realists" and the "fantasists," the "Ingrists" and the "colorists" as they were called, and it was not at all unusual

to see the followers of rivals, the pupils of Delacroix, Couture and Ingres, fraternize at their tables laden with beer. The discussions here centered not so much around the perennial struggle between classicism and romanticism as around the new issue of realism, which Courbet had so forcefully proclaimed in 1855. Fernand Desnoyers, a thin and loud poet, never missed an occasion to affirm his belief in the new style. In a challenging article, published at the end of 1855, he had hailed the breach which realism had made in the "brushwood, the battle of the Cimbri, the Pandemonium of Greek temples, of lyres and Jew's harps, of alhambras and tubercular oak-trees, of sonnets, odes, daggers and hamadryads in the moonlight."[31]

"Let's be a little ourselves, even though we might be ugly!" Desnoyers proclaimed enthusiastically. "Let's not write, not paint anything except what is, or at least what we see, what we know, what we have lived. Don't let us have any masters or pupils! A curious school it is, don't you think, where there is neither master nor pupil, and whose only principles are independence, sincerity, individualism." And quoting Courbet's friend Proudhon he added: " 'Any figure, whether beautiful or ugly, can fulfill the ends of art.' Realism, without being a defense of the ugly or the evil, has the right to show what exists and what one sees."[31]

Another young author and habitué of the Brasserie des Martyrs, Edmond Duranty, had founded in 1856 a short-lived review, *Réalisme,* to excoriate vehemently the literary romanticists. In an article devoted to painting he complained about the abundance of "Greek visions, Roman visions, medieval visions, visions of the 16th, 17th and 18th centuries, with the 19th century absolutely forbidden!" "The man of the antiquity created what he saw," he told the painters: "Create what you see!"[32]

Courbet himself apparently did not contribute much to the general discussions, for he was seldom inclined to speeches and doctrines, but was perfectly happy amidst the heated verbal fights, making drawings with the beer spilled on his table. When he spoke, he did so mainly about himself and had a tendency to repeat the same things over and over. If actually engaged in an argument, as once for instance with Couture, he was likely to raise his voice in the fire of the debate until the passers-by would stop in the street. At the Brasserie Courbet was surrounded by friends such as Baudelaire, Champfleury and de Banville, the critic Castagnary, the painters Amand Gautier and Bonvin. The smaller fry seldom actually approached him, all those "runners after imagery and chiselers of sentences, knights-errant of the pen and brush, seekers after the infinite, merchandisers of chimeras, contractors for towers of Babel,"[33] who were generally more productive in discussions than in works.

Among the habitués of these cafés was also a young medical student, Paul Gachet, who later finished his studies in Montpellier, where he met Courbet's friend, Bruyas, and who was never to give up the vivid interest in art with which the sessions at the brasseries had inspired him.

The noisy atmosphere of these cafés, where idols were created or demolished within a few minutes, where no title to glory was well enough earned to prevent insults, where logic was often replaced by vehemence and comprehension by enthusiasm—this atmosphere was in violent contrast to that of the official art circles. Here were life and a tremendous will to conquer, and even if many erred or exaggerated, there was in their fight against prejudice and tradition a positive element, the desire to prove the value of new beliefs through the quality of new works. Pissarro's often proclaimed opinion that the Louvre ought to be burned may well have had its root in these discussions where the heritage of the past was considered harmful for those who wanted to build a world of their own. (In one of his articles Duranty had almost openly advocated that fire be set to the palace.) The more the Academy claimed to embody

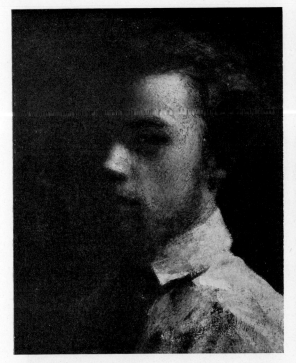

FANTIN-LATOUR: *Self Portrait, d. 1858. 16 x 12½".*
Philadelphia Museum of Art (Chester Dale loan).

WHISTLER: *Self Portrait, c. 1858. 18½ x 15¼". Freer*
Gallery of Art, Washington, D. C.

sacred traditions, the more these traditions became suspect at the Brasserie. But those able to grasp the new ideas and to apply them found more than the negation of the past and glorious dreams of the future; they found directions for their efforts as well as stimulating comradeship. And comradeship is invaluable, since courage and will power are not always enough in the tracing of new roads. To feel oneself in harmony with others, to be convinced of participation in a "movement" gives added strength. Around the tables of the cafés were born numerous friendships of which later Salon reviews bear ample proof. Many an artist's struggle for recognition may have been shortened by the praise which some critic, met at the Brasserie, printed in more or less obscure papers.

Zacharie Astruc, a writer and artist, one of those whose pen was to serve the new cause, summed up the situation when he wrote: "The new school is detaching itself little by little. It has to build upon ruins . . . but it builds with consciousness of a duty. Feeling has become greatly simplified and rarefied. It becomes studious, honest and wise. . . . Tradition is but a pale principle of teaching; romanticism, a soul without body. . . . The future therefore belongs entirely to the young generation. The latter loves truth and to it devotes all its fire."[34]

In the face of rising realism the Academy apparently convinced itself that it had nothing to fear any more from the old and ailing Delacroix. In 1857 he was finally elected *membre de l'Institut.* But to the embittered painter this honor, accorded after long hesitation and with no real conviction, had no longer the meaning it could have had. If this election had come earlier, he wrote to a friend, he might

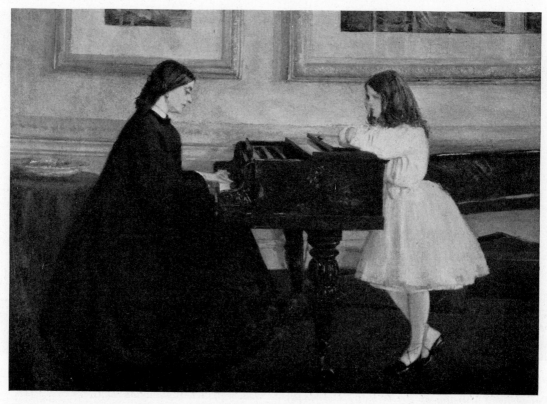

WHISTLER: *At the Piano, 1859. 26 x 36". Rejected at the Salon of 1859; exhibited in Bonvin's studio. Private collection, Cincinnati, Ohio.*

have become a professor at the *Ecole* and there he could have exerted some influence. However, as a member of the Academy, Delacroix also became a member of the Salon jury, and here at least he saw some possibility for fruitful action. "I flatter myself that I can be of use there, because I shall be nearly alone in my opinion," he stated with satisfaction but also with few illusions.[35]

Two years later Delacroix lived up to his intentions. When Edouard Manet, who in the meantime had left Couture's studio, first presented a painting to the Salon jury, Delacroix declared himself in favor of the work. But just as he had anticipated, his voice was not strong enough to prevent rejection; Couture, also a member of the jury, voted against his former pupil's work. Manet's friend, Fantin—they had met in 1857 while copying in the Louvre—did not fare better, nor did Whistler. The paintings of all three aroused the jury's anger, because, although rather somber, they were conceived as harmonies of masses modeled in color without the aid of lines; yet there was nothing really "revolutionary" in them. But the jury this time was particularly harsh, even rejecting a canvas by Millet.

Fantin and Whistler were fortunate enough to interest the good-hearted painter Bonvin in their fate, and Bonvin decided to show some of the refused works in his own studio, where all his friends would be able to judge the injustice of the jury which had rejected these paintings. Among Bonvin's friends was Courbet, who came and, according to Fantin's souvenirs, "was struck with Whistler's picture."[36] The

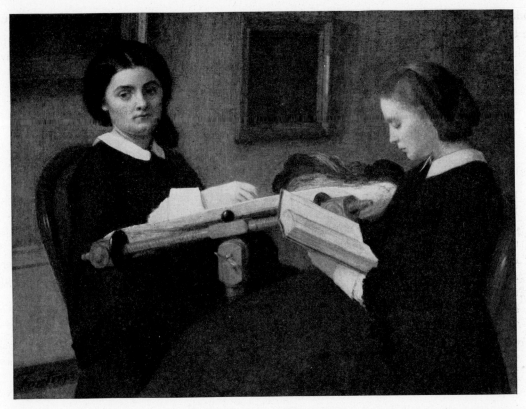

FANTIN–LATOUR: *The Artist's Sisters Embroidering, d. 1859. 39¼ x 52". Rejected at the Salon of 1859. City Art Museum, St. Louis.*

whole affair made a scandal; the exhibition at Bonvin's became famous, and the pictures impressed many artists besides Courbet. Thereafter both Whistler and Fantin could call on Courbet and ask for his advice. As for Manet, his first rejection was soon followed by another one: a portrait he had painted of a lady was refused by the family of the sitter, apparently because in it he had shown himself more interested in the opposition of lights and shadows, as well as in fluid brushstrokes, than in flattering his model.

Only Pissarro was successful with the jury. Having spent the summer of the previous year near Paris at Montmorency, where he could work in the open, he had sent a landscape of that locality to the Salon of 1859. It was accepted. Since beginners customarily indicated the name of their teacher, the Salon catalogue lists Pissarro as *pupil of Antoine Melbye*. The picture must have hung quite inconspicuously; at least it did not attract the attention of any critic, and if Zacharie Astruc mentioned it in his review, he did so to please a comrade rather than because he was convinced of its qualities. He said merely that it was well painted and almost omitted Pissarro's name.[37] Nevertheless Pissarro could proudly inform his parents that within four years after his arrival in France one of his paintings was being shown at the Salon. At the same time this "success" probably gave the timid artist the courage to return to Corot and ask for an opinion concerning the road he should follow.

Among the visitors of the Salon of 1859 was an enthusiastic young man who eagerly studied the

29

works of all the famous painters whose names he had heard so often pronounced by his friend Boudin. He too, presumably, paid little attention to Pissarro's modest canvas nor did he know of Bonvin's small "exhibition of the rejected." His name was Monet and he had just arrived from Le Havre to study art in Paris.

NOTES

1. Rapport de S. A. I. le Prince Napoléon, président de la Commission impériale; see Salon de 1857, official catalogue, p. xxx-xxxvi. Speeches made at the distribution of awards, etc., are always reproduced in the catalogue of the next Salon.

2. *Illustrated London News,* June 9, 1855. For plans of the World's Fair and of the Palais des Beaux-Arts, see *Magazine Pittoresque,* 1855, p. 210 and 215.

3. There are several versions concerning the way in which Degas met Ingres. The artist himself gave two different accounts to Paul Valéry; see Valéry: Degas, Danse, Dessin, Paris, 1938, p. 59-62. (See also E. Moreau–Nélaton: Deux heures avec Degas, *L'Amour de l'Art,* July 1931; P. A. Lemoisne: Degas, Paris, n. d. [1912], p. 7; P. Lafond: Degas, Paris, 1919, v. I, p. 31-32; P. Jamot: Degas, Paris, 1924, p. 23). The version here given is based on information provided by Valéry and Moreau–Nélaton. The advice given by Ingres is quoted after Valéry, *op. cit.,* p. 61, and M. Denis: Théories, Paris, 1912, p. 94, where Degas is identified simply by his initial.

4. C. Baudelaire: Exposition universelle de 1855, ch. II; repr. *in:* L'art romantique. Baudelaire's various writings on art have been assembled by him in two volumes: L'art romantique and Curiosités esthétiques, of which there exist different editions. See Oeuvres complètes, v. IV and V, Paris, 1923 and 1925; C. Baudelaire: Oeuvres, Paris, 1932 (Bibl. de la Pléiade) v. 2; also C. Baudelaire: Variétés critiques, 2 v. edited by E. Faure, Paris, 1924. Mr. Meyer Schapiro is now preparing an English translation of Baudelaire's writings on art.
On the World's Fair see also E. and J. de Goncourt: Etudes d'art, Paris, 1893, and T. Gautier: Les Beaux-Arts en Europe–1855, Paris, 1856, 2 v.

5. Delacroix, Journal, Aug. 3, 1855; see The Journal of Eugène Delacroix, New York, 1937, p. 479-480.

6. Courbet to Bruyas, spring, 1855; see P. Borel: Le roman de Gustave Courbet, Paris, 1922, p. 74.

7. Courbet: Le Réalisme; see G. Riat: Gustave Courbet, Paris, 1906, p. 132-133.

8. Corot, notes from a sketchbook; see E. Moreau-Nélaton: Corot raconté par lui-même, Paris, 1924, v. I, p. 126.

9. F. de Lasteyrie: Review of the Salon of 1864, *Fine Arts Quarterly Review,* Jan. 1865.

10. P. de Saint-Victor *in* Hommage à C. F. Dennecourt—Fontainebleau, paysages, légendes, souvenirs, fantaisie, edited by F. Desnoyers, Paris, 1855.

11. See M. de Fels: La vie de Claude Monet, Paris, 1929, p. 59.

12. Chassériau to his brother, Sept. 9, 1840; see L. Bénédite: Théodore Chassériau, sa vie et son oeuvre, Paris, 1931, v. I, p. 138.

13. See Amaury-Duval: L'atelier d'Ingres, edited by E. Faure, Paris, 1924, especially p. 88-90; also M. Denis: Les élèves d'Ingres *in* Théories, Paris, 1912.

14. C. Baudelaire: Salon de 1859, ch. VII; repr. *in* L'art romantique.

15. Delacroix, Journal, June 17, 1855; *op. cit.,* p. 468.

16. Ingres, quoted by E. Faure *in* Amaury-Duval, *op. cit.,* p. 211.

17. J. Champfleury: Histoire de l'imagerie populaire, Paris, 1869, p. xii.

18. T. Gautier: Salon de 1837, *La Presse,* March 8, 1837.

19. See R. Cortissoz: John La Farge, New York, 1911, p. 85. John La Farge met Chassériau in 1856.

20. J. Breton: Nos peintres du siècle, Paris, 189[?], p. 48.

21. E. and J. de Goncourt: Manette Salomon, Paris, 1866, ch. III.

22. J. La Farge: The Higher Life in Art, New York, 1908, p. 14.

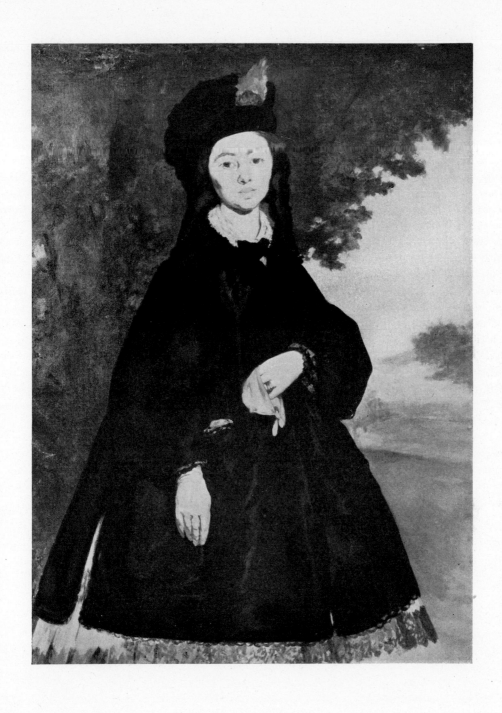

MANET: *Portrait of Mme Brunet, 1860. 52 x 39¼". Refused by the family of the sitter.*
Collection Mrs. C. S. Payson, New York.

23. E. Viollet-le-Duc: Réponse à M. Vitet à propos de l'enseignement des arts et du dessin, Paris, 1864; partly repr. *in* P. Burty: Maîtres et petits maîtres, Paris, 1877, p. 7-8.

24. E. Viollet-le-Duc: L'enseignement des arts, *Gazette des Beaux-Arts,* June, 1862 (series of four articles: May, June, July, Sept., 1862).

25. On Lecoq de Boisbaudran see Viollet-le-Duc, *op. cit.,* Burty, *op. cit.,* also A. Jullien: Fantin-Latour, sa vie et ses amitiés, Paris, 1909, and the book by Lecoq de Boisbaudran: Education de la mémoire pittoresque, 2nd ed., Paris, 1862 (Engl. transl.: The Training of the Memory in Art, London, 1911).

26. On Couture see his: Méthodes et entretiens d'atelier, Paris, 1867; Paysage, causeries de l'atelier, Paris, 1869; as well as: Thomas Couture, sa vie, son oeuvre, son caractère, ses idées, sa méthode, par lui-même et par son petit-fils, Paris, 1932. Also E. W. Longfellow: Reminiscences of Thomas Couture, *Atlantic Monthly,* August, 1883; H. T. Tuckerman: Book of the Artists, American Artist Life, New York, 1867, v. II, p. 447-448 [the name is misspelled: Coiture] and Cortissoz, *op. cit.* On Manet at Couture's studio see A. Proust: Edouard Manet, Souvenirs, Paris, 1913, p. 17-23 and p. 27-35.

27. Longfellow, *op. cit.*

28. Cortissoz, *op. cit.,* p. 96.

29. See H. M. Knowlton: Art-Life of William Morris Hunt, Boston, 1899, p. 8 and 11.

30. Degas, notes; see P. A. Lemoisne: Les carnets de Degas au Cabinet des Estampes, *Gazette des Beaux-Arts,* April 1921.

31. F. Desnoyers: Du Réalisme, *L'Artiste,* Dec. 9, 1855.

32. E. Duranty: Notes sur l'art, *Réalisme,* July 10, 1856.

33. F. Maillard: Les derniers bohèmes, Paris, 1874, quoted by G. Geffroy: Claude Monet, sa vie, son oeuvre, Paris, 1924, ch. III. On the brasseries see also A. Schanne: Souvenirs de Chaunard, Paris, 1887, ch. XLI; P. Audebrand: Derniers jours de la bohème, Paris, n. d., p. 77-233; J. Champfleury: Souvenirs et portraits de jeunesse, Paris, 1872, ch. XXVII; A. Delvau: Histoire anecdotique des Cafés et Cabarets de Paris, Paris, 1862; J. Grand-Carteret: Raphaël et Gambrinus ou l'art dans la Brasserie, Paris, 1886; T. Silvestre: Histoire des artistes vivants, Paris, 1856, p. 244; as well as the monographs on Courbet by G. Riat, T. Duret, H. d'Ideville *et al.* See also: Courbet and the Naturalist Movement, edited by G. Boas, Baltimore, 1938.

34. Z. Astruc: Le Salon intime, Paris, 1860, p. 108.

35. Delacroix to Pérignon, Jan. 21, 1857; see Correspondance générale de Eugène Delacroix, publiée par A. Joubin, Paris, 1937, v. III, p. 369.

36. See E. R. and J. Pennell: The Life of James McNeill Whistler, London, 1908, v. I, p. 75.

37. See Z. Astruc: Les 14 stations au Salon, Paris, 1859; Pissarro's name is given in the index but not with the description of his painting, p. 370.

1859 - 1861

MONET AND BOUDIN

MANET AND DEGAS

L'ACADEMIE SUISSE

THE ATELIER OF COURBET

Though born in Paris, Claude Oscar Monet—his parents called him Oscar—had passed his youth in Le Havre, where his father owned a grocery store, together with a brother-in-law, Lecadre. Monet's youth had been essentially that of a vagabond, as he himself later remarked;[1] it had been spent more on the cliffs and in the water than in the classroom. He was undisciplined by nature, and school always seemed to him a prison. He diverted himself by decorating the blue paper of his copybooks and using it for sketches of his teachers, done in a very irreverent and disfiguring manner. He soon acquired a great deal of skill at this game. At fifteen he was known all over Le Havre as a caricaturist.[2] His reputation was so well established that he was sought after from all sides and asked to make caricature-portraits. The abundance of these orders, and the insufficiency of the subsidies derived from maternal generosity, inspired him with a bold resolve which scandalized his family: he took money for the portraits . . . 20 francs.

Having gained a certain reputation by these means, Monet was soon "an important personage in the town." In the shop window of the sole frame-maker his caricatures were arrogantly displayed, five or six in a row, and when he saw the loungers crowding in admiration and heard them exclaiming: "That is so and so!" he "nearly choked with vanity and self-satisfaction." Still, there was a shadow in all this glory. Often in the same shop window, hung above his own productions, he beheld marines, which he, like most of his fellow citizens, thought "disgusting."

33

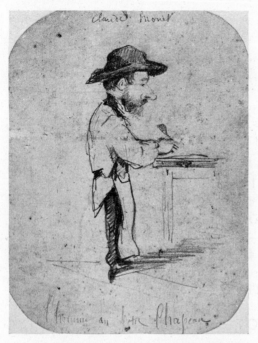

MONET: L'homme au petit chapeau, *1856-58.*
Drawing 7¾ x 5⅞". Art Institute, Chicago
(Gift of C. H. Harrison).

MONET: *Rufus Croutinelli, 1856-58.*
Drawing 5⅛ x 3⅜". Art Institute,
Chicago (Gift of C. H. Harrison).

The author of these marines that inspired Monet "with an intense aversion" was Eugène Boudin, and without knowing the man Monet hated him. He refused to make his acquaintance by way of the frame-maker, until one day he entered the shop without having noticed Boudin's presence at the rear. The frame-maker grasped the opportunity and presented Monet as the young man who had so much talent for caricature.

"Boudin, without hesitation, came up to me," Monet remembered, "complimented me in his gentle voice and said: 'I always look at your sketches with pleasure; they are amusing, clever, bright. You are gifted; one can see that at a glance. But I hope you are not going to stop there. It is all very well for a beginning, but soon you will have had enough of caricaturing. Study, learn to see and to paint, draw, make landscapes. The sea and the sky, the animals, the people and the trees are so beautiful, just as nature has made them, with their character, their genuineness, in the light, in the air, just as they are.'

"But," according to Monet himself, "the exhortations of Boudin had no effect. The man, after all, was pleasing to me. He was earnest, sincere, I felt it; yet I could not digest his paintings, and when he offered to take me with him to sketch in the fields, I always found a pretext to decline politely. Summer came—my time was my own—I could make no valid excuse; weary of resisting, I gave in at last, and Boudin, with untiring kindness, undertook my education. My eyes were finally opened and I really understood nature; I learned at the same time to love it."

Young Oscar Monet, then seventeen years old, could not have found a better teacher, for Boudin was

Monet: *Caricature of the Artist's Teacher, M. Orchard, 1856-58. Drawing, 12⅝ x 9¾". Art Institute, Chicago (Gift of C. H. Harrison).*

Monet: *Caricature of a Lawyer, 1856-58. Drawing, 24⅛ x 17⅞". Art Institute, Chicago (Gift of C. H. Harrison).*

neither doctrinaire nor theorist; all that he knew he had learned with his eyes and his heart, trusting them with genuine naiveté. A simple man with a humble devotion to nature and to art, he was well aware of his own limitations, having no other aspiration than to express himself with the conscientiousness of an artisan. It was Boudin who, fourteen years earlier (in 1844, when he himself was twenty years old) had opened the stationery and framing shop where he later met Monet. There he had framed and even sold the works of the numerous artists who used to spend their summers at the coast. Among his clients were Couture, and Troyon, author of innumerable pleasant landscapes crowded with sheep and cows, and Boudin himself began to paint in Troyon's manner. When, around 1845, Millet arrived in Le Havre, still unknown and obliged to earn his living by doing portraits of wealthy citizens for 30 francs apiece, he too bought his supplies at Boudin's. One day the painter-shopowner brought out his own studies, which Millet corrected. From that moment Boudin lost interest in his business and decided to become an artist, although Millet did not fail to stress all the difficulties and the poverty that might be expected from such a decision. Boudin left the shop to his associate and went to Paris, where he made copies in the Louvre. In 1850 two pictures of his were bought by the "Society of Art Friends of Le Havre," and the next year, sponsored by his former clients Troyon and Couture, he obtained from the city a three-year fellowship destined to enable him to live in Paris and study seriously. But at the end of those years, which he had mostly spent far from the classes of the *Ecole des Beaux-Arts*, Boudin had not made the progress his bene-factors had expected. Instead of doing pleasant genre pictures he had turned to studies painted directly in

the open, and all he brought back from Paris was the conviction that "the romantics have had their day. Henceforth we must seek the simple beauties of nature . . . nature truly seen in all its variety, its freshness."[3]

This conviction Boudin now wished to communicate to his young pupil, and under his influence Monet was not long in sharing it, for he not only watched Boudin at work but also profited by the other man's conversation. Boudin had both a sensitive eye and a clear mind, knowing how to put his observations and experience into simple words. "Everything that is painted directly on the spot," he stated, for instance, "has always a strength, a power, a vividness of touch that one doesn't find again in the studio." He was also in favor of "showing extreme stubbornness in retaining one's first impression, which is the good one," while insisting that "it is not one part which should strike one in a picture but indeed the whole."[4]

Boudin was too modest a man, however, to think that his lessons would be enough to put Monet on the right track. He used to say that "one never arrives alone, unless with very powerful propensities, and yet, and yet . . . one does not invent an art all by oneself, in an out-of-the-way spot, without criticism, without means of comparison. . . ."[5] After six months of such admonition, and in spite of his mother, who had begun to worry seriously on account of the company her son was keeping, believing him lost in the society of a man in such bad repute as Boudin, Monet announced to his father that he wished to become a painter and that he was going to settle down in Paris to learn. Monet's father was not exactly opposed to the idea, especially since Oscar's aunt in Le Havre, Madame Lecadre, did some painting in her leisure time and was willing to let her nephew work in her attic studio (where he discovered a small painting by Daubigny, which he admired so much that his aunt gave it to him). Although understanding and possibly even proud of his talents, Monet's family was partly unwilling, partly unable to help him financially, and in March 1859 his father wrote to the Municipal Council, hoping that it would do for his son what it had done once for Boudin:

"I have the honor to state to you that my son Oscar Monet, aged eighteen years, having worked with MM. Orchard [Monet's art teacher at school, a former pupil of David], Vasseur and Boudin, wishes to become a candidate for the title of pensioner of Fine Arts of the city of Le Havre. His natural inclinations and his taste, which he definitely fixed upon painting, oblige me not to turn him away from his vocation, but since I have not the necessary means to send him to Paris to attend the courses of the important masters, I hereby beg you to be so kind as to accept favorably my son's candidacy. . . ."[6] Two months later the Municipal Council examined this request, as well as the still life that had been submitted at the same time, and rejected it, fearing that Monet's "natural inclinations" for caricature might "keep the young artist outside the more serious, but less rewarding, studies which alone deserve municipal generosity."[7]

Without even waiting for this answer, Monet's father gave permission for a short trip to Paris so that his son might ask advice of some artists and see the Salon, which was to close in June. Fortunately Monet was in a position to get along without aid, at least for a while, since he had made it a practice to entrust his earnings from his caricature-portraits to his aunt Lecadre, keeping only small sums for pocket money. Before leaving he obtained from several picture lovers who looked out for Boudin, and possibly also from Boudin himself, some letters of introduction to different more or less well-known painters. He departed from Le Havre in light spirits.

Shortly after his arrival in Paris in May, 1859, Monet sent his first report to Boudin: "I haven't

Monet: *Still Life, c. 1859. 15⅜ x 23¼". Possibly the painting submitted to the Municipal Council of Le Havre. Present owner unknown.*

yet been able to go more than once to the Salon. The Troyons are superb, the Daubignys are for me something truly beautiful. There are some nice Corots. . . . I have paid visits to several painters. I began with Amand Gautier who is counting on seeing you in Paris in the near future. That is everyone's opinion. Don't stay, letting yourself become discouraged in that cotton town.—I have been to see Troyon. This is what he advised me to do: I showed him two of my still lifes: on that score he told me: 'Well, my good fellow, you'll have color, all right; it's correct in the general effect; but you must do some serious studying, for this is very nice, but you do it too easily; you'll never lose that. If you want to heed my advice and be serious about art, begin by entering a studio where they do nothing but the figure, learn to draw; that's what you'll find almost everyone lacks today. Listen to me and you will see that I'm not wrong; but draw with all your might; one never knows too much about it. Don't neglect painting, however; from time to time go to the country to make sketches, carry them through. Make some copies in the Louvre. Come to see me often; show me what you do, and, with courage, you'll get there.' "

And Monet added: "My parents have decided to let me stay a month or two, in accordance with Troyon's advice, who urges me to draw hard. 'In this way,' he told me, 'you'll acquire abilities, you'll go to Le Havre and you'll be able to do good sketches in the country, and in the winter you'll come back to settle here definitely.' This has been approved by my parents."[8]

Monet's second letter to Boudin was not written until two weeks later and he excused himself because "work, and this overwhelming Paris, make me forget a little the duties of a friend." But he does now give a detailed account of the Salon, which he has revisited several times. He admires Troyon's huge canvases of animals, yet thinks they are a little bit too black in the shadows; he likes Rousseau's landscapes but is severe toward a painting by Monginot (a pupil of Couture and comrade of Manet) whom Boudin had advised him to see; Hamon, a favorite of the crowd, displeases him because he has no "idea of nature"; Delacroix, in his opinion, has done better things than those exhibited, but he finds in them "animation, movement"; he is again enthusiastic about Daubigny's paintings and considers Corot's canvases "out-and-out marvels." He is happy to state that "marine paintings are completely missing" and thinks that this is for Boudin "a road that should take you far." He has also been to see Monginot, who has received him with great kindness—"he's a charming fellow. He is young. He showed me a little seascape of yours. He does very beautiful things. He has put his studio at my disposal and I shall take advantage of it from time to time."[9]

Monet questioned Troyon and Monginot about the classes they would recommend; both pronounced themselves for Couture, but Monet decided not to heed their advice, because he disliked Couture's work and apparently also because he felt a bit apprehensive about losing freedom of action. Paris was too new and too exciting an adventure for him to give it up in favor of regular courses at the *Ecole des Beaux-Arts*. Instead, Monet attended the "sessions" at the Brasserie des Martyrs, where he found what he had missed in Le Havre, stimulating company and vivid discussions. But he did not see Courbet, who had left for Le Havre.

While Courbet was strolling in Le Havre with his friend Schanne, he saw in the lone frame-shop some small seascapes which immediately interested him; he asked for the name and address of the painter. Boudin was of course enchanted by the visit Courbet paid him and volunteered to guide the two friends through Le Havre and its outskirts, especially leading them to the modest inn of *mère* Toutain at the Ferme Saint-Siméon, whence they could admire the vast panorama of the Seine estuary. One morning while the three painters were walking along the harbor, they met Baudelaire and spent the day with him.[10] Courbet did not fail to mention his admiration for Boudin's paintings, particularly for the skies, and Baudelaire not only went to see them in Boudin's humble abode, he immediately made a last-minute insertion in his review of the Salon of 1859, devoting a page full of praise and poetic interpretation to Boudin's pastel sketches.[11] But even more important for Boudin than these eulogistic lines were his talks with Courbet; Boudin jotted down in his notebook: "Courbet has already freed me somewhat of timidity, I shall try some broad paintings, things on a big scale and more particular in tone. . . . He has a broad principle that one may appropriate, but it nevertheless seems to me rather coarse, rather careless as to detail. . . ."[12]

Monet was doubtless informed of these important events and he in turn kept his friend informed of all the news of the Paris art world and of his own work in particular the more since he was eager to have Boudin join him and to ask him "advice about my work." After his first two months, Monet had decided to remain indefinitely in Paris. This might have been all right, as far as his parents were concerned, had he not refused to enter the *Ecole des Beaux-Arts*. His father cut his allowance, and Monet had to live on his savings, which were forwarded by his aunt. At the Brasserie des Martyrs he now sometimes saw Courbet but never had an opportunity to speak to him. Courbet's friend Champfleury had just

BOUDIN: *Cloud Study, c. 1859 [?]. Pastel, 7⅜ x 11¼". Present owner unknown.*

published a short novel, *Les amis de la nature,* which doubtless was the center of the many discussions in the midst of which Monet found himself. In this novel Champfleury gently ridiculed all those poets and painters, *lovers of nature,* who spent their days and their nights in the smoke-filled Brasserie, debating the problems of their art. He had even gone further and more or less attacked Courbet and his philosopher friend Proudhon by a malicious assault upon their theories about subject matter in art and its social meaning. Shortly afterward Champfleury was to break with Courbet.

In his novel Champfleury described a session of the Salon jury in which a painting of a Chester cheese by an English artist had just been accepted; next was submitted a canvas by a Flemish painter portraying a Dutch cheese. This had hardly been admitted when there arrived a third painting, this time of a French Brie by a Parisian artist, represented with such fidelity that the jury members automatically held their noses. They now had enough of cheese and rejected the last painting. The grief of the French artist was described as particularly intense because he considered the works of his rivals to be executed without any *realism* (Champfleury must have used this word intentionally). But a philosopher friend of the Frenchman then explains the deeper reasons for the rejection:

"In France, painting with ideas is not liked. . . . There is an idea in your picture, that is what got you excluded. The members of the jury accepted the Chester and the Dutch cheese because they don't contain anything subversive; but they judged your Brie to be a demagogic picture. . . . The *idea* must have shocked them. It is a poor man's cheese; the knife with its horn handle and worn blade is a

proletarian's knife. It was noted that you have a fierce liking for the utensils of poor people: you are judged demagogic, and you are. You are an anarchist without knowing it."[13]

This mockery reflects well enough the subjects of discussion at the Brasserie, for Courbet had antagonized his opponents not only through the conception and execution of his works, but also through his new approach to the question of subject matter. In his reaction against classicism and romanticism Courbet had found in the representation of everyday life new pictorial and political possibilities. Ingres, with his willful ignorance of the trivial aspects of life, which led his followers toward pettiness, and Delacroix, with his tendency to emphasize emotional values that opened a dangerous trend toward melodrama, had both neglected to see the plain people around them. Even when Delacroix had derived inspiration from the revolution of 1830, he had represented, in his painting of the *Barricade,* less the actual fighters than the spirit of the event and the symbol of liberty, the allegorical woman carrying the Tricolor into the street battle. And the title was actually not *Barricade* but *Liberty leading the People.* Courbet, except for his *Studio* canvas, which was intended as the first of a series but was never followed by other compositions of its kind, had avoided any allegories and devoted himself to the observation of his contemporaries, preferably of the lower classes. In doing so he had by no means rejected subject as such but had striven to give it a new meaning. Abetted, if not really urged on, by his philosopher friend Proudhon, Courbet saw in the peasants he painted not simply a medium for pictorial realization—as did Millet, who cared little for his peasant models—but considered his paintings social commentaries. So insistent were his arguments that he apparently even succeeded for a while in making his unpolitical and gentle friend Boudin look upon his own paintings from the same point of view. Questioned about his subject preferences, Boudin defended his exclusive interest in people observed on the beaches with words that might have come directly from Courbet's mouth:

"The peasants have their painters. . . ." Boudin wrote to a friend, "that is fine, but, between ourselves, those middle-class people who are strolling on the jetty at the hour of the sunset, have they no right to be fixed upon canvas, to be brought to our attention? Between us, they are often resting from strenuous work, these people who leave their offices and cubbyholes. If there are a few parasites among them, are there not also people who have fulfilled their task? Here is a serious, irrefutable argument."[14]

Monet, however, seems not to have cared at all whether anybody had the *right* to be depicted on canvas. He thoroughly despised the citizens of his home town Le Havre, parasites or not, and was interested only in what captivated his eye, an approach in which Boudin himself had encouraged him. Monet never gave a thought to the moral considerations with which Courbet adorned his works. It therefore seems doubtful whether he took an active part in the discussions at the Brasserie in which the value and interest of subjects were weighed according to their social implications. For the moment, anyhow, he had surrounded himself with friends who were all exclusively landscapists. If there was anything of interest for him in Champfleury's book, it might have been this statement, contributed by Duranty in his introduction: "Minds imbued with correctness are resigned to sacrificing the new and the original to their beloved correctness; they buy it thus, and it is somewhat expensive. In the same way, others pay the price of certain lapses from correctness for the invaluable discoveries which they make in the fields of newness, delicacy, sensibility and originality, and this is assuredly cheaper."[15] Wasn't this exactly Monet's case, for he had discarded the "correctness" of Couture's teaching so as to be ready for some "invaluable discoveries."

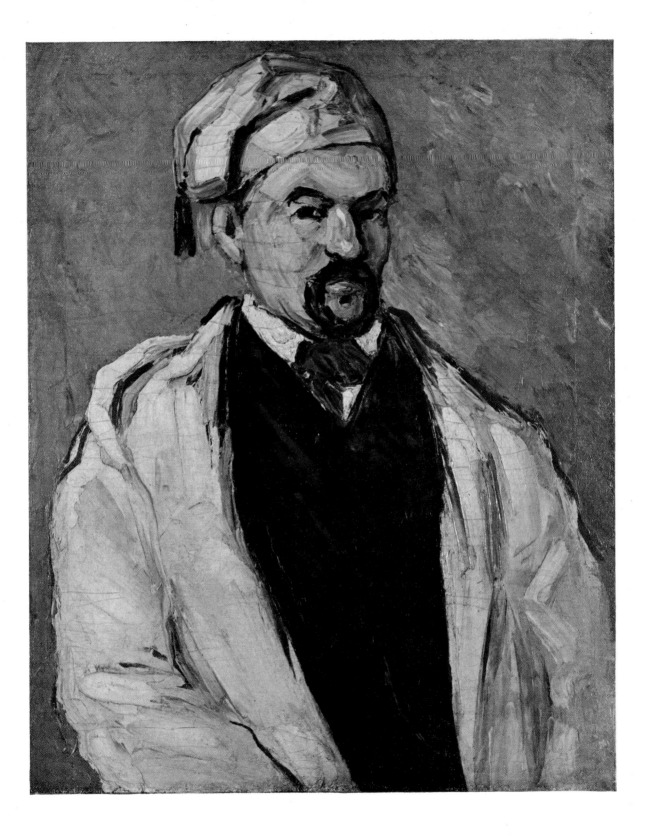

CÉZANNE: Man in a Blue Cap (Uncle Dominic). 1865-66. 31⅜″ x 25¼″. The Museum of Modern Art. The Lillie P. Bliss Collection.

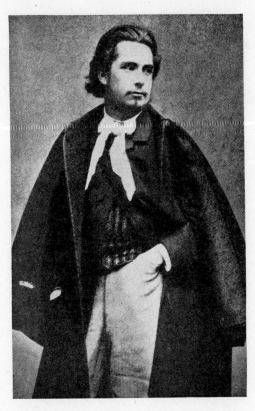

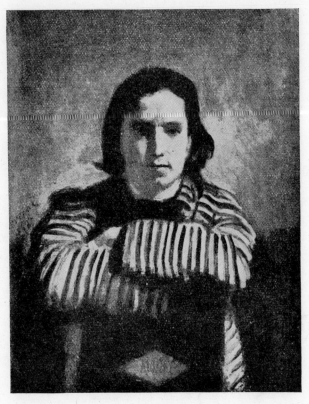

Photograph of Claude Monet at the age of eighteen (1858).

DÉODAT DE SÉVERAC: *Portrait of Claude Monet, 1858. Collection Michel Monet, Giverny.*

As a matter of fact, Monet had made some progress since arriving in Paris. At the studio where he worked occasionally he had made friends with other young artists. As a result of their exchange of ideas and of his own new experiences, his taste had become firmer and his appreciation more discriminating. He had an opportunity to exercise these faculties when, at the beginning of 1860, a large exhibition of modern paintings, lent by private collectors and organized without the Academy's interference, was opened on the boulevard des Italiens. This exhibition offered a startling contrast to the Salon of the preceding year, in which a "stale harmony, obtained by the sacrifice of all virgin colors and of all vigour" had reigned. As Théophile Gautier put it: "What is striking, upon observing these walls, is the strength, the brilliance, the intensity of color. . . ."[16] Monet had exactly the same impression—he had never seen anything but the 1859 Salon—and he exclaimed with joy that this new show proved "that we are not so far gone in decadence as it is said."[17] In a long letter to Boudin he shows himself enthralled by the eighteen canvases by Delacroix, by the landscapes of the Barbizon painters, by Courbet's and Corot's works, by Millet's *La Mort et le Bûcheron,* which had been refused by the Salon jury the year before. But Monet does not even mention Ingres or Meissonier and relaxes in his admiration for Troyon, since the latter's works could not be compared with those of the others. As for Couture, he considers his paintings outright bad, as well as those of Rosa Bonheur, then at the height of her vogue. Monet also informs his friend that "the only seascape painter we have, Jongkind, is dead to art; he is completely mad. The artists are

COROT: *Le Martinet near Montpellier, d. 1836. Drawing, 13¼ x 19¾". This drawing was given by the artist to Pissarro. Metropolitan Museum of Art, New York.*

taking a subscription to cover his needs." And he adds naively: "There is a nice seat for you to take."[17]

In his letter to Boudin, Monet gives some details concerning his own work: "I am surrounded by a small group of young landscape painters who will be very happy to get to know you. Besides, they are real painters. . . . I find myself very well fixed here: I am drawing figures hard; that's a fine thing. And at the Academy, there are only landscapists. They begin to perceive that it's a good thing."[17]

The "Academy" that Monet mentions in his letter was not a real Academy but an establishment opened by a former model, where artists could for a small fee work from the living model without any examinations or tuition, and where many landscape painters came to study human anatomy. From the name of its owner, it was called the *Académie Suisse*. It was located on the quai des Orfèvres, near the Pont Saint-Michel, in an old and sordid building where a well-known dentist pulled teeth at one franc apiece. Courbet once had worked there, Manet had come there to draw freely while still a pupil of Couture, and Pissarro occasionally dropped in when he was in town, in order to work from the nude or simply to meet some friends. There Monet soon became acquainted with him, and it is possible that Pissarro was one of the two companions with whom he went to paint some landscapes at Champigny-sur-Marne, near Paris, in April, 1860. According to Monet's recollections Pissarro was then "tranquilly working in Corot's style. The model was excellent; I followed his example."[18] In a drawing of a

PISSARRO: *Rue St. Vincent at Montmartre, d. 1860. Drawing, 5⅞ x 8¾". Private collection, New York.*

street in Montmartre which Pissarro did that very year he was already combining Corot's poetic charm with a forceful opposition of light and dark masses that reflects his connection with Courbet. Corot had given him one of his own drawings, not one of his later sketches with trees and planes summarily indicated, but an earlier study, full of patient detail, possibly to attract Pissarro to a less bold approach to nature.

Monet's work in the company of Pissarro cannot have lasted long, because his conscription term had arrived. He looked forward to it without fear, and so did his parents, who had not forgiven him his flight and had allowed him to live as he chose only because they thought they would catch him at this moment. Military service then was decided by a lottery, and those who drew unlucky numbers had seven years in the army before them. Since it was possible, however, to "buy" a substitute, Monet's father intended to do so if his son would bend to his will, but the latter was firm. "The seven years of service that appalled so many," he explained later, "were full of attraction to me. A friend who was in a regiment of the Chasseurs d'Afrique and who adored military life, had communicated to me his enthusiasm and inspired me with his love for adventure. Nothing attracted me so much as the endless cavalcades under the burning sun, the *razzias,* the crackling of gunpowder, the sabre thrusts, the nights in the desert under a tent, and I replied to my father's ultimatum with a superb gesture of indifference. I drew an unlucky number. I succeeded, by personal insistence, in being drafted into an African regiment. In Algeria

I spent two really charming years. I incessantly saw something new; in my moments of leisure I attempted to render what I saw. You cannot imagine to what extent I increased my knowledge, and how much my vision gained thereby. I did not quite realize it at first. The impressions of light and color that I received there were not to classify themselves until later; they contained the germ of my future researches."[18]

While Monet was combining his military life with new visual experiences, Pissarro continued to work in the country around Paris, where he met the landscape painters Chintreuil, who like him had profited by the advice of Corot, and Piette, a former pupil of Couture. Piette soon became one of Pissarro's most intimate friends and sat for a portrait, done in 1861. Doubtless it was again a landscape which Pissarro sent to the Salon of that year, but this time the jury, in whose decisions neither Ingres nor Delacroix participated, rejected his canvas.

Fate having reversed its favors, two paintings submitted by Manet were accepted, although very badly hung. For obvious reasons Manet omitted calling himself in the catalogue notice a pupil of Couture. He exhibited a portrait of his parents and a *Spanish Guitar Player,* a picture which in spite of its bad place immediately attracted attention. Its broad execution, its vivid colors, its pleasing subject and lively attitude inspired critics, especially Théophile Gautier, who had been in Spain, to warm praise, for here was a work that combined the observation of real life with the "glamor" of an exotic and colorful costume. And the extraordinary happened: owing to the favorable comments the picture was rehung, assigned a place in the center of a panel and finally awarded an "honorable mention." It is said that Delacroix had something to do with this recompense. Through the success of his first works at the Salon, Manet, then twenty-nine years old, found himself overnight with a reputation that assigned him an enviable place among the "promising young men" of new tendencies.

Manet's *Spanish Guitar Player* drew the attention of many young painters, who were interested particularly in Manet's achievement of translating a visible influence of Goya and especially Velasquez into modern accents. Only the previous year Champfleury had stated in an article on Courbet that "the master, with his rehabilitation of *the modern* and the excellent manner in which he recaptures the presentation of the modern, will perhaps facilitate the arrival of a noble and great Velasquez, of a scoffing and satirical Goya."[19]

Champfleury, without knowing it, had been a prophet, for Manet, with the conscious or unconscious help of Courbet, had succeeded in establishing a link with the past which was not merely a slavish dependence on his predecessors; quite to the contrary, he had added new life to an admirable tradition. In the midst of the repetitions and imitations at the Salon his canvas struck a new and brilliant note. According to Fernand Desnoyers, mouthpiece of the Brasserie des Martyrs, who told the story a few years later half seriously, half jokingly, "a group of painters: Legros [a former pupil of Lecoq de Boisbaudran who himself obtained this very year a considerable success with a painting inspired by Courbet], Fantin [who had already met Manet], Carolus–Duran, Bracquemond [an etcher and friend of Degas], Amand Gautier, stopped short before a *Spanish Guitar Player*. This painting, which made so many painters' eyes and mouths open wide, was signed by a new name, Manet. This Spanish musician was painted in a certain strange, new fashion, of which the young, astonished painters believed themselves alone to possess the secret, a kind of painting that stands between that called realistic and that called romantic. . . . It was decided then and there, by this group of young artists, to go in a body to M. Manet's. This striking manifestation of the new school took place. M. Manet received the deputation very graciously and replied

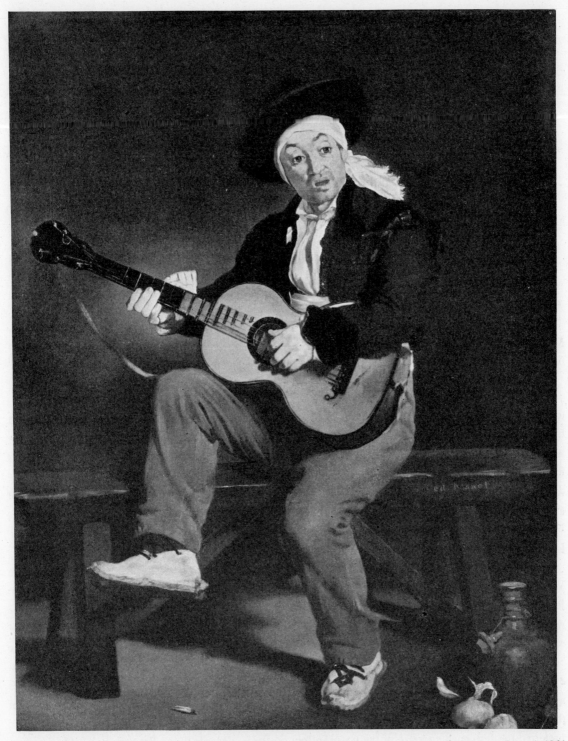

MANET: *Spanish Guitar Player*, 1860. 57 x 44⅝". *Awarded "honorable mention" at the Salon of 1861. Collection William Church Osborn, New York.*

MANET: *Portrait of Baudelaire, 1862. Etching, 4¼ x 3½"*.

MANET: *Portrait of Baudelaire, 1865. Etching, 3¾ x 3¼"*.

to the spokesmen that he was no less touched than flattered by this proof of sympathy. He gave, about himself and about the Spanish musician, all the information desired. He informed the speakers, to their great astonishment, that he was a pupil of M. Thomas Couture. They did not limit themselves to this first visit. The painters even brought a poet and several art critics to M. Manet."[20] These critics were doubtless the very men who defended Courbet and had thus shown their receptiveness to new forms of art: Castagnary, a staunch supporter of realism, Astruc, Desnoyers himself, Champfleury, whose books Bracquemond had adorned with frontispieces, Duranty, for whose first novel, published the previous year, Legros had contributed four etchings, and possibly also Théophile Gautier.

In spite of the fact that Courbet himself expressed some criticism concerning Manet's relation to Velasquez, his followers greeted Manet as a welcome addition to their camp. But Manet abstained from joining the artists and writers around Courbet at the Brasserie. A Parisian dandy of wealthy parents, he was jealous of his independence and also of his career, not wanting to compromise himself in their company. Notwithstanding his disputes with Couture, he had spent six years in his studio because he believed that he could realize his ambitions within the framework of official institutions, and now that a sudden success had crowned his efforts, it was certainly not the moment to join those whose very names were identical with revolution. Manet had just rented a studio in the quartier des Batignolles, far from the spots where Courbet met his friends; more attracted by the Parisian "high life" than by Bohemia, he preferred the fashionable terrace of the Café Tortoni on the boulevards to the Brasserie.

The poet who was introduced to Manet by his new painter friends can have been no other than Baudelaire. For a short time a comrade of Courbet, Baudelaire had long since detached himself from this

painter and, as he said, "the mob of vulgar artists and literary men whose short-sighted intelligence takes shelter behind the vague and obscure word *realism.*"[21] He had not, however, relinquished a constant interest in all manifestations of art. Ardent admirer of Delacroix, friend of the lonely Constantin Guys, severe but just critic of Ingres (whose foibles had not distracted him from his qualities), one of the few who recognized in Daumier more than a mere caricaturist, Baudelaire had a sensibility more receptive to visual impressions than almost any other man in literature. This faculty made him respond untailingly to the pictorial qualities which it took the majority of his contemporaries decades to discover. As a poet he knew how to value words not only for their meaning but as conveyors of images as well and, further, he knew how to exploit their rhythm and their sound. It may have been this that enabled him to recognize in painting the qualities which lie beyond the subject: the vigor of execution, the harmony of color and the creative power which through inanimate means achieves what Hugo had called in Baudelaire's own case *"un frisson nouveau."*

Eleven years older than Manet, Baudelaire approached the painter with both the curiosity of an eternal seeker after new sensations and the indulgence of the isolated genius who sees a younger man headed for the same fate of a lifelong struggle for recognition. He immediately perceived Manet's "brilliant faculties" but also his "feeble character," ill adapted to the struggle ahead. "Never will he completely overcome the gaps in his temperament," he wrote later to a friend, "but he *has* temperament,

COURBET: *Portrait of Baudelaire, 1848-50. 21¼ x 24½". Musée Fabre, Montpellier (Bruyas Bequest).*

DEGAS: *Madonna and Child, study after a Milanese work of about 1500, c. 1857. Drawing 13 x 14", Durand-Ruel Galleries, New York.*

DEGAS: *Study after a drawing in red chalk in the Uffizi, Florence, attrib. to Pontormo, c. 1857. Drawing, 14½ x 11". Collection Robert L. Rosenwald, Jenkintown, Penn.*

that is the important thing."[22] Attracted by Manet's work, Baudelaire did not take long to express his appreciation publicly. About one year after they had met, in the fall of 1862, he published an article in which he lauded Manet for knowing how to unite with "a decided taste for modern truth . . . a vivid and ample, sensitive, daring imagination without which all the better faculties are but servants without a master."[23] In the same year, 1862, Manet etched Baudelaire's profile and introduced it into his painting *Concert in the Tuileries Gardens,* one of his first canvases concerned with contemporary life. This painting also contains portraits of several others among Manet's new friends: Champfleury, Astruc, Théophile Gautier and a military man, Commandant Lejosne, a mutual friend of Manet and Baudelaire.

At about the same period during which Manet met Baudelaire, he made the acquaintance also of Edgar Degas. Degas he might have met through Bracquemond, but it seems that Manet first spoke to him when he watched Degas copy in the Louvre and was amazed by his audacity. Only two years younger than Manet, as removed from Bohemian milieu as he himself, well dressed, of elegant manners, highly intelligent and witty, Degas was the perfect companion for the worldly Manet, and they soon became fast friends.

From several trips to Italy, where his father had many relatives and where his married sister lived,

DEGAS: *Study for "The Daughter of Jephthah"* [*in the Smith College Museum of Art*], *1860-65. Drawing, 7 x 10¼". Private collection, New York.*

Degas had brought home a large number of drawings after models as well as after Italian masters, and a series of family portraits, to which he added others done in Paris of his younger brothers and of himself. These portraits were executed in Ingres' tradition, with a reverent respect for linear precision, but Degas had not refrained from livening their austere color scheme with certain vivid accents, nor from adding some lively strokes to his smooth brush work. While his earlier portraits, such as those of his brothers, still show a dependence upon more or less rigid and classical poses, he was soon to introduce into his pictures attitudes that were far from what Ingres would have approved. Painting in 1859 the family of his father's sister, Baroness Bellelli in Florence,[24] he depicted his uncle almost from the back and showed the central figure of his little cousin seated on a chair with one leg folded and entirely hidden under her ample skirt. Whereas Ingres, preoccupied with his style, told his sitters how he wanted them to pose, Degas was more interested in doing, as he said, "portraits of people in familiar and typical attitudes, above all in giving to their faces the same choice of expression as one gives to their bodies."[25] Yet, in spite of a certain inclination toward the unorthodox and a gift for observation unhampered by any conventions, Degas had not turned to subjects derived from the life around him. When he met Manet, Degas was painting historical scenes which in their themes, though not in their conception, were closely linked to those of the

49

DEGAS: *Portrait of the Artist's Brother, René De Gas, 1855. 36¼ x 29½". Smith College Museum of Art, Northampton, Mass.*

DEGAS: *Portrait of the Artist's Brother, Achille De Gas, in the Uniform of a Cadet, c. 1856. 25¼ x 20". National Gallery of Art, Washington, D. C. (Chester Dale loan).*

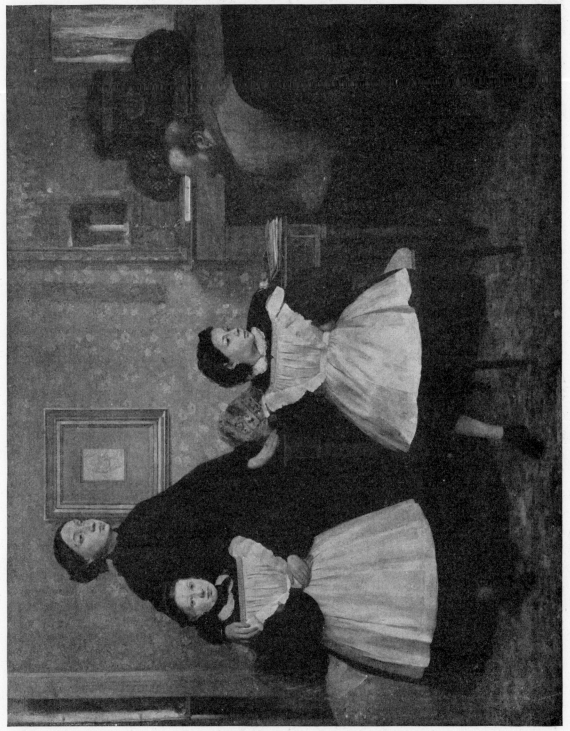

DEGAS: *Portrait of the Bellelli Family in Florence, 1859. 78¾ x 99½". Louvre, Paris.*

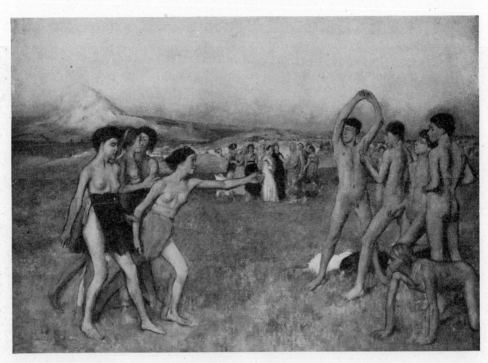

DEGAS: *Young Spartans Exercising, 1860. 43¼ x 60¾". National Gallery, London.*

Ecole des Beaux-Arts. In 1860 he had worked on a composition representing young Spartan girls pro-voking young men to a contest, in which he had willfully neglected to imitate the conventional type of Greeks, choosing instead for models what have been called children from Montmartre and thus combining in a strange way a historical theme and a classical execution with types and observation drawn from his own period. The same holds true for another painting, *Semiramis Founding a Town,* executed in 1861. In a third picture, issuing from the same inspiration, *The Daughter of Jephthah,* he abandoned a certain stiffness, as well as his fashion of grouping the figures on horizontal levels parallel to the surface of the canvas, in favor of a more intricate composition into which there also entered some of the agitation and liveliness that distinguished Delacroix's treatment of similar topics. Degas even mentioned the name of Delacroix in some notes referring to this painting, the largest he ever did.[26] None of these works shows in any way the hand of a beginner: there is neither exuberance nor hesitancy, neither awkwardness nor narrow clinging to given models. From the very start Degas reveals himself as a clever and disciplined craftsman, avoiding facileness, disregarding cheap effects, solving ambitious problems in a style that shows his kinship with Ingres, and in a spirit that sometimes approaches Delacroix's.

In spite of their friendship Manet did not at all approve of Degas' choice of subjects. The *Ecole des Beaux-Arts* had inspired Manet with a horror for historical scenes—*peintre d'histoire* was the worst insult he could think of. It therefore seems very possible that at the beginning of their relationship Manet was more attracted by the man Degas than by the artist, happy to find a companion of culture and distinction, open-minded but not too anarchistic in his beliefs. Degas, who had not yet exhibited at the Salon, was a mere beginner compared to Manet, who in the fall of 1861 appeared for the second time before the public

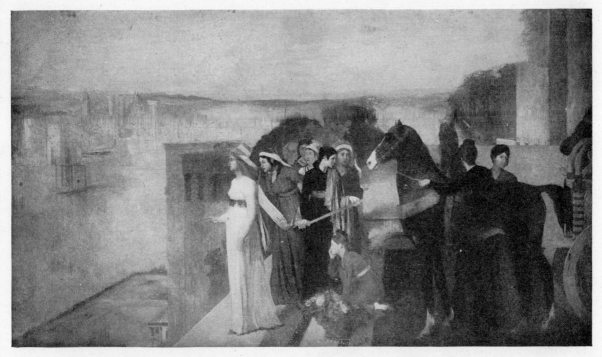

DEGAS: *Semiramis Founding a Town, 1861. 59⅜ x 102¼". Louvre, Paris.*

eye with a group of recent paintings exhibited in the gallery of Louis Martinet on the boulevard des Italiens; from then on this dealer had on hand almost constantly some of Manet's works.

During this same year of 1861 Delacroix at last finished his murals in the church of Saint-Sulpice in Paris, and Manet's friend Fantin was among those who immediately went to study and admire them. To those who used every available argument against Delacroix and now accused him of decadence, Baudelaire replied that never had the artist "displayed more splendidly and cleverly supernatural colors, never more consciously epic drawing."[27] But more than the color and the drawing, Delacroix's admirers among the artists were interested in a purely technical problem that had here been brilliantly solved. Since the murals were destined to be seen at a certain distance, Delacroix had adopted large and separate brushstrokes, which blended naturally at that distance and gave to the color more energy and freshness.

Among those who saw Delacroix's new decorations probably was Boudin, who spent part of the year 1861 in Paris. In order to help him financially Troyon had asked Boudin to brush in the skies and backgrounds for his landscapes, eternally crowded with cattle, for which the demand was so heavy that he could hardly supply the quantities wanted. During his stay in Paris, Boudin saw Courbet again and possibly Baudelaire; he also met Champfleury and Corot, but he apparently made no acquaintance with the friends Monet had wanted him to meet, Pissarro for instance.

Pissarro continued to work in the outskirts of Paris and to drop in at the *Académie Suisse*. There he was soon attracted by a young man from southern France whose heavy provincial accent and strange behavior were no less ridiculed by all the other artists than were his figure drawings, full of strong feeling.[28] He was the son of a well-to-do banker of Aix-en-Provence, Louis-Auguste Cézanne. For three

53

CÉZANNE: *Study of a Negro Model, 1860-65.*
Drawing, 19¾ x 13⅜". Probably done at the
Académie Suisse. Present owner unknown.

CÉZANNE: *Study of a Nude, Standing,*
1860-65. Drawing, 19¼ x 12¼". Prob-
ably done at the Académie Suisse. Pres-
ent owner unknown.

years Paul Cézanne had struggled with his father in order to obtain permission to devote himself to art but had been obliged instead to study law in Aix. Having finally overcome his father's opposition, Cézanne, at the age of twenty-two, had hurried to Paris to join his college friend, Emile Zola. He worked regularly at the *Académie Suisse* from 6 a.m. to 11 a.m., no doubt so as to prepare himself for the entrance examinations at the *Ecole des Beaux-Arts*.[29] Besides Pissarro, who instantly discerned some personal elements in his works, and Armand Guillaumin,[30] a somewhat younger man whom he met also at Suisse's, Cézanne seemed completely isolated and even saw his old friend Zola less frequently than he had hoped. He was soon disgusted with the large city, and since his juvenile dreams of success failed to become true at once, he decided, in spite of Zola's most fervent exhortations, to return to Aix. He left Paris in the fall of 1861 with the intention of entering his father's bank as a clerk and of giving up art once and for all.

The *Ecole des Beaux-Arts,* which had seemed the logical goal to Cézanne and even more so to his father, continued to be far from a heaven to those who did manage to matriculate. The end of 1861 was to see a serious uprising by a group of students—pupils of both Picot and Couture—who were dissatisfied with their masters' methods and were eagerly looking for a new teacher. Their first thought was of Courbet because that artist, in the midst of sterile struggles and of uncertainties, was telling his followers

54

CÉZANNE: *Nude Studies, 1860-65. Drawing. Probably done at the Académie Suisse. Present owner unknown.*

to break with the past, to go forward and be venturesome. Nothing appealed more to their own inner impulses than this call to set free their youthful forces and to assert themselves in large, even brutal works of bold conception and vigorous treatment. They therefore asked Courbet whether he would accept them as pupils and initiate them. Courbet, in a long letter written with the help of Castagnary, told them that he could not be their teacher because every artist ought to be his own, but that he was willing to open a studio, not unlike those of the Renaissance, where, considering them not as pupils but as collaborators, he would explain to them how he himself had become a painter; each of them would remain entirely free to search for the expression of his individual conceptions.[31]

During the first weeks of January 1862, the students began to flock to the studio which had been rented in the rue Notre-Dame des Champs, and there were soon over forty of them; each contributed 20 francs for the rent and the model. This model was in turn a horse or a bull, chained to the wall and guarded by a peasant. The unusual sight of a bull in a Paris studio was soon the talk of the town, and it was not long until gangs of *gamins* besieged the studio while Courbet passed from one easel to the other—Fantin was among his "pupils"—talking about art in general and his methods in particular. It is not known whether it occurred to anyone that instead of bringing a bull into a studio it would have been more natural to go out into the suburbs and study the animal in its proper surroundings; at any rate the

Courbet's Studio, rue Notre-Dame-des-Champs. Wood-engraving by A. Prévost, published in Le Monde Illustré, *March 15, 1862.*

experiment did not last very long. Courbet got tired of "teaching," and the students were probably weary, after a while, of his repetitions. In April 1862, the studio was disbanded, but even its shortlived existence had been enough to show once more that the *Ecole des Beaux-Arts* was slowly losing its hold upon the students. Whether in consequence of this event or not, it remains a fact that in March 1862, a special commission was officially appointed in order to study means of introducing some improvements into the *Ecole,* the Academy in Rome and the rules governing the Salon.

"I regret very much not being able to induce you to come to Paris at this time," Troyon had written in January 1862 to Boudin, then returned to Le Havre. "The situation is trying: the artists are in general little satisfied. . . . The poor young folk have some right to complain."[32] And Fantin said at about the same time in a letter to some friends in England: "Paris—that's free art. No one sells, but there one has freedom of expression and people who strive, who struggle, who approve; there one has partisans, sets up a school; the most ridiculous as well as the most exalted idea has its ardent supporters. . . . At bottom, an atrocious place to live."[33] Yet this atrocious place continued to attract young talents from all over the country, if not from all over the world. Only in Paris, it seemed, could they find stimulation, meet companions, lose or find themselves and plant the seeds of glory. Pissarro had come from the West Indies, Boudin and Monet from Le Havre, Cézanne and Zola from Aix; others like them were to take the road for Paris full of hope and expectations.

NOTES

1. The first five paragraphs of this chapter are based more or less literally on an account of his youth given by Monet himself in an interview with Thiébault-Sisson. See Thiébault-Sisson: Claude Monet, an Interview. Originally publ. in *Le Temps,* Nov. 27, 1900, transl. and repr. in English for Durand-Ruel Galleries, New York.

2. See H. Edwards: The caricatures of Claude Monet, *Bulletin of the Art Institute of Chicago,* Sept.-Oct. 1943.

3. Boudin, note, Feb. 27, 1856; see G. Jean-Aubry: Eugène Boudin, Paris, 1922, p. 31. The author of this book had access to hundreds of letters by Boudin as well as to the painter's notebooks, registers, *et al.* His book offers much valuable information concerning Monet's youth. On Boudin see also G. Cahen: Eugène Boudin, sa vie et son oeuvre, Paris, 1900 and R. L. Benjamin: Eugène Boudin, New York, 1937 (which makes available in English the evidence collected by Jean-Aubry and Cahen).

4. Boudin, notes from sketchbooks, quoted by Jean-Aubry, *op. cit.,* p. 181, 184, 194.

5. Boudin to his brother, April 20, 1868; see Jean-Aubry, *op. cit.,* p. 66.

6. A. Monet to the municipal council of Le Havre, March 21, 1859; see Jean-Aubry, *op. cit.,* p. 171.

7. Séance du conseil municipal, Le Havre, May 18, 1859; see M. de Fels: La vie de Claude Monet, Paris, 1929, p. 32-33.

8. Monet to Boudin, May 19, 1859; see G. Geffroy: Claude Monet, sa vie, son oeuvre, Paris, 1924, v. I, ch. IV.

9. Monet to Boudin, June 3, 1859; see Geffroy, *op. cit.,* v. I, ch. IV.

10. See G. Riat: Gustave Courbet, Paris, 1906, p. 179-180; also A. Schanne: Souvenirs de Chaunard, Paris, 1867, p. 229-230.

11. See C. Baudelaire: Salon de 1859, ch. VIII; repr. *in* L'art romantique.

12. Boudin, note, June 18, 1859; see Jean-Aubry, *op. cit.,* p. 39.

13. J. Champfleury: Les amis de la nature, Paris, 1860, ch. II.

14. Boudin to Martin, Sept. 3, 1868; see Jean-Aubry, *op. cit.,* p. 70.

15. E. Duranty: Caractéristique des oeuvres de M. Champfleury; introduction to Champfleury: Les amis de la nature, *op. cit.,* p. XXI. It seems interesting to note that Degas, who later became one of the closest friends of Duranty, was also in those years an ardent admirer of Champfleury.

16. T. Gautier: Exposition de tableaux modernes, *Gazette des Beaux-Arts,* Feb. 1860. On the same exhibition see Z. Astruc: Le Salon intime, Paris, 1860.

17. Monet to Boudin, Feb. 20, 1860 (and *not* 1856, as often indicated); see Geffroy, *op. cit.,* v. I, ch. IV. Occasionally, however, Monet continued to draw caricatures. Geffroy relates that he did one of Bénassit at the Brasserie des Martyrs where the young artist met Cajart, in whose shortlived weekly, *Diogène,* there appeared in 1860 a *portrait-charge* of the actor Laferrière by Monet (see E. Bouvy: Une lithographie inconnue de Manet, *l'Amateur d'Estampes,* Jan. 1928). But, according to Geffroy (ch. III), Monet seems to have refused to contribute regularly to *La Presse de la Jeunesse,* published by Andrieu, another habitué of the Brasserie.

18. Monet to Thiébault-Sisson; see Interview, *op. cit.*

19. J. Champfleury: Courbet en 1860; repr. *in* Grandes figures d'hier et d'aujourd'hui, Paris, 1861, p. 252.

20. F. Desnoyers: Le Salon des Refusés, Paris, 1863. p. 40-41.

21. C. Baudelaire: L'oeuvre et la vie d'Eugène Delacroix, ch. III; repr. *in* L'art romantique.

22. Baudelaire to Mme Paul Meurice, May 24, 1865. Baudelaire's letters to Manet or concerning the painter are assembled by E. Faure in his edition: C. Baudelaire: Variétés critiques, Paris, 1924, v. II, appendix p. 223-225.

23. C. Baudelaire: Peintres et aqua-fortistes, *Le Boulevard,* Sept. 1862; repr. *in* Curiosités esthétiques.

24. See M. Guérin: Remarques sur des portraits de famille peints par Degas, *Gazette des Beaux-Arts,* June 1928.

25. Degas, notes; see P. A. Lemoisne: Les carnets de Degas au Cabinet des Estampes, *Gazette des Beaux-Arts,* April 1924.

26. See E. Mitchell: "La fille de Jephté" par Degas, genèse et évolution, *Gazette des Beaux-Arts,* Oct. 1937. The painting is in the Smith College Museum of Art, Northampton, Mass. Degas may also have been influenced by Chassériau's decorations for the Paris Cour des Comptes (destroyed during the *Commune*), the drawings for some of which are reproduced in *l'Art Vivant,* Jan. 1938.

27. C. Baudelaire: L'oeuvre et la vie d'Eugène Delacroix, ch. III; repr. *in* L'art romantique.

28. See: Camille Pissarro, Letters to his son Lucien, New York, 1943, p. 277.

29. Cézanne had been thrilled by the Salon and wrote a long letter to a friend about it; see Paul Cézanne, Letters, London, 1941, p. 57-59.

30. On Guillaumin see: E. des Courrières: Armand Guillaumin, Paris, 1924; G. Lecomte: Guillaumin, Paris, 1924; Tabarant: Les Quatre-vingts ans de Guillaumin, *Bulletin de la vie artistique,* Feb. 15, 1921; G. Rivière: Armand Guillaumin, *L'Art Vivant,* July 15, 1927, C. L. Borgmeyer: Armand Guillaumin, *The Fine Arts,* Feb. 1914, also G. Coquiot: Armand Guillaumin, *Le Carnet des Artistes,* Feb. 15, 1917.

31. Courbet's letter to his pupils, dated Dec. 25, 1861, was published in *Le Courrier du Dimanche,* Dec. 29, 1861; see C. Léger: Courbet, Paris, 1929, p. 86-88. On Courbet's studio see G. Riat: Gustave Courbet, Paris, 1906, p. 193-195. Riat reports that the studio was opened in the first days of Dec. 1861, but it must have been rather early in Jan. 1862, after the publication of Courbet's letter. This letter is partly translated in: Artists on Art, edited by R. Goldwater and M. Treves, New York, 1945, p. 295-296.

32. Troyon to Boudin, Jan. 29, 1862; see Jean-Aubry, *op. cit.,* p. 53.

33. Fantin to Edwards, Nov. 23, 1861; see A. Jullien: Fantin-Latour, sa vie et ses amitiés, Paris, 1909, p. 23.

BOUDIN: *Beach Scene, d. 1865. Watercolor, 4¼ x 9¼". City Art Museum, St. Louis.*

GLEYRE'S STUDIO
THE SALON DES REFUSES (1863)
AND THE REORGANIZATION OF THE
ECOLE DES BEAUX-ARTS

At the beginning of the year 1862 Claude Monet fell seriously ill in Algiers and was sent home to recuperate. He spent six months of convalescence in drawing and painting with redoubled energy. Seeing him thus persistent, his father became at last convinced that no will was going to curb the young artist. As the doctor had warned that his son's return to Africa might have fatal consequences, the father decided, toward the end of Monet's furlough, to "buy him out." Again Monet was free to work on the beaches, alone or in company with Boudin. It so happened that at precisely the same time Jongkind was also painting at Le Havre, he whom Monet had thought "dead to art," but who through the help of some painter friends (Bracquemond, Bonvin, Diaz, Corot and Cals, among them) had recovered his self-confidence and his will to work. An Englishman who had watched Monet painting in the open introduced him to Jongkind; Monet, in turn, introduced Boudin to his new acquaintance.

Monet was deeply impressed by Jongkind, then in his forties, at the same time gay and melancholy, cordial and shy, speaking French not only with a strong Dutch accent but also with a complete disregard for grammar and syntax. A tall, husky and bony man with the awkwardness of a sailor on solid ground, haunted by a strange persecution mania, Jongkind was at ease only when he could work, or talk about art. His agitated and unhappy life had not deprived him of his freshness of vision, his sureness of instinct. Like Boudin he had conserved a certain innocence of the eye that had saved him from dry learning and routine. There were for him no other subjects than the ever varying aspects of nature which his agile hand, in quick annotations, transformed into nervous lines and luminous spots of color without ever being repetitious. Less placid than Boudin, he infused into his work something of his own agitation, a curious element of excitement, admirably blended with the naiveté of his eye, the lyricism of his heart and the tranquil audacity of his mind. It is therefore not surprising that Baudelaire was attracted by his etchings, which he admired together with prints by Manet, Whistler and Meryon in a group exhibition at Cadart's in the fall of 1862.

A warm friendship soon united Jongkind with Monet and Boudin. Monet later recalled that Jongkind "asked to see my sketches, invited me to come and work with him, explained to me the why and the wherefore of his manner and thereby completed the teaching that I had already received from Boudin. From that time he was my real master; it was to him that I owe the final education of my eye."[1]

Monet's aunt, Mme Lecadre, watched her nephew's progress with an apprehensive and distrustful eye, complaining in a letter to the painter Amand Gautier: "His sketches are always rough drafts, like those you have seen; but when he wants to complete something, to produce a picture, they turn into appalling daubs before which he preens himself and finds idiots to congratulate him. He pays no attention to my remarks. I am not up to his level, so I now keep the most profound silence."[2]

The "idiots" who complimented Monet on his efforts can have been no others than Boudin and Jongkind. It may have been to detach him from this bad company that Monet's father now agreed to send him back to Paris. But, according to the painter's recollections, "It is well understood," the older Monet said to his son, "that this time you are going to work in dead earnest. I wish to see you in a studio under the discipline of a well-known master. If you resume your independence, I will stop your allowance without more ado. . . ."[1] This arrangement no more than half suited Monet, but he felt it was necessary not to oppose his father. He accepted. It was agreed that he should have at Paris an art tutor, the painter Toulmouche, who had just married one of his cousins. Toulmouche, a pupil of Gleyre, was then highly successful, a specialist in gracious ladies, lovely children and all kinds of sweetness. Astruc once said of his paintings: "It's pretty, charming, highly-colored, refined—and it's nauseating."[3]

In November 1862, Claude Monet reached Paris and immediately went to Toulmouche. To give a sample of his ability, Monet painted for him a still life with a kidney and a small dish of butter. "It's good," was Toulmouche's comment, "but it's tricky! You must go to Gleyre. Gleyre is master of all of us. He'll teach you to do a picture."[4] And it was decided that Monet should enter the studio of Gleyre.

At the very same moment another young man was arriving in the French capital. Like Cézanne he came from southern France, like Cézanne he was of a wealthy family and like Cézanne he had been obliged to study in a field that did not attract him. But Frédéric Bazille from Montpellier—where he lived not far from Courbet's friend, the collector Bruyas—had been able to reach a compromise with his parents, who permitted him to go to Paris and there equally divide his time between the study of medicine and of art. He, too, entered Gleyre's studio and very shortly afterward remarks in a letter to his family that his two best friends are a Viscount Lepic and Monet.

Monet was not very happy at Gleyre's. "Grumbling," he later said, "I set up my easel in the studio full of pupils over whom this celebrated artist presided. The first week I worked there most con-scientiously and made, with as much application as spirit, a study of the nude from the living model, which Gleyre corrected on Mondays. The following week, when he came to me, he sat down and, solidly planted on my chair, looked attentively at my production. Then he turned round and, leaning his grave head to one side with a satisfied air, said to me: 'Not bad! not bad at all, that thing there, but it is too much in the character of the model—you have before you a short thickset man, you paint him short and thickset—he has enormous feet, you render them as they are. All that is very ugly. I want you to remember, young man, that when one executes a figure, one should always think of the antique. Nature, my friend, is all right as an element of study, but it offers no interest. Style, you see, is everything.' "[5]

To Monet, who had learned from Boudin and Jongkind to record faithfully his observations, this

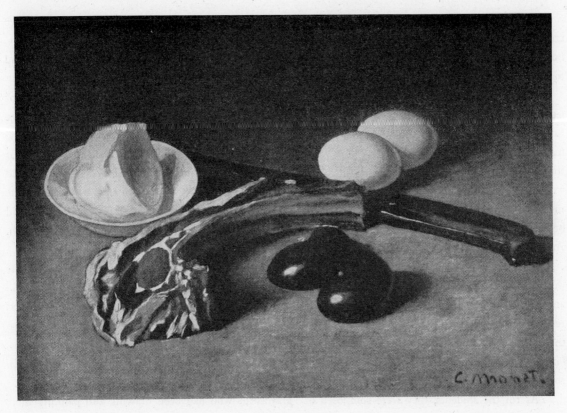

MONET: *Still Life, 1862. Painted for his cousin Toulmouche. Present owner unknown.*

advice came as a shock and immediately erected a barrier between him and his teacher. But Monet was not the only student with whose work Gleyre was dissatisfied. There was also a young Parisian, Auguste Renoir, who did not seem able to work properly in the academic spirit. He too had entered the studio in 1862 and like Monet had tried in his very first week to copy the model as carefully as he could. Gleyre, however, had only glanced at his work and said dryly:

"No doubt it's to amuse yourself that you are dabbling in paint?"

"Why, of course," Renoir replied, "and if it didn't amuse me, I beg you to believe that I wouldn't do it!"[6]

This unexpected answer came from the bottom of the pupil's heart. For several years Renoir, one of five children of a poor tailor from Limoges, had tried his hand at different jobs and carefully put aside every penny so as to be able to pay his tuition. Originally apprenticed as a painter of porcelain, he had begun to paint under the guidance of an older colleague at the china shop. This colleague of his had succeeded in convincing Renoir's parents that their son was destined for something better than to decorate cups and dishes with flowers or copies after Boucher. Thereupon Renoir had set out to earn money and had soon been successful, owing to his tremendous facility and the speed with which he painted blinds, murals, etc.[7] At the age of twenty-one he had saved enough to enter the *Ecole des Beaux-Arts*. Full of good will and eager to learn, he could not understand why his apprenticeship should not "amuse" him.

The dissatisfaction Gleyre had voiced over the studies of Monet and Renoir must have contributed to create a sympathy between these two, and when they were joined by a young Englishman, Alfred Sisley, born in France of British parents, they formed a group of four "chums"—Bazille, Monet, Renoir and Sisley—keeping to themselves apart from most of the other students at Gleyre's.

The studio of Gleyre, like those of most of the other teachers at the *Ecole des Beaux-Arts*—that of Couture, for instance—was only indirectly connected with the *Ecole*. Whereas the latter offered free tuition to all those who passed the various examinations, it presented the great inconvenience that the teaching was done in rotation by the different masters without any real consistency of method. Most of the teachers, therefore, had opened private classes where the pupils, whether at the *Ecole* or not, could work under their exclusive guidance. Those who were enrolled at the *Ecole* participated at the same time in the obligatory courses and sat for the periodic examinations. This was the case with Renoir, who had been admitted to the *Ecole* in April 1862, and continued to pass examinations in August 1862, March, August and October 1863, as well as in April 1864.[8]

In Gleyre's studio, according to a friend of Whistler, who had worked there for a while, "some thirty or forty art students drew and painted from the nude model every day but Sunday from 8 till 12, and for two hours in the afternoon, except on Saturdays. . . . One week the model was male, the next female. . . . The bare walls were adorned with endless caricatures in charcoal and white chalk; and also the scrapings of many palettes, a polychrome decoration not unpleasing. A stove, a model-throne, stools, boxes, some fifty strongly-built low chairs with backs, a couple of score easels and many drawing-boards, completed the *mobilier*."[9]

As for the students, they were composed of "graybeards who had been drawing and painting there for thirty years and more, and remembered other masters . . . younger men, who in a year or two, or three or five, or ten or twenty, were bound to make their mark . . . others as conspicuously singled out for failure and future mischance—for the hospital, the garret, the river, the Morgue, or, worse the traveler's bag, the road, or even the paternal counter. Irresponsible boys, mere *rapins*, all laugh and chaff and mischief . . . little lords of misrule—wits, butts, bullies; the idle and the industrious apprentice, the good and the bad, the clean and the dirty (especially the latter)—all more or less animated by a certain *esprit de corps*, and working very happily and genially together, on the whole. . . ."[9]

But this *esprit de corps* was more evident in the fun than in the devotion to art. Raffaëlli, a young painter who at about that time studied under Gérôme, discovered with surprise that "the wretched young fellows, most of them coarse and vulgar, indulge in disgusting jokes. They sing stupid obscene songs. They make up shameful masquerades. . . . And never, never, in this assemblage of men called to be artists, is there a discussion about art, never a noble word, never a lofty idea. Over and over again, this dirty and senseless humbug, always filth."[10] The pupils of Gleyre certainly did not differ much from those of Gérôme; they too staged shows and even gave a presentation of *Macbeth*, which Whistler and Gérôme attended, and which Fantin, Champfleury, Duranty, Manet and Baudelaire are also said to have seen.

Monet participated little in the life of the Gleyre studio, but in order not to exasperate his family he continued to appear regularly at the studio, remaining just long enough to execute a rough sketch from the model and to be present at inspection. Bazille, Renoir and Sisley, however, really applied themselves, and Sisley seems even to have intended to present himself at the competition for the *Prix de Rome*, a five-year scholarship at the Academy in Rome and the highest award bestowed by the *Ecole*. Although

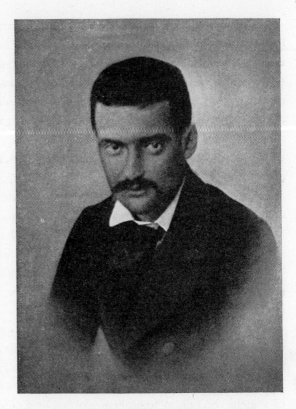

Photograph of Auguste Renoir, 1861. *Photograph of Paul Cézanne, 1861.*

in disagreement with their teacher, the three friends felt that they might profit from serious work at his classes. Their situation was very much like that of Odilon Redon, another student of Gérôme's, who in later years thus summed up his experiences:

"At the *Ecole des Beaux-Arts,*" he wrote, "I paid a lot of attention to the rendering of form. . . . I was prompted, in going to the Academy, by the sincere desire to place myself behind other painters, myself a pupil as they had been, and I expected from the others approval and justice. I was counting without that art formula which was to guide me, and I was also forgetting my own disposition. I was tortured by the professor. Whether he recognized the sincerity of my serious inclination for study, whether he saw in me a timid person of good will, he tried visibly to inculcate in me his own manner of seeing and to make a disciple—or to make me disgusted with art itself. . . . He cried up to me enclosing with a contour a form which I myself saw as palpitating. Under pretext of simplification (and why?) he made me close my eyes to light and neglect the viewing of substances. . . . The teaching I was given did not suit my nature. The professor had for my natural gifts the most obscure, most complete lack of appreciation. He didn't understand anything about me. I saw that his obstinate eyes were closed before what mine saw. . . . Young, sensitive, and irrevocably of my time, I was there hearing I don't know what rhetoric, derived one doesn't know how, from the works of a fixed past. . . . An impossible link between the two, impossible union, submission would have required the pupil's being a saint, which was impossible."[11]

Whereas Redon felt himself tortured by his teacher Gérôme, Renoir, Bazille and Sisley were fortunate

enough to work under a professor with much less instinct for domination, even though his views may not have differed from those of Gérôme. Gleyre was a modest man, disliking to lecture, and all in all rather indulgent; he seldom took up a brush and corrected a student's work.[12] Renoir afterwards stated that Gleyre had been "of no help to his pupils," but added that he had at least had the merit "of leaving them pretty much to their own devices."[13] Gleyre did not even have any preferences in subject matter, and let his students paint what they wanted. On his visits to the studio, twice a week, he went the round slowly, spending a few minutes at each drawing board or easel. He was content to advise his pupils to draw a great deal and to prepare the tone *in advance* on their palette so that, even while painting, they might devote themselves undisturbed to the linear aspect of the subject. Gleyre always feared that *"devilish color"* might go to their head. If ever he was irritated, it was by the sketches of pupils whose preoccupation was too much with color, to the exclusion of drawing.[12]

Since Renoir seems to have succumbed from the beginning to the "vice" of color, he made himself something of an outsider in the studio in spite of his genuine application. "While the others shouted, broke the window panes, martyrized the model, disturbed the professor," he once told a friend, "I was always quiet in my corner, very attentive, very docile, studying the model, listening to the teacher . . . and it was I whom they called the revolutionary."[14]

Notwithstanding differences of conception between Gleyre and his students, nobody apparently was really unhappy in his studio, and most of his pupils, Bazille and Renoir included, showed a real respect for their teacher. This respect Gleyre seems to have particularly deserved by his unpretentiousness, as well as by his refusal to accept any payment for advice. From the moment when he had agreed to take charge of a studio, he had, in remembrance of his own difficult youth, charged his students for rent and model fees only, exactly ten francs a month, while all the other teachers demanded substantial contributions. As to Gleyre's works, they distinguished themselves by a lifeless but "correct" drawing and a dull coloring; their anemic grace and cold mannerism could hardly inspire admiration.

While Renoir had no real conflicts with Gleyre, he was less at ease at the *Ecole des Beaux-Arts,* where he attended evening courses in drawing and anatomy. According to his reminiscences, an oil study he had brought to the class aroused the antagonism of his teacher, Signol, famous for peremptoriness. "He was fairly beside himself on account of a certain red that I had used in my picture. 'Be careful not to become another Delacroix!' he warned me."[13]

Whereas Renoir, Sisley and Bazille had entered the studio of Gleyre without any idea of revolt, on the contrary, with an eagerness to learn and to do as the others, Monet's case was entirely different. Obliged to study under Gleyre against his own will, he had been from the very first day a more or less open rebel, especially since he lacked both the will and the capacity to submit. It was therefore natural that Monet should take the lead over his new friends, all the more so because he could not be considered a mere beginner like them. While they only instinctively felt some disagreement with their teacher, he had the necessary experience and knew the arguments that could free them from the academic formula. He could tell them of his work with Boudin and Jongkind, of the discussions at the Brasserie, of what he had heard about Courbet from Boudin and about Corot from Pissarro. Through Monet they came in touch with the art life outside the *Ecole,* with the new movements and ideas. Their confidence in Gleyre's methods more and more fell to pieces; they turned to the masters in the Louvre for instruction. For many painters of their generation the Louvre became a healthy counterbalance to the instruction at the *Ecole,* notwith-

HOMER: *Art Students and Copyists in the Louvre Gallery, 1867. Wood-engraving, published in Harper's Weekly, Jan. 11, 1868.*

standing Duranty's incendiary intentions. In the Louvre they were free to choose their own masters, could erase the traces of their one-sided education and find in the works of the past a guidance congenial to their own longings. The huge gallery of the Louvre was always crowded with copyists, and the sight of the numerous artists working there so startled Winslow Homer on a short visit to France in 1867 that it inspired him to do a woodcut, one of the very few related to his trip abroad.

Manet had copied not only Delacroix but also, among others, Titian, Velasquez, Rembrandt and Tintoretto; Degas had chosen Holbein, Delacroix, Poussin and the Italian Primitives; Whistler had done a copy after Boucher, and, together with his friend Tissot, another one after Ingres' *Angélique;* he admired Velasquez and Rembrandt. Cézanne, like Manet, copied Delacroix's *Dante and Virgil*. But by far the greatest number of copies was done by Fantin, who very often made copies to earn a living. His admiration went particularly to Delacroix, Veronese, Titian, Giorgione, Tintoretto, to Rubens, Rembrandt, Hals, de Hooch and Vermeer, as well as to Chardin and Watteau.

Soon after he had entered Gleyre's Renoir had fallen in with Fantin, whose studio was nearby. Fantin would take him off to work after Renoir had come from the *Ecole,* lavishing advice and repeating without end: "The Louvre! the Louvre! there is only the Louvre! You can never copy the masters enough!" And Fantin carried him away to the museum, where the lesson was continued by insistence as to the choice among the masterpieces.[15] While Renoir studied with pleasure the French painters of the eighteenth cen-

MANET: *Spanish Dancers, d. 1862. 24½ x 36½". Exhibited at Martinet's in 1863. Phillips Memorial Gallery, Washington, D. C.*

tury, he almost had to force Monet to accompany him to the Louvre.[16] Monet looked only at landscapes, felt annoyed by most of the pictures and detested Ingres. Bazille, in the meantime, copied Rubens and Tintoretto.

While working in the Louvre, Fantin and his friend Bracquemond had been introduced by Bracquemond's former teacher, Guichard, to two ladies in their early twenties who copied there under his supervision. Edma and Berthe Morisot, daughters of a rich magistrate, had taken up painting with more seriousness and assiduity than do most women of their standing, who look upon it merely as a pleasant pastime. Berthe especially surprised many visitors to the Louvre by the intrepidity with which she worked on copies of Veronese and other masters. Not satisfied with their copying, the two sisters had told Guichard they wished to abandon his method of working from memory and wanted instead to paint out-of-doors. A pupil of both Delacroix and Ingres, Guichard felt unable to take this venture in hand and introduced them, in 1861, to Corot, who permitted the young ladies to watch him while he painted a landscape at Ville d'Avray, near Paris. He also lent some of his paintings to them, so that they might copy them. Like Pissarro, the sisters Morisot now became "pupils" of Corot.

Corot attracted the more timid of the new generation; the bolder natures turned to Courbet and Manet. Just as Monet had established some kind of intellectual contact between his young comrades

MANET: *Concert in the Tuileries Gardens, 1862. 30 x 46¾". Exhibited at Martinet's in 1863. National Gallery, London.*

and his older friends Boudin and Jongkind, Fantin could speak to them about Manet, his friend, and Courbet, his erstwhile teacher. At the same time Bazille discovered that the Commandant Lejosne, a distant relative of his, was a friend of Baudelaire and Manet, who had depicted the military man in the crowd of his *Concert in the Tuileries Gardens*. This very painting, together with thirteen other canvases by Manet, was shown at Martinet's in an exhibition that opened March 1, 1863. Several of these works represented members of a troop of Spanish dancers who had arrived in Paris the previous year, quickening Manet's enthusiasm for Spain by their colorful costumes and picturesque dances.[17] But even critics who were not particularly hostile to new tendencies saw in these paintings a "medley of red, blue, yellow and black which is the caricature of color and not color itself."—"The art," one of them wrote, "may be very straightforward but it isn't healthy and we certainly are not taking it upon ourselves to plead M. Manet's cause before the Salon jury."[18]

And indeed the time for the opening of the Salon of 1863 was drawing closer. Neither Monet (who had been deeply impressed by Manet's exhibition) nor Bazille, Renoir or Sisley could yet think of submitting anything, but among their comrades at Gleyre's there were certainly many advanced pupils who did so. The four friends thus had ample occasion to learn about all the intrigues, tricks and undercover work which usually precede the decisions of the jury. In the years before it had happened that the jury,

without paying attention to signatures, had rejected the works of some of its own members; the recurrence of such unpleasant incidents had fortunately been eliminated by establishing a rule which made all members of the Academy and all artists awarded medals *hors concours:* their works were accepted without being submitted to the jury. The danger of being rejected therefore menaced only those who had not yet obtained recognition. As was natural, the teachers in the different studios—members of the jury—protected their own students as much as they could by trading votes with their colleagues: "If you vote for my pupils, I shall vote for yours." But even without actual bartering the members of the jury showed the greatest indulgence to the followers of their colleagues. Couture tells in his memoirs how he was once assigned to examine a number of paintings, together with Ingres, and how he betrayed his own convictions by "admiring" whatever work he thought executed by a pupil of the master or at least an imitator. Yet to be accepted by the jury was not always enough for the satisfaction of the artists; there still remained the important problem of obtaining an auspicious place, a goal that could be achieved to some extent, by those who could afford it, by distributing money among the janitors who did the hanging. Another vital problem to be solved was that of obtaining favorable comments in the press. Upon all these factors depended to a high degree the artist's chance to sell his works and to achieve social position.

"They have rejected my picture on whose sale I was legitimately counting," complained a former pupil of Couture in a letter to a friend, "the picture which had already been recommended to likely buyers who had promised to acquire it at the exhibition, if it appeared to them to merit the high praise which had been made of it to them. . . . A series of articles was all ready, by influential critics, to brew for me a success at the Salon, and here these ruffians, these daubers with pontifical positions, of which the jury has been composed, make me lose the fruits of that campaign! . . ."[19]

To be admitted or rejected was thus more than a question of pride, it was a vital issue, and few were those who, like Fantin, attached little importance to it. Fantin was unable to understand why his friend Whistler was so preoccupied with the "received or not received" problem, because he should have known that rejections did not necessarily strike the bad paintings. To the general public, however, the decisions of the jury were final. People not only refused to buy pictures rejected by the jury (which at one time was cruel enough to stamp an *R* on the stretchers), they even returned those previously bought, as happened to Jongkind, who, having sold a landscape a few days before he sent it to the Salon, had to make a refund when the jury returned the canvas. On the other hand, an accepted painting was likely to sell, to create a favorable impression among the author's patrons, to bring offers from dealers and even commissions. But the jury had little consideration for the fate of the artists it held in its hands, unless they had some "pull." It was a common practice, for instance, to choose among the different works submitted by an artist the least important and the smallest, if all were not to be rejected. Courbet had this experience in 1855.

In 1863 the jury was even more severe than it had been in previous years, owing, it appears, to the uncompromising attitude of M. Signol, Renoir's teacher at the *Ecole des Beaux-Arts;* neither Ingres nor Delacroix participated in the deliberations. This time many artists who had been more or less regularly admitted heretofore, like Jongkind, or who had received honorable mentions, like Manet, were turned down. The rejections were so numerous—more than four thousand works were refused—that they resulted in a real agitation in artist circles, which finally came to the ears of the Emperor. On the afternoon of April 22, Napoléon III went to the *Palais de l'Industrie,* built for the 1855 World's Fair, where the

DEGAS: *At the Races—Before the Start, d. 1862. 19⅛ x 24¼". Partly repainted around 1880. Louvre, Paris.*

Salons had since been held. There he inspected part of the rejected works before summoning Count Nieuwerkerke, director general of the museums, superintendent of Fine Arts and president of the jury. As reversal of the judgments seemed inadvisable, the Emperor made a sensational decision which was announced two days later in the official *Moniteur:*

"Numerous complaints have reached the Emperor on the subject of works of art that have been refused by the jury of the exhibition. His Majesty, wishing to leave the public as judge of the legitimacy of these complaints, has decided that the rejected works of art be exhibited in another part of the *Palais de l'Industrie.* This Exhibition will be elective, and the artists who may not want to take part will need only to inform the administration, which will hasten to return their works to them. This Exhibition will open on May 15 [the Salon proper was to open on May 1]. Artists have until May 7 to withdraw their works. Beyond this limit, their pictures will be considered not withdrawn and will be placed in the galleries."[20]

"When the notice announcing this decision appeared in the *Moniteur,*" wrote the prominent critic

Ernest Chesneau a few days later, "there was great excitement among the artists directly concerned, and this excitement is not yet calmed. The public which is interested in art questions, received this ruling with real joy. At the same time as it was looked upon from the point of view of the greatest liberality, the public saw in it a lesson to the excessive and boastful pride of people without talent who are all the more prompt to complain as their merit is less. But will this lesson have any effects? We cannot yet answer that question. In fact, uncertainty is great among the so-called victims of the jury. Since this exhibition is elective, the most disturbing perplexity moves all minds: 'Shall we exhibit or shall we not? . . .' "[21]

Whereas Chesneau seemed to presume that all the rejected artists were people without talent, Castagnary, who championed Courbet and his friends, described the dilemma of the rejected more justly: "To exhibit means to decide to one's detriment perhaps the issue that has been raised; it means to deliver oneself to the mocking public, if the work is judged definitely bad; it means testing the impartiality of the commission, siding with the Institute not only for the present but for the future. Not to exhibit means to condemn oneself, to admit one's lack of ability or weakness; it means also, from another approach, to accomplish a glorification of the jury."[22]

In reality the whole problem can have existed only for a few undecided individuals. Those among the rejected artists who sincerely believed in the principles of the *Ecole des Beaux-Arts* had to accept the jury's verdict and, considering their works inferior to academic standards, had to withdraw them. Those, on the contrary, who had little or no sympathy with the conceptions of the Institute and believed in their right to follow new directions could but welcome the chance to measure their strength with the "official art." Whoever hesitated proved that he did not believe in his own efforts; whoever feared to arouse the anger and vengeance of the jury by participating in the counter-exhibition proved that he did not believe in art at all but only in his career.

Courbet's followers and all other uncompromising artists were delighted with the new decree. Whistler, who had sent but one large canvas from England—the rejection of which he expected, for it had been refused at the London Academy the previous year—had already made arrangements with Martinet to exhibit the painting together with other rejected works in his gallery. But when his friend Fantin informed him of the Emperor's decision and asked for instructions, Whistler immediately replied: "It's marvelous for us, this business of the Exhibition of Rejected Painters! Certainly my picture must be left there and yours too. It would be folly to withdraw them in order to place them with Martinet."[23] And he inquired what impression his canvas had made at the Café de Bade.

The Café de Bade had become the new headquarters of Manet. It is not known how Whistler's new work was considered there, but one thing is certain: Manet and his friends did not hesitate any more than did Whistler; they welcomed the *Salon des Refusés* and would have felt disgraced had they withdrawn their paintings. Manet hardly considered himself a revolutionary and probably did not even want to be one; there was none of the provocative element in him which had always made Courbet the center of discussions; his independence was not an attitude chosen to force attention, it was the natural condition in which he lived and worked. Little did he expect that this independence might be considered a challenge by others and that he would have to fight in order to maintain his right to be himself. But he was ready to fight. He had been and still was of the opinion that the Salon was the natural place for an artist to introduce himself, yet this did not mean that he accepted the jury's decision. Somehow he hoped, as doubtless most of the others did, that the public would be on his side and prove the jury wrong. There

Corot: *Nanteuil-les-Meaux, 1850-55. 13¾ x 9½". Knoedler Galleries, New York.*

Pissarro: *In the Woods, d. 1862. Drawing heightened with white, 12¼ x 9⅞". Private collection, England.*

even seemed to be a vague possibility that a success of the *Salon des Refusés* might lead to the complete suppression of the jury, an issue upon which the realists and their friends had already fought for years.

The commission appointed to study the introduction of improvements into the *Ecole des Beaux-Arts* and the blow which the Imperial decree had dealt to the jury, threatening to undermine its authority, put the academic painters on the defensive. For them it was of vital importance that the *Salon des Refusés* should be a "flop." The way in which they went about it has been best described by the English critic Hamerton, who could hardly be accused of sympathizing with the extremists. "It is dangerous," he wrote from Paris to a London periodical, "to allow the jury, or any members of the jury, to have any influence over the hanging of pictures rejected by the jury. Their first object is, of course, to set themselves right with the public, and, to achieve this, they have in this instance reversed the usual order of things by carefully putting the worst pictures in the most conspicuous places."[24] The fear of this very thing might have been an additional reason for many painters to withdraw their works, thus indirectly helping the jury to justify itself. Then, too, many artists withdrew in the more or less justified expectation of future reprisals from the jury; others, although they exhibited, did not want their names to appear in the catalogue for the very same reason. Commented Hamerton: "The Emperor's intention of allowing the rejected painters to appeal to the public has been in a great measure neutralized by the pride of the painters themselves.

With a susceptibility much to be regretted, and even strongly condemned, the best of these have withdrawn their works, to the number of more than six hundred. We are consequently quite unable to determine, in any satisfactory manner, how far the jury has acted justly towards the refused artists as a body."[24]

The catalogue of the *Salon des Refusés* is very incomplete because, as a preliminary note by a committee of rejected artists explains, it was established without any help from the administration and because many artists could not be reached in time. Among those listed are Manet with three paintings and three etchings, Jongkind with three canvases, Pissarro with three landscapes, Whistler with his single work, Bracquemond with etchings, and Fantin, Amand Gautier and Legros, who had works both in the Salon and in the counter-exhibition. Not listed, although exhibiting, were Guillaumin and his friend Cézanne, who had given up his work as a clerk in his father's bank and returned to painting, although he had failed the entrance examination for the *Ecole des Beaux-Arts*.

From the very day of its opening the *Salon des Refusés* attracted an enormous crowd; on Sundays there were record numbers of three to four thousand visitors. People were, of course, more attracted by the unusual features of the rejected works, which the press described as hilarious, than by the more or less annoying achievements in the Salon proper. "On entering the present exhibition of refused pictures," Hamerton reports, "every spectator is immediately compelled, whether he will or no, to abandon all hope of getting into that serious state of mind which is necessary to a fair comparison of works of art. That threshold once past, the gravest visitors burst into peals of laughter. This is exactly what the jurymen desire, but it is most injurious to many meritorious artists. . . . As for the public generally," the author adds, "it is perfectly delighted. Everybody goes to see the refused pictures."[24]—"One has to be doubly strong," commented Astruc, "to keep erect beneath the tempest of fools, who rain down here by the million and scoff at everything outrageously."[25]

According to Hamerton, although this can hardly be proved, the critics were rather kinder to the refused than to the accepted; it is at least true that the refused were given lengthy comments. The press even published jokes about Salon exhibitors who hoped to be refused the next year in order to attract more attention, and Jongkind wrote to his friend Boudin, who had been accepted: "My pictures are among those refused and I have some success."[26]

The critic friends of the *Refusés* naturally took advantage of the occasion to proclaim their heretical views. Fernand Desnoyers, formerly of the Brasserie, wrote a brochure devoted solely to insulting both the cowardly artists who had withdrawn their works and the stupid bourgeois who indulged in ridicule.[27] In Courbet he saw the hero of the *Salon des Refusés,* the "most rejected of the rejected," for notwithstanding the fact that he was now *hors concours,* one of his paintings had been refused for "moral reasons" and was not even permitted at the *Salon des Refusés.* Zacharie Astruc expressed himself more specifically about the rejected artists. For the duration of the exhibition he founded a daily paper, *Le Salon de 1863,* in which he had the courage to write: "Manet! One of the greatest artistic characters of the time! I would not say that he carries off the laurels in this Salon . . . but he is its brilliance, inspiration, powerful flavor, surprise. Manet's talent has a decisive side that startles; something trenchant, sober and energetic, that reflects his nature, which is both reserved and exalted, and above all sensitive to intense impressions."[25]

Of the three paintings exhibited by Manet, two derived their color accents from picturesque Spanish costumes; one was a portrait of his brother, *Young Man in the Costume of a Majo;* the other, *Mlle V. in the Costume of an Espada,* had been posed for by his favorite model Victorine Meurent. The third

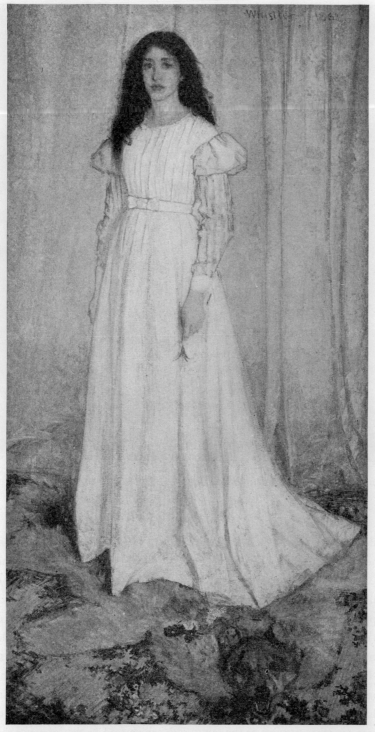

WHISTLER: *The White Girl [Jo], d. 1862. 85½ x 43". Exhibited at the* Salon des Refusés, *1863. National Gallery of Art, Washington, D. C. (H. Whittemore Collection).*

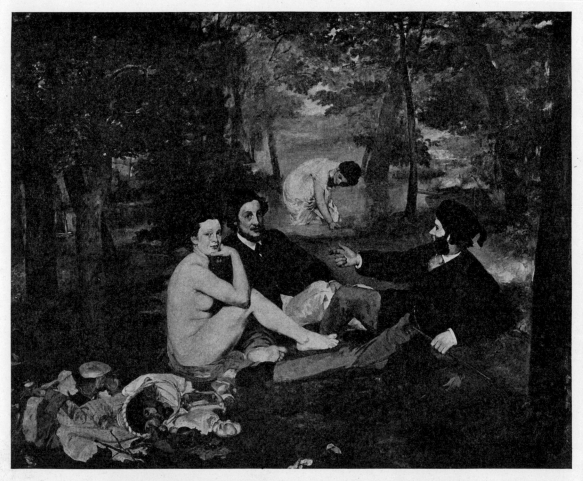

MANET: *Le déjeuner sur l'herbe, d. 1863. 84¼ x 106¼". Exhibited at the* Salon des Refusés, *1863. Louvre, Paris.*

canvas, listed under the title *Le Bain,* was later to be called *Le déjeuner sur l'herbe.* It was this last picture that immediately attracted all visitors, the more so because the Emperor had pronounced it "immodest." Mr. Hamerton agreed with the monarch when he wrote: "I ought not to omit a remarkable picture of the realist school, a translation of a thought of Giorgione into modern French. Giorgione had conceived the happy idea of a *fête champêtre* in which although the gentlemen were dressed, the ladies were not, but the doubtful morality of the picture is pardoned for the sake of its fine color. . . . Now some wretched Frenchman has translated this into modern French realism, on a much larger scale, and with the horrible modern French costume instead of the graceful Venetian one. Yes, there they are, under the trees, the principal lady, entirely undressed, . . . another female in a chemise coming out of a little stream that runs hard by, and two Frenchmen in wide-awakes sitting on the very green grass with a stupid look of bliss. There are other pictures of the same class, which lead to the inference that the nude, when painted by vulgar men, is inevitably indecent."[24]

It may be doubted whether Manet's painting would have provoked such criticism had it not been

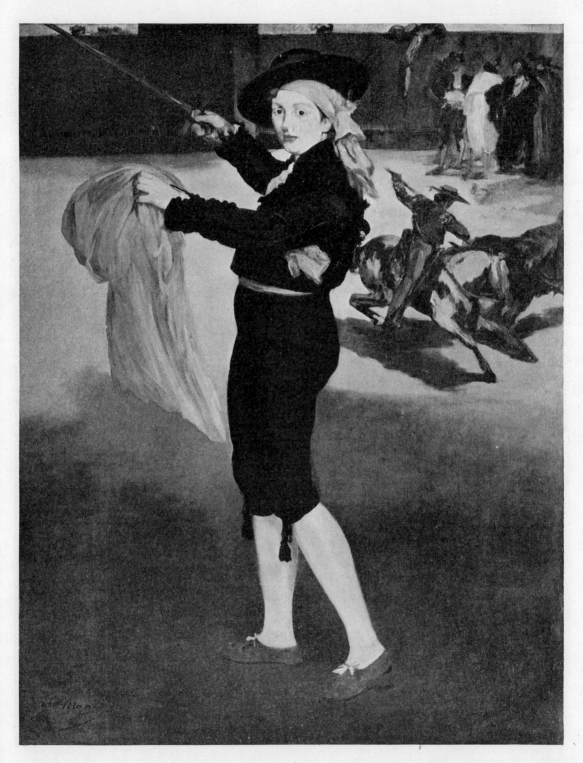

MANET: *Mlle V. [Victorine Meurent] in the Costume of an Espada, 1863. 65½ x 50¾". Exhibited at the* Salon des Refusés, *1863. Metropolitan Museum of Art, New York (H. O. Havemeyer Collection).*

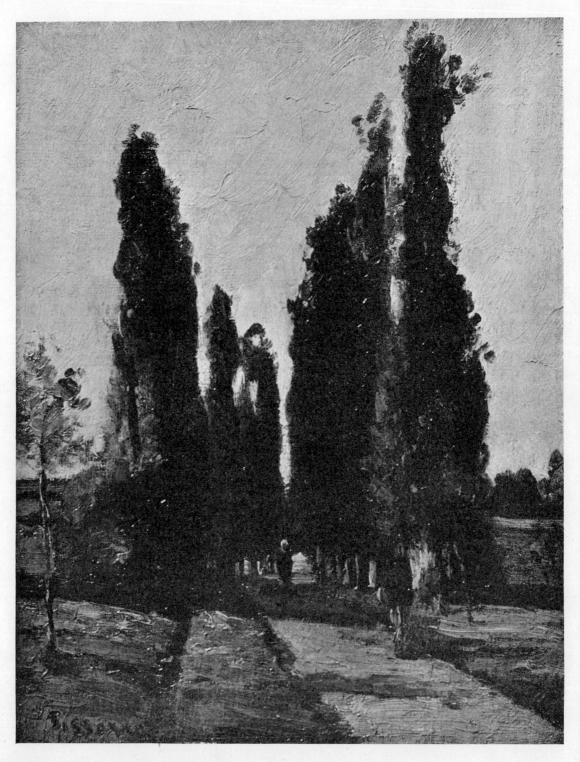

PISSARRO: *The Road, c. 1864. 13¾ x 10¼". Collection Gordon Pollock, New York.*

painted in broad contrasts and frank oppositions, with a tendency to simplification. His "vulgarity," in the eyes of the public, lay probably even more in his execution than in his subject matter. It was his renunciation of the customary slick brushwork, his fashion of summarily indicating background details and of obtaining forms without the help of lines, by opposing colors or by sketching his contours, if necessary, with decisive brushstrokes in color (which helped to model volumes instead of limiting them), that were responsible for the almost universal disapproval he met. This seems proven by the similar reception accorded Whistler's *White Girl,* whose subject hardly lent itself to moral or other such objections. Considered particularly ugly, Whistler's painting had been given a "place of honor" before an opening which every visitor had to pass, so that none could miss it. Emile Zola, who visited the exhibition together with his friend Cézanne, later reported that "folk nudged each other and went almost into hysterics; there was always a grinning group in front of it."[28] According to a description by an American critic, the canvas represented "a powerful female with red hair, and a vacant stare in her soulless eyes. She is standing on a wolf-skin hearth rug—for what reason is unrecorded."[29] That unrecorded, and apparently insufficient reason was a purely pictorial one, a *tour de force* to obtain a harmony of different shades of white enlivened by the model's red hair and by some color touches in the rug, painted in with short brushstrokes. All this was achieved by a more or less lively technique not very different from Manet's, except that Whistler had chosen to be subtle where Manet had been forceful.

Compared with the prestige of ridicule obtained by Manet and Whistler, most of the other exhibitors at the *Salon des Refusés* fared rather well with the public and the reviewers. Pissarro even drew a few favorable lines from a renowned critic, who advised him, nevertheless, to be careful not to imitate Corot. Whereas among the young painters outside the Academy, Manet's stature grew immensely through this exhibition, so as to make him appear the leader of the new generation (Cézanne, Bazille and Zola were among those deeply impressed), the favor of the general public went to a *Venus* by Cabanel, shown in the official Salon. Though "wanton and lascivious," she was considered "not in the least indecent" and charmed all the onlookers because, as one reviewer put it, she was "cleverly rhythmical in pose, offers curves that are agreeable and in good taste, the bosom is young and alive, the hips have a perfect roundness, the general line is revealed as harmonious and pure."[30] This thoroughly insignificant but highly pleasant achievement not only was purchased by the Emperor but brought its author a promotion in the Legion of Honor and election to the Institute.

A few weeks before Cabanel was elected to the Academy of Fine Arts, the only liberal member, Eugène Delacroix, had died. The old and lonely painter closed his eyes at the very moment when many of those who—while under Ingres' tutelage—had benefited from his liberating influence, were beginning to rally around Manet, a man of their own time. Delacroix's isolation had increased during the last years of his life, and he may himself have been ignorant of how great was the respect in which he was held by the new generation. Indeed, he had lost all contact with it. Little did he know that one night at an official ball he had been ardently watched by young Odilon Redon, who had then followed him through the dark streets of Paris all the way to his house, 6 rue de Furstemberg. Nor did Delacroix suspect that in this same house Monet and Bazille, from the window of a friend's apartment, used to observe him at work in his garden studio. Usually they were able to discern only Delacroix's arm and hand, seldom more. They were astonished to see that the model did not actually pose but moved freely about while Delacroix drew it in action, and that sometimes he began to work only after the model had left.[31]

Among Delacroix's latest admirers there was also a young customs official, Victor Chocquet, who spent his meagre earnings on building up a collection of Delacroix's works. He even wrote to the painter, expressing veneration, and asked whether he would be willing to accept a commission for a portrait of Mme Chocquet. Delacroix declined, excusing himself because "for several years I have entirely given up doing portraits on account of a certain sensitiveness in my eyes."[32] Many years later, when Chocquet first met Cézanne, it was their mutual admiration for Delacroix that established the foundation for a long friendship. "Delacroix acted as intermediary between you and me,"[33] Cézanne used to say, and it is reported that both men had tears in their eyes when, together, they looked at the Delacroix watercolors owned by Chocquet.

Delacroix's death, on August 13, 1863, immediately inspired Fantin with the idea of painting a picture in the master's honor. Around a portrait of the artist he grouped those of his own friends and acquaintances who were, like himself, true admirers of Delacroix's genius. The group was almost identical with that which had approached Manet after his first exhibition at the Salon: Champfleury and Baudelaire —who actually disliked each other—Legros, Bracquemond, Duranty, Manet and Fantin, as well as Whistler. The latter had requested that a friend he had recently met in London, Dante Gabriel Rossetti, be included in the picture, but Rossetti was unable to come to Paris and sit for his likeness. According to Fantin his large canvas turned out to be too somber, too much black being used in the shadows; yet he was satisfied enough with the ambitious composition to send it to the Salon of 1864.

The excitement caused by the *Salon des Refusés* and by the death of Delacroix had hardly quieted down when the art world was again stirred up by an imperial decree published on November 13, 1863.[34] Although the *Salon des Refusés* had proved to be a "flop," inasmuch as the general public had sided openly with the jury and shown by its laughter and witticisms that it considered the rejections justified, the commission appointed to study means of improving certain obsolete rules had won the Emperor's approval of several drastic measures. (One of the most active members of this commission was the author and academician Mérimée, a personal friend of the monarch and supposedly the natural father of Duranty.) The new regulations abolished the Institute's supervision of the *Ecole des Beaux-Arts,* especially its right to appoint professors, a measure which deeply hurt Ingres.[35] These rulings also established a yearly instead of a biennial Salon and in addition provided that only one-fourth of the jury were to be nominated by the administration, while three-fourths were to be elected by exhibiting artists. To this clause, however, there was attached an important restriction: only those artists might vote who had already received a medal. Since all such artists were *hors concours,* the consequence was that the jury members were elected exclusively by artists who did not themselves have to submit their works to the jury. And there was no provision whatsoever for a renewal of the counter-exhibition.

A minor point which created great dissatisfaction at the *Ecole des Beaux-Arts* was the reduction of the age limit (from thirty to twenty-five) for those who wanted to compete for the *Prix de Rome.* Among those who signed a protest note—mostly candidates for the Rome prize—was Alfred Sisley.[36] But in general the new decree met with approval. An address to the Emperor, with praise for his liberal measures, was sponsored by Daubigny, Troyon, Chintreuil (one of the organizers of the *Salon des Refusés*) and about one hundred other artists. Neither Manet nor his friends, however, seem to have signed this address. Though delighted to see "the Institute chased from the *Ecole des Beaux-Arts,*"[37] as Cézanne put it, they were quick to realize that the new decree, beneath its apparent liberalism, was made up of

CABANEL: *The Birth of Venus. Engraving after the painting exhibited at the Salon of 1863 and purchased by the French Emperor.*

opportunist half-measures, which left the main problem untouched. After its generosity to the rejected artists in the organization of the *Salon des Refusés,* the government had now been careful not to extend to them any participation in the election of the jury; yet, by establishing an *elected* jury, the administration had rid itself of its responsibility. Furthermore, having broken the Institute's jurisdiction over the *Ecole des Beaux-Arts,* the government had immediately appeased the angry body of academicians by appointing as new teachers men chosen from among the Institute's members. Thus, very little was changed with regard to the situation as a whole, except perhaps that the newly nominated professors were less intransigent and more willing to compromise with public taste: that is to say, they were mediocre without even the excuse of being idealistic. Among these new professors were Gérôme and the creator of *Venus,* Alexandre Cabanel.

While these men were entering the *Ecole des Beaux-Arts,* others abandoned their own classes. Owing to the violent attacks of which he had been the subject, Couture finally decided, in this same year (1863), to close his studio and end his teaching. A few months later, at the beginning of 1864, Gleyre did the same, although for different reasons. Threatened with loss of sight and having great difficulty in meeting expenses out of his students' contributions, Gleyre, to Renoir's chagrin, gave up his classes, but not without advising both Monet and Renoir to continue to work and to make serious progress apart from his supervision.[38] The year 1864 thus found Sisley, Bazille, Renoir and Monet entirely on their own.

79

NOTES

1. Monet to Thiébault-Sisson; see Claude Monet, an Interview, *Le Temps,* Nov. 27, 1900.

2. Mme Lecadre to Gautier, 1862; see R. Régamey: La formation de Claude Monet, *Gazette des Beaux-Arts,* Feb. 1927.

3. Z. Astruc, quoted by M. de Fels: La vie de Claude Monet, Paris, 1929, p. 54.

4. See M. Elder: A Giverny chez Claude Monet, Paris, 1924, p. 19-20.

5. See Monet interview, *op. cit.*

6. A. André: Renoir, Paris, 1928, p. 8.

7. See J. Rewald: Renoir and his Brother, *Gazette des Beaux-Arts,* March, 1945.

8. For a complete record of Renoir's career at the *Ecole des Beaux-Arts* see R. Rey: La renaissance du sentiment classique, Paris, 1931, p. 45-46.

9. G. du Maurier: Trilby, London, 1895, ch. "Chez Carrel" (alias for Gleyre). Another description of an official studio is given by J. and E. de Goncourt: Manette Salomon, Paris, 1866, ch. V.

10. Raffaëlli *in* L'Art dans une démocratie, quoted by A. Alexandre: J. F. Raffaëlli, Paris, 1909, p. 31-32.

11. O. Redon: A soi-même, Paris, 1922, p. 22-24.

12. See C. Clément: Gleyre, étude biographique et critique, Paris, 1878, p. 174-176.

13. See A. Vollard: Renoir, An Intimate Record, New York, 1925, p. 31.

14. See E. Faure: Renoir, *Revue Hebdomadaire,* April 17, 1920; also C. L. de Moncade: Le peintre Renoir et le Salon d'Automne, *La Liberté,* Oct. 15, 1904.

15. See Rewald, *op. cit.*

16. See A. Segard: Mary Cassatt. Paris, 1913, note p. 47.

17. One of the paintings, representing *Lola de Valence,* was accompanied by the following quatrain by Baudelaire: Entre tant de beautés que partout on peut voir/ je comprends bien, amis, que le désir balance/ mais on voit scintiller en Lola de Valence/ le charme inattendu d'un bijou rose et noir.

18. P. Mantz: Exposition du Boulevard des Italiens, *Gazette des Beaux-Arts,* April 1, 1863.

19. Desboutin to Simonnet, April 17, 1874; see Clément-Janin: La curieuse vie de Marcellin Desboutin, Paris, 1922, p. 84-85.

20. *Moniteur,* April 24, 1863. On the Emperor's visit to the *Palais de l'Industrie* see E. Chesneau: Salon de 1863, *L'Artiste,* May 1, 1863; on his visit to the *Salon des Refusés,* see A. Proust: Edouard Manet, Paris, 1913, p. 46.

21. Chesneau, *op. cit.*

22. Castagnary: Le Salon des Refusés, *L'Artiste,* August 1, 1863; repr. *in* Salons (1857-1870), Paris, 1892, v. I, p. 155.

23. Whistler to Fantin, spring 1863; see L. Bénédite: Whistler, *Gazette des Beaux-Arts,* June 1905 (series of articles, May, June, August, Sept. 1905).

24. P. G. Hamerton: The Salon of 1863, *Fine Arts Quarterly Review,* Oct. 1863.

25. Z. Astruc: article in *Le Salon de 1863,* May 20, 1863; quoted by E. Moreau-Nélaton: Manet raconté par lui-même, Paris, 1926. v. I, p. 51-52.

26. Jongkind to Boudin, June 6, 1863; see G. Cahen: Eugène Boudin, Paris, 1900, p. 51.

27. See F. Desnoyers: Le Salon des Refusés, la peinture en 1863, Paris, 1863.

28. E. Zola: L'Oeuvre, Paris, 1886, ch. V.

29. Quoted by H. T. Tuckerman: Book of the Artists, American Artist Life, New York, 1867, v. II, p. 486.

30. P. Mantz: Le Salon de 1863, *Gazette des Beaux-Arts,* June 1863.

31. See G. Poulain: Bazille et ses amis, Paris, 1932, p. 47.

32. Delacroix to Chocquet, March 14, 1862; see J. Joëts: Les Impressionnistes et Chocquet, *L'Amour de l'Art,* April 1935.

33. Cézanne to Chocquet, May 11, 1886; see Paul Cézanne, Letters, London, 1941, p. 184.

34. On this decree see Nieuwerkerke's: Rapport à son Excellence le Maréchal de France, *Gazette des Beaux-Arts,* Dec. 1, 1863.

35. Ingres protested in: Réponse au rapport sur l'Ecole Impériale des Beaux-Arts, Paris, 1863. See also E. Chesneau: Le Décret du 13 Novembre et l'Académie des Beaux-Arts, Paris, 1864.

36. See H. Lapauze: Histoire de l'Académie de France à Rome (1853-1866), *La Nouvelle Revue,* June 1, 1909. For a diatribe against the *Ecole de Rome* and the distribution of the *Prix de Rome* see E. and J. de Goncourt, *op. cit.,* ch. XVI-XVII.

37. Cézanne to Coste, Feb. 27, 1864; see Paul Cézanne, Letters, p. 66.

38. See Poulain, *op. cit.,* p. 35.

1864-1866

BARBIZON AND ITS PAINTERS

NEW SALONS

SUCCESSES AND DISAPPOINTMENTS

MANET: *Portrait of Courbet, 1878. Drawing.*
Present owner unknown.

In the year prior to 1864 Monet and Bazille had spent their Easter holidays in Chailly, a village on the edge of Fontainebleau forest, not far from Barbizon. They had gone there for a week to do some studies of trees out-of-doors, in the woods that were famous for their enormous oaks and picturesque rocks. As soon as Bazille was back in Paris— he returned in order to continue his medical studies, which still took up half of his time—he informed his parents that he had been away with his friend, "who is pretty good at landscape; he gave me some advice that has helped me a great deal. . . . The forest is truly wonderful in certain sections."[1] It was indeed so wonderful that Monet stayed on alone, detained by the beautiful weather and by the work he had begun. His cousin and tutor, Toulmouche, did not

fail to remind him that, in his own opinion, "it's a serious mistake to have deserted the studio so soon," but Monet replied immediately: "I haven't at all deserted it. I found here a thousand charming things which I couldn't resist."[2]

Exactly one year later, after the closing of Gleyre's studio, Monet took his whole group of friends to Chailly and, together with Renoir, Sisley and Bazille, devoted himself to studies of forest interiors. Whereas for the others this seems to have been their first real contact with nature, for which the work at Gleyre's had hardly prepared them, Monet, owing to his friendship with Boudin and Jongkind, was simply continuing to develop the knowledge derived from their experience. His comrades naturally turned

81

Photograph of C. Daubigny, c. 1862. *Photograph of Camille Corot, c. 1867.*

to him for guidance. Soon, however, they also were to receive the advice of older men, the actual "masters of Barbizon," with whom they were brought in touch through chance encounters in the woods.

Barbizon had been popular among artists for almost twenty years. Théodore Rousseau had settled there first, in 1836, in order to get away from Paris, where he had become discouraged by lack of success at the Salons. Diaz, Millet, Jacque and scores of others had later joined him in the tiny village close to the forest, surrounded on three sides by a plain stretching as far as the eye could reach. Around Barbizon, with its whitewashed peasant cottages covered with thatched roofs overspread with patches of green moss, they found a rustic landscape that appealed to their longing for solitude and an intimate communion with nature; yet Paris was close enough to permit occasional visits which enabled these painters to remain in touch with the art movements there. As to Chailly, lying only a mile and a half away and hardly more than a large village, it was equally frequented by numerous artists.

There were two inns in Barbizon, monopolized, at least in summer, by painters who were scattered throughout the forest, dotting it with their white umbrellas. At the Auberge Ganne, where the pension was two francs and seventy centimes a day, the Goncourt brothers noticed with some dismay the "monotony of omelettes, the spots on the tablecloth, the pewter forks that stained the fingers."[3] The artists, however, cared less, since they did not go for gastronomic reasons but because Barbizon had become synonymous with landscape painting in general.

At Barbizon, Rousseau, Diaz and their friends, among them Corot and Daubigny, whose association with the group had been a more or less close one but who at one time or another had also worked in Fontainebleau forest, together had rediscovered nature. They tried to forget all the official precepts concerning historical and heroic landscapes with learned composition and endeavored instead to let themselves

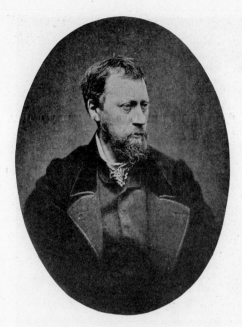

Photograph of J. B. Jongkind, 1862. *Photograph of Gustave Courbet.*

become steeped in the actual spectacle offered by rural surroundings. After long years of struggle they were slowly achieving fame, owing in part to the relentless efforts of their dealer, Durand-Ruel, and Rousseau had already seen, at the World's Fair of 1855, a whole room assigned to his works. Although the methods and conceptions of the Barbizon painters showed considerable differences, they had in common a complete devotion to nature and a desire to be faithful to their observations. Yet each of them deliberately saw in nature only those elements that corresponded to his own temperament and satisfied himself with the pursuit of one peculiar *note,* his own.

Rousseau, a meticulous draftsman, was striving to ally a minute consideration for detail with the achievement of a general harmony in which no single feature would distract the eye from the whole. His colors were low-keyed and equally subject to the general effect. Diaz, quite to the contrary, excelled in somber woodland interiors in which spots of light or strips of sky shining through the branches would create almost dramatic contrasts. A fanatic adversary of line as well as of the slick academic technique, he loved color and the rough texture of heavily applied paint. Corot preferred the hours of dawn or dusk, when light is tempered, when nature wraps itself in a transparent veil that softens contrasts, hides details and simplifies lines, planes, the essential forms and colors. For Millet, too, harmony of color consisted more in a just balance of light and dark than in a juxtaposition of specific colors. However, none of these painters actually worked in the open; they were mostly content to make sketches for pictures which they executed in their studios or, like Corot, they used to begin a canvas out-of-doors and finish it in the atelier. But in doing so they sought, as Rousseau said, to "keep in mind the virgin impression of nature."[4] Millet usually did not even take notes from nature. He could, he explained to the American painter Wheelwright, "fix any scene he desired to remember so perfectly in his memory as to be able to

DIAZ: *Forest Scene, d. 1867. 32 x 41½". City Art Museum, St. Louis.*

reproduce it with all the accuracy desirable."[5] The work in the studio, far from the distractions and temptations offered by nature, of course favored the obtaining of the desired effects, but it also exposed the artists to the danger of succumbing to a favored style while they transcribed their impressions without being able to control them on the spot. Baudelaire had already remarked that "style has unfortunate consequences" for Millet; "instead of simply extracting the inherent poetry of his subject," he wrote, "M. Millet wants at all costs to add something to it."[6] The new generation could not overlook the fact that the closer these painters remained to their impressions, the more they preserved their spontaneity, the better they escaped the dangers of style and mannerism.

When Monet and his friends came to Chailly, they consciously or unconsciously approached the forest with eyes that had been trained by interpretations received from the Barbizon painters. Sisley especially was deeply impressed with Corot's work, Renoir oscillated between Corot and Courbet, whereas Monet admired Millet. But unlike these masters they began, as Boudin had taught Monet, to do their work entirely in the open. While Renoir was thus working in his old porcelain-decorator's blouse, some loafers made fun of his costume until they were driven away by the heavy cane of a man with a wooden leg, who then looked at Renoir's canvas and said: "It's not badly drawn, but why the devil do you paint so black?"[7] The stranger was Diaz, who might have been attracted by Renoir's unusual attire because he himself had begun his career as a painter on porcelain.

Monet: *Le Pavé de Chailly, c. 1867. 38¼ x 51⅛". Durand-Ruel Galleries, New York.*

According to all who met him there seems to have been nothing in Diaz' mind which was not kindly and generous. Always cheerful in spite of his lameness, he was "obliging, good-natured and gentle as a lamb with those whom he liked. He was not jealous of his contemporaries and sometimes bought their pictures, which he showed and praised to everyone."[8] Diaz immediately took a great liking to Renoir, whose admiration for the older man grew as he came to know him better. Aware of Renoir's precarious financial situation (at Gleyre's studio he had often picked up the tubes thrown away by others and squeezed them to the very last drop), Diaz put his own paint-dealer's charge account at the disposal of his young friend and thus discreetly provided him with colors and canvas.[9] As to the advice he gave Renoir, it seems that Diaz told him "no self-respecting painter ever should touch a brush if he has no model under his eyes,"[10] although this was hardly the way in which he proceeded himself. And Renoir soon changed to brighter colors, much to the amazement of the more conservative Sisley.[7]

Renoir introduced his new acquaintance to his companions, who apparently also met Millet, possibly through Diaz. Unlike the latter, Millet never unbent to the first comer and always retained a sort of heavy dignity which checked any familiarity. His relations with Gleyre's former pupils cannot have been very close, and Monet seems never to have met him, for once when he saw Millet in a crowd and wanted to speak to him, he was held back by a friend who told him: "Don't go, Millet is a terrible man, very proud and haughty. He will insult you."[11] Nor did the young friends see much of Corot. "He was always sur-

COURBET: *Forest Scene. 21¼ x 28¾". Present owner unknown.*

rounded by a circle of idiots," Renoir remembered later, "and I didn't want to find myself a part of them. I liked him from a distance."[12] But once when he did speak to him, several years later, Corot told Renoir that "one can never be sure about what one has done; one must always go over it in the studio."[13] And to Gérôme's unhappy pupil Redon, Corot said: "Go to the same place every year, copy the same tree."[14]

While Monet and his friends had little contact with Corot, Pissarro seems to have seen him frequently, for he received permission to attach to the two landscapes which he sent to the Salon of 1864 the notation, *pupil of A. Melbye and Corot.* "Since you are an artist," Corot had told him, "you don't need advice. Except for this: above all one must study values. We don't see in the same way; you see green and I see grey and 'blond.' But this is no reason for you not to work at values, for that is the basis of everything, and in whatever way one may feel and express oneself, one cannot do good painting without it."[15] According to his friend Théophile Silvestre, Corot always "advised his pupils to choose only subjects that harmonize with their own particular impressions, considering that each person's soul is a mirror in which nature is reflected in a particular fashion. He often told them: 'Don't imitate, don't follow others; you'd stay behind them.' "[16] He also used to say, "I recommend to you the greatest naiveté in study. And do precisely what you see. Confidence in yourself, and the motto: Integrity and confidence."[17]

Of all those to whom he gave advice Corot seems to have felt himself in special sympathy with Berthe Morisot and her sister, to the extent of agreeing, contrary to his solitary habits, to dine every Monday at

CÉZANNE: *Forest Scene, 1865-68. 9⅛ x 11⅞". Collection Paul Cézanne, Paris.*

their parents' house. The two young artists had spent the summer of 1863 between Pontoise and Auvers on the Oise River, painting landscapes. With the ardor of neophytes they started off extremely early each morning, faithfully observing the advice of Corot. Their teacher, Corot's pupil Oudinot, introduced them to Daubigny, who lived at Auvers, and to Daumier, whose house was in a neighboring village. Berthe Morisot sent two landscapes done that summer to the Salon of 1864, where she exhibited for the first time, but unlike Pissarro she did not designate herself as a pupil of Corot, giving instead as references her former teacher Guichard as well as Oudinot.

Although Daubigny did not at that time work in Barbizon, his example was always present in the mind of Monet, who, from the very first, had felt a vivid admiration for him. Of all the landscapists of the period, except Boudin, Daubigny seems to have been the only one to work directly from nature. Through the freshness of his execution he retained in his canvases a certain character of improvisation which had put a serious obstacle to his being recognized. His paintings at the Salons had been regularly subject to violent attacks, and even Théophile Gautier, usually sympathetic to new efforts, could not help writing: "It is really too bad that this landscape painter, who possesses such a true, such a just and such a natural feeling, is satisfied by an *impression* and neglects details to this extent. His pictures are nothing but rough drafts, and very slightly developed rough drafts. . . . Each object is indicated by an apparent or real contour, but the landscapes of M. Daubigny offer merely spots of color juxtaposed."[18]

RENOIR: *Clearing in the Woods, c. 1865. 21½ x 32". Lefèvre Galleries, London.*

PISSARRO: *Montmorency Forest, c. 1867. 23⅝ x 28¾". Present owner unknown.*

SISLEY: *Fontainebleau Forest, d. 1865. 49¼ x 80¾". Petit Palais, Paris.*

MONET: *Forest Road, d. 1864. 16½ x 23¼". Wildenstein Galleries, London.*

COROT: *Daubigny Working on his* Botin *near Auvers-sur-Oise, d. 1860. 9⅝ x 13⅜". Knoedler Galleries, New York.*

Yet to summarize his impressions was precisely Daubigny's intention (in 1865, one critic even called him "chief of the school of the impression"[19]) and he was ready to sacrifice some of the literal truth so as to come closer to the expression of the ever changing aspects of nature. In order to carry out his purpose with greater ease he had, as early as 1857, constructed on a boat a small cabin painted with large stripes of various colors, and on this craft had made yearly excursions on the Oise. From his small boat he could paint in comfort the river traffic as well as the banks of the Oise, with their reflections in the water and with gentle hills in the background meeting the white clouds. Amused by the floating studio, christened "Le Botin," which was rowed by Daubigny's son, Corot had made an oil sketch of the painter working in the middle of the river.

In spite of the fact that Hamerton heartily disliked Daubigny's work because of its lack of drawing, that critic, in his review of the 1863 Salon, had designated the artist as "the chief of French landscape painters, so far as fame goes."[20] This statement seems, however, grossly exaggerated, for Daubigny's reputation was not secure even among his fellow artists, not to speak of the general public and the critics. When, in 1864, three-fourths of the jury members were elected for the first time by all the artists who had previously received medals, Corot alone of the great landscapists obtained enough votes to become a jury member, and even he lagged far behind Cabanel and Gérôme. Gleyre was elected only as a substitute, while Ingres did not gather sufficient votes to achieve even this modest success.

DAUBIGNY: *The Artist in his Floating Studio, 1861. Etching, 4 x 5⅛".* Baltimore *Museum of Art.*

DAUBIGNY: *The Ferry, c. 1860* [?]. *8 x 17½". E. and A. Silberman Galleries, New York. The prow appearing in the foreground is probably that of Daubigny's* Botin *which is being towed by the ferry.*

DAUBIGNY: *Evening, 22¾ x 36½". Metropolitan Museum of Art, New York.*

It soon became clear that the new jury, as even the "opposition" admitted, was more intelligent and generous in its admissions, more equitable and comprehensive in its distribution of awards. Not only did it reserve one room for the rejected and give a medal to Millet, but it accepted the works of several artists rejected the previous year. Manet exhibited two canvases, a *Christ with Angels* and a Spanish bull-fight scene painted from imagination; Fantin also showed two works, one of which was his *Hommage à Delacroix*. Without consulting either Manet or Fantin, Baudelaire recommended their paintings to a friend of his on the jury so that they would be favorably hung. And when a critic of the poet's acquaintance, W. Bürger, blended his praise with reproaches to Manet for imitating and copying Velasquez as well as Goya and Greco, Baudelaire immediately protested by letter, pretending that his friend had never seen works by Greco and Goya and that "these astonishing parallels may turn up in nature."[21] Yet it seems certain that the painter did see at the Louvre Louis Philippe's rich "Spanish Museum" (he was sixteen years old when it was dismantled after the revolution of 1848). W. Bürger, notwithstanding his doubts, loyally reproduced Baudelaire's letter and declared Manet "more of a painter in himself than the whole band of Grand-Prix-de-Rome recipients."[22]

Berthe Morisot and Pissarro had two landscapes each at the Salon, and Renoir, figuring in the catalogue as *pupil of Gleyre,* was represented by a painting entitled *La Esmeralda,* which he destroyed when it was returned to him after the closing, because his studies in Barbizon had in the meantime completely changed his point of view and stiffened his self-criticism. And Manet, discouraged by the violent attacks which he had again suffered, cut his bullfight scene to pieces, preserving only two fragments.[23] There is

92

MONET: *Farm in Normandy, c. 1863. 22 x 32½". Louvre, Paris.*

no record of Monet, Bazille or Sisley's having sent anything to the Salon. As for Cézanne, he had been rejected.

During the summer of 1864 one of the dramas of the American Civil War took place off the French Channel coast when a Confederate ship that had taken refuge at Cherbourg had to face a much superior Union ship on the open sea. Manet rushed to the scene and made notes for a painting of the *Kearsarge* sinking the *Alabama.* He exhibited the canvas a little later at Cadart's. At about the same time Manet made studies of horse races at Longchamps (where Degas had already worked in 1862) while Degas sketched several portraits of him. Degas also painted a likeness of Manet at home, listening to his wife, a Dutch musician whom he had married in the fall of 1863, playing the piano. This painting Degas offered to his model, but Manet, because he disliked the portrait of his wife, simply cut off that part of the canvas.[24]

Meanwhile Pissarro worked on the banks of the Marne, went to La Roche-Guyon near the Seine and visited his friend Piette on his farm in Montfoucault, working there in his company. At the same time Bazille in Paris presented himself for the dreaded medical examinations. While he awaited, not too confidently, the outcome, Monet persuaded him to accompany him to Honfleur, whence Bazille wrote his parents: "As soon as we arrived in Honfleur, we looked for landscape motifs. They were easy to find, because the country is heaven. One could not see richer meadows and more beautiful trees, everywhere there are cows and horses at pasture. The sea, or rather the Seine broadening out, gives a delightful horizon to the masses of green. We are staying in Honfleur itself, at a baker's, who has rented us two

MANET: *Combat of the* Kearsarge *and the* Alabama, *1864. 54⅝ x 51⅛". Philadelphia Museum of Art (J. G. Johnson Collection).*

small rooms; we eat at the Saint-Siméon farm, situated on the cliff a little above Honfleur; it's there that we work and spend our days. The port of Honfleur and the costumes of the Normans with their cotton caps, interest me greatly. I've been to Le Havre. . . . I had lunch with Monet's family; they are charming people. They have at Sainte-Adresse, near Le Havre, a delightful place. . . . I had to refuse the hospitable invitation they made me to spend the month of August there. I get up every morning at five o'clock, and I paint the whole day, until eight in the evening. However, you mustn't expect me to bring back good landscapes; I'm making progress and that's all—it's all that I want. I hope to be satisfied with myself

MANET: *Portrait of Zacharie Astruc, d. 1864. 35½ x 45¾". Kunsthalle, Bremen.*

after three or four years of painting. I'll have to go back to Paris soon and apply myself to that horrible medicine, which I more and more detest. . . ."[25]

The Saint-Siméon farm, where Boudin had once lodged Courbet and Schanne, was famous among artists on the coast. In fact, so many painters had worked there—Diaz, Troyon, Cals, Daubigny and Corot—that the rural inn above the Seine estuary had been called the "Barbizon of Normandy." During his sojourn there Bazille met Monet's friend Boudin, but he could not work beside them very long, since he had to return to Paris, where he learned that he had failed his examinations. He subsequently left for Montpellier, and his parents finally allowed him to give up medicine and devote himself solely to painting.

Not long after Bazille's departure, on July 15, Monet wrote him a long letter: ". . . Everyday I discover more and more beautiful things; it's enough to drive one mad, I have such a desire to do everything; my head is bursting with it! . . . I am fairly well satisfied with my stay here, although my sketches are far from what I should like; it is indeed frightfully difficult to make a thing complete in all aspects. . . . Well, my good friend, I intend to struggle, scrape off, begin again, because one can produce what one sees and what one understands. . . . It is on the strength of observation and reflection that one finds it. . . . What I'm certain of is that you don't work enough, and not in the right way. It's not with playboys, like your [friend] Villa and others that you can work. It would be better to be alone, and yet,

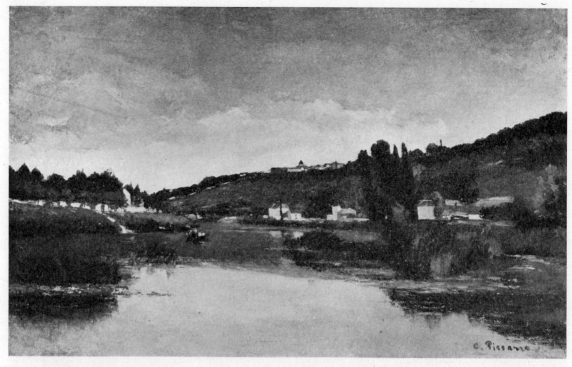

PISSARRO: *The Marne at Chennevières, 1864-65. 37¼ x 56¾". Probably exhibited at the Salon of 1865. Lefèvre Galleries, London.*

all alone, there are some things that one cannot fathom; well, all that is terrific and it's a stiff job. I have in mind splendid things for the time I shall be at Saint-Adresse and in Paris in the winter. Things are fine at Saint-Siméon and they often talk to me about M. Bazille."[26]

Some weeks later, in the fall, Monet again wrote from Honfleur to Bazille: "There are a lot of us at the moment in Honfleur. . . . Boudin and Jongkind are here; we are getting on marvelously. I regret very much that you aren't here, because in such company there's a lot to be learned and nature begins to grow beautiful; things are turning yellow, grow more varied; altogether, it's wonderful. . . . I shall tell you I'm sending a flower picture to the exhibition at Rouen; there are very beautiful flowers at present. . . . Now do such a picture, because I believe it's an excellent thing to paint."[27]

Monet was so possessed by his work that he repeatedly put off his departure. "I'm still at Honfleur," he wrote to Boudin, who had left, "it is definitely very hard for me to leave. Besides, it's so beautiful now that one must make use of it. And then I've worked myself up in order to make tremendous progress before going back to Paris. I am quite alone at present and, frankly, I work all the better for it. That good fellow Jongkind has left. . . ."[28]

During this same summer Monet also spent some time in nearby Sainte-Adresse with his family, but new disputes had quickly arisen, and the artist was finally entreated to leave and not return any too soon. Fearing that his parents might even cut off his allowance, Monet decided to send three paintings to Bazille in Montpellier; he asked him to see whether they would perhaps interest his neighbor, the

PISSARRO: *Path by the River, d. 1864. 22¼ x 17¾". Maryland Institute (G. A. Lucas Collection) on loan to the Baltimore Museum of Art.*

Photograph of Edouard Manet, 1863.

DEGAS: *Edouard Manet at the Races, c. 1864. Drawing, 12¾ x 9¾". Metropolitan Museum of Art, New York.*

collector and special patron of Courbet, M. Bruyas. "Of these three canvases," he explained, "there is a simple sketch which you saw me begin; it is based entirely on nature, you will perhaps find in it a certain relationship to Corot, but that this is so has absolutely nothing to do with imitation; the motif and especially the calm and misty effect are the only reasons for it. I have done it as conscientiously as possible, without having any painter in mind."[29] But Bruyas declined to buy any of the three canvases.

There can be no doubt that Monet was sincere in saying that he had no other artist in mind while he worked. From the very beginning he had shown an immense eagerness to learn but had always endeavored not to imitate his self-chosen masters. He was aware of the difficulties which confronted him and the need to develop his gifts. But he never doubted his abilities and was devoured by a steadily growing passion to create. It had been his particular luck to be formed by men like Boudin and Jongkind, who, far from trying to make proselytes, had striven to help him find his own personality. They had educated his eyes and doubtless given him technical advice, they had taught him the fundamental laws of their craft, but their own respect for nature had prevented them from imposing their vision on the

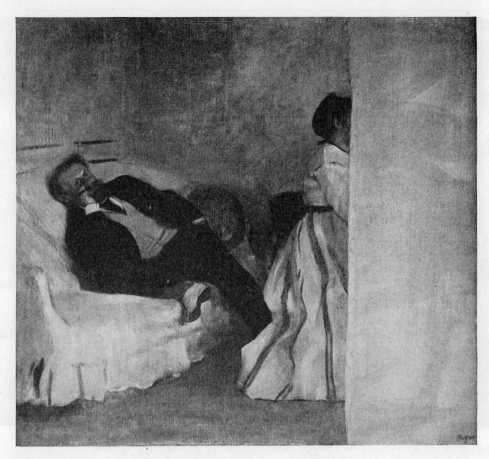

DEGAS: *Portrait of Manet Listening to his Wife Playing the Piano, c. 1864 [?]. Formerly owned by Manet who cut off the portrait of his wife. Present owner unknown.*

younger man. And Monet had been happy in their company because they treated him as a companion rather than a pupil, having esteem for his great susceptibility and need of freedom. Thus he had gained experience at their side and was working ever more strenuously to attain a perfect command of his perceptions as well as of his means of expression.

Since Jongkind was the stronger personality of the two friends, his ascendency over Monet probably was the more decisive one. Unlike Boudin he did not paint landscapes in the open, yet his sketches and watercolors done on the spot, his vivid brushstrokes and his intimate feeling for color helped him remain true to his observations and reproduce them in all their freshness. "I love this fellow, Jongkind," Courbet's friend Castagnary had written, "he is an artist to the tip of his fingers; I find him a genuine and rare sensibility. With him everything lies in the *impression*."[30] In order to be faithful to his impressions, Jongkind tried to represent in his works not what he knew of his subject but how it appeared to him under specific atmospheric conditions. Before he had come to Honfleur in the summer of 1864, he had painted two views of the apse of Notre-Dame in Paris, once in the silvery light of a winter morning

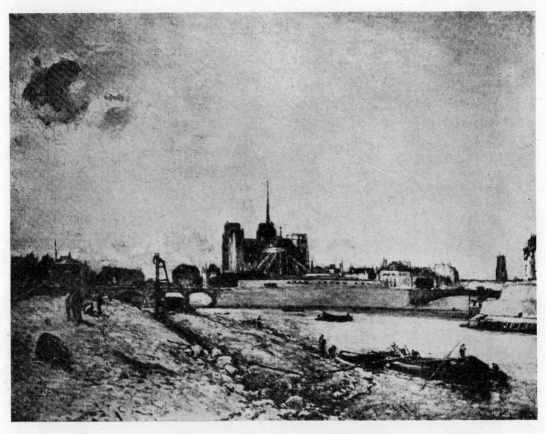

JONGKIND: *View of Notre-Dame, Paris, d. 1863. Collection C. Roger-Marx, Paris.*

and once under the flaming sky of a sunset. Several weeks or even months lay between the execution of these two paintings, but the artist had chosen in both cases to stand at the very same place and to reproduce what he saw. While under a bright light every architectonic detail had clearly appeared to him, these same details had vanished in the shadowy mass under the setting sun, and Jongkind had refrained from tracing in the flying buttresses when he could no longer perceive them distinctly. Thus replacing the form of reality by the form of appearance, Jongkind—as before him Constable and Boudin—had made atmospheric conditions the real subject of his studies. Monet was soon to follow him in the same direction, painting a road in Normandy once beneath a clouded sky and once covered by snow. In observing how the so-called "local colors" and known forms varied according to their surroundings, he made a decisive step toward the full understanding of nature.

Monet returned to Paris late in 1864 with a series of paintings, among them two marines which he intended to send to the Salon. In January 1865, Bazille rented the studio at 6 rue de Furstemberg from which they once had watched Delacroix at his easel, and Monet joined him. It was there that Pissarro came to see his old acquaintance from the *Académie Suisse,* accompanied by Cézanne. And Courbet came too, for in spite of his tireless self-admiration, he took a vivid interest in the efforts of the new generation and did not think it beneath his dignity to visit the studios of younger people.

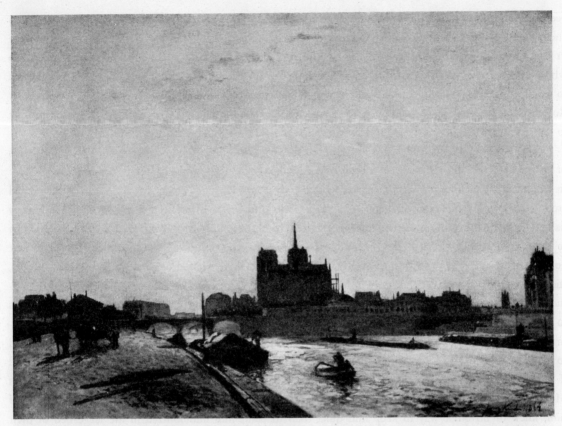

JONGKIND: *View of Notre-Dame at Sunset, d. 1864. Collection Mme G. Cachin-Signac, Paris.*

During this winter Monet and Bazille frequently visited Bazille's relative, the Commandant Lejosne, at whose home they met Fantin, Baudelaire, Barbey d'Aurevilly, Nadar, Gambetta, Victor Massé and Edmond Maître, who became a special friend of Bazille and Renoir. They apparently did not find Manet there, although he was a member of Lejosne's circle. Discussions at that period centered very often around musical questions and particularly around the much-debated art of Wagner, for whom Bazille had conceived a veritable passion which was shared by Baudelaire, Fantin and Maître, among others. They also greatly admired Berlioz. Together with Renoir and the judge Lascaux, of whose daughter Renoir had just painted a portrait, Bazille frequented the Concerts Pasdeloup and manifested his admiration loudly, if need be, against the protesting clamors. Cézanne, too, valued the "noble tones of Richard Wagner" and meditated upon painting a picture *Ouverture du Tannhäuser*,[31] whereas Fantin had already shown a *Scène du Tannhäuser* at the Salon of 1864.

Fantin was then working at a new composition, *Hommage à la vérité*, in which he again introduced likenesses of the same friends who had been represented in his *Hommage à Delacroix:* Bracquemond, Duranty, Manet, Whistler and himself, as well as Astruc (a patient, always welcome model for his colleagues; Manet had painted his portrait in 1864) and some others. Whistler appeared dressed in a colorful kimono. This time Fantin might well have added Whistler's friend Rossetti, for the latter had

been in Paris late in the fall of 1864, and Fantin had taken him in the master's absence to Courbet's studio and also to Manet's. But Rossetti's reactions had been such that they hardly warranted his appearance in a painting dedicated to realism. "There is a man named Manet," Rossetti had written his mother, "to whose studio I was taken by Fantin, whose pictures are for the most part mere scrawls, and who seems to be one of the lights of the school. Courbet, the head of it, is not much better."[32] Whereupon Rossetti had returned to London with the conviction that "it is well worth while for English painters to try and do something now, as the new French school is simple putrescence and decomposition."[32]

What Rossetti had considered a proof of putrescence—the eagerness for new expression in all fields of artistic activity, the effervescence that reigned among young artists, the animated discussions that treated theoretical issues with a vehemence as if life or death depended upon them, the battles that raged around paintings, symphonies or books—all these signs of a feverish intellectual activity, which formerly had delighted Monet, now seemed to interest him to a much lesser degree. He was eager to return to Fontainebleau forest, for he had in mind an ambitious composition of figures in the open, a subject not unlike Manet's *Déjeuner sur l'herbe* but, in contrast to that, painted as far as possible out-of-doors, showing a group of loungers not only in natural light against a real background but also in the casual attitudes and poses of an everyday picnic. Too large to be actually executed in the forest, the painting was to be done after numerous studies sketched on the spot. In April 1865, Monet was back in Chailly, looking for a suitable site, and he soon wrote Bazille, asking him to come in order to approve the choice and to pose for one or even several of the figures. "I think of nothing but my picture," he added, "and if I knew I wouldn't bring it off, I believe I'd go mad."[33] Bazille joined him, but shortly afterwards Monet was injured in the leg. In spite of his fury he had to stay in bed, and Bazille, who took care of him, knew of no other way to keep him quiet than to paint him immobilized in the large bed of their country inn. No sooner was he up again than Monet returned to work with renewed passion, whereas Bazille, in his spare time, sketched several landscapes at Chailly. Courbet came to watch Monet work while Bazille posed, and introduced the two friends to Corot. Renoir and Sisley also had returned to Fontainebleau but apparently had chosen quarters at the Auberge de la *mère* Anthony in the tiny village of Marlotte, where Monet and Pissarro seem to have joined them occasionally. Renoir had come with his younger brother Edmond, who accompanied the painters everywhere, carrying his share of equipment, drinking in their words, dumbfounded by their amazing remarks. Renoir now met his idol, Courbet, possibly through Claude Monet.

Meanwhile the time for the Salon had again come around. The jury, composed almost exactly as the previous year (although Corot had obtained even fewer votes), once more showed a certain clemency toward new talents. Fantin exhibited his homage to truth, now called *Le Toast,* Manet showed two paintings, *Christ Insulted by the Soldiers* and *Olympia* (painted in 1863), which he had sent at Baudelaire's insistence.[34] Berthe Morisot and Pissarro (pupil of A. Melbye and Corot) also had two canvases each accepted; so had Renoir, who was represented by a portrait of a man and a *Summer Evening.* But whereas Renoir again designated himself in the catalogue as a pupil of Gleyre, Monet, exhibiting for the first time, indicated no teacher. Edgar Degas, who was also showing for the first time, had sent a *War Scene from the Middle Ages,* a carefully composed but rather conventional work which he had probably executed several years earlier and for which he was complimented by Puvis de Chavannes. (The catalogue for 1865 and for several years after lists his name as his father spelled it: De Gas.)

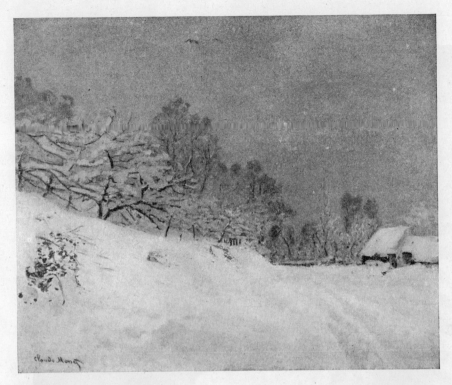

MONET: *Road near Honfleur in Winter, 1865. 32 x 39⅜". Present owner unknown.*

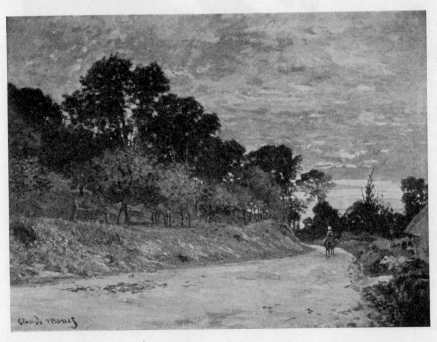

MONET: *Road near Honfleur, 1866. 23¼ x 31½". Present owner unknown.*

BAZILLE: *Monet after his accident at the Inn in Chailly, d. 1865. Collection Meynier de Salinelle, Montpellier.*

MONET: *Study for the Déjeuner sur l'herbe, d. 1866. 51⅛ x 48". Bazille posed for the man at the extreme left as well as for the one stretched out on the grass. Museum of Modern Western Art, Moscow.*

MONET: *The Lighthouse of Honfleur. Wood-engraving after a drawing by Monet, representing his paint-ing exhibited at the Salon of 1865; published in* L'autographe au Salon. *Present owner unknown.*

The two canvases shown by Monet were views of the Seine estuary, done the previous year at Honfleur. Since the works at the Salon were now hung in alphabetical order to prevent favoritism, Monet's works found themselves in the same room with Manet's. When Manet entered this room on the opening day, he had the disagreeable surprise of being congratulated by several persons upon his seascapes. Having studied the signatures on the two pictures attributed to him, Manet at first thought it to be some cheap joke, and his anger was conceivably not lessened by the fact that the seascapes continued to have more success than his own works. He left in a rage and openly complained to some friends: "I am being complimented only on a painting that is not by me. One would think this to be a mystification."[35]

As a matter of fact Monet's paintings immediately met with real success, and since they showed the same directness of approach, the same freedom of execution that characterized the works of Courbet and his followers (not to mention the similarity of his name and signature with Manet's), it was little surprising that they should have been ascribed, at first glance, to the author of the *Déjeuner sur l'herbe.* But the critics did not make this mistake and, while some of them sharply objected to Manet's paintings, they reserved applause for Monet. In a large album, *L'autographe au Salon,* there even appeared a sketch by Monet after one of his canvases, together with this comment: "Monet. The author of a seascape the most original and supple, the most strongly and harmoniously painted, to be exhibited in a long time. It has a somewhat dull tone, as in Courbet's; but what richness and what simplicity of view! M. Monet, unknown yesterday, has at the very start made a reputation by this picture alone."[36] This comment was signed *Pigalle,* and behind the pseudonym was doubtless hidden one of Monet's acquaintances, possibly Astruc, for the same album also reveals an unusual sympathy for Jongkind, Boudin *et al.* But

JONGKIND: *The Lighthouse of Honfleur, d. 1864. Etching after his painting exhibited at the Salon of 1865.*

not only friends sang Monet's praises; for instance, the reviewer for the *Gazette des Beaux-Arts,* Paul Mantz, wrote: ". . . . The taste for harmonious schemes of color in the play of analogous tones, the feeling for values, the striking point of view of the whole, a bold manner of seeing things and of forcing the attention of the spectator, these are qualities which M. Monet already possesses in high degree. His *Mouth of the Seine* abruptly stopped us in passing and we shall not forget it. From now on we shall certainly be interested in following the future efforts of this sincere marine-painter."[37]

This sudden and unexpected success was not only a great moral stimulant for Monet, it could not fail to impress favorably his family in Le Havre. But Monet did not stay long in Paris to savor his triumph; his large composition called him back to Chailly, and Bazille informed his parents: "Monet has had a much greater success than he expected. Several talented painters with whom he is not acquainted have written him complimentary letters. He is at the moment at Fontainebleau and I wish I were too."[38] It seems that before Monet left Paris, Astruc offered to Manet to introduce the newcomer, but, with a sweeping gesture, Manet is said to have refused.

Manet was profoundly depressed by the disastrous reception his canvases had met. "The crowd, as at the morgue, throngs in front of the gamy *Olympia* and the horrible *Ecce Homo* of M. Manet," wrote Paul de Saint-Victor.[39] And Jules Claretie spoke of those "two awful canvases, shams thrown to the crowd, jokes or parodies, what shall I say? Yes, jokes. What is this odalisque with yellow belly, a degraded model picked up I don't know where, and representing Olympia?"[40] Courbet, whose friend Castagnary had already accused Manet of "lack of conviction and sincerity,"[41] came out against the artist, too, comparing *Olympia* to a playing card. The discussions aroused by Manet's paintings put his

MONET: *The Lighthouse of Honfleur, 1864. Exhibited at the Salon of 1865. Present owner unknown.*

MANET: *Olympia, d. 1863. 51¼ x 74¾". Exhibited at the Salon of 1865. Louvre, Paris.*

MANET: *Bullfight in Spain*, 1866. 19¼ x 24". Art Institute, Chicago (Gift of Mr. and Mrs. M. A. Ryerson).

name forward to such a degree that Degas could pretend laughingly that his friend was now as famous as Garabaldi.

It must have seemed to Manet as if whatever he did appeared an offense to others. The delicacy of his color accords, the virtuosity with which he created harmonies of blacks, greys and whites enlivened by some strong or subtle notes, unexpected and delightful, the mastery with which he combined in his technique a clear and almost cold sense of lines and values with an execution full of temperament, all these rare gifts of the true painter seemed nowhere to find the slightest recognition. Touched by Manet's despair, Baudelaire wrote from Brussels a letter of encouragement and also asked a mutual friend to tell Manet "that turning on either a small or large amount of heat, that ridicule, insult, injustice, are excellent things and that he would be ungrateful if he were not to thank injustice . . . really, Manet has such brilliant and such delicate faculties that it would be a misfortune if he has become discouraged."[42]

It could be of little comfort to Manet that Courbet's picture at the Salon, a portrait of his friend Proudhon, who had just died, was also very badly received and that even the admirers of Courbet said they "had never seen such a bad painting" by the master.[43] Indeed, there was matter enough for concern, for Courbet's apparent weakness and Manet's so-called jokes set the adversaries of realism raving. The moment seemed particularly grave, and it looked as if the whole battle might have to be fought over again. "Today evolution is accomplished," wrote one critic. "There are no more Neo-Greeks, and the realists, too, are inclined to make themselves more scarce, as if, once the disease had vanished, the remedy had become useless. M. Courbet . . . retires. Of the younger people who, from near or far, followed in his path, some have been converted, others have left us. M. Alphonse Legros has gone to settle in London; M. Amand Gautier . . . has become exceedingly prudent. M. Carolus–Duran is in Rome and, one may anticipate . . . , he will return from there transformed. Clearly, enthusiasm is dying down, the group is confused and breaks up. The Salon offers us proof. One portrait painter who is, in a certain measure, connected with the school of whose decadence we are talking . . . M. Fantin, having conceived of uniting in *Hommage à la Vérité,* the last friends of nature, took all the trouble in the world to assemble a few realists and, since his picture could not remain empty, he was obliged to give a place . . . to M. Whistler, who lives in close communion with fantasy, to M. Manet, who is the prince of visionaries. It will be acknowledged that, the moment the creator of *Olympia* can pass as a realist, the confusion of Babel starts anew, intoxicated words speak nonsense, or rather, there are no more realists."[44]

Realist or not, Manet suddenly felt the urge to leave Paris; he decided to go to Spain, probably hoping to gain new inspiration from acquaintance with the country whose painters and whose life played such a large part in his conceptions and imagination. However, Manet did not follow the itinerary Astruc had arranged for him and spent only two weeks in Spain, writing to Fantin that decidedly Velasquez was "the painter of painters. He didn't surprise me, but he enchanted me. . . ."[45] Yet his short stay left a deep impression on the artist. Equally attracted by exoticism and the observation of reality, Manet now saw his dreams of Spain replaced by actual knowledge of the country, a country that was less romantic than he had thought. He seems to have realized that what the Spanish masters he so admired had done in depicting their own people he could do as well for his contemporary Paris. He left Spain poorer in colorful illusions but engrossed with a new approach to his surroundings. Thus the "Spanish period" of his evolution came to a nearly abrupt end after his visit to Spain, except for several bullfight scenes which he painted shortly after his return, from sketches done in Madrid.

COURBET: *Normandy Coast, c. 1865. 8½ x 16". Smith College Museum of Art, Northampton, Mass.*

In the meantime Monet was working again on the coast, this time in the company of Boudin and Courbet, whom Whistler joined. It was the first time that Monet painted actually beside Courbet and he was to draw new and decisive benefits from this experience. The same "broad principle" of Courbet that had once fascinated the hesitant Boudin now found a much prompter response in Monet, because he felt a need for a broad technique and an almost coarse style. In contact with nature Courbet was superb in his certitude, amazing in his dexterous handling of brushes and palette knife, instructive in his mastery of blending the delicate with the rough, and exciting in his animation, which made everyone happy and by his example communicated to others a real fever for working.

"Courbet," as Monet later remembered, "always painted upon a somber base, on canvases prepared with brown, a convenient procedure, which he endeavored to have me adopt. 'Upon it,' he used to say, 'you can dispose your lights, your colored masses; you immediately see your effect.' "[46] But Monet did not follow suit, he preferred white canvas, as Manet had been the first to do. By rejecting this century-old tradition (which Degas still respected), Monet renounced conceiving his paintings primarily in terms of light and dark masses, around which intermediary values were filled in. Working directly on the white canvas, he was able to establish his scale of values[47] without concern for predetermined effects, and although this system put a greater strain on his visual imagination—as long as the canvas was not completely covered he could not obtain an equilibrium of harmonies—he was rewarded by the generally lighter aspect of his work, obtained in spite of using mostly opaque colors.

Though Monet did not accept Courbet's old-master procedure, he acquired through him a preference

MONET: *Normandy Coast, c. 1865. Drawing, 6⅞ x 12¼". Private collection, New York.*

for large canvases, a preference shared by all his comrades. To find an outlet for their overflowing energies they thought nothing of covering thirty square feet of canvas, occasionally using the palette knife dear to Courbet. But whereas the huge stretchers invited the artists to paint broadly and vigorously, they also obliged them to proceed piece by piece, thus sometimes menacing the unity of the projected whole, and equally prevented them from working directly in the open. "I've seen Courbet and others who venture at large canvases, the lucky ones," Boudin writes his brother; "Monet has one to cover that's twenty feet in length."[48]

While painting in Trouville, where Daubigny also had arrived and where Monet apparently met him for the first time, Courbet enjoyed an immense popularity among the distinguished summer guests. His studio was invaded, as he said, by two thousand ladies, but among the abundance he was attracted only by "the beauty of a superb red-haired girl whose portrait I have started."[49] She was Jo, Whistler's Irish mistress, the same who had posed for his famous *White Girl* of the *Salon des Refusés*. Her portrait by Courbet shows, in contrast to his seascapes, a certain lack of vigor, which seems to explain why he was now favored by a public that heretofore had cared little for his "brutalities."

Near Fontainebleau forest, meanwhile, Sisley and Renoir were continuing to paint at Marlotte, where Sisley was doing a view of a village corner intended for the next Salon. Monet returned there, too, in order to finish the large canvas of his *Déjeuner sur l'herbe*. During the first weeks of 1866, doubtless because unable to work out-of-doors, Renoir painted some of his friends seated around a table *At the Inn of Mother Anthony,* a large composition that shows him, too, akin to Courbet. It represents

RENOIR: *At the Inn of Mother Anthony, Marlotte, d. 1866. 76 x 51". (From left to right: Nana, the painter Lecoeur, an unknown man, Mother Anthony, Sisley. On the wall a caricature of Murger.) National Museum, Stockholm.*

SISLEY: *Village Street in Marlotte, 1865-66. Exhibited at the Salon of 1866. Present owner unkown.*

among others the painter Lecoeur, Sisley holding before him the newspaper *L'Evénement* (to which Cézanne's friend Zola had just been appointed editor), Lecoeur's white poodle and Nana, the daughter of *mére* Anthony, said to have been rather generous in her favors to the guests of her mother, who herself appears in the background. On the wall one can make out a caricature of Murger, author of *La vie de Bohême.*

In Paris, Bazille had now decided to move to new quarters. On this occasion Monet did not follow him. "I'm not put out at living somewhat alone," Bazille wrote his parents. "There are a good many disadvantages in living two together, even when there is mutual understanding."[50] He also mentioned two canvases in preparation for the Salon, one of which represented a young girl at a piano. "Not being able to launch out into a large composition," Bazille explained, "I tried to paint to the best of my ability a subject as simple as possible. Besides, in my opinion, the subject has little importance as long as what I do is interesting from the point of view of painting. I chose the modern period, because that is what I understand best, what I find to be most alive for people who are alive, and that is what will get me rejected."—"I have an appalling fear of being rejected," he added (for this would be the first time he submitted anything to the Salon), "so I shall send at the same time a still life of fish, which will probably be accepted. . . . If I am rejected, I shall sign with both hands a petition requesting an exhibition for the *refusés.*"[51]

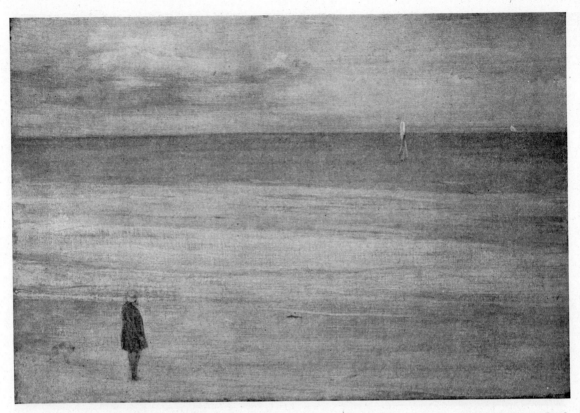

WHISTLER: *Courbet at Trouville—Harmony in Blue and Silver, 1865. 19½ x 29¾". Isabella Stewart Gardner Museum, Boston.*

Cézanne had even fewer illusions concerning his chances to be admitted. He actually enjoyed the idea of his works making "the Institute blush with rage and despair."[52] Since he saw in every refusal a confirmation of his originality, he did not suffer from the setback. Quite the opposite, according to one of his companions, he "hopes not to be accepted at the exhibition and the painters he is acquainted with are getting ready an ovation for him."[53] As for his friend Pissarro, he had had a serious discussion with Corot before submitting new works to the Salon. Corot was very severe and did not approve of the new tendency which his disciple was displaying, more or less under the influence of Courbet and Manet. Consequently Pissarro no longer designated himself as *pupil of Corot*.[54]

While Monet in Chailly was putting the final touches to his huge composition, Courbet, who had grown fond of him to the extent of helping him financially, paid him a visit and suggested a few last-minute changes. Monet heeded the advice, to his regret, for the canvas which he had intended for the Salon no longer satisfied him in its new form. He took it from the stretcher, rolled it and, unable to pay his landlord, left it behind in Chailly, where it started to rot.[55] Instead, he painted within a few days a large full-length portrait of a young girl, Camille, whom he had apparently met shortly before and who was soon to share his misery, his hopes and his disappointments.

Courbet: *Jo, the Beautiful Irish Girl (Whistler's Mistress), 1865. 25 x 20¾". William Rockhill Nelson Gallery, Kansas City.*

NOTES

1. Bazille to his parents, Easter 1863; see G. Poulain: Bazille et ses amis, Paris, 1932, p. 34.
2. Monet to Toulmouche, May 23, 1863; see R. Régamey: La formation de Claude Monet, *Gazette des Beaux-Arts,* Feb. 1927. This letter as well as information supplied by Poulain, *op. cit.,* contradicts Monet's often repeated account that he spent only two weeks at Gleyre's, after which period he induced Bazille, Renoir and Sisley to leave the studio with him. Monet has frequently tried to emphasize his independence as manifested already in early days, but his versions do not always withstand thorough investigation. He also very often made errors in dates, etc. Information supplied by Monet himself therefore should not be taken at face value.
3. Goncourt brothers quoted by M. Donel: Barbizon, *L'Art Vivant,* Sept. 15, 1926; see also E. and J. de Goncourt: Manette Salomon, Paris, 1866, ch. LXXI.
4. Rousseau to a friend; see A. Stevens: Le Salon de 1863, Paris, 1866, p. 73.
5. E. Wheelwright; Recollections of Jean François Millet, *Atlantic Monthly,* Sept. 1876.
6. C. Baudelaire: Salon de 1859, ch. VIII; repr. *in* L'art romantique.
7. See A. Vollard: Renoir, An Intimate Record, New York, 1925, p. 33-34.
8. T. Silvestre: Histoire des artistes vivants, Paris, 1856, p. 226. On Diaz see also J. Claretie: Peintres et sculpteurs contemporains, Paris, 1873, p. 33-34, and J. La Farge: The Higher Life in Art, New York, 1908, p. 122.

9. See A. André: Renoir, Paris, 1928, p. 34.

10. See J. Rewald: Renoir and his brother, *Gazette des Beaux-Arts,* March 1945.

11. See R. Gimpel: At Giverny with Claude Monet, *Art in America,* June 1927.

12. See André, *op. cit.,* p. 57.

13. Quoted by M. de Fels: La vie de Claude Monet, Paris, 1929, p. 92.

14. O. Redon: A soi-même, Paris, 1922, p. 36.

15. Quoted by A. Alexandre: Claude Monet, Paris, 1921, p. 38.

16. See Silvestre, *op. cit.,* p. 92-93.

17. Corot to Auguin, Aug. 20, 1859; see E. Moreau-Nélaton: Corot raconté par lui-même, Paris, 1924, v. I, p. 125.

18. T. Gautier quoted by E. Moreau-Nélaton: Daubigny raconté par lui-même, Paris, 1925, p. 81.

19. See J. Laran: Daubigny, Paris, n.d.[1912], p. 14.

20. P. G. Hamerton: The Salon of 1863, *Fine Arts Quarterly Review,* Oct. 1863.

21. Baudelaire to Bürger, 1864; see C. Baudelaire: Oeuvres complètes, Paris, 1918-1937, v. VIII.

22. W. Bürger: Salon de 1864; repr. *in* Salons, 1861-1868, Paris, 1870, v. II, p. 137-138.

23. These fragments are: *Toreros in Action,* Frick Collection, New York, and *The Dead Torero,* National Gallery of Art, Washington, D. C. (Widener coll.). They are reproduced *in* Jamot, Wildenstein, Bataille: Manet, Paris, 1932, v. 2, p. 158-159.

24. According to Mme Ernest Rouart, daughter of Berthe Morisot and niece of Manet, this double portrait was painted in 1877 (see *ibid,* v. I, p. 94) but for stylistic reasons an earlier date seems more probable. Manet himself, around 1867, painted his wife at the piano, in the same corner of their apartment, rue de Saint-Pétersbourg (see *ibid,* v. II, p. 50).

25. Bazille to his parents, spring 1864; see Poulain, *op. cit.,* p. 40-41.

26. Monet to Bazille, July 15, 1864; see Poulain, *op. cit.,* p. 38-39. There are differences in syntax and expression between this document as reproduced in Poulain's book and in the same author's article: Un languedocien, Frédéric Bazille, *La Renaissance,* April 1927.

27. Monet to Bazille, fall 1864; see Poulain, *op. cit.,* p. 44.

28. Monet to Boudin, fall 1864; see G. Cahen: Eugène Boudin, sa vie et son oeuvre, Paris, 1900, p. 61.

29. Monet to Bazille, Oct. 14, 1864; see Poulain, *op. cit.,* p. 45.

30. Castagnary: article in *L'Artiste,* Aug. 15, 1863.

31. See M. Scolari and A. Barr, Jr.: Cézanne in the letters of Marion to Morstatt, 1865-1868, *Magazine of Art,* May 1938 (a series of three articles, Feb., April, May 1938).

32. Rossetti to his mother, Nov. 12, 1864; also letter to his brother, Nov. 8, 1864; see D. G. Rossetti: His Family Letters, London, 1895, v. II, p. 179-180.

33. Monet to Bazille, spring 1865; see Poulain, *op. cit.,* p. 50.

34. See J. de Biez: Edouard Manet, Paris, 1884, p. 21.

35. See Thiébault-Sisson: Claude Monet, an Interview, *Le Temps,* Nov. 27, 1900. Monet places this incident in 1866, but in that year Manet had no painting accepted by the jury; this must therefore have happened in 1865. See also E. Moreau-Nélaton: Manet raconté par lui-même, Paris, 1926, v. I, p. 90.

36. Pigalle: L'autographe au Salon, Paris, 1865.

37. P. Mantz: Salon de 1865, *Gazette des Beaux-Arts,* July 1865.

38. Bazille to his family, spring 1865; see Poulain, *op. cit.,* p. 49.

39. P. de Saint-Victor, article in *La Presse,* May 28, 1865, quoted by E. Moreau-Nélaton: Manet raconté par lui-même, Paris, 1926, v. I, p. 69.

40. J. Claretie: Deux heures au Salon de 1865; *in* Peintres et sculpteurs contemporains, Paris, 1873, p. 109.

41. Castagnary, article in *L'Artiste,* Aug. 15, 1863.

42. Baudelaire to Mme Paul Meurice, May 24, 1865; quoted by Moreau-Nélaton, *op. cit.,* p. 71. See also J. J. Jarves: Art Thoughts, Boston, 1869, p. 269.

43. W. Bürger: Salon de 1865; *op. cit.,* v. II, p. 269.

44. P. Mantz: Salon de 1865, *Gazette des Beaux-Arts,* July 1865. On Fantin's *Toast* see L. Bénédite: Le "Toast" par Fantin-Latour, *Revue de l'art ancien et moderne,* Jan., Feb. 1905. Fantin destroyed the painting after it returned from the Salon, preserving however Whistler's portrait, now in the Freer Gallery, Washington, D. C.

45. Manet to Fantin, summer 1865; see Moreau-Nélaton, *op. cit.,* v. I, p. 72. On Manet's trip to Spain see L. Rosenthal: Manet et l'Espagne, *Gazette des Beaux-Arts,* Sept., Oct. 1925.

46. See M. Elder: A Giverny chez Claude Monet, Paris, 1924, p. 52.

MONET: *Village Street in Normandy [probably Pont-l'Evèque], c. 1865. 22¾ x 24". Collection John T. Spaulding, Boston.*

47. See de Trévise: Le pèlerinage de Giverny, *Revue de l'art ancien et moderne,* Jan., Feb. 1927.

48. Boudin to his brother, Dec. 20, 1865; see G. Jean-Aubry: Eugène Boudin, Paris, 1922, p. 62.

49. Courbet to Bruyas [?], 1865; see P. Borel: Le roman de Courbet, Paris, 1922, p. 99.

50. Bazille to his parents, Feb. 1866; see Poulain, *op. cit.,* p. 62. Monet lived with Bazille from Jan. 15, 1865, to Feb. 4, 1866.

51. Bazille to his parents, beginning 1866; *ibid.* p. 63.

52. Cézanne to Pissarro, March 15, 1865; see Cézanne, Letters, London, 1941, p. 68-69.

53. See Scolari and Barr, *op. cit.*

54. See E. Moreau-Nélaton: Corot raconté par lui-même, Paris, 1924, v. II, p. 22.

55. See Poulain, *op. cit.,* p. 57, also G. Geffroy: Claude Monet, sa vie et son oeuvre, Paris, 1924, v. I, ch. VI, and de Trévise, *op. cit.*

CÉZANNE: *Portrait of Valabrègue, c. 1866. 45⅝ x 38⅛". Probably the portrait rejected at the Salon of 1866.
Collection J. V. Pellerin, Paris.*

Among the jury members of 1866 were not only Corot but also Daubigny, who, just as Delacroix before him, now tried to induce his colleagues to show a more open mind in their admissions. When Cézanne's portrait of his friend Valabrègue, a rather coarsely painted canvas, came up for decision, Daubigny did his best, to no avail, and Valabrègue informed a comrade: "Paul will without doubt be refused at the exhibition. A Philistine in the jury exclaimed on seeing my portrait, that it was not only painted with a knife but even with a pistol. Many discussions already have arisen. Daubigny said some words in defense [of the portrait]. He declared that he preferred pictures brimming over with daring to the nullities which appear at every Salon. He didn't succeed in convincing them."[1]

This new rejection did not come unexpectedly to Cézanne. It may have disturbed him even less than in former years, since a friend of his, Antoine Guillemet, met at the *Académie Suisse,* had just shown some of his still lifes to Manet, who had considered them "powerfully handled." Thereupon Cézanne had paid a visit to Manet, and the latter had promised to call on him in his own studio. "Cézanne is very happy about this," Valabrègue recorded, "though he does not expatiate about his happiness and does not insist on it as is his wont."[1]

Manet himself had not been more successful this year than Cézanne. Apparently considering that its previous tolerance toward him had not received the approval of the critics and the public, the jury now rejected the two canvases Manet had submitted. Guillemet and several other young artists of the "realist school" had similar experiences. Monet, however, had both his *Camille* and a *Road in Fontainebleau Forest* accepted, while his friend Bazille saw his apprehensions justified: his *Girl at the Piano* was rejected and only the *Still Life of Fish,* for which he cared less, was admitted to the Salon. As Renoir had done before, Bazille designated himself in the catalogue as *pupil of Gleyre,* and so did Sisley, who exhibited

two paintings. Of the group of four from Gleyre's studio, only Monet never publicly indicated his former teacher.

Pissarro (now once more simply *pupil of A. Melbye*) this time had but one landscape accepted; Berthe Morisot again had two in the exhibition; and Degas showed a scene from the races. As for Renoir, he was so anxious to learn the outcome that he went to the *Palais de l'Industrie* and waited there for the jury members' departure. But when he caught sight of Corot and Daubigny, he felt too timid to ask them about his canvas; instead, he introduced himself as a friend of Renoir, inquiring whether his work had been accepted. Daubigny immediately remembered the painting, described it to Renoir and added: "We are very disappointed on your friend's account, but his picture is rejected. We did everything we could to prevent it, we asked for that picture again ten times, without succeeding in getting it accepted; but, what do you expect, there were six of us on his side against all the others. Tell your friend not to become discouraged, that there are great qualities in his picture. He should make a petition and request an exhibition of *Refusés*."[2]

It is not known whether Renoir heeded this advice, or whether Bazille, Guillemet or Manet protested against their rejections. Cézanne, however, did so. When the first letter to the Director of Fine Arts, Count Nieuwerkerke, remained without answer, he unhesitatingly mailed a second, dated April 19, 1866.

"Sir," wrote Cézanne, "Recently I had the honor of writing to you concerning the two pictures that the jury has just turned down. Since I have had no reply, I feel compelled to insist on the motives which caused me to apply to you. As you have no doubt received my letter, I need not repeat here the arguments that I thought necessary to submit to you. I shall content myself with saying once more that I cannot accept the unfair judgment of colleagues whom I myself have not commissioned to appraise me. I am, therefore, writing to you to emphasize my demand. I wish to appeal to the public and show my pictures in spite of their being rejected. My desire does not seem to me extravagant, and if you were to ask all the painters in my position, they would reply without exception that they disown the jury and that they wish to take part in one way or another in an exhibition which should be open as a matter of course to every serious worker. Therefore, let the *Salon des Refusés* be re-established. Even were I to be there alone, I ardently desire the public to know at least that I do not wish to be confused with these gentlemen of the jury any more than they seem to wish to be confused with me.—I hope, Monsieur, that you will not choose to remain silent. It seems to me that any decent letter deserves a reply."[3]

This letter, which appears to reflect the attitude of the entire group, was no more favorably received than its forerunner. If Cézanne was honored by an answer at all, its general tenor can be deduced easily from the marginal note made by an official on the original letter: "What he asks is impossible. We have come to realize how inconsistent with the dignity of art the exhibition of the *Refusés* was, and it will not be re-established."

There can be no doubt that Cézanne in writing his letter was aided by his old comrade Zola, whose skillful journalistic mixture of impertinence, pride and mockery can be detected without difficulty. Even before Cézanne had joined him in Paris, Zola had shown a great interest in art, but ever since he had visited the *Salon des Refusés* together with Cézanne (who also took him to the studios of some friends), the problems of the new movements in art had preoccupied him intensely. Through Cézanne he had made the acquaintance of Pissarro, Guillemet and others in whose company Manet's paintings were often discussed and, while employed at the Hachette publishing house, he had met Duranty, who also had

FANTIN-LATOUR: *Portrait of Ingres, d. 1865. Drawing, 6⅞ x 4⅝". Art Institute, Chicago.*

INGRES: *Portrait of Count Nieuwerkerke, d. 1856. Drawing, 13⅛ x 9½". Fogg Art Museum, Cambridge, Mass. (G. L. Winthrop Bequest).*

spoken to him of Manet. In January 1866, after having published a rather sad and sentimental novel dedicated to Cézanne, that did not attract great attention, Zola had left Hachette and become book reviewer for the widely-read daily newspaper *L'Evénement*. In 1865 he had already been discussing Proudhon's posthumously published *Du principe de l'art et de sa destination sociale* and had visited Courbet's studio before attacking in the name of independence the theories of that master's friend. To Proudhon's definition of art, "an idealistic representation of nature and of ourselves, with a view to the physical and moral perfecting of our species," he had opposed his own concept of a work of art as a "bit of creation seen through the medium of a powerful temperament." Zola had stressed the importance of "temperament" just as Baudelaire had stressed it in admiring Manet, and he had stated that his own admiration for Courbet was not conditioned by the painter's social views but by the "energetic manner in which he has grasped and conveyed nature."[4]

From long discussions with Cézanne and his friends Zola had drawn the conclusion that an artist "exists by virtue of himself and not of the subjects he has chosen." "The object or person to be painted are pretexts," he had written, "genius consists in conveying this object or person in a new, more real or greater sense. As for me, it is not the tree, the countenance, the scene offered to me which touches me: it is the man I find in the work, the powerful individual who has known how to create, alongside God's

world, a personal world which my eyes will no more be able to forget and which they will recognize everywhere."[4]

These convictions Zola decided to emphasize in a long series of articles after he had learned of the numerous rejections by the jury and had witnessed the failure of Cézanne's appeal for a new *Salon des Refusés*. He obtained upon request a special assignment to review the Salon of 1866 for *L'Evénement* and set to work even before the Salon had been opened. In a short notice announcing his articles he proclaimed, concerning the jury: "I have a violent suit to bring against it. I shall no doubt annoy many people, as I am quite resolved to speak awkward and terrible truths, but I shall experience an inner satisfaction in getting off my chest all accumulated rage."[5]

Zola's first two articles dealt with the jury, with its election by those who did not have to submit works themselves, the manner in which it passed judgment, mostly guided by indifference, jealousy, rancor or design, and the principles (or lack of principles) according to which it "hacks at art and offers the crowd only the mutilated corpse." His exposé culminated in the request for a new *Salon des Refusés*: "I entreat all my colleagues to join with me, I should like to magnify my voice, to have supreme power to obtain the reopening of those exhibition rooms where the public would judge the judges and the condemned in turn."[6]

No sooner had Zola begun this series than he paid a visit to Manet, to whom he was introduced by Guillemet and Duranty. In the painter's studio he examined the rejected canvases together with earlier works and discussed with Manet his views and his attitude in the face of the laughing public. This visit left Zola with a deep impression of the man and his talent. He now wrote a special article devoted to the rejected artist, an unheard-of procedure for a Salon review. Analyzing Manet's personality, Zola went so far as to predict: "M. Manet's place in the Louvre is marked out, like that of Courbet, like that of any artist of original and strong temperament."[6]

In order to prove that he was not in favor of any special school or group, Zola, in the next article, made a study of the realists at the Salon. "The word 'realist' means nothing to me who asserts that the real should be subordinated to temperament," he said, explaining that he cared little for a "realistic subject" if it was not treated in an individual manner. He gave high praise to Monet, whom he did not yet know personally but of whom Cézanne and Pissarro must have spoken. "Here is a temperament, here is a man in the midst of that crowd of eunuchs!" he exclaimed, ". . . a delicate and strong interpreter, who has known how to convey each detail without falling into dryness."[6]

Meanwhile, however, the editorial office of *L'Evénement* had been flooded with letters of protest, indignation and threat, demanding "to improve the criticism a little by placing it in hands that have been washed."[7] Obliged to satisfy his readers, the editor made a compromise with Zola whereby the latter was to publish only three more articles (instead of the dozen still planned), while a critic of less heretical convictions was allotted the same number so that he might cover with glory the official artists whose talent Zola denied. But Zola, disgusted, did not even take advantage of this arrangement and contented himself with two more articles. In one he discussed the decline of some of the masters he admired—Courbet, Millet and Rousseau—accusing them of having lost much of their vigor and explaining the success they now had on the grounds that "the admiration of the crowd is always in indirect ratio to individual genius. You are the more admired and understood as you are the more ordinary."[6]

Zola devoted his last article to a few comments on the artists at the Salon whom he esteemed, Corot,

CÉZANNE: *Self Portrait, 1865-66. 16⅛ x 17¾". Formerly in the collection of Emile Zola. Collection R. Lecomte, Paris.*

Daubigny and especially Pissarro (the last admitted only after great difficulties, overcome apparently by Daubigny's insistence). "M. Pissarro is an unknown, about whom no one will probably talk," wrote Zola. "I consider it my duty to shake his hand warmly, before I leave. Thank you, Monsieur; your winter landscape refreshed me for a good half hour, during my trip through the great desert of the Salon. . . . You should realize that you will please no one, and that your picture will be found too bare, too black. Then why the devil do you have the arrant clumsiness to paint solidly and to study nature frankly; . . . An austere and serious kind of painting, an extreme concern for truth and accuracy, a rugged and strong will. You are a great blunderer, sir,—you are an artist that I like."[6]

It may seem surprising that Zola nowhere mentioned Cézanne, not even among those painters toward whom the jury had been too harsh. But in those days he considered Cézanne still far from having given the full measure of his genius, especially since the artist himself very seldom showed satisfaction with his paintings. Therefore Zola apparently preferred to await some major works. However, when he reprinted his articles in a small brochure, published in May 1866, under the title *Mon Salon* and with the motto: "What I seek above all in a picture is a man and not a picture," Zola wrote a special preface in letter form, *To my Friend Paul Cézanne*. In this he exalted their ten-year-old friendship. "You are my whole youth," he said, "I always find you mingled in each of my joys, in each of my sufferings. Our minds, in their kinship, developed side by side. . . . We turned over a mass of shocking ideas, we examined and rejected all systems, and after such strenuous labor, we told ourselves that outside of powerful and individual life there was nothing but deceit and stupidity."[8] And Cézanne, in reply to this tribute which established his spiritual collaboration upon *Mon Salon,* painted with the palette knife a huge portrait of his father reading a newspaper that bears in large letters the title *L'Evénement.*

Of all the friends who exhibited at the Salon, it was again Monet who obtained the greatest success, although his works were badly hung. Zola had not been the only one to recognize that powerful talent; Bürger had praised both *Camille* and the *Road in Fontainebleau Forest,* stating that "when one is truly a painter, one does all that one wishes."[9] Castagnary also had written a few well-meaning lines, commending Monet as a new recruit to the camp of the "naturalists," under which term he united "the whole idealistic and realistic younger generation."[10] Even those reviewers who disliked *Camille* devoted considerable space to it, and Astruc managed to introduce the young artist to Manet, who received him with the same friendliness as he had Cézanne shortly before. Monet's success was complete when Ernest d'Hervilly wrote a poem on *Camille* published in the periodical *L'Artiste,* and when he was commissioned to paint a small version of the picture which a dealer intended for the United States.[11] The papers again carried Monet's name to Le Havre and won him once more the esteem of his family. With their esteem came—temporarily at least—a resumption of his allowance.

The designation "naturalist," coined by Castagnary as early as 1863, is an eloquent proof of the fact that the efforts of the new generation could no longer be covered by the word "realism." Courbet, and especially Proudhon, had narrowed its sense to such an extent that it applied less to a concept and a technique than to subject matter. Manet's romantic interest in Spain, the other painters' almost exclusive devotion to landscape, their complete disregard for the social implications of their subjects, made it necessary to create a new word for them.

"The naturalist school," Castagnary explained, "declares that art is the expression of life under all phases and on all levels, and that its sole aim is to reproduce nature by carrying it to its maximum power

CÉZANNE: *Portrait of the Artist's Father Reading* L'Evénement, *1866-68. 78¾ x 47¼". Collection R. Lecomte, Paris.*

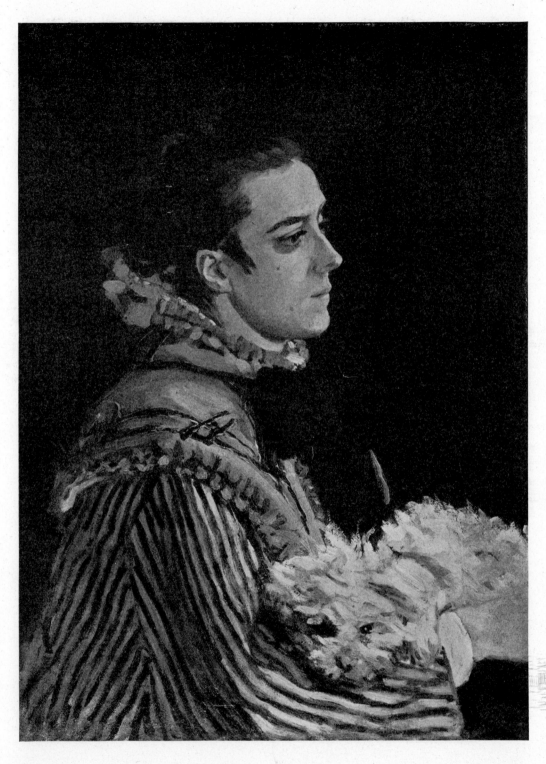

MONET: *Portrait of Camille, d. 1866. 28¾ x 21¼". Collection Col. and Mrs. R. W. Reford, Montreal.*

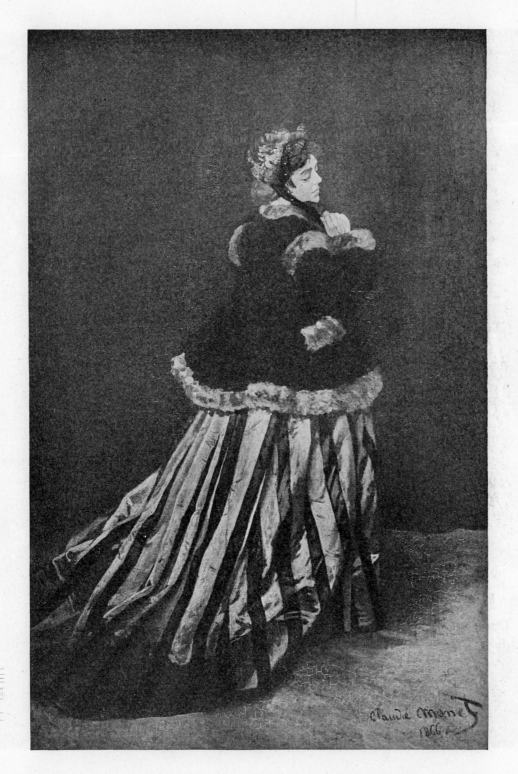

MONET: *Camille, d. 1866. 91½ x 60". Exhibited at the Salon of 1866. Kunsthalle, Bremen.*

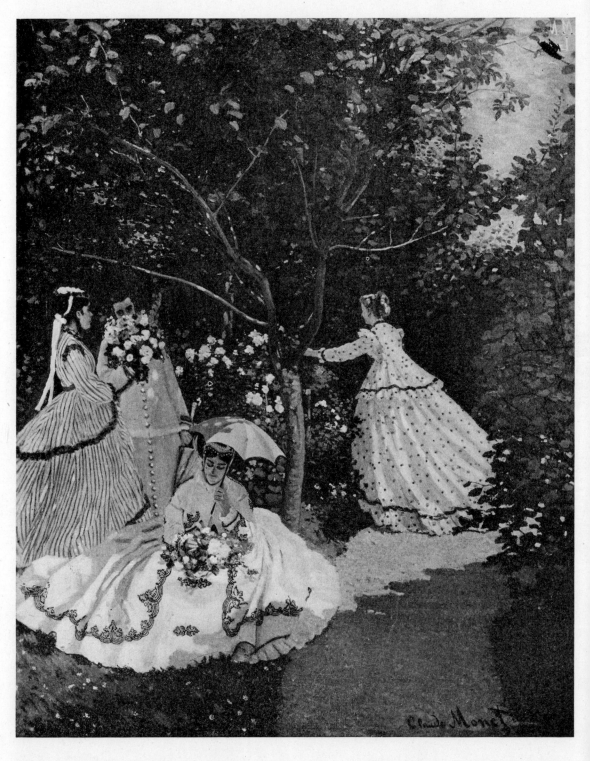

MONET: *Women in the Garden, 1866. 100¼ x 81¾". Formerly in the collection of Bazille, later in that of Manet. Louvre, Paris.*

and intensity: it is truth balanced with science.—The naturalist school re-establishes the broken relationship between man and nature. By its twofold attempt, in the life of the fields, which it is interpreting with so much uncouth force, and in town life, which reserves for it the most beautiful triumphs, the naturalist school tends to embrace all the forms of the visible world. It has already brought back to their true role line and color, which in its works no longer part. By placing the artist again in the center of his time, with the mission of reflection, it determines the genuine utility, in consequence, the morality of art."[12]

Whence does it come?" Castagnary asked. "It is the outcome of the very depths of modern rationalism. It springs from our philosophy, which, by putting man back into society from which the psychologists have withdrawn him, has made society the principal object of our scrutiny from now on. It springs from our ethics, which, by putting the commanding idea of justice in place of the vague law of love, has established the relationship between men and illuminated with a new gleam the problem of destiny. It springs from our politics, which, by positing as a principle the equality of individuals and as a *desideratum* the equalizing of conditions, has caused false hierarchies and deceptive differentiations to disappear from the mind. It springs from all that is ourselves, from all that makes us think, move, act."[12]

And Castagnary added: "Naturalism, which accepts all the realities of the visible world and, at the same time, all ways of understanding these realities is . . . the opposite of a school. Far from laying down a boundary, it suppresses all barriers. It does not do violence to the temperament of painters, it liberates it. It does not bind the painter's personality, but gives it wings. It says to the artist: 'Be free!' "[13]

Manet and his friends, however, seem to have cared little for this designation, but Zola was to take it up with fervor and use it both in connection with his artist friends and with his own literary tendencies. Yet, whether they called themselves "naturalists" or not, it remains true that Castagnary's definition applied extremely well to the efforts of the young painters.

Monet, meanwhile, continued to devote himself undisturbed to what he called "experimenting with effects of light and color."[14] He had decided to do some cityscapes and was working on a balcony of the Louvre palace, from which he painted a view of the church *St. Germain l'Auxerrois* as well as the *Garden of the Princess* with the Pantheon in the background. This canvas he sold to Latouche, who had a small paint shop where his artist customers used to meet in the evening. Latouche also occasionally bought their works and exhibited them in his window. When he thus displayed Monet's *Garden of the Princess* to passers-by, Daumier impatiently summoned him to take this "horror" out of the window, while Diaz manifested great enthusiasm and predicted that Monet would go far. Manet also stopped in the street, it seems, and said disdainfully to some friends: "Just look at this young man who attempts to do the 'plein air'! As if the ancients had ever thought of such a thing!"[15] But Monet's ambition went even further: he wanted now to execute large paintings with figures *entirely* in the open. In Ville d'Avray near St. Cloud, where he spent the summer (and where Corot usually lived), he had a trench dug in his garden, into which he could lower a huge canvas in order to work at the upper part. In this fashion he painted *Women in the Garden,* for which Camille posed, while Courbet came from time to time and watched with amusement. When Courbet found him idle one day and asked the reason, Monet explained that he was waiting for the sun. "Never mind," the other answered, "you could always do the landscape background."[16] Monet did not accept this advice, for he knew that he could obtain complete unity only if the whole painting was executed under always identical conditions of light; otherwise, there seemed no reason to go to the trouble of doing it out-of-doors.

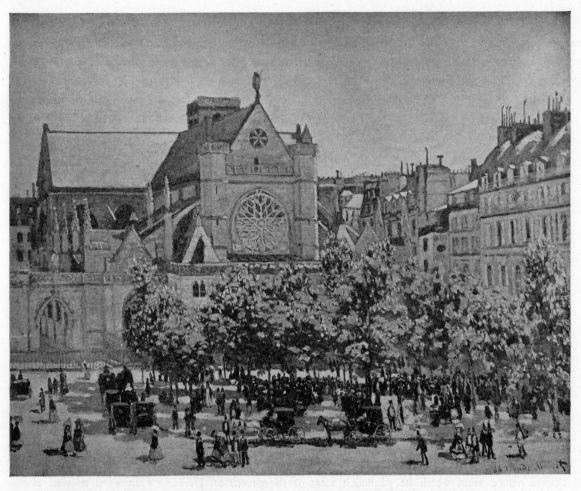

MONET: *Saint-Germain l'Auxerrois, Paris, d. 1866. 32 x 39⅜". National Galerie, Berlin.*

Photograph of the same subject, 1938.

MONET: *The Garden of the Princess, Paris, 1866. 36¼ x 24⅜". Present owner unknown.*

At that time Monet's work was being done with large brushes in rapid strokes; he applied colors thickly and enjoyed the rough texture of the pigment. He vigorously insisted on forms yet treated them mostly as flat surfaces offset by deep shadows. Although these shadows are no longer bituminous, as in official Salon pictures—they are, in fact, sometimes surprisingly light in tone—their heavy masses divide the canvas brutally into lighted and unlighted areas. His opaque colors endeavor to depict light without being themselves penetrated by it. In combination with these opaque colors Monet occasionally resorted to the use of bright, pure blues, reds or yellows, the vivid accents of which enliven the entire composition.[17] When he painted in the fall of 1866 the *Terrace at the Seaside near Le Havre* he not only made extensive use of such unmixed colors, he also adopted in various places, short, small strokes which dot the canvas in an attempt to reproduce textures as well as vibrations of light. He had used the same technique for the blooming chestnut trees in front of *St. Germain l'Auxerrois,* opposing the dotted foliage to the more or less uniform masses of architecture and sky. Through his colors and his execution, but also through his somewhat unsentimental approach to nature, Monet overcame Courbet's influence and began to adapt the latter's "broad principles" to a vision and technique all his own.

Curiously enough, at the very moment when Monet was leaving Courbet's path and when the master himself, to his admirers' regret, was beginning to show a tendency toward the pretty, which earned him compliments even from Cabanel, Courbet's impact on Monet's friends appeared stronger than ever. Sisley alone seemed to escape it, his faithfulness to Corot being not only a question of conviction but also of disposition. But Renoir, Pissarro and Cézanne were all now trying in one way or another to appropriate those "broad principles" of Courbet's earlier works, not hesitating even to imitate his palette-knife technique. Cézanne, whose vision was scarcely affected by direct studies of nature, marveled at Courbet's "unlimited talent, for which no difficulty exists,"[18] and tried to combine the master's vigor with his own admiration for the Spanish. Unlike the author of *Olympia,* however, Cézanne's inspiration was derived not from virtuosos like Velasquez and Goya; his preference was for the more dramatic effects of Zurbaran and Ribera, whose chiaroscuro contrasts Cézanne attempted to impregnate with Courbet's monumental simplifications and with colors that show occasional indebtedness to Manet.

In a letter written to Zola in the fall of 1866 Cézanne explained that "pictures painted indoors, in the studio, will never be as good as things done outside. When out-of-door scenes are represented, the contrast between the figures and the ground is astounding and the landscape is magnificent. I see some superb things and I shall have to make up my mind to do only things out-of-doors."[19] But Cézanne did not make up his mind, and among his works of this period there are few that appear to have been done in the open.

Oscillating between observation and the strange and violent dreams with which his imagination seemed to overflow, Cézanne sometimes succeeded, sometimes failed to dominate his visions. But whenever he was able to unite the baroque tendencies of his fantasy with the study of reality—and here Courbet's influence seems to have been most salutary—he created works of unsuspected power. His chromatic sensibility indulged in vibrant contrasts, and his still lifes and portraits, as compared with those of Manet and Monet, show an even greater simplification of forms, a bolder technique and stronger oppositions of color. Cézanne "is growing greater and greater," a friend of his wrote in 1866. "I truly believe that of us all it is he who will turn out to have the most violent and powerful temperament. Nevertheless he is continually discouraged."[20] But whenever his doubts were mastered, Cézanne's works

MONET: Terrace at the Seaside near Le Havre, 1866. 23½ x 31½". Collection the Rev. T. Pitcairn, Bry-Athyn, Penn.

MONET: *The Harbor of Honfleur, d. 1866. 59½ x 91". Probably the painting exhibited at the Salon of 1868. Present owner unknown.*

MONET: *The Havre Jetty, c. 1868. 57⅞ x 89". Probably the painting rejected at the Salon of 1868. Private collection, France.*

MONET: *The Beach at Sainte-Adresse, d. 1867. 22¼ x 32¼". Art Institute, Chicago (Mr. and Mrs. L. L. Coburn Collection).*

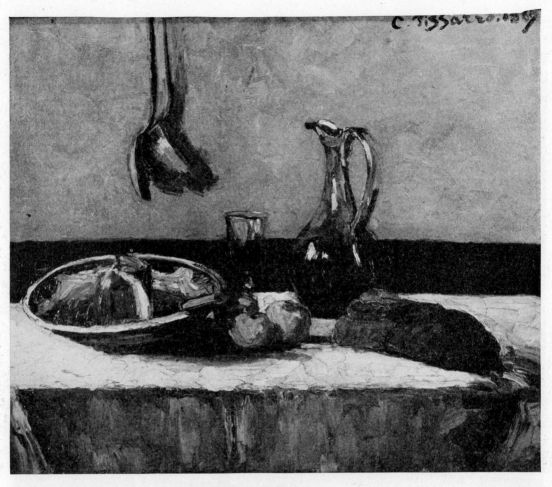

PISSARRO: *Still Life, d. 1867. 32 x 39½". Viau Estate, Paris.*

GUILLAUMIN: *Still Life, d. 1867.* **18** x 21⅞". *Present owner unknown.*

138

CÉZANNE: *Still Life, c. 1870. 24⅞ x 31½". Collection G. Bernheim de Villers, Paris.*

reflected a superb self-confidence and audacity, though his style varied among diametrically opposed modes of expression, revealing him in search of an appropriate technique. Portraits done with a palette knife alternated with imaginary scenes such as *The Rape,* which he gave to Zola and in which he used small, comma-like brushstrokes, whereas his still lifes are painted with large brushes in big strokes. "Cézanne keeps on working violently and with all his might to regulate his temperament and to impose upon it the control of cold science,"[20] commented one of his friends.

Pissarro was likewise attracted by Courbet's palette-knife methods and executed a few canvases in this technique, among them a still life that bears a strong resemblance to Cézanne's treatment of analogous themes. It is likely, however, that Pissarro's painting was done before Cézanne adopted a similar style of expression. But Pissarro abandoned it soon, since his sensitivity and perception called for a more subtle representation of nature. He had settled down in 1866 at Pontoise, not far from Paris, where the hills around the town, the orchards and the Oise River offered a great variety of tranquil subjects. He depicted these sometimes in large canvases reminiscent of Courbet, although he preferred broad brushes to the palette knife and adopted a scale of subdued colors, browns and greys and various low greens, never

CÉZANNE: *The Rape, d. 1867. 35¼ x 46". Formerly in the collection of Emile Zola. Collection J. M. Keynes, London.*

using the colors pure as they came from the tube. Though large in size and execution, his canvases still retain some of the intimate quality of Corot as opposed to the more robust character of Courbet.

Some of the others, too, succumbed for a moment to this robust character, a fact of which Bazille's portrait of Sisley and early works by Pissarro's friend Guillaumin bear proof; even Degas, in his portrait of *Mlle Fiocre in the Ballet "La Source"* is revealed to have carefully studied Courbet's colors. But Renoir was more than the others fascinated by Courbet's example. Apparently unable yet to grasp the exact nature of his manifold gifts, Renoir seems to have tried his hand at various modes of expression. Less ready than Monet to disregard the heritage of the past, desirous rather to remain within the framework of tradition instead of breaking away from it, he at this time went through a phase of experimentation. Averse to everything even slightly methodical, Renoir was far from Monet's single-mindedness of purpose and thought nothing of essaying a wide range of styles, from Courbet's palette knife to almost academic conceptions. It is probable, however, that he did so not out of hesitancy but because he wanted to acquaint himself with different methods and because his amazing facility permitted him to oscillate between

CÉZANNE: *The Negro Scipion, 1866-68. 42 x 33½". Collection Michel Monet, Giverny.*

CÉZANNE: *Forest Scene, 1865-68. 25½ x 21¼". Formerly A. Vollard collection, Paris.*

RENOIR: *The Painter Lecoeur in Fontainebleau Forest, d. 1866. 41¾ x 31¼". Knoedler Galleries, New York.*

FANTIN-LATOUR: *Still Life, d. 1866. 23¼ x 28¾". Exhibited at the Salon of 1866. National Gallery of Art, Washington, D. C. (Chester Dale loan).*

extremes without much effort. His casual inconsequence could have disconcerted his companions had they not known that Renoir was somehow never too "serious" about what he did. There was no "system" in his evolution; he always felt perfectly free to follow his fancy wherever it might lead him, ready to look for new solutions should he not find satisfaction in any given direction. He knew nothing of Manet's ambition and hurt pride because he had neither ambition nor pride. He was spared Cézanne's burning doubts and Monet's bitter struggles, the self-consciousness of Degas and the solemn eagerness of Bazille because he was neither introspective nor an introvert; in spite of his utter poverty he was carefree and gay because he found complete happiness in his work. As he had already told Gleyre, he painted for his own enjoyment, and his pleasure amply justified the various styles which he took up as enthusiastically as he dropped them. Even if a work did not fulfill his expectations, no minute ever seemed lost to him if spent with brushes and paints.

In Fontainebleau forest, Renoir had painted with the palette knife some landscapes which are closer to Courbet than almost anything done by the rest of the group, but this technique did not satisfy him because it prevented him from retouching any part of his canvas without first scraping it. These landscapes were therefore succeeded by a large flower still life in delicate shades, executed with a smooth brushwork that shows a certain relationship to the still lifes Fantin was then beginning to paint, except

RENOIR: *Still Life, d. 1866. 41 x 31½". Fogg Art Museum, Cambridge, Mass. (G. L. Winthrop Bequest).*

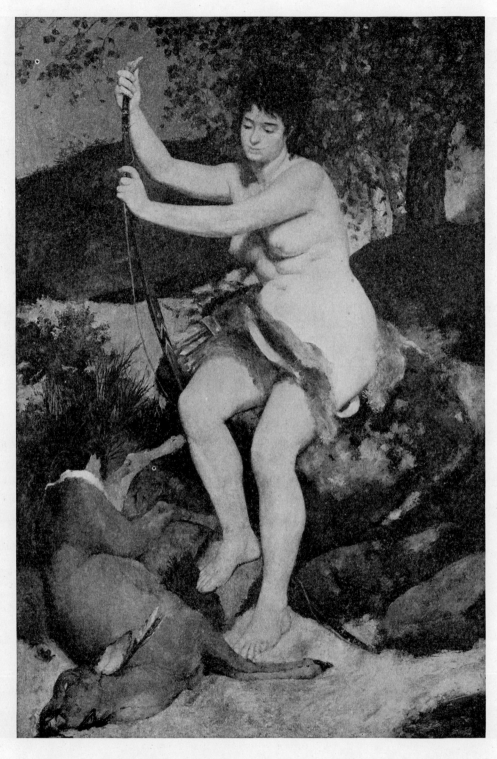

RENOIR: *Diana, d. 1867. 77 x 51¼". Rejected at the Salon of 1867. National Gallery of Art, Washington, D. C. (Chester Dale loan).*

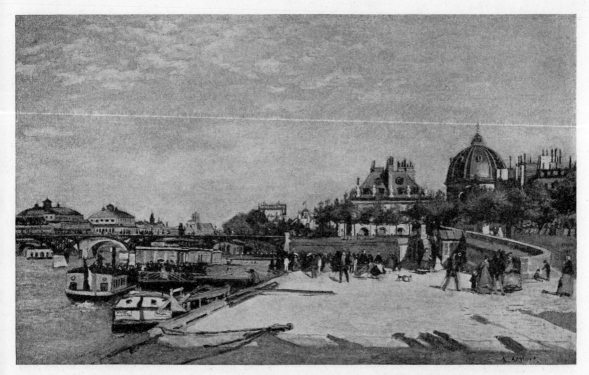

RENOIR: *The Pont des Arts, Paris, c. 1868. 24½ x 40¼". Private collection, New York.*

that Fantin was not devoid of a certain dryness, whereas Renoir handled the subject with tenderness and a subtle feeling for textures. Yet he suddenly turned again to Courbet's palette knife for a huge painting of a nude, in which he strangely combined realism and academicism without taking full advantage of the former nor escaping the dangers of the latter. He might have hoped that such a compromise would once more open to him the doors of the Salon, but he was already too fond of nature to engage himself further in a direction that prevented his spontaneity from expressing itself.

While Monet and his friends thus absorbed to various degrees the influence of Courbet and while they endeavored to find in the master's art those elements that might help them to develop and define their own personalities, Whistler, in England, tried to turn away from his past. He, too, had profited from Courbet and had since 1859 gone through similar experiences; he had last worked beside Courbet at Trouville in 1865, but one year later, after long self-examination, he began to deny his indebtedness to Courbet and to curse "Realism."

"The period when I came [to Paris] was very bad for me!" he exclaimed in a letter to Fantin. "Courbet and his influence were disgusting. The regret I feel and the rage and even hatred that I have for that now would perhaps astonish you, but here is the explanation. It isn't poor Courbet who revolts me, nor is it his works. I admit, as always, their qualities. Nor am I complaining of the influence of his painting on mine. There wasn't any, and none will be found in my canvases. It couldn't be otherwise, for I am very personal and I was rich in qualities which he had not and which were adequate for me. But here is why all that was extremely harmful for me. It is because that damned Realism made an

immediate appeal to my painter's vanity and, sneering at all traditions, cried aloud to me with the assurance of ignorance: 'Long live Nature!' Nature, my dear boy, that cry was a great misfortune for me. Where could one find an apostle readier to accept this thesis so convenient for him, this sedative for all restlessness? Why, the fellow had only to open his eyes and paint what happened to be before him, beautiful nature and the whole mess. It was just that! Well, one would see! And we saw the *Piano, The White Girl,* the *Thames,* the view of the sea . . . , that is, canvases produced by a spoiled child swollen with the vanity of being able to show painters splendid gifts, qualities that required only a strict training to make their possessor a master, at this very moment, and not a debauched schoolboy. Oh, my friend, if only I had been a pupil of Ingres! I don't say this out of enthusiasm for his pictures. I like them only moderately. . . . But, I repeat, if only I had been his pupil! What a teacher he would have been! How he would have guided us sanely!"[21] And Whistler went on, loathing color, "the vice," which had made him neglect drawing.

In his distress Whistler evidently forgot that the strict training he desired was not the work of a teacher but of the pupil's own discipline. Manet's long apprenticeship at the *Ecole des Beaux-Arts* had failed to impregnate him with those Ingresque principles of drawing which now appeared to Whistler as ultimate salvation; and Degas' work outside the *Ecole* had not prevented him from remaining closer to Ingres than any of the master's direct pupils. Their education had been entirely their own, as was that of Monet and his friends, who had chosen to heed Courbet's call to nature. The development of their personalities was not due to their strictly following any master's doctrines but to the choice they had made from what their elders offered, to their adopting only what suited their own temperaments and remaining free to go their own ways. What Whistler did not grasp was that nature, too, imposed "strict training" on those who knew how to approach it. By turning his back to nature, by ignoring Courbet's message, Whistler henceforth condemned himself never to penetrate beneath the surface of appearances, to be satisfied with decorative arrangements. Instead of acquiring a discipline, he succumbed on the contrary to a dexterity which checked any progress. It was precisely the absence of contact with nature that favored the development of his virtuosity and induced him to put taste above creative power.

Whistler's friend Fantin was also to take a course that led him away from nature and imprisoned him in a formula which lacked both imagination and strength. Abandoning positive colors and vivid brushwork, he endeavored in portraits and still lifes to renounce his own personality in order to obtain an almost photographic precision. Whether this was the result of too many copies done in the Louvre it is hard to judge, but the fact remains that his works began more and more to acquire a lusterless quality of meticulous and uninspired reproduction. Thus these two artists who at the start had found themselves on the path of realism and had given great promise, little by little abandoned the group of their former companions and detached themselves from a movement of which they might have become eminent representatives. The others meanwhile continued the study of nature, often under very difficult conditions, but with the unalterable conviction of progressing in the right direction, a certainty that gave them courage to endure adversity and keep on without hesitating.

After having finished or almost completed his *Women in a Garden* at Ville d'Avray, Monet left that spot for Le Havre in the fall of 1866, apparently to escape his many creditors. With a knife he slit the canvases he could not take with him, about two hundred according to his own estimate,[22] but even this did not prevent them from being seized and sold in lots of fifty at 30 francs a lot. In Le Havre, Monet

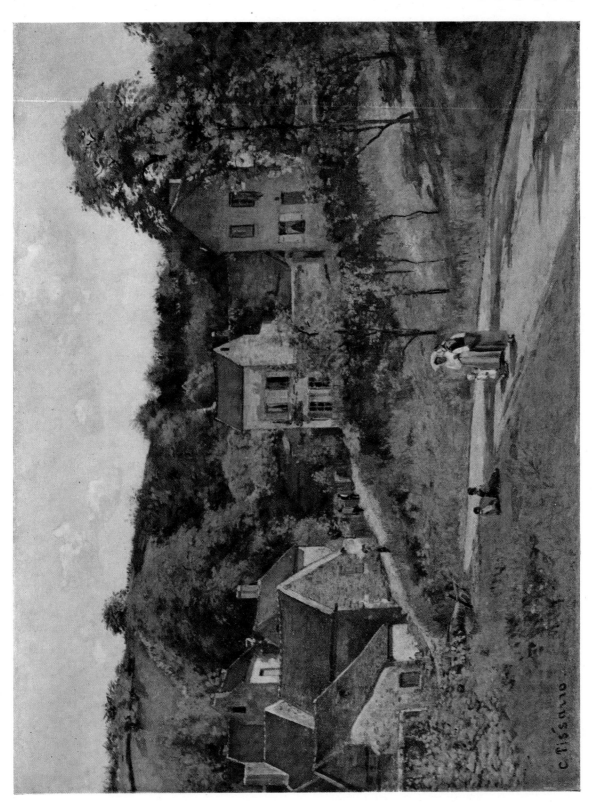

Pissarro: The Hermitage at Pontoise, c. 1867. 59⅛ x 78¾". Collection J. K. Thannhauser, New York (on loan to the National Gallery of Art, Washington, D. C.).

could not manage to solve his financial embarrassments any better than in Ville d'Avray. In order to continue work he begged Bazille in December to send him a series of pictures left in Paris so that he might scrape them and use the canvases for new paintings.[23]

A few weeks later Boudin, then in Paris, received a letter dated from Honfleur in which a friend told him: "Monet is still here, at work on enormous canvases, which have remarkable qualities, but which I nevertheless find inferior, or less convincing, than the famous *Robe* [*Camille*], which merited him a success that I understand and that is deserved. There is a canvas nearly three meters high with width in proportion: the figures are a little less than life-size, these are women in elegant costume picking flowers in a garden, a canvas begun from nature and out-of-doors. There are qualities in it, but the effect seems to me a little dimmed no doubt because of a lack of opposition, for the color is vigorous. He is also undertaking a large marine, but it is not yet sufficiently advanced to be able to judge. He has also done some rather effective snow scenes. The poor fellow is very anxious to know what is happening in the studios: every day he asks me if I have news of you. . . ."[24]

What made Monet's position particularly precarious was the fact that Camille was expecting a child and that there seemed nowhere any hope for easier days ahead. To help him Bazille decided to buy the *Women in the Garden* for the high price of 2,500 francs, to be paid, however, in monthly installments of 50 francs. Though his wealthy parents provided him with a sufficient allowance and though he was always certain to have a roof and bread—a certainty which his friends must have envied—Bazille was in no position to be generous, and even these 50 francs evidently taxed his monthly budget heavily. But he endeavored to do what he could and readily shared his meals and studio with any one of his three companions from Gleyre's; in 1867 Renoir took advantage of this generosity, and in the following year Sisley and Monet, too, dropped in at Bazille's studio in the rue de la Paix in the Batignolles quarter. But in spite of his good intentions Bazille's response to letters begging for money was always slow, if it was made at all, a circumstance that often infuriated Monet. Since Bazille did not himself know what it meant to get up in the morning without a single penny in the house, he somehow failed to realize, especially at a distance, how desperate the situation of his friends sometimes was. And there also was a certain monotony in these constant cries for help addressed to him, the only person from whom the others dared expect some relief, a monotony that weakened Bazille's sensitiveness to these appeals. The result was some bitter quarrels with Monet, who reproached him for insufficient promptness, but the discord never lasted long, because Bazille's friendship and affability could not be seriously doubted.

Good will and affability, however, were not enough to pull Monet out of his predicament. Bazille's fifty francs a month, and the amount of two hundred francs for which he managed to sell a still life by Monet to the Commandant Lejosne, were far from enough for Monet's own needs, not to speak of Camille's. Bazille therefore took it upon him to write directly to Monet's father and to explain to him the dire difficulties in which the son found himself. The answer was polite but in the nature of an ultimatum. Claude Monet was welcome in the house of his father's sister, Mme Lecadre, at Sainte-Adresse; there he would find a room and meals—of money he would receive none. As for Camille, the father calmly suggested that his son separate from her once and for all.[25] Obliged to yield, Monet had to leave Camille temporarily in Paris without any financial support, while he went to stay with his aunt in Sainte-Adresse. He could not even raise the train fare in order to visit her after she had given birth to their son Jean, in the month of July. Bazille agreed to be godfather to the child.

MORISOT: *Paris seen from the Trocadero, 1866. 18¼ x 32". Exhibited at the Salon of 1867. Collection Mr. and Mrs. J. T. Ryerson, Chicago.*

If Monet's situation could be further aggravated, this was done by the rejection dealt out to his *Women in the Garden,* submitted to a jury from which both Corot and Daubigny were absent that year. This decision was a particular blow to Monet's hopes of being able to sell some of his works, especially because the Salon of 1867 coincided with a new World's Fair in Paris. After Zola's vigorous campaign the previous year, followed later by another series of articles on Manet, the friends had looked forward with some eagerness to the attitude which the jury would adopt in 1867. Only too soon it became clear what this attitude was, and Zola informed Valabrègue: "Paul [Cézanne] is refused, Guillemet is refused, every one is refused; the jury, irritated by my *Salon,* has shut the door on all those who take the new road."[26] The fate of Sisley, Bazille, Pissarro and Renoir (in spite of the academic character of his *Diane*) was not different from that of the others. Again they signed a petition for a *Salon des Refusés* but without believing that it would be granted. And it was not.

Whistler and Fantin were more successful with the jury, the latter exhibiting a portrait of Manet. Degas had two family portraits accepted, which Castagnary commended, and Berthe Morisot showed a view of Paris that seems to have startled Manet by its composition as well as by its freshness and delicacy. Although the influence of Corot remained still evident in the low-keyed harmonies of her painting, the execution was much freer than that of the master. The treatment of large planes with sketchy indications of details revealed a surprising audacity that was strangely combined with the general charm of the painting. Here was more than promise: a talent already in full possession of its means, a sensitivity that lacked neither confidence nor temerity. This canvas induced Manet to paint the same view, except that he chose to represent it with the temporary structures of the World's Fair.

MANET: *View of the Paris World's Fair, 1867. 42½ x 77⅛". Nasjonal Galleriet, Oslo.*

It is not surprising that Manet should have adopted Berthe Morisot's motif, for a curious lack of imagination had already led him repeatedly to "borrow" subjects from other artists. The central group of his *Déjeuner sur l'herbe* had been adapted from an engraving after Raphael. Many of his works, if not based directly on other masters, were at least inspired by remembrance (Manet had travelled extensively), by reproductions, prints, etc.[27] Although Manet himself never made any allusions to his sources, he often used them with so little disguise that it would have been easy to identify them had anybody cared to do so. But in Manet's case the whole question seemed of little importance, since what mattered was not the subject but the way in which he treated it. He found in works of the past—and, in Berthe Morisot's case, of the present—only compositional elements; he never copied, because only his inspiration, not his talent, needed an occasional guide. Yet the irony of fate wanted him to be attacked for the "vulgarity" of his inspiration, even in cases where he had derived his themes from classic masters. Weary of constant rejections, Manet therefore now decided to do what Courbet had done in 1855, to build his own pavilion at the World's Fair where he could show some fifty of his works. Since Courbet did likewise, their two one-man shows became the center of attraction for all those who followed the new movements. Another point of interest was a memorial show for Ingres, who had died early that same year, having lived to see all that he believed in become synonymous with reaction and been himself the powerless protagonist of a tradition that had lost every contact with life.

An explanatory notice, apparently written by Astruc, pointed out to the visitors to Manet's exhibition: "Since 1861, M. Manet has been exhibiting or attempting to exhibit. This year he decided to offer directly to the public a collection of his works. . . . The artist does not say, today: 'Come and look at

works without fault,' but: 'Come and look at sincere works.' It is the effect of sincerity to endow works with a character that makes them resemble a protest, although the painter has only intended to convey his impression.—M. Manet has never desired to protest. On the contrary, it has been against him, who did not expect it, that there has been protest, because there exists a traditional teaching about forms, methods, aspects, painting; because those brought up on such principles do not admit any others. . . . To exhibit is the vital question . . . for the artist, because it happens that after several examinations people become familiar with what surprised them and, if you will, shocked them. Little by little, they understand it and accept it. . . . For the painter, it is thus only a question of conciliating the public, which has been his so-called enemy."[28]

At the last minute Manet had painted for his exhibition a large canvas representing the *Execution of Emperor Maximilien,* a canvas inspired by the tragic events of June 1867 (and not unrelated to the treatment of a similar subject by Goya). For political reasons he was prevented from showing it.

Manet's exhibition was much less of a success than he had expected. People again came more to laugh at his works than to study them seriously; even the praise of his admirers was moderate. Monet informed Bazille, who had left for Montpellier before the opening, that he did not consider Manet to be progressing, and Cézanne, who had remained in Aix, learned from a friend: "His paintings so amazed me that I had to make an effort to get used to them. All in all these pictures are very fine, very 'seen' in their purity of tone. But his work has not yet reached its fullest bloom; it will become more rich and complete."[29] As for Courbet, he did not even go to see the exhibition, delegating his sister instead and explaining to her: "I myself shouldn't like to meet this young man, who is of a congenial nature, hard-working, who tries to achieve something. I should be obliged to tell him that I don't understand anything about his painting and I don't want to be disagreeable to him."[30]

Courbet's own exhibition was a disappointment for his friends but quite a success with the public. Monet thought the recent paintings downright bad, and one of Cézanne's friends, although deeply astonished by Courbet's "immense and integral power," found the latest paintings "awful: so bad they make you laugh."[29] He considered Cézanne already better than both Manet and Courbet.

Courbet, this time, had constructed his pavilion of solid materials and decided to rent it after the closing of the exposition. This, together with their wholesale rejection, had inspired Monet and his friends with the resolution to organize henceforth exhibitions of their own, possibly in Courbet's pavilion. In a letter to his family, Bazille explained the project: "I shan't send anything more to the jury. It is far too ridiculous . . . to be exposed to these administrative whims. . . . What I say here, a dozen young people of talent think along with me. We have therefore decided to rent each year a large studio where we'll exhibit as many of our works as we wish. We shall invite painters whom we like to send pictures. Courbet, Corot, Diaz, Daubigny and many others whom you perhaps do not know, have promised to send us pictures and very much approve of our idea. With these people, and Monet, who is stronger than all of them, we are sure to succeed. You shall see that we'll be talked about. . . ."[31] But this letter was soon followed by another: "I spoke to you of the plan some young people had of making a separate exhibition. Bleeding ourselves as much as possible, we were able to collect the sum of 2,500 francs, which is not sufficient. We are therefore obliged to give up what we wanted to do. . . ."[32]

Although they had to drop their project, the friends never abandoned it in their hearts, for this seemed the only way to present themselves as a group. And they were indeed a little group by now, this

152

DEGAS: *Mlle Fiocre in the Ballet* La Source, *c. 1867. 51⅛ x 56⅝". Exhibited at the Salon of 1868. Brooklyn Museum, N. Y.*

"dozen young people" mentioned by Bazille. Besides the four companions from Gleyre's studio, there were Pissarro, whom Monet had met back in 1859 and who, in turn, had known Cézanne as early as 1861; Fantin, a friend of Renoir's since 1862, who was close to Manet, and Manet himself, to whom Cézanne, Pissarro and Monet had been introduced in 1866; Guillemet, a friend of Manet and Cézanne; possibly Degas, for almost fifteen years an intimate of Manet, and Berthe Morisot, although she knew only Fantin among the friends; and still others, like the engraver Bracquemond, or Guillaumin, who had just left his position at the Compagnie d'Orléans so as to devote all his time to painting. Most of these friends were terribly poor. Only Degas, Manet, who had inherited a sizable fortune (although always in need of money) and Berthe Morisot might be considered really wealthy, for Cézanne was, in spite of

his rich father, even less well off than Bazille, and it had recently taken the intervention of Guillemet to bring the banker to decide upon a better allowance for Paul. Under these circumstances it seems truly amazing that the group had been able to raise 2,500 francs. Though they had fallen short of the goal, the friends now at least had the comforting certainty that older men like Courbet, Corot, Diaz and Daubigny were wholeheartedly with them in their struggle.

"I believe," Manet wrote somewhat later to Fantin, "that, if we want to remain close together and above all not to grow discouraged, there would be a means of reacting against the mediocre crowd that is strong only because of its unity."[33]

In the small group of friends Degas seems to have maintained the position of an outsider, and it is not even certain whether at that moment he knew many of the others. Rather solitary by nature and little inclined to let anyone penetrate the privacy of his life and work, he did not have much in common with Manet's old and new acquaintances. He was not in the slightest attracted by work done out-of-doors (sharing Manet's prejudices), very seldom did landscapes and focused his attention instead on the human figure. The portraits which he did of members of his family, or of friends chosen in the social circle in which he grew up, had led Duranty to state jokingly that Degas was "on the way to becoming the painter of high-life."[33] This, however, was not exactly true, for what preoccupied Degas was not "high-life" but life in all its manifestations: contemporary life.

Degas had been deeply interested in certain remarks made by the Goncourt brothers in their new novel, *Manette Salomon,* published in 1866. The central figures of this book were artists, and one of them had in a long soliloquy expressed the authors' own *credo:* "All ages carry within themselves a Beauty of some kind or other, more or less close to earth, capable of being grasped and exploited. . . . It is a question of excavation. . . . It is possible that the Beauty of today may be covered, buried, concentrated . . . to find it, there is perhaps need of analysis, a magnifying glass, near-sighted vision, new psychological processes. . . . [. . . .] The question of what is modern is considered exhausted, because there was that caricature of truth in our time, something to stun the bourgeois: *realism!* . . . because one gentleman created a religion out of the stupidly ugly, of the vulgar ill-assembled and without selection, of the modern . . . but common, without character, without expression, lacking what is the beauty and the life of the ugly in nature and in art: *style!* [. . . .] The feeling, the intuition for the contemporary, for the scene that rubs shoulders with you, for the present in which you sense the trembling of your emotions and something of yourself . . . everything is there for the artist [. . . .] The nineteenth century not produce a painter!—but that is inconceivable. . . . A century that has endured so much, the great century of scientific restlessness and anxiety for the truth. . . . [. . . .] There must be found a line that would precisely render life, embrace from close at hand the individual, the particular, a living, human, inward line in which there would be something of a modeling by Houdon, a preliminary pastel sketch by La Tour, a stroke by Gavarni. . . . A drawing truer than all drawing . . . a drawing . . . more human."[34]

Degas in his notebooks had traced for himself as early as 1859 a program that was similar in many points to that of the Goncourt brothers. "Do expressive heads (in the academic style), a study of modern feeling," he had written. "Do every kind of object in use, placed, associated in such a way that they take on the life of the man or woman, corsets that have just been removed, for instance, and that retain, as it were, the shape of the body, etc. . . ." He also jotted down: "Never yet have monuments or houses been done from below, from close to, as one sees them passing by in the street." And he set up a

DEGAS: *Portrait of the Painter James Tissot, c. 1868. 59⅓ x 44¼". Metropolitan Museum of Art, New York.*

whole list of various series in which he might study contemporary subjects: a series on musicians with their different instruments; another on bakeries seen from a variety of angles, with still lifes of all kinds of bread and tarts; a series on smoke, smoke of cigarettes, locomotives, chimneys, steamboats etc.; a series on mourners in various kinds of black, veils, gloves, with undertakers; still other subjects, such as dancers, their naked legs only, observed in action, or the hands of their hairdressers, and endless impressions, cafés at night with the "different values of the lamps reflected in the mirrors. . . ." etc., etc.[35]

Many of the subjects listed here Degas was never to treat, others were to play a dominant role in his work throughout his life, but, as he soon found out, more important than a great variety of subjects were the spirit, the inventiveness and the skill with which they were approached and exploited. Curiously enough, the more original Degas was in his conception and composition, in what has been called the "mental side of painting," the less he seemed preoccupied with initiating a new technique or color scheme. Quite the opposite, he strove to remain within the path of tradition, as far as execution goes, and thus succeeded in giving even to the extraordinary a natural aspect.[36]

Degas often explained: "No art was ever less spontaneous than mine. What I do is the result of reflection and study of the great masters; of inspiration, spontaneity, temperament I know nothing."[37] He also said that "the study of nature is of no significance, for painting is a conventional art, and it is infinitely more worthwhile to learn to draw after Holbein."[38] His main concern was thus to find that "living, human, inward line" of which the Goncourts had spoken, while the other artists concentrated on color and on the changing aspects of nature.

Bazille was spending the summer of 1867 on the estate of his parents near Montpellier. There he had attacked a large composition grouping all the members of his family on a shadowy terrace. Having neither the investigating mind of Degas nor the strong artistic temper of Monet nor the natural facility of Renoir, he tried to replace these by naive application and a sincere humility. As a result his work, although somewhat dry and stiff, is not devoid of an austere charm. Conscious of his shortcomings, Bazille knew that he had still to free himself from a certain awkwardness and hesitancy in order to develop his gifts fully.

Monet meanwhile had settled in Sainte-Adresse, where he was obediently staying with his aunt. He informed Bazille in June: "I've cut out a lot of work for myself; I have about twenty canvases on the way, some stunning marines, and some figures, gardens and, finally, among my marines, I'm doing the regattas at Le Havre with many people on the beach and the roadstead full of little sails. For the Salon I am doing an enormous steamship, it's very curious."[39]

Shortly afterward Monet had to stop for a while all work in the open, because of eye trouble, but when he came to visit his friends in Paris, late in the fall, Bazille wrote his sisters: "Monet has fallen upon me from the skies, with a collection of magnificent canvases. . . . Counting Renoir, that makes two hard working painters I'm housing . . . , I'm delighted."[40] During this winter of 1867-68 Bazille spent all his evenings with Edmond Maître. Together they played German music or went to concerts, occasionally accompanied by Renoir.

Renoir had again worked during the summer in Chailly; Sisley had been in Honfleur before joining him and devoting himself to a forest interior for the next Salon. In the forest Renoir too had now painted a large full-length figure of a woman, executed entirely in the open but softer in line and color than Monet's *Camille.* His *Lise,* and the *Portrait of Sisley and his Wife* which he was to do in 1868,

156

RENOIR: *Lise, d. 1867. 71½ x 44½". Exhibited at the Salon of 1868. Folkwang Museum, Essen.*

BAZILLE: *Portrait of Alfred Sisley, 1867-68. 11 x 12¼". Wildenstein Galleries, Paris.*

are the first great pictures in which, notwithstanding traces of Courbet's influence, he affirmed his own personality. He achieved form exclusively through modeling and, what is more, he observed the interplay of colored shadows. The critic Bürger was the first to recognize this when he wrote concerning Renoir's *Lise:* "The dress of white gauze, enriched at the waist by a black ribbon whose ends reach to the ground, is in full light, but with a slight greenish cast from the reflections of the foliage. The head and neck are held in a delicate half-shadow under the shade of a parasol. The effect is so natural and so true that one might very well find it false, because one is accustomed to nature represented in conventional colors. . . . Does not color depend upon the environment that surrounds it?"[41]

In 1868 Renoir was also to paint a portrait of Bazille sitting in front of his easel. Manet admired the portrait very much, and to him Renoir apparently offered it (at least it seems unlikely that Manet would have bought it). Manet himself did a likeness of his friend Zola at this time.

The year 1868 did not start under too favorable auspices. Monet was still without money, he had left his aunt, and there was not even coal for Camille and the baby. In the spring, however, Boudin induced the organizers of an "Exposition Maritime Internationale" at Le Havre to invite Courbet, Manet and Monet to participate. All three, as well as Boudin, were awarded silver medals. Monet also

RENOIR: *Portrait of Frédéric Bazille before his Easel, 1868.* 41⅞ x 29¼". *Formerly in the collection of Manet. Louvre, Paris.*

RENOIR: *Sisley and his Wife, 1868. 42¼ x 30". Wallraf Richartz Museum, Cologne.*

SISLEY: *Alley of Chestnut Trees near La Celle Saint-Cloud, d. 1867. 38 x 45". Exhibited at the Salon of 1868. Present owner unknown.*

received from a M. Gaudibert a commission for a portrait of his wife, which he painted in a château at Etretat, near Le Havre.[42] But he remained depressed and wrote Bazille: ". . . all this is not enough to give me back my former ardor. My painting doesn't go, and I definitely do not count any more on fame. I'm getting very sunk. To sum up, I've done absolutely nothing since I left you. I've become utterly lazy, everything annoys me as soon as I make up my mind to work; I see everything black. In addition, money is always lacking. Disappointments, insults, hopes, new disappointments—you see, my dear friend. At the exhibition at Le Havre, I sold nothing. I possess a silver medal (worth 15 francs), some splendid reviews in local papers, there you are; it's not much to eat. Nevertheless, I've had one sale which, if not financially advantageous, is perhaps so for the future, although I don't believe in that any more. I have sold the *Woman in Green* [*Camille*] to Arsène Houssaye [inspector of Fine Arts and editor of *L'Artiste*], who has come to Le Havre, who is enthusiastic and wants to get me launched, so he says."[43]

Houssaye paid only 800 francs for *Camille,* but even this seemed high compared to the prices which some seascapes by Monet were soon to bring at auction. After the closing of the exhibition in Le Havre creditors had seized Monet's canvases, which were then acquired, according to Boudin, by M. Gaudibert for 80 francs apiece.[44] Fortunately there was good news from Paris. Daubigny was again on the jury, and his influence made itself felt immediately. He himself took the trouble to drop a line to some of his

161

PISSARRO: *The Côte du Jallais at Pontoise, d. 1867. Exhibited at the Salon of 1868. Collection William Church Osborn, New York.*

protégés. "Dear Mr. Pisaro [*sic*]," he wrote, for instance, "your two pictures have been received. Yours sincerely, C. Daubigny."[45] Monet may have received a similar message, although only one of his canvases was accepted. "Daubigny told me," Boudin informed a friend, "that he had had to fight to get one of his pictures admitted; that at first the *Ship* had been accepted and that, when the other came up in turn, Nieuwerkerke said to him: 'Ah no, we've had enough of that kind of painting.' "[43]

As a matter of fact the Director of Fine Arts was very dissatisfied with Daubigny's intervention. "M. de Nieuwerkerke complains of Daubigny," Castagnary explained in an article. "If the Salon this year is what it is, a Salon of newcomers; if the doors have been opened to almost all who presented themselves; if it contains 1,378 more items than last year's Salon; if in this abundance of free paintings, the official art cuts a rather poor figure, it is Daubigny's fault. . . . I do not know whether Daubigny has done all that M. de Nieuwerkerke attributes to him. I should gladly believe it, because Daubigny is not only a great artist, he is, further, a fine man who remembers the miseries of his youth and who would like to spare others the harsh ordeals which he himself underwent."[46]

On the whole the results of Daubigny's insistence and of his example were very satisfactory, except for Cézanne, who was rejected once more. Manet had two paintings admitted (among them his *Portrait of Zola*), so had Bazille (whose family group was received) and Pissarro (who exhibited two views of Pontoise); Degas, Monet, Renoir, Sisley and Berthe Morisot were represented by one painting

BAZILLE: *The Artist's Family on a Terrace near Montpellier (second version). Exhibited at the Salon of 1868; retouched and dated 1869. 60¾ x 91". Louvre, Paris.*

each: Degas by his *Portrait of Mlle Fiocre,* Renoir by *Lise,* Sisley by his forest interior and Berthe Morisot by a landscape from Finistère. But the hanging commission counterbalanced Daubigny's liberalism by relegating the works of Renoir, Bazille, Monet and Pissarro to the so-called *dépotoir,* also hanging Manet's canvases very badly. However, this did not prevent either Manet or the others from obtaining a certain success. Castagnary publicly protested against the unfavorable treatment their works received, complaining especially that Pissarro had seen his landscapes again "placed too high this year, but not high enough to prevent art lovers from observing the solid qualities that distinguish him."[47] Astruc was full of praise; so was Redon, turned art critic for the occasion, who commended in *La Gironde* the paintings of Courbet, Manet, Pissarro, Jongkind and Monet. Zola also wrote a new *Salon.* But he made it a point (or was obliged to) not to mention by name any of the official artists he loathed. These articles, therefore, lack the combativeness of his earlier series, the more so as Manet seemed no longer so vehemently discussed as in 1866. "In my opinion, the success of Edouard Manet is complete," he stated. "I didn't dare to dream it would be so complete, so worthy."[48] As for Pissarro, Zola commented: "A beautiful picture by this artist is the act of an honest man." Monet again obtained some success. "At the Salon, I ran into Monet who gives us all the example of the tenacity of his principles," noted Boudin. "There is always in his painting a praiseworthy search for *true tone,* which begins to be respected by everyone."[49]

But new difficulties awaited Monet after he had left Paris again. From Fécamp he wrote Bazille toward the end of June: "I am writing you a few lines in haste to ask your speedy help. I was certainly born under an unlucky star. I have just been thrown out of the inn, and stark naked at that. I've found shelter for Camille and my poor little Jean for a few days in the country. This evening I'm leaving for Le Havre to see about trying something with my art lover. My family have no intention of doing anything more for me. I don't even know where I'll have a place to sleep tomorrow. Your very harassed friend—Claude Monet. P. S. I was so upset yesterday that I had the stupidity to throw myself into the water. Fortunately, no harm came of it."[50]

Monet's patron in Le Havre, doubtless M. Gaudibert, was more sensitive than the parents to the painter's plight. He seems to have provided Monet with an allowance that permitted him to find temporary peace and new courage for his work. A letter to Bazille, dated September, 1868, is full of quiet contentment. "I am surrounded here with all that I love," Monet wrote from Fécamp. "I spend my time out-of-doors on the pebble-beach when the weather is stormy or else when the boats are going out for fishing; or I go into the country, which is so beautiful here that I perhaps find it more agreeable in winter than in summer. And naturally I've been working all this time, and I believe that this year I'll do some serious things. And then, in the evening, my dear friend, I find a good fire and a cozy little family in my cottage. If you could see your godson—how sweet he is at present. It's fascinating to watch this little being grow, and, to be sure, I am very happy to have him. I shall paint him for the Salon, with other figures around, of course. This year I shall do two pictures with figures, an interior with a baby and two women, and some sailors out-of-doors.[51] And I want to do them in a stunning manner. Thanks to the gentleman of Le Havre who comes to my aid, I am enjoying the most complete tranquillity. Consequently, my wish would be to continue always this way in a hidden bit of quiet nature. I assure you that I don't envy your being in Paris. Frankly, I believe that one can't do anything in such surroundings. Don't you think that directly in nature and alone one does better? I'm sure of it; besides, I've always been of this mind and what I do under these conditions has always been better. One is too much taken up with what one sees and hears in Paris, however firm one may be, and what I am painting here will have the merit of not resembling anyone, at least I think so, because it will be simply the expression of what I shall have felt, I myself, personally. The farther I go, the more I regret how little I know, that is what bothers me most."[52]

Monet concluded by saying that since his paint shop had refused him further credit, he would like Bazille to send some of the canvases left behind in his studio. But this time Monet was careful to specify that he wanted only unused canvases or those of unfinished paintings. As to the finished ones, he asked Bazille to take good care of them: "I've lost so many that I cling to those that are left."

While Monet secluded himself in the country, the life of his friends continued with little change in Paris. Renoir portrayed the ice skaters in the Bois de Boulogne, but decided not to work out-of-doors again in cold weather. Always hard up, Guillaumin, in 1868, painted blinds for a living, as Renoir had done before. For a while Pissarro was obliged to join him, in order to support his family, and Guillaumin did a portrait-sketch of him showing Pissarro at his commercial work.[53] During that same winter, in the studio of the Belgian painter Stevens, Bazille frequently met Manet, to whom Fantin had introduced Berthe Morisot (her sister had married meanwhile and abandoned painting). She was deeply impressed by Manet's talent; he in turn was fascinated by her feminine charm and natural distinction.

GUILLAUMIN: *Pissarro painting Blinds, c. 1868. Present owner unknown.*

Manet had spent the summer in Boulogne and made a two-day excursion to England. He had returned with a very favorable impression, both of the atmosphere of London and of the reception he had been given by British artists. "They don't have the kind of ridiculous jealousy that we have; they are almost all gentlemen,"[54] he wrote to Zola. And to Fantin he spoke of his conviction that "something could be done there," adding: "What I want right now is to earn money."[55] His longing both for social and financial success induced him to submit to a ruse invented by Duret, a journalist whom he had met in Madrid and who was now a colleague of Zola's on the anti-imperial newspaper *La Tribune.* Manet had just painted Duret's portrait, and his model had suggested that he sign the work unostentatiously, for Duret meant to show it to all his bourgeois acquaintances as the work of any one of the well-known Salon artists. Once the portrait had been duly admired, he intended to reveal the real painter's name, embarrass the "admirers" and oblige them to recognize Manet's talent. Although Manet did not sign his painting in a dark spot, as Duret has suggested,[56] he complied so far as to put his signature upside down, making it practically impossible to decipher.

In the fall of 1868 Manet, who hated professional models, asked Berthe Morisot whether she would agree to pose for a painting, *The Balcony* (inspired by Goya's *Majas on a Balcony*), which he was then planning and in which Guillemet was also to appear. She accepted, attending regularly the sittings in his studio, accompanied by her mother.

In the evenings at this time the painters frequently gathered in the Café Guerbois in the Batignolles quarter, and when Monet returned to Paris early in 1869 Manet invited him to join them there.

NOTES

1. Valabrègue to Marion, April 1866; see M. Scolari and A. Barr, Jr.: Cézanne in the letters of Marion to Morstatt, 1865-1868. *Magazine of Art*, Feb., April and May 1938.

2. Letter by Mme F., sister of Renoir's friend J. Lecoeur, June 6, 1866; see *Cahier d'Aujourd'hui,* Jan. 1921.

3. Cézanne to de Nieuwerkerke, April 19, 1866; see Cézanne, Letters, London, 1941, p. 70-71 [here retranslated].

4. E. Zola: Proudhon et Courbet, repr. *in* Mes Haines, Paris, 1867. (See also Oeuvres Complètes, Paris 1927-1929).

5. E. Zola: Un suicide, *L'Evénement,* April 19, 1866. (This article is not incorporated in the reprints of the series.)

6. E. Zola: Mon Salon, *L'Evénement,* April 27-May 20, 1866. Reprint: Mon Salon. Paris, 1866, later included *in* Mes Haines, Paris, 1867; see E. Zola, Oeuvres complètes, notes et commentaires de Maurice Le Blond, Paris, 1928.

7. Three of these letters are reproduced *in*: Mon Salon, Paris, 1866, but were not incorporated *in*: Mes Haines, Paris, 1867.

8. E. Zola: A mon ami Paul Cézanne, preface to: Mon Salon, repr. *in* Mes Haines. On Zola's friendship with Cézanne and on his art criticism, see J. Rewald: Cézanne, sa vie, son oeuvre, son amitié pour Zola, Paris, 1939.

9. W. Bürger: Salon de 1866; repr. *in* Salons, 1861-1868, Paris, 1870, v. II, p. 325.

10. Castagnary: Le Salon de 1866; repr. *in* Salons (1857-1870), Paris, 1892, v. I, p. 224 and 240.

11. This is apparently the version formerly in the collection of Dr. de Bellio and now in the Museul Simu, Bucharest.

12. Castagnary: Le Salon de 1863, *op. cit.,* v. I, p. 105-106 and 140.

13. Castagnary: Le Salon de 1868, *op. cit.,* v. I, p. 291.

14. Monet to Thiébault-Sisson, interview; see *Le Temps,* Nov. 27, 1900.

15. There are several versions concerning this incident; see M. Elder: Chez Claude Monet à Giverny, Paris, 1924, p. 55-56. P. Valéry: Degas, Danse, Dessin, Paris, 1938, p. 21-22, reproduces the same story as told by Monet, except that the compliments come from Decamps instead of Diaz. According to M. de Fels: La vie de Claude Monet, Paris, 1929, p. 88, Latouche had exhibited *Women in the Garden* and the blame came from Corot, the compliments from Diaz. G. Geffroy: Claude Monet, sa vie, son oeuvre, Paris, 1924, v. I, ch. VIII, mentions *Women in the Garden* as exhibited by the dealer and laughed at by Manet. A similar version is given by W. Pach: Queer Thing, Painting, New York-London, 1938, p. 102-103. A. Alexandre: Claude Monet, Paris, 1921, p. 46 says that Manet made his remarks in connection with Monet's *Déjeuner sur l'herbe,* shown by Latouche. But in his interview with Thiébault-Sisson, *op. cit.,* Monet speaks of a *Seascape* that was ridiculed by Manet. Since a letter by Monet to Bazille, June 25, 1867 (see G. Poulain: Bazille et ses amis, Paris, 1932, p. 92) confirms that Latouche had bought Monet's *Garden of the Princess,* there seems every reason to believe that this was the canvas shown

in his window. However, the dealer may also have exhibited other paintings by Monet under similar circumstances. As a matter of fact, Boudin reports in 1869 in a letter to a friend (see G. Jean-Aubry: Eugène Boudin, Paris, 1922, p. 72) that Latouche was showing a study of Sainte-Adresse by Monet which attracted crowds in front of his window.

16.. See de Trévise: Le pèlerinage de Giverny, *Revue de l'art ancien et moderne,* Jan., Feb. 1927; also Geffroy, *op. cit.,* v. I, ch. VIII. On the composition of Monet's *Women in the Garden,* see G. Poulain: L'origine des "Femmes au jardin" de Claude Monet, *L'Amour de l'Art,* March, 1937.

17. In a letter to Bazille, spring 1868, Monet asks his friend for the following colors: ivory black, white lead, cobalt blue, lake (fine), yellow ochre, burnt ochre, brilliant yellow, Naples yellow, burnt Sienna. See Poulain, *op. cit.,* p. 150.

18. See K. Osthaus: article in *Das Feuer,* 1920, quoted by J. Rewald, *op. cit.,* p. 395.

19. Cézanne to Zola, Oct. 1866; see Cézanne, Letters, p. 74.

20. Marion to Morstatt, see Scolari and Barr, *op. cit.*

21. Whistler to Fantin, fall 1867, see L. Bénédite: Whistler, *Gazette des Beaux-Arts,* Sept. 1, 1905.

22. See R. Gimpel: At Giverny with Claude Monet, *Art in America,* June 1927. Information corroborated by K. Koechlin: Claude Monet, *Art et Décoration,* Feb. 1927.

23. Monet to Bazille, Dec. 22, 1866; see Poulain, *op. cit.,* p. 70-71. Bazille was slow in fulfilling the request, which may explain why several of the pictures seem still to exist. Here is a list of some of the paintings for which Monet had asked: "Les deux grandes avenues de Fontainebleau de la même dimension [one is possibly the painting ill. p. 89]; le tableau chinois où il y a des drapeaux [possibly the color plate opp. p. 134]; le rosier; l'effet de neige tout blanc où il y a des corbeaux [possibly the landscape ill. p. 103]; la marine aux canots bleus; Le Havre vu du lointain avec petites cabanes et mer à vagues blanches; Camille [possibly the portrait ill. p. 128], la femme blanche" —Monet said he wanted to paint an important seascape on this last canvas.

24. Dubourg to Boudin, Feb. 2, 1867; see G. Jean-Aubry: Eugène Boudin, Paris, 1922, p. 64.

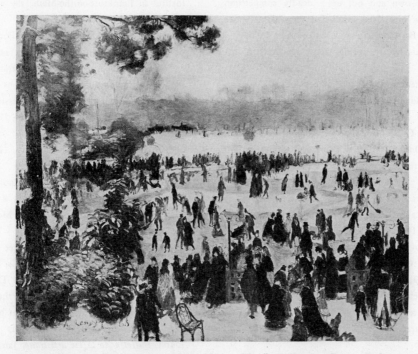

RENOIR: *Skating in the Bois de Boulogne, d. 1868. 28⅞ x 36⅛". Collection Baron Robert von Hirsch, Basle.*

25. A. Monet to Bazille, summer 1867; see Poulain, *op. cit.*, p. 74-77.

26. Zola to Valabrègue, April 4, 1867; see E. Zola: Correspondance (1858-1871), Paris, 1928, p. 299-300.

27. See G. Bazin: Manet et la tradition, *L'Amour de l'Art,* May 1932 and C. Zervos: A propos de Manet, *Cahiers d'Art,* No. 8-10, 1932; also G. Pauli: Raffael und Manet, *Monatshefte fuer Kunstwissenschaft,* 1908, p. 53; C. Sterling: Manet et Rubens, *L'Amour de l'Art,* Sept.-Oct. 1932; M. Florisoone: Manet inspiré par Venise, *L'Amour de l'Art,* Jan. 1937 and P. Colin: Manet, Paris, 1932, p. 1-20.

28. Notice for the catalogue of the Manet exhibition, Avenue de l'Alma, Paris, 1867. Quoted by E. Bazire: Edouard Manet, Paris, 1884, p. 54.

29. Marion to Morstatt, Paris, Aug. 15, 1867; see Scolari and Barr, *op. cit.*

30. See G. Riat; Gustave Courbet, Paris, 1906, p. 146. The author does not indicate with which exhibition this episode is connected, but there seems reason to assume that it applies to Manet's show in 1867.

31. Bazille to his family, spring 1867; see Poulain, *op. cit.*, p. 78-79. A similar idea had already been expressed by Cézanne's friend Marion, who wrote in April 1866: "All we have to do is to plan an exhibition of our own and put up a deadly competition against those blear-eyed idiots [of the Salon]." See Scolari and Barr, *op. cit.*

32. Bazille to his family, spring 1867; see Poulain, *op. cit.*, p. 83.

33. Manet to Fantin, Aug. 28, 1868; see E. Moreau-Nélaton: Manet raconté par lui-même, Paris, 1926, v. I, p. 103.

34. E. and J. de Goncourt: Manette Salomon. Paris, 1866, ch. CVI. On Degas' often expressed admiration for the Goncourts see J. Elias Degas, *Neue Rundschau,* Nov. 1917.

35. Degas, notes; see P. A. Lemoisne: Les carnets de Degas au Cabinet des Estampes, *Gazette des Beaux-Arts,* April 1921.

36. See P. Jamot: Degas, Paris, 1924, p. 49.

37. Quoted by G. Moore: Impressions and Opinions, London, 1891, ch. on Degas.

38. From a notebook of Berthe Morisot; see P. Valéry: Degas, Dance, Dessin, Paris, 1938, p. 148.

39. Monet to Bazille, June 25, 1867; see Poulain, *op. cit.*, p. 92.

40. Bazille to his sisters, fall 1867; see G. Poulain: Un Languedocien, Frédéric Bazille, *La Renaissance,* April 1927.

41. W. Bürger: Salon de 1868; repr. *in* Salons, 1861-1868, Paris, 1870, v. II, p. 531.

42. The portrait of Mme Gaudibert is reprod. in A. Alexandre: Claude Monet, Paris, 1921, opp. p. 40.

43. Monet to Bazille, spring 1868; see Poulain, *op. cit.*, p. 149. According to Bürger, *op. cit.*, v. I, p. 420, A. Houssaye had also written to Whistler in 1863, anxious to buy his *White Girl* at the *Salon des Refusés.* Apparently he did not offer enough money, since the deal was never concluded.

44. Boudin to Martin, 1868; see Jean-Aubry, *op. cit.*, p. 71-72.

45. Unpublished document, found in the papers of Pissarro, courtesy M. Ludovic-Rodo Pissarro, Paris.

46. Castagnary: Le Salon de 1868, *op. cit.*, v. I, p. 254.

47. *Ibid.* p. 278.

48. E. Zola: Salon de 1868, *L'Evénement,* May, 1868; see Rewald, *op. cit.*, p. 143-148.

49. Boudin to Martin, May 4, 1868; see Jean-Aubry, *op. cit.*, p. 68.

50. Monet to Bazille, June 29, 1868; see Poulain, *op. cit.*, p. 119-120.

51. The interior, *Le déjeuner,* is now in the Staedelsche Institut in Frankfort-on-the-Main; the whereabouts of the other canvas is unknown.

52. Monet to Bazille, Sept. 1868; see Poulain, *op. cit.*, p. 130-132, and the article by the same author in *La Renaissance,* April, 1927. The transcription and the excerpts vary in both publications and are here combined. The article says "impression" where it reads "expression" in the book; the latter word has been adopted here.

53. See G. Lecomte: Guillaumin, Paris, 1926, p. 9 and 26-27.

54. Manet to Zola, summer 1868; see Jamot, Wildenstein, Bataille: Manet, Paris, 1932, v. I, p. 84.

55. Manet to Fantin, summer 1868; see Moreau-Nélaton, *op. cit.*, v. I, p. 104.

56. Duret to Manet, July 20, 1868; see A. Tabarant: Manet, histoire catalographique, Paris, 1931, p. 183-184. Tabarant was given access to Duret's private papers and has published many of them in various articles quoted throughout the present book. See also T. [Tabarant]: Quelques souvenirs de Théodore Duret, *Bulletin de la vie artistique,* Jan. 15, 1922 and Duret's own writings, listed in the Bibliography.

In the days of gaslight, when artists put down their brushes at dusk, they often spent the late afternoon and evening in one of the many cafés where painters, authors and their friends used to meet. Until 1866 Manet could be found as early as five-thirty on the terrace of the Café de Bade, but he soon abandoned this much-frequented establishment in the heart of Paris for a quieter little café, at number 11, Grande rue des Batignolles (later Avenue de Clichy).[1] There, at the Café Guerbois, undisturbed by noisy crowds, Manet and all those who were immediately or indirectly interested in his efforts or in the new movement in general gathered around a few marble-top tables. Just as Courbet had held forth at his Brasserie, Manet now became the center of a group of admirers and friends. Astruc, Zola, Duranty, Duret, Guillemet, Bracquemond and Bazille, accompanied by the Commandant Lejosne, were almost daily guests at the Café Guerbois; Fantin, Degas and Renoir came frequently; Alfred Stevens, Edmond Maître, Constantin Guys and the photographer Nadar appeared on occasion, and whenever they happened to be in Paris, Cézanne, Sisley, Monet and Pissarro would drop in. Thursday evenings had been set aside for regular gatherings, but any evening one was certain to find there a group of artists engaged in an animated exchange of opinions. "Nothing could be more interesting," Monet later remembered, "than these *causeries* with their perpetual clash of opinions. They kept our wits sharpened, they encouraged us with stores of enthusiasm that for weeks and weeks kept us up, until the final shaping of the idea was accomplished. From them we emerged tempered more highly, with a firmer will, with our thoughts clearer and more distinct."[2]

Manet was not only the intellectual leader of the little group, he was, next to Pissarro, the oldest, being thirty-seven years old in 1869; Degas was thirty-five, Fantin thirty-three, Cézanne thirty; Monet, Renoir and Sisley were twenty-nine, Bazille was not yet twenty-eight. Surrounded by his friends, Manet was, in the words of Duranty, "overflowing with vivacity, always bringing himself forward, but with a gaiety, an enthusiasm, a hope, a desire to throw light on what was new, which made him very attractive."[3]

Dressed with great care, Manet was, according to Zola, "of medium size, small rather than large,

with light hair and a somewhat pink complexion, a quick and intelligent eye, a mobile mouth which was at moments a little mocking; the whole face irregular and expressive, with I don't know what expression of sensitiveness and energy. For the rest, in his gestures and tone of voice, a man of the greatest modesty and kindness."[4]

Yet modesty and kindness seem to have been more the result of a perfect education than the expression of Manet's inner nature. Not only was he ambitious and impetuous, but he showed even a certain disdain for those who did not belong to his own social sphere and had little sympathy for those members of the group who sought a new style entirely outside museum tradition. His actual enemies he would crush by *bons mots* that were often witty, although seldom as sharp as those of Degas. Moreover, Manet did not permit contradiction or even discussion of his views. As a result he sometimes had violent arguments, even with friends. Thus a discussion once led to a duel between him and Duranty, in which Zola acted as second for the painter.[5] Paul Alexis, a friend of both Cézanne and Zola, who also was often to be seen at the Café, reported that "completely ignorant of the art of fencing, Manet and Duranty threw themselves upon each other with such savage bravery that, when the four astonished seconds had separated them [Duranty being slightly wounded], their two swords appeared to have been turned into a pair of corkscrews. That very evening they had become the best friends in the world again. And the habitués at the Café Guerbois, happy and relieved, composed a triolet of nine lines in their honor. . . ."[6]

At another time Manet and Degas had a vehement run-in and subsequently returned the paintings each had given the other. When Degas thus received back the portrait he had done of Manet listening to his wife playing the piano, from which Manet had cut off the likeness of Mme. Manet, the mutilation did anything but assuage his anger. He immediately added to the painting a piece of white canvas, apparently with the intention of redoing the part cut off (p. 99) but never did so.

Even when they were not actually quarrelling, Degas and Manet retained a few "grudges." Manet never forgot that Degas had still been painting historical scenes at a time when he himself was already studying contemporary life, whereas Degas was proud to have painted horse races long before Manet discovered this subject. Nor could he help noticing that Manet never did "a brushstroke without the masters in mind."[7] Nevertheless, of all the painters at the Café Guerbois, Degas unquestionably was closest to Manet, both in taste and in the *esprit* with which he was so richly endowed.

Rather small, very slim, with an elongated head, "a high, broad and domed forehead crowned with silky, chestnut hair, with quick, shrewd, questioning eyes deep-set under high arched eyebrows shaped like a circumflex, a slightly turned-up nose with wide nostrils, a delicate mouth half hidden under a small mustache,"[8] Degas had a somewhat mocking expression. He must have appeared almost frail compared with the others, especially as there was in his features as well as in his manners and his speech an aristocratic, even old-fashioned refinement that contrasted sharply with his surroundings at the Café. In his opinions and preferences he often stood alone, although it was not always clear where in him seriousness ended and irony began. To oppose him in a discussion was particularly difficult, not only because he had at his disposal a wide range of arguments, but because he little hesitated to confound his opponents with inescapable aphorisms, sometimes malicious, sometimes even cruel, always extremely clever.

Duranty noted apropos Degas: "an artist of rare intelligence, preoccupied with ideas, which seemed

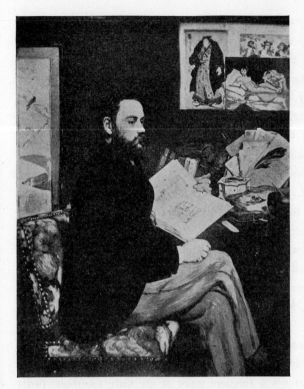

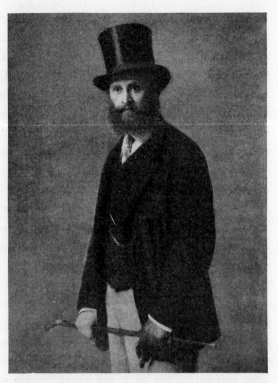

MANET: *Portrait of Emile Zola, 1868. 57¼ x 43¼".*
Exhibited at the Salon of 1868. Louvre, Paris (Gift
of Mme Zola).

FANTIN-LATOUR: *Portrait of Edouard Manet, d.*
1867. 46 x 35½". Exhibited at the Salon of 1867.
Art Institute, Chicago.

strange to the majority of his fellows. Taking advantage of the fact that there was no method or transition in his brain which was active and always boiling over, they called him the inventor of social chiaroscuro."[9] One of Degas' favorite topics was, indeed, "the unsuitability of making art available to the lower classes and allowing the production of pictures to be sold for 13 sous."[10] While such views must have been violently contested by the extremely social-minded Pissarro and Monet, Degas caused even more surprise by his tendency to consider seriously and even to defend the works of artists in whom his listeners were unable to discover any qualities. Apparently his great respect for the specific problems tackled made him indulgent toward the results obtained. Where the others saw only the ultimate failure, he remained conscious of the initial effort and was unable to withhold sympathy. Once in front of a landscape by Rousseau, questioned about the trouble in rendering details meticulously—in this case, the leaves of trees—his immediate answer was: "If it weren't trouble, it wouldn't be fun."[11]

Among the habitués of the Guerbois, Degas was particularly friendly with Duranty, an excellent debater whose ideas often coincided with Degas' and who was brilliant enough not to be intimidated by him. Of the others only Bazille seems to have had enough education and taste for verbal skirmishes to engage such adversaries as Degas or Manet. Although apparently somewhat shy, Bazille was firm in his beliefs and stood up for them. From his letters it appears that his arguments had more of the calmness and precision which distinguished a lawyer than the passion that might be expected from a young artist.

He always went right to the center of the problem with a clarity of mind blurred by no sentimentalities, and he approached all questions with a matter-of-factness quite uncommon for his age.

When he later assembled notes for the central figure of one of his novels, Zola drew the following portrait of Bazille: "Blond, tall and slim, very distinguished. A little the style of Jesus, but virile. A very handsome fellow. Of fine stock, with a haughty, forbidding air when angry, and very good and kind usually. The nose somewhat prominent. Long, wavy hair. A beard a little darker than the hair, very fine, silky, in a point. Radiant with health, a very white skin with swiftly heightened color under emotion. All the noble qualities of youth: belief, loyalty, delicacy."[12]

While Manet, Degas and Bazille represented the same type of cultivated and wealthy bourgeois, most of their companions came from lower social rank. Cézanne, in spite of the fortune amassed by his father—a former hat-manufacturer—and in spite of his law studies, liked to exhibit rather rough manners or to exaggerate his Southern accent out of defiance for the polished style of the others. It was as if he were not satisfied to show his contempt for official art only in his works, as if his entire being had to express a challenge, to underline his revolt. He willfully neglected his appearance and seemed to take pleasure in shocking others. Monet later remembered, for instance, how Cézanne would shake hands with his friends but take off his hat in front of Manet and say: "I am not offering you my hand, Monsieur Manet, I haven't washed for eight days."[13]

Cézanne was tall, "thin, with twisted movements of articulation, a strong, bearded head. The nose was very delicate, lost in the bristly mustache, the eyes narrow and clear. . . . In the depth of his eyes, great tenderness. His voice was strong."[14] He was not a frequent guest at the Café Guerbois, partly because he used to spend half the year in his native Aix, partly because he did not care for discussions and theories. If he showed any interest at all in what was going on around him, he would sit in a corner and listen quietly. When he spoke up, he did so with the vehemence of deep inner conviction, but often, when others expressed opinions radically opposed to his own, he simply got up abruptly and, instead of answering, left the gathering without taking leave of anybody.

Cézanne's friend Zola, quite the contrary, assumed a prominent role in the group. Short and plump, outspoken and energetic, he had become its mouthpiece in the press and its ardent defender. Yet his adherence to the group had been dictated by his search for new forms of expression rather than by a full understanding of the artistic problems involved. His taste lacked both refinement and discrimination, but his heart was with those who, ridiculed by the masses, had set out in the pursuit of a new vision. He was happy to find in their theories many analogies to his own views on literature and saw in their common struggle the promise of a common triumph. With enthusiasm and stubbornness he had embraced the cause of Manet and the others, eager not to miss any occasion for proclaiming his faith. "I was passionate in my convictions," he later wrote of those days, "I should have liked to cram my beliefs down other people's throats."[15]

Monet, too, had something of the fire of Zola, but was apparently unwilling to put himself forward. The almost brutal refusal to compromise, which he had shown in his youth, seems to have worn off with the years so rich in bitter trials. Not that his views had changed or his self-confidence vanished, but he now was somehow less eager to manifest his robust pride. He who had been the leader of the little group of his friends thus became an unobtrusive guest at the Café Guerbois, more concerned with listening to the others than with contributing to the discussions. Having left school early, as had Renoir,

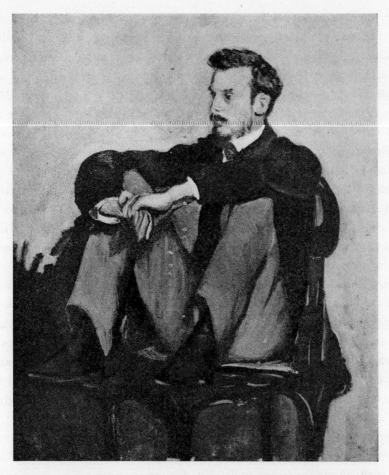

BAZILLE: *Portrait of Auguste Renoir, 1867. 24½ x 20". Musée National des Beaux-Arts, Algiers.*

he may have felt a certain lack of education that prevented his entering into the debates, just as his ignorance of the masters of the past deprived him of arguments in controversies for or against certain traditions. Yet his incomplete education does not appear to have inspired him with any regret; instead, he relied with superb confidence on his instincts. After all, it mattered little whether he won an argument or surprised the others by a witty remark. When he put up his easel somewhere in the open, no erudition, no cleverness would help him solve problems. The only experience he cared for was that which was gained through work: the perfect blending of his energetic temperament and the delicacy of his visual sensations, the complete command of his means of expression.

Although Manet and Degas did not show very much consideration for the pure landscapists, Monet needed the Café Guerbois in order to overcome the feeling of complete isolation which may have oppressed him occasionally during his retreats in the country. It was good for him, no doubt, to find there kindred spirits, cordial friends and the assurance that ridicule or rejection were powerless against the determination to carry on. Together the friends constituted a movement; and in the end success could not be denied them.

Like Monet, Renoir was not the man to raise his voice in collective and noisy debates. He had formed himself, had read through many nights, as a young man, and later had studied ardently the masters of the Louvre. Though he could hardly compete with Manet or Degas, a natural and vivid intelligence helped him to grasp the essence of all problems that were presented. He had a great sense of humor, was quick, witty, without too much passion but hard to convince. He could listen to others and acknowledge the faultless structure of their arguments yet feel free to cling to his convictions, even if nobody shared them. When Zola reproached Corot for putting nymphs instead of peasant women into his landscapes, Renoir could not see why this should make any difference, so long as Corot's works satisfied him. And while the others stressed their independence, he never faltered in his belief that it was at the museum that one learned best how to paint. "I used to have frequent discussions on this subject," he said later, "with some of my friends who argued against me in favor of studying strictly from nature. They held against Corot his re-working his landscapes in the studio. They found Ingres revolting. I used to let them talk. I thought that Corot was right and in secret I delighted in *La Source's* pretty belly and in the neck and arms of *Madame Rivière* [by Ingres]."[16]

Thin, nervous, modest and poor, Renoir was always lively and full of an irresistible gaiety. His speech was more or less deliberately adorned with Parisian slang and he readily laughed at jokes even when they were not so clever as Degas' *bon mots*. He showed complete unconcern for solemn theories and deep reflections; they seemed to annoy him. Life was enjoyable, painting was an inseparable part of it, and to create a work of art a happy mood seemed to him more important than any profound remark about the past, present or future. He refused to consider himself a revolutionary, often repeating that he only "continued what others had done—and much better—before me."[17] And he willingly confessed that he did not have "a fighter's spirit."

Widely divergent as they were in character and conceptions, the friends who met at the Café Guerbois nevertheless constituted a group, united by a common contempt for official art and a determination to seek the truth outside the beaten track. But since nearly every one of them was seeking it in a different direction, it was logical that they were not considered as a "school" and instead received the designation *Le groupe des Batignolles*. This neutral term simply underlined their affinities without limiting their efforts to any specific field. When Fantin undertook in 1869 to paint another of his group compositions, *A Studio in the Batignolles Quarter*, according to his own description, he showed, around Manet, seated in front of his easel: Renoir, "a painter who will get himself talked about"; Astruc, "a whimsical poet"; Zola, "a realistic novelist, great defender of Manet in the newspapers"; Maître, "a highly refined mind, amateur musician"; Bazille, "manifesting talent"; Monet and the German painter, Scholderer.[18] For the first time Fantin neglected to depict himself in the midst of his friends, as if he considered his place was no longer among them. But he also omitted a rather prominent member of the group, Camille Pissarro.

The dean of the painters, two years older than Manet and ten years older than Monet, father of two children, Pissarro now lived with his little family in Louveciennes but paid frequent visits to Paris. He seems to have been always a welcome guest at the Café Guerbois, for there was no one among the painters and authors who did not feel deep esteem for this gentle and calm artist, who united profound goodness with an indomitably belligerent spirit. More conscious than the others of the social problems of the times, he had nothing of Degas' casual frivolity or of Manet's occasional showmanship. Passionately

FANTIN-LATOUR: *A Studio in the Batignolles Quarter,* 1870. 68½ x 82". (*From left to right: Scholderer, Manet, Renoir, Astruc, Zola, Maître, Bazille, Monet.*) Exhibited at the Salon of 1870. Louvre, Paris.

interested in political questions, a socialist strongly tinted with anarchist ideas, a convinced atheist, he linked the painters' struggle to the general position of the artist in modern society. But radical as his opinions were, they were free from hatred, and everything he said was illuminated by unselfishness, a purity of intention that commanded the respect of the others. They knew about his own difficulties and admired the complete lack of bitterness, indeed, the cheerfulness, with which he could discuss the most radical issues.

The son of Jewish parents, Pissarro had many of the characteristics of the Semitic type: abundant dark hair, a noble, aquiline nose and large, somewhat sad eyes that could be both fiery and tender. His mind was clear, his heart generous. Those who came to know him felt not only respect for Pissarro but genuine affection. It is no chance that two of the most distrustful, most undependable members of the group, Cézanne and Degas, felt real friendship for him. Never flattering, never behaving with unwarranted harshness, he inspired complete confidence because in his actions and in his views he resembled the just of the Bible.

While, at the Café Guerbois, Pissarro may have occasionally brought up political questions, the discussions centered more frequently upon theoretical or technical problems of painting. One of the subjects of wide interest to the artists was that of oriental art in general—they had been able to study it at the 1867 World's Fair—and of Japanese prints in particular.

As far back as 1856 Bracquemond had discovered a little volume of Hokusai, which had been used for packing china; he had carried it around with him for quite a while, showing it to everybody. A few years later, in 1862, Madame Soye, who with her husband had lived in Japan, opened under the arcades of the rue de Rivoli *La Porte Chinoise,* an oriental shop, which soon attracted a great number of artists. Whistler began to collect blue and white china as well as Japanese costumes which he bought there. In 1865 he posed in a kimono for Fantin's *Toast* and exhibited the *Princesse du Pays de Porcelaine* (Jo dressed in oriental silks) at the Salon. Rossetti and Degas' friend Tissot also began to buy Japanese costumes; there is a painting of a Japanese subject on the wall of Tissot's studio in the portrait Degas painted of him. Japanese prints and Japanese fans found their way into almost every studio. Monet and Renoir owned some, and there are two Japanese prints next to Zola's table in his portrait by Manet. Fantin, Manet, Baudelaire and the Goncourt brothers were among those to be seen frequently at Madame Soye's.[19]

Of the Batignolles group, Degas apparently showed the greatest interest in Japanese prints. Their graphic style, their subtle use of line, their decorative qualities, their daring foreshortenings and, above all, the way in which their principal subjects were often placed off-center, the whole composition and organization of space seem to have impressed him deeply. Some of these characteristics were to find an echo in his own works, but, unlike Tissot or Whistler, he did not make any direct use of picturesque Japanese subjects or elements. Quite the contrary, he endeavored to absorb those of the new principles which he could adapt to his own vision and used them, stripped of their fancy oriental character, to enrich his repertory. "From Italy to Spain, from Greece to Japan," he liked to say, "there is not very much difference in technique; everywhere it is a question of summing up life in its essential gestures, and the rest is the business of the artist's eye and hand."[20]

Cézanne seems not to have been at all attracted by oriental art, since it had no connection whatsoever with the regions haunted by his fertile imagination. But prints in the cheap fashion journals to which his

PIETTE: *Camille Pissarro at Work, c. 1870 [?]. Gouache, 10¾ x 13¼". Collection Mme Bonin-Pissarro, Paris.*

two young sisters subscribed interested him occasionally. When he fell short of inspiration, which did not happen often, he thought nothing of copying the insipid ladies in these plates, infusing them with a strange and dramatic power. Just as Manet had frequently adopted certain elements from the masters, Cézanne found in these fashion prints merely pretexts for creations of his own.

Renoir too was very little interested in Japanese prints. He was at this period greatly impressed by Delacroix's treatment of oriental subjects and found in that painter's odalisques and Algerian scenes more excitement and richer color schemes than in the meticulous harmonies from Japan. Pissarro, on the other hand, was inclined to admire the technical accomplishments in Japanese prints, being particularly interested in the various processes of the graphic arts. As for Monet, he apparently had admired Japanese prints in Le Havre at about the same time as Bracquemond had discovered them in Paris, and he later said: "Their refinement of taste has always pleased me and I approve of the suggestions of their aesthetic code, which evokes presence by means of a shadow, the whole by means of a fragment."[21]

The whole subject of shadows may well have been often under discussion at the Café Guerbois; in fact, it constituted one of the painters' main problems. Manet liked to maintain that for him "light appeared with such unity that a single tone was sufficient to convey it and that it was preferable, even though apparently crude, to move abruptly from light to shadow than to accumulate things which the eye

doesn't see and which not only weaken the strength of the light but enfeeble the color scheme of the shadows, which it is important to concentrate on."[22] But those among Manet's companions who had already worked out-of-doors, that is, all the landscapists in the group, must have objected to his manner of dividing a subject merely into lighted and shadowed areas. Their experience with nature had taught them otherwise. Little by little they were abandoning the usual method of suggesting the third dimension by letting the so-called local color of each object become more somber as the object itself seemed further away from the source of light and plunged into the shadow. Their own observations had taught them that the areas in the shadow were not devoid of color or merely darker than the rest, but that they were simply not so bright. Being to a lesser degree penetrated by the light, the shadowed areas did not, of course, show the same color values as those exposed to the sun, but they were just as rich in color, among which complementaries and especially blue seemed to dominate. By observing and reproducing these colors, it became possible to indicate depth without resorting to any of the bitumens customarily reserved for shadows. At the same time the general aspect of the work became automatically brighter. In order to study these questions further Monet, Sisley and Pissarro began to devote themselves especially to winter landscapes. There could be no question that a shadow cast on snow was not bituminous and that instead of the original white there appeared in the shadowed region colors postulated by the object that barred the light and by the general atmospheric condition. It thus became clear that surroundings exposed to light influenced the colors of those parts remaining in the shadow.

As a result of these observations any discussion of the problems of light and shadow at the Café Guerbois became actually a debate for or against the "plein air." Although Manet, Degas and Fantin did not withhold their opposition to working out-of-doors—partly because the old masters had never done so—Monet and his friends could not fail to praise the infinite variety of colors and the much greater penetration of light and its reflections which their method permitted them to attain.

It seems certain that the word *impression* was frequently heard in these discussions. Critics had used it for some time to characterize the efforts of such landscapists as Corot, Daubigny and Jongkind. Rousseau himself had spoken of his attempts to remain faithful to the "virgin impression of nature," and even Manet though not primarily interested in landscapes, had insisted on the occasion of his large show in 1867 that his intention was "to convey his impression." According to his friend Proust, Manet had already been using this word for about ten years.

It is probable that the discussions at the Café Guerbois also touched upon more practical questions, such as the immense difficulties all the members of the group encountered in trying to earn a living through their art. Almost every one of them knew a few collectors who occasionally bought paintings; the singer Faure and the bankers Hecht showed interest in Manet's works, another banker, Arosa, favored Pissarro, Monet had his patron Gaudibert in Le Havre, but there did not exist as yet a real market for their canvases. There were practically no dealers interested in handling their works. Martinet did not make much progress in selling Manet's paintings, and Latouche was not to be greatly relied upon either. When he showed again in his window in 1869 a view of Sainte-Adresse by Monet, there was, according to Boudin, "a crowd before the windows during the whole exhibition and, in the younger people, the unexpected element in this violent painting produced *fanaticism*,"[23] but the picture apparently was not sold. Cézanne had had a similar experience when a dealer in Marseilles exhibited one of his works. "The result was a great to-do," Valabrègue informed Zola. "Mobs formed in the street; the crowd was

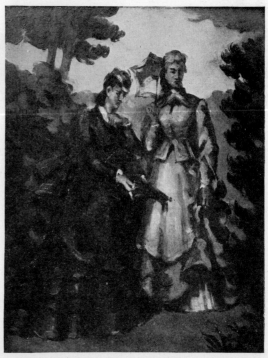

Fashion Print published in La Mode Illustrée.

CÉZANNE: *Copy after a Fashion Print, c. 1870.
23¼ x 18½". Collection Paul Cézanne, Paris.*

dumbfounded. They asked Paul's name; in this regard there was evidence and a slight *succès de curiosité.* Otherwise, I believe that if the picture had stayed long on exhibit, people would have ended by breaking the glass and tearing the canvas to pieces."[24]

The only regular dealer who at that time showed some interest in the works of the young men was *père* Martin, who used to handle occasionally the works of Corot and more or less exclusively those of Jongkind. Pissarro had begun to have dealings with him around 1868, but Martin paid only from 20 to 40 francs, according to the size of the canvas, reselling at prices between 60 and 80 francs. Sisley did not obtain more, whereas *père* Martin apparently charged up to 100 francs for works by Monet but was satisfied with 50 for canvases by Cézanne. There seemed little hope for the painters to command higher prices in the near future unless they managed to attract the public's attention and favor, which could be done only at the Salon.

The opinions concerning the Salon were rather divided in the Batignolles group. Renoir, who hated to "play the martyr," regretted his occasional rejections simply because to exhibit at the Salon seemed the natural thing to do.[25] But Manet used to proclaim that the "Salon is the real field of battle. It's there one must take one's measure."[26] Since it was the only place where the artists could present themselves, Manet argued, they should accept the challenge of the public and the jury and force their way, for there was no doubt that sooner or later their day would come. Cézanne advocated that the painters regularly send their most "offensive" works to the Salon. In doing so he radically departed from the established custom, already honored by Corot and Courbet, of submitting to the jury only the "tamest"

PISSARRO: *Louveciennes, the Road to Versailles in Winter,* 1870. 15⅛ x 18¼". Walters Art Gallery, Baltimore (G. A. Lucas Collection).

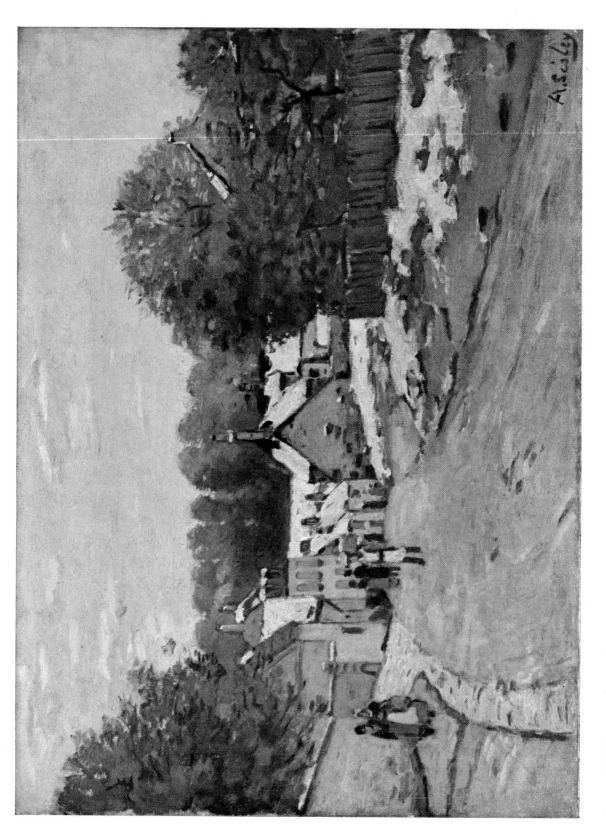

SISLEY: Early Snow at Louveciennes, c. 1870. 21⅜ x 28⅞". Collection John T. Spaulding, Boston.

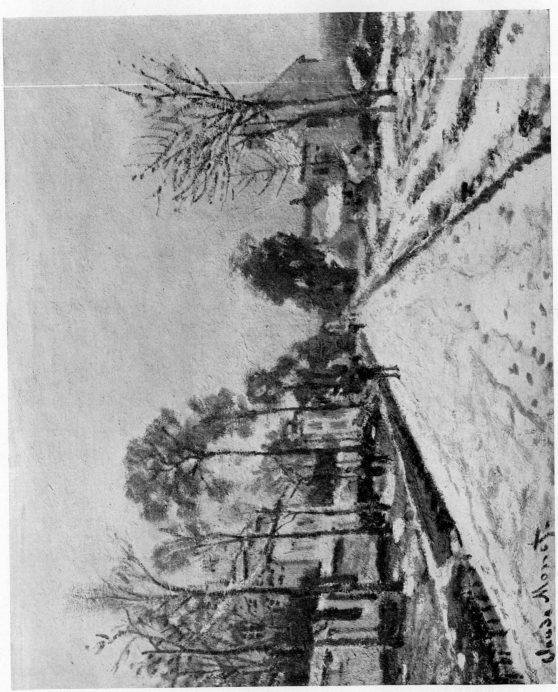

MONET: *Snow-effect in Argenteuil*, 1874. 22 x 29¼". *Formerly in the Faure collection. Private collection, New York.*

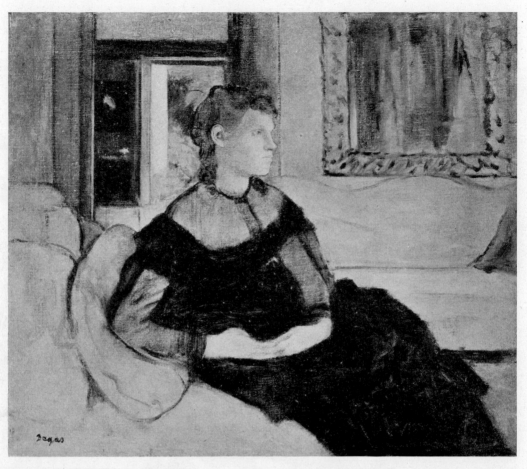

DEGAS: *Portrait of Berthe Morisot's Sister Yves, Mme Gobillard, 1869. 21⅜ x 25⅝". Metropolitan Museum of Art, New York.*

works. This custom actually led many artists to distinguish between their paintings executed for the Salon and their regular work done without compromise. But Cézanne's purpose was less to be admitted to the Salon than to put the refusing jury into the wrong. Zola expected him to be refused for another ten years, and the painter himself apparently did not think otherwise. In the meantime he treated the jury to the strongest words in his extended vocabulary and vowed: "They'll be blasted in eternity with even greater persistence!"[27]

Both Manet and Cézanne had sufficient resources to allow them to wait, but for the others the question was not merely one of principle. Besides being obliged to sell their works, they must have felt also that the endless struggle against the jury condemned them to isolation by depriving them of the only means to exhibit their canvases. Next to creating, nothing seemed more essential than to show the results of their efforts, to try at least to interest the public in their honest intentions, their ceaseless labor and their new discoveries.

In 1869 a decree appeared which seemed to promise that admission to the Salon would at last be made easier. Beginning in that year *all* painters who had once been admitted to the Salon were entitled

DEGAS: *Portrait of Mme Camus, 1870. 28¾ x 36". Exhibited at the Salon of 1870. National Gallery of Art, Washington, D. C. (Chester Dale loan).*

to participate in the election of two-thirds of the jury. This meant that, except for Cézanne, who had shown only at the *Salon des Refusés,* all the members of the Batignolles group could now participate in the elections. But Bazille, realistic as ever, told his parents: "I shall not vote, because I should prefer not to have any jury at all, and because the one which has been functioning for several years perfectly represents the majority."[28] As a matter of fact the jury in 1869 did not differ substantially from that of previous years. Daubigny was again elected, so were Cabanel and Gérôme, but Corot was not. And the decisions too were similar to those in the past. Stevens, who had tried to interest some jury members in the works of Bazille, was proud to announce that at least one of his friend's canvases had been accepted. Degas and Fantin also had one work admitted and one rejected. Pissarro and Renoir, too, figured in the catalogue with but one painting. Only Manet had two works accepted. Sisley and Monet were refused.

"What pleases me," Bazille wrote to Montpellier, "is that there is genuine animosity against us; it is M. Gérôme who has done all the harm; he has treated us as a band of lunatics and declared that he believed it his duty to do everything to prevent our paintings from appearing; all that isn't bad." And

he added: "I am as badly hung as possible. . . . I have received a few compliments which have flattered me a lot, from M. Puvis de Chavannes [whom he had met at Stevens'], among others. The Salon as a whole is deplorably weak. There is nothing really fine except the pictures of Millet and Corot. Courbet's, which are very feeble for him, make the effect of masterpieces in the midst of the universal platitude. Manet is beginning to be a little more to the taste of the public."[29]

Berthe Morisot had not sent anything to the Salon that year, but a portrait of herself was on exhibition, in Manet's *Balcony*. She went to see it on the opening day and wrote her sister Edma: "One of my first concerns was to make my way to the M. room. There I found Manet, with a bewildered air. He begged me to go and look at his painting because he didn't dare put himself forward. I have never seen such an expressive face; he was laughing in an anxious way, at the same time insisting that his picture was very bad and that it was having a lot of success. I consider him indeed a charming person, who pleases me infinitely. His paintings as usual make the impression of a wild or even slightly green fruit; they are far from displeasing me. I am strange rather than ugly [in the *Balcony*]; it seems that the epithet *femme fatale* has circulated among the curious.

"Friend Fantin cuts a rather dreary figure with a little insignificant canvas, placed unbelievably high. . . . Degas has a very pretty little portrait of an extremely ugly woman in black, wearing a hat and letting her shawl fall off, the whole thing against a background of a very light room, a fireplace in half-tone in the background. It is very sensitive and distinguished.

"Tall Bazille has done something I consider fine: it is a little girl in a very light dress under the shadow of a tree behind which one glimpses a village. There is a lot of light, of sun. He is attempting what we have so often tried, putting a figure out-of-doors; this time he seems to me to have succeeded."[30]

Berthe Morisot also informed her sister that "M. Degas seems very satisfied with his portrait. . . . He came and sat beside me, pretending that he was making love to me, but this was limited to a long commentary on Solomon's proverb: 'Woman is the desolation of the just.' "[31]

"Poor Manet is sad," she wrote a little later. "His show, as usual, was little appreciated by the public; but for him this is a continually new cause of astonishment. Nevertheless, he told me that I brought him luck and that he had had an offer for the *Balcony*. I should like it to be true for his sake, but I am very much afraid that his hopes will again be disappointed."[32] And Berthe Morisot's mother told her daughter, concerning Manet: "He tells you in a very natural way that he meets people who avoid him in order not to discuss his painting with him and that, observing this, he no longer has courage to ask anyone to pose for him."[33]

However, Manet was soon to have this "courage" again, for when he met Eva Gonzalès, the twenty-year-old daughter of a then well-known author, he was so fascinated by her dark beauty that he asked her whether she would agree to sit for him. Eva Gonzalès, who was painting under the supervision of the highly fashionable Chaplin, thereupon left her teacher and entered as a "pupil" Manet's studio, rue Guyot.[34] Berthe Morisot, ardent but timid, seems to have resented the presence of a more worldly rival in the intimacy of Manet's studio and suffered from seeing the other replace her as a model.

". . . At the moment," she wrote to her sister, "all his admiration is concentrated on Mlle Gonzalès; but her portrait makes no progress. He tells me that he is at the fortieth sitting, and the head has again been scraped off. He is the first to laugh about it."[35]

"The Manets came to see us," she wrote a little later. "We went to the studio. To my great

MANET: *The Balcony (Berthe Morisot, Antoine Guillemet and the violinist Jenny Claus), 1869.*
67¾ x 49¼". Exhibited at the Salon of 1869. Louvre, Paris (Caillebotte Bequest).

RENOIR: *Summer, 1868-69. Exhibited at the Salon of 1869. National Galerie, Berlin.*

DEGAS: *Mme Gaujelin, d. 1867. 23½ x 17½". Exhibited at the Salon of 1869. Isabella Stewart Gardner Museum, Boston.*

MONET: *The River, d. 1868. 32 x 39". Art Institute, Chicago (H. and P. Palmer Collection).*

surprise and satisfaction, I received the highest praise. It seems that what I do is decidedly better than Eva Gonzalès. Manet is too frank for one to be mistaken about it. I am certain that it pleased him a lot. Only, I recall what Fantin says: 'He always finds good the painting of people he likes.' "[35]

Manet particularly admired a canvas Berthe Morisot had just painted in Lorient, representing her sister Edma against a *View of the Petit Port at Lorient,* in which she had tried what Bazille had attempted in his Salon picture, to reproduce a figure in "plein air." Overjoyed by Manet's appreciation, which was shared by Puvis de Chavannes, she offered the painting to him. Degas meanwhile painted a portrait of Berthe's sister, Yves, Madame Gobillard, either before a trip he made in 1869 to Italy or after his return.

Manet spent the summer of 1869 again at Boulogne. Observing the bathers on the beach and the people on the Channel boats for Folkstone, he applied himself to the same problems which had already preoccupied his friends at the Café Guerbois: to retain his impressions in small, rapidly painted canvases. In doing so he may also have remembered Castagnary's recent criticism concerning his canvases at the Salon:

"Until now Manet has been more fanciful than observant, more whimsical than powerful. His work is meager, if one prunes it of still-life and flowers, which he handles as an absolute master. What does

BAZILLE: *The Pink Dress, 1865. 58⅛ x 44". Louvre, Paris.*

BAZILLE: *View of the Village, d. 1868. 52⅛ x 35⅝". Exhibited at the Salon of 1869. Musée Fabre, Montpellier.*

this sterility come from? From the fact that, while basing his art upon nature, he overlooks giving it the goal of the interpretation of life. His subjects are borrowed from the poets or taken from his imagination; he doesn't bother to discover them in the living figure of human society."[36]

In Boulogne during this summer Manet began to observe the life around him. And as he did so, the works he executed there lost that element of a "museum souvenir" which characterized so many of his large canvases.

Renoir, meanwhile, spent his summer quietly with Lise at his parents' house in Ville d'Avray, frequently visiting Monet in nearby Bougival. Monet was again in a desperate situation: no money, no paints, no hope. His new rejection by the jury had been a frightful blow. Remembering Arsène Houssaye's enthusiasm upon buying *Camille* in Le Havre and his advice that Monet should come and live in or near Paris, where it would be easier for him "to take advantage of my small talent," the painter now swallowed his pride and wrote in June to the collector: "M. Gaudibert has just now again had the kindness to enable me to settle here and send for my little family. The settling-in is finished and I am in very good condition and full of courage for work, but, alas, that fatal rejection has almost taken the bread out of my mouth and in spite of my not at all high prices, dealers and art lovers turn their backs on me. Above all, it is saddening to see how little interest there is in a piece of art that has no list

MORISOT: *Harbor of Lorient (with the artist's sister Edma at right), 1869. 17¼ x 29". Offered by the artist to Manet. Collection Mme G. Thomas, Paris.*

price.—I have thought, and I hope you will *excuse* me, that since you formerly found a canvas of mine to your taste, you might like to see the few that I have been able to save, for I thought that you would be good enough to come to my aid a little, since my position is almost desperate and the worst is that I cannot even work. It is useless to tell you that I'll do anything at all and at any price in order to get out of such a situation, and to be able to work from now on for my next Salon so that a similar thing doesn't occur."[37]

Yet Arsène Houssaye does not seem to have done much for the artist or bought another of his works. Shortly afterwards Monet asked Bazille to send him paints, that he might at least continue to work. But in August paints were no longer his worry: "Renoir is bringing us bread from his house so that we don't starve," he wrote Bazille. "For a week no bread, no kitchen fire, no light—it's horrible."[38] By the end of August, Monet had no colors left and could not continue to work. Bazille was apparently unable to help to any extent, for he had even pawned his own watch. As for Renoir, he was not much better off; he was in debt with his dealers and did not have enough money to stamp his letters to Bazille. "We don't eat every day," he wrote to the latter. "Yet I am happy in spite of it, because, as far as painting is concerned, Monet is good company." But he added: "I do almost nothing because I haven't much paint."[39]

Notwithstanding his hopeless situation Monet did not lose faith, and Renoir later remembered gratefully that it was Monet who inspired him with new courage whenever he abandoned himself to despair.[40]

Together the two friends frequented *La Grenouillère,* a bathing place on the Seine near the restaurant Fournaise in Bougival, where the river with its boats and gay bathers formed an attractive motif. But again work had to be interrupted and late in September Monet exclaimed in a letter to Bazille: "Here I'm at a halt, from lack of paints. . . ! Only I this year will have done nothing. This makes me rage against everybody. I'm jealous, mean; I'm going mad. If I could work, everything would go all right. You tell me that it's not fifty, or a hundred, francs that will get me out of this; that's possible, but if you look at it this way, there's nothing for me except to break my head against a wall, because I can't lay claim to any instantaneous fortune. . . . I have indeed a dream, a picture of bathing at *La Grenouillère,* for which I've made some bad sketches, but it's a dream. Renoir, who has been spending two months here, also wants to do this picture."[41]

The study of water played an important role in the development of the style of Monet and his friends. In 1868 Monet had painted a picture of a woman seated on a river bank in which the reflec-

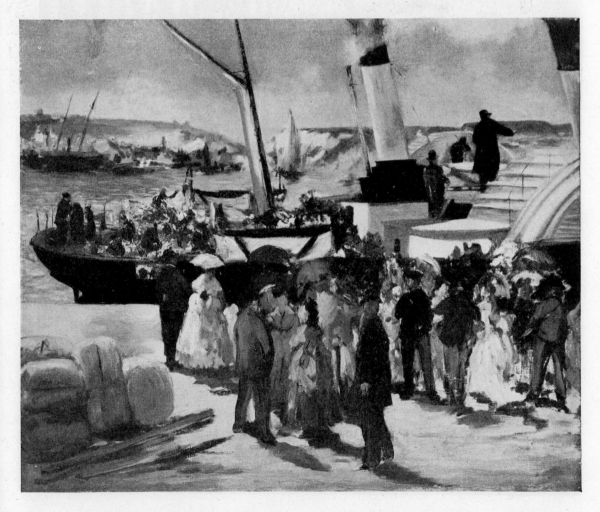

MANET: *The Folkstone Boat, Boulogne,* 1869. 23½ x 28⅞". *Collection Carroll S. Tyson, Philadelphia.*

191

MONET: *La Grenouillère*, 1869. 29⅜ x 39¼". Metropolitan Museum of Art, New York (H. O. Havemeyer Collection).

RENOIR: *La Grenouillère, 1869. 26 x 31⅞". National Museum, Stockholm.*

Monet: *Still Life, c. 1869* [?]. *Present owner unknown.*

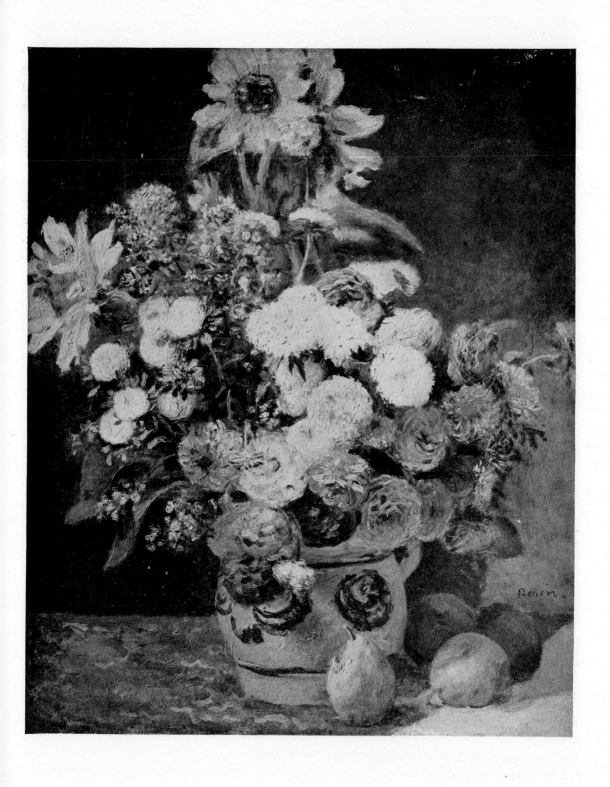

RENOIR: *Still Life, c. 1869* [?]. *25¼ x 21". Collection John T. Spaulding, Boston.*

tions on the water had constituted the main interest. Just as snow scenes had permitted the artists to investigate the problem of shadows, the study of water offered an excellent opportunity to observe reverberations and reflections. Thus they could further develop their knowledge of the fact that so-called local color was actually a pure convention and that every object presents to the eye a scheme of color derived from its proper color, from its surroundings and from atmospheric conditions. Moreover, the study of water gave pretext for the representation of formless masses livened only by the richness of nuances, of large surfaces whose texture invited vivid brushstrokes.[42]

Monet had already made extensive use of vivid brushstrokes, and so had Renoir, who in his study *Summer,* exhibited at the Salon of 1869, had introduced large dots into the background, representing leaves. At the *Grenouillère* the two friends now used rapid strokes, dots and commas to capture the glistening atmosphere, the movement of the water and the attitudes of the bathers. What official artists would have considered "sketchiness"—the execution of an entire canvas without a single definite line, the use of the brushstroke as a graphic means, the manner of composing surfaces entirely through small particles of pigment in different shades—all this became now for Monet and Renoir not merely a practical method of realizing their intentions, it became a necessity if they were to retain the vibrations of light and water, the impression of action and life. Their technique was the logical result of their work out-of-doors and their efforts to see in subjects not the details they recognized but the whole they perceived. While Monet's execution was broader than Renoir's his colors were still opaque, whereas the other was using brighter colors and a more delicate touch.

From the weeks they spent together at the *Grenouillère* dates a real work-companionship between the two. Whether they studied the same flowers in the same vase or whether they put up easels in front of the same motif, Renoir and Monet, during the years ahead, were to paint more frequently the same subjects than any other members of their group. And in this communion of work they were to develop a style of expression which at times also brought them closer to each other than to the rest.

After having each painted two or more studies at *La Grenouillère,* Monet and Renoir separated in October, 1869. Monet went to Etretat, then to Le Havre and settled in November with Camille and little Jean at Saint-Michel near Bougival, not far from Paris. Renoir joined Bazille, who had just taken a new studio in Paris, rue de la Condamine, in the Batignolles quarter, close to the Café Guerbois. Bazille, too, had devoted the summer months to a study of bathers in the open. But in his large canvas, *Summer Scene,* the figures are not yet completely integrated with the landscape because the artist had not executed his canvas entirely out-of-doors and had used a more or less smooth brushwork for the bodies of his bathers, reserving small and vivid strokes for the grass, trees and water, thus impeding the unity of the composition. Bazille now planned to paint a nude in his studio, a room which so enchanted him that he made it the subject of a canvas, representing in the huge atelier a number of his friends. But unlike Fantin, who used to group his models almost solemnly, Bazille endeavored to show them with all the informality that reigned in his abode. While Maître plays the piano, Zola leans over a flight of steps, speaking to Renoir seated on a table; Manet looks at a canvas on an easel; Monet, smoking, watches from behind him, and Bazille stands close to them, palette in hand. After the artist had done the portraits of his friends, Manet took his friend's brushes and himself added Bazille's likeness to the canvas.[43]

In May 1870, Bazille left his studio on the rue de la Condamine and crossed the Seine to live in

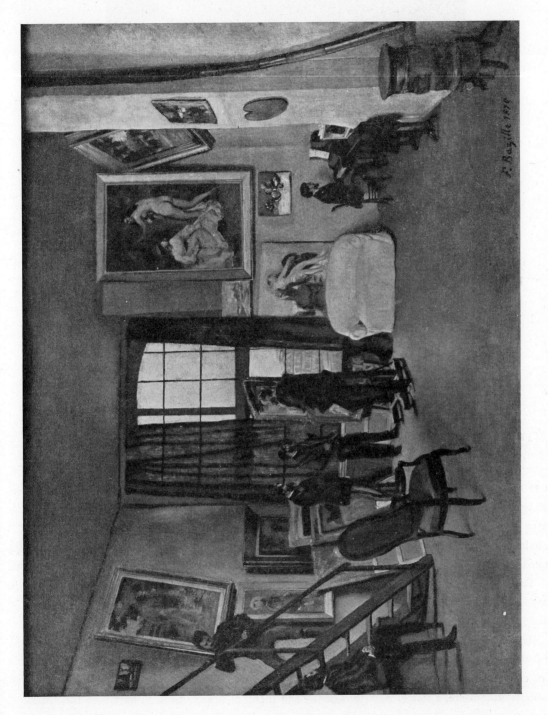

F. Bazille 1870

BAZILLE: *The Artist's Studio, rue de la Condamine, Paris, d. 1870. 38⅞″ x 47″. Louvre, Paris.*

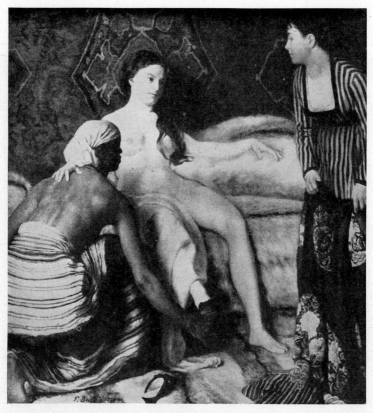

BAZILLE: *The Toilet, d. 1870. 52⅞ x 50⅞". Rejected at the Salon of 1870. Musée Fabre, Montpellier.*

the rue des Beaux-Arts, in the same house where Fantin had his studio. Renoir did not accompany him to the other side of the river. While Bazille thus moved away from the Café Guerbois, a new guest appeared at this establishment. He was a strange and amusing man, Marcellin Desboutin, a painter, engraver and author, but above all a Bohemian. Of vaguely noble origin, he had managed to lose a large fortune, to live in a huge castle in Italy until forced by his debts to sell it, to have a piece accepted by the *Théâtre Français* and to maintain a perfect dignity in spite of his more or less romantic rags. Full of original ideas and conversant with many fields of knowledge, he was extremely brilliant in society, especially when he could let himself go in monologues. His presence was highly appreciated at the Café Guerbois.[44]

The Café probably saw a good deal of agitation early in 1870. Since the right to vote for the jury had been extended to every accepted artist, some of these had conceived the idea of presenting a list of their own candidates, a list conspicuous by the absence from it of any members of the Institute. Jules de la Rochenoire, a former pupil of Couture and friend of Manet, seems to have been the instigator. Among those whom a hurriedly formed committee slated for the jury were Corot, Daubigny, Millet, Courbet, Daumier, Manet, Bonvin, Amand Gautier and some others. Manet immediately asked Zola

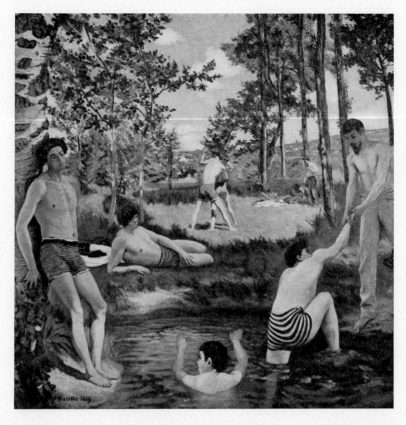

BAZILLE: *Summer Scene, Bathers, d. 1869. 63¼ x 63¼". Exhibited at the Salon of 1870. Fogg Art Museum, Cambridge, Mass.*

to publish a notice in several newspapers, requesting the artists to vote for this list. But the plan failed miserably. Of those listed, only Daubigny and Corot were elected, but these two had also figured on the official list. Although both of them received more votes than any other jury member, they were compromised by their agreement to head the dissenting and defeated list. Their authority was thus paralyzed, and when Daubigny was unable to have even one painting by Monet accepted, he resigned. "From the moment that I liked this picture," he explained, "I wouldn't allow my opinion to be contradicted. As well say that I don't know my trade."[45] Corot resigned along with Daubigny, but not because of any esteem for Monet.

It almost seems as if the jury members had particularly resented Daubigny's consistent defense of Monet, for of the entire Batignolles group he was singled out for special ostracism. Both of Monet's paintings were refused, whereas Manet, Berthe Morisot, Pissarro, Renoir, Sisley and Fantin had two canvases accepted, and Bazille and Degas at least one each. Manet exhibited his *Portrait of Eva Gonzalès*, who herself had a painting strongly influenced by Manet at the Salon. Renoir had sent a *Baigneuse* still slightly reminiscent of Courbet and a *Woman of Algiers* full of scintillating colors which openly proclaimed his admiration for Delacroix. Sisley showed two landscapes of Paris, Berthe Morisot a double

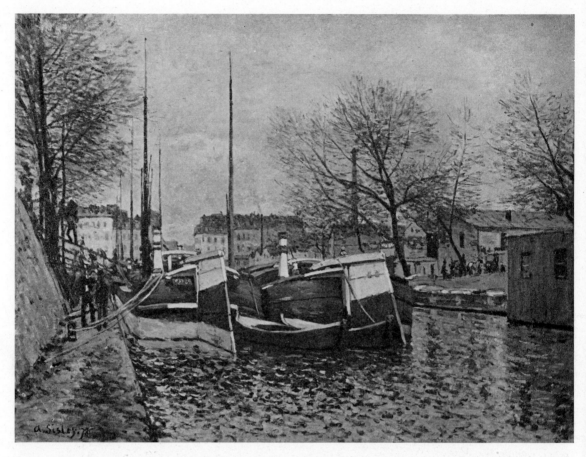

SISLEY: *The Canal Saint-Martin in Paris, d. 1870. 22 x 29¾". Exhibited at the Salon of 1870. Collection Dr. Oskar Reinhart, Winterthur, Switzerland.*

portrait of her mother and her sister Edma, Degas a portrait of a lady with a Japanese fan, while Fantin was represented by *A Studio in the Batignolles Quarter,* and a *Lecture* which was awarded a medal.

This time it was Duret who defended his friends in a series of Salon reviews, giving special praise to Manet, Pissarro and Degas. But since his articles appeared in a paper belonging to the opposition, they very nearly compromised those he had meant to commend.[46] Arsène Houssaye also wrote, finally, in favor of Monet.

Cézanne, rejected as always, was in Paris for the Salon and acted, on the last day of May, as best man at the wedding of Zola. A few weeks later, on June 26, Monet was married to Camille. As for Cézanne, he had met shortly before a young model, Hortense Fiquet, who had agreed to share his life. He was still in Paris or already on his way to Aix when, on July 18, 1870, France "lightheartedly" declared war on Prussia over a question of prestige and the throne of Spain.

The declaration of war surprised Bazille at his parents' country house near Montpellier, where he had just been painting a small canvas of a woman reading in a garden, a work in which his great sensitiveness had at last found free and spontaneous expression. He seemed to have attained finally that intimacy

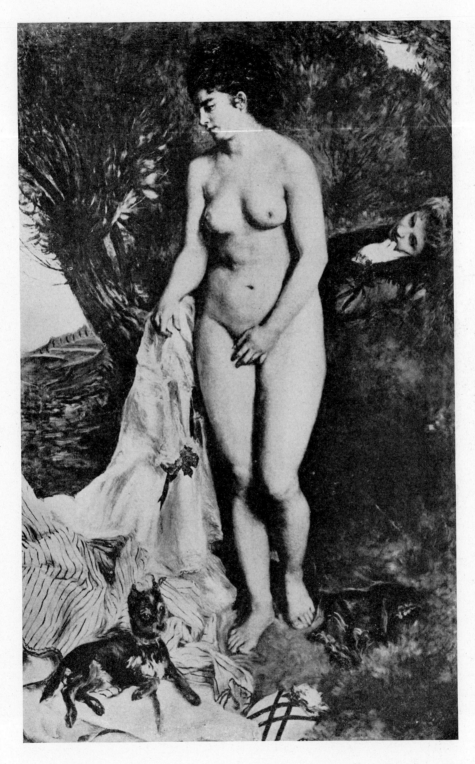

RENOIR: *Bather, d. 1870. 73½ x 46⅛". Exhibited at the Salon of 1870. Formerly Cassirer Gallery, Berlin.*

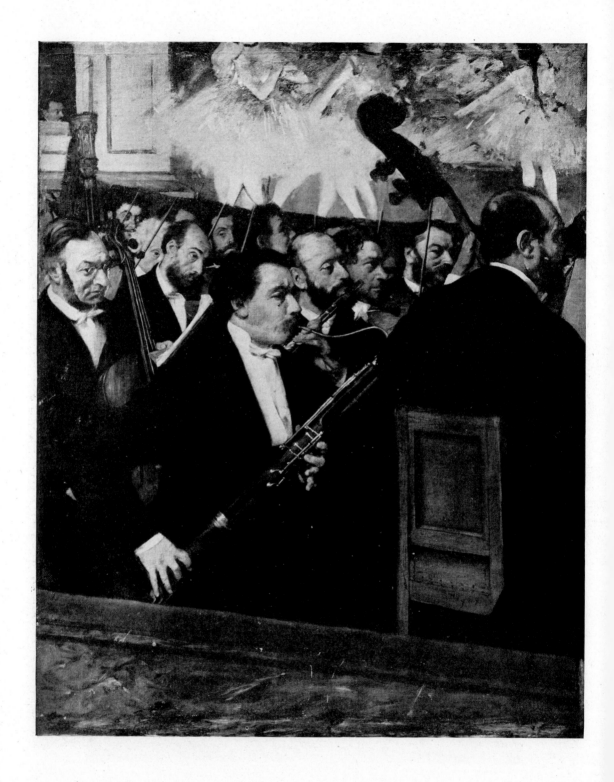

DEGAS: *The Orchestra of the Paris Opera (in the center Désiré Dihau)*, 1868-69. 22½ x 18½". *Formerly Dihau collection. Louvre, Paris.*

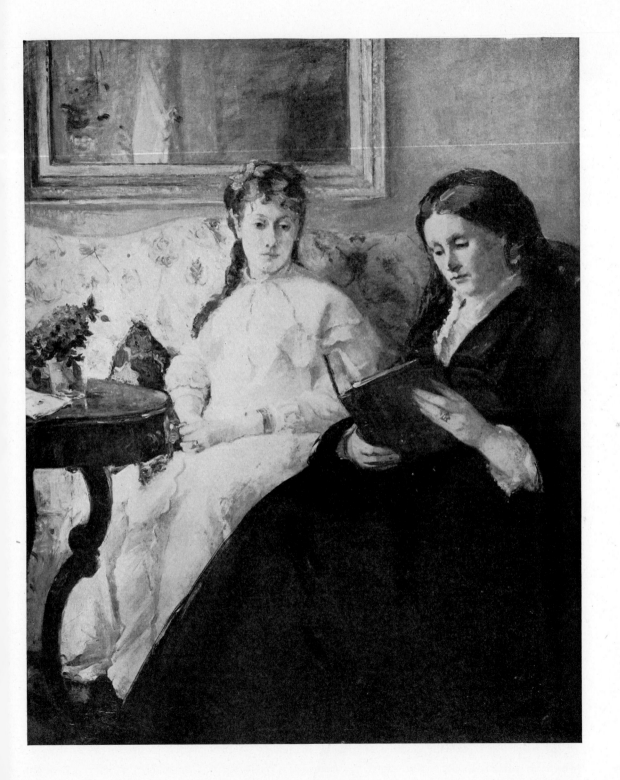

MORISOT: *The Artist's Sister Edma and their Mother, 1869. 39½ x 32″. Exhibited at the Salon of 1869. National Gallery of Art, Washington, D. C. (Chester Dale loan).*

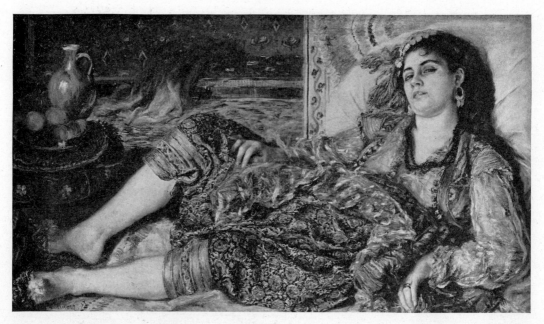

RENOIR: *Woman of Algiers (Odalisque), d. 1870. 27 x 48½". Exhibited at the Salon of 1870. National Gallery of Art, Washington, D. C. (Chester Dale loan).*

with nature which distinguished Pissarro, that ease of expression for which he may have envied Renoir and that certainty of his own capacities which was Monet's strength. But in the face of the perils menacing his country he did not feel like painting any longer. On August 10 he enlisted in a regiment of Zouaves, well-known for the dangerous tasks it usually assumed.

Degas, who had been on the coast painting some broad studies in the open, returned to Paris. Monet remained in Le Havre. Renoir, inducted into a regiment of cuirassiers, was sent to Bordeaux and later to Tarbes in the Pyrenees. Zola, as the only son of a widow, was exempt from military service and prepared to go to Marseilles. Cézanne, who once had drawn an "unlucky number" for conscription but for whom his father had bought a substitute, was not very eager to don a uniform. He left his parents' house in Aix and went to work in nearby L'Estaque on the Mediterranean shore, not far from Marseilles, where he lived with Hortense Fiquet, hiding the liaison from his father. In L'Estaque, where Zola later joined him for a short while, Cézanne devoted his time mostly to landscape painting, endeavoring to replace the agitated conceptions of his imagination by faithful observation of the nature spread before him. In doing so he remembered that years ago Pissarro had already eliminated from his palette "black, bitumen, burnt sienna and the ochres. 'Never paint except with the three primary colors [red, blue, yellow] and their immediate derivatives!' " he had told Cézanne.[47] Although Cézanne did not yet proceed to a radical change in his color scheme, he nevertheless began to adopt the smaller brushstrokes of his friends and generally resorted to brighter harmonies. A new portrait of his friend Valabrègue, which he painted at that period, shows this transition. While the face is modeled in small and bright touches, the rest is rendered in a sweeping style and in rather dark tones.

The war meanwhile was daily taking a turn for the worse. Opposed by an experienced enemy, which

204

BAZILLE: *Lady in a Park, d. 1870. 16¾ x 10″. Fogg Art Museum, Cambridge. Mass. (G. L. Winthrop Bequest).*

SISLEY: *View of Montmartre, d. 1869. 27½ x 46". Musée de Grenoble.*

MONET: *Mme Monet in a Red Cape, c. 1870. 39½ x 31½".*
Collection E. Molyneux, London.

PISSARRO: *Louveciennes, the Road to Versailles (the artist's wife*
and daughter), d. 1870. 40⅛ x 32½". Rosenberg Galleries, N. Y.

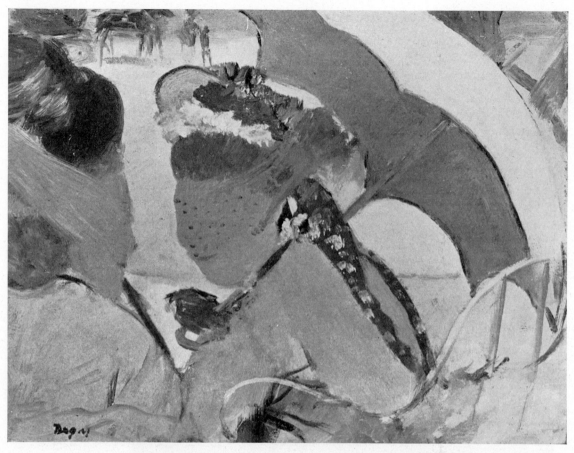

DEGAS: *Ladies at the Races, c. 1870. 19¼ x 33". Collection Marcel Guérin, Paris.*

was superior in number and equipment, the French armies, completely unprepared, lacking the most essential supplies, commanded by incapable and even treacherous Court favorites, were engaged in a hopeless fight. Defeat followed defeat until the catastrophe of Sedan sealed France's fate. There, on September 2, 1870, Napoleon III surrendered. Two days later the Third Republic was proclaimed in Paris. Victor Hugo came back from exile; he was received in Paris by the new mayor of Montmartre, Georges Clemenceau, who had returned from the United States, where he had lived since 1865. And Gambetta exhorted his countrymen to unite against the powerful invader, to carry on to death and save the nation's honor.

Manet had always been an ardent republican, as were his friends Zola and Duret. He had sent his family to safety in the south of France; a profound admirer of Gambetta, he now frequented, with his brother Eugène and with Degas, political meetings in Paris. Whereas his two brothers and Guillemet were in the mobile guard, he enlisted in the artillery of the national guard and became a staff officer, with Meissonier as his superior. Bracquemond, Puvis de Chavannes, Carolus-Duran and Tissot also served in the same outfit. Degas, though hardly in favor of the Republic, enlisted in the infantry but was

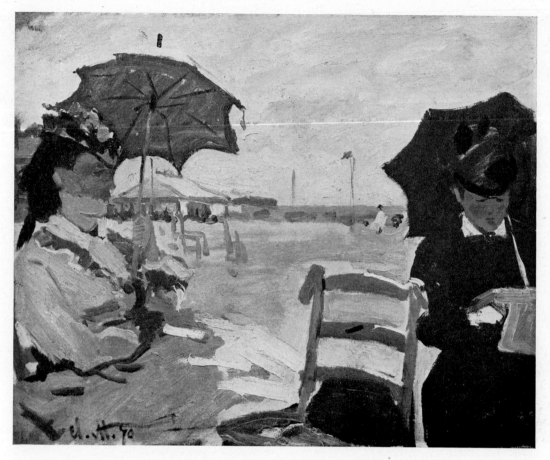

MONET: *The Beach at Trouville, d. 1870. 14½ x 18". National Gallery, London.*

placed in the artillery because of a bad right eye. In his regiment he met a former school friend of his, the painter and engineer Henri Rouart, who from then on was to remain one of his closest companions.

As the Prussians advanced on Paris, Pissarro was obliged to flee from Louveciennes without being able to take with him the canvases representing almost his entire work done since 1855, as well as a certain number of paintings by Monet which the latter left with him for safekeeping.[48] Pissarro first took refuge with his family at the farm of his friend Piette, at Montfoucauld in Brittany, later leaving for London, where a half-sister lived and where his mother also went. While the Germans established a butcher-shop in Pissarro's house, Courbet in Paris became president of a commission to safeguard the nation's art treasures.[49] He managed to place his own works in relative safety by depositing them in the new galleries of Durand-Ruel, rue Laffitte.

At the beginning of September, Monet witnessed at Le Havre a frantic rush onto boats starting for England. Boudin contemplated going to London but later changed in favor of Brussels, where some of his friends had fled. Diaz went there too. Monet finally decided to leave his wife and child behind and managed to reach London.[50] Daubigny and Bonvin, among others, also went to England.

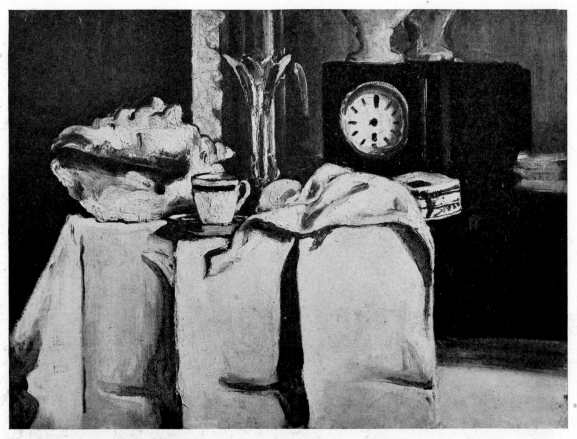

CÉZANNE: *The Black Clock, 1869-71. 21¾ x 29¼". Formerly in the collection of Emile Zola. Collection Edward G. Robinson, Hollywood.*

Corot fled from his house in Ville d'Avray to Paris and offered a large amount of money for the manufacture of cannon in order to chase the Prussians from Ville d'Avray forest. On the nineteenth of September the siege of Paris began. Three weeks later Gambetta left the city by balloon to organize resistance in the provinces. The government was established in Bordeaux, and Zola went there to become secretary to the cabinet minister Glaize-Bizoin, whom he had met, together with Duret, as a contributor to the anti-imperial *Tribune.*

From Paris, Manet wrote in November to his wife: "My knapsack is equipped with everything necessary for painting and I shall begin soon to do some sketches from nature."[51] But the grimness of the situation seems to have prevented him from painting. "The Café Guerbois is my only resource," he wrote a little later, "and that is getting pretty monotonous."[52]

On November 28 Frédéric Bazille was killed in the battle of Beaune-la-Rolande.

In Paris hunger and epidemics slowly began their terrible reign. Manet informed his wife that people were eating cats, dogs and rats; the lucky ones would obtain horse meat. In a letter to Eva Gonzalès he complained that donkey meat was too expensive.[53] Bitter cold was soon added to the trials of

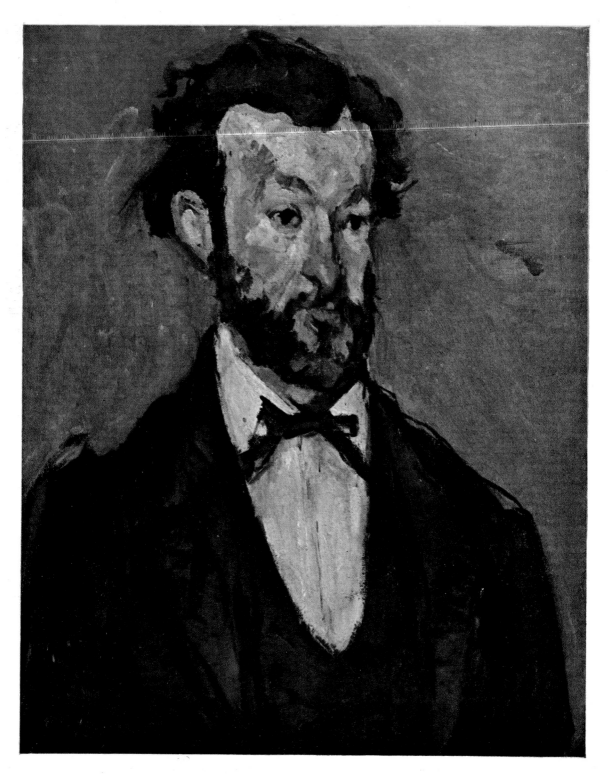

CÉZANNE: Portrait of Anthony Valabrègue, c. 1870. 24½ x 20″. Collection Hugo Moser, New York.

CÉZANNE: *L'Estaque, c. 1871. 16¾ x 22". Formerly in the collection of Emile Zola. Collection J. V. Pellerin, Paris.*

the Parisians. And on January 5, 1871, the Prussians began to bombard the city. Food supplies now gave out completely. The enemy guns blasted Paris day and night. On January 28 the French capital surrendered. France had lost the war. On March 1 German troops symbolically occupied Paris for forty-eight hours while the city's streets remained empty.

In London, meanwhile, Monet again lived through difficult days until he met Daubigny, who was then painting scenes on the Thames, which met with great success in England. Daubigny was moved by Monet's distress and introduced him in January, 1871, to his dealer, Paul Durand-Ruel, who had also fled to London after sending ahead most of his pictures. He had just opened a gallery in New Bond Street. It seems that Daubigny went so far as to offer to replace by his own canvases those of Monet which Durand-Ruel might not be able to sell.[54] But Daubigny did not need to insist much. Durand-Ruel had already been attracted by the few paintings by Monet which had occasionally appeared at the Salon and was glad to meet the young painter. As a matter of fact, the reviewer of the Salon of 1870 in the *Revue internationale de l'art et de la curiosité,* edited by Durand-Ruel, had insisted on the importance of

MONET: *Hyde Park, London, 1871. 15¾ x 28¾". Museum of Art, Providence, R. I.*

Pissarro, Degas and Manet, as well as of Monet in spite of the fact that his canvases had been rejected. Furthermore, Durand-Ruel apparently already owned works by these painters, since the exhibitions which he organized in London during the years 1870-71 contained two paintings by Pissarro, two by Sisley and one each by Monet, Renoir, Degas and Manet.[55]

It seemed only natural that, having been for many years the dealer for the Barbizon group and having by obstinacy and courage contributed to their final recognition, Durand-Ruel should now take some interest in the successors of Corot, Diaz and Courbet among the new generation. As a matter of fact, when, during the same month of January, Pissarro came to Durand-Ruel's gallery and left a canvas, he immediately received the encouraging reply:

"My dear Sir, you brought me a charming picture and I regret not having been in my gallery to pay you my respects in person. Tell me, please, the price you want and be kind enough to send me others when you are able to. I must sell a lot of your work here. Your friend Monet asked me for your address. He did not know that you were in England."[56]

Durand-Ruel subsequently bought two canvases by Pissarro, paying 200 francs apiece, which was more than the artist used to obtain from *père* Martin in Paris; he paid 300 francs for the paintings of Monet. Henceforth he introduced their works at every exhibition he organized in London but, in spite of all his efforts, was unable to sell them in England.

Sisley, who, as a British subject, also had fled to England, seems not to have been in contact there either with Durand-Ruel or with Pissarro and Monet.[57] However, a painting which he did of Charing Cross Bridge in 1871 testifies to Sisley's presence in the English capital during the Franco-Prussian war, unless he went there shortly after hostilities ceased.

212

Monet and Pissarro were extremely happy to find each other in London and began to meet frequently. Pissarro later remembered: "Monet and I were very enthusiastic over the London landscapes. Monet worked in the parks, whilst I, living at Lower Norwood, at that time a charming suburb, studied the effect of fog, snow and springtime. We worked from nature. . . . We also visited the museums. The water-colors and paintings of Turner and of Constable, the canvases of Old Crome, have certainly had influence upon us. We admired Gainsborough, Lawrence, Reynolds, etc., but we were struck chiefly by the landscape-painters, who shared more in our aim with regard to "plein air," light, and fugitive effects. Watts, Rossetti, strongly interested us amongst the modern men."[58] Yet Pissarro emphasized that "Turner and Constable, while they taught us something, showed us in their works that they had no understanding of the *analysis of shadow,* which in Turner's painting is simply used as an effect, a mere absence of light. As far as tone division is concerned, Turner proved the value of this as a method, among methods, although he did not apply it correctly and naturally."[59] And Monet likewise stated in later years that Turner's art had had a limited bearing on his evolution. Both he and Pissarro, through direct observation, had already in 1870 come closer to nature than Turner, whose work—Monet did not conceal this in remarks to friends—"was antipathetic to him because of the exuberant romanticism of his fancy."[60]

The two friends had, in the words of Pissarro, "the idea of sending our studies to the exhibition of the Royal Academy. Naturally we were rejected."[58] Had it not been for Durand-Ruel's moral and financial support, they might have become discouraged, for the news from France, as was to be expected, did not sound heartening. Pissarro, who had asked one of his acquaintances—the painter Béliard—for a detailed report, received a letter toward the end of February:

"All your friends are well. Manet left for the South [to join his family] a few days ago. Zola . . . , back in private life, is staying at Bordeaux awaiting events. He asks me to send you his regards. Guillemet

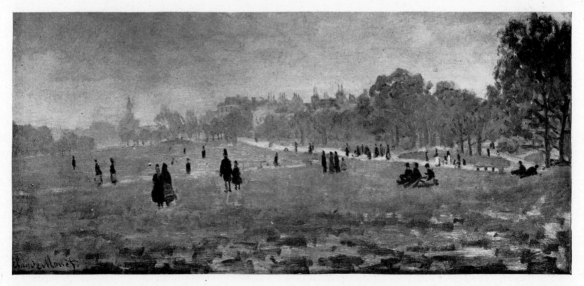

MONET: *Hyde Park, London, 1871. 13½ x 28⅝". Philadelphia Museum of Art (Willstach Collection).*

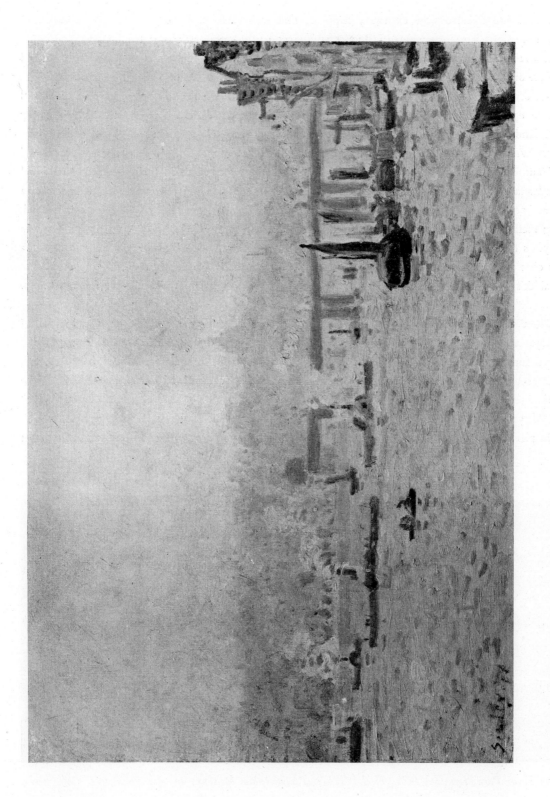

SISLEY: *View of the Thames and Charing Cross Bridge, London, d. 1871. 12¾ x 18". Private collection, Paris.*

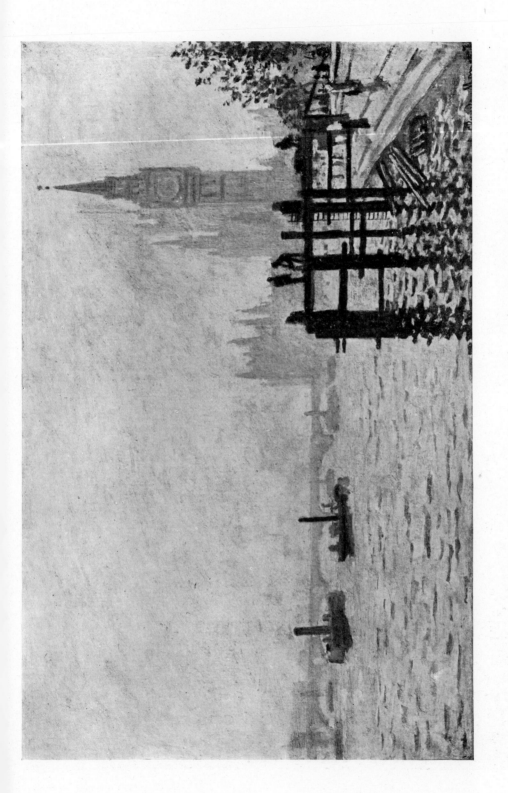

MONET: *View of the Thames and the House of Parliament, London, d. 1871. 18¾ x 25½". Collection the Hon. J. J. Astor, London.*

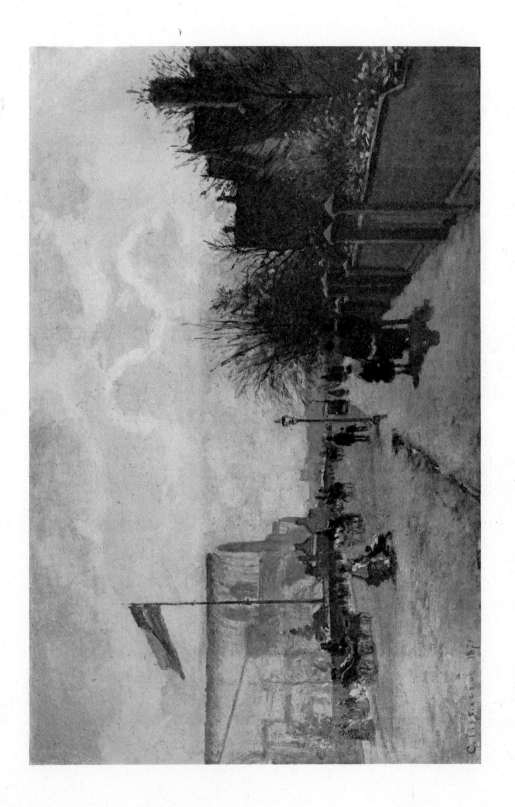

PISSARRO: *The Crystal Palace, London, d. 1871. 18⅞ x 28¾". The first picture by the artist to be purchased by Durand-Ruel. Private collection, New York.*

PISSARRO: *The Road from Rocquencourt, d. 1871. 20¼ x 30". Private collection, New York.*

DEGAS: *Portrait of Hortense Valpinçon, c. 1871. 29¾ x 44¾". Wildenstein Galleries, New York.*

is well, Guillaumin also. Duranty is always the same. Cézanne is in the South; Degas is a bit mad, Duranty tells me. I haven't seen Fantin, Sisley, Renoir for an age. Monet, I believe is in Dieppe or in England. Oudinot is working at the city hall, and I'm not working at all. No coal!—. . . I have no news of your house at Louveciennes! Your blankets, suits, shoes, underwear, you may go into mourning for—believe me—and your sketches, since they are generally admired, I like to think will be ornaments in Prussian drawing rooms. The nearness of the forest will no doubt have saved your furniture.

"Daubigny has just come back from London, where he earned a lot of money.—I think that your mother will do well to stay in London until things are settled. There is reason to believe that the peace treaty will be signed, but many complications may arise, and events both before and after. . . ."[61]

Indeed, fate still held plenty of events in store. In March the exasperated population of Paris opposed certain military measures by the new government, which thereupon fled to Versailles, while the *commune* was proclaimed in the capital. Courbet was elected a representative of the people and also became president of a general assembly of artists in whose name he abolished the Academy in Rome, the *Ecole des Beaux-Arts,* the Fine Arts section of the Institute, and all medals, etc. distributed at the Salons. But the status of the Salon jury remained unchanged. Among those who most regularly attended the reunions of the artist assembly were Amand Gautier and Berthe Morisot's former teacher Oudinot.[62]

Designated as "Curator of Fine Arts," Courbet was associated with the destruction of the Vendôme Column, considered a symbol of wars of aggression and a glorification of the Bonaparte dynasty. The Vendôme Column was re-erected after the downfall of the *Commune.* This downfall occurred after a new investment of Paris, this time by French troops of the Versailles government, which started to bombard the city during the first days of May. The troops entered Paris on May 21, and a terrible reprisal began. For one week the capital was literally drenched in blood. On May 28 all resistance ceased.

Manet, whose friend Duret had barely escaped execution during the *Commune,* returned to Paris before the last street battles of May and retained views of these conflicts in two lithographs. Zola had arrived in Paris four days before the insurrection and remained there until the middle of May. Renoir, discharged, had also come back to the city but managed to leave again during the *Commune,* joining his mother in nearby Louveciennes. Degas, who had left Paris after the armistice, spent the months of the *Commune* with his friends Valpinçon at their estate in the country, where he is supposed to have painted a portrait of the young daughter of his hosts. Berthe Morisot had left Paris with her parents and gone to join Puvis de Chavannes at Saint-Germain, just outside the city. At about the same time Pissarro's patron Arosa welcomed to Paris his godson, Paul Gauguin, who had just finished conscription service as a sailor and who now entered the banking firm of Bertin on Arosa's recommendation.

Pissarro, in London, continued to receive rather unpleasant news from France. The owner of his house in Louveciennes informed him that the "Prussians have caused plenty of havoc. . . . Some of the pictures we have taken good care of, only there are a few which these gentlemen, for fear of dirtying their feet, put on the ground in the garden to serve them as a carpet."[63] And Duret wrote to Pissarro after the suppression of the *Commune:* ". . . . Dread and dismay are still everywhere in Paris. Nothing like it has ever been known. . . . I have only one wish and that's to leave, to flee from Paris for a few months. . . . Paris is empty and will get still emptier. . . . As for painters and artists, one might think there had never been any in Paris."[64]

Duret mentioned to Pissarro his intention of going to London, whereupon the painter answered, in

DAUBIGNY: *The Mills of Dordrecht, d. 1872. 33½ x 57½". Detroit Institute of Arts.*

June: ". . . . I'm here for only a very short time. I count on returning to France as soon as possible. Yes, my dear Duret, I shan't stay here, and it is only abroad that one feels how beautiful, great and hospitable France is. What a difference here! One gathers only contempt, indifference, even rudeness; among colleagues there is the most egotistical jealousy and resentment. Here there is no art; everything is a question of business. As far as my private affairs, sales, are concerned, I've done nothing, except with Durand-Ruel, who bought two small pictures from me. My painting doesn't catch on, not at all; this follows me more or less everywhere. . . . Perhaps I'll be in a little while at Louveciennes, I've lost everything there. About forty pictures are left to me out of fifteen hundred."[65]

When Duret met Pissarro a little later in London, he was enthusiastic about the painter's recent work but found the situation in England almost worse than Pissarro had described it. "The English, with regard to French painters, like only Gérôme, Rosa Bonheur, etc.," he wrote to Manet. "Corot and the other great painters don't exist as yet for them. Things here are the way they were twenty-five years ago in Paris. . . ."[66] Leaving Great Britain for the United States on a trip around the world, Duret was happy to report that in the New World besides many bad pictures he had also seen some good ones. "The modern French school is getting in here now," he stated. "I saw again in Boston Courbet's *Curée*. It is really a masterpiece. I also saw in Boston some very beautiful Troyons. . . . A Courbet and some Troyons compensate for many errors of taste."[67] While Duret was writing these lines to Manet, Courbet was arrested in Paris and put in prison to await trial for active participation in the *Commune* and especially for the destruction of the Vendôme Column, for which he denied any responsibility.

MONET: *A Mill in Zaandam, 1871-72. 19¼ x 29¾". Present owner unknown.*

Monet had left England in the meantime but instead of returning to France had first made a trip to Holland. This he had done possibly on the advice of Daubigny, if not actually invited by him, for the latter did work in Holland during the years 1871 and 1872; he even purchased one of Monet's views of the Canal at Zaandam. Monet was to remain in Holland until the end of the year, attracted by the picturesque windmills with their red wings, the immensity of the skies over the flat lands, the canals with their boats, the cities with their houses that seemed to grow out of the water—all this presenting itself in a great variety of greys, the kind of tonal values to which Boudin had been so sensitive.

Finally Pissarro, too, packed up. By the end of June 1871, he was back in Louveciennes. A painting he did shortly after his return of the *Route de Rocquencourt* seems to be filled with a certain cheerfulness, a quiet but glowing confidence, a feeling that appears to be stronger than the lyricism of his earlier works because it attains serenity.

Pissarro had expressed the ardent hope that "Paris will recover her supremacy,"[65] and he now found a France united in the desire to rebuild what was destroyed and to reassume the place she had occupied in the world. A public loan by the government was oversubscribed two and a half times; the enormous amount of reparations requested by the Prussians was paid within the shortest possible time, and throughout the entire country, liberated from an incompetent tyrant, deeply humiliated on the battlefield but proud of its new republic, there seemed to reign a new spirit, a new will for great achievements. In science, in art, in literature, in the field of engineering, great projects were formed and their realization begun with confidence. "It is our reign coming,"[68] Zola announced to Cézanne.

While the Germans rejoiced in their easy victory over the corrupt Second Empire, Friedrich Nietzsche had the courage to tell his countrymen:

"Public opinion in Germany appears almost to prohibit speaking of the evil and dangerous consequences of wars, and above all of a victoriously ended war. . . . Nevertheless, it must be said: a great victory is a great danger. Human nature bears it with more difficulty than defeat, and it even seems to be easier to obtain victory than to carry it off in such a manner that it is not changed to defeat. Of all the dangerous consequences following upon the late war with France, the most dangerous is perhaps that widespread, even general error that German culture has likewise been victorious in this battle and that it has a right to the palms awarded such success. This illusion is extremely harmful, not because it is an illusion—for there are some beneficent illusions—but because it is on the way to transform our victory into a complete defeat. . . . There cannot be any question of the victory of German culture for the very simple reason that French culture continues to exist and that we depend on it as in the past."[69]

During the decades ahead not only Germany but the entire world was to depend upon the culture of France, and in perhaps no field was her lead to be less disputed than in that of the arts. But it took many years before her role and that of her painters were to be universally recognized, almost as many as it took France herself to become aware of her greatest artists.

MANET: *Civil War, d. 1871. Lithograph inspired by the Paris Commune, 15⅝ x 20½". New York Public Library.*

NOTES

1. It is not known at what date exactly the artists began to come together at the Café Guerbois. Tabarant (Pissarro, Paris, 1924, p. 15) and Duret (Manet and the French Impressionists, London, 1910, p. 108) assert that they began to do so in 1866. It is known that until 1866 Manet went every day from 5:30 to 7 p.m. to the Café de Bade, 26 Boulevard des Italiens (see Manet's letter to Zola, May 7, 1866; Jamot, Wildenstein, Bataille: Manet, Paris, 1932, v. I, p. 81). But already in the spring of 1868 a friend of Zola speaks of the *Batignolles group* (see Solari's letter to Zola; J. Rewald: Cézanne, sa vie, son oeuvre, son amitié pour Zola, Paris, 1939, p. 143). In 1868-69 Manet invited Monet to join his friends at the Café Guerbois and the group seems to have been really complete around 1869, when Monet, in turn, came there with Renoir, Sisley, etc. A. Proust: Edouard Manet, Souvenirs, Paris, 1913, is obviously mistaken when he pretends that Manet already abandoned the Café Guerbois after 1865.

2. Monet to Thiébault-Sisson; see Claude Monet, an Interview, *Le Temps,* Nov. 27, 1900.

3. E. Duranty: Le pays des arts, Paris, 1881, p. 345.

4. E. Zola: Mon Salon, 1866; repr. *in* Mes Haines.

5. This duel took place in the forest of Saint-Germain on Feb. 23, 1870. On this event see Proust, op. cit., p. 38.

6. P. Alexis: article in *Le Cri du Peuple,* Jan. 8, 1885, quoted by D. Le Blond-Zola: Paul Alexis, ami des peintres, bohème et critique d'art, *Mercure de France,* March 1, 1939. The poem went: "Manet-Duranty sont deux gas/ Qui font une admirable paire;/ Aux poncifs, ils font des dégats,/ Manet-Duranty sont deux gas./ L'Institut qui les vitupère/ Les méprise autant que Degas./ Parce qu'ils font des becs de gaz./ Manet-Duranty sont deux gas/ Qui font une admirable paire."

7. From Berthe Morisot's notebook; see P. Valéry: Degas, Dance, Dessin, Paris, 1938, p. 148.

8. P. Lafond: Degas, Paris, 1919, p. 99.

9. E. Duranty, *op. cit.,* p. 335.

10. Manet to Fantin, Aug. 26, 1868; see E. Moreau-Nélaton: Manet raconté par lui-même, Paris, 1926, v. I, p. 102.

11. See Valéry, *op. cit.,* p. 88.

12. E. Zola: Le Rêve; Oeuvres complètes, Paris, 1928; see Notes et commentaires de M. Le Blond, p. 232.

13. M. Elder: A Giverny chez Claude Monet, Paris, 1924, p. 48.

14. Excerpts from Zola's notes for his novels: L'Oeuvre and Le Ventre de Paris, quoted by J. Rewald: Cézanne, sa vie, son oeuvre, son amitié pour Zola, Paris, 1939, p. 123.

15. E. Zola: Preface for Nouveaux Contes à Ninon, 1874.

16. See A. André: Renoir, Paris, 1928, p. 56.

17. *Ibid.,* p. 14.

18. Fantin to Edwards, June 15, 1871; see A. Jullien: Fantin-Latour, Paris, 1909, p. 74-75.

19. See E. Chesneau: Le Japon à Paris, *Gazette des Beaux-Arts,* Sept. 1, 1878 and H. Focillon: L'estampe japonaise et la peinture en occident, Congrès d'Histoire de l'Art, Paris, Sept.-Oct. 1921.

20. See G. Geffroy: La vie artistique, troisième série, Paris, 1894, p. 148.

21. See R. Marx: Maitres d'hier et d'aujourd'hui, Paris, 1914, p. 292.

22. Proust, *op cit.,* p. 31-32.

23. Boudin to Martin, April 25, 1869; see Jean-Aubry: Eugène Boudin, Paris, 1922, p. 72.

24. Valabrègue to Zola, Jan. 1867; see Rewald, *op cit.,* p. 141.

25. See André, *op. cit.,* p. 53.

26. See Proust, *op. cit.,* p. 43.

27. Marion to Morstatt, April 1868; see M. Scolari and A. Barr, Jr.: Cézanne in the letters of Marion to Morstatt, 1865-1868, *Magazine of Art,* Feb., April, May 1938.

28. Bazille to his parents, spring 1869; see G. Poulain: Bazille et ses amis, Paris, 1932, p. 111.

29. Bazille to his parents, spring 1869; *ibid.,* p. 147-148.

30. B. Morisot to her sister Edma, May 1, 1869; see M. Angoulvent: Berthe Morisot, Paris, 1933, p. 30-32.

31. B. Morisot to the same, spring 1869; *ibid.,* p. 28.

32. B. Morisot to the same, May 1869; *ibid.,* p. 32-33.

33. Mme Morisot to the same, May 23, 1869; *ibid.,* p. 33.

34. On Eva Gonzalès see the richly illustrated article by P. Bayle: Eva Gonzalès, *La Renaissance,* June 1932.

35. Letters by B. Morisot to her sister Edma, 1869; see Moreau-Nélaton, *op. cit.,* v. I, p. 113.

36. Castagnary: Salon de 1869, repr. *in* Salons (1857-1870), Paris, 1892, v. II, p. 364.

37. Monet to A. Houssaye, June 2, 1869; see R. Chavance: Claude Monet, Le Figaro illustré, Dec. 16, 1926.

38. Monet to Bazille, **August** 9, 1869; see Poulain, *op. cit.,* p. 157.

39. Renoir to Bazille, fall 1869; *ibid.,* p. 155.

40. See André, *op. cit.,* p. 60.

41. Monet to Bazille, Sept. 25, 1869; see Poulain, *op. cit.,* p. 160.

42. Bazille, for instance, noted in a sketchbook: "I must not forget to compare the color-value of bright water with that of sunlit grass." Poulain, *op. cit.,* p. 153.

43. The identity of the different friends assembled in Bazille's studio has not been established with certainty. It is possible that instead of the identification here given one should read Monet for Zola, Sisley for Renoir and Astruc for Monet; see Poulain, *op. cit.,* p. 179.

44. On Desboutin see Clément-Janin: La curieuse vie de Marcellin Desboutin, Paris, 1922.

45. See A. Alexandre: Claude Monet, Paris, 1921, p. 61.

46. Duret's articles on the Salon of 1870 are repr. *in* T. Duret: Critique d'avant-garde, Paris, 1885.

47. See J. Gasquet: Cézanne, Paris, 1921, p. 90.

48. See A. Tabarant: Pissarro, Paris, 1924, p. 18.

49. See A. Darcel: Les musées, les arts et les artistes pendant le siège de Paris, *Gazette des Beaux-Arts,* Oct., Nov. 1871.

50. An often repeated version has it that Monet went first to Holland and thence to London, but there is little evidence to support it. G. Geffroy: Claude Monet, sa vie, son oeuvre, Paris, 1924, v. I, p. 58 pretends that Monet went to Holland in company of Pissarro and that they travelled together to England, but Pissarro did not go to Holland in 1870 and only learned in January 1871 of Monet's presence in London through a letter from Durand-Ruel. Among the paintings done by Monet in Holland there seem to be none dated 1870 and those dated 1871 must have been done towards the end of that year, *after* he left England, since he is known to have been in London in January 1871. In his interview with Thiébault-Sisson Monet asserts that he went directly to England.

51. Manet to his wife, Nov. 19, 1870; see Moreau-Nélaton, *op. cit.,* v. I, p. 124.

52. Manet to his wife, Nov. 23, 1870; *ibid.,* p. 125.

53. See Manet's letters to his wife and to Eva Gonzalès quoted by Moreau-Nélaton, *op. cit.,* p. 121-127.

54. See M. de Fels: La vie de C. Monet, Paris, 1929, p. 130.

55. See: Mémoires de Paul Durand-Ruel *in* L. Venturi: Les Archives de l'Impressionnisme, Paris-New York, 1939, v. II, p. 175-180.

56. Durand-Ruel to Pissarro, Jan. 21, 1871; see Venturi, *op. cit.,* v. II, p. 247-248.

57. It should be mentioned, however, that fifty years later, Durand-Ruel said in an interview that Sisley was introduced to him by Monet in London. See F. F. [Fénéon]: Les grands collectionneurs—M. Paul Durand-Ruel, *Bulletin de la vie artistique,* April 15, 1920.

58. Pissarro to Dewhurst, Nov. 1902; see W. Dewhurst: Impressionist Painting, London-New York, 1904, p. 31-32.

59. Pissarro to his son, May 8, 1903; see Camille Pissarro, Letters to his Son Lucien, New York, 1943, p. 355-356. Concerning Turner's influence on Monet and Pissarro it should be recorded that Signac, who had known Pissarro well, later attributed to it a much greater importance than did the painters themselves, when he wrote: ". . . In London . . . they study his works, analyzing his technique. They are first of all struck by his effects of snow and ice. They are astonished at the way in which he has succeeded in giving the feeling of the whiteness of the snow, they who until now have not been able to achieve it, with their large spots of white spread out flat with broad brush-strokes. They come to the conclusion that this marvelous result is obtained, not by a uniform white but by a number of strokes of different colors, placed one beside the other and reproducing at a distance the desired effect." (P. Signac: De Delacroix au Néo-impressionnisme, Paris, 1899, ch. III, par. 1).

60. See R. Koechlin: Claude Monet, *Art et Décoration,* Feb. 1927.

61. Béliard to Pissarro, Feb. 22, 1871; quoted from the partly unpublished original found among Pissarro's papers.

62. See A. Darcel; Les musées, les arts et les artistes pendant la Commune, *Gazette des Beaux-Arts,* Jan., Feb., March, May, June 1872.

63. Mme Ollivon to Pissarro, March 27, 1871; see L. R. Pissarro and L. Venturi: Camille Pissarro, Paris, 1939, v. I, p. 23-24: see also Letter by J. Grave, published in *Bulletin de la vie artistique,* April 1, 1924.

64. Duret to Pissarro, May 30, 1871; quoted from the partly unpublished original found among Pissarro's papers.

65. Pissarro to Duret, June 1871; see Tabarant, *op. cit.,* p. 20.

66. Duret to Manet, Liverpool, July 7, 1871; see A. Tabarant: Manet et Théodore Duret, *L'Art Vivant,* August 15, 1928.

67. Duret to Manet, New York, Aug. 9, 1871; *ibid.*

68. Zola to Cézanne, July 4, 1871; see A. Vollard: Paul Cézanne, Appendix II.

69. F. Nietzsche: David Strauss, the confessor and writer, *in* Thoughts Out of Season, part I; Complete Works, v. IV, New York, 1911, p. 4-5 [here newly translated].

1872-1874

THE YEARS AFTER THE WAR

THE FIRST GROUP EXHIBITION (1874) AND THE ORIGIN OF THE WORD "IMPRESSIONISM"

Toward the end of 1871 almost all the friends were back in Paris or nearby and began to meet again at the Café Guerbois. Zola, however, made less frequent appearances, being hard at work on his series of novels, the *Rougon-Macquart,* the publication of the first volume of which had been interrupted by the war. Cézanne, returned from the south, now occupied a small apartment opposite the Halle aux Vins in Paris where, in January 1872, Hortense Fiquet gave birth to a child who received the name of his father, Paul Cézanne. At about the same time Monet arrived from Holland, and Boudin informed a friend: "He is very well settled and appears to have a strong desire to make a position for himself. He has brought from Holland some very beautiful studies, and I believe that he is destined to fill one of the first places in our school."[1]

No sooner was he back than Monet, together with Boudin and Amand Gautier, went to pay a visit to Courbet, who, after several months in prison, had been transferred to a nursing home for reasons of health. They were among the very few who remembered their debt of gratitude, now that Courbet was facing trial for his participation in the *Commune* and for the destruction of the Vendôme Column. Courbet was deeply moved by their solicitude at a moment when most of his acquaintances were careful to forget him. In spite of the fact that he felt no sympathy at all for Courbet's political ideas, Durand-Ruel was also among those who refused to abandon the painter; he bought a large number of his works. (While in Ste.-Pélagie prison Courbet had painted mostly still lifes, among them one combining a colorful bouquet with a portrait of Whistler's mistress, Jo, whose gaudy beauty apparently still haunted his memory.)

After his return to France, Durand-Ruel had continued to invest heavily in the works of the Barbizon masters, some of whom sold exclusively to him. But he also showed an increasing interest in the efforts of the younger men; when Monet and Pissarro introduced friends to him, especially Sisley and Degas, he immediately bought several of their canvases. In December 1871, Durand-Ruel discovered two paintings by Manet in the studio of the then popular Stevens, with whom Manet had left some of his work in the hope that it might find a buyer. The dealer not only acquired these but a few days later visited Manet's studio, where he bought the entire lot of canvases he found, altogether twenty-three paintings, for which he paid 35,000 francs. Manet's prices varied from 400 to 3,000 francs, this amount being asked for the *Spanish Guitar Player* (p. 45), the first picture ever exhibited by Manet at the Salon, for *Mademoiselle V. in*

MONET: *Mills in Holland, 1871-72. 18 x 28". Collection Mr. and Mrs. G. Bjorkman, New York.*

the Costume of an Espada (p. 75), from the *Salon des Refusés,* and for the *Battle of the Kearsarge and the Alabama* (p. 94). Among the paintings sold were also the *Spanish Dancers* (p. 66) and the *Bullfight* (p. 110).[2] This transaction had hardly been concluded when Durand-Ruel returned and bought several other canvases which Manet had hastily retrieved from various friends. Among these were the *Concert in the Tuileries Gardens* (p. 67). In the exhibitions which Durand-Ruel organized in London during the year 1872 Manet was represented by eleven canvases, Pissarro by seven and Sisley by four.

Through these mass acquisitions of paintings by the members of the Batignolles group Durand-Ruel began to link his career definitely with that of the young painters, although he had not yet been able to sell any of their works. But it was his conviction that "a genuine picture dealer should be at the same time an enlightened patron, ready, if necessary, to sacrifice his immediate interest to his artistic convictions and preferring a fight against the speculators to an association with their interests."[3]

Durand-Ruel's interest brought not only financial but also moral support to the painters. This may have been one of the reasons why those who were in contact with him—Monet, Pissarro, Sisley and Degas —seem not to have sent anything to the Salon of 1872. Manet, Renoir and possibly Cézanne, however, true to their convictions, submitted their works to the jury. So did Berthe Morisot. But at that time neither she nor Cézanne or Renoir had as yet had any dealings with Durand-Ruel. While Manet and Berthe Morisot saw their works accepted, Renoir's canvas of *Parisian Women Dressed as Algerians,* a painting strongly influenced by Delacroix, was turned down. Courbet's works were also rejected, because Meissonier, a jury member, opposed their admission for purely political reasons. The jury, which acceded to his views, was no longer elected by all admitted artists, a new ruling having again restricted the right

MONET: *Vineyards in Argenteuil, c. 1872. 18 x 29". Wildenstein Galleries, New York.*

to vote to those who had received medals. As was to be expected, a protest was launched by a number of artists, and a claim for a new *Salon des Refusés* was put forward, but to no avail. The Director of Fine Arts of the Republic adopted in this matter an attitude identical with that of Count Nieuwerkerke.

After the closing of the Salon, Manet went to Holland to study particularly the works of Frans Hals at Haarlem. Monet also returned to that country to paint more views of canals, boats and windmills. Berthe Morisot, deeply depressed by the general situation, made a short trip to Spain. Duret continued his world tour and after leaving the United States visited Japan, China, Java and India.

Degas meanwhile continued to roam behind the scenes of the Paris Opera, where shortly before the war Stevens had brought Bazille. But while Bazille had been disappointed by backstage life, Degas discovered there a whole series of new subjects, seen from various angles, which offered unusual aspects and lent themselves admirably to the kind of pictorial exploration of which he had always dreamt. He had made friends with a member of the orchestra, Désiré Dihau, and introduced his portrait into several compositions in which the stage represents the background with the musicians and their instruments as foreground (p. 202). Sometimes he also showed a number of spectators, choosing these from among his friends, such as Manet's patron, the banker Hecht, or the engraver, Viscount Lepic, whom Monet and Bazille had met in Gleyre's studio ten years before.

Degas also paid frequent visits to the classes where the balletmaster of the Opera trained groups of young girls, the so-called *rats,* for their difficult and gracious task. Here he found what interested him most: movement—but not a free and spontaneous one, quite the contrary—precise and studied exercises, bodies submitted to rigorous discipline, gestures dictated by an inescapable law, as were the movements of the horses

227

DEGAS: *Portraits in an Office—The Cotton Office of the Artist's Uncle, Mr. Musson* [*in the left foreground*], *at New Orleans, d. 1873. 29⅛ x 36⅛". Musée Municipal, Pau.*

he liked to observe at the races. In the same way in which he followed these horses, registering every one of their attitudes in his memory so as to be able to paint them in the studio, he took only occasional notes at the dancing classes, relying on his memory for the works he planned. Whereas his friends insisted with growing emphasis that they could represent what they saw only by studying the subject while they worked, Degas adopted the opposite principle and showed an increasing tendency to observe without actually painting and to paint without observing.

As if they all felt an urge to go abroad in the first year following the war, Degas, after Duret, Manet, Berthe Morisot and Monet, decided to leave France. In the fall of 1872 he accompanied his brother René to New Orleans, where their mother had been born and where his two brothers had established themselves as cotton merchants. "How many new things I've seen!" he wrote to a friend shortly after his arrival; "How many projects it has put into my head. . . . I've already given them up, I want to see nothing but my corner and dig away obediently. Art doesn't grow wider, it recapitulates. And, if you will have comparisons, I shall tell you that in order to produce good fruit, one must grow espalier-fashion. You

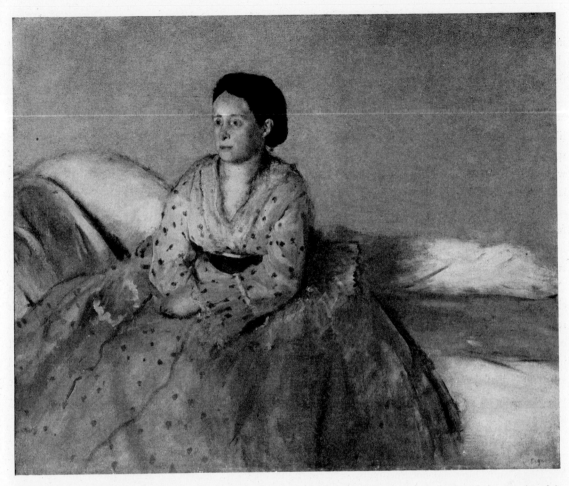

DEGAS: *Portrait of Mme René De Gas, née Estelle Musson, the Artist's Cousin and Sister-in-law, painted in New Orleans, 1872-73. 29 x 36". National Gallery of Art, Washington, D. C. (Chester Dale loan).*

remain there throughout life, arms outspread, mouth open to take in what passes, what is around you, and to live from it. . . . So I am hoarding projects which would require ten lives to put into execution. I shall abandon them in six weeks, without regret, to return to and to leave no more *my home.*"[4]

Degas was greatly attracted by the beauty of the colored women, the colonial houses, the steamboats, the fruit merchants, the picturesque gowns, the orange trees and so on, but he felt that it was impossible to paint in Louisiana as he had done in Paris and that a long sojourn would be necessary for him to grasp the true character of this new world. He thought of Manet, who, better than he, might have painted beautiful things there. But for himself he realized that "one likes and one makes art only of that to which one is accustomed. The new captivates and bores in turn."[5] He therefore satisfied himself with painting some sketches and a view of the interior of a cotton dealer's office, that of his uncle, Mr. Musson. He also did a few family portraits, a task he could not refuse. Among these portraits was that of his blind cousin, Estelle Musson, who was his sister-in-law, having married René De Gas (she was then expecting her fourth child, of whom the painter was to be the godfather).

Early in 1873 Degas sailed back to France, where he was, in the autumn, deeply affected by the burning of the Opera, which deprived him of one of his favorite objects of study. But as soon as the dancing classes were installed in new, temporary quarters, he began again to paint the little *rats,* the musicians and the balletmaster. Edmond de Goncourt paid him a visit and noted in his journal:

"Yesterday I spent the afternoon in the studio of a painter named Degas. After many attempts, many bearings taken in every direction, he has fallen in love with the modern and, in the modern, he has cast his choice upon laundresses and dancers. I cannot find his choice bad, since I, in *Manette Salomon,* have spoken of these two professions as ones that provide for a modern artist the most picturesque models of women in this time. . . . And Degas places before our eyes laundresses and laundresses, while speaking their language and explaining to us technically the downward pressing and the circular strokes of the iron, etc., etc. Next dancers file by. It is the foyer of the dancing school where, against the light of a window, are fantastically silhouetted dancers' legs coming down a little staircase, with the brilliant spot of red in a tartan in the midst of all those white, ballooning clouds. . . . And right before us, seized upon the spot, is the graceful twisting of movements and gestures of the little monkey-girls.

"The painter shows you his pictures, from time to time adding to his explanation by mimicking a choreographic development, by imitating, in the language of the dancers, one of their *arabesques*—and it is really very amusing to see him, his arms curved, mixing with the dancing master's esthetics the esthetics of the artist. . . . What an original fellow, this Degas—sickly, hypochondriac, with such delicate eyes that he fears losing his sight [ever since his military service in 1871 Degas had complained of eye trouble and said that he had only a few good years left], and for this very reason is especially sensitive and aware of the reverse character of things. He is the man I have seen up to now who has best captured, in reproducing modern life, the soul of this life."[6]

At about the same time as Degas returned to France, Duret too arrived, particularly enthusiastic about what he had seen in Japan and eager to provide his friends with new details about that strange country. Yet Degas and Duret did not find many of their friends in Paris. Except for Manet and Renoir there was actually no one: Pissarro had settled in Pontoise, where Cézanne had joined him. Sisley, after having worked in Argenteuil, was in Louveciennes, and Monet, back again from Holland, now lived in Argenteuil. Renoir was the only one not to have completely abandoned the city. He was also the last of the group to be introduced to Durand-Ruel, whom he met only in 1873 and who, as a result of his first acquisitions, enabled Renoir to take a large studio in the rue St. Georges. It was Degas who now introduced Renoir to Duret.

Renoir had remained in Paris for various reasons. Only there could he find occasional commissions for portraits, meet the slowly augmenting number of collectors interested in the group and have models pose in his studio. Besides, to his enchanted eye Paris had no less charm than a field of poppies or a hill by a river, and it offered the added attraction of gay animation, of that easygoing, colorful and radiant life which he liked to share and to record. There were buildings and water and trees, elegant and charming women, graceful girls and pretty children, there were sunshine and good humor, all the things he loved, that excited his eyes and his heart and found their way onto his canvases. Thus he painted the crowd on the sun-bathed Pont Neuf, while standing at a window on the second floor of a small café opposite the bridge. To his brother Edmond fell the task of stopping the passers-by momentarily and making them "pose." While Edmond Renoir asked this gentleman the time and that lady where such and such a street

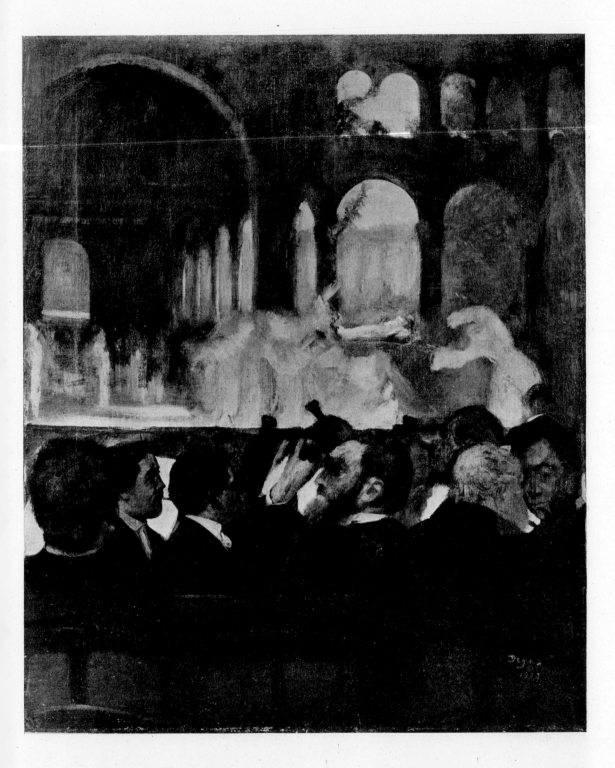

DEGAS: *The Ballet of* Robert le Diable, *d. 1872. 26 x 21⅛". Metropolitan Museum of Art, New York* (H. O. Havemeyer Collection).

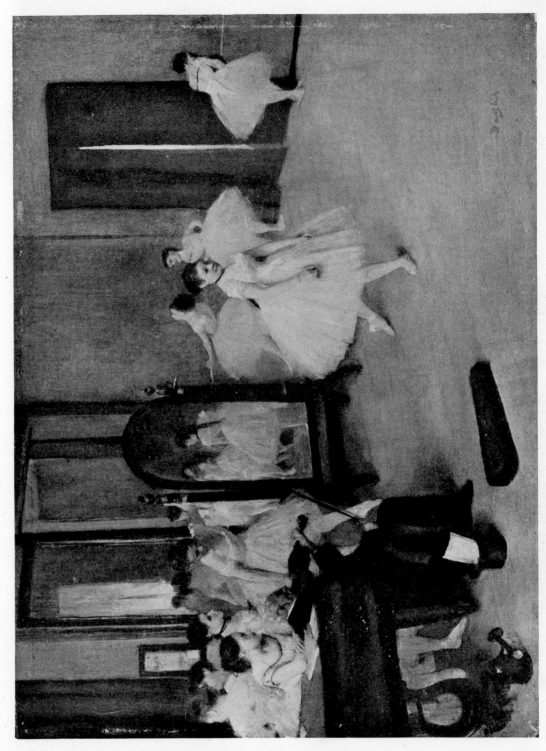

DEGAS: *Foyer de Danse, c. 1873. Oil on Panel, 7¾ x 10⅝". Metropolitan Museum of Art, New York (H. O. Havemeyer Collection— bought through Mary Cassatt).*

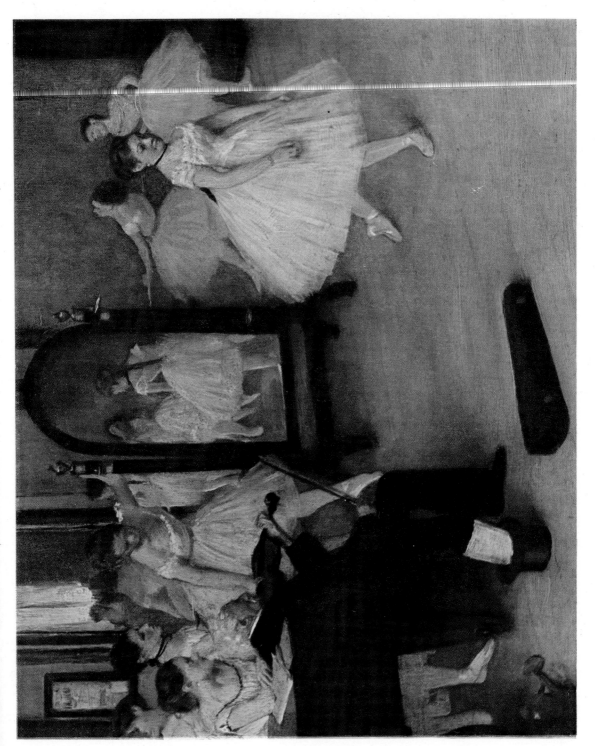

DEGAS: Foyer de Danse, *detail.*

DEGAS: *Foyer de Danse, c. 1873. 18¾ x 24½". Corcoran Gallery of Art, Washington, D. C. (W. A. Clark Collection).*

MONET: *The Pont Neuf, Paris, c. 1872. Collection Sir M. Sadler, England.*

was located, insisting upon some unneeded bit of information, the painter had time to sketch the person. And in this spontaneous way the cheerfulness of the hour was preserved in Renoir's work.

Although deeply attached to the city, Renoir frequently left Paris to join Monet in Argenteuil. On the banks of the Seine in the outskirts of the capital, Argenteuil at that period offered all the advantages of a suburb with a variety of open-country motifs, but its main attraction for the painters was the broad river with sailing boats and picturesque bridges. Monet had rented a little house close to the water, and whenever Renoir came to stay with him they again put up their easels in front of the same views, studying the same motifs. They both now adopted a comma-like brushstroke, even smaller than the one they had chosen for their works at *La Grenouillère,* a brushstroke which permitted them to record every nuance they observed. The surfaces of their canvases were thus covered with a vibrating tissue of small dots and strokes, none of which by itself defined any form, yet all of which contributed to recreate not only the particular features of the chosen motif but even more the sunny air which bathed it and marked trees, grass, houses or water with the specific character of the day, if not the hour. Nature was no longer, as for the Barbizon painters, an object susceptible of interpretation; it became the direct source of pure sensations, and these sensations could best be reproduced by the technique of small dots and strokes which—instead of insisting on details—retained the general impression in all its richness of color and life.

234

RENOIR: *The Pont Neuf, Paris, d. 1872. 29¼ x 36½". Collection Marshall Field, New York.*

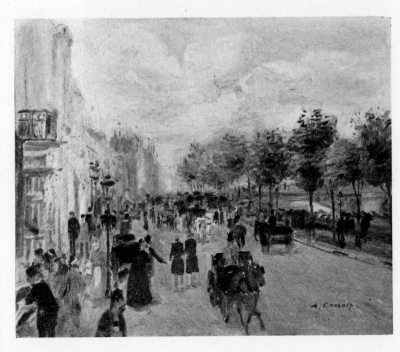

RENOIR: *Quai de Conti, Paris, c. 1872. Private collection, Paris.*

MONET: *The Artist's Garden in Argenteuil, d. 1873. 24⅛ x 32½". (Monet probably did this canvas while posing for Renoir's painting reproduced below.) Private collection, Paris.*

RENOIR: *Monet Working in his Garden in Argenteuil*, 1873. 19¾ x 42". Collection Mrs. A. P. Titzell, Georgetown, Conn.

RENOIR: *Duck Pond, 1873. 20 x 24½". Louvre, Paris.*

At that period Monet and Renoir both did paintings of a house on a duck pond in which their technique is absolutely similar. Renoir also made a portrait of Monet, observed while painting in his garden. Of the entire group, it was Renoir who delighted most in rendering the likenesses of his companions; he repeatedly chose Monet, Sisley and Cézanne as his models, also painting several portraits of Camille, now Madame Monet.

Sisley, during that time, worked chiefly in Louveciennes and its lovely vicinity. Timid and modest, he isolated himself after having found in the works of his friends, and particularly in Monet, direction for a new approach to nature. It had taken him longer than the others to liberate himself completely from the influence of Corot, but now that he had done so there appeared in his works a note of daring, a fertile confidence. In close communion with nature he found the strength of feeling and expression which he had lacked before. His lyricism is no longer merely gentle; his works radiate with a new assurance, an eagerness for discoveries and the enjoyment of a newly won freedom. Among the landscapes he painted during this period—he seldom painted anything else—are two views of a path between gardens and houses,

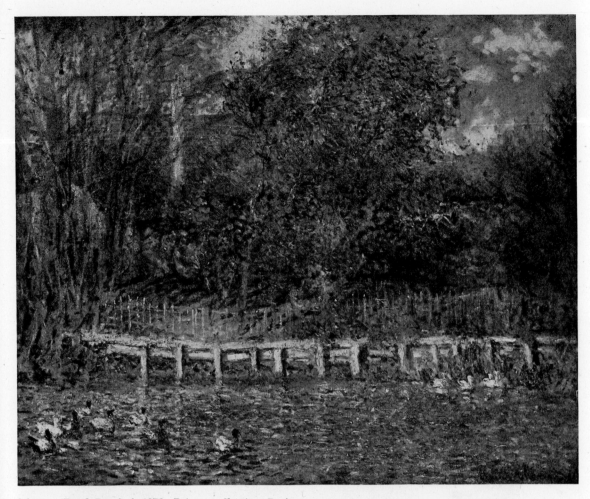

MONET: *Duck Pond, d. 1873. Private collection, Paris.*

executed at different seasons. As Monet had done, Sisley was studying the changes in coloring, aspect and form which summer and winter bestow upon the same motif.

In Pontoise, meanwhile, Pissarro had gathered a small group of friends around him, all younger men who looked to him for advice and guidance. Urged by Pissarro, Cézanne had joined him with his little family. Guillaumin, obliged to re-enter the *Administration des Ponts et Chaussées* in order to earn a living and support his grandparents, managed somehow to devote all his spare time to painting in the company of his friends. Béliard was there too, and in September 1872 Pissarro proudly informed Antoine Guillemet:

"Béliard is always with us. He is doing very serious work at Pontoise. . . . Guillaumin has just spent several days at our house; he works at painting in the daytime and at his ditch-digging in the evening, what courage! Our friend Cézanne raises our expectations and I have seen, and have at home, a painting of remarkable vigor and power. If, as I hope, he stays some time at Auvers, where he is going to live, he will astonish a lot of artists who were in too great haste to condemn him."[7]

Since he had first met him, ten years before, Pissarro had never failed in his conviction that Cézanne

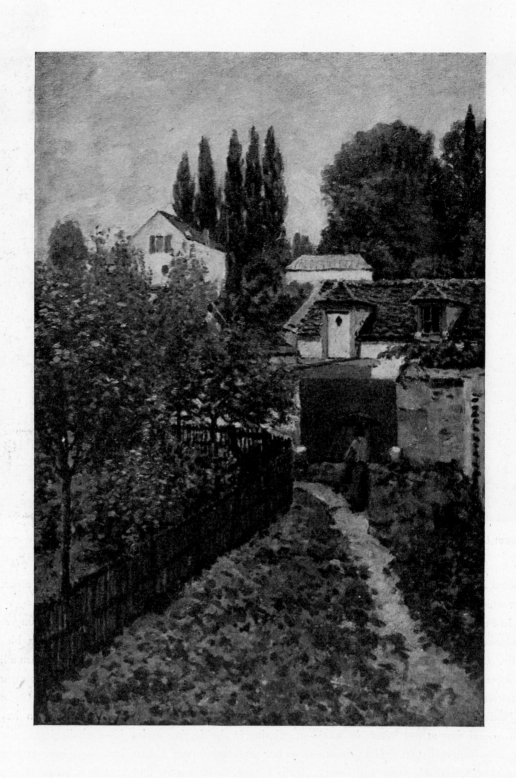

SISLEY: *Louveciennes, d. 1873. Collection Percy M. Turner, London.*

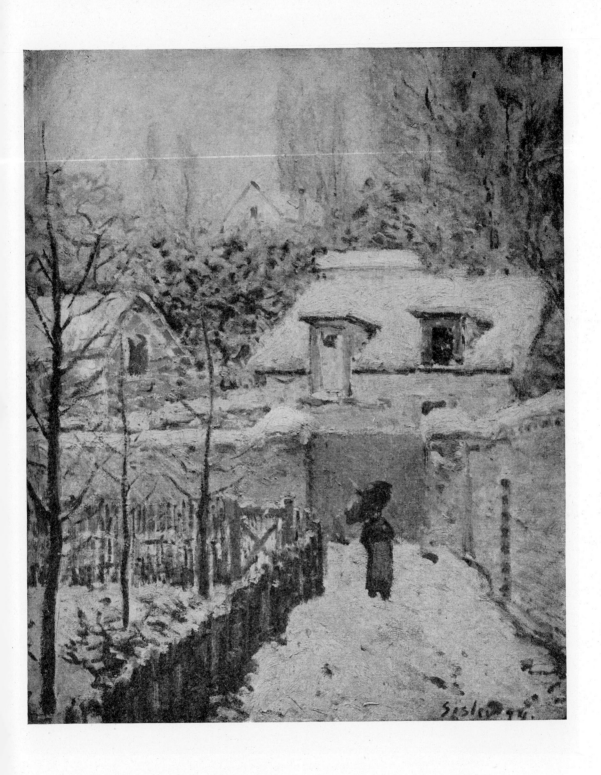

SISLEY: *Louveciennes, Winter, d. 1874. 22 x 18". Phillips Memorial Gallery, Washington, D. C.*

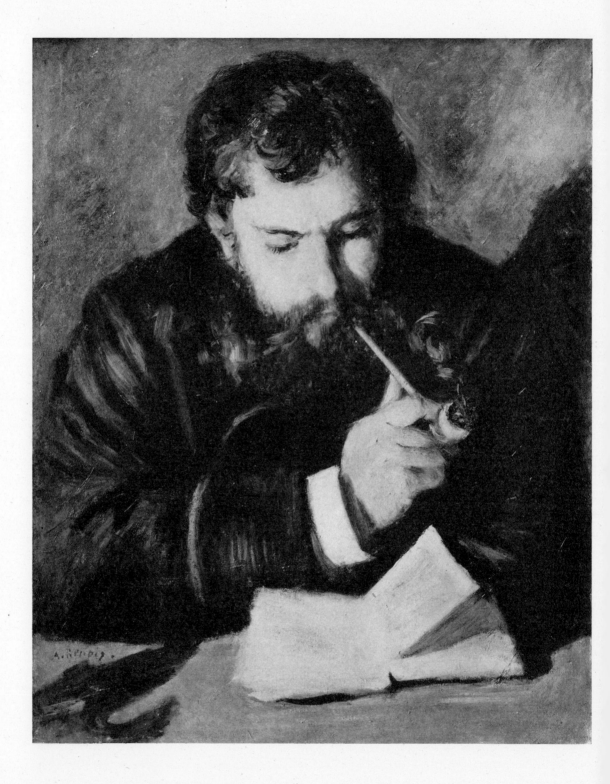

RENOIR: *Portrait of Claude Monet, 1872. 23¾ x 1″. Collection Arthur Sachs, Santa Barbara, Calif.*

Photograph of Paul Cézanne on his way to work near Pontoise, c. 1874.

CÉZANNE: *Pissarro on His Way to Work, c. 1874. Drawing, 7¼ x 4½". Louvre, Paris.*

was endowed with extraordinary gifts, even if Manet and others did not share this view. He was happy now to see Cézanne gain control of his ebullient temperament in intimate contact with nature, but he was too modest to insist on the part he himself played in this decisive period of Cézanne's evolution. Cézanne, however, willingly recognized that his new approach to nature was based on Pissarro's experience. He even went so far as to copy faithfully one of Pissarro's views of Louveciennes,[8] appropriating completely his friend's technique of small strokes as well as substituting the study of tones for modeling. Not only did he abandon his fiery execution, he now also purified his palette at the other's example.

Just as Monet and Renoir occasionally painted the same motif, Cézanne and Pissarro now sometimes worked side by side. In this way Cézanne became intimately familiar with the methods and conceptions of his friend. Thus they painted a view of a suburban street in winter as well as other subjects around Pontoise or nearby Auvers-sur-Oise. "We were always together," Pissarro remembered later, "but what cannot be denied is that each of us kept the only thing that counts, the unique *sensation*."[9] When Zola and Béliard were surprised by the similarity of some of their works, Pissarro pointed out that it was wrong to think "that artists are the sole inventors of their styles and that to resemble someone else is to be unoriginal."[9] Conscious of the give-and-take between artists who work together, Pissarro later acknowledged having been influenced by Cézanne even while influencing him.

Pissarro was developing in those years a style that, for all its poetic values, showed firmness of form and expression. "You haven't Sisley's decorative feeling nor Monet's fanciful eye," Duret said in one of his letters to Pissarro, "but you have what they have not, an intimate and profound feeling for nature and a power of brush with the result that a beautiful picture by you is something absolutely definitive. If I had a piece of advice to give you, I should say: Don't think of Monet or of Sisley, don't pay attention to what they are doing, go on your own, your path of rural nature. You'll be going along a new road, as far and as high as any master."[10] But when Duret, in his admiration for Pissarro's works, began to depreciate Monet, the painter immediately replied: "Aren't you afraid that you are mistaken about Monet's talent, which in my opinion is very serious and very pure? . . . It is a highly conscious art, based upon observation and derived from a completely new feeling; it is poetry through the harmony of true colors."[11]

There was in Pissarro's approach to nature a humility which the others did not seem to possess and which they admired, for they knew that it offered the key to real penetration of nature. Both Monet and Sisley adopted a similar attitude, as far as their temperaments allowed, but none came closer in humility to Pissarro than Paul Cézanne.

Early in 1873 Cézanne left Pontoise for Auvers, only a few miles up the Oise River. Daubigny lived there, yet it was not his presence which attracted Cézanne but that of Dr. Gachet. An eccentric person vitally interested in art, the doctor had not given up his concern in advanced ideas and especially painting, which had led him in his student days to the Andler Keller. He later had been among the habitués

CÉZANNE: *Street in Pontoise, Winter, 1873. 15¼ x 18½". Collection J. Bernheim-Jeune, Paris.*

of the Café Guerbois and had become a close friend of Pissarro and Guillaumin. After the war he had acquired a beautiful house on a hillside overlooking the Oise valley, where his ailing wife and their two children went to live, while he himself continued to practice in Paris, spending three days every week with his family.[12] Though the doctor did some painting himself, he was particularly interested in the art of etching and had installed in his house a comfortable studio which he readily shared with his friends, lending them his copper plates and presses. Cézanne was to take full advantage of Gachet's hospitality. The only etchings he ever did—one of them a portrait of Guillaumin—were made in the doctor's house. He also painted there a number of still lifes, for which Madame Gachet picked and arranged the flowers in various beautiful Delft vases.

Dr. Gachet purchased several of Cézanne's canvases, among them a strange composition entitled *A Modern Olympia,* which seemed to be almost a parody of Manet's painting. In it appears on a large couch a nude woman whom a gentleman in the foreground watches admiringly. This gentleman bears a strong resemblance to Cézanne himself. In the right corner there is a huge bouquet of scintillating flowers in brilliant colors. The canvas is spirited in execution and remarkably free in handling for Cézanne at this stage of his development.

In fact this picture was far from typical of the paintings he did at Auvers. At this time he commonly worked out-of-doors, and the outdoor interests dictated a quite different style. While Pontoise was a town with rural character, Auvers was little more than a village of thatched cottages on unpaved country lanes.

245

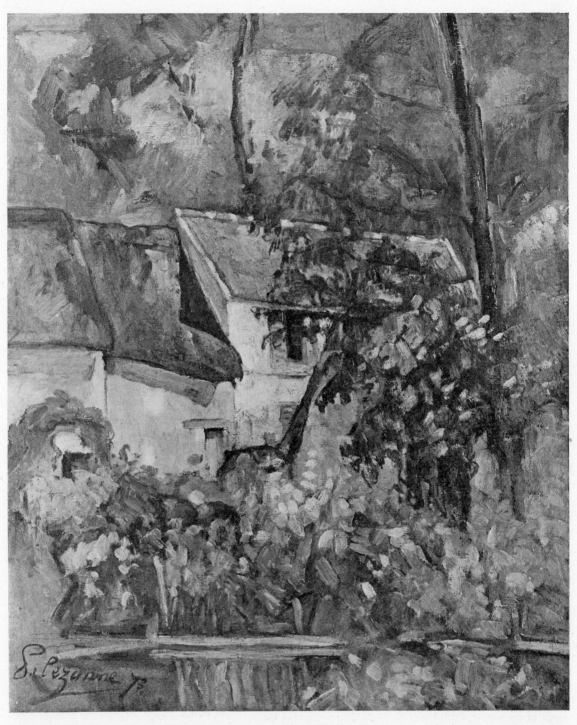

CÉZANNE: *The House of père Lacroix, Auvers, d. 1873. 24¼ x 20". National Gallery of Art, Washington, D. C. (Chester Dale loan).*
A detail of the painting above is shown on the opposite page.

PISSARRO: *Portrait of Cézanne*, 1874. 29¼ x 24". Collection Robert von CÉZANNE: *The House of Dr. Gachet at Auvers*, c. 1874. 24⅞ x 20¾".
Hirsch, Basle. *Art Institute, Chicago (Mr. and Mrs. M. A. Ryerson Collection).*

CÉZANNE: *A Modern Olympia, 1872-73. 18½ x 22". Exhibited at the first impressionist show, 1874. Collection P. Gachet, Auvers-sur-Oise.*

Here the painter could work at ease without being watched by curious spectators, whether he painted on the road that led to Gachet's house or out in the fields. And he did so with untiring effort, never quite satisfied with the results achieved. He was now proceeding with extreme slowness, and the realization of his *sensations* seems to have been obtained often through many difficulties. His previous independence of nature was now replaced by a scrupulous fidelity to his observations. His canvases are covered with heavy layers of pigment, for although he had adopted Pissarro's small brushstrokes, he used to put touch upon touch in a constant endeavor to improve, to add, to record every nuance he perceived. But in spite of the actual labor and strenuous effort Cézanne's paintings done in Auvers retain a certain spontaneity. So intense were his impressions, so tremendous his will to penetrate the secrets of nature, so humble his attempt to retain his sensations, that even countless hours of work upon the same canvas did not destroy the naiveté and truth, the delicacy and power of his perceptions.

It is said that Daubigny once watched Cézanne work and could not restrain his enthusiasm. "I've just seen on the banks of the Oise an extraordinary piece of work," he told a friend. "It is by a young and unknown man: a certain Cézanne!"[13]

Cézanne's financial position was far from easy at that time. Not daring to confess to his father the circumstances of his private life, he was obliged to subsist on his bachelor's allowance. Fortunately Dr. Gachet helped him by occasional purchases, and Pissarro introduced him to the color-grinder *père* Tanguy. Before the war Tanguy had been a traveling paint-salesman and had often appeared with his merchandise in Fontainebleau forest or on the outskirts of Paris, there meeting Pissarro, Renoir, Monet and other artists.[14] A volunteer with the troops of the *Commune,* he had been made prisoner by the Versailles

army, condemned and deported. Only the intervention of Degas' friend Rouart had saved him from a death sentence. It was after his return to Paris, where he rented a small shop in the rue Clauzel, that *père* Tanguy was recommended to Cézanne by Pissarro, who tried to help him out of sympathy for his political views. Tanguy immediately took a fancy to Cézanne; he agreed to provide him with paints and canvases and took some paintings in exchange. Cézanne wanted to make a similar arrangement with his grocer in Pontoise, but the latter was less ready to accept works instead of payment; after consulting Dr. Gachet and Pissarro, however, he was persuaded to take Cézanne's canvases.

Pissarro's own credit had risen very suddenly, early in 1873, when some of his paintings, possibly "pushed" by Durand-Ruel, brought unexpectedly high prices at an auction sale in Paris. Enchanted, Pissarro wrote to Duret: "The reactions from the sale are making themselves felt as far as Pontoise. People are very surprised that a picture of mine could go as high as 950 francs. It has even been said that that was astonishing for a straight landscape."[15] Shortly afterwards he remarked in another letter to Duret: "You are right, my dear Duret, we are beginning to make ourselves a niche. We meet a lot of competition from certain masters, but mustn't we expect these differences of view, when we have succeeded as intruders in setting up our little banner in the midst of the crowd? Durand-Ruel is steadfast; we hope to advance without worrying about opinion."[16]

Pissarro had every reason to be confident in Durand-Ruel's tenacity, for the dealer was then preparing

PISSARRO: *Entrance to the Village of Voisins, d. 1872. 18⅜ x 22". Louvre, Paris.*

the publication of a huge catalogue in three volumes with three hundred reproductions of the choicest paintings in his possession. Among these were twenty-eight works by Corot, twenty-seven by Millet, twenty-six by Delacroix, twenty by Rousseau, ten by Troyon and by Diaz, seven by Courbet and by Manet, but also five by Pissarro, four by Monet, three by Sisley and two by Degas. Only Renoir was not yet represented. The introduction was written by Armand Silvestre, a critic who had frequently appeared at the Café Guerbois and who now insisted that there was a logical line of development and progress which led from Delacroix, Corot, Millet and Courbet to the young generation, the Batignolles group. Recommending this voluminous catalogue to the reader, he wrote: "It is to the public that these endeavors are directly submitted, to the public which makes reputations even though appearing only to accept them and which does not fail to turn away, one day, from those who are satisfied to serve its taste, toward those who make an effort to guide."[17]

Examining the works of his friends, Silvestre stated: "At first glance one has difficulty in distinguishing what differentiates the painting of M. Monet from that of M. Sisley and the latter's manner from M. Pissarro's. A little study will soon teach you that M. Monet is the most adept and daring, M. Sisley the most harmonious and hesitant, M. Pissarro the most genuine and naive. . . . In looking at their painting, what strikes you first of all is the immediate caress which the eye receives from it—it is above all harmonious. What next distinguishes it is the simplicity of the means of harmony. One discovers soon, in fact, that its whole secret is a very delicate and very exact observation of relationships of tone." And the author added: "What apparently should hasten the success of these newcomers is that their pictures are painted according to a singularly cheerful scale. A 'blond' light floods them and everything in them is gaiety, clarity, spring festival. . . ."[17]

While Silvestre was convinced that these painters would soon be recognized, Manet in his eyes had already won his battle against a refractory public. "The moment has come for the public to be convinced, enthusiastic or disgusted, but not dumbfounded," he wrote. "Manet still belongs in the field of discussion, but no longer of bewilderment."[17]

Indeed, at the Salon of that very year, 1873, Manet was to obtain his first great success since 1861. The painting he exhibited, the *Bon Bock,* represented the engraver Bellot sitting at a table in the Café Guerbois. The good-naturedness of the heavy man, the nonchalance of his attitude, the simplicity of the subject highly pleased the public and even those critics who had heretofore manifested only contempt for the artist. Manet's friends, however, missed in this portrait his usual vigor and temperament, regretting the old-master aspect of this work. When a triumphant critic stated that Manet had put "some water into his *bock,*" Alfred Stevens, alluding to the influence which Manet's recent study of Frans Hals had had upon this painting, wittily replied: "Some water? It's pure Haarlem beer."[18]

Manet was deeply vexed by these remarks but was equally angry with his Batignolles colleagues for keeping away from the Salon. Only Berthe Morisot had submitted work, and Renoir, whose two canvases had again been rejected. Thus, of the group, Manet was practically alone at the Salon (with the exception of Eva Gonzalès, who faithfully exhibited with him), and although his success flattered his pride, he was indignant about the isolation into which his friends seemed to be forcing him, accusing them bitterly of having "left him in the lurch."[19]

If anything could have conclusively decided the friends against exhibiting at the Salon, it was precisely the success obtained by Manet's *Bon Bock*. It became increasingly evident that the jury had no

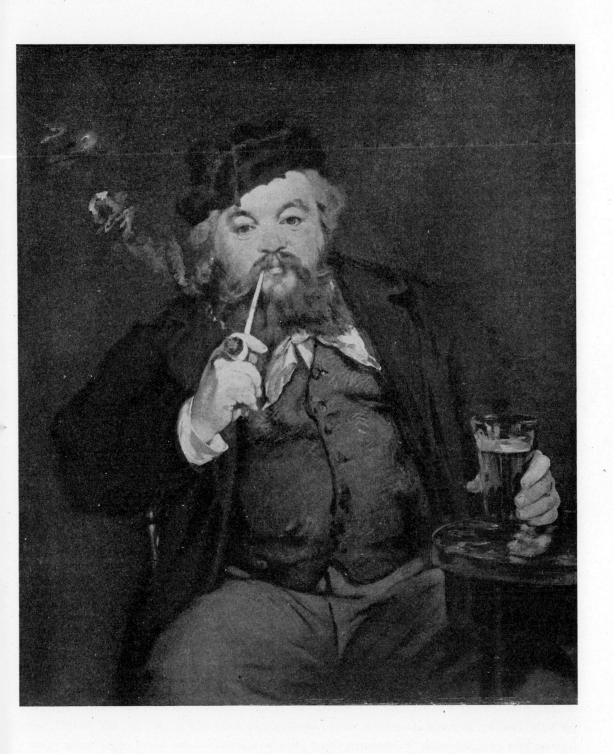

MANET: *Le Bon Bock—The Engraver Bellot at the Café Guerbois, d. 1873. 37 x 32⅝". Exhibited at the Salon of 1873; bought by Faure the same year. Collection Carroll J. Tyson, Philadelphia.*

intention of liberalizing its views and that only a certain compromise with tradition would open the Salon doors to them. Less than ever were they inclined to seek such a compromise or to paint "tame" pictures for the jury while otherwise remaining faithful to their conceptions. The consequence for them was inevitably to abandon any attempt to exhibit at the Salon. However, as a result they would have to find another way to submit their works to the public.

It was apparently Monet who in 1873 took up once more the idea which he and Bazille had cherished back in 1867, that of opening at their own expense a group exhibition. There seemed to be no reason why such a venture should not attract public interest, for the friends had slowly found a nucleus of collectors, and their prices were rising (Monet obtained 1,000 to 1,500 francs for his early canvases, Pissarro 500 for recent ones). When, at the beginning of 1874, the director of a Paris department store, Hoschedé, sold at auction a group of works by Pissarro, Sisley, Monet and Degas, the prices were again relatively high. But while the painters found in this an argument for a successful exhibition of the group, Duret took an opposite view and pronounced himself strongly against it.

"You have still one step to take," Duret wrote in February 1874 to Pissarro, "that is to succeed in becoming known to the public and accepted by all the dealers and art lovers. For this purpose there are only the auctions at the Hôtel Drouot and the big exhibition in the *Palais de l'Industrie* [where the Salons were held]. You possess now a group of art lovers and collectors who are devoted to you and support you. Your name is familiar to artists, critics, a special public. But you must make one more stride and become widely known. You won't get there by exhibitions put on by special groups. The public doesn't go to such exhibitions, only the same nucleus of artists and patrons who already know you.

"The Hoschedé sale did you more good and advanced you further than all the special exhibitions imaginable. It brought you before a mixed and numerous public. I urge you strongly to round that out by exhibiting this year at the Salon. Considering what the frame of mind seems to be this year, your name now being known, they won't refuse you. Besides, you can send three pictures—of the three, one or two will certainly be accepted.—Among the 40,000 people who, I suppose, visit the Salon, you'll be seen by fifty dealers, patrons, critics who would never otherwise look you up and discover you. Even if you only achieve that, it would be enough. But you'll gain more, because you are now in a special position in a group that is being discussed and that is beginning to be accepted, although with reservations.

"I urge you to select pictures that have a subject, something resembling a composition, pictures that are not too freshly painted, that are already a bit staid. . . . I urge you to exhibit; you must succeed in making a noise, in defying and attracting criticism, coming face to face with the big public. You won't achieve all that except at the Salon."[20]

But Pissarro chose not to heed this advice. Instead he strongly supported Monet's plan for a separate group exhibition. In doing so he may have been prompted by essentially practical considerations, for early in 1874 Durand-Ruel had suddenly been obliged to suspend all further acquisitions. The business boom of unexpected intensity which France had enjoyed shortly after the disastrous war, and which may explain the high prices for paintings obtained at various auctions, had come to a sudden end late in 1873, being followed by a great depression.[21] Moreover, Durand-Ruel's efforts to sell the works of the young painters had not only encountered enormous obstacles but had made him lose the confidence of many collectors who refused to share his admirations and even thought him mad. The steady growth of his unsaleable stock had brought him into serious difficulties, and he was now forced to sell at a loss some major works

252

of the Barbizon painters in order to meet his obligations. In these circumstances he was obliged, temporarily, to abandon the Batignolles group, although he succeeded in persuading the singer Faure to buy a certain number of their canvases. In their again uncertain situation after a few years of stability, the friends became doubly eager to appeal to the large public through a manifestation which promised to have more prestige than their participation at the Salon ever could, especially because it would permit them to show more canvases than the three allowed at the Salon.

Monet's plan was therefore well received by his comrades, but the actual formation of the group involved various complications, since each of the painters had his own ideas about how the exhibition should be organized. The former plan of inviting older men like Corot, Courbet (now an exile in Switzerland), Daubigny and others, seems to have been abandoned, possibly because some of these men no longer wished to be associated with the Batignolles group.

The first dissent arose when Degas expressed fear that the exhibition might be considered a manifestation put on by *refusés,* even though the friends were determined not to send any works to the Salon and to open their show two weeks before the official exhibition. Berthe Morisot, who had always been admitted, courageously accepted this principle and, in joining the others, decided to submit no more to the jury. Degas, however, did not change his opinion. He insisted that the friends invite as many artists as possible, preferably some who showed at the Salon, so as not to give the enterprise too revolutionary a character. The others argued that an exhibition limited to the members of their group would present greater unity and more strongly underline the specific nature of their efforts. To this Degas retorted that they would make themselves less conspicuous and have a better chance of being considered favorably if they associated themselves with artists whose tendencies seemed less offensive to the general public. Thereupon the others suspected that Degas, being himself only vaguely in sympathy with their studies of nature, did not care to identify himself with them unless he was certain not to be alone in their midst. If Degas' proposal finally prevailed, it was for the very practical reason that a greater number of participants would automatically reduce the contribution to be paid by each exhibitor.

Pissarro insisted that a cooperative association be formed and proposed as a model the charter of a professional bakers' organization, which he had studied at Pontoise and which he read to his friends. To these he added, on his own, regulations loaded with prohibitions and penalties. But Renoir, out of horror of administrative rules, succeeded in defeating this suggestion.[22] It was agreed simply that each painter turn over to a common fund one-tenth of the income from possible sales.

Pissarro also suggested a system designed to give equal chances for good position and thus eliminate the almost inevitable battles about hanging: a drawing of lots was to determine the place for each canvas unless the exhibitors preferred to decide the positions by vote. In order to obtain a more harmonious display, a compromise was adopted by which the paintings were first to be classified by size, and only then would lots decide where they should hang.

Once these principles were agreed upon, the friends had to secure a proper location for their exhibition. This presented itself in the form of the studios just vacated by the photographer Nadar, who, according to Monet, lent them the premises without fee. They were located on the second floor of a building in the rue Daunou, which formed an angle on the boulevard des Capucines, right in the heart of Paris. It was a series of large rooms with red-brown walls which received the light sidewise, as in an apartment. A large staircase led from the boulevard des Capucines directly to these galleries.

The location of these premises induced Degas, still anxious to give a "neutral" character to the project, to propose that the group call itself *La Capucine* [nasturtium] and that this flower be used as an emblem on the posters announcing the exhibition. But this was not accepted. Renoir was also against a title with a precise signification. "I was afraid," he later explained, "that if we were called merely *Some* or *Certain*, . . . critics would immediately begin talking about a 'new school'."[23] It was finally agreed that the group be called simply *Société anonyme des artistes peintres, sculpteurs, graveurs, etc.* . . .

It was then that an active campaign to recruit participants began among the initial members: Monet, Renoir, Sisley, Pissarro, Degas and Berthe Morisot. As was to be expected, Degas obtained the greatest number of adherents. Among others he induced his friends Lepic, Levert and Rouart to join the group, and also persuaded the Italian painter de Nittis, a mutual friend of his and Manet's. He even insisted that de Nittis send something important, adding: "Since you are exhibiting at the Salon, people who are not conversant with things won't be able to say that we are an exhibition of rejected artists."[24]

Pissarro invited Béliard, Guillaumin and Cézanne but had apparently a little difficulty in getting some of the others to accept Cézanne's participation, for they feared that the public would feel too outraged by his canvases. But Pissarro pleaded the cause with so much conviction that Cézanne was finally admitted, in spite of the fact that Degas and even Monet showed little enthusiasm. There was also some opposition to Guillaumin.

Of the older generation only Boudin joined the group, doubtless at the request of Monet. There were altogether twenty-nine participants when, at the last minute, Bracquemond decided, on the recommendation of the critic Burty, to exhibit with the group. Degas immediately wrote him:

"A line from Burty informs me that he has made of you yesterday a new adherent, my dear Bracquemond, and that you would like to arrange for a talk. First, we are going to open on the 15th [of April]. Therefore, we must hurry. You should have your things in by the 6th or 7th, or even a little later, but in plenty of time so that we can have the catalogue by opening day. There is space there (boulevard des Capucines, Nadar's old studio) and a unique location, etc., etc., etc. . . . I suggest that you meet me . . . at that very place. You will see the spot; we can afterwards discuss things if it is still necessary. We are gaining a famous recruit in you. Be assured of the pleasure and good you are doing us. (Manet, stirred up by Fantin and confused by himself, is still holding out, but nothing seems to be final in that direction.)"[25]

Although Degas hoped until the last minute that Manet would join the group, the painter of the *Bon Bock* had no intention of doing so. One of the reasons given when he was invited to exhibit with the others was: "I'll never commit myself alone, with M. Cézanne."[26] But his more decisive arguments were the same as those of Duret in trying to convince Pissarro that only participation in the Salon could bring real recognition. Manet thought along the same lines. Pointing to the recent success of his *Bon Bock*, he repeated over and over to Berthe Morisot, Renoir and Monet: "Why don't you stay with me? You can see very well that I am on the right track!"[27] And to Degas he said: "Exhibit with us; you'll receive an honorable mention."[28]

Fantin, for similar reasons, abstained from exhibiting with his former comrades. So did Guillemet, who likewise preferred success at the Salon to an act of independence. Corot, incidentally, approved of Guillemet's decision and told him: "My dear Antoine, you have done very well to escape from that gang."[27]

The "gang" brought together 165 works for exhibition. Of these Cézanne sent three: two landscapes

SISLEY: *Landscape, Louveciennes, Autumn, c. 1873. 20 x 25½". Probably exhibited at the first impressionist show, 1874. Private collection, New York.*

of Auvers and his *Modern Olympia*; Degas ten paintings, drawings and pastels of horse races, dancers and laundresses; Guillaumin three landscapes; Monet five paintings, among them one entitled: *Impression, Sunrise,* some of his early works and seven pastel sketches; Berthe Morisot nine paintings, water colors and pastels; Pissarro five landscape paintings; Renoir six canvases, including his *Loge* and *Dancer* painted in 1873, and one pastel; Sisley five landscapes. The remaining 114 works belonged to the others: Astruc (the critic, who occasionally did sculpture and painted), Attendu, Béliard, Boudin, Bracquemond, Brandon, Bureau, Cals, Colin, Desbras, Latouche, Lepic, Lépine, Levert, Meyer, de Molins, Mulot-Durivage, A. Ottin, L. Ottin, Robert and Rouart.[29]

A committee, of which Renoir was a member, supervised the hanging. But the others soon tired of the job and left Renoir practically alone to arrange the show. One of his main problems was apparently to achieve some kind of unity with the widely different works. When he could find no place for de Nittis' more or less academic canvas, he simply left it out. It was only hung, doubtless upon Degas'

insistence, a few days after the opening, when—as de Nittis later complained—the critics and the first visitors had come and gone.[24]

The opening took place on April 15, 1874. The exhibition was to last for one month; the hours were from ten to six and also—as an innovation—in the evenings from eight to ten. The entrance fee was one franc, catalogues being sold for fifty centimes. From the beginning the exhibition seems to have been well attended, but the public went there mainly to laugh. Someone invented a joke to the effect that these painters' method consisted in loading a pistol with several tubes of paint and firing at a canvas, then finishing off the work with a signature. The critics were either extremely harsh in their comments or simply refused to consider the show seriously. On April 25 there appeared in the *Charivari* an article signed by Louis Leroy which, under the title "Exhibition of the Impressionists," summed up the attitude of both its author and the general public.

"Oh, it was indeed a strenuous day," wrote the critic, "when I ventured into the first exhibition on the boulevard des Capucines in the company of M. Joseph Vincent, landscape painter, pupil of [the academic master] Bertin, recipient of medals and decorations under several governments! The rash man had come there without suspecting anything; he thought that he would see the kind of painting one sees everywhere, good and bad, rather bad than good, but not hostile to good artistic manners, to devotion to form and respect for the masters. Oh, form! Oh, the masters! We don't want them any more, my poor fellow! We've changed all that.

"Upon entering the first room, Joseph Vincent received an initial shock in front of the *Dancer* by M. Renoir.

" 'What a pity,' he said to me, 'that the painter, who has a certain understanding of color, doesn't draw better; his dancer's legs are as cottony as the gauze of the skirts.'

" 'I find you hard on him,' I replied. 'On the contrary, the drawing is very tight.'

"Bertin's pupil, believing that I was being ironical, contented himself with shrugging his shoulders, not taking the trouble to answer. Then, very quietly, with my most naive air, I led him before the *Ploughed Field* of M. Pissarro. At the sight of this astounding landscape, the good man thought that the lenses of his spectacles were dirty. He wiped them carefully and replaced them on his nose.

" 'By Michalon!' he cried. 'What on earth is that?'

" 'You see . . . a hoar-frost on deeply ploughed furrows.'

" 'Those furrows? That frost? But they are palette-scrapings placed uniformly on a dirty canvas. It has neither head nor tail, neither top nor bottom, neither front nor back.'

" 'Perhaps . . . but the impression is there.'

" 'Well, it's a funny impression! Oh . . . and this?'

" '*An Orchard* by M. Sisley [possibly the painting p. 255]. I'd like to point out the small tree on the right; it's gay; but the impression . . .'

" 'Leave me alone, now, with your impression . . . it's neither here nor there. But here we have a *View of Melun* by M. Rouart, in which there's something to the water. The shadow in the foreground, for instance, is really peculiar.'

" 'It's the vibration of tone which astonishes you.'

" 'Call it the sloppiness of tone and I'd understand you better—Oh, Corot, Corot, what crimes are committed in your name! It was you who brought into fashion this messy composition, these thin washes,

256

RENOIR: *Dancer, d. 1874.* 55⅞ x 36⅜". *Exhibited at the first impressionist show, 1874. National Gallery of Art, Washington, D. C. (Widener Collection).*

these mud-splashes, in front of which the art-lover has been rebelling for thirty years and which he has accepted only because constrained and forced to it by your tranquil stubbornness. Once again, a drop of water has worn away the stone!'

"The poor man rambled on this way quite peacefully, and nothing led me to anticipate the unfortunate accident which was to be the result of his visit to this hair-raising exhibition. He even sustained, without major injury, viewing the *Fishing Boats Leaving the Harbor* by M. Claude Monet, perhaps because I tore him away from dangerous contemplation of this before the small, noxious figures in the foreground could produce their effect.

"Unfortunately, I was imprudent enough to leave him too long in front of the *Boulevard des Capucines*, by the same painter.

"'Ah-ha!' he sneered in Mephistophelean manner. 'Is that brilliant enough, now! There's impression, or I don't know what it means. Only, be so good as to tell me what those innumerable black tonguelickings in the lower part of the picture represent?'

"'Why, those are people walking along,' I replied.

"'Then do I look like that when I'm walking along the boulevard des Capucines? Blood and thunder! So you're making fun of me at last?'

"'I assure you, M. Vincent . . .'

"'But those spots were obtained by the same method as that used to imitate marble: a bit here, a bit there, slap-dash, any old way. It's unheard-of, appalling! I'll get a stroke from it, for sure.'

"I attempted to calm him by showing him the *St. Denis Canal* by M. Lépine and the *Butte Montmartre* by M. Ottin, both quite delicate in tone; but fate was strongest of all; the *Cabbages* of M. Pissarro stopped him as he was passing by and from red he became scarlet.

"'Those are cabbages,' I told him in a gently persuasive voice.

"'Oh, the poor wretches, aren't they caricatured! I swear not to eat any more as long as I live!'

"'Yet it's not their fault if the painter . . .'

"'Be quiet, or I'll do something terrible.'

"Suddenly he gave a loud cry upon catching sight of the *Maison du pendu* by M. Paul Cézanne. The stupendous impasting of this little jewel accomplished the work begun by the *Boulevard des Capucines*: *père* Vincent became delirious.

"At first his madness was fairly mild. Taking the point of view of the Impressionists, he let himself go along their lines.

"'Boudin has some talent,' he remarked to me before a beach scene by that artist; 'but why does he fiddle so with his marines?'

"'Oh, you consider his painting too finished?'

"'Unquestionably. Now take Mlle Morisot! That young lady is not interested in reproducing trifling details. When she has a hand to paint, she makes exactly as many brushstrokes lengthwise as there are fingers, and the business is done. Stupid people who are finicky about the drawing of a hand don't understand a thing about impressionism, and great Manet would chase them out of his republic.'

"'Then M. Renoir is following the proper path; there is nothing superfluous in his *Harvesters*. I might almost say that his figures . . .'

"'. . . are even too finished.'

MONET: Boulevard des Capucines, Paris, 1873. 31½ x 23⅝″. Exhibited at the first impressionist show, 1874. Collection Marshall Field, New York.

MONET: *Impression—Sunrise, d. 1872 (painted in Le Havre). Exhibited at the first impressionist show, 1874. Bought by Dr. de Bellio. Collection Donop de Monchy, Paris.*

" 'Oh, M. Vincent! But do look at those three strips of color, which are supposed to represent a man in the midst of the wheat!'

" 'There are two too many; one would be enough.'

"I glanced at Bertin's pupil; his countenance was turning a deep red. A catastrophe seemed to me imminent, and it was reserved for M. Monet to contribute the last straw.

" 'Ah, there he is, there he is!' he cried, in front of No. 98. 'I recognize him, *papa* Vincent's favorite! What does that canvas depict? Look at the catalogue.'

" '*Impression, Sunrise.*'

" '*Impression*—I was certain of it. I was just telling myself that, since I was impressed, there had to be some impression in it . . . and what freedom, what ease of workmanship! Wallpaper in its embryonic state is more finished than that seascape.' [. . . .]

"In vain I sought to revive his expiring reason [. . .] but the horrible fascinated him. *The Laundress*, so badly laundered, of M. Degas drove him to cries of admiration. Sisley himself appeared to him affected and precious. To indulge his insanity and out of fear of irritating him, I looked for what was tolerable

259

PISSARRO: *Public Garden in Pontoise, d. 1874. 24 x 29". Exhibited at the first impressionist show, 1874.* Collection A. Murray, New York.

among the impressionist pictures, and I acknowledged without too much difficulty that the bread, grapes and chair of *Breakfast,* by M. Monet,[30] were good bits of painting. But he rejected these concessions.

"'No, no!' he cried. 'Monet is weakening there. He is sacrificing to the false gods of Meissonier. Too finished, too finished! Talk to me of the *Modern Olympia!* That's something well done.'

"Alas, go and look at it! A woman folded in two, from whom a Negro girl is removing the last veil in order to offer her in all her ugliness to the charmed gaze of a brown puppet. Do you remember the *Olympia* of M. Manet? Well, that was a masterpiece of drawing, accuracy, finish, compared with the one by M. Cézanne.

"Finally the pitcher ran over. The classic skull of *père* Vincent, assailed from too many sides, went completely to pieces. He paused before the municipal guard who watches over all these treasures and, taking him to be a portrait, began for my benefit a very emphatic criticism.

"'Is he ugly enough?' he remarked, shrugging his shoulders. 'From the front, he has two eyes

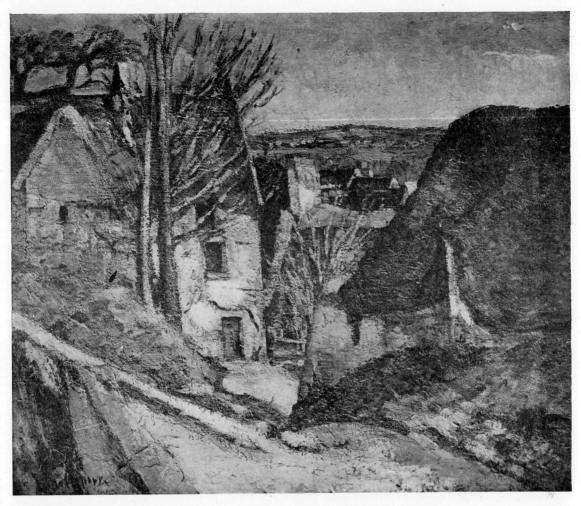

CÉZANNE: *La maison du pendu at Auvers, 1873-74. 22¼ x 26¾". Exhibited at the first impressionist show, 1874. Louvre, Paris.*

. . . and a nose . . . and a mouth! Impressionists wouldn't have thus sacrificed to detail. With what the painter has expended in the way of useless things, Monet would have done twenty municipal guards!'

" 'Keep moving, will you!' said the 'portrait.'

" 'You hear him—he even talks! The poor fool who daubed at him must have spent a lot of time at it!'

"And in order to give the appropriate seriousness to his theory of esthetics, *père* Vincent began to dance the scalp dance in front of the bewildered guard, crying in a strangled voice:

" 'Hi-ho! I am impression on the march, the avenging palette knife, the *Boulevard des Capucines* of Monet, the *Maison du pendu* and the *Modern Olympia* of Cézanne. Hi-ho! Hi-ho!' "[31]

It seemed conclusive that Duret and Manet had been right in advising against a separate exhibition. At the very moment when Durand-Ruel was unable to help them, and when a financial success was even more important than a moral one, the group had gained nothing but ridicule. It could have been of small comfort to them that Manet had fared little better at the Salon, the jury having refused two of his

MONET: *Wild Poppies, d. 1873. Possibly included in the first impressionist show, 1874. Present owner unknown.*

RENOIR: Meadow, d. 1873. 18½ x 24⅛". Collection Siegfried Kramarsky, New York.

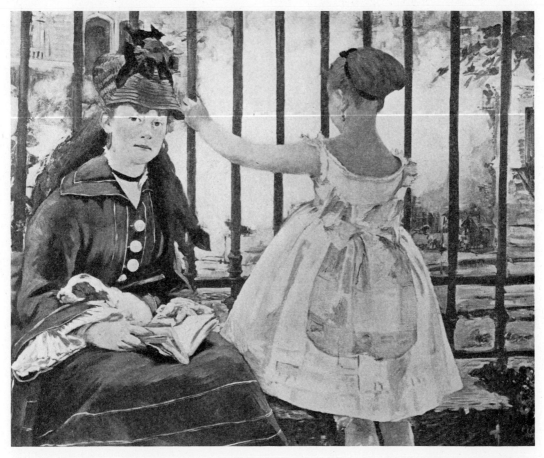

MANET: *The Railroad, 1873. (The last painting posed by Victorine Meurent for Manet.) 37¼ x 45". Exhibited at the Salon of 1874. Private collection, New York.*

three canvases, accepting only his *Railroad* and a watercolor. But, even worse, the critics did not fail to establish Manet's connection with the group in spite of his efforts to detach himself from it.[32] The result could hardly have been different had he actually exhibited with his friends. An American critic, once more confounding Manet and Monet, even informed the readers of *Appletons' Journal* that the author of one "fearful daub" at the Salon, called *The Railroad* and representing a young girl and a child, "both cut out of sheet-tin apparently," had also shown two pictures, *Breakfast* and *The Boulevard des Capucines,* at "that highly comical exhibition, gotten up by the Anonymous Society of Painters and Sculptors." He added that they had been "two of the most absurd daubs in that laughable collection of absurdities."[33] Although avoiding this mistake, one of the best-known Paris Salon reviewers could not help stating: "M. Manet is among those who maintain that in painting one can and ought to be satisfied with the *impression*. We have seen an exhibition by these *impressionalists* on the boulevard des Capucines, at Nadar's. M. Monet—a more uncompromising Manet—Pissarro, Mlle Morisot, etc., appear to have declared war on beauty."[34]

After the closing of the exhibition Cézanne left suddenly for Aix, and Sisley went once more to

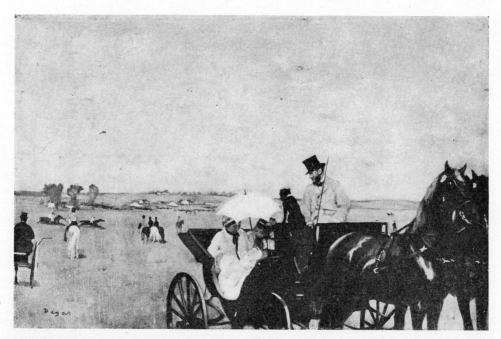

DEGAS: *Carriage at the Races, 1873. 14⅜ x 22″. (Paul Valpinçon with his family.) Exhibited at the first impressionist show, 1874. Museum of Fine Arts, Boston.*

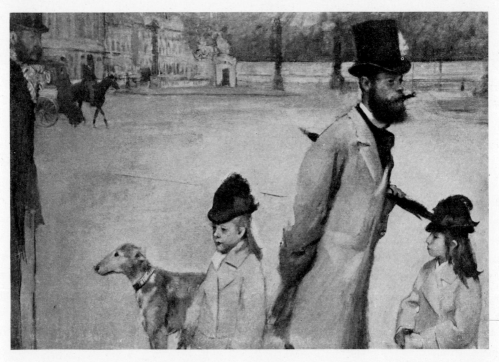

DEGAS: *Place de la Concorde, Paris (Portrait of Viscount Lepic and his daughters), c. 1873. 31¾ x 47⅜″. Present owner unknown.*

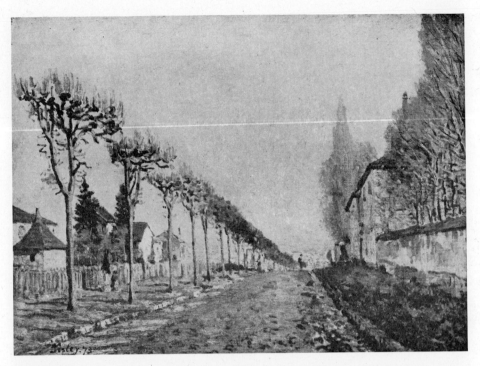

SISLEY: *The House of Mme Du Barry in Marly, d. 1873. Louvre, Paris.*

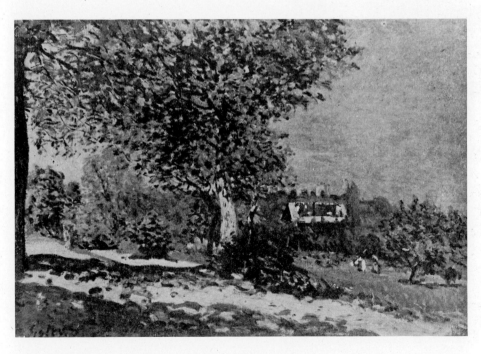

SISLEY: *Landscape near Louveciennes—in the background the Aquaduct of Marly, d. 1872. 21¼ x 31⅞". Durand-Ruel Galleries, New York.*

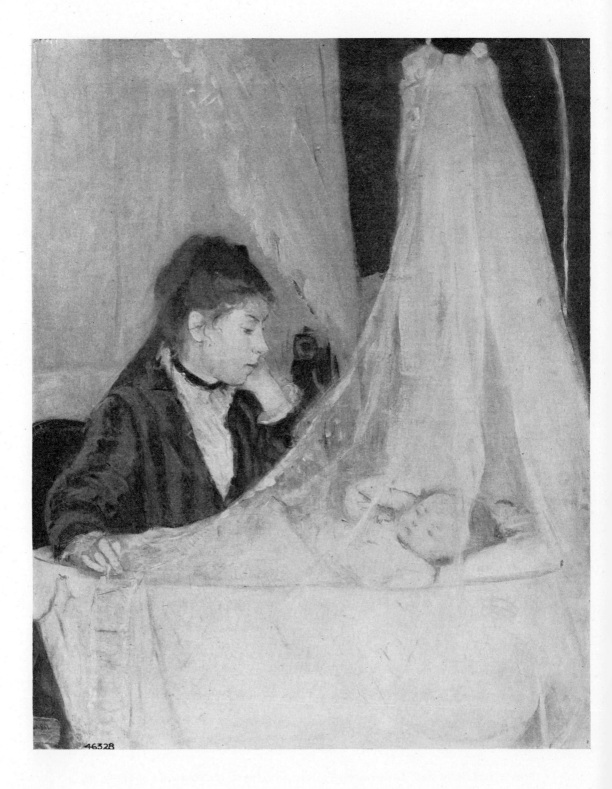

MORISOT: *The Cradle, 1873. Exhibited at the first impressionist show, 1874. 22½ x 18½". Louvre, Paris.*

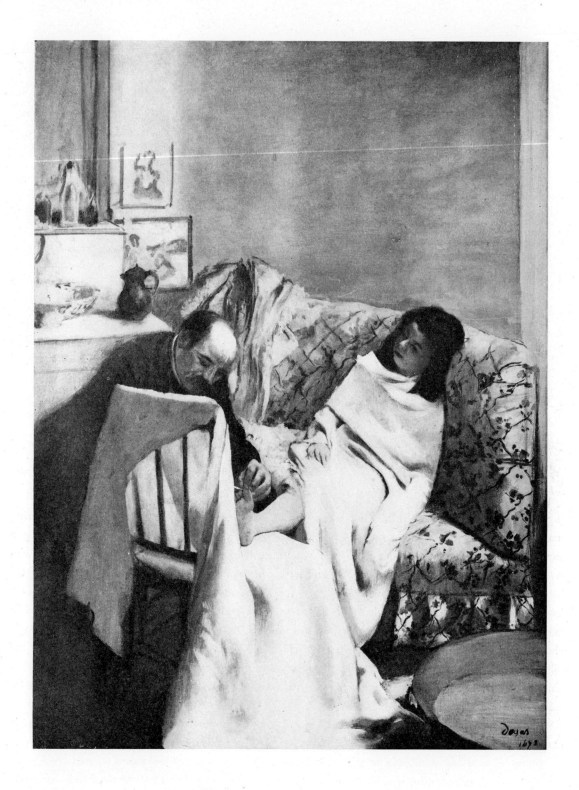

DEGAS: *The Pedicure, d. 1873. 24½ x 18½". Louvre, Paris.*

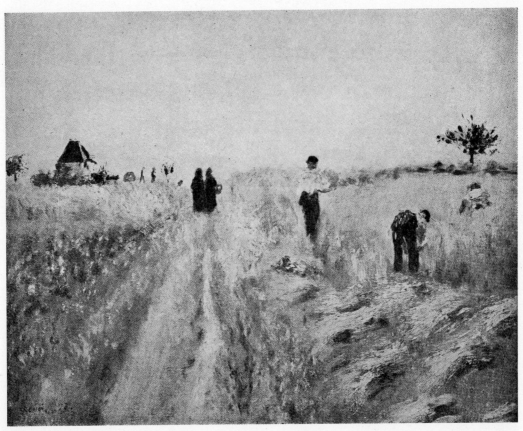

RENOIR: *Harvesters, d. 1873. 22⅞ x 28½". Exhibited at the first impressionist show, 1874. Present owner unknown.*

England. Pissarro had returned to Pontoise, where he received a long letter from Duret, who, fearing that the painter might be discouraged, tried to sum up the situation: "You have succeeded after quite a long time in acquiring a public of select and tasteful art-lovers, but they are not the rich patrons who pay big prices. In this small world, you will find buyers in the 300, 400 and 600 francs class. I am afraid that before getting to where you will readily sell for 1,500 and 2,000, you will need to wait many years. Corot had to reach seventy-five to have his pictures get beyond the 1,000 franc note. . . . The public doesn't like, does not understand good painting; the medal is given to Gérôme, Corot is left behind. People who understand what it's all about and who defy ridicule and disdain are few and very few of them are millionaires. Which doesn't mean that you should be discouraged. Everything is achieved in the end, even fame and fortune, and while counting upon the judgment of connoisseurs and friends you compensate yourself for the neglect of the stupid."[35]

But the nutritive value of this judgment was nil and there were, after the exhibition, few people who would spend even 300 francs for a painting by Pissarro. "What I have suffered is beyond words," the painter wrote a few years later to a friend. "What I suffer at the actual moment is terrible, much more than when young, full of enthusiasm and ardor, convinced now as I am of being lost for the future. Nevertheless, it seems to me that I should not hesitate, if I had to start over again, to follow the same path."[36]

NOTES

1. Boudin to Martin, Jan. 2, 1872; see G. Jean-Aubry: Eugène Boudin, Paris, 1922, p. 79.

2. See: Mémoires de Paul Durand-Ruel *in* L. Venturi: Les Archives de l'Impressionnisme, Paris-New York, 1939, v. II, p. 189-192; also E. Moreau-Nélaton: Manet raconté par lui-même, Paris, 1926, v. I, p. 132-133.

3. Article in *Revue internationale de l'art et de la curiosité,* Dec. 1869, quoted by Venturi, *op. cit.,* v. I, p. 17-18.

4. Degas to Frölich, New Orleans, Nov. 27, 1872; see Lettres de Degas, Paris, 1931, p. 3-8.

5. Degas to H. Rouart, New Orleans, Dec. 5, 1872; *ibid.,* p. 9-14.

6. E. de Goncourt, Journal, Feb. 13, 1874; see: Journal des Goncourt, v. V, 1872-1877, Paris, 1891, p. 111-112.

7. Pissarro to Guillemet, Sept. 3, 1872; see J. Rewald: Cézanne, sa vie, son oeuvre, son amitié pour Zola, Paris, 1939, p. 196.

8. The two pictures are reproduced in *La Renaissance,* special issue: Cézanne, May-June 1936.

9. Pissarro to his son, Nov. 22, 1895; see Camille Pissarro, Letters to his son Lucien, New York, 1943, p. 276.

10. Duret to Pissarro, Dec. 6, 1873; see L. Venturi and L. R. Pissarro: Camille Pissarro, son art, son oeuvre, Paris, 1939, v. I, p. 26.

11. Pissarro to Duret, May 2, 1873; *ibid.,* p. 25.

12. On Gachet see V. Doiteau: La curieuse figure du Dr. Gachet, *Aesculape,* Aug.-Sept. 1923, as well as Tabarant's review of this article, *Bulletin de la vie artistique,* Sept. 15, 1923.

13. See J. Laran: Daubigny, Paris, n.d. [1912], p. 12.

14. On Tanguy see O. Mirbeau: Des artistes, Paris, 1922, v. I, p. 181-186; E. Bernard: Julien Tanguy, *Mercure de France,* Dec. 16, 1908; T. Duret: Van Gogh, Paris, 1919, ch. IV; G. Coquiot: Vincent van Gogh, Paris, 1923, p. 138-139, and C. Waern: Notes on French Impressionists, *Atlantic Monthly,* April 1892.

15. Pissarro to Duret, beginning 1873; see A. Tabarant: Pissarro, Paris, 1924, p. 24. (Five canvases by Pissarro had brought 270, 320, 250, 700 and 950 francs respectively.)

16. Pissarro to Duret, Feb. 2, 1873; *ibid.,* p. 21.

17. A. Silvestre, introduction to: Galerie Durand-Ruel, recueil d'estampes, Paris, 1873, v. I. (The three volumes have never been put actually on the market.)

18. See T. Duret: Manet, Paris, 1919, p. 104.

19. See L. Vauxcelles: Un après-midi chez Claude Monet, *L'Art et les Artistes,* Dec. 1905.

20. Duret to Pissarro, Feb. 15, 1874; see Venturi and Pissarro, *op. cit.,* p. 33-34.

21. On the various periods of booms and depressions in France see S. B. Clough: France, A History of National Economics, New York, 1939, ch. VII.

22. See G. Rivière: Renoir et ses amis, Paris, 1921, p. 43-44.

23. See A. Vollard: Renoir, ch. VII.

24. See J. de Nittis: Notes et Souvenirs, Paris, 1895, p. 237.

25. Degas to Bracquemond, March 1874; see Lettres de Degas, p. 18-20.

26. See M. Elder: Chez Claude Monet à Giverny, Paris, 1924, p. 49.

27. See Vauxcelles, *op. cit.*

28. See J. Elias: Degas, *Neue Rundschau,* Nov. 1917.

29. For a summarized catalogue of the exhibition, see Venturi, *op. cit.,* v. II, p. 255-256. In the catalogues of the impressionist exhibitions only titles were given, but neither dimensions nor dates. It therefore is not always possible to identify the exhibited works, especially since the artists did not always show only recent canvases. Sometimes also paintings were added or changed during the run of the exhibitions, and in other instances works listed in the catalogues were not shown at all; Degas often announced more works than he actually sent.

30. This was an early canvas, *Le déjeuner,* now in the Staedelsches Institut in Frankfort-on-the-Main; see p. 164.

31. L. Leroy: L'exposition des impressionnistes, *Charivari,* April 25, 1874.

32. In 1877 a "poetic" critic wrote: "Qui donc jette la pierre à l'impressionnisme?/ C'est Manet/ Qui donc, dans sa fureur, cri au charlatanisme?/ C'est Manet/ Et pourtant . . . qui donna le premier branle au schisme?/ Tout Paris le connaît,/ Manet, encore Manet." H. Polday: Le Salon humoristique, Paris, 1877, quoted by Jamot, Wildenstein, Bataille: Manet, Paris, 1932, v. I, p. 95.

33. The Salon of 1874; unsigned letter from Paris, May 25, 1874, *Appletons' Journal,* June 20, 1874.

34. J. Claretie: Le Salon de 1874, repr. *in* L'art et les artistes français contemporains, Paris, 1876.

35. Duret to Pissarro, June 2, 1874; see Venturi and Pissarro, *op. cit.,* v. I, p. 34.

36. Pissarro to Murer, [summer 1878]; see Tabarant, *op. cit.,* p. 43.

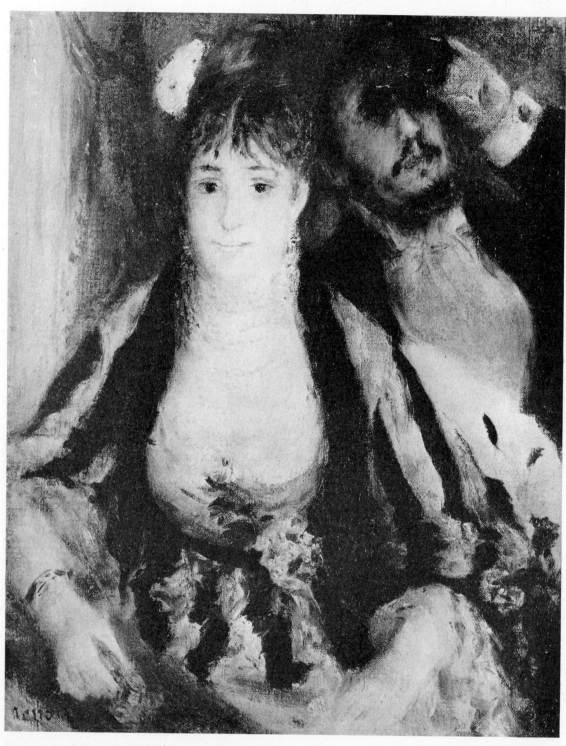

RENOIR: *La Loge, 1874. 10¾ x 8½". Sold at auction in 1875. A larger version was included in the first impressionist show, 1874. Private collection, Boston.*

1874-1877

ARGENTEUIL

CAILLEBOTTE AND CHOCQUET

AUCTION SALES
AND FURTHER EXHIBITIONS

DURANTY'S PAMPHLET
"LA NOUVELLE PEINTURE"

MANET: *Portrait of Claude Monet, 1880. Drawing. Present owner unknown.*

The term *impressionism,* coined in derision, was soon to be accepted by the friends. In spite of Renoir's aversion to anything that might give them the appearance of constituting a new "school" of painting, in spite of Degas' unwillingness to admit the designation with regard to himself, and in spite of Zola's persistence in calling the painters "naturalists," the new word was there to stay. Charged with ridicule and vague as it was, *impressionism* seemed as good a term as any other to underline the common element in their efforts. No one word could be expected to define with precision the tendencies of a group of men who placed their own sensations above any artistic program. But whatever meaning the word might have had originally, its true sense was to be formulated not by ironical critics but by the painters themselves. Thus it was that from among their midst—and doubtless with their consent—came the first definition of the term. It was one of Renoir's friends who proposed this definition, writing a little later: "Treating a subject in terms of the tone and not of the subject itself, this is what distinguishes the impressionists from other painters."[1]

In their efforts to do this, and to find a form closer to their first impression of the appearance of things than had ever been achieved, the impressionists had created a new style. Having freed themselves completely from traditional principles, they had elaborated this style so as to be able to follow unhampered

271

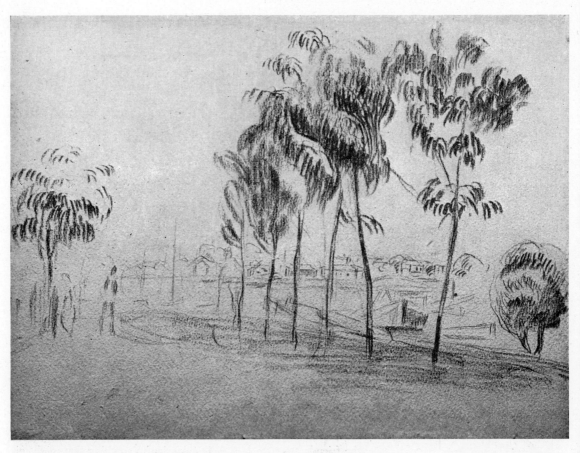

RENOIR: *Argenteuil, 1875. Drawing, 10⅜ x 14". Present owner unknown.*

the discoveries made by their intense sensibilities. And in doing so they had openly renounced even the pretense of recreating reality. Rejecting the objectivity of realism, they had selected one element from reality—light—to interpret all of nature.[2]

Their new approach to nature had prompted the painters gradually to establish a new palette and create a new technique appropriate to their endeavor to retain the fluid play of light. The careful observation of colored light appearing in a scene at a particular moment had led them to do away with the traditional dark shadows and to adopt bright pigments. It had also led them to ignore local colors, subordinating the abstract notion of local tones to the general atmospheric effect. By applying their paint in perceptible strokes, they had succeeded in blurring the outlines of objects and merging them with the surroundings. This method had further permitted introducing one color easily into the area of another without degrading or losing it, thus enriching the color effects. But, above all, the multitude of obvious touches and the contrasts among these had helped to express or suggest the activity, the scintillation, of light, and to recreate these to a certain extent on canvas.[3] Moreover, this technique of vivid strokes seemed best suited to their efforts at retaining rapidly changing aspects. Since the hand is slower than the eye—quick to perceive instantaneous effects—a technique which permitted the painters to work rapidly was essential to

enable them to keep pace with their perceptions. Alluding to these problems, Renoir used to say, "out-of-doors one is always cheating."[4] Yet their "cheating" merely consisted in making a choice among the multitude of aspects which nature offered in order to translate the miracles of light into a language of pigment and two dimensions, and also to render the chosen aspect with the color and the execution that came closest to their impression.

The public, obviously, was not yet ready to accept their innovations, but the impressionists, having tested their methods individually and together, knew that they had accomplished a great step forward in the representation of nature since the days of their masters, Corot, Courbet, Jongkind and Boudin. The general hostility could not shake their convictions but it could and did make life miserable for them. Yet they stoically accepted, without ever deviating from their path, a situation which obliged them literally to create in a void. If it took courage to enter upon a way of poverty, how much more was needed to continue for many years making unbelievable efforts without any encouragement? Such a decision required strength to overcome one's own doubts and to progress with no other guide than oneself. Without hesitation the impressionists continued in complete isolation their daily efforts toward creation, like a group of actors playing night after night to an empty theater.

No single place, probably, could be identified more closely with impressionism than Argenteuil, where at one time or another practically all of the friends worked but where, in 1874 particularly, Monet, Renoir and Manet went to paint. After the closing of their exhibition, Monet again had trouble with his land-

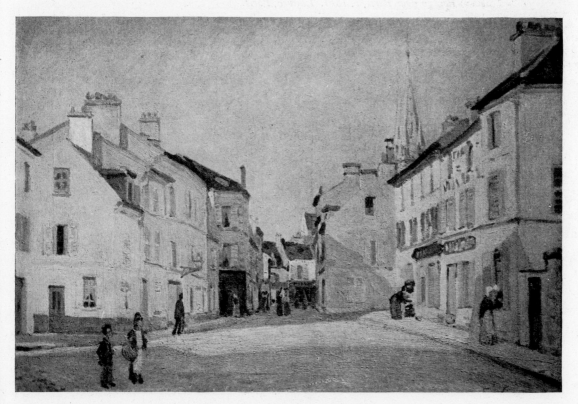

SISLEY: *Petite Place, Argenteuil, d. 1872. 18½ x 26⅛". Louvre, Paris.*

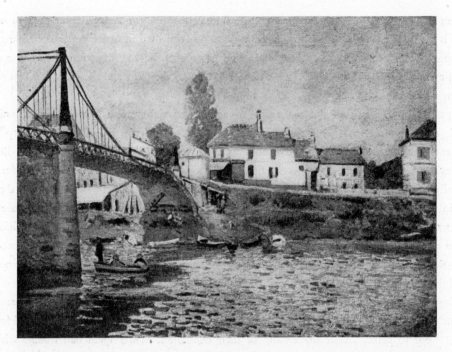

SISLEY: *Bridge near Paris, c. 1873. Louvre, Paris.*

MORISOT: *Bridge near Paris, c. 1874. 15¼ x 18¼". Private coll., Providence, R. I.*

RENOIR: *The Argenteuil Bridge, c. 1875. Present owner unknown.*

MANET: *The Seine at Argenteuil, d. 1874. 24 x 39⅜". Courtauld Collection, London.*

MONET: *Manet Painting in Monet's Garden in Argenteuil, 1874. Collection Mrs. Riezler-Liebermann.*

lord, and it was Manet who, through friends of his, found him a new house in Argenteuil. Renoir made frequent visits there, once more painting at Monet's side, choosing the same motifs; and eventually Manet himself decided to spend several weeks in Argenteuil.

It was in Argenteuil, where he watched Monet paint, that Manet was definitely convinced by work done out-of-doors. He adopted his brighter colors and smaller touch but, less interested than the other in pure landscape paintings, preferred to study people in the open. Using models or friends for his compositions, he placed them against natural backgrounds—gardens, shores or river—attempting to achieve the unity of central figures and landscape surroundings which had already preoccupied Bazille, Monet, Renoir and Berthe Morisot. Manet thus painted in Monet's garden the latter's wife and son under a tree, with Monet himself appearing at the left. When Renoir arrived and found Manet working while the others posed, he could not resist the charm of the scene and asked Monet for his palette, a canvas and paints, so as to do the same motif at Manet's side. Monet later remembered that Manet began to observe Renoir "out of the corner of his eye and from time to time would approach the canvas. Then, with a kind of grimace, he passed discreetly close to me to whisper in my ear, indicating Renoir, 'He has no talent at all, that boy! You, who are his friend, tell him please to give up painting.'"[5]

Renoir, however, was well satisfied with his painting, brushed in in merely one sitting; since it represented Monet's wife, he immediately offered it to his companion, who little by little accumulated a small collection of likenesses of Camille, executed by himself and by Renoir. There existed among these three a close friendship, knit together through bad and happy days, to which Camille's quiet charm, Monet's

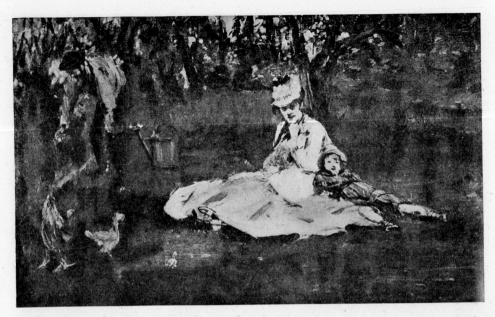

MANET: *The Monet Family in their Garden in Argenteuil, 1874. 19¼ x 38⅛". Present owner unknown.*

RENOIR: *Mme Monet and Her Son in their Garden in Argenteuil, 1874. 20 x 27¼". Collection Michel Monet, Giverny.*

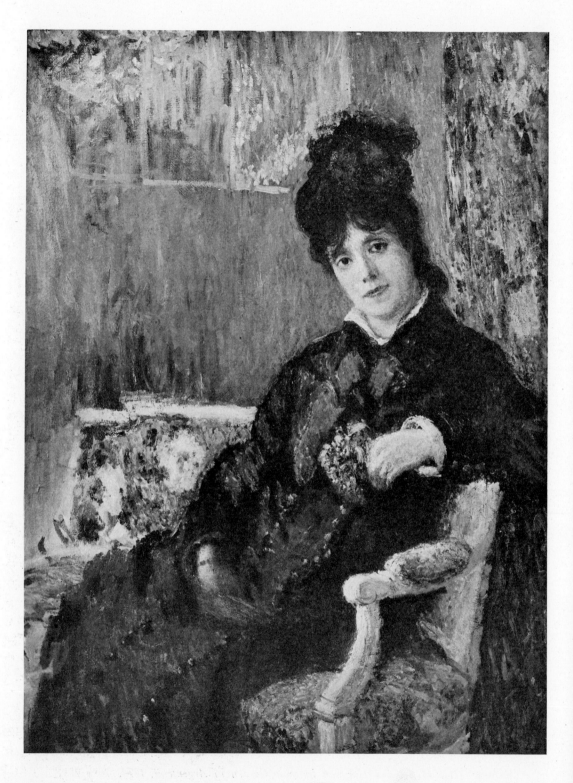

MONET: *Portrait of the Artist's Wife, c. 1877. 46 x 35". Wildenstein Galleries, New York.*

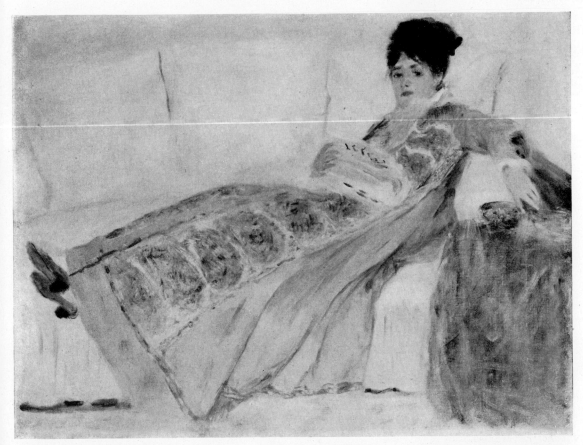

RENOIR: *Mme Monet Reading* Le Figaro, *c. 1874. 21 x 28¼". National Gallery, London (Gulbenkian loan).*

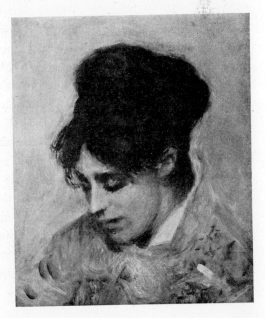

RENOIR: *Portrait of Mme Monet, c. 1874. 14⅜ x 12⅞".*
Private collection, New York.

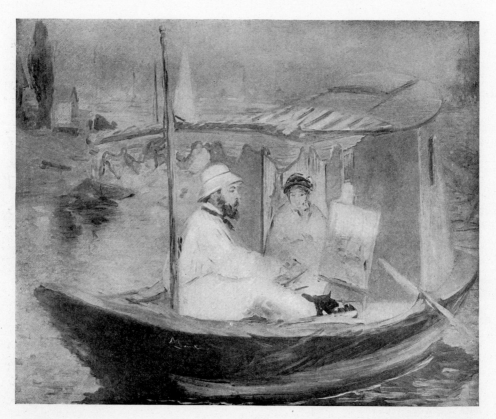

MANET: *Monet working on his Boat, 1874. 32 x 39¼". Formerly in the Chocquet Collection. Neue Pinakothek, Munich.*

realistic outlook and Renoir's happy unconcern must have given a peculiar character both of intimacy and of contrast.

While Manet showed little liking for Renoir—though, of course, he did not always exhibit so much irritation as in the moment of rivalry before the same subject—he certainly did justice to Monet, both the man and the artist. The robust strength of Monet's character and talent apparently impressed Manet and inspired him with a certain admiration. Whereas Manet could not help being deeply concerned with the attitude of the public, Monet, in spite of all his difficulties, remained superbly indifferent to success and, notwithstanding his ambitions, showed himself preoccupied solely with his art. In his Argenteuil paintings of 1874 Monet achieved a greater luminosity than ever before. His colors are brighter and richer, his execution is full of vigor. His effects are not, like those of Manet, provided by brilliant accents in generally low-keyed harmonies; the whole scale of his values is concentrated on the greatest purity of high colors, among which the brightest constitutes the dominant note.

During the summer which they spent together at Argenteuil, Manet painted several portraits of Monet and his wife, whom he represented twice in Monet's boat-studio. Undoubtedly inspired by Daubigny's famous *Botin,* Monet had a similar boat constructed, large enough so that he could even sleep there. From this floating studio he liked to observe "the effects of light from one twilight to the next. . . ."[6] Monet later made real trips with his boat, once taking his family all the way down the Seine to Rouen. In many

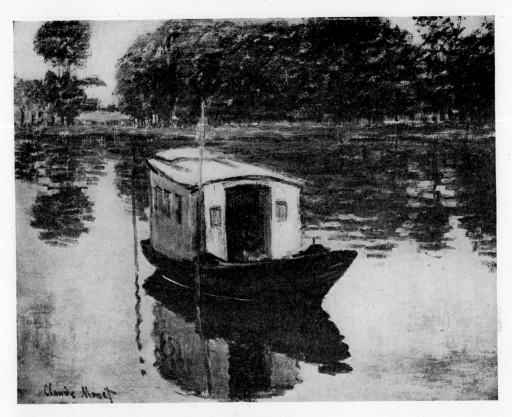

MONET: *The Studio-Boat, c. 1874. Present owner unknown.*

of the paintings which he did in Argenteuil the little vessel is to be seen, with its wooden cabin of blue-green, anchored among the idle sailing boats.

Although he never mentioned the fact, it seems possible that Monet was helped in the construction of this boat by an Argenteuil neighbor with whom he became acquainted during this period. Gustave Caillebotte, an engineer, was a specialist in ship construction and owner of several yachts; he also painted in his spare time. Their common enthusiasm for painting and for navigation soon created between the two men a real bond, which Caillebotte immediately extended to Renoir, who from then on used to go sailing with him on the Seine.

A bachelor, wealthy, living quietly outside Paris, cultivating his garden, painting, and building ships, Caillebotte was a modest man, whose calm existence seems to have been radically changed by his new friendships. Not unlike Bazille in social position and in character—he had the same clear mind, dispassionate approach and deep-rooted loyalty—he was now to take in the group the place left vacant since Bazille's death: the place of a comrade and a patron. He began to buy works by Renoir and Monet, acquiring them both because he liked them and because he wanted to help. And his help was often desperately needed.

Only Renoir was able occasionally to sell some pictures, partly because he painted besides landscapes also portraits and nudes, partly because his works had a pleasing character, a charm which sometimes was

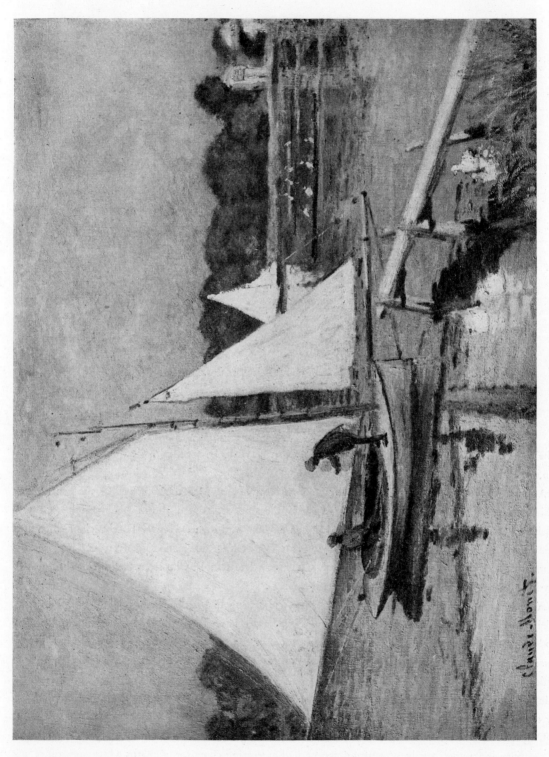

MONET: *Sailboats in Argenteuil, 1873-74. 24 x 32½". Durand-Ruel Galleries, Paris.*

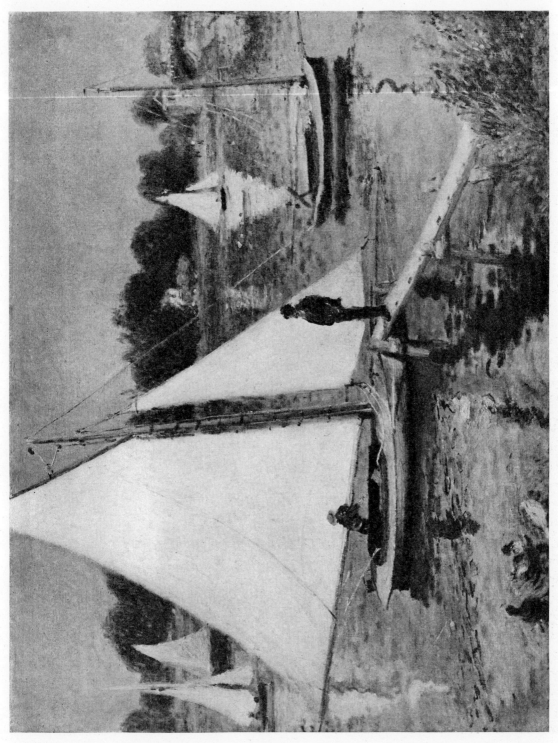

RENOIR: *Sailboats in Argenteuil*, 1873-74. 20 x 26". *Portland Art Museum, Ore.*

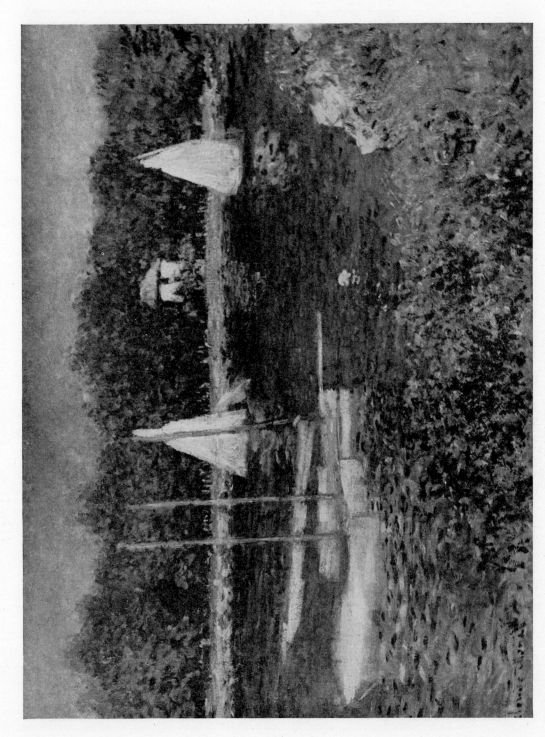

MONET: *The Basin in Argenteuil, c. 1874. 28⅜ x 20⅞". Museum of Art, Providence, R. I.*

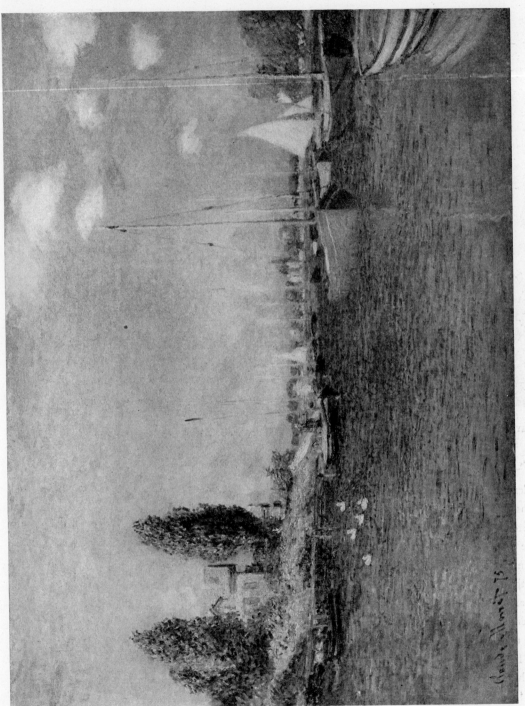

MONET: *Boats in Argenteuil, d. 1875. 21¼ x 25½". Collection Maurice Wertheim, New York.*

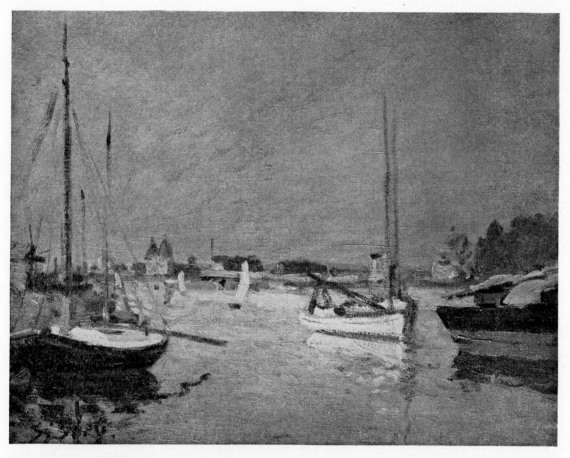

SISLEY: *Boats at Anchor in Argenteuil, c. 1874. 14⅜ x 11⅜". Present owner unknown.*

not denied even by those who objected to impressionism in general. Grumbling, the dealer *père* Martin, for instance, paid 425 francs for Renoir's *Loge,* exhibited at Nadar's, while he firmly refused to handle Pissarro's canvases any more. He went so far as to tell everyone that Pissarro had no chance of getting out of the rut if he continued to paint in his "heavy, common style with that muddy palette of his."[7]

In the fall of 1874 Manet left for Venice. The approaching winter with its increased problems filled the others with anxiety. Unable to earn a living, Pissarro had left Pontoise and taken refuge with his wife and children on the farm of his friend Piette. While Durand-Ruel was in no position to assist the painters and while they found it ever harder to sell their works, living expenses were steadily rising, menacing their bare existence.

"Everything is going up here in a frightening manner," one of Pissarro's aunts wrote to a nephew in St. Thomas, "beginning with taxes on rents, which have nearly doubled, then on food in general. The new taxes imposed since the war have produced a rise in price for all commodities. To give you an idea: coffee for which one used to pay 2 francs a pound is 3 francs 20 centimes, wine has gone from 80 centimes to 1 franc a litre, sugar from 60 to 80 centimes; meat is out of sight in price, cheese, butter, eggs have gone up

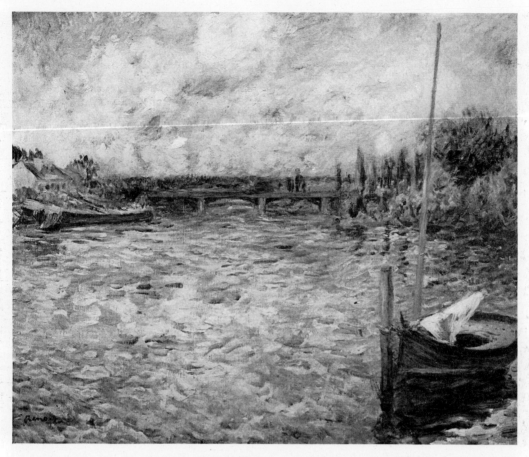

RENOIR: *The Seine at Chatou, c. 1874. 21¼ x 25¾". Durand-Ruel Galleries, New York.*

in proportion. By means of the greatest economy, one doesn't die, but fares badly. Business is at a stand-still and our young people are sad."[8]

The public showed less interest in art than ever, and what interest existed was confined exclusively to the academic masters, whose works seemed to constitute secure investments. "You need a stiff dose of courage to keep hold of your brush in these times of neglect and indifference," Boudin wrote to a friend.[9] In their desperate situation Renoir convinced Monet and Sisley that the best way to raise some money would be to organize an auction sale of a number of paintings at the Hôtel Drouot, where all Paris auctions take place under government supervision. Although born to comfortable circumstances, Sisley had seen his father deprived of his fortune as a result of speculations and losses incurred during the war and the *Commune.* He now was as poor as the others and had a wife and two children to support. The three friends were joined by Berthe Morisot, who in December 1874 had married Manet's brother Eugène. She did not actually need the money but was unwilling to remain apart while her colleagues faced new trials. Determined to share whatever fate had in store for them, she bravely took part in the venture.

In order to help them gain public attention Manet wrote on behalf of his friends a letter to the much

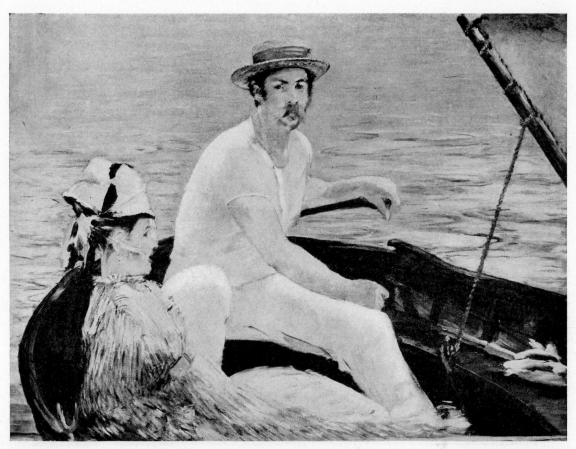

MANET: *Boating in Argenteuil, 1874. 38¼ x 51¼". Metropolitan Museum of Art, New York (H. O. Havemeyer Collection).*

feared, much read but little liked Albert Wolff, critic for the *Figaro,* who called himself the wittiest man in Paris. His sharp tongue made or ruined reputations of the day. "My friends MM. Monet, Sisley, Renoir and Mme Berthe Morisot," Manet explained, "are going to have an exhibition and sale at the Hôtel Drouot. One of these gentlemen is to bring you the catalogue and an invitation. He has asked me for this letter of introduction. You do not as yet, perhaps, like this kind of painting; but you will like it. And it would be very kind of you to mention it a little in the *Figaro.*"[10]

The notice which subsequently appeared in the *Figaro* hardly came up to Manet's expectation. "Perhaps there is here some good business for those who are speculating upon art in the future," it read, with this reservation: "The impression which the impressionists achieve is that of a cat walking on the keyboard of a piano or of a monkey who might have got hold of a box of paints."[11]

The auction took place on March 24, 1875. It included seventy-two paintings, of which Sisley contributed twenty-one, Monet twenty, Renoir nineteen and Berthe Morisot twelve (among them seven pastels and watercolors). In a cautious introduction to the catalogue Philippe Burty stated: "We have in no way forgotten that this group of artists, systematically excluded from the Salon, assembled about one hundred

288

works in the building formerly occupied by Nadar. . . . These paintings, differing as to personal expression, but conceived according to a very precise line of thought, received in this case what their colleagues in power refuse them—discussion. This test, which was to their profit, is to be repeated in the spring. Meanwhile, the artists invite the public to the Hôtel Drouot."[12]

Commenting upon the works, the critic wrote: "They are as it were little fragments of the mirror of universal life, and the swift and colorful, subtle and charming things reflected in it well deserve our attention and our praise."[13] Burty subsequently tried to convince his readers that these works, though cheap at the moment, might increase in value in the future. But his efforts were of no avail.

The sale, at which Durand-Ruel officially assisted in the capacity of expert, became the scene of unprecedented violence. According to his reminiscences, the auctioneer was obliged to summon the police to prevent the altercations from degenerating into real battles. The public, exasperated by the few defenders of the unfortunate exhibitors, wanted to obstruct the sale and howled at each bid.[14] Unable to buy anything for himself, Durand-Ruel was the powerless witness of this spectacle and saw the paintings of his friends sell for practically nothing. However, he bought back for them a certain number of canvases, for which the bids hardly covered the cost of the frames.

Berthe Morisot obtained relatively the best prices, an average of 250 francs for her paintings, the highest bid being 480, the lowest 80 francs. Monet's prices varied between 165 and 325 francs, Sisley's between 50 and 300. Renoir, surprisingly enough, obtained the lowest. Of his works, ten did not reach 100 francs and several of them had to be bought back by him. Among Renoir's paintings were a small version of his *Loge* (p. 270), *La Source,* which he decided to keep because it brought only 110 francs,[15] and the *Pont Neuf* (p. 235), which was sold for 300 francs. The net result of the sale was 10,349 francs (this amount including the works bought back by the artists); the average price per canvas was thus 144 francs. And the painters had not only seen their works go for at least half of what they had obtained before, they had again exposed themselves to ridicule and laughter.

Among the few friends who had tried to push the bids and had acquired some canvases were Duret and Caillebotte. But there also appeared among the buyers a man unknown to them all, Victor Chocquet. He subsequently told Monet that he had wished to visit the exhibition at Nadar's but that friends had persuaded him against it. They did not succeed, however, in preventing his going to this sale, where he bought for 100 francs one of Monet's Argenteuil views. When he was later presented to the painter, he said with tears in his eyes: "When I think of how I have lost a year, how I might have got to know your painting a year sooner! How could I have been deprived of such a pleasure!"[16]

A modest chief supervisor in the customs administration, Chocquet had the spirit of the true collector, preferring to make his discoveries for himself, taking as his guide only his own taste and pleasure, never thinking of speculation and wholly uninterested in what others did or thought. Although his resources were limited, he had lovingly brought together through the years an extremely rich collection of works by Delacroix. He could not forget that thirteen years earlier the aging Delacroix had declined to paint a portrait of his wife, and he was to take no chances this time. Having detected in Renoir's canvases certain qualities that reminded him of his idol, he wrote to him the very evening after the sale. "He paid me all sorts of compliments on my painting," Renoir later remembered, "and asked me if I would consent to do a portrait of Mme Chocquet."[17] Renoir immediately accepted. Shortly afterward he met Chocquet in his apartment on the rue de Rivoli, overlooking the Tuileries Gardens, in order to arrange for the

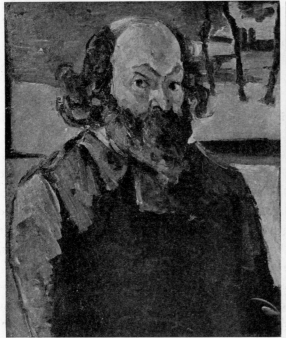 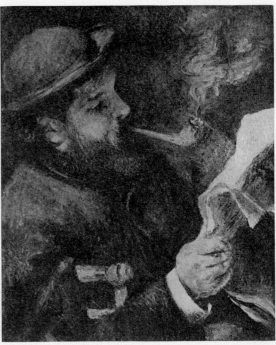

CÉZANNE: *Self Portrait, 1875-76. 25¾ x 20⅞". Collection H. J. Laroche, Paris.* RENOIR: *Portrait of Claude Monet, c. 1874. Present owner unknown.*

sittings. The collector begged him to have his wife pose in such a manner, against a wall of the room, that one of his Delacroix paintings would appear in the portrait. "I want to have you together, you and Delacroix," he explained.[17]

Renoir was deeply touched by the sincerity, the enthusiasm, the warmth of Chocquet. A close friendship soon developed between them, and Renoir subsequently did two portraits of the collector. The artist was eager to introduce his new patron to his friends, for such was their spirit of comradeship that none ever thought only of himself but always tried to let the others benefit from new acquaintances. No matter how urgently any one of them might need to make a sale, he never failed to share with the rest of the group the benefits of a newly won supporter, even advising the others as to the prices they might charge. Manet himself would occasionally hang canvases by his colleagues in his studio where they might be seen by prospective buyers. It thus seemed only natural for Renoir to take Chocquet to Tanguy's small shop in order to show him some of Cézanne's paintings.

In spite of his meager allowance Cézanne was better off than the others, for he had at least a certain fixed amount to count on. He was living in 1875 on the quai d'Anjou in Paris, next to Guillaumin, in whose company he occasionally painted on the Seine quais. Renoir knew that nothing could mean more to his friend than to find a new admirer of his works. In a letter to his mother Cézanne had just proclaimed: "Pissarro has a good opinion of me, who have a very good opinion of myself. I am beginning to consider myself stronger than all those around me. . . ."[18] But he lived in much greater isolation than the others and had fewer friends with whom to share these convictions. Chocquet, if he responded to

290

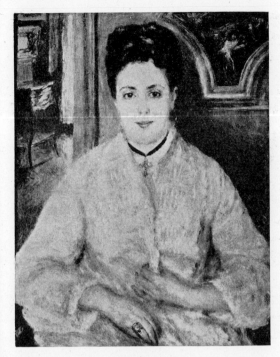

RENOIR: *Portrait of Mme Chocquet, d. 1875. 28¾ x 23⅜". Collection W. Halvorsen.*

RENOIR: *Portrait of Victor Chocquet, c. 1875. 18 x 14¼". Fogg Art Museum, Cambridge (G. L. Winthrop Bequest).*

Cézanne's art, could become an important factor in the painter's life. And Renoir had guessed right. At Tanguy's, Chocquet immediately acquired one of Cézanne's canvases, exclaiming: "How nice this will look between a Delacroix and a Courbet."[17] A little later the collector met Cézanne through Renoir, and Cézanne in turn took Chocquet for lunch to Monet's in Argenteuil early in 1876.

The year 1875 had been a very difficult one for Monet, and time and again he had been obliged to borrow money from various people. Several times he had appealed to Manet for help, writing in June: "It's getting more and more difficult. Since day before yesterday, not a cent left and no more credit, neither at the butcher nor the baker. Although I have faith in the future, you see that the present is very painful. . . . Could you not possibly send me by return mail a 20-francs note? That would help me for a quarter of an hour."[19]

At other times urgent appeals went out to Zola. When his second child was born Monet wrote the author: "Can you help me? We don't have a single cent in the home, not even anything to keep the pot boiling today. On top of this my wife is ailing and needs care, for, as you perhaps know, she has given birth to a superb boy. Could you lend me two or three *louis,* or even only one? . . . I ran around all day yesterday without being able to find a cent."[20] And again, probably from Argenteuil, Monet wrote to Zola: "Can you and would you come to my help? If I don't pay 600 francs by tomorrow night, Tuesday, our furniture and all I own will be sold and we will be out on the street. I don't have a single penny of this amount. None of the transactions on which I have been counting can be concluded at this moment. I would be desperate to reveal the situation to my poor wife.—I am making a last effort and approaching

CAILLEBOTTE: *The Seine at Argenteuil, c. 1874 [?]. 26¼ x 32½". Present owner unknown.*

you with the hope that you may possibly lend me 200 francs. This would be an installment which may help me obtain a delay. I don't dare to come myself; I would be capable of seeing you without daring to tell you the reason of my visit. Please send me word, and in any case don't speak about this, for it is always a fault to be in need."[21]

In July 1875 Monet's wife had fallen seriously ill; yet neither her illness nor the continuous threats of his landlord could prevent him from working. And when Camille eventually died he noticed, in spite of all his grief, as he contemplated her at daybreak, that his eyes perceived more than anything else the different colorations of her young face. Even before he had decided to retain for a last time her likeness, his painter's instinct had seen the blue, yellow and grey tonalities cast by death. With horror he felt himself a prisoner of his visual experiences and compared his lot to that of the animal which turns the millstone.[22]

Manet, meanwhile, was spending the summer of 1875 at Montgeron on the country estate of the collector Hoschedé. There he again met with Carolus-Duran, living nearby, and painted a portrait of him. Carolus-Duran had long since abandoned the path of original work and study to follow the road of easy success. Owing to his dexterity he had been quick to achieve fame as a society painter, and Manet could not help but admire the career his colleague had made for himself. At the bottom of his heart Manet desired the same kind of success. To be accepted by the crowd, to obtain a social position as a painter, to receive medals from the jury and possibly the red ribbon of the Legion of Honor from the government—this seemed to him the ultimate goal for an artist of his time. Since so many mediocrities managed to achieve this ambition, he did not see why he, superior to them, should not eventually be rewarded in the same way. But in spite of all his determination his moment had not yet come. To forestall refusals,

MONET: *Boats Sailing at Argenteuil, c. 1874. 23½ x 38¾". Private collection, New York.*

he had sent only one canvas to the Salon of 1875—one of his paintings done the previous year at Argenteuil. Although admitted, the work had again stirred up violent attacks and failed to win the public's approval.

Teased by his ambitions, Manet tried to keep close to those who decided success at the Salon, renewing his friendship with Carolus-Duran and even beginning a portrait of the critic Albert Wolff, who, however, soon tired of sitting. Notwithstanding careful efforts to become "acceptable" to the officials, Manet continued to prove his warm sympathy for Monet. He helped him repeatedly at difficult times, for since the number of his supporters was very limited, Monet was constantly obliged to approach the same persons. If it was not Manet, it was Zola, whose novels began to sell slowly, or else Duret, Caillebotte, Hoschedé, the singer Faure, the Roumanian doctor de Bellio and the publisher Charpentier, who began to buy impressionist paintings, or Chocquet.

Great as was his admiration both for Monet and for Renoir, Chocquet's real enthusiasm was for Cézanne, who painted several portraits of him but never any of his wife. During the long years of their friendship Chocquet was to add a considerable number of Cézanne's works to his collection of Delacroix, rounding this out by a certain number of canvases by the other impressionists, particularly Renoir and Monet.[23]

To have met Chocquet was practically the only benefit the friends drew from their sale in 1875. The pitiful prices obtained apparently prompted them to revise their plan of holding another group exhibition that same year, a plan which Burty had announced in his introduction to the catalogue. Only in 1876 did they decide to approach the public with a second show. But the number of participants was considerably smaller this time than the first, since many of the former exhibitors did not care to compromise themselves again in the company of the impressionists.

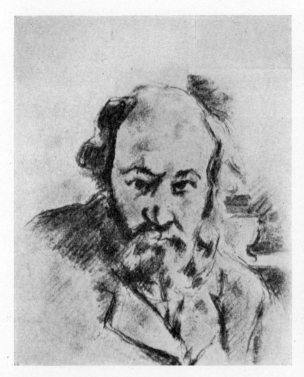

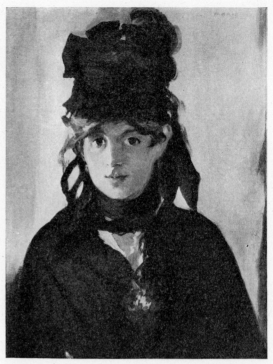

CÉZANNE: *Self Portrait, c. 1875. Drawing. Present owner unknown.*

MANET: *Portrait of Berthe Morisot, d. 1872. 22 x 15¼". Collection Mme. E. Rouart, Paris.*

De Nittis had not forgotten the ill treatment he had suffered; besides, he had set his heart on the Legion of Honor and, therefore, stayed away. Astruc and thirteen others did likewise, among them Bracquemond and Boudin. Guillaumin, whose job had prevented him from doing much painting, did not participate. Nor did Cézanne, who was again in the South and had resolved to send a painting to the Salon. But he soon informed Pissarro that "a certain letter of rejection has been sent me. This is neither new nor astonishing."[24] On the other hand Degas' friends Lepic, Levert and Rouart were present again, and there were even some newcomers: Caillebotte, Desboutin, Legros (who still lived in England, where Pissarro had met him in 1871), Degas' friend Tillot and a few more. Manet declined once more to join his friends, although the jury had that year refused both paintings he had sent to the Salon: *Le linge,* and *L'artiste,* a portrait of Marcellin Desboutin. Eva Gonzalès had been accepted and exhibited for the first time as "pupil of Manet." Outraged by his rejection, Manet invited the public to his studio, where in April he exhibited the rejected canvases.[25] (That same year he painted a portrait of his friend Mallarmé, whom Victor Hugo called "my dear impressionist poet.")

The impressionists also held their exhibition in April at Durand-Ruel's gallery, rue Le Peletier. It comprised 252 paintings, pastels, watercolors, drawings and etchings by twenty exhibitors. Degas was represented by more than twenty-four works, among which was his *Portraits in an Office,* painted in New Orleans (p. 228); Monet showed eighteen paintings, many of which were lent by the singer Faure, who had followed Durand-Ruel's advice and begun to invest in his canvases. There was also one landscape lent by

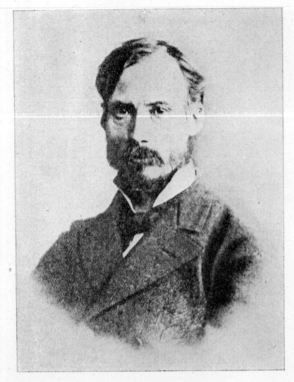

Photograph of Auguste Renoir, 1875.

Photograph of Claude Monet, 1877.

Chocquet. The canvas of Monet which attracted the greatest attention was entitled *Japonnerie* and represented a young woman in a richly embroidered kimono; it was sold for the high price of 2,000 francs. Berthe Morisot figured in the catalogue with seventeen works. Pissarro sent a dozen canvases, one of which belonged to Chocquet and two to Durand-Ruel. Renoir had fifteen paintings in the exhibition, of which no less than six were owned by Chocquet (one was apparently his portrait). There were eight landscapes by Sisley. The friends also included two canvases by Bazille in their show, one lent by Manet.[26]

Fewer visitors came to this exhibition than to the first, but the press was just as violent as before. Although there were some critics who tried in their reviews to do a little justice to the painters,[27] the general attitude was reflected in a widely read article by Albert Wolff.

"The rue Le Peletier has bad luck," he wrote in the *Figaro*. "After the Opera fire, here is a new disaster overwhelming the district. At Durand-Ruel's there has just opened an exhibition of so-called painting. The inoffensive passer-by, attracted by the flags that decorate the façade, goes in, and a ruthless spectacle is offered to his dismayed eyes: five or six lunatics—among them a woman—a group of unfortunate creatures stricken with the mania of ambition have met there to exhibit their works. Some people burst out laughing in front of these things—my heart is oppressed by them. Those self-styled artists give themselves the title of non-compromisers, impressionists; they take up canvas, paint and brush, throw on a few tones haphazardly and sign the whole thing. . . . It is a frightening spectacle of human vanity gone astray to the point of madness. Try to make M. Pissarro understand that trees are not violet, that the sky

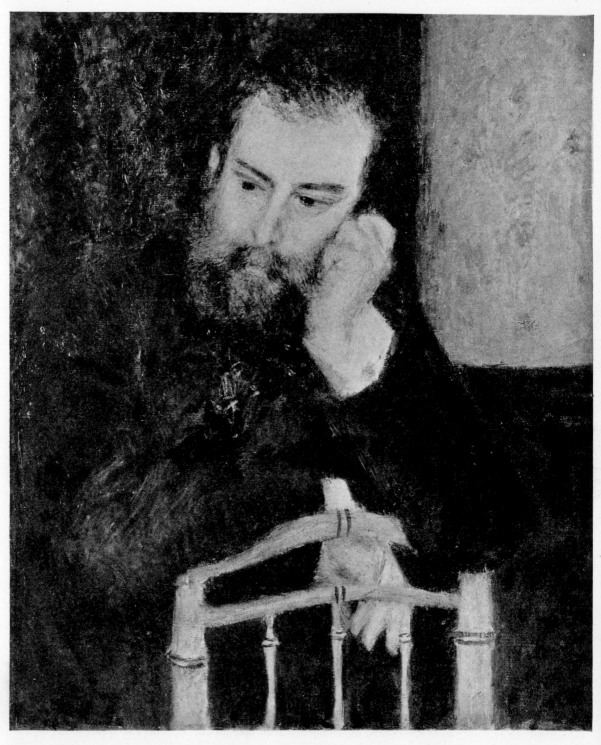

RENOIR: *Portrait of Alfred Sisley, c. 1875. 25⅝ x 21¼". Exhibited at the third impressionist show, 1877. Art Institute, Chicago (Mrs. L. L. Coburn Collection).*

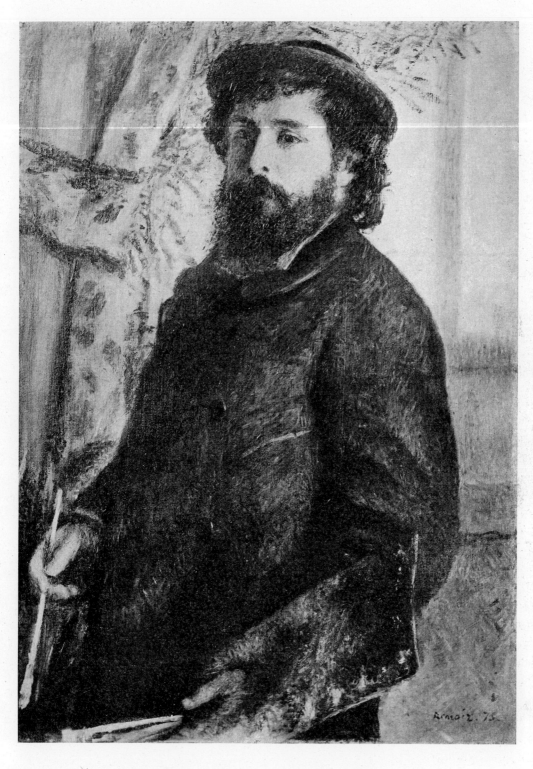

RENOIR: *Portrait of Claude Monet, d. 1875. 33¾ x 24". Louvre, Paris.*

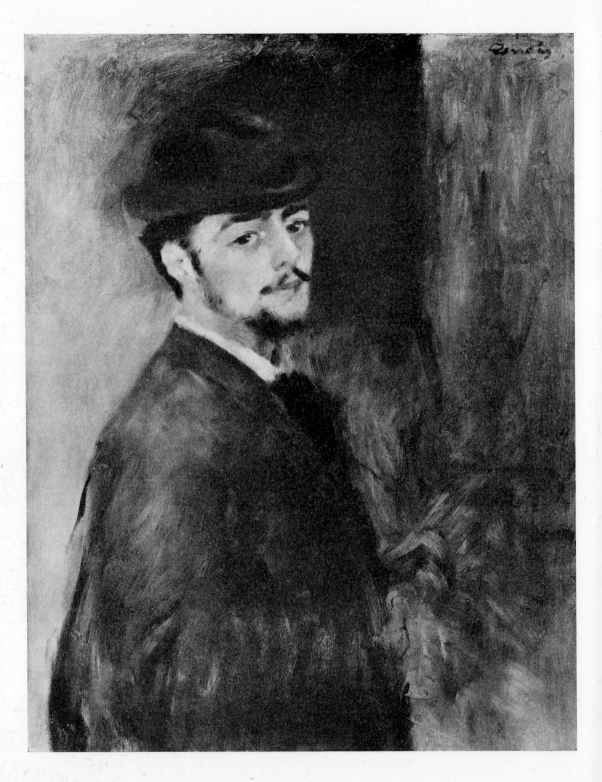

RENOIR: *Self Portrait, c. 1876. 29 x 22½". Collection W. C. Taylor, Philadelphia.*

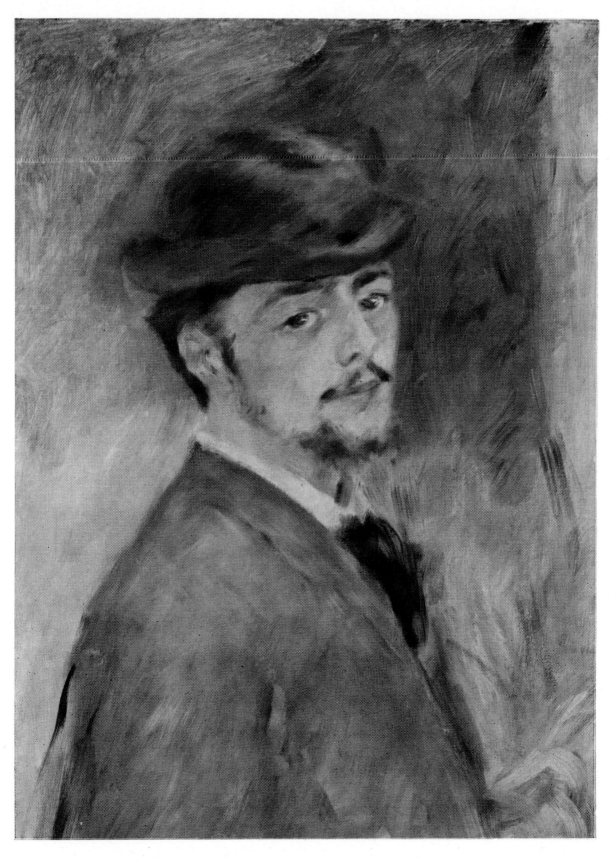

RENOIR: Self Portrait, *detail*.

is not the color of fresh butter, that in no country do we see the things he paints and that no intelligence can accept such aberrations! Try indeed to make M. Degas see reason; tell him that in art there are certain qualities called drawing, color, execution, control, and he will laugh in your face and treat you as a reactionary. Or try to explain to M. Renoir that a woman's torso is not a mass of flesh in the process of decomposition with green and violet spots which denote the state of complete putrefaction of a corpse! . . .

"And it is this accumulation of crudities which are shown to the public, with no thought of the fatal consequences that may result! Yesterday a poor soul was arrested in the rue Le Peletier, who, after having seen the exhibition, was biting the passers-by. Seriously, these lunatics must be pitied; benevolent nature endowed some of them with superior abilities which could have produced artists. But in the mutual admiration of their common frenzy the members of this group of vain and blustering extreme mediocrity have raised the negation of all that constitutes art to the height of a principle: they have attached an old paint rag to a broomstick and made a flag of it. Since they know perfectly well that complete absence of artistic training prevents them from ever crossing the gulf that separates an effort from a work of art, they barricade themselves within their lack of capacity, which equals their self-satisfaction, and every year they return, before the Salon opens, with their ignominious oils and watercolors to make a protest against the magnificent French school which has been so rich in great artists. . . . I know some of these troublesome impressionists; they are charming, deeply convinced young people, who seriously imagine that they have found their path. This spectacle is distressing. . . ."[28]

Again the efforts of the painters appeared to have been in vain. Yet, while no words seemed harsh enough to describe their work, their influence made itself felt even among the official art at the Salon. Castagnary was the first to acknowledge this fact when he wrote: "The salient feature of the present Salon is an immense effort to obtain light and truth. Everything that suggests the conventional, the artificial, the false, is out of favor. I saw the first dawn of this return to frank simplicity, but I did not think its progress had been so rapid. It is conspicuous, it is startling, this year. The younger artists have flung themselves into it to a man and, without suspecting it, the crowd acknowledges that the innovators have the right on their side. . . . Well, the impressionists have had a share in this movement. People who have been to Durand-Ruel's, who have seen the landscapes, so true and so pulsating with life, which MM. Monet, Pissarro and Sisley have produced, entertain no doubts as to that."[29]

But the change that was taking place at the Salon, for all its indebtedness to impressionism, had only a superficial connection with it. A new generation of artists was trying to accommodate the impressionist discoveries to the corrupt taste of the public. It invented a hybrid art—if art it can be called—in which an academic conception was allied with an occasionally impressionistic execution. It used fewer bituminous colors and sometimes visible brushstrokes—not in order to remain close to nature, observed on the spot, but as a welcome means to infuse dying academicism with a semblance of new life. The impressionists, instead of benefiting from this development, rather suffered from it, since public approval went to the opportunists, not to them.

Their position was changed little, if any, by their second exhibition. On the contrary, some internal dissensions made themselves felt more strongly and began seriously to menace their unity. Pissarro must have written about these matters to Cézanne (who was then at L'Estaque, where he painted two views of the Mediterranean for Chocquet, while the latter provided him from Paris with newspaper clippings concerning the exhibition). "If I dared," Cézanne answered Pissarro, "I should say that your letter bears

the marks of sadness. The painting business does not go well; I am much afraid that morally you are rather gloomily influenced by this, but I am convinced that it is only a passing thing." Then, commenting on some disagreements with Monet and also expressing himself against the inclusion of non-impressionists in their exhibitions, Cézanne went on to say: "Too many successive exhibitions seem to me bad [Renoir shared this opinion]; furthermore, people who may think they are going to see the impressionists will see nothing but cooperatives and cool off." He added: "I shall end by saying with you that since there is a common aim amongst some of us, let us hope that necessity will force us to act jointly and that self-interest and success will strengthen the ties which good will, as often as not, was unable to consolidate." But at the same time Cézanne informed his friend of his decision to continue sending pictures to the Salon, in spite of the hostile attitude of the jury, explaining: "If the background of the impressionists should be advantageous for me, I shall exhibit with them the best I have and with the others something neutral."[30]

While differences of opinion among Cézanne, Monet and Pissarro still remained an internal affair, Degas' somewhat heretical views—or at least what the others thought to be his views—were to find their way into print when Duranty published a pamphlet on the group. Taking issue with an article by the painter-author Fromentin, who had regretfully stated that "plein air" in painting was assuming an importance which it did not deserve, Duranty treated the whole question of "new painting" (he was careful not to use the word "impressionism") in a booklet entitled *La nouvelle peinture: à propos du groupe d'artistes qui expose dans les galeries Durand-Ruel*. It is impossible to say now to what extent Duranty's writing reflects the opinions of Degas, but it is certain that his pamphlet was not, as some charged, actually the work of the painter. Ever since he had edited his magazine *Réalisme*, twenty-five years before, Duranty had been interested in underlining certain common tendencies in the writing and in the art of his time. One of the forerunners of the naturalistic movement in literature, which now centered around Zola and in which he himself occupied only a minor position, Duranty—like the Goncourts—had discovered in the life around him subjects for realistic novels and had also seen there motifs for the artists. Back in 1856 he had proclaimed:

"I have seen a form of society, various actions and events, professions, faces and *milieux*. I have seen comedies of gesture and countenance that were truly *paintable*. I've seen a large movement of groups formed by relations among people, where they met on different levels of life—at church, in the dining room, the drawing room, the cemetery, on the parade-ground, in the studio, the Chamber of Deputies, everywhere. Differences in dress played a big role and corresponded to the variations in physiognomy, carriage, feeling and action. Everything appeared to me arranged as if the world had been made expressly for the joy of painters, the delight of the eye."[31]

Among all of Duranty's painter friends Degas seemed the only one who shared his interest in daily life, in the exact description of people and things. After Courbet it was he who first had the idea of removing the partition which separated the artist's studio from ordinary life. It was he also who had tried to represent the individuals of his time in their typical attitudes, their professional actions; who was able, in Duranty's words, to reveal through a simple gesture an entire range of feeling.

Approaching pictorial art with a literary and social bias conditioned by his former association with and admiration for Courbet, Duranty saw in Degas above all the commentator of modern life, just as Edmond de Goncourt had done. It was this limited but sincere appreciation of his efforts which had brought him Degas' friendship. It is possible, of course, that as a result of this friendship some of Degas' own

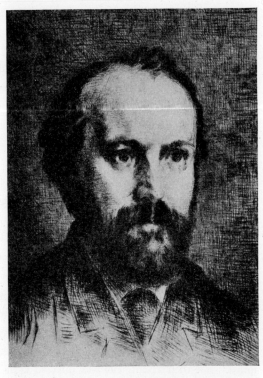

DESBOUTIN: *Profile Portrait of Edgar Degas, 1876. Etching, 3⅜ x 2¾".*

DESBOUTIN: *Portrait of Edmond Duranty, c. 1876. Etching.*

ideas were instrumental in the shaping of Duranty's opinions. Yet this does not mean that the painter guided the other's pen.

After attacking the *Ecole des Beaux-Arts,* chiefly by quoting the writings of Lecoq de Boisbaudran, Duranty set out to prove that the new art movement had its roots in the more or less recent past, pointing to Courbet, Millet, Corot, Chintreuil, Boudin, Whistler, Fantin and Manet, even including among its ancestors Ingres, who never "cheated when confronted with modern forms"—a statement which might have been suggested by Degas. Duranty even voiced the hope that some of the younger men among the initiators and their companions might join the group in the years to come, again doubtless expressing the wishes of the painter.

"It is a great surprise," Duranty wrote, "in a period like this, when there has seemed to be nothing left to discover . . . to see new ideas suddenly arising. . . . A new branch has developed on the old trunk of art." Then he pointed to the new qualities of this group of artists: "A color scheme, a kind of drawing and a series of original views. . . . In the field of color they have made a genuine discovery whose origin cannot be found elsewhere. . . . The discovery properly consists in having recognized that full light decolorizes tones, that sunlight reflected by objects tends, by virtue of its clarity, to bring them back to the luminous unity which dissolves its seven spectral rays into a single colorless refulgence, which is light. From intuition to intuition, they have succeeded little by little in splitting up sunlight into its beams, its elements, and in recomposing its unity by means of the general harmony of the colors of the spectrum which they spread on their canvases. From the point of view of delicacy of eye, of subtle penetration of

the art of color, it is an utterly extraordinary result. The most erudite physicist could not quarrel with their analysis of light."

While discussing modern drawing, Duranty credited Degas especially with new conceptions and new ideas and defended "plein-air" painting against the reproach of lack of finish, explaining that its essence was to capture the instant. It was in his summary that he finally showed his half-hearted adherence, insinuating reservations, which Degas apparently shared. Of the group of painters he said that it was made up of "original personalities along with eccentric and ingenuous characters, visionaries alongside profound observers, naive ignoramuses alongside scholars who want to find again the naiveté of the ignorant; real painting delight, for those who know and like it, beside unfortunate attempts which irritate the nerves [this was apparently meant for Cézanne[32]]; there is a leavening idea in one brain, almost unconscious daring bursting from another brush. That is the company.

"Will these artists become the primitives of a great artistic renaissance?" Duranty asked. "Will they simply be the victims of the first rank, fallen in the front line of fire, whose bodies piled in the ditch will form the bridge over which are to pass the fighters who will come after?" And Duranty concluded: "I wish the fleet fair wind, so that it may be carried to the Hesperides; I urge the pilots to be careful, resolute and patient. The voyage is dangerous and they should have embarked in large and more solid ships; some of the vessels are very small, shallow and fit only for coasting. Let us remember that, on the contrary, it is a question of ocean-wise painting!"[33]

These last words, with the lack of confidence they implied, the painters considered particularly badly timed. But their resentment was directed even more to Degas than to the author, since they recognized the attitude of the painter in Duranty's limited approval and careful reservations. Renoir, without showing his feelings, was extremely annoyed, while Monet treated the publication with mute disdain.[34] Attacked by their adversaries and ill supported by their friends, the painters could find hope and relief only in their own work.

In spite of continual worries the year 1876 was to be a particularly fertile one for the painters. Sisley, after his return from England, again worked in Louveciennes and Marly, where heavy floods provided subjects for an entire series of paintings which were to remain among the best he ever did. Monet went to stay for some time with Hoschedé at Montgeron (Sisley too once paid a visit), painting a number of landscapes, of which his host acquired several. Monet then settled for a while in Paris, and there the Gare St. Lazare immediately attracted him. The huge enclosure, with its glass roof against which the heavy locomotives threw their opaque vapor, the incoming and outgoing trains, the crowds and the contrast between the limpid sky in the background and the steaming engines—all this offered unusual and exciting subjects, and Monet untiringly put up his easel in different corners of the station. As Degas liked to do, he explored the same motif from a variety of angles, proceeding with both vigor and subtlety to seize the specific character of the place and its atmosphere. Duranty might have hailed in these works the conquest of one of the most typical scenes of modern life—and a scene never before treated by artists—had it not been that Monet's approach was devoid of any social consciousness. He found in the railroad station a pretext rather than an end in itself; he discovered and probed the pictorial aspects of machinery but did not comment upon its ugliness or usefulness or beauty, nor upon its relationship to man.

Degas, too, kept on investigating new *milieux,* yet his interest remained centered around man and his psychological problems. He began to frequent music halls, café concerts and circuses, once more attracted

by the attitudes of performers obeying a merciless routine. "You need natural life," he explained to his colleagues, "I, artificial life."[35] But the difference between him and the impressionists was not entirely defined by this statement. "I always tried," Degas later explained to the English painter Sickert, "to urge my colleagues to seek for new combinations along the path of draftsmanship, which I consider a more fruitful field than that of color. But they wouldn't listen to me, and have gone the other way."[36] Degas apparently considered their approach to nature too passive and disapproved of their complete fidelity to a chosen motif. Their principle of not omitting or changing anything, their sole preoccupation with their immediate sensations made them, in his eyes, slaves of the chance circumstances of nature and light. "It is very well to copy what one sees," he said to a friend, "it's much better to draw what one has retained in one's memory. It is a transformation in which imagination collaborates with memory. One reproduces only that which is striking; that is to say, the necessary. Thus, one's recollections and invention are liberated from the tyranny which nature exerts."[37]

Degas was master of his inspiration. He felt free to modify the features of his subjects, according to compositional need, as he did in the series representing the same *Foyer de Dance,* where the room, in each picture, shows a variety of details not to be found in other canvases. But while the impressionists, bound by their sensations, were obliged to finish their paintings on the spot—whether in one or in several sessions— and were prevented from retouching them later, Degas' method of work carried with it a curse of which he became the victim: the curse of perfectionism. Never satisfied with his paintings, he hated to sell and was often reluctant to exhibit them, continually planning improvements. This tendency led him, for instance, to make a curious deal with Manet's patron Faure, who in 1874 bought back from Durand-Ruel six canvases which Degas regretted having sold and returned them to the painter so that he might rework them. In exchange Degas promised to paint four large compositions for the singer. Two of these were delivered in 1876. After waiting eleven more years for the remaining two, Faure finally haled Degas into court in order to obtain satisfaction.[38]

It was around 1876 that Degas seems to have given up the greater part of his fortune to ease the financial predicament of one of his brothers, who was supposed to have lost everything by imprudent speculation in American securities.[39] Degas would never speak of such private affairs, yet it is known that he began from then on to depend on occasional sales. He did not have much trouble in finding buyers and obtaining reasonably high prices, but he was now obliged—much to his regret—to part with his works. Although the two facts may not be related, he started at this time doing more and more pastels, which are a kind of momentary expression and can bear little retouching. In this medium he achieved steadily growing freedom of expression, at the same time showing a predilection for more vivid colors and for effects less sophisticated than in his oils.

In his studio in the rue St. Georges, Renoir meanwhile devoted himself mostly to portraits and nudes. He had met M. Charpentier, the publisher of Zola and Daudet, who commissioned him to do likenesses of his wife and daughters. It was this commission, apparently, which enabled Renoir to rent—for 100 francs a month—a small house with a garden on the heights of Montmartre, rue Cortot. His studio had become, in the late afternoons, the gathering place for a number of friends. These included Maître, Duret and Chocquet, as well as several young newcomers, among them the painters Franc-Lamy and Cordey.[40] They had been students at the *Ecole des Beaux-Arts* in the classes of Ingres' disciple Lehmann, until they had staged, along with others, a revolt against their master. Since Lehmann refused to resign, and the

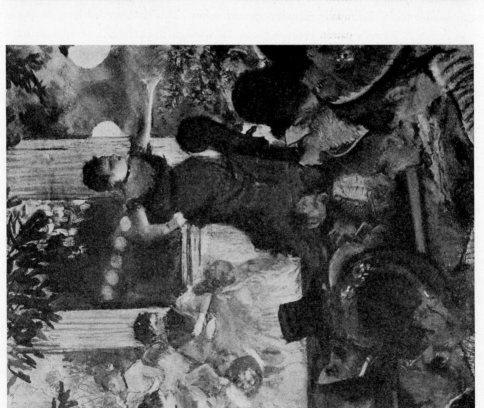

DEGAS: *Miss Lola at the "Cirque Fernando," c. 1879. 47 x 31¼". Exhibited at the fourth impressionist show, 1879. National Gallery, London.*

DEGAS: *The Café-Concert, "Les Ambassadeurs," c. 1877. Pastel, 14¾ x 10¾". Exhibited at the fourth impressionist show, 1879. Musée de Lyon.*

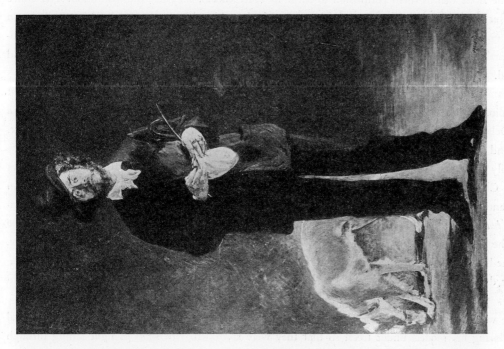

MANET: *The Artist (Portrait of Marcellin Desboutin), 1875. 77 x 51⅜". Rejected at the Salon of 1876. Present owner unknown.*

DEGAS: *L'absinthe (the actress Ellen Andrée and Marcellin Desboutin at the Café de la Nouvelle-Athènes), c. 1876. 37 x 27½". Louvre, Paris.*

director of the *Ecole* denied them permission to enrol in other classes, they left the institution. The entire group of insurgents then wrote an eloquent letter to Manet, asking him to accept them as pupils in an *atelier libre* under his direction. But Manet declined, partly, no doubt, for fear of alienating official sympathy and partly because he may have felt little inclination to try anew a venture in which Courbet had already failed.

Franc-Lamy and Cordey, with their friends Rivière and Lestringuez, now became daily visitors at Renoir's studio. After the latter had spent some weeks with Daudet at Champrosey (where he picked a rose from Delacroix's grave), they followed him to Montmartre. The large garden—an abandoned park, rather—behind his house in the rue Cortot offered Renoir ample opportunity to paint in the open. His friends readily posed for him, as did a young actress, Mlle Samary, whom Renoir had apparently met through the Charpentiers and whose beauty and radiant smile were famous on and off stage. It was in his garden and with his friends as models that Renoir now painted *La Balançoire*. But his large composition, *Le bal au Moulin de la Galette,* which he executed at the same period, was done nearby, in the garden of the well-known establishment itself, where his friends helped Renoir carry the canvas each day. Again, Franc-Lamy, Cordey, Rivière, Lestringuez and the painter Lhote posed for him, while Renoir recruited their dancing partners from among the young girls who came to waltz every Sunday at the old *Moulin.*[41]

In these works and in others painted at this time Renoir showed himself preoccupied with a special problem. Placing his models under trees, so that they were sprinkled with spots of light falling through the foliage, he studied the strange effects of green reflections and luminous speckles on their faces, dresses or nude bodies. His models thus became merely media for the representation of curious and momentary effects of light and shadow which partly dissolved forms and offered to the observer the gay and capricious spectacle of dancing light. Monet, too, occasionally studied similar effects.

Caillebotte, who had made it a principle—as did de Bellio—to buy especially those works of his friends which seemed particularly unsaleable, acquired both *La Balançoire* and *Le bal au Moulin de la Galette* (a smaller version of which was bought by Chocquet). While timid in his own works, Caillebotte readily admired the daring of his friends. In the short time since he had met them Caillebotte had already assembled such a collection that he began to plan its final disposition. In November 1876, though he was then only twenty-seven, he wrote his will, leaving all his pictures to the State with the condition that they be ultimately hung in the Louvre; he named Renoir as executor. Haunted by the presentiment of an early death, Caillebotte was particularly anxious to provide financial security for a new group exhibition. Indeed, the first paragraph of his will read: "I desire that from my estate the necessary sum be taken to arrange in 1878, under the best possible conditions, an exhibition of the painters who are called *Les Intransigeants* or *Les Impressionnistes*. It is rather difficult for me to fix that sum now; it may amount to thirty or forty thousand francs, or even more. The painters to take part in this exhibition are Degas, Monet, Pissarro, Renoir, Cézanne, Sisley, Berthe Morisot. I name these, not to the exclusion of others."[42]

Having thus made generous provision for the future, Caillebotte continued to devote his disinterested efforts to the present. It was largely due to his untiring enthusiasm and tenacity that the third exhibition of the group was organized—not in 1878, as he had planned—but already in the spring of 1877.

"We are having some trouble about our exhibition," he wrote in January to Pissarro, from whom he had just bought another painting. "Durand-Ruel's whole premises are rented for a year. . . . But don't

RENOIR: *The Artist's Studio, rue St. Georges, Paris, 1876. 18⅜ x 15¼". (From left to right: Lestringuez, Rivière, Pissarro, the musician Cabaner; in the foreground Cordey.) Present owner unknown.*

MONET: *Woman in a Garden, Springtime, c. 1875. 19⅝ x 25¾". Bought from the artist by Mary Cassatt. Walters Art Gallery, Baltimore.*

let's get discouraged; even now several arrangements offer possibilities. The exhibition will take place; it must. . . ."[43] The artists finally discovered an empty apartment on the second floor of a building, 4 rue Le Peletier, the same street where Durand-Ruel's galleries were located. Its large and well lighted rooms with high ceilings offered long walls particularly suited for the purpose. Caillebotte, who knew the owner of the building, advanced money for the rent. His diplomatic attitude prevented too many controversies among the exhibitors, and the preparations advanced rather smoothly, although Degas was violently opposed to the plan of calling the show *Exposition des Impressionnistes.* He could not, however, prevent the others from announcing it in this way and thus accepting for the first time—much to the delight of M. Leroy—the name given them in derision.

Only eighteen painters took part in the exhibition of 1877. Several of the participants in former shows, like Béliard and Lepic, dropped out, but there were also a few newcomers. Renoir had invited his friends Franc-Lamy and Cordey, and Pissarro had introduced Piette. Both Cézanne and Guillaumin now again joined the others. The complete list of exhibitors comprised Caillebotte, Cals, Cézanne, Cordey,

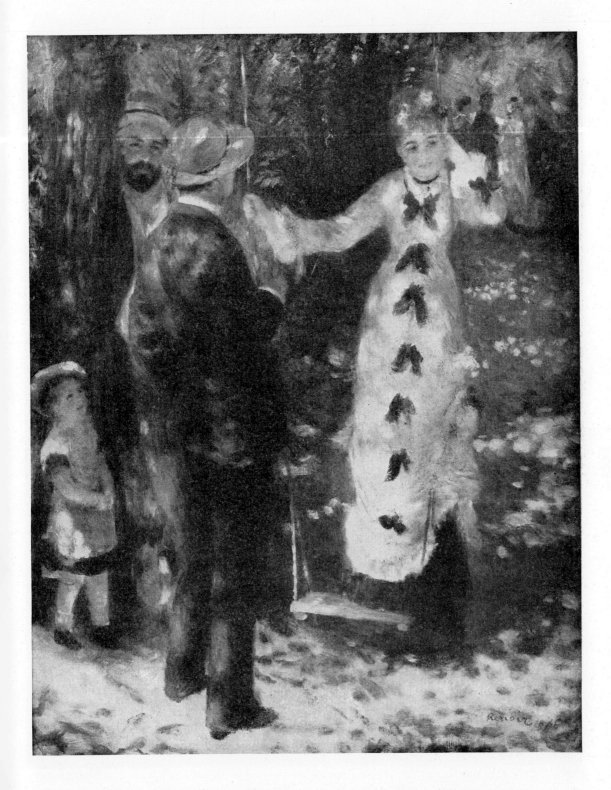

RENOIR: *La Balançoire (The Swing)*, *d. 1876. 36½ x 28½". Louvre, Paris (Caillebotte Bequest)*.

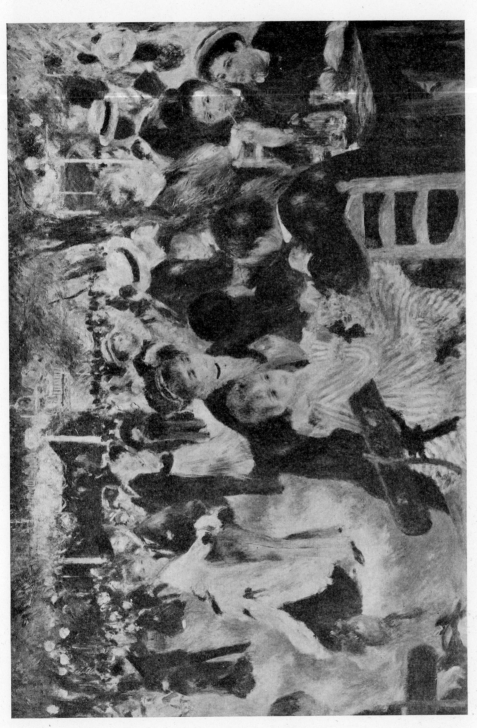

RENOIR: *Dancing at the Moulin de la Galette, Montmartre*, 1876. 31 x 44¾". Formerly in the Chocquet Collection. (*A larger version, exhibited at the third impressionist show, 1877, was bequeathed to the Louvre by Caillebotte.*) *Among the dancers are Renoir's friends Frank-Lamy, Goeneutte, Rivière, Gervex, Cordey, Lestringuez and Lhote. Private collection, New York.*

Above, RENOIR: *Paris Boulevards, d.* 1875. 20 x 24½". *Collection Henry P. McIlhenny, Philadelphia.*

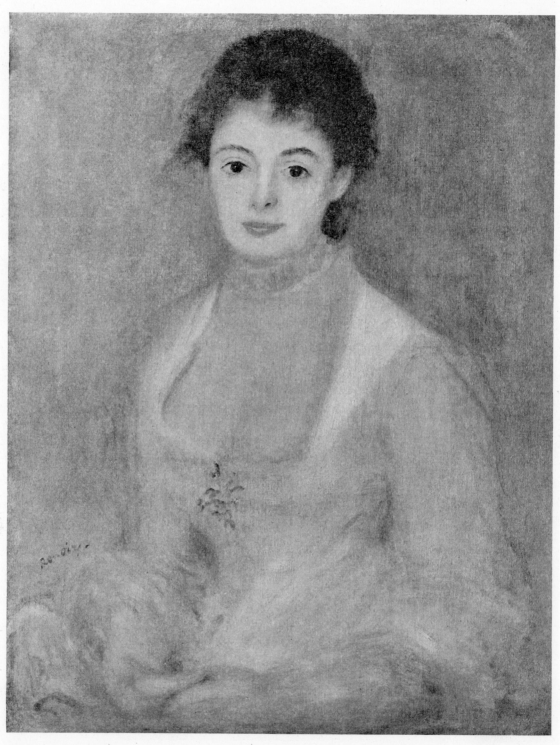

RENOIR: *Portrait of Mme Henriot, c. 1877. 27⅝ x 21⅝". Collection Dr. and Mrs. David M. Levy, New York.*

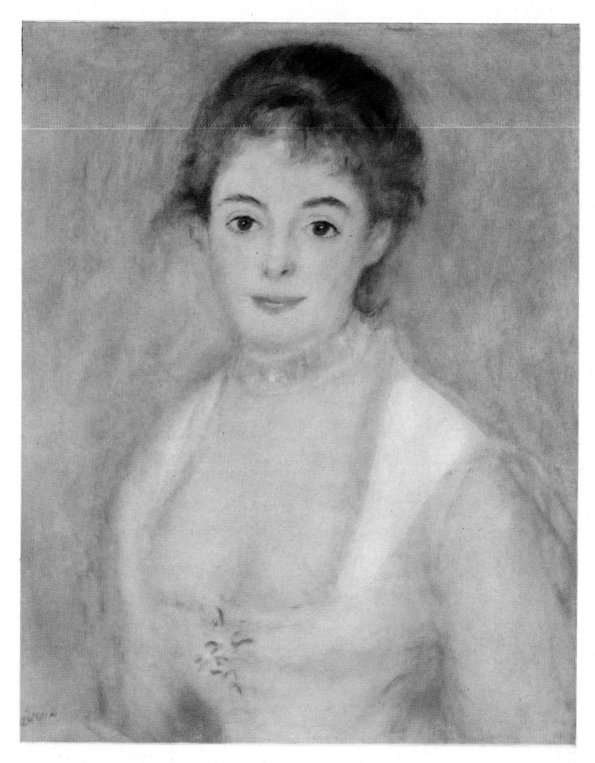

RENOIR: Portrait of Mme Henriot, *detail*.

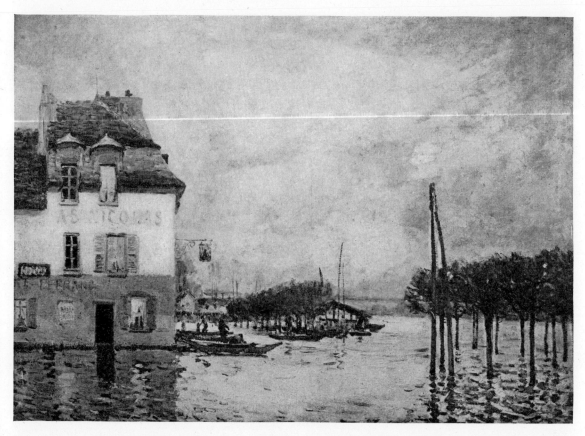

SISLEY: *Flood at Port-Marly, d. 1876. 23⅝ x 31⅞". Probably exhibited at the third impressionist show, 1877. Louvre, Paris.*

Degas, François, Guillaumin, Franc-Lamy, Levert, Maureau (a friend of Degas), Monet, Morisot, Piette, Pissarro, Renoir, Rouart, Sisley and Tillot.[44]

More than two hundred and thirty works were put on exhibit, each of the impressionists contributing a larger number than before. Cézanne exhibited three watercolors and thirteen canvases, mostly still lifes and landscapes, as well as a portrait of Chocquet. Degas sent in twenty-five paintings, pastels and drawings, representing dancers, scenes from the café concerts and women washing themselves; he also showed a likeness of his friend Henri Rouart. Guillaumin was represented by twelve oils. Monet had thirty paintings in the exhibition, among them several landscapes from Montgeron and no fewer than seven views of the Gare St. Lazare. Of his canvases, eleven were lent by Hoschedé, two each by Duret, Charpentier and Manet (who owned an Argenteuil landscape) and three by Dr. de Bellio. Pissarro's contribution consisted of twenty-two canvases, landscapes of Auvers, Pontoise and Montfoucault (where Piette lived); three of them were lent by Caillebotte. To heighten the effect of his colors, Pissarro presented his works in white frames such as Whistler had occasionally used. Among Renoir's twenty-one paintings were his *Balançoire* and *Le bal au Moulin de la Galette,* as well as portraits of Mme Charpentier, her little daughter, Mlle Samary, Sisley and Mme Daudet; there also were several flower pieces, landscapes and heads of young girls. Sisley showed seventeen landscapes of the environs of Paris, among them a view of the *Flood at*

Photograph of Caillebotte.

Marly. Of his works, three were lent by Hoschedé, three by Dr. de Bellio, two by Charpentier, one by Duret, and another, the *Bridge of Argenteuil,* by Manet.

The hanging committee was composed of Renoir, Monet, Pissarro and Caillebotte. In the first room they placed works by Monet, Caillebotte and Renoir; the second was devoted to a large decorative composition by Monet, *Les dindons blancs,* Renoir's *Balançoire* and other canvases by these two as well as by Pissarro, Sisley, Guillaumin, Cordey and Franc-Lamy. The vast drawing room in the center of the apartment had one entire wall occupied by the paintings of Cézanne and another reserved for those of Berthe Morisot; both thus occupied places of honor. This room was completed by Renoir's *Bal au Moulin de la Galette* and a large landscape by Pissarro. The adjoining room contained further works by Monet, Sisley, Pissarro and Caillebotte, while a smaller gallery at the end of the apartment had been more or less completely given over to Degas.[45]

The opening took place early in April. There was a large attendance, and the public seemed less mocking than at the previous exhibitions. But with a few exceptions the press in the days following rivaled again in stupid attacks and facile jokes, a monotonous repetition of its former comments.[46] The artists, who had hoped to meet this time with a little more comprehension, who had thought that their re-repeated manifestations might overcome the general hostility and earn them at least the consideration owed to serious effort, were soon faced with another laughing crowd. Cézanne's works, especially, excited the hilarious public. No one was more outraged by the attitude of the public than Victor Chocquet, who spent all his time at the exhibition. Renoir's friend Rivière later told how the collector tried relentlessly to convince stubborn visitors: "He challenged the laughers, made them ashamed of their jokes, lashed them with ironical remarks, and in these animated, daily repeated discussions, his adversaries did not have the last word. Scarcely would he have left one group before he would be discovered further away, dragging a perverse art lover almost by force in front of the canvases of Renoir, Monet or Cézanne and trying to make the other share his admiration for these disgraced painters. He found eloquent phrases and ingenious arguments to convince his hearers. With clarity he explained the reasons for his partiality. Persuasive, vehement, domineering in turn, he devoted himself tirelessly without losing the urbanity which made him the most charming and formidable of opponents."[47]

Chocquet's efforts were reinforced by Georges Rivière, to whom Renoir had suggested publishing a little paper to defend the painters and reply to the attacks of M. Wolff and his like. The others agreed, and for the duration of the exhibition Rivière brought out *L'Impressionniste, journal d'art,* writing most of the articles himself, occasionally aided by Renoir.[48] Rivière asserted that his friends had adopted the name "Impressionist" so as to assure the public that in their exhibition would be found no historical, biblical, oriental or genre pictures. This essentially negative explanation was motivated apparently by the unwillingness of the painters to come forth with any theoretical explanations of their efforts. In the absence

"But these are the colors of a cadaver!"—Painter: "Unfortunately, I can't make them smell." Caricature by Cham, published in Le Charivari on the occasion of the third impressionist show, 1877.

Policeman: "Lady, it would be unwise to enter!" Caricature by Cham, published in Le Charivari on the occasion of the third impressionist show, 1877.

of these Rivière's outright support of the painters and especially his high praise of Cézanne aroused little attention, however. His writing was somewhat amateurish and his connection with the impressionists was too obvious to make his enthusiasm convincing to the reader.

According to Duret, "the majority of the visitors were of the opinion that the exhibiting artists were perhaps not devoid of talent and that they might have painted good pictures if they had been willing to paint like the rest of the world, but that above all they were trying to create a rumpus to stir up the crowd."[49] Rivière's paper must simply have been considered as part of this rumpus.

After the closing of the exhibition on the last day of April, the friends again decided to organize an auction. Neither Berthe Morisot nor Monet took part in it. Instead, Pissarro participated this time, as did Caillebotte, who had no reason to do so except that he intended to stand by the others. As was to be expected, the results of the second auction were not very different from those of the first.[50]

By now impressionism had become thoroughly notorious in Paris. Newspapers carried caricatures of impressionist painters and the artists even became the subject of jokes on the stage. Degas' friend, the playwright Halévy, was one of the authors of a comedy put on with great success in October, 1877. The central figure of this comedy, *La Cigale,* was an "impressionist" painter whose works could be contemplated both in the normal way and upside down; a landscape with a white cloud, for instance, became, if turned around, a seascape with a sailing boat. Degas contributed a scenic sketch for the studio set, since—as he explained to Halévy—"in spite of certain reservations, it pleases me a lot to do it. . . ."[51]

CÉZANNE: *Portrait of Victor Chocquet, 1876-77. 18¼ x 14". Exhibited at the third impressionist show, 1877. Collection Lord Victor Rothschild, London.*

RENOIR: *Portrait of Victor Chocquet, c. 1875. 14⅜ x 18⅜". Collection Dr. O. Reinhart, Winterthur, Switzerland.*

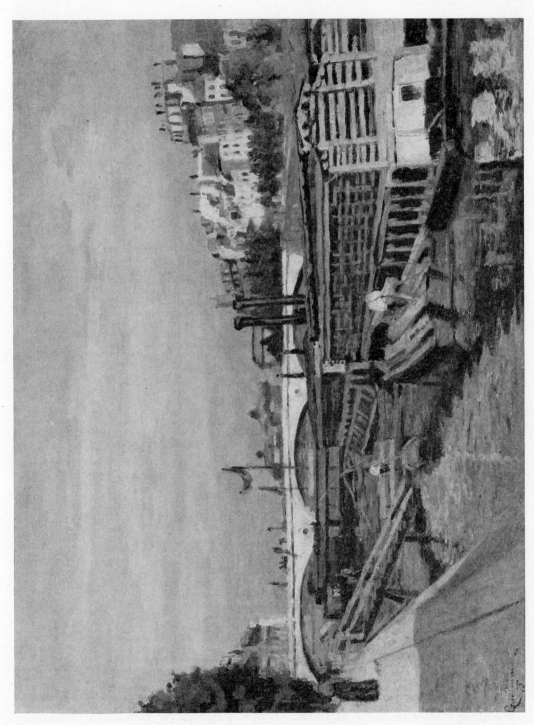

GUILLAUMIN: *The Pont Louis-Philippe, Paris, d. 1875. 18 x 23¾". National Gallery of Art, Washington, D. C. (Chester Dale loan).*

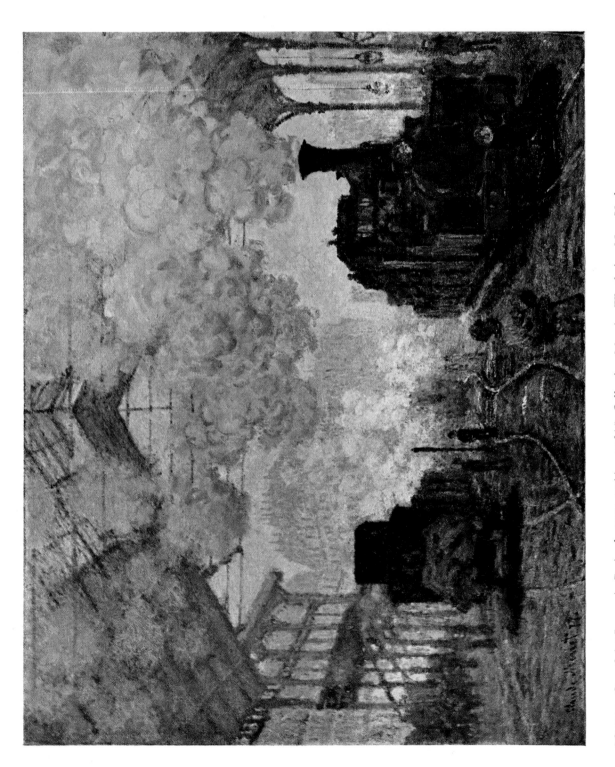

MONET: Gare Saint-Lazare in Paris, d. 1877. 32½ x 39¾". Collection Maurice Wertheim, New York.

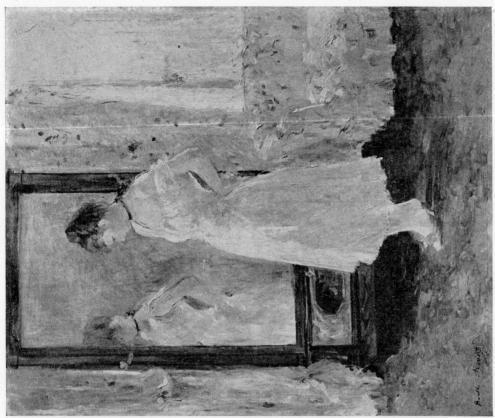

CASSATT: *Woman Reading, d. 1876. 13⅜ x 10½". Collection John T. Spaulding, Boston.*

MORISOT: *Young Woman in Front of a Mirror, 1875. 25⅝ x 21¼". Exhibited at the second impressionist show, 1876. Durand-Ruel Galleries.*

CÉZANNE: *Still Life, c. 1877. 18⅛ x 21⅝". Probably exhibited at the third impressionist show, 1877. Formerly in the Chocquet collection. Private collection, Paris.*

Yet, at the very moment when public favor seemed more and more elusive, after the most representative exhibition ever held by the impressionists had failed to produce the expected change of attitude, two new recruits presented themselves to the group. One was a young American painter, Mary Cassatt, whose work Degas had noticed earlier when she had shown at the Salon of 1874. Although since then her admiration for Courbet, Manet and especially Degas had been steadily growing, she had continued to send to the Salon. She had done so with indifference, however, after a portrait rejected in 1875 had been accepted the following year simply because she had darkened the background in obedience to academic convention. But in 1877 the jury again refused her work. A mutual friend subsequently brought Degas to her studio, and the latter invited her to join the group and to take part in their shows. "I accepted with delight," she later explained. "At last I could work in complete independence, without bothering about the eventual judgment of a jury."[52]

Except for her strong urge toward independence, nothing appears to have predestined Miss Cassatt

SISLEY: *Road at Louveciennes, d. 1875. Durand-Ruel Galleries, Paris.*

PISSARRO: *Orchard in Pontoise, Quai de Pothuis, d. 1877. 26⅛ x 32½". Exhibited in the fourth impressionist show, 1879. Louvre, Paris (Caillebotte Bequest).*

to abandon the quiet life of a lady painter exhibiting at the Salon for the ungrateful role of a woman adhering to the most ridiculed band of artists. The daughter of a wealthy Pittsburgh banker, she had traveled extensively in Europe since about 1868, had visited France, Italy, Spain and Holland, had studied the old masters there and had returned to Paris in 1874 in order to enter the studio of Chaplin, the former master of Eva Gonzalès. But, with increasing experience and passionate self-criticism, she began to feel that she could never express herself freely in following the beaten track. She had become a painter more or less against her father's will and at the age of thirty-two she now decided to go where her intuition led her, whether or not it was consistent with her background. She managed to draw the almost impossible line between her social life and her art and never compromised with either. Although at no time a real pupil of Degas, she was particularly influenced by him. She shared with him the intellectual quality of his emotions and his emphasis on draftsmanship, but she added a mixture of sentiment and crispness which was all her own.

CÉZANNE: *Orchard in Pontoise, Quai de Pothuis, 1877. 20 x 24½". Formerly in the collection of Camille Pissarro. Present owner unknown.*

At about this same time Pissarro met, apparently through his patron Arosa, the latter's godson, Paul Gauguin, by then a well-to-do stock broker. It was doubtless Arosa who first stimulated the former sailor's interest in art, but Gauguin had met in his bank another employee, Schuffenecker, who devoted his spare time to painting. Shortly after his marriage, in 1873, Gauguin, who was then twenty-five years old, began to draw and soon also to paint. In 1876 he had submitted a landscape to the Salon, which was accepted. Yet he was quick to discover in the impressionist exhibitions an art which appealed more strongly to him than anything he had ever seen before. Little by little he began to buy works by Jongkind, Manet, Renoir, Monet, Pissarro, Sisley and Guillaumin as well as by Cézanne (spending 15,000 francs on his collection). Impressionist paintings thus became the framework of his life and compelled him to continue his own efforts in similar directions. He even made a copy of Manet's *Olympia* and another after a *Study of a Mulatto Woman* by Delacroix. Feeling the need for professional advice, he was glad to meet Pissarro, always approachable and willing to help. Through

323

GAUGUIN: *The Seine in Paris, Winter, d. 1875. 25¼ x 36¼". Louvre, Paris.*

him Gauguin made somewhat later the acquaintance of Guillaumin and Cézanne. Although Pissarro became Gauguin's teacher and endeavored to develop his gifts through close contact with nature, it was Cézanne who most deeply impressed Gauguin.

Cézanne spent part of the year 1877 together with Pissarro at Pontoise, both of them again painting side by side. Cézanne also worked, together with Guillaumin, in the park at Issy-les-Moulineaux, just outside Paris. "I am not too dissatisfied," he wrote to Zola, "but it appears that profound desolation reigns in the impressionist camp. Gold is not exactly flowing into their pockets and the pictures are rotting on the spot. We are living in very troubled times and I do not know when unhappy painting will regain a little of its lustre."[53]

Cézanne was more and more strongly aware of an urge to isolate himself, to work in the South, far from the distracting noise and discussions and intrigues of Paris, to advance on his own, unconcerned with the opinions of others. There, in his native Aix, he believed that he would best be able to devote himself to his chosen task, that of "making out of impressionism something solid and durable like the art of museums."[54]

NOTES

1. G. Rivière: L'exposition des Impressionnistes, *L'Impressionniste,* April 6, 1877; quoted in L. Venturi: Les Archives de l'Impressionnisme, Paris-New York, 1939, v. II, p. 309.

2. On the foregoing see L. Venturi: The Aesthetic Idea of Impressionism, *The Journal of Aesthetics,* Spring 1941, and L. Venturi: Art Criticism Now, Baltimore, 1941, p. 12.

3. On the foregoing see J. C. Webster: The Technique of Impressionism, a Reappraisal, *College Art Journal,* Nov. 1944.

4. See R. Régamey: La formation de Claude Monet, *Gazette des Beaux-Arts,* Feb. 1927.

5. See M. Elder: Chez Claude Monet à Giverny, Paris, 1924, p. 70.

6. *Ibid.,* p. 35.

7. See A. Tabarant: Pissarro, Paris, 1924, p. 44.

8. Letter of Mme Lopes-Dubec to her nephew Eugène Petit, Jan. 31, 1874; unpublished document, courtesy Mr. Maurice Petit, St. Thomas.

9. Boudin to Martin, Nov. 9, 1876; see G. Jean-Aubry: Eugène Boudin, Paris, 1922, p. 83.

10. Manet to A. Wolff, March 19 [1875]; see E. Moreau-Nélaton: Manet raconté par lui-même, Paris, 1926, v. II, p. 41. The author dates this letter 1877, on the assumption that it was written for the second auction held by Manet's friends. This second auction, however, was not organized by Monet, Sisley, Renoir and Morisot, but by Caillebotte, Pissarro, Sisley and Renoir. Moreover, the 1877 auction took place on May 28, whereas the 1875 sale was held on March 24, five days after the writing of Manet's letter.

11. "Masque de Fer" in *Le Figaro;* quoted by G. Geffroy: Claude Monet, sa vie, son oeuvre, Paris, 1924, v. I, ch. XIII.

12. P. Burty, introduction to the catalogue: Vente du 24 mars 1875—Tableaux et aquarelles par Cl. Monet, B. Morisot, A. Renoir, A. Sisley; quoted by Geffroy, *ibid.*

13. *Ibid.,* quoted by Venturi: Archives, v. II, p. 290.

14. P. Durand-Ruel: Mémoires, *in* Venturi: Archives, v. II, p. 201. On the sale see also Venturi, *op. cit.,* v. II, p. 290-291 and 300; Geffroy, *op. cit.,* v. I, ch. XIII; R. Marx: Maîtres d'hier et d'aujourd'hui, Paris, 1914, p. 309; A. Vollard: Renoir, ch. VIII; M. Angoulvent: Berthe Morisot, Paris, 1933, p. 50-51.

15. Now in the Barnes collection, Merion, Pa.

16. See F. Fels: Claude Monet, Paris, 1925, p. 16.

17. See Vollard, *op. cit.,* ch. VIII, and for a similar version M. Denis: Nouvelles Théories, Paris, 1922, p. 115-116.

18. Cézanne to his mother, Sept. 26, 1874; see Cézanne, Letters, London, 1943, p. 98.

19. Monet to Manet, June 28 [1873]; see A. Tabarant: Autour de Manet, *L'Art Vivant,* May 4, 1928.

20. Monet to Zola, April 7 [1878], 26, rue d'Edimbourg; unpublished document preserved among Zola's papers at the Bibliothèque Nationale, Paris.

21. Monet to Zola [no date], 17, rue de Moncey; unpublished document preserved among Zola's papers at the Bibliothèque Nationale, Paris.

22. See G. Clemenceau: Claude Monet, Paris, 1928, p. 19-20. Monet spoke of a person "very dear to him" without naming Camille, but this incident unquestionably refers to her. Camille died in 1879.

23. In the sale of his collection after Chocquet's death figured 31 canvases by Cézanne, 11 each by Monet and Renoir, 5 by Manet, 1 by Pissarro and 1 by Sisley. On Chocquet see: Geffroy, *op. cit.,* v. II, ch. XII; J. Joëts: Les impressionnistes et Chocquet, *L'Amour de l'Art,* April 1935, and G. Rivière: Renoir et ses amis, Paris, 1921, p. 36-42.

24. Cézanne to Pissarro, April 1876; see Cézanne, Letters, p. 101.

25. See Moreau-Nélaton, *op. cit.,* v. II, p. 37-38, and A. Proust: Edouard Manet, souvenirs, Paris, 1913, p. 79-82.

26. For a condensed catalogue see Venturi: Archives, v. II, p. 257-259.

27. For articles on the exhibition see *ibid.,* p. 286, 298, 301-305 and Geffroy, *op. cit.,* v. I, ch. XIV.

28. A. Wolff, article in *Le Figaro,* April 3, 1876, quoted by Geffroy, *ibid.*

29. Castagnary, article in *Le Siècle,* quoted by Tabarant: Pissarro, p. 35-36.

30. Cézanne to Pissarro, July 2, 1876; see Cézanne, Letters, p. 102-104.

31. E. Duranty quoted by himself *in:* La nouvelle peinture, Paris, 1876, p. 31.

32. Duranty used some traits of Cézanne for a rather plump caricature in his novel: Le peintre Louis Martin, published posthumously *in* Le pays des arts, Paris, 1881. See J. Rewald: Cézanne, sa vie, son oeuvre, son amitié pour Zola, Paris, 1939, ch. XVI.

33. Duranty, La nouvelle peinture, Paris, 1876.

34. See G. Rivière: Renoir et ses amis, p. 102.

35. See G. Moore: Impressions and Opinions, New York, 1891, p. 308.

36. W. Sickert: Degas, *Burlington Magazine,* Nov. 1917.

37. G. Jeanniot: Souvenirs sur Degas, *La Revue Universelle,* Oct. 15, Nov. 1, 1933. See also J. Rewald: The Realism of Degas, *Magazine of Art,* Jan. 1946. For comparisons of impressionist landscapes with photographs of the motifs see E. Loran: Cézanne's composition, Berkeley, 1943; F. Novotny: Cézanne und das Ende der wissenschaftlichen Perspective, Wien, 1938; Rewald: Cézanne etc.; L. Venturi: Paul Cézanne, Paris, 1939; Venturi: Archives, *op. cit.* See also ill. articles by E. Johnson in *The Arts,* April 1930 and by Rewald in *L'Amour de l'Art,* Jan. 1935, *Art News,* March 1-14, 1943, Oct. 1-14, 1943, Feb. 15-29, 1944, Sept. 1-14, 1944.

38. See Lettres de Degas, Paris, 1931, footnote p. 16.

39. See Moore, *op. cit.,* p. 310.

40. On Renoir's studios rue St. Georges and rue Cortot see Rivière, *op. cit.,* p. 56 and 61-67.

41. On Renoir's garden rue Cortot and the Moulin de la Galette see *ibid.,* p. 121-137.

42. See A. Tabarant: Le peintre Caillebotte et sa collection, *Bulletin de la vie artistique,* Aug. 1, 1921; Caillebotte's will is partly translated *in* G. Mack: Cézanne, New York, 1936, p. 331-332.

43. Caillebotte to Pissarro, Jan. 24, 1877; unpublished letter found among Pissarro's papers.

44. For a condensed catalogue see Venturi: Archives, v. II, p. 262-264.

45. On the exhibition see Rivière, *op. cit.,* p. 156-159; Rivière: Le maître Paul Cézanne, Paris, 1923, p. 84-85 and Geffroy, *op. cit.,* ch. XIX.

46. For press comments see Venturi: Archives, v. II, p. 291-293, 303-304, 330; and M. Florisoone: Renoir, Paris, 1938, p. 162-163.

47. See Rivière: Renoir et ses amis, p. 40.

48. For excerpts from *L'Impressionniste, journal d'art,* see Venturi: Archives, v. II, p. 306-329.

49. See T. Duret: Les peintres impressionistes, Paris, 1878.

50. According to Geffroy, *op. cit.,* v. I, ch. XIX, Pissarro's landscapes brought between 50 and 260 francs, Renoir's canvases between 47 and 285 francs, Sisley's between 105 and 165 francs, while Caillebotte obtained up to 655 francs. The forty-five canvases sold totaled 7,610 francs, the average price paid being 169 francs.

51. Degas to Halévy, 1877 and *not* 1888 as supposed by Guérin; see Lettres de Degas, p. 119-120, and Rivière: Mr. Degas, Paris, 1935, p. 88-89. According to Sacha Guitry (*Bulletin de la vie artistique,* March 1, 1925, p. 118) Monet and Renoir painted scenic decorations for the third act of *La Cigale,* but this seems extremely doubtful.

52. See A. Segard: Mary Cassatt, Paris, 1913, p. 8; also G. Biddle: Some Memories of Mary Cassatt, *The Arts,* Aug. 1926.

53. Cézanne to Zola, August 24, 1877; see Cézanne, Letters, p. 106-107.

54. See M. Denis: Théories, 1890-1910, Paris, 1912, p. 242.

GAUGUIN: *Four Sketches of the Artist's Son, Emil, 1874-75. 3⅞ x 11¾". Cleveland Museum of Art.*

THE CAFE DE LA NOUVELLE-ATHENES

RENOIR, SISLEY AND MONET AT THE
SALON

SERIOUS DISAGREEMENTS

Marcellin Desboutin, who thoroughly disliked the rowdy neighborhood of the Café Guerbois, had begun to patronize a quieter place, the Café de la Nouvelle-Athènes, on the Place Pigalle, not far from the Cirque Fernando where Renoir and Degas occasionally went. When, around 1876, Degas painted a portrait of Desboutin and the actress Ellen Andrée, entitled *L'absinthe* (p. 305), he represented them on the terrace of the Nouvelle-Athènes. The others had little by little followed him and established their evening quarters there, although the company was not altogether the same as that which had frequented the Café Guerbois. Of the impressionists only Renoir, who continued to live in Paris, appeared more or less frequently, and Pissarro came whenever he was in town, that is, once every month. Monet and Sisley were almost never to be seen at the Nouvelle-Athènes, nor was Cézanne, who joined the others only when his friend, the eccentric but amiable musician Cabaner, succeeded in bringing him along.[1] Guillaumin, working for a living and painting in his free hours, had no time to come.

Next to Desboutin, the most regular patrons of the Nouvelle-Athènes were Manet and Degas. In the latter's company sometimes could be found his young friends and indirect pupils, the painters Forain, Raffaëlli and Zandomeneghi. The engraver Henri Guérard, who in 1878 married Eva Gonzalès, was likewise a frequent guest. So were a few critics and authors, among them Duranty, Armand Silvestre and Burty, as well as Ary Renan, Jean Richepin, Villiers de l'Isle-Adam, Zola's friend Alexis and others; Manet's former model, Victorine Meurent,[2] was also to be seen at the café. A young Irishman, George Moore, who had come to Paris in 1873 to study painting under Cabanel but had given it up a few years later, used to meet the others there and join in their conversations.

George Moore, then in his middle twenties, was later described by Duret as a golden-haired fop of whom nobody thought anything, but who, in spite of a certain snobbishness, was welcome everywhere because his manners were amusing and his French very funny.[3] Manet liked him and sketched three portraits of him, yet the likeness which he intended to paint of Moore against the background of the Nouvelle-Athènes, where they had first met, did not satisfy the artist and was ultimately destroyed. When Moore began to write, Degas was quick to break with him because of an innate horror of art criticism and a conviction that literature had done only harm to art. Moreover, he was incensed by Moore's mentioning Degas' family's financial affairs.

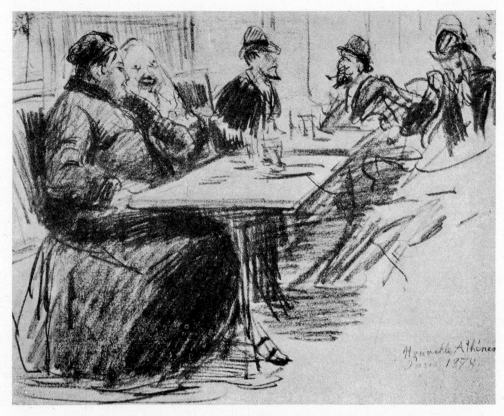

DEGAS: *The Café de la Nouvelle-Athènes, d. 1878. Drawing. Collection Exteens, Paris.*

Although Moore did not frequent the Nouvelle-Athènes for very long, it was he who later gave the most vivid description of the café and its guests. There was a partition rising a few feet or more over the hats of the men sitting at the usual marble tables, separating the glass front from the main body of the café. Two tables in the right-hand corner were reserved for Manet, Degas and their friends. Moore noticed Manet's square shoulders that swaggered as he crossed the room; he admired the finely cut face from whose prominent chin a closely cut blond beard came forward, and the aquiline nose, the clear grey eyes, the decisive voice, the remarkable comeliness of the well-knit figure, scrupulously but simply dressed. He was impressed by the frank passion in Manet's convictions, his loyal and simple phrases, clear as well-water, sometimes a little hard, sometimes even bitter. Moore had the feeling that Manet was in despair because he could not paint atrocious pictures like Carolus-Duran and be fêted and decorated; yet his vanity was rendered attractive and engaging by a strange boyishness of disposition.[4]

Manet's undisguised craving for the red ribbon brought about a violent run-in with Degas when their mutual friend, de Nittis, received the Legion of Honor in 1878. Degas had no sympathy for such weaknesses, not from modesty, but because his immense pride made him independent of external signs of success and even led him to avoid anything that might distinguish him from the anonymous crowd. His disdain for de Nittis' satisfaction was without limit, and he made no secret of it. De Nittis later recalled

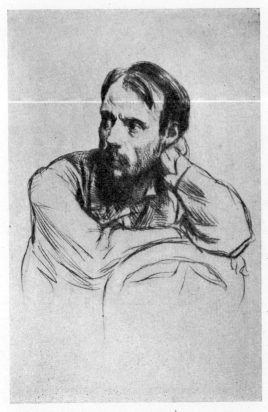 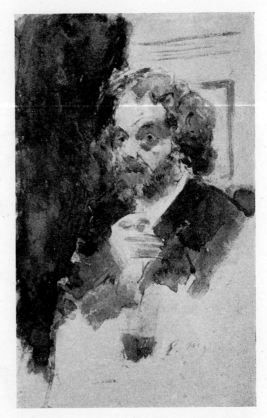

DESBOUTIN: *Portrait of Auguste Renoir, 1877.*
Etching, 6¼ x 4⅝". New York Public Library.

MANET: *Portrait of Desboutin, c. 1875. Water-
color, 8¾ x 5⅛". Fogg Art Museum, Cam-
bridge, Mass. (G. L. Winthrop Bequest).*

that Manet "listened to him with that young, mischievous boy's smile, a bit mocking, which drew back his nostrils.

"'All that contempt, my boy,' Manet replied to Degas, 'is nonsense. You have it, that is the point; and I congratulate you with all my heart. . . . If there were no rewards, I wouldn't invent them; but they exist. And one should have everything that singles you out . . . when possible. It is one step in advance. . . . It is another weapon. In this beastly life of ours, which is wholly struggle, one is never too well armed. I haven't been decorated? But it is not my fault, and I assure you that I shall be if I can and that I shall do everything necessary to that end.'

"'Naturally,' Degas interrupted furiously, shrugging his shoulders. 'It isn't as of today that I know how much of a bourgeois you are.'"[5]

According to Moore, Degas would come to the Nouvelle-Athènes late in the evening, about ten o'clock. For those who knew him, his round shoulders, his rolling gait, his pepper-and-salt suit and his bright masculine voice were brimming with individuality.

With books and cigarettes the time passed in agreeable estheticisms: Manet loud, declamatory; Degas sharp, more profound, scornfully sarcastic; Duranty clearheaded, dry, full of repressed disappointment. Pissarro, looking like Abraham—his beard was white and his hair was white and he was bald, though

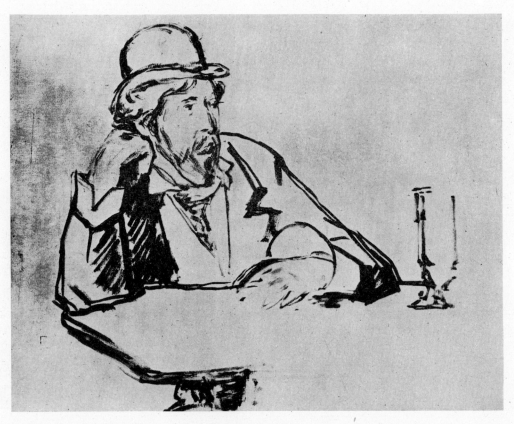

MANET: *George Moore at the Café de la Nouvelle-Athènes, c. 1879. Oil sketch, 26⅛ x 31¾". Collection Albert S. Henraux, Paris.*

at the time he was not yet fifty—sat listening, approving of their ideas, joining in the conversation quietly. No one was kinder than Pissarro, Moore later remembered. He would always take the trouble to explain to students from the *Ecole des Beaux-Arts* why their teacher Jules Lefebvre was not a great master of drawing.[6] Pissarro's innate pedagogical gifts expressed themselves on every occasion with soft insistence and perfect clarity. "He was so much a teacher," Mary Cassatt once stated, "that he could have taught stones how to draw correctly."[7]

Degas was much less interested in initiating the new generation. It was enough for him to advise beginners to burn their model-stool[8] and to work from memory. His young painter friends may have done so, but they were apparently unable to blot from their memory the works of Degas they had studied: their efforts relied more or less heavily on Degas' guidance. While Degas seemed not to mind this at all, his impressionist friends felt somewhat uneasy on the subject of his eager imitators.

Renoir came often to the café. What most struck Moore was the hatred with which he used to denounce the nineteenth century—the century in which he used to say there was no one who could make a piece of furniture or a clock that was beautiful and that was not a copy of an old one. Indeed, Renoir began to show an increasing interest in craftsmanship, which was to find its expression in his own efforts.[9]

Moore never met Cézanne at the Nouvelle-Athènes, but what he occasionally heard there about this

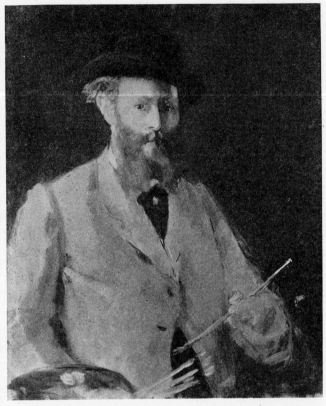 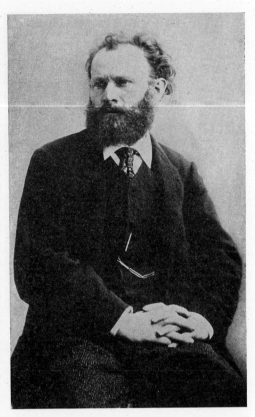

MANET: *Self Portrait, 1878. 34 x 28". Collection Jakob* *Photograph of Edouard Manet.*
Goldschmidt, New York.

"rough, savage creature," supposed to wander in jackboots about the hillsides in the outskirts of Paris, abandoning his paintings in the fields, proves that legends began to be spun about Cézanne as soon as he went into retreat.

While the evenings at the café were passed in lively discussions, all the landscapists who were absent from Paris continued their bitter struggle for existence and lived often without knowing where their next meal would come from. The vicious reviews, the ridiculous prices obtained at auctions, the criticisms of *père* Martin, maddening in themselves, had above all one terrible repercussion: they meant less bread. There was a dreadful monotony in the suffering of these painters, an unbearable succession of events which seemed to push them ever deeper into misery with nowhere the slightest sign of relief.

In April, 1878, speculating on possible gains, Faure sold part of his collection at auction. The results were depressing. The absence of serious bids obliged the singer to buy most of the paintings back, and the prices for those actually sold did not even cover expenses. Two months later Hoschedé, ruined, was forced by a court judgment to sell his collection, comprising among others five canvases by Manet, twelve by Monet, thirteen by Sisley and nine by Pissarro. The bids were again catastrophically low.[10] Though the average for Manet's works was 583 francs, it was much less than what Durand-Ruel had originally paid for them. Monet's paintings averaged only 184 francs, and those of Sisley 114. Yet Sisley was satisfied,

331

PISSARRO: *Portrait of Mlle Marie Murer,*
d. 1877. Pastel, 23¾ x 19½". Exhibited
at the fourth impressionist show, 1879.
Formerly Collection Chester Dale, New
York.

RENOIR: *Portrait of Mlle Marie Murer, c. 1877.*
24¾ x 20". Eugène Murer commissioned this
portrait for 100 francs. Collection Chester
Dale, New York.

having apparently expected worse. But Pissarro was discouraged. "I had at last discovered an enthusiast," he wrote to a friend, "but the Hoschedé sale finished me off. He will buy some inferior pictures of mine, which he will be able to get at a low price at the Hôtel Drouot. Here I am still without a cent."[11] Pissarro was now again reduced to accepting 50 to 100 francs for his canvases, if he could sell them at all.

During the summer of 1878 Duret came to the aid of his friends by publishing a pamphlet, *Les peintres impressionnistes,* in which he tried to convince the public that innovators were always laughed at before they were recognized. Duret devoted short biographical notices and commentaries to Monet, Sisley, Pissarro, Renoir and Berthe Morisot, thus for the first time singling out these five as the true impressionists, the leaders of the group. He endeavored to prove that their efforts were not opposed to tradition but in harmony with it, adding the contemporary link to a great past. He also insisted that there were already critics like Burty, Castagnary, Chesneau and Duranty, authors like Daudet, d'Hervilly and Zola, collectors like de Bellio, Charpentier, Chocquet, Faure and others, who appreciated the impressionists, and he concluded by predicting that the day would come when their art would be generally accepted.

Shortly after this pamphlet appeared Manet informed Duret that he had met some of the impressionists, who had been filled with new hope by this promise of better days ahead. "And they need it badly," Manet added, "for the pressure is tremendous at the moment."[12]

Among the collectors of impressionist works listed by Duret figured a new name, that of Eugène Murer, who had only recently assumed the role of art patron. A former school friend of Guillaumin,

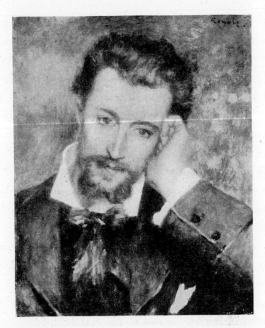

PISSARRO: *Portrait of the Pastry Cook Eugène Murer, d. 1878. 26⅞ x 22½". Murer objected to the painter's price of 150 francs for this portrait. Collection Jean Pédron, Paris.*

RENOIR: *Portrait of the Pastry Cook Eugène Murer, c. 1877. 18½ x 15¼". Present owner unknown.*

Murer was a pastry cook and owner of a small but flourishing restaurant. He had Pissarro and Renoir decorate his shop and also bought some of their canvases, often by offering meals in exchange. When he commissioned them to paint portraits of himself and of his sister, the painters had trouble in getting him to agree to their modest prices. Renoir's friend Rivière later accused Murer of having offered help only at the most desperate moments, when the artists were ready to accept anything.[13] Every Wednesday the painters met for dinner at his place, the most frequent guests being Guillaumin, Renoir, Sisley, Guérard, Cabaner, *père* Tanguy and some others.

In the course of the year 1878 Murer repeatedly assisted Pissarro, whose letters became increasingly gloomy. "I am going through a frightful crisis," he wrote to Murer, "and I don't see a way to get out of it. . . . Things are bad." Pissarro owed money to the butcher, to the baker, everywhere, and his wife, expecting her fourth child, was completely discouraged. "My work is done without gaiety," he explained, "as a result of the idea that I shall have to give up art and try to do something else, if it is possible for me to begin over again. Depressing!"[14]

Accused by Duret of not being a good salesman, Pissarro swallowed his pride and replied: "I'll do anything within my power in order to make some money, and I'll even renew business relations with *père* Martin, if the opportunity should come up. But you must realize that it is very hard for me, after he has run me down so, because he didn't hesitate to say that I was lost for good. . . . All my customers are convinced of it. I was even afraid that you might have been influenced by him. . . ."[15]

Although Duret considered him a smart businessman, Monet was by no means better off. In the fall

of 1877 he had once more been obliged to go begging for help. He had asked Chocquet "to be good enough to take one or two daubs which I'll let you have at any price you may make: 50 francs, 40 francs, whatever you are able to pay, because I can't wait any longer."[16]

Toward the end of 1877 Monet became so weary of the struggle that he began to lose faith in the future. It was then that Manet conceived a plan for rescuing him. "I went to see Monet yesterday," he wrote to Duret. "I found him quite broken down and in despair. He asked me to find him someone who would take ten or twenty of his pictures at 100 francs each, the purchaser to choose which he liked. Shall we arrange the matter between us, say 500 francs each? Of course nobody, he least of all, must know that the offer comes from us. I had thought of some dealer or collector, but I foresaw the possibility of a refusal. It is unhappily necessary to be as well informed as we are, in order to bring off, in spite of the repugnance we may feel, an excellent business transaction and, at the same time, to do a good turn to a man of talent."[17]

Duret, apparently, was in no position to associate himself with Manet in this, whereupon Manet decided to act alone. On January 5, 1878, he undertook in writing to pay Monet 1,000 francs "against merchandise."[18] It was doubtless this money which helped the painter establish himself in Vétheuil, on the banks of the Seine, farther away from Paris than Argenteuil and offering more plain country motifs, more solitude. But by the end of the year he found himself again without money, too poor to buy canvas and paints.

While Duret had been unable to help Monet, he managed a little later to come to the support of Sisley, who asked him, in August 1878, whether he did not know someone willing to pay him 500 francs monthly for six months, in return for thirty canvases. "For me," Sisley explained, "it is a question of not letting the summer pass without working seriously, free of worry, to be able to do good things, convinced that in the fall things will be better."[19] Duret found among his business connections a man willing to buy seven paintings by Sisley.

Even Cézanne had in 1878 serious financial troubles and, like Pissarro, thought of giving up painting to earn a living otherwise. His father had opened a letter addressed by Chocquet to the painter and had found in it a mention of "Madame Cézanne and little Paul." The old banker was furious and promised to "rid" the son of his dependents. In the face of evidence the painter denied everything, whereupon his father reduced his allowance from 200 francs a month to 100, arguing that a bachelor could well get along on that. Cézanne turned immediately to Zola, appealing to his "friendship for me to ask you to use your influence to find me a position, if you think such a thing possible."[20]

Zola had just obtained his first great success with the novel *L'Assommoir* and was about to buy with his royalties a little country place in Médan, on the Seine. He persuaded Cézanne not to provoke a complete rupture with his father and offered to help. While Cézanne remained in Aix with his parents, playing as best he could a role of unconcern, Zola for almost a year supported Hortense Fiquet and the child, who lived in Marseilles.

Renoir was not less depressed than his friends. Since he—like the others—had made so little headway in their exhibitions, he decided in 1878 to send again a painting to the Salon. Renoir later explained his decision to Durand-Ruel by stating: "There are in Paris scarcely fifteen art-lovers capable of liking a painting without Salon approval. There are 80,000 who won't buy even a nose if a painter is not admitted to the Salon. . . . Furthermore, I don't want to descend to the folly of thinking that anything is good or

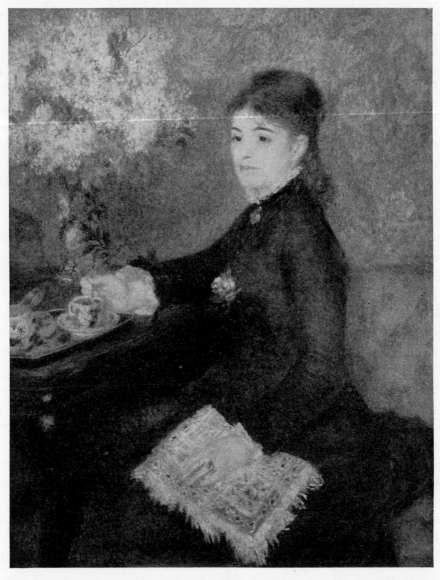

RENOIR: *La tasse de chocolat, 1877. 39⅜ x 31⅞". Exhibited at the Salon of 1878. Private collection, Detroit.*

bad according to the place where it is hung. In a word, I don't want to waste my time in resentment against the Salon: I don't even want to give that impression. I believe one must do the best painting possible. That's all. Well, if I were accused of neglecting my art or by idiotic ambition of making sacrifices against my convictions, then I should understand the carpers. But since that doesn't come into the question, there is nothing to say against me. . . . My submitting to the Salon is entirely a business matter. In any case, it is like certain medicines: if it doesn't do any good, it doesn't do any harm."[21]

Renoir, who designated himself in the catalogue as pupil of Gleyre, had his *Tasse de chocolat* admitted

to the Salon, while both canvases submitted by Manet were rejected once more. Manet thought of organizing again an exhibition of his own, but nothing came of it.

When the impressionists met in Paris toward the end of March 1878 to decide about a fourth group exhibition, they were faced with Renoir's defection but also with a series of other problems, ranking high among them the fact that a new World's Fair was to be held in Paris that same year. The jury of the art section had once more succeeded in excluding from the exposition not only the great living, but also the great dead: Delacroix, Millet, Rousseau *et al.* Durand-Ruel thereupon determined to organize a show of his own, dedicated to these men and the other masters of the Barbizon school. He was able to assemble no less than 380 outstanding works.[22] Sisley proposed that the impressionists hold a show of their own at Durand-Ruel's, but the others, doubtful of its success amidst the agitation of a World's Fair, preferred to have no exhibition at all.

"Useless to count on our exhibition," Pissarro wrote to Murer, "It will be a madhouse at Durand-Ruel's, where our most renowned masters are gathered. Not a living soul—the most complete indifference. People have had enough of this dreary art, this over-particular, dull painting which requires attention, thought. All that is too serious. As a result of progress, we are supposed to see and feel without effort, and above all to enjoy ourselves. Besides, is art necessary? Is it edible? No. Well then!"[23]

For his exhibition Durand-Ruel had been obliged to borrow pictures from his clients, as he no longer owned enough important works himself. The preceding years had abounded in difficulties for him, too. One by one the Barbizon masters had died, Millet in 1874, Corot in 1875, Diaz in 1876, Courbet in 1877, Daubigny in 1878; Daumier was blind and ill. The various sales which had followed the disappearance of these painters had thrown upon the market a large quantity of their works, and with this prices had gone down, while the demand began to dwindle. Moreover, the depression which had followed the war showed no indication of subsiding. At the same time Durand-Ruel's most serious Parisian rival, Georges Petit, increased his activity, though he waited for some kind of official recognition before he felt ready to approach the impressionists. Fortunately, there were signs of a growing interest in the United States; American dealers began to buy paintings by Corot and Troyon in increasing quantities but were as yet unwilling to take interest in more advanced works.

In 1879 Manet decided to sound his chances in the new world by exhibiting there his *Execution of Emperor Maximilien.* The canvas was taken by the singer Emilie Ambre on a concert tour in the States. In New York the press showed both astonishment and admiration; some painters were excited. Five hundred posters were displayed, but the response of the public was unenthusiastic, and expenses were not covered. In Boston a mere fifteen to twenty persons daily came to see the painting; again a deficit was registered, and the exhibition planned in Chicago was prudently called off. Finally Mlle Ambre brought the canvas back to France.[24]

In Paris, meanwhile, Sisley informed Duret: "I am tired of vegetating, as I've been doing for so long. The moment has come for me to make a decision. It is true that our exhibitions have served to make us known and in this have been very useful to me, but I believe we must not isolate ourselves too long. We are still far from the moment when we shall be able to do without the prestige attached to official exhibitions. I am, therefore, determined to submit to the Salon. If I am accepted—there are possibilities this year —I think I'll be able to do some business. . . ."[25] Renoir also sent to the Salon. So did Cézanne; and when Pissarro invited the latter to participate in a new group show, he received the reply: "I think that, amidst

336

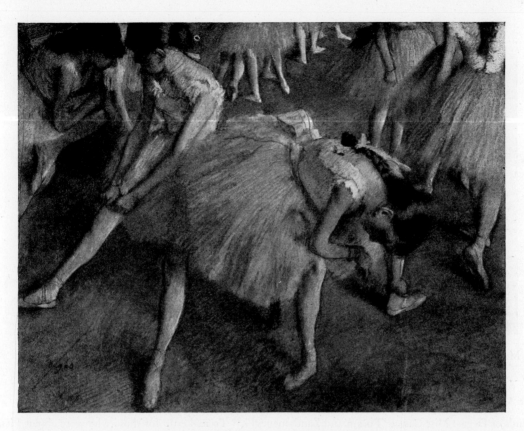

DEGAS: *Awaiting the Cue, 1879. Pastel, 18¾ x 21¼". Private collection, New York.*

all the difficulties caused by my submitting to the Salon, it will be more suitable for me not to take part in the impressionists' exhibition."[26]

In spite of the absence of Renoir, Sisley, Cézanne and Berthe Morisot (who abstained because she was pregnant), the friends went ahead with their fourth exhibition, to be held at 28 avenue de l'Opéra. This time it was decided, at the insistence of Degas, to drop the word "impressionist" from the announcements and to replace it by "independent." And Armand Silvestre commented in *La Vie Moderne:* "You are invited to attend the funeral service, procession and interment of the impressionists. This painful invitation is tendered to you by the *Independents*. Neither false tears nor false rejoicing. Let there be calm. Only a word has died. . . . These artists have decided, after serious conference, that the term which the public adopted to indicate them signified absolutely nothing and have invented another."[27] But in spite of this change of name, the painters continued to be known as impressionists.

Discouraged by his continual bad luck, Monet did not even leave Vétheuil to participate in the preparation for the new show. Caillebotte thereupon took care of everything, borrowed pictures from collectors, looked after the frames, wrote eager letters and tried to rouse his friend's courage. "If you could see how energetic Pissarro is!" he exclaimed.

There were only fifteen exhibitors this time: Bracquemond and his wife, Caillebotte, Cals, Degas, Monet, Pissarro, Piette (who had recently died), Rouart, Tillot and, as newcomers, Lebourg and three

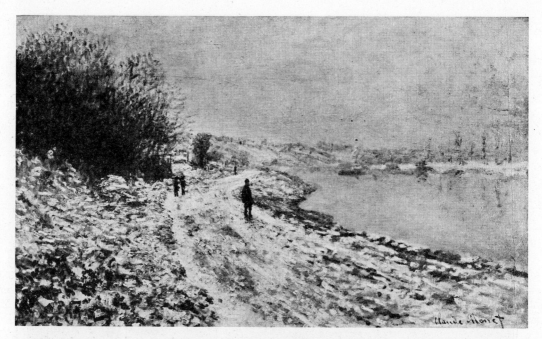

MONET: *Winter in Argenteuil, 1878. 23½ x 39". Albright Art Gallery, Buffalo.*

friends of Degas: Miss Cassatt, Forain and Zandomeneghi.[28] To make up for those who were absent Pissarro sent thirty-eight works (seven of which were lent by Caillebotte), Monet twenty-nine, and Degas listed twenty-five in the catalogue. On the opening day, April 10, a jubilant note from Caillebotte went out to Monet:

"We are saved. By five o'clock this afternoon the receipts were more than 400 francs. Two years ago on the opening day—which is the worst—we had less than 350. . . . There's no need to point out to you certain ridiculous circumstances. Don't think, for instance, that Degas sent his twenty-seven or thirty pictures. This morning there were eight canvases by him. He is very trying, but we have to admit that he has great talent."[29]

The press was again hostile, but the visitors came in greater numbers. "The receipts continue good," Caillebotte announced on May 1, "we have now about 10,500 francs. As for the public—always in a gay mood. People have a good time with us. . . ."[29] When the exhibition closed on May 11 there remained, with expenses covered, more than 6,000 francs. Some of the exhibitors wanted to keep this as a reserve in order to guarantee future exhibitions, but since few works had been sold the majority voted for distribution of the money. Each participant received 439 francs. With this amount Miss Cassatt bought two paintings, one by Monet and one by Degas.

Meanwhile the Salon had been opened. Cézanne had been rejected once more, as well as Sisley, but Manet and Renoir were represented. (Eva Gonzalès exhibited, again as "pupil of Manet," a canvas strongly influenced by her master.) Renoir had sent a portrait of Jeanne Samary and a large group portrait of Mme Charpentier and her two daughters, painted the previous year. While the likeness of the actress had

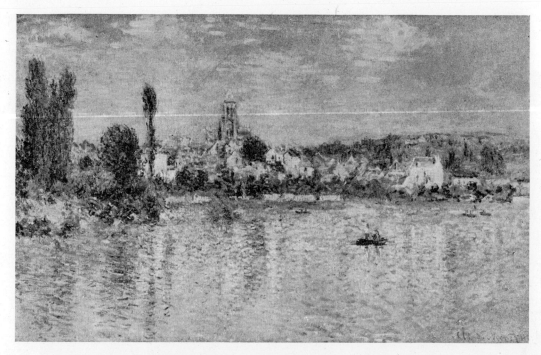

MONET: *Vétheuil in Summer, 1880. 25¾ x 39½". Collection William Church Osborn, New York.*

been relegated to the third row in the *dépôtoir*, Mme Charpentier had seen to it that her portrait received a favorable place in the center of a wall. There can be little doubt that the success this canvas obtained was partly due to the prestige of the sitter. The portrait lacked the spontaneous quality of most of Renoir's works. The painter had obviously proceeded with restraint and much application; he had refrained from abandoning himself to the happy, random discoveries of his sensibility and had tuned down his colors. There was nothing of his natural gaiety in this work; instead, a somewhat solemn opulence prevailed. Renoir had clearly aimed at a stately effect, and this he had achieved. The critics unanimously acclaimed the painting; for the first time Renoir could feel he had almost arrived. Castagnary, still hostile to Manet, whom he accused of making concessions to the bourgeois, highly praised Renoir's "agile and intellectual brush," his "lively and happy grace," the enchantment of his color.[30] "Renoir has a big success at the Salon," Pissarro wrote to Murer. "I believe he is launched. So much the better! Poverty is so hard."[31]

Renoir's patroness, Mme Charpentier, had been instrumental in setting up a new weekly, *La Vie Moderne,* devoted to artistic, literary and social life, which her husband started in the spring of 1879. The painter's brother, Edmond, took charge of an exhibition room on the editorial premises and began to organize a series of one-man shows. In June he presented a group of pastels by Renoir, writing at the same time in *La Vie Moderne* a comprehensive article on his brother's work.[32] Renoir proposed that an exhibition of works by his less fortunate comrade Sisley be held; but to no avail. He went to spend some time in Berneval (Normandy) and then returned once more to Chatou, where he painted his *Boating Party at Chatou,* a feast of gay sunlight and radiant water that shows him preoccupied with the same problems tackled in *La Balançoire* and *Le bal au Moulin de la Galette.*

RENOIR: *Mme Charpentier and her Daughters, d. 1878. 60½ x 74⅞". Exhibited at the Salon of 1879. Metropolitan Museum of Art, New York.*

RENOIR: Boating Party at Chatou, d. 1879. 31⅞ x 39¼". (In the foreground, Gustave Caillebotte.) Collection Mr. and Mrs. Sam A. Lewisohn, New York.

Renoir's sudden success at the Salon must have had great influence on Monet. With the example of Renoir and Sisley, he now came to wonder whether their struggle for independence had not been sterile and whether success could ever be obtained outside the Salon. Should he too break with the self-imposed rules of the group? Renoir, after all, had always kept himself aloof from any rigid line of conduct, confessing frankly, "I have never been able to know the day before what I'd do the next day."[33] But Monet's case was different. He had been one of the staunchest supporters of the impressionist exhibitions: in fact, he had been their initiator. To him, opposition to the jury had been more than a necessity, it had been an article of faith. To abandon these principles now would seem an admission of failure. Yet, above the question of principle, there was also the problem of the future. For more than twenty years he had toiled without progressing much in public favor; he had even lost some of the sympathy he had won at the beginning. Could he afford to pursue deliberately a course which alienated the esteem of the majority? The time had come when he had to grasp success regardless of where it offered itself, and since the Salon seemed to promise better luck, he had apparently no choice except to seek it there. Monet, therefore, resolved in 1880 to submit two canvases to the jury.

Monet's decision met with the most profound contempt on the part of Degas. In a letter to Duret Monet complained that his friends treated him as a renegade and explained that he had taken this step mainly in the hope that Durand-Ruel's competitor, Petit, might make some purchases, once Monet's canvases had been admitted to the Salon.[34] (Sisley, too, gave the same reason to justify his abandoning the group.) But, superbly indifferent to Monet's motives, Degas saw only his infidelity, his loathsome compromise with officialdom. He accused Monet of "frantic log-rolling" and refused to have anything more to do with him. Of the original group there now remained only Pissarro, Berthe Morisot, Degas, Caillebotte, Guillaumin and Rouart. With the exception of Pissarro none of them depended on sales, and their scorn of the jury, admirable as it was, had nothing of the heroism displayed by Pissarro, who, in renouncing possible Salon success, chose indefinite poverty.

With Monet, Renoir, Sisley and Cézanne absent, the fifth exhibition of the group, organized in 1880, was indeed no longer an impressionist show. It included Bracquemond and his wife, Caillebotte, Guillaumin, Lebourg, Berthe Morisot, Degas with his friends: Miss Cassatt, Forain, Levert, Rouart, Zandomeneghi, Tillot, as well as two newcomers invited by him, Raffaëlli and Vidal; finally, there was Pissarro, who introduced Gauguin for the first time, and a fourth newcomer, Vignon.

The exhibition, held at 10 rue des Pyramides throughout the month of April, was announced on Degas' advice as an exhibition of "Independent Painters." But Degas was defeated in a discussion concerning the posters for the show and wrote bitterly to Bracquemond:

"It opens the first of April. The posters will be up tomorrow or Monday. They are in bright red letters against a green background. There was a great fight with Caillebotte about whether or not to publish names. I had to give in to him and allow them to appear. When will there be an end of this star billing? Mlle Cassatt and Mme Morisot were definitely against being on the posters. . . . Every good reason and good taste are powerless against the others' inertia and Caillebotte's stubbornness. . . . Next year I shall certainly arrange so that it doesn't continue. I am upset, humiliated by it."[35]

Degas' new protégé Raffaëlli contributed no less than thirty-five works, a fact which seems to have surprised the old-timers. They heartily disliked his weak attempts to ally a diluted impressionism with anecdotic subjects, both realistic and sophisticated. Degas himself once more neglected to send the works

341

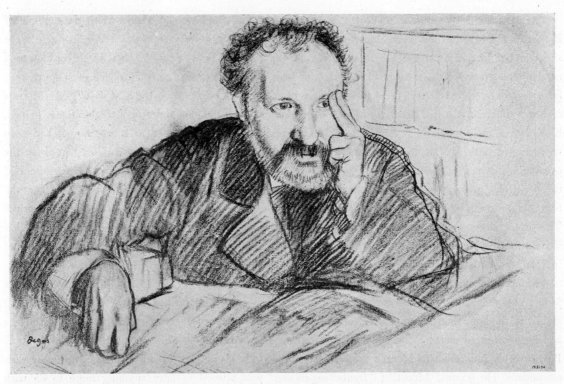

DEGAS: *Portrait of Edmond Duranty, c. 1879. Drawing, 12⅛ x 18⅛". Metropolitan Museum of Art, New York.*

he had announced in the catalogue, for instance, a statuette in wax of a young dancer to which he had devoted considerable time. However, he did send, though after the opening, a portrait of Duranty which had been promised for the previous exhibition. (Duranty died suddenly nine days after the opening, and Degas apparently wanted to pay a last tribute to his friend.) Zandomeneghi exhibited among others a strange portrait of Paul Alexis, standing against a wall to which were affixed innumerable birdcages. Guillaumin, Berthe Morisot and Pissarro were represented by over a dozen works each. Pissarro, who had experimented in etching with Degas and Miss Cassatt, showed also several prints mounted on yellow paper and surrounded by purple frames, a startling innovation. Gauguin presented a still life, several landscapes (some of which he had painted while in Pontoise with Pissarro), and a carefully polished marble bust.[36]

The public was smaller than before. Since the first shock produced by the impressionists had worn off, general hostility was replaced by indifference. The critics sympathetic to the group began to distinguish between those of the exhibitors who were true impressionists and the others who had little to do with the movement. Armand Silvestre insisted that Pissarro at least had remained faithful to impressionism. At the same time Zola's friend, the novelist J. K. Huysmans, expressed little understanding for the impressionists, especially Berthe Morisot, and instead hailed Degas and his associates, Forain, Raffaëlli and Zandomeneghi. The exhibition was clearly divided into two opposing groups, of which that constituted by Pissarro, Berthe Morisot, Guillaumin and Gauguin apparently represented the minority.

While impressionism was no longer the keynote of the group exhibition, it did not fare too well at

342

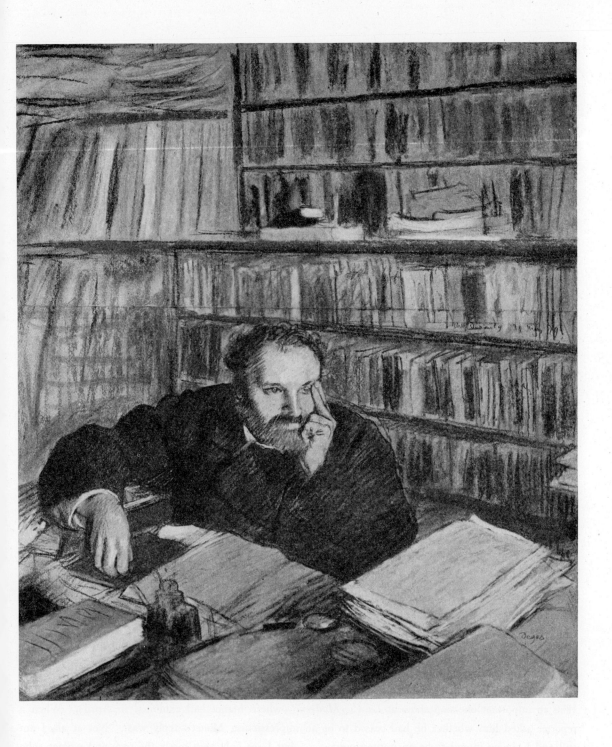

DEGAS: *Portrait of Edmond Duranty, d. 1879. Pastel, 20½ x 18". Collection Mr. and Mrs. Sam. A. Lewisohn, New York.*

the Salon either. The more important of the two landscapes submitted by Monet, *Floating Ice on the Seine,* was rejected. Renoir's two canvases were accepted, but only one of these, a girl with a cat in her arms asleep on a chair, was representative of his impressionist style. Manet exhibited a rather conventional portrait of his friend Antonin Proust, now member of the French Chamber of Deputies, and a couple dining, *Chez le père Lathuile,* painted in the open. Sisley was not represented. The jury considered awarding Manet a second medal, but finally did not do so, much to the disappointment of the artist, whose health was failing.

Monet's and Renoir's works were very badly hung, and they conceived the idea of protesting to the Minister of Fine Arts, asking for a promise of better treatment the following year. They sent a copy of their letter to Cézanne with the request that he forward it to Zola. They hoped that Zola, whose name now carried weight, would publish it in one of the papers to which he contributed and would add a few words of his own to show "the importance of the impressionists and the real interest which they aroused."[37] Zola indeed published a series of three articles, under the title *Le naturalisme au Salon,* but these articles did not exactly come up to the expectations of the painters.

Since fame had begun to reward Zola's stubborn efforts, he had become more and more convinced of the all-embracing mission of "naturalism." He had not forgotten that he and the painters had once started together, unknown but confident, and he now measured their achievements against the success obtained. The impressionists had failed, as he saw it, not because the public was blind—since the same public admired his own novels—but because, it seemed to him, they had not attained complete expression. These considerations explain Zola's patronizing attitude toward his former comrades-in-arms. In his articles Zola began with disapproval of the separate group exhibitions, which in his opinion had profited only Degas; he joined Manet in the thesis that the battle for recognition ought to be fought at the Salon. He was pleased to see that Renoir had been the first to return and was now followed by Monet, although they had thus become renegades. The group no longer existed, Zola proclaimed, but its influence could be felt everywhere, even among the official painters. "The real misfortune," Zola concluded, repeating the arguments of Duranty, "is that no artist of this group has achieved powerfully and definitely the new formula which, scattered through their works, they all offer. The formula is there, endlessly diffused; but in no place, among any of them, is it to be found applied by a master. They are all forerunners. The man of genius has not arisen. We can see what they intend, and find them right, but we seek in vain the masterpiece that is to lay down the formula. . . . This is why the struggle of the impressionists has not reached a goal; they remain inferior to what they undertake, they stammer without being able to find words."[38]

There was something tragic in the misunderstanding, the lack of comprehension, which slowly but surely drew the former comrades apart. The disintegration of the impressionist group was further underlined by Monet, who, in answer to the partial refusal which the jury returned to him, organized in June 1880 an important one-man show at *La Vie Moderne* (where Manet had exhibited in April). When a reporter asked him whether he had ceased to be an impressionist, Monet's reply was: "Not at all, I am still and I always intend to be an impressionist . . . , but I see only very rarely the men and women who are my colleagues. The little clique has become a great club which opens its doors to the first-come dauber. . . ."[39] Whether this was meant for Raffaëlli or for Gauguin is hard to decide, but the fact remains that Monet's remarks certainly did not help to smooth his relations with the others.

344

RENOIR: *Girl with a Cat, d. 1880. 48¼ x 36⅛". Private collection, New York.*

RENOIR: *Bather, 1879-80. 18¼ x 15¼". Albright Art Gallery, Buffalo.*

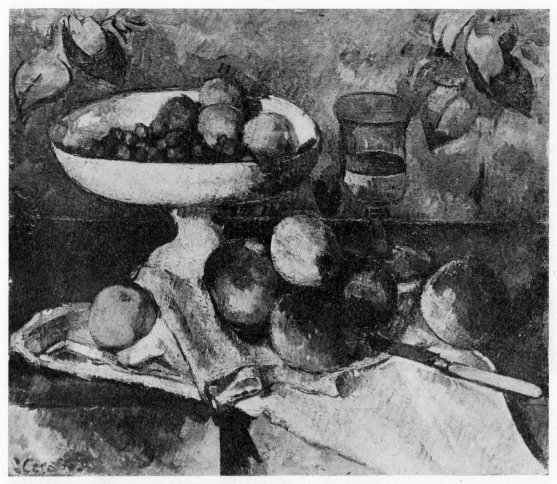

CÉZANNE: *Still Life, c. 1880. 18½ x 22⅛". Formerly in the collection of Paul Gauguin. Collection R. Lecomte, Paris.*

In these circumstances there remained only two men devoted with all their heart to the common cause, Pissarro and Caillebotte. Yet when they began, in January 1881, to discuss the possibility of a new group exhibition, even they no longer agreed. Caillebotte resented the way in which Degas had imposed his friends upon the others, he was outraged by the meager contributions Degas himself made to their shows, and he felt offended by the manner in which Degas passed judgment on Monet and Renoir for their participation in the Salon. He therefore proposed that they rid themselves of Degas and his circle, hoping that this might even decide Monet and Renoir to return. In a long letter to Pissarro, Caillebotte explained his attitude:

"What is to become of our exhibitions? This is my well-considered opinion: we ought to continue and continue only in an artistic direction, the sole direction, in the final sense, that is of interest to us all. I ask, therefore, that a show should be composed of all those who have contributed real interest to the subject, that is, you, Monet, Renoir, Sisley, Mme Morisot, Mlle Cassatt, Cézanne, Guillaumin; if you wish, Gauguin, perhaps Cordey, and myself. That's all, since Degas refuses a show on such a basis.—I should

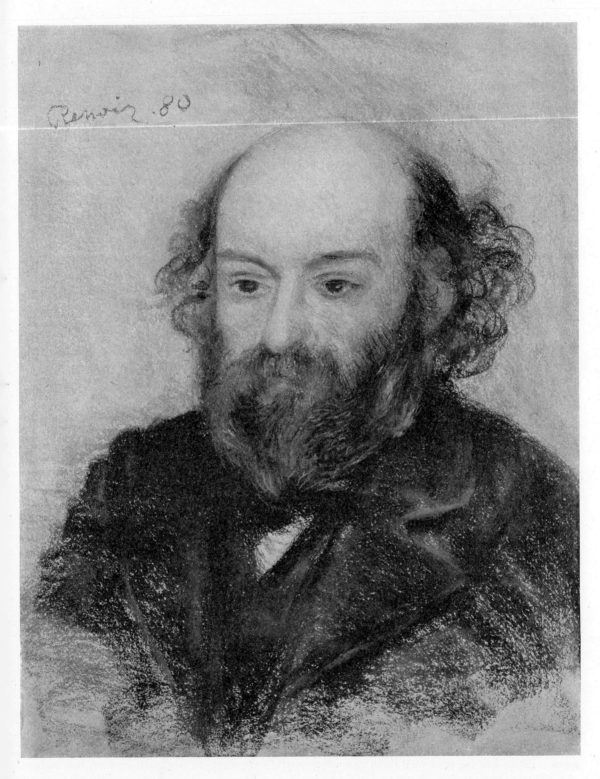

RENOIR: *Portrait of Paul Cézanne, d. 1880. Pastel, 21¾ x 17¼". Durand-Ruel Galleries, New York.*

rather like to know wherein the public is interested in our individual disputes. It's very naive of us to squabble over these things. Degas introduced disunity into our midst. It is unfortunate for him that he has such an unsatisfactory character. He spends his time haranguing at the Nouvelle-Athènes or in society. He would do much better to paint a little more. That he is a hundred times right in what he says, that he talks with infinite wit and good sense about painting, no one doubts (and isn't that the outstanding part of his reputation?). But it is no less true that the real arguments of a painter are his paintings and that even if he were a thousand times more right in his talk, he would still be much more right on the basis of his work. He now cites practical necessities, which he doesn't allow Renoir and Monet. But before his financial losses was he really different from what he is today? Ask all who knew him, beginning with yourself. No, this man has gone sour.—He doesn't hold the big place that he ought according to his talent and, although he will never admit it, he bears the whole world a grudge.

"He claims that he wanted to have Raffaëlli and the others because Monet and Renoir had reneged and that there had to be someone. But for three years he has been after Raffaëlli to join us, long before the defection of Monet, Renoir and even of Sisley.—He claims that we must stick together and be able to count on each other (for God's sake!); and whom does he bring us?—Lepic, Legros, Maureau. . . . (But he didn't rage against the defection of Lepic and Legros, and moreover, Lepic, heaven knows, has no talent. He has forgiven him everything. No doubt, since Sisley, Monet and Renoir have talent, he will never forgive them.) In 1878 [he brought us] Zandomeneghi, Bracquemond, Mme Bracquemond; in 1879 Raffaëlli . . . , and others.—What a fighting squadron in the great cause of realism! ! ! !

"If there is anyone in the world who has the right not to forgive Renoir, Monet, Sisley and Cézanne, it is you, because you have experienced the same practical demands as they and you haven't weakened. But you are in truth less complicated and more just than Degas. . . . You know that there is only one reason for all this, the rights of existence. When one needs money, one tries to pull through as one can. Although Degas denies the validity of such fundamental reasons, I consider them essential. He has almost a persecution complex. Doesn't he want to convince people that Renoir has Machiavellian ideas? Really, he is not only not just, but he is not even generous.—As for me, I have no right to condemn anyone for these motives. The only person, I repeat, in whom I recognize that right is you. I say the only person; I do not recognize that right in Degas who has cried out against all in whom he admits talent, in all periods of his life. One could put together a volume from what he has said against Manet, Monet, you. . . .

"I ask you: isn't it our duty to support each other and to forgive each other's weaknesses rather than to tear ourselves down? To cap it all, the person who has talked so much and wanted to do so much has always been the one who has contributed the least personally. . . . All this depresses me deeply. If there had been only one subject of discussion among us, that of art, we would always have been in agreement. The person who shifted the question to another level is Degas, and we should be very stupid to suffer from his follies.—He has tremendous talent, it is true. I'm the first to proclaim myself his great admirer. But let's stop there. As a human being, he has gone so far as to say to me, in speaking of Renoir and Monet: 'Do you invite those people to your house?' You see, though he has great talent, he hasn't a great character.

"I shall sum up: do you want an exclusively artistic exhibition? I don't know what we shall do in a year. Let us first see what we'll do in two months.—If Degas wants to take part, let him, but without the crowd he drags along. The only ones of his friends who have any right are Rouart and Tillot. . . ."[40]

348

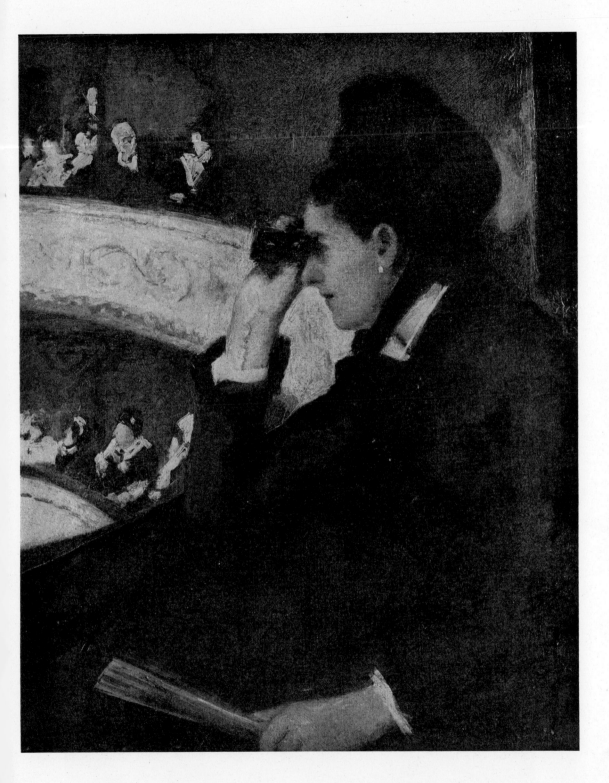

CASSATT: *At the Opera, c. 1880. 32⅝ x 26½". Museum of Fine Arts, Boston.*

PISSARRO: *Woman with a Goat, d. 1879. 25½ x 21¼". Bought from the artist by Mary Cassatt. Collection Count Jan Deym, New York.*

GAUGUIN: *Farmhouse in Brittany, d. 1879. 12½ x 18⅞". Present owner unknown.*

350

CÉZANNE: *The Mill on the Couleuve near Pontoise, c. 1881. 29⅜ x 36⅞". Formerly in the collection of* père *Tanguy. National Galerie, Berlin.*

But Pissarro could not take it upon him to "leave friends in the lurch" and stood by Degas. "He's a terrible man, but frank and loyal," he used to say, and he always remembered that Degas had helped him repeatedly in difficult moments.[41] Moreover, Caillebotte's proposition had been entirely his own; it was by no means certain whether Renoir and Monet would return to the group in any circumstances.—It seemed hardly wise, therefore, to break with Degas.

"I don't know what I shall do," Caillebotte thereupon replied. "I don't believe that an exhibition is possible this year. But I certainly shan't repeat the one held last year."[42]

The chances for a sixth exhibition of the group appeared slim, yet it was organized in spite of the absence of Renoir, Monet, Sisley, Cézanne and now also of Caillebotte. It was held during the month of April again at Nadar's, 35 boulevard des Capucines, but it had little resemblance to the first show of the impressionists. Degas sent only half a dozen works (mostly sketches) and his statuette of a little dancer. Berthe Morisot did not contribute a greater number. Mary Cassatt exhibited studies of children, of interiors

351

and of gardens. Pissarro was represented by twenty-seven paintings and pastels; of these two were lent by Miss Cassatt, one by Rouart, one by Gauguin. Gauguin exhibited eight canvases, of which one belonged to Degas; he also showed two sculptures.[43] (That same year Gauguin carved a wooden box with reliefs of ballet girls after studies by Degas and in 1882 he dedicated and offered to Pissarro a statuette of a girl combing her hair.[44])

Two distinctly different groups were present at the 1881 exhibition: Pissarro and Berthe Morisot, Guillaumin, Gauguin and Vignon on the one side, Degas with Mary Cassatt, Forain, Raffaëlli, Rouart, Tillot, Vidal and Zandomeneghi on the other. And a third group was constituted by those who exhibited or tried to exhibit at the Salon: Renoir, Monet, Sisley and Cézanne. There was every sign that Zola had been right in stating that the impressionist group no longer existed.

NOTES

1. On Cabaner see G. Rivière: Renoir et ses amis, Paris, 1921, ch. VII and G. Moore: Confessions of a Young Man, London, 1888, ch. VI.

2. She had started to paint and had exhibited a self portrait at the Salon of 1876. · On Victorine Meurent see A. Tabarant: Celle qui fut "L'Olympia," *Bulletin de la vie artistique,* May 15, 1921.

3. On Moore see D. Cooper: George Moore and Modern Art, *Horizon,* Feb. 1945.

4. The foregoing is quoted freely from Moore: Reminiscences of the Impressionist Painters, Dublin, 1906, p. 12-14 and 24, as well as from the same author's: Modern Painting, New York, 1898, p. 30-31.

5. J. de Nittis: Notes et souvenirs, Paris, 1895, p. 187-188. On the relationship between Manet and Degas also see F. F. [Fénéon]: Souvenirs sur Manet (interview of Henri Gervex), *Bulletin de la vie artistique,* Oct. 15, 1920.

6. The foregoing is quoted freely from Moore: Reminiscences of the Impressionist Painters, p. 24 and 39, as well as from the same author's: Impressions and Opinions, New York, 1891, ch. Degas.

7. See A. Segard: Mary Cassatt, Paris, 1913, p. 45.

8. See H. Detouche: Propos d'un peintre, Paris, 1895, p. 86.

9. Renoir later expressed his views on craftsmanship in his introduction to Cennino Cennini's "Livre d'Art," Paris, 1911.

10. On the Faure and Hoschedé sales see: Mémoires de Paul Durand-Ruel *in* L. Venturi: Les Archives de l'Impressionnisme, Paris-New York, 1939, v. II, p. 204-205 and 206-207.

11. Pissarro to Murer, summer 1878; see A. Tabarant: Pissarro, Paris, 1924, p. 325-326.

12. Manet to Duret, summer 1878; see *Kunst und Künstler,* March 1914, p. 325-326.

13. See Rivière, *op. cit.,* p. 79-80. On Murer see G. Geffroy: Claude Monet, sa vie, son oeuvre, Paris, 1924, v. II, ch. IX; C. Pissarro: Letters to His Son Lucien, New York, 1943; Duret: Les peintres impressionnistes, ch. on Sisley; Coquiot: Vincent van Gogh, Paris, 1923, p. 239-241; but above all Tabarant, *op. cit.,* whose book is based partly on Murer's private papers. See also Murer's letter to Duret, July 18, 1905 *in* L'impressionnisme et quelques précurseurs, *Bulletin des expositions,* III, Jan. 22-Feb. 13, 1932, Galerie d'Art Braun & Cie., Paris. Paul Alexis published an article on Murer's collection, *Le Cri du Peuple,* Oct. 21, 1887, according to which Murer then owned 8 paintings by Cézanne, 25 by Pissarro, 16 by Renoir, 10 by Monet, 28 by Sisley, 22 by Guillaumin, etc.

14. Pissarro to Murer, 1878; see Tabarant, *op. cit.,* p. 38.

15. Pissaro to Duret, Nov. 1878, *ibid.,* p. 43.

16. Monet to Chocquet, fall 1877; see J. Joëts: Les impressionnistes et Chocquet, *L'Amour de l'Art,* April 1935.

17. Manet to Duret, winter 1877; see T. Duret: Manet and the French Impressionists, Philadelphia-London, 1910, p. 73-74. Duret dated this letter 1875, but Tabarant (Autour de Manet, *L'Art Vivant,* May 4, 1928) has furnished proof that it must have been written late in 1877.

18. See Tabarant, *ibid.* It seems doubtful, however, that Manet actually took some of Monet's paintings in exchange, for at the time of his death, Monet still owed

DEGAS: *Portrait of Mary Cassatt, c. 1879 [?]. Present owner unknown.* DEGAS: *Mary Cassatt at the Louvre, c. 1879. Pastel, 20¼ x 27".*
Private collection, New York.

him money while his estate did not list any particular number of works by Monet.

19. Sisley to Duret, Aug. 18, 1878; see Duret: Quelques lettres de Manet et de Sisley, *Revue Blanche,* March 15, 1899.

20. Cézanne to Zola, March 23, 1878; see Cézanne, Letters, London, 1941, p. 109.

21. Renoir to Durand-Ruel, March 1881; see Venturi: Archives, v. I, p. 115.

22. See Mémoires de Durand-Ruel, *ibid.,* v. II, p. 209.

23. Pissarro to Murer, summer 1878; see Tabarant: Pissarro, p. 41-42.

24. See E. Moreau-Nélaton: Manet raconté par lui-même, Paris, 1926, v. II, p. 75-76.

25. Sisley to Duret, March 14, 1879; see Duret: Quelques lettres de Manet et de Sisley, *op. cit.*

26. Cézanne to Pissarro, April 1, 1879; see Cézanne, Letters, p. 136.

27. A. Silvestre: Le monde des arts, *La Vie Moderne,* April 24, 1879.

28. For a condensed catalogue see Venturi: Archives, v. II, p. 262-264.

29. For Caillebotte's letters concerning this exhibition see: Geffroy, *op. cit.,* v. II, ch. VII.

30. See L. Bénédite: "Madame Charpentier and Her Children," by Auguste Renoir, *Burlington Magazine,* Dec. 1907.

31. Pissarro to Murer, May 27, 1879; see Tabarant, Pissarro, p. 45.

32. On *La Vie Moderne* see J. Rewald: Renoir and his Brother, *Gazette des Beaux-Arts,* March 1945; Edmond Renoir's article on his brother is repr. *in* Venturi: Archives, v. II, p. 334-338.

33. Renoir to Monet, Aug. 23, 1900; see Geffroy, *op. cit.,* v. II, ch. V.

34. See Monet's letter to Duret, spring 1880, quoted *in* H. Graber: Pissarro, Sisley, Monet, nach eigenen und fremden Zeugnissen, Basle, 1943, p. 225-226. Sisley wrote on March 28, 1879, to Charpentier: "Since I decided to exhibit at the Salon I find myself more isolated than ever." See R. Huyghe: Unpublished Letters of Sisley, *Formes,* March 1931.

35. Degas to Bracquemond, March 1880; see Lettres de Degas, Paris, 1931, p. 31-32.

36. This bust was apparently that of Gauguin's wife, done in 1879. It is reproduced, together with other little-known works of those years, *in* P. Gauguin: My father Paul Gauguin, New York, 1937.

37. Cézanne to Zola, May 10, 1880; see Cézanne, Letters, p. 145-146.

38. Zola: Le naturalisme au Salon, *Le Voltaire,* June 18-22, 1880; partly quoted in Venturi: Archives, v. II, p. 276-280; see also Rewald: Cézanne, sa vie, son oeuvre, son amitié pour Zola, Paris, 1939, p. 251-258.

39. See E. Taboureux: Claude Monet, *La Vie Moderne,* June 12, 1880.

40. Caillebotte to Pissarro, Jan. 24, 1881; unpublished document found among Pissarro's papers.

41. See Pissarro's letter to Mirbeau, Oct. 10, 1891, Louvre, Paris.

42. Caillebotte to Pissarro, Jan. 1881; unpublished document found among Pissarro's papers.

43. For a condensed catalogue see Venturi: Archives, v. II, p. 265-267.

44. The box is reproduced in P. Gauguin, *op. cit.,* opp. p. 67, and the statuette is listed in the catalogue of a sale: Tableaux modernes, Paris, June 14, 1930, No. 14, where it is erroneously described as *Tahitienne se coiffant.* According to Pissarro's son, Ludovic Rodo, his father also owned in Osny [1883] a portrait bust of Mme Gauguin.

MORE EXHIBITIONS AND
DIVISIONS OF OPINION

THE DEATH OF MANET

SEURAT, SIGNAC
AND THE SALON DES INDEPENDANTS

At long last the affairs of Durand-Ruel began to take a turn for the better. The effects of the crisis of 1873 had worn off; business began to recover. There was extensive railway building in France, the Bourse was feverish with speculation (Gauguin possibly earned a lot of money at that time), new companies were founded and credit was greatly expanded. In 1880 a newly won friend, Feder, had put large amounts at Durand-Ruel's disposal which made possible several important transactions and at the same time enabled him to help the impressionists. He immediately bought works from Sisley, the poorest and least successful of them all. In 1881 he began once more to acquire regularly the paintings of Monet, Pissarro and Renoir. He also bought Degas' works whenever the latter wanted to sell. Durand-Ruel offered decent prices and instead of purchasing individual paintings often arranged monthly payments according to the painters' needs. They, in turn, sent him more or less their entire output, and accounts were settled periodically. Thus they were able to work without too much worry. "I am not rolling in money," Pissarro wrote to Duret, "I am enjoying the results of moderate but steady sales. I dread only a repetition of the past."[1] Under these circumstances the general outlook took on a better light, and work was accomplished in a happier frame of mind.

Renoir began to travel. Early in 1881 he went to Algiers, attracted by the colorful Orient that had played such an important role in Delacroix's art, and there he painted a *Fantasia* which shows him following in the older painter's footsteps. In Algiers, Renoir met Lhote, Lestringuez and Cordey. In Paris meanwhile his friend, the banker Ephrussi, had been commissioned to send two portraits by Renoir to the Salon; they were admitted.

In 1881 an important change took place in the status of the official exhibition. The State finally abandoned its supervision; an artists' association was formed and entrusted with the organization of the yearly Salons. Every artist whose work had been accepted once was entitled to participate in the election of the jury. Although as a result a more liberal jury was elected (among its members was Guillemet), Manet with difficulty obtained the necessary votes for a second-class medal.

Shortly before the opening of the Salon, Renoir left Algiers. By Easter he was back in the capital, or rather in Chatou and Bougival, where he went to work with renewed enthusiasm. Duret had invited

him to a trip across the Channel, but after having lunched with Whistler at Chatou and possibly questioned him about the young English ladies and their charms, Renoir decided to stay. "I am struggling with trees in bloom, with women and children, and I don't want to look any further," he explained to Duret, adding: "Nevertheless, I constantly have regrets. I think of the trouble I have given you for nothing and I wonder if you will easily swallow my pretty woman's whims, and yet in the midst of all this I am continually catching glimpses of charming English girls. What a misfortune, always to hesitate, but that is the basis of my character, and as I grow older I am afraid I won't be able to change. The weather is very fine and I have some models. This is my only excuse."[2]

It seems, however, that Renoir had an even better excuse. In the large canvas which he then painted in Bougival, at the restaurant Fournaise, there appears for the first time a young girl, Alice Charigat, who was shortly to become his wife. This painting, *Le déjeuner des canotiers,* belongs in the same category with *Le bal au Moulin de la Galette* and with the *Boating Party at Chatou,* painted two years before. It is another effort to seize the animated outdoor mingling of people in an atmosphere glistening with sunshine and the joy of living. Once more Renoir's friends posed for him. Opposite the future Mme Renoir, who holds a little dog, appears Caillebotte, seated backwards on a chair (he seems to be represented younger than he actually looked at that time). Next to Caillebotte sits Angèle, the model whom Renoir had painted asleep in a chair with a cat on her lap. In the background, in a top hat, stands Ephrussi, on the right are Lestringuez, and Lhote in a straw hat.

Though Renoir had renounced a trip to England, Sisley crossed the Channel and spent the summer on the Isle of Wight. In Pontoise, meanwhile, Pissarro again gathered his friends around him. Cézanne was there, and so was Gauguin, watching Cézanne's efforts to find a unique expression for his rich sensations. In his own works Gauguin came steadily closer to Pissarro's technique and palette. He did so entirely upon his own, for it was far from Pissarro's intention to press his conceptions on others. The advice he offered Gauguin cannot have been very different from that he gave to his own sons, who began to draw and to paint (his oldest, Lucien, was then nineteen). "Scorn my judgment," he told them. "I have such a longing for you all to be great that I cannot hide my opinions from you. Accept only those that are in accord with your sentiments and mode of understanding. Although we have substantially the same ideas, these are modified in you by youth and a milieu strange to me; and I am thankful for that; what I fear most is for you to resemble me too much. Be bold, then, and to work! . . ."[3]

A young painter of his acquaintance later noted down the more specific advice given by Pissarro, advice which seems to sum up the conceptions and methods of all the impressionist landscapists. This was the gist of what Pissarro told him: "Look for the kind of nature that suits your temperament. The motif should be observed more for shape and color than for drawing. There is no need to tighten the form which can be obtained without that. Precise drawing is dry and hampers the impression of the whole, it destroys all sensations. Do not define too closely the outlines of things; it is the brushstroke of the right value and color which should produce the drawing. In a mass, the greatest difficulty is not to give the contour in detail, but to paint what is within. Paint the essential character of things, try to convey it by any means whatsoever, without bothering about technique.—When painting, make a choice of subject, see what is lying at the right and what at the left, and work on everything simultaneously. Don't work bit by bit but paint everything at once by placing tones everywhere, with brushstrokes of the right color and value, while noticing what is alongside. Use small brushstrokes and try to put down your perceptions immedi-

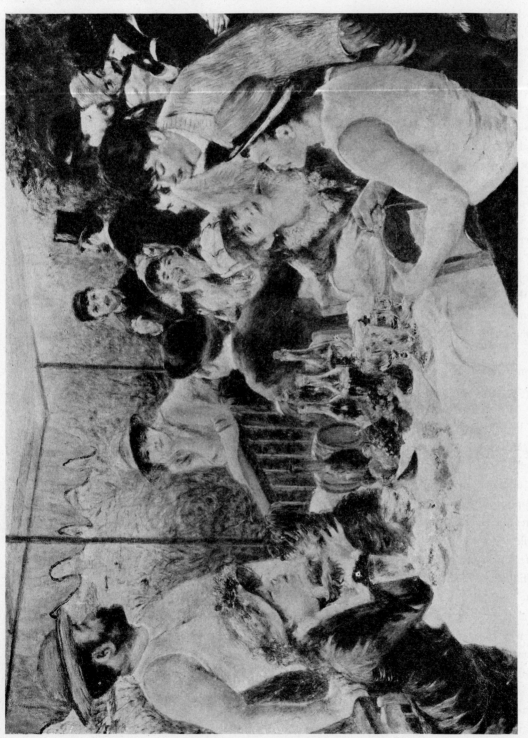

RENOIR: *Le déjeuner des canotiers, Bougival, d. 1881. (At the left, holding a little dog, is the future Mme Renoir.) 51 × 68". Phillips Memorial Gallery, Washington, D. C.*

ately. The eye should not be fixed on one point, but should take in everything, while observing the reflections which the colors produce on their surroundings. Work at the same time upon sky, water, branches, ground, keeping everything going on an equal basis and unceasingly rework until you have got it. Cover the canvas at the first go, then work at it until you can see nothing more to add. Observe the aerial perspective well, from the foreground to the horizon, the reflections of sky, of foliage. Don't be afraid of putting on color, refine the work little by little.—Don't proceed according to rules and principles, but paint what you observe and feel. Paint generously and unhesitatingly, for it is best not to lose the first impression you feel. Don't be timid in front of nature: one must be bold, at the risk of being deceived and making mistakes. One must have only one master—nature; she is the one always to be consulted."[4]

But Gauguin had not yet enough confidence in his own gifts to be bold and preferred to follow his master. After he had returned from his holidays to Paris and to the bank, he missed Pissarro so much that he complained in a letter: "There is a theory I have heard you profess, that to paint it is absolutely necessary to live in Paris, so as to keep up with ideas. No one would say so at this moment when the rest of us poor wretches are going to the Nouvelle-Athènes to be roasted, while you are not concerned for a single instant with anything except living as a hermit. . . . I hope to see you turn up one of these days." Gauguin also inquired: "Has M. Cézanne found the exact *formula* for a work acceptable to everyone? If he discovers the prescription for compressing the intense expression of all his sensations into a single and unique procedure, try to make him talk in his sleep by giving him one of those mysterious homeopathic drugs, and come immediately to Paris to share it with us."[5] Cézanne, nervous and suspicious, did not take this pleasantry too well and seriously began to fear that Gauguin was out to steal his sensations.

Manet's bad health had obliged him to heed his doctor's advice and take some rest in the country. In 1880 he had gone to Bellevue in the outskirts of Paris; in 1881 he rented a house with a garden in Versailles. "The country has charms only for those who are not obliged to stay there,"[6] he complained to Astruc, but he tried to make the best of it. Prevented from working on large paintings, he began to paint in his garden and to observe the phenomena of light which so attracted the impressionists. In doing so he completely adopted their technique of small and vivid strokes as well as their bright colors. The various corners of the garden in Versailles, which he painted registering every shift of light, are represented in a truly impressionist fashion. They show his virtuosity combined with a close observation of nature. The happy results, however, did not prevent Fantin from accusing Manet of degenerating through "contact with those dilettantes who produce more noise than art."[7]

After his return to Paris, Manet had the pleasant surprise of seeing his old friend Antonin Proust become Minister of Fine Arts in a cabinet formed by Gambetta. One of Proust's first acts was to acquire for the State a series of paintings by Courbet, the contents of whose studio were then being sold at auction. Proust also put both Faure and Manet on the list of those to be decorated with the Legion of Honor. Renoir, who received these bits of news at Capri, was delighted. "I have wanted for a long time to write you about Proust's nomination," he wrote in December to Manet, "and I haven't done so. However, an old number of the *Petit Journal* has just come into my hands, referring with delight to the purchase of paintings by Courbet, something that gives me intense pleasure; not for Courbet's sake, the poor fellow, who cannot enjoy his triumph, but for the sake of French art. So there is at last a cabinet minister who suspects that painting exists in France. And I was expecting to see in the following issues of the *Petit Journal* your nomination as chevalier of the Legion of Honor, which would have brought applause from

358

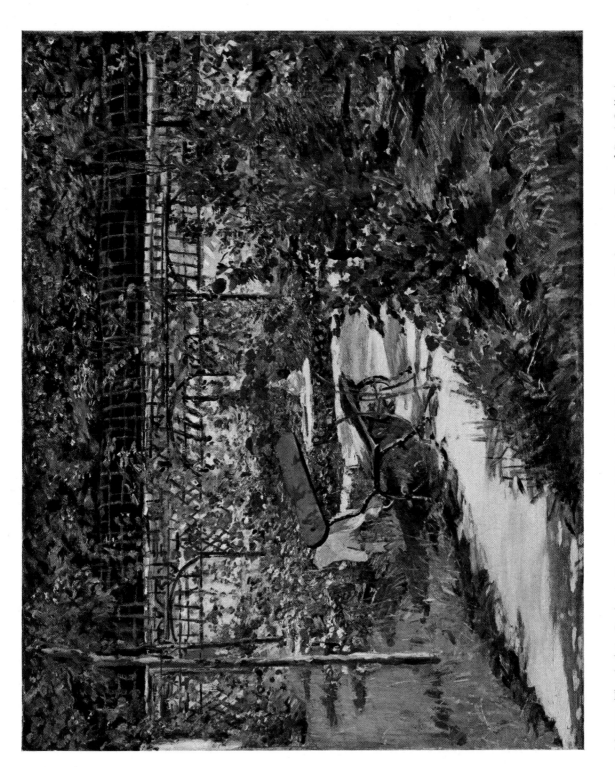

MANET: The Artist's Garden in Versailles, 1881. 25⅝ x 31⅞″. Private collection, New York, courtesy Durand-Ruel Galleries.

RENOIR: *Gondola in Venice, 1881. 21¼ x 25¾". Collection Siegfried Kramarsky, New York.*

me on my distant island. But I hope it is only being delayed and that when I return to the capital I shall have to salute you as the painter beloved of everyone, officially recognized. . . . I don't think you will imagine that there is a single complimentary word in my letter. You are the happy fighter, without hatred for anyone, like an ancient Gaul; and I like you for that gaiety maintained even in the midst of injustice."[8]

From Capri (where this letter was mailed) Renoir went to Palermo and there, on January 15, 1882, the day after Wagner had finished *Parsifal,* he painted during a short sitting a portrait of the composer, who was unwilling to grant more than twenty-five minutes.[9] Renoir did this portrait at the request of his old friend Judge Lascaux, who with Bazille and Maître had taken him to Wagner's first concerts in Paris. The painter then returned to Naples, where he had stopped on his way south, attracted by the city, the bay and Vesuvius as well as by the Museum. But the reason that had prompted his trip to Italy was Renoir's desire to study the works of Raphael, which he had done at Rome, after having spent some time in Venice painting the Lagoon, admiring Veronese and Tiepolo. His mind was full of all these new impressions, and from Naples he wrote to Durand-Ruel: "I have been to see the Raphaels in Rome. They are wonderful and I should have seen them before. They are full of knowledge and wisdom. Unlike me, he did not

359

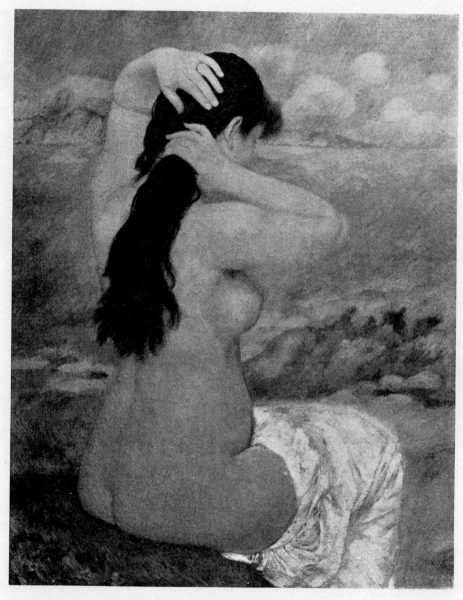

RENOIR: *Bather, d. 1885. 36¼ x 28¾". Private collection, New York.*

seek the impossible. But it's beautiful. I prefer Ingres for oil painting. But the frescoes are admirable in simplicity and grandeur." As for his own efforts, he was little satisfied. "I am still suffering from experimenting. I'm not content and I am scraping off, still scraping off. I hope this craze will have an end. . . . I am like children in school. The white page must always be nicely written and bang—a blot. I am still at the blotting stage—and I'm forty."[10]

On his way back to Paris, Renoir met Cézanne in Marseilles and decided to stay with him for a short while at L'Estaque. There he found natural scenery which does not change much with the seasons (it

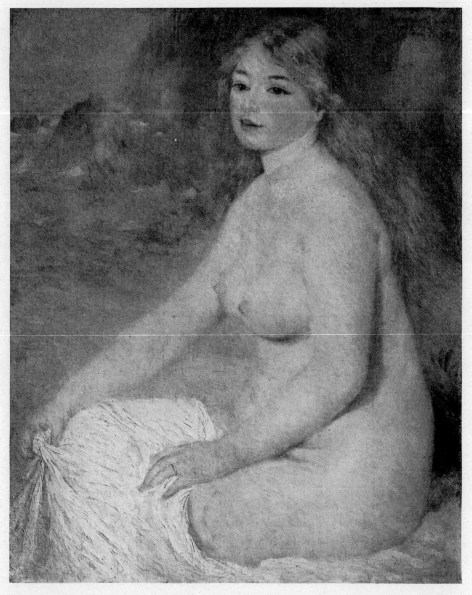

RENOIR: *Bather, supposedly painted in Naples, d. 1881. 33 x 25¾". Collection Sir Kenneth Clark, London.*

was January 1882) and which is bathed every day in the same strong light. Enchanted, he delayed his return to Paris, where Mme Charpentier was expecting him to do a pastel portrait of one of her daughters. "I am in the process of learning a lot," he explained to her, "and the longer I take, the better the portrait will be. . . . I have perpetual sunshine and I can scrape off and begin again as much as I like. This is the only way to learn, and in Paris one is obliged to be satisfied with little. I studied a great deal in the Naples museum; the Pompeii paintings are extremely interesting from every point of view; then too, I am staying in the sun, not to do portraits in full sunlight, but, while warming myself and observing a

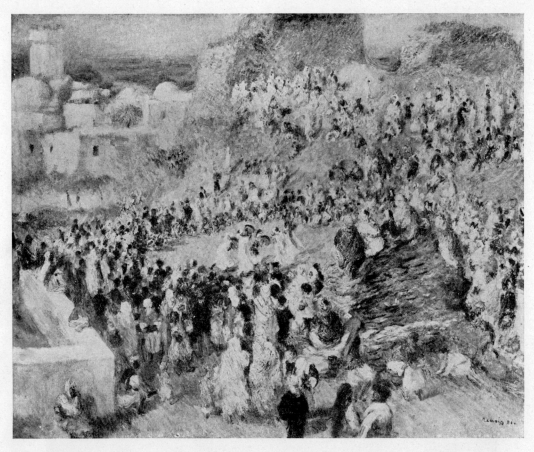

RENOIR: *Fantasia, Algiers, d. 1881. 28¾ x 35¾". Wildenstein Galleries, New York.*

great deal, I shall, I believe, have acquired the simplicity and grandeur of the ancient painters. Raphael, who did not work out-of-doors, nevertheless studied sunlight, for his frescoes are full of it. Thus as a result of seeing the out-of-doors, I have finished by not bothering any more with the small details that extinguish instead of kindling the sun."[11]

While in L'Estaque, Renoir fell seriously ill with pneumonia. Cézanne and his old mother hurried to his side and nursed him with a devotion that deeply touched him; in a letter to Chocquet he expressed his gratitude for their tender care. During this illness Renoir received—and with rather bad humor— an invitation from Caillebotte to participate in a seventh exhibition of the impressionist group.

Early in 1882 Caillebotte had set out once more to organize a new exhibition for his friends. He went to see Rouart, who, inclined to be conciliatory, promised to persuade Degas to separate from Raffaëlli. But those efforts failed, and Caillebotte bitterly informed Pissarro: "Degas won't give up Raffaëlli for the simple reason that he is asked to, and he'll do it all the less, the more he is asked to do so."[12] Discouraged, Pissarro passed on this news to Gauguin, who immediately suggested that an exhibition be held without Degas. To Gauguin a new exhibition seemed vital, since it was the sole possibility to show his work, which was little by little absorbing the greater part of his energies. "You will say that I am always impetuous

RENOIR: *Rocky Crags at L'Estaque, d. 1882. 25¾ x 32". Museum of Fine Arts, Boston.*

and that I want to hurry things," Gauguin replied to Pissarro, "but you will nevertheless have to admit that in all this my calculations were correct. . . . Nobody will ever dissuade me that, for Degas, Raffaëlli is a pure pretext for a break; that man has a perverse spirit which destroys everything.—Think about it all, and *let's act,* I entreat you."[13]

Caillebotte proposed that they organize an exhibition without Degas, grouping Pissarro, Monet, Renoir, Cézanne, Sisley, Berthe Morisot, Gauguin, himself, as well as Miss Cassatt if she would consent to show without Degas. Pissarro went to invite Berthe Morisot. She was in Nice; Manet received him instead and then wrote his sister-in-law: "I have just had a visit from that difficult fellow Pissarro who talked to me about your next exhibition; those gentlemen do not give the impression of being of one mind. Gauguin plays the dictator; Sisley, whom I also saw, would like to know what Monet is to do. As for Renoir, he hasn't yet returned to Paris."[14] Berthe Morisot accepted the invitation.

Meanwhile Caillebotte had written to Monet, who was working in Dieppe and answered that the exhibition should be done either properly or not at all, without promising his participation. Renoir replied that he was ill and unable to come; he too, it seems, expressed little inclination to take part. Disgusted with his lack of success, Caillebotte was ready to give up.

At this moment, apparently, Durand-Ruel took the matter into his own hands. Since he was again the dealer who exclusively handled the pictures of the impressionists, he was not only annoyed by their disputes but actually interested in the projected exhibition. He had just been dealt a terrible blow: the flurry of prosperity inaugurated in 1880 was followed by a crash in 1882 with a series of bankruptcies. Among the bankrupt figured Durand-Ruel's friend Feder, and this put the dealer under obligation to return the money which Feder had advanced. But Durand-Ruel was determined not to let this interfere with his plans. He himself now wrote to Monet and Renoir, pressing them to join the others. Renoir's answer was that he would follow Durand-Ruel in whatever projects he had, but he declined to deal with his colleagues. He was sour because the show had been discussed without him, because he had not been invited to the three previous exhibitions and because he suspected that he was invited only to fill a gap. He wrote several ill-tempered letters to Durand-Ruel, explaining that he was again exhibiting at the Salon and refusing to join in any show of the so-called *Indépendants*. He first accepted the idea of a group formed exclusively by Monet, Sisley, Berthe Morisot, Pissarro and Degas, then voiced distrust of Gauguin and Pissarro, making some disagreeable comments on the latter and finally accusing him of political and revolutionary tendencies with which he would have nothing to do. Yet he definitely authorized Durand-Ruel to show pictures of his, owned by the dealer, on condition that they be listed as loaned by Durand-Ruel and not by himself.

Monet's answer was more or less the same. He refused to be associated with artists who did not belong to the real impressionist group. But upon Durand-Ruel's insistence he too felt embarrassed in declining an invitation from the man who had done so much for him and his comrades. Since Pissarro had asked that next to the old-timers three of his friends—Guillaumin, Gauguin and Vignon—be admitted, Monet specified that he had nothing against these men but felt himself bound to Caillebotte. He was ready to take part, and even to separate himself from Caillebotte, if Pissarro would abandon his protégés. He repeated, however, that he could accept only if Renoir also was willing.[15] In a new letter to Durand-Ruel Renoir finally agreed to show with the others after explaining once more his attitude: "I hope indeed that Caillebotte will exhibit, and I also hope that these gentlemen will drop this ridiculous title *Indépendants*. I would like you to tell these gentlemen that I am not going to give up exhibiting at the Salon. This is not for pleasure but, as I told you, it will dispel the revolutionary taint which frightens me. . . . It is a small weakness for which I hope to be pardoned. Since I exhibit with Guillaumin, I may as well exhibit with Carolus-Duran. . . . Delacroix was right to say that a painter ought to obtain at any cost all honors possible. . . ."[16]

Eventually Caillebotte as well as Pissarro's friends were admitted; Monet joined, and with him Renoir, who even apologized for some nasty remarks made during his illness. But Renoir was unable to attend the exhibition. In March he left L'Estaque and returned to Algiers. As for Degas, he declined to participate in the show since his followers were barred. Mary Cassatt loyally went into "exile" with him.

The exhibition was opened on March 1, 1882, at 251 rue St.-Honoré, in premises rented by Durand-Ruel. Manet went there and informed Berthe Morisot: "I found the whole brilliant crowd of impressionists at work hanging a great many pictures in an enormous room. . . . Degas remains a member, pays his subscription, but doesn't exhibit. The association keeps the name, *Indépendants*, with which he adorned it. . . ."[17]

Never had the impressionists organized an exhibition so lacking in alien elements, never had they been so much to themselves. After eight years of common struggle they managed for the first time (but

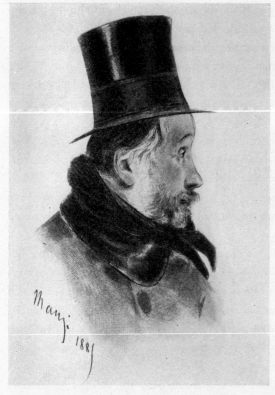

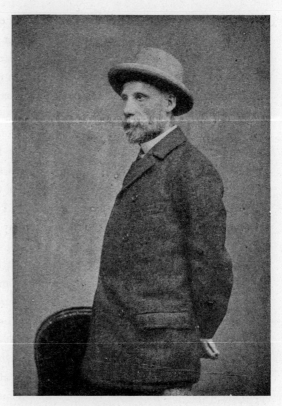

MANZI: *Portrait of Edgar Degas, d. 1885.*

Photograph of Auguste Renoir, 1880-85.

with what difficulties!) to stage an exhibition which truly represented their art. Monet exhibited thirty-five paintings, mostly landscapes and still lifes. Pissarro showed twenty-five oils and eleven gouaches (Durand-Ruel refused his request to present these in white frames). Renoir's share was twenty-five canvases, among them his *Déjeuner des canotiers.* Sisley was represented by twenty-seven works, Berthe Morisot by nine, Gauguin by thirteen, Caillebotte by seventeen, Vignon by fifteen and Guillaumin by thirteen paintings and as many pastels.[18] The catalogue listed very few lenders; most of the exhibited works belonged to Durand-Ruel, who soon had every reason to be satisfied. The press was less aggressive this time, there appeared even a series of favorable notices, and several new buyers turned up.

Apparently Durand-Ruel had not cared to invite Cézanne to this exhibition, not having yet manifested great interest in his work. But Cézanne would probably have refused to join the others, since he had in 1882, for the first time in his life, the satisfaction of being accepted at the Salon. After his works had been once more rejected, Guillemet made use of a prerogative granted all jury members, that of having admitted without discussion the work of one of their students. Consequently Cézanne's name was accompanied in the catalogue by the note: "pupil of Guillemet."

At the Salon of 1882 Manet, now *hors concours,* exhibited a large canvas, *Le bar aux Folies-Bergère,* an ambitious composition painted with tremendous virtuosity. Once more he revealed the power of his brush, the subtlety of his observation and courage to be unconventional. Like Degas he had remained consistently interested in contemporary subjects—he even planned to paint an engineer on a locomotive—

yet he approached these not with the eye of a cold observer but with the brilliant enthusiasm of the explorer on a trail of new aspects of life. As a matter of fact Degas did not like his last painting, calling it "dull and subtle." *Le bar aux Folies-Bergère* had cost Manet great efforts, for he began to suffer severely from locomotor ataxia. He was disappointed when the public again refused to understand his work, seeing in the canvas the subject rather than its masterly rendition. In a letter to Albert Wolff he could not keep from saying half jokingly and half in earnest: "I shouldn't mind reading after all, while I'm still alive, the splendid article which you will write about me once I am dead."[19]

After the closing of the Salon, Manet was at last officially nominated *Chevalier de la Légion d'Honneur*. Great as was his satisfaction, it was tinged with some bitterness. When the critic Chesneau congratulated him and also conveyed the best wishes of Count Nieuwerkerke, Manet bluntly replied: "When you write to Nieuwerkerke, you may tell him that I appreciate his kind thought, but that he might have conferred the decoration. He could have made my fortune; and now it is too late to compensate for twenty year's lack of success. . . ."[20]

Manet spent another summer close to Paris, at Rueil, too ill to engage in any absorbing work. He did pastels and watercolors, wrote charming letters to many of his elegant lady friends, begged them to visit him, to come and pose for portraits. When he returned to Paris in the fall, his friends began to be alarmed about his condition. The winter brought no improvement. Early in 1883 his strength visibly abandoned him, and he soon had to stay in bed. As a result of paralysis, gangrene threatened his left leg, and two surgeons advised amputation to avert it. Dr. Gachet, a convinced homeopath, was opposed to the intervention and argued that Manet would never be able to endure life on crutches. In April he was operated upon, but the amputation failed to save him. On his sickbed he was haunted by the thought of Cabanel and his perpetual hostility. "That man has good health," he groaned. These were among his last words. Manet died on April 30, 1883.[21] "He was greater than we thought," Degas mournfully admitted.

The sad news reached Monet at Giverny, where he was just moving from Poissy. He left everything and hurried to Paris. The funeral took place on May 3. The pall-bearers were Antonin Proust, Claude Monet, Fantin-Latour, Alfred Stevens, Emile Zola, Théodore Duret and Philippe Burty. Proust spoke a few words full of emotion. Among those who attended were Pissarro and Cézanne and doubtless also Berthe Morisot, who lost more than a brother-in-law. Eva Gonzalès was unable to come; she had just given birth to a child and learned of Manet's death while still in bed. Griefstricken, she insisted on herself making a funeral wreath for her master. A few days later, on May 5, she died within a few seconds, of an embolism.

Albert Wolff's obituary article would not have satisfied Manet; it was extremely reticent. Soon, however, a noticeable change could be observed in the general attitude toward the painter. The prices of his pictures began to rise, and less than one year after his death a large memorial show was prepared, to be held—of all places—at the *Ecole des Beaux-Arts*. The officials were now eager to seize their share of Manet's mounting fame. Pissarro witnessed this with sadness and disgust. There appeared a dreadful cynicism in Manet's posthumous fate, made even more unbearable by the fact that the impressionists had again to struggle with misery.

The new blow suffered by Durand-Ruel slowly revealed repercussions: he no longer was able to pay his painters regularly nor could he take all their work. But he did his best to hold out against odds. His position was rendered even more difficult by the increasing activity of his sole great rival, Georges Petit,

MANET: *Le bar aux Folies-Bergère*, d. 1882 *(but painted in 1881). 37¾ x 50". Exhibited at the Salon of 1882. National Gallery, London.*

MONET: *View of Vernon, d. 1883. 26¾ x 23⅝". Private collection, U.S.A.*

who in 1882 had founded with de Nittis *L'Exposition Internationale,* which immediately attracted elegant crowds to his luxurious galleries. Monet and Pissarro, impressed by Petit's sumptuous display, even asked Durand-Ruel whether he might not organize a new group show in his opponent's gallery. But Durand-Ruel, having just established new quarters on the boulevard de la Madeleine, was naturally opposed to this. Apparently unwilling to go through another ordeal of arranging a group exhibition, Durand-Ruel decided instead to put up a series of one-man shows, although Sisley and Monet were against this project. He opened a show of Monet's works in March (Monet complained that it had not been properly prepared), of Renoir's in April, Pissarro's in May and Sisley's in June 1883.[22] At the same time he exhibited a number of their paintings in London and planned other exhibitions abroad. There was little interest, however, and, as Durand-Ruel now asked higher prices—more than 1000 francs for many canvases—there were no buyers. Confronted with this fiasco, the painters felt gloomy again. Monet was particularly depressed because his works had never before met with so much indifference. A letter which he received from Pissarro could hardly cheer him up.

"As to giving you news of our relations with Durand-Ruel," Pissarro wrote in June, "I can only make

CAILLEBOTTE: *The Market Place, d. 1883. 26⅛ x 32½". Present owner unknown.*

guesses. Besides, the trouble we have in seeing any money come in is enough to show that the situation is difficult; we all suffer from it. . . . I know that sales are at a standstill, in London and in Paris. My show did nothing as far as receipts are concerned. . . . As for Sisley, it is even worse—nothing, nothing at all.—Some of our pictures have been sent to Boston. . . . There is also question of an exhibition in Holland. You see Durand-Ruel is really very active and anxious to push us at any cost. . . . I certainly hear other dealers, brokers and art-speculators saying, 'He will only last another week,' but that kind of talk has been going on for several months. Let's hope it is only a bad crossing. . . ."[23]

While Durand-Ruel's multiple efforts failed to reap any fruit, the painters once more experienced agonizing uncertainties, had once more to borrow money, if they could find it, to lose days and weeks chasing after possible buyers, to beg friends to purchase on humiliating terms, to rely on the generosity of Caillebotte and a few others, but above all to work without any peace of mind. Moreover, most of them were profoundly dissatisfied with their work.

Pissarro, who had left Pontoise for nearby Osny, where Gauguin joined him, was hesitant. The compliments which he received at his show in May 1883 did not quiet his doubts. "The ones I value most,"

he wrote his son Lucien, "came from Degas, who said he was happy to see my work becoming more and more pure. The etcher Bracquemond, a pupil of Ingres, said—possibly he meant what he said—that my work shows increasing strength. I will calmly tread the path I have taken, and try to do my best. At bottom, I have only a vague sense of its rightness or wrongness. I am much disturbed by my unpolished and rough execution; I should like to develop a smoother technique, while retaining the old fierceness"[24] He felt himself sad, tame and lusterless next to the *éclat* of Renoir.

Renoir, at the same time, was equally assailed by doubts. The study of Raphael and the Pompeian frescoes had left a deep impression and made him wonder whether he had not neglected drawing too much. "Around 1883," he later acknowledged, "a sort of break occurred in my work. I had gone to the end of impressionism and I was reaching the conclusion that I didn't know how either to paint or to draw. In a word, I was at a dead end."[25] He destroyed a number of canvases and set out with determination to acquire the craftsmanship which he thought he lacked. Turning toward line as a means of discipline, he applied himself to simplifying forms at the expense of color. Searching at times for a simple, at times for an elegant line, he tried to imprison breathing forms in rigorous contours—he did not always completely escape the danger of rigidness and dryness.

For guidance Renoir now turned once more to the works of the masters of the past, to the museum. And he remembered also that Corot had once told him that one can never be sure about what one does out-of-doors, that one must always go over it in the studio. He began to realize that while working in the open he had been too preoccupied with the phenomena of light to devote enough attention to other problems. "While painting directly from nature," he stated, "the artist reaches the point where he looks only for the effects of light, where he no longer composes, and he quickly descends to monotony."[25] So great was his dissatisfaction with what he had achieved hitherto that he was seized by an actual hatred for impressionism. As an antidote he painted several canvases in which every detail—including tree leaves— was first carefully drawn with pen and ink on the canvas before he took his brushes and added color. But at the same time he complained of having lost much time by working in the studio and regretted not having followed Monet's example. In an effort to reconcile these opposite conceptions he labored for three years on a large canvas of bathers (p. 405) in which he tried to escape impressionism and to re-establish the link with the eighteenth century; he actually based his composition on a relief by Girardon.[26] He also painted a series of nudes and three large panels of dancers, for which a young model posed, Suzanne Valadon, who customarily worked for Puvis de Chavannes.

Like Renoir, Monet was dissatisfied with his work and destroyed several canvases in a sudden fit of discontent, later regretting his action. He began to rework many of his recent canvases in a constant effort to improve them, and he complained in a letter to Durand-Ruel: "I have more and more trouble in satisfying myself and I have come to a point of wondering whether I am going crazy or whether what I do is neither better nor worse than before, but that the fact is simply that I have more difficulty now in doing what I formerly did with ease."[27]

In December 1883 Monet and Renoir left together for a short trip to the Côte d'Azur, in the search for new motifs. (They met Cézanne briefly, probably in Marseilles.) Monet was immediately taken with the beauty of the Mediterranean landscape, with the violence of its blues and pinks. He decided to return there early the following year but was careful to beg Durand-Ruel not to reveal his plans to anybody, explaining frankly: "Nice as it has been to make a pleasure-trip with Renoir, just so would it be upsetting

RENOIR: *Dance at Bougival, d. 1883. (Suzanne Valadon posed for this painting.) 70 x 38". Museum of Fine Arts, Boston.*

for me to travel with him to work. I have always worked better alone and from my own impressions."[28] The old community of work had ceased to exist. The rift among the painters was no longer merely one of personal antagonism: they began to abandon the common ground, each searching in a different direction.

It seems symbolical that some of the painters now established themselves farther away from Paris and that their contact thus became less frequent. In 1883 Monet had moved to Giverny, where he lived with Mme Hoschedé, who was to become his second wife. Giverny, halfway down the Seine to Rouen, offered a great variety of subjects with the river, the countryside and especially the garden of Monet's house. The year before Sisley had settled on the other side of Paris, at Saint-Mammès near Moret, close to the Loing canal, the Seine and Fontainebleau forest. In 1884 Pissarro rented a house in Eragny, three times as far from Paris as Pontoise. Cézanne remained for increasingly long intervals in the South, working in Aix, particularly on his father's estate, Le Jas de Bouffan, or in neighboring towns and villages. To keep in touch to some extent the painters and their friends, like Duret, Mallarmé, Huysmans *et al.*, decided to meet at least once every month in Paris at "impressionist dinners," but these gatherings were seldom complete. Cézanne could not attend, and Pissarro often found himself unable to raise the necessary money.

At these dinners Degas apparently showed himself less entertaining, more morose than before. He went through a period of discouragement and looked upon himself almost as an old man, now that he had reached fifty. Explaining his state of mind he wrote to a friend: ". . . One closes, like a door, and not only upon friends. One cuts off everything around one and, when quite alone, extinguishes, in a word, kills oneself, out of disgust. I was so full of projects; here I am blocked, powerless. And furthermore, I've lost the thread. I always thought I had time; what I didn't do, what I was prevented from doing—in the midst of all my difficulties and in spite of the weakness of my eyes—I never gave up hope of starting one fine day. I hoarded all my plans in a cupboard of which I always carried the key with me, and I've lost that key. Lastly, I feel that the state of coma I am in I shan't be able to throw off. I shall keep myself occupied, as those who do nothing say, and that will be all."[29]

Degas spent the summer of 1884 with the Valpinçons at Ménil-Hubert, modeling there a large bust of their daughter Hortense, which was destroyed while being cast in plaster.

Renoir continued to lead an unsettled life, traveling much and repeatedly visiting new friends, the Bérards, at Wargemont. It was from La Roche-Guyon, where he spent the summer of 1885 (and where Cézanne joined him before visiting Zola at Médan) that Renoir announced to Durand-Ruel his having finally found the new style which satisfied him, "I have taken up again, for good, the old painting soft and gracious. . . . It is nothing new, but it is a continuation of the pictures of the eighteenth century."[30] Monet meanwhile—also travelling frequently, looking for new subjects—progressed in an opposite direction, accentuating his colors and modeling forms more vigorously; Sisley tried to renovate his style on similar lines. As for Pissarro, he was still undecided.

Pissarro had spent the fall of 1883 in Rouen, where Murer had opened a hotel. Gauguin announced that he would join them, explaining to Pissarro that since the city was full of wealthy people, they might very well be induced to buy some paintings. Having finally resolved to abandon the bank in order to "paint every day" (the crash may have prompted this decision), Gauguin thus moved with his Danish wife and their five children to Rouen. "Gauguin disturbs me very much," Pissarro wrote to his oldest son. "He is so deeply commercial, at least he gives that impression. I haven't the heart to point out to him how false and unpromising is his attitude; true his needs are great, his family being used to luxury, just

DEGAS: *The Laundress, 1882. 32½ x 26⅛". Formerly in the Faure Collection. Private collection, Paris.*

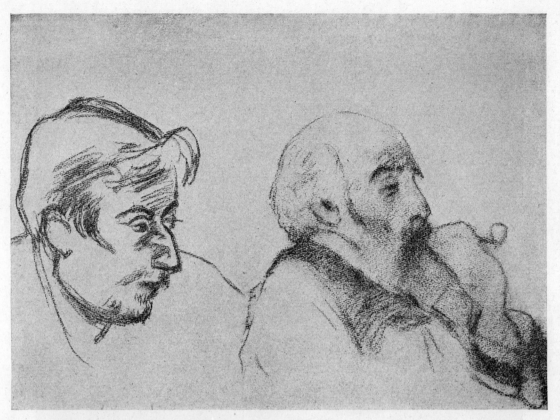

PISSARRO: *Portrait of Gauguin* — GAUGUIN: *Portrait of Pissarro, c. 1883. Drawing. Collection Paulémile Pissarro, Paris.*

the same his attitude can only hurt him. Not that I think we ought not try to sell, but I regard it a waste of time to think *only* of selling, one forgets one's art and exaggerates one's value."[31] Moreover, Pissarro was faced with the unpleasant task of explaining to Gauguin that he, Monet and Renoir had decided not to hold a new exhibition in 1884. Recognizing that Gauguin had still his reputation to make, he knew that this would be a blow.

Gauguin was soon to be disillusioned in Rouen. Unable to sell anything, living on his savings, he saw them dwindle rapidly. And his wife, unhappy and completely uprooted, could not get used to the idea of having for a husband an unsuccessful painter instead of a well-to-do business man. Pissarro insisted on warning his friend. "Tell Gauguin," he wrote to Murer in August 1884, "that after thirty years of painting . . . I'm turning my pockets inside out. Let the younger generation remember!"[32] Toward the end of the year Mme Gauguin had enough of this life and tried to persuade the painter to go with her and the children to Denmark, where they could stay with her family. Her secret hope probably was that her relatives might succeed in convincing Gauguin to abandon art and take up a business career again. Reluctantly Gauguin agreed to leave for Copenhagen.

Apparently Gauguin had expected Durand-Ruel to take some interest in his works, but from what Pissarro told him he was obliged to give up this hope. As a matter of fact the dealer was constantly on

374

PISSARRO: *The Road from Pontoise at Osny, d. 1883. 16½ x 13". Present owner unknown.*

GAUGUIN: *The Road from Pontoise at Osny, d. 1883. 14⅛ x 10½". Present owner unknown.*

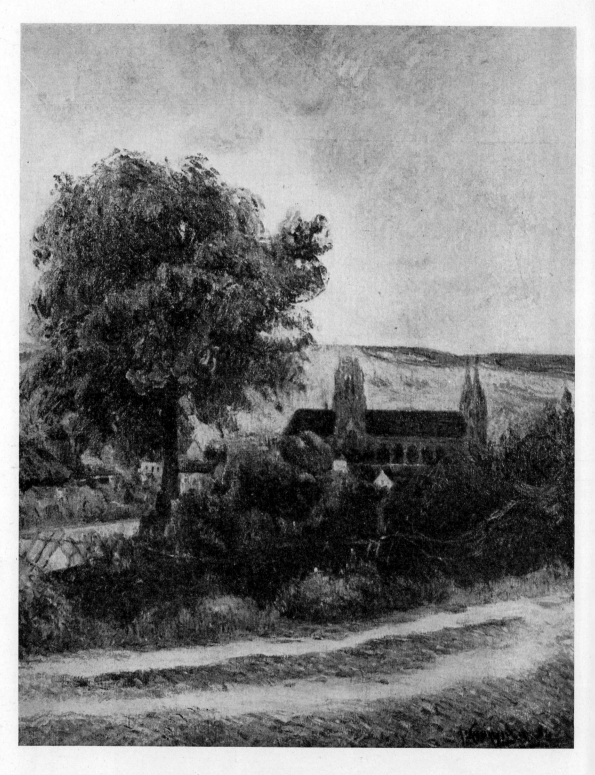

GAUGUIN: *Landscape near Rouen, d. 1884. 36 x 29". French Art Galleries, New York.*

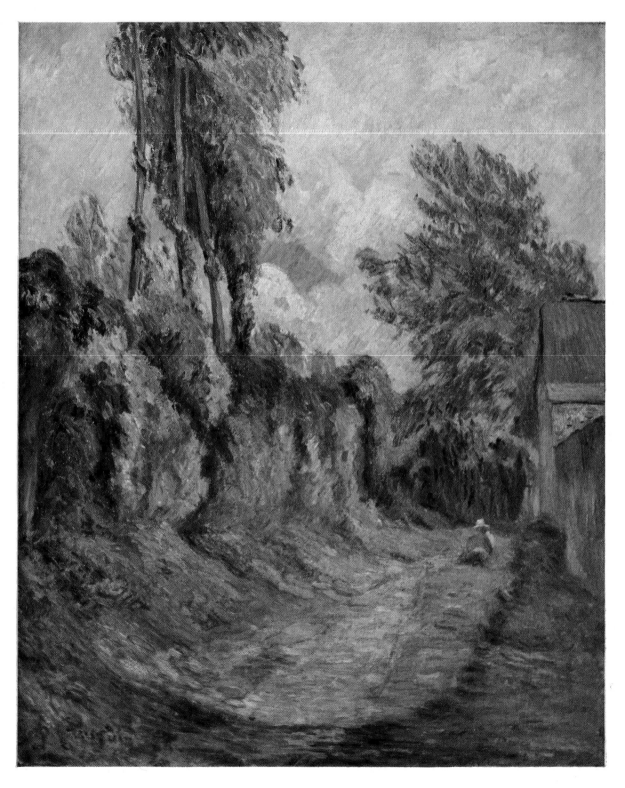

GAUGUIN: Country Lane, d. 1884. 28¼ x 23½". Collection J. K. Thannhauser, N. Y.

the verge of ruin. He later confessed that he owed more than a million francs in 1884.[33] "I wish I were free to go and live in the desert!" he exclaimed, and more than once he had to tell his painters: "I am terribly sorry to leave you without a penny, but I have nothing at all at the present moment. I must even greet misfortune with a smile and have to give the appearance of being almost rich."[34] The other dealers did all they could to contribute to Durand-Ruel's defeat. They threatened, for instance, to get hold of all the impressionist pictures they could and to sell them, without frames, at the Hôtel Drouot. This measure was destined to devaluate his enormous stock. While his adversaries in the end did not dare resort to such extremes, they tried to discredit Durand-Ruel in an affair of fakes. He was able, however, to clear himself and to prove that he was the victim of intrigues.[35] It was no wonder that in these circumstances Durand-Ruel had often nothing to offer but promises when the painters asked for much-needed help. At one point Renoir spontaneously proposed that Durand-Ruel sacrifice his paintings, if this could bring relief, offering to furnish new and better ones; yet the dealer refused the suggestion, determined in his own interest and in that of the artists to hold their prices.

Miss Cassatt did all in her power to ease the critical situation—it seems that she even lent money to Durand-Ruel. Besides she not only bought paintings for herself and her family (her brother was a high official of the Pennsylvania Railroad system), she also tried to interest her American friends and acquaintances in the works of her colleagues: first the Havemeyers of New York, later the Stillmans and the Whittemores. Pissarro used to leave canvases with her which she would try to show and to sell at tea parties, or she would send prospective buyers directly to the studios of the painters. But once, when she advised somebody to visit Degas, the latter said something about her art which deeply embarrassed her, and for several years she stopped seeing him.[36]

In these apparently hopeless circumstances, with improvement nowhere in sight, Monet decided in 1885 to join the *Exposition Internationale* at Petit's. Durand-Ruel naturally disapproved of Monet's passing over to his most formidable rival, but the painter argued that it would be a good thing for the artists to detach themselves from their dealer. While he admired Durand-Ruel's courage and devotion, he felt also that the public lacked confidence because Durand-Ruel, and he alone, handled the works of the impressionists. By establishing contact with other dealers he hoped to convince the public that impressionism was not merely a whim of Durand-Ruel's. Renoir soon followed Monet's example, and Sisley and Pissarro approved of his arguments.

Pissarro, unable to live on what Durand-Ruel gave him, often had to spend weeks in Paris, running from one small dealer to another, in a desperate effort to sell some works. There was little or no demand. Occasionally Portier, formerly connected with Durand-Ruel, would buy a small canvas or a gouache; Beugniet, another dealer, would object to Pissarro's already low prices, while a young employee of the large gallery Boussod & Valadon, a Hollander, Theo van Gogh, began to do his best in interesting his superiors in impressionist paintings.

When, in the fall of 1885, Durand-Ruel received an invitation from the American Art Association to organize a large exhibition in New York, he seized the opportunity with a determination steeled by despair. But the painters manifested little confidence. Why should the Americans show more comprehension and sympathy than their own countrymen? And while their dealer prepared to select three hundred of their best paintings, they began instead to discuss the possibility of a new group exhibition. There had been none since 1882. In December 1885 Pissarro approached Monet. "For some time there has been much talk

CÉZANNE: *View of Mont Sainte-Victoire near Aix, 1885-87. 24½ x 29⅜". Phillips Memorial Gallery, Washington, D. C.*

CÉZANNE: *The Alley of Chestnut Trees at the Jas de Bouffan*, 1885-87. 29½ x 37". The Frick Collection, New York.

CASSATT: *The Loge, c. 1882. 31½ x 25¼". National Gallery of Art, Washington, D. C. (Chester Dale loan).*

PISSARRO: *Peasant Girl Drinking her Coffee, d. 1881. 26 x 21⅝". Exhibited at the seventh impressionist show, 1882. Art Institute, Chicago (Gift of H. and P. Palmer).*

SIGNAC: *The Coast at Port-en-Bessin, d. 1883. Formerly in the collection of Félix Fénéon, Paris.*

about a show," he wrote, "it is discussed on every side. I paid a visit to Miss Cassatt. . . . From the very first we spoke about the show. Can't we come to an understanding about it? All of us, Degas, Caillebotte, Guillaumin, Berthe Morisot, Miss Cassatt and two or three others would make an excellent nucleus for a show. The difficulty is in coming to an agreement. I think that, on principle, we shouldn't arrange it as a show of only ourselves; that is, the Durand-Ruel element among us. The exhibition ought to come from the initiative of the artists and should above all prove this by its make-up. What do you think about it?"[37]

Pissarro had a special reason for insisting that the new show be not formed exclusively by what he called the "Durand-Ruel element." He wished to introduce among his friends two young artists whom he had met recently. In the studio of Guillaumin he had, shortly before, made the acquaintance of Paul Signac, who had immediately introduced him to his comrade Georges Seurat. In discussions with these young men, belonging to the generation of his own son Lucien, Pissarro had gained a new outlook and discovered the new constructive element for which he had been searching. He had found in their theories scientific means to guide his sensations and replace his instinctive approach to nature by the rigorous observation of the laws of colors and contrasts.

Seurat and Signac had met only the year before, in 1884, when the Salon jury had once more attempted to strangle unorthodox efforts and when hundreds of rejected artists had come together and founded the *Société des Artistes Indépendants*. This new association, which consciously or not usurped

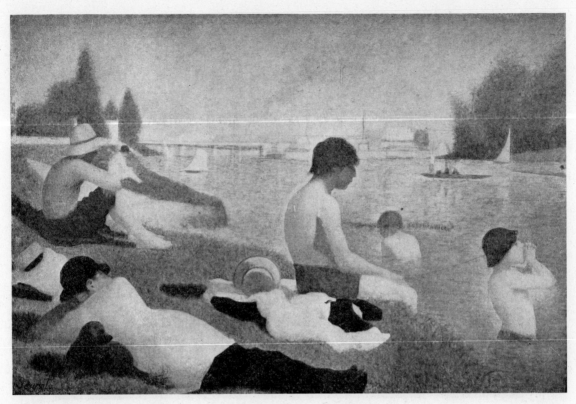

SEURAT: *Une Baignade, 1883-84. 79 x 118½". Exhibited at the first and second shows of the* Indépendants, *1884, and in New York, 1886. National Gallery, Milbank, London.*

the name under which the impressionists had exhibited for several years, pledged itself to organize regular exhibitions without the interference of any jury. Thus, more than twenty years after the *Salon des Refusés,* a permanent institution had finally been set up which took a stand against the abuses of power committed by the jury and opened its doors to all artists without discrimination. It was at the meetings in which the bylaws for this association were drawn up, and over which Odilon Redon presided, that Seurat and Signac had spoken to each other for the first time.[38]

Then only twenty-one years old, Signac was an ardent admirer of Monet, to whom he had written for advice after Monet's one-man show at *La Vie Moderne* in 1880. At the first *Salon des Indépendants* in 1884 he exhibited landscapes which strongly underlined his dependence on his self-chosen master. He was startled to discover in the canvas shown by Seurat, *Une Baignade,* the methodical separation of elements —light, shade, local color and the interaction of colors—as well as their proper balance and proportion. However, the painting was executed with a palette resembling Delacroix's and combining pure and earthly colors. Though one critic linked Seurat's efforts with Pissarro, it is not certain whether he even knew of Pissarro at that time. It was Signac who directed Seurat's attention to the impressionists and induced him to abandon his earthy colors.

Seurat, four years older than Signac, had been for several years, at the *Ecole des Beaux-Arts,* a pupil

MONET: *Cliffs at Pourville, d. 1882. 26⅛ x 32½". Durand-Ruel Galleries, Paris.*

of Ingres' disciple Lehmann, who had infused him with a pious devotion to his master. Yet, while he copied Ingres' drawings and absorbed the religion of the classical line, Seurat had also carefully analyzed the paintings of Delacroix, had read with avidity the writings of the Goncourt brothers and had studied scientific treatises on color harmonies by Chevreul, whose theories had already interested Delacroix. This had led him to conceive the idea of reconciling art and science, an idea inseparable from the general trend of the time to replace intuition by knowledge and to apply the results of incessant research to all fields of activity. Taking advantage of the discoveries of Chevreul and others, Seurat limited his palette to Chevreul's circle of four fundamental colors and their intermediate tones: *blue,* blue-violet, violet, violet-red, *red,* red-orange, orange, orange-yellow, *yellow,* yellow-green, *green,* green-blue and blue again. These he mixed with white, but to assure the benefits of luminosity, color and harmony, he did not mix the colors among themselves. Instead, he chose to employ tiny dots of pure color, set next to each other, and to permit the mixture to be accomplished optically, that is, in the eye of the onlooker, placed at a proper distance. This method he called *divisionism.*[39] He replaced the "disorder" of the impressionist strokes by a meticulous execution of carefully posed dots which conferred upon his works a certain austerity, an atmosphere of quiet and stability. Abandoning the spontaneous expression of sensations hailed by the impressionists and leaving nothing to chance, he found in the observation of the laws of optics a new discipline, a means to new achievements.

SEURAT: *Fishing Fleet at Port-en-Bessin, 1888. 21½ x 25½". Museum of Modern Art, New York (Lillie P. Bliss Collection).*

While the small oil sketches which Seurat painted out-of-doors in preparation for his compositions often show an impressionist technique, his large canvases were done in his studio. In these, contrary to the impressionists, he did not tax his ingenuity to retain fugitive effects but endeavored to transpose what he had observed on the spot into a rigorously planned harmony of lines and colors. Eliminating non-essentials, insisting on contours and structure, he avoided the sensuous charms which had fascinated the impressionists and sacrificed instantaneous sensations to an almost rigid stylization.[40] No longer interested in retaining the aspect of a landscape at a specific hour, he endeavored to fix its "silhouette of the whole day."[41] When he met Pissarro in 1885, Seurat had already been working for an entire year on a new composition, *A Sunday Afternoon on the Island of La Grande Jatte,*[42] in which he summed up his conceptions.

Pissarro was immediately taken with the theories and technique of Seurat; without hesitation he embraced his views. In a letter to Durand-Ruel he explained that what he wanted from now on was "to seek a modern synthesis by methods based on science, that is, based on the theory of colors developed by Chevreul, on the experiments of Maxwell and the measurements of O. N. Rood[43]; to substitute optical mixture for the mixture of pigments, which means to decompose tones into their constituent elements; for this type of optical mixture stirs up luminosities more intense than those created by mixed pigments." And with characteristic modesty Pissarro insisted: "It is M. Seurat, an artist of great merit, who was the first

SEURAT: *A Boat on the Seine (possibly a study for* La Grande Jatte), *c. 1885. Wood panel, 6¼ x 9¾".*
Collection G. Renand, Paris.

to conceive the idea and to apply the scientific theory after having made thorough studies. I have merely followed his lead. . . ."[44]

Having joined Seurat and Signac, Pissarro began to consider his former comrades *romantic impressionists,* thus emphasizing the differences in principle which separated them from the new group of *scientific impressionists.*

NOTES

1. Pissarro to Duret, Feb. 24, 1882; see A. Tabarant: Pissarro, Paris, 1924, p. 46.

2. Renoir to Duret, Easter 1881; see M. Florisoone: Renoir et la famille Charpentier, *L'Amour de l'Art,* Feb. 1938.

3. Pissarro to his son, Sept. 18, 1893; see Camille Pissarro, Letters to his Son Lucien, New York, 1943, p. 216.

4 From the unpublished private notes of the painter Louis Le Bail, who received Pissarro's advice during the years 1896-97. At about the same time Louis Le Bail also met Monet, who told him: "One ought to be daring in the face of nature and never be afraid of painting badly nor of doing over the work with which one is not satisfied, even if it means to ruin what one has done. If you don't dare while you are young, what are you going to do later?"

5. Gauguin to Pissarro, summer 1881; partly unpublished document, found among Pissarro's papers.

6. Manet to Astruc, summer 1880; see E. Moreau-Nélaton: Manet raconté par lui-même, Paris, 1926, v. II, p. 68.

7. See Pissarro's letter to his son, Dec. 28, 1883, *op. cit.,* p. 51.

8. Renoir to Manet, Dec. 28, 1881; see Moreau-Nélaton, *op. cit.,* v. II, p. 88.

9. See A. Vollard: Renoir, ch. XI and Renoir's letter published in *L'Amateur d'Autographes,* 1913, p. 231-233.

10. Renoir to Durand-Ruel, Nov. 21, 1881; see L. Venturi: Les Archives de l'Impressionnisme, Paris-New York, 1939, v. I, p. 116-117.

11. Renoir to Mme Charpentier [beginning 1882]; see Florisoone, *op. cit.*

12. Caillebotte to Pissarro [beginning 1882]; unpublished document found among Pissarro's papers.

13. Gauguin to Pissarro, Jan. 18, 1882; unpublished document found among Pissarro's papers.

14. Manet to Berthe Morisot [beginning 1882]; see M. Angoulvent: Berthe Morisot, Paris, 1933, p. 62.

15. For Monet's letters to Durand-Ruel, concerning the exhibition, see Venturi, *op. cit.,* v. I, p. 227-230; for Renoir's letters *ibid.,* p. 119-122.

16. Renoir to Durand-Ruel [beginning 1882], not included in Venturi's Archives; see Catalogue d'Autographes No. 61, Marc Loliée, Paris, 1936, p. 35.

17. Manet to Berthe Morisot, March 1, 1882; see Angoulvent, *op. cit.,* p. 62-63.

18. For a condensed catalogue see Venturi, *op. cit.,* **v. II,** p. 267-269.

19. Manet to A. Wolff, May 1882; see Wolff's article in *Le Figaro,* May 1, 1883.

20. Manet to Chesneau [summer 1882]; see Moreau-Nélaton, *op. cit.,* v. II, p. 90.

21. On the circumstances of Manet's death see A. Tabarant: Manet se sut-il amputé? *Bulletin de la vie artistique,* March 1, 1921.

22. On these exhibitions see: Mémoires de Paul Durand-Ruel *in* Venturi, *op. cit.,* v. II, p 212-213; *ibid.,* letters by Monet, Renoir, Sisley to Durand-Ruel; also Pissarro, Letters to his son Lucien and G. Geffroy: Claude Monet, sa vie, son oeuvre, Paris, 1924, v. I, ch. XXIV.

23. Pissarro to Monet, June 12, 1883; see Geffroy, *op. cit.,* **v. II, ch. III.**

24. Pissarro to his son, May 4, 1883; *op. cit.,* p. 30.

25. See A. Vollard: Renoir, ch. XIII.

26. See A. Fontainas: The Encounter of Ingres and Renoir, *Formes,* March 1931; also T. de Wyzewa: Pierre Auguste Renoir, *L'Art dans les deux Mondes,* Dec. 6, 1890.

27. Monet to Durand-Ruel, Dec. 1, 1883; see Venturi, *op. cit.,* v. I, p. 264.

28. Monet to Durand-Ruel, Jan. 12, 1884; *ibid.,* p. 267-268.

29. Degas to Lerolle, Aug. 21, 1884; see Lettres de Degas, Paris, 1931, p. 64-65.

30. Renoir to Durand-Ruel, fall 1885; see Venturi, *op. cit.,* v. I, p. 131.

31. Pissarro to his son, Oct. 31, 1883; *op. cit.,* p. 44.

32. Pissarro to Murer, Aug. 8, 1884; see Tabarant, *op. cit.*

33. See F. F. [Fénéon]: Les grands collectionneurs, M. Paul Durand-Ruel, *Bulletin de la vie artistique,* April 15, 1920.

34. Durand-Ruel to Pissarro, Nov. 1883; see Pissarro, *op. cit.,* p. 60.

35. See Venturi, *op. cit.,* v. II, p. 249-252.

36. See G. Biddle: Some Memories of Mary Cassatt, *The Arts,* Aug. 1926.

37. Pissarro to Monet, Dec. 7, 1885; see Geffroy, *op. cit.,* v. II, ch. III.

38. See J. Rewald: Georges Seurat, New York, 1943, p. 13-18. On the general history of the *Société des Artistes Indépendents* see G. Coquiot: Les Indépendants, Paris, 1921.

39. See Signac's explanation of divisionism in his: De Delacroix au Néo-impressionnisme, Paris, 1899, translated in: Artists on Art, edited by R. Goldwater and M. Treves, New York, 1945, p. 377-378.

40. See J. J. Sweeney: Plastic Redirections in 20th Century Painting, Chicago, 1934, p. 7-10.

41. See G. Kahn: La vie artistique, *La Vie Moderne,* April 9, 1887.

42. On the *Grande Jatte* see D. Catton Rich: Seurat and the Evolution of "La Grande Jatte," Chicago, 1935.

43. On Rood's own attitude toward impressionism and neo-impressionism see R. Rood: Professor Rood's Theories on Colour and Impressionism, *The Scrip,* April 1906.

44. Pissarro to Durand-Ruel, Nov. 6, 1886; see Venturi, *op. cit.,* v. II, p. 24.

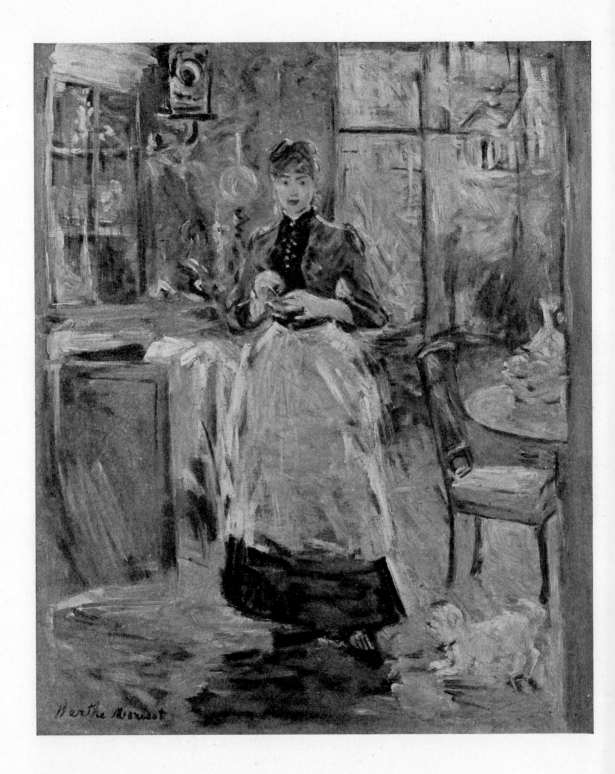

MORISOT: *In the Dining Room (the artist's maid in her house, rue de Villejuste, in Paris), 1884. 24¼ x 19¾". National Gallery of Art, Washington, D. C. (Chester Dale loan).*

THE EIGHTH AND LAST
IMPRESSIONIST EXHIBITION

DURAND-RUEL'S FIRST SUCCESS
IN AMERICA

GAUGUIN AND VAN GOGH

Berthe Morisot and her husband, Eugène Manet, took it upon themselves, early in 1886, to visit their friends and begin discussing a new group exhibition, after Pissarro had already consulted Miss Cassatt and Monet. The task was particularly complicated, for not only was there the eternal question of Degas and his circle, but this time there was also Pissarro's request that Seurat and Signac be admitted, a request which met with little or no sympathy. Moreover, Degas insisted that the exhibition be held from May 15 to June 15, that is, while the official Salon was open, and this seemed absurd to the others. In February the situation had reached a deadlock; both Berthe Morisot and Monet seemed to abandon hope. Guillaumin tried to act as go-between for the different parties. The difficulty for him as well as for Pissarro lay in the fact that if Degas, Miss Cassatt and Berthe Morisot abstained, there was almost no one left to advance the necessary funds and take the risk of a possible loss. When discussions were taken up again, they soon centered around the admission of Seurat's large canvas, *La Grande Jatte*.

Early in March, Pissarro wrote his son Lucien of the difficulties he was having with Manet's brother: ". . . I had a violent run-in with M. Eugène Manet on the subject of Seurat and Signac. The latter was present, as was Guillaumin. You may be sure I rated Manet roundly—which will not please Renoir.— But anyhow, this is the point: I explained to M. Manet, who probably didn't understand anything I said, that Seurat has something new to contribute which these gentlemen, despite their talent, are unable to appreciate, that I am personally convinced of the progressive character of his art and certain that in time it will yield extraordinary results. Besides I am not concerned with the appreciation of artists no matter whom. I do not accept the snobbish judgments of 'romantic impressionists' to whose interest it is to combat new tendencies. I accept the challenge, that's all. But before anything is done they want to stack the cards and ruin the exhibition. M. Manet was beside himself! I didn't calm down. They are all underhanded, but I don't give in. Degas is a hundred times more loyal. I told Degas that Seurat's painting was very interesting. 'I would have noted that myself, Pissarro, except that the painting is so big!' Very well, if Degas sees nothing in it so much the worse for him. This simply means there is something precious that escapes him. We shall see. M. Manet would have liked to prevent Seurat from showing his figure

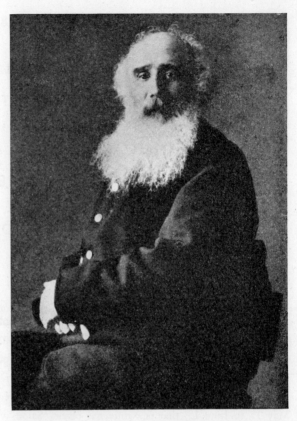

DESBOUTIN: *Portrait of Edgar Degas Reading,* *Photograph of Camille Pissarro, c. 1880. Unpub-*
c. 1884. Formerly Collection J. Guiffrey, Paris. *lished document, courtesy S. Martinez, Amsterdam.*

painting [*La Grande Jatte*]. I protested against this, telling Manet that in such a case we would make no concessions, that we were willing, if space were lacking, to *limit our paintings* ourselves, but that we would fight anyone who tried to impose his choice on us. But things will arrange themselves somehow!"[1]

It was finally decided that Pissarro and his friends were to show in a room by themselves. Besides those of Pissarro, Seurat and Signac there would also appear in this room the first paintings of Pissarro's son Lucien, who closely followed his father and Seurat.

Among the other exhibitors was Gauguin, who had returned to Paris in 1885 after a most unhappy year in Copenhagen. There he had tried to represent some commercial firms and had failed. He had organized an exhibition which had been closed after five days at the order of the Academy; favorable articles in the press had been halted; the opposition had been so violent that no framemaker had dared make frames for him, fearing to lose customers. Leaving his wife and four of their children in Denmark, he finally returned to France with his boy Clovis, who soon fell seriously ill. Thereupon he had accepted a job as a bill-poster. Later he himself had been obliged to spend several weeks at the hospital. Putting Clovis in a boarding-house, he had finally managed to go to the Normandy coast, possibly by selling some of the pictures from his collection. At the coast he had met Degas and had quarreled with him. It may be that, like Pissarro, Degas objected to Gauguin's desire to succeed quickly, for Gauguin later said, "As for Degas

388

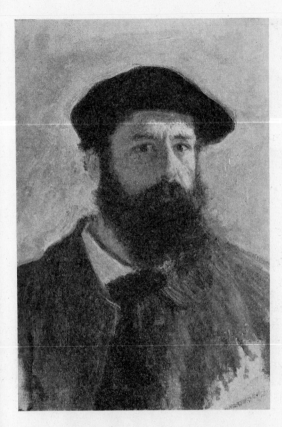

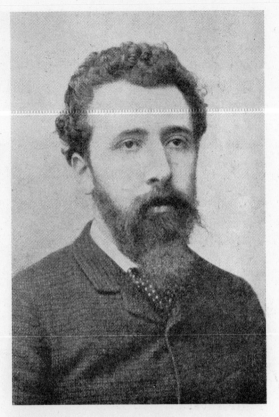

MONET: *Self Portrait, 1880-86. 22 x 18½". Present owner unknown.*

Photograph of Georges Seurat.

I don't care at all and am not going to spend my life fiddling over one detail with a model for five sittings; the way things are, it's too expensive."[2] In spite of his tremendous hardships, Gauguin went on working obstinately and the new exhibition found him ready with a number of recent works.

Gauguin introduced to the painters his friend and former colleague at the bank, Schuffenecker; Berthe Morisot and her husband agreed to admit his works. It is unknown whether it was the inclusion of Gauguin and Schuffenecker that decided Monet to decline participation, but it is more likely that his decision was prompted by the presence of Seurat and Signac. Caillebotte took his stand with Monet. After some hesitation Renoir also made it known that he would not take part; Sisley likewise refused to join the others. Both Monet and Renoir decided instead to exhibit at Petit's *Exposition Internationale.*

Raffaëlli did not participate in the new show, either because Degas decided to drop him (since this time nobody had asked him to do so), or simply because Raffaëlli himself had finally become aware of the fact that he was little welcome among the impressionists. Of Degas' friends only Mme Bracquemond, Miss Cassatt, Forain, Rouart, Tillot and Zandomeneghi took part in the show. Odilon Redon joined as a newcomer.

While the painters were busily preparing their eighth group exhibition, Durand-Ruel was assembling the three hundred canvases which he intended to take to America. Pissarro succeeded in persuading him

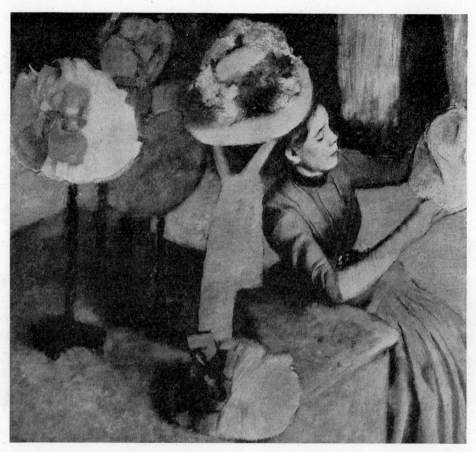

DEGAS: *The Millinery Shop, c. 1882. 39 x 43¼". Probably exhibited at the eighth impressionist show, 1886. Art Institute, Chicago (Mr. and Mrs. L. L. Coburn Collection).*

to include some works of Signac and Seurat; the latter entrusted the dealer with his *Baignade* shown at the first *Salon des Indépendants*. In March 1886 Durand-Ruel left for New York with a very fine selection from his large stock.[3] On the success of this venture depended not only his own future but to a certain extent also that of his painters.

Whereas Durand-Ruel's exhibition in New York was announced as *Works in Oil and Pastel by the Impressionists of Paris,* the painters themselves banned once more the word "impressionist" from their posters and instead called their show *Eighth Exhibition of Paintings*. It was scheduled to run during the period chosen by Degas, from May 15 to June 15, and was held above the Restaurant Doré in a building forming an angle at the rue Laffitte and the boulevard des Italiens.[4]

Degas exhibited several pastels of women at the milliner's (Mary Cassatt sometimes posed for him, trying on hats) and a series of ten pastels, entitled: "Series of nudes of women bathing, washing, drying, rubbing down, combing their hair or having it combed." In these pastels he endeavored to represent nudes from an entirely new point of view. "Hitherto," he explained, "the nude has always been represented in poses which presuppose an audience." Instead of showing the undressed models in attitudes chosen by the artist and conscious of their nakedness, he preferred to observe them while they were naked in a

390

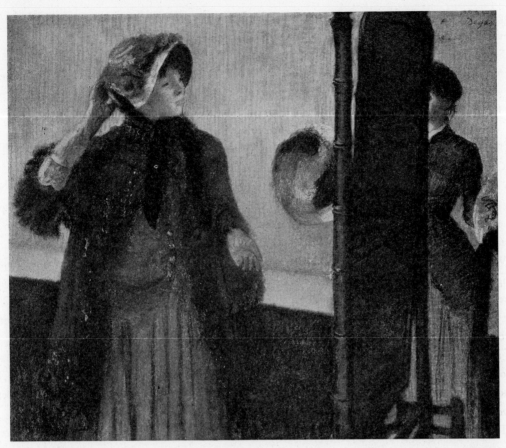

DEGAS: *At the Milliner's, d. 1882. Mary Cassatt posed for this pastel. 30 x 34". Probably exhibited at the eighth impressionist show, 1886. Metropolitan Museum of Art, New York (H. O. Havemeyer Collection).*

natural way, "as if you looked through a keyhole."[5] He installed tubs and basins in his studio and watched the models engaged in ablutions and personal care.

Pissarro, Guillaumin and Gauguin each showed about twenty paintings and pastels. Those of Pissarro were representative of his new manner; among the works of Gauguin were several done in Rouen, in Normandy, Brittany, and also in Denmark. Berthe Morisot had a dozen paintings and a series of watercolors and drawings. Seurat too sent some drawings, a number of landscapes painted at Grandcamp, where he had spent some of the summer months in 1885, and his large canvas, *La Grande Jatte,* showing in a hieratic and simplified composition a group of Sunday visitors on the lawns and beneath the trees on the island of La Grande Jatte, at Asnières, near Paris, with boats floating by at the side. Among the people walking in the shade figured prominently a lady in a blue dress holding a little monkey on a leash.

The new show met with considerable advance curiosity aroused by rumors concerning Seurat's large composition. George Moore was told by a friend that there was a huge canvas in three tints: pale yellow for the sunlight, brown for the shadow, and all the rest sky-blue. Besides, there was said to be a lady with a ring-tailed monkey, the tail of which was three yards long. Moore hurried to the opening, and, although the painting did not quite correspond to the description, there was indeed the monkey, and there were

enough other strange things to justify laughter, "boisterous laughter, exaggerated in the hope of giving as much pain as possible."[6]

Signac later recalled that on the day of the opening Manet's friend Stevens "continually shuttled back and forth between the Maison Doré and the neighboring Café Tortoni to recruit those of his cronies who were sipping on the famous terrace, and brought them to look at Seurat's canvas to show how far his friend Degas had fallen in welcoming such horrors. He threw his money on the turnstile and did not even wait for change, in such a hurry was he to bring in his forces."[7]

The exhibition, in which the impressionist element was represented only by Berthe Morisot, Guillaumin and Gauguin, aroused many discussions. While some visitors were shocked by Degas' nudes and proclaimed them obscene,[8] the greater part were intrigued and amused by the works of Seurat and his followers, which, hung in too narrow a room, could not be seen to full advantage. Few recognized the profound originality of these paintings; when the Belgian poet, Verhaeren, spoke of them admiringly to some artists, they heaped laughter and ridicule upon him.[9]

What added to the general confusion was the fact that the public and the critics were unable to distinguish between the works of Seurat, Signac and the two Pissarros. The novelty of pictures produced by different artists working with an identical palette and relying on a common method was too striking to allow the visitors to take note of subtle differences of personal quality. Seurat's *Grande Jatte* dominating the room, the lyricism of Signac and the naive rigidity of Camille Pissarro were ignored, and the critics were able to claim that the new method had completely destroyed the personalities of the painters who employed it. George Moore at first even looked for some hoax and—since the pictures were hung low— had to go down on his knees and examine closely the canvases before he was able to distinguish between the works of Pissarro and Seurat.[10]

The critics, with their disinclination for careful investigation, were quick to greet this new art with their customary witticisms. But even serious and openminded writers could not hide their disapproval, seeing in these works only "exercises of highly mannered virtuosos."[11] Pissarro's newly won friend, the novelist Octave Mirbeau, went so far as to question Seurat's sincerity. His attitude appears to have been typical of that of the few admirers whom Pissarro had acquired after thirty years of painting. Nobody was ready to follow him onto the new road which he had chosen. It seemed as if he would have to begin his struggle all over again, surrounded by men young enough to be his sons.

Thus matters stood when Durand-Ruel returned to Paris, a few days after the exhibition at the Maison Doré had closed. Various rumors immediately circulated in the art world; some said that he had made a fortune in America with miraculous luck, others pretended that he had engaged in sharp practice and had been forced to decamp. What Durand-Ruel had to tell was much less spectacular, but it was reassuring: he returned from his trip with the conviction that great things were to be expected from America, and while the immediate results of his exhibition were rather limited, the outlook seemed particularly bright.

The reception given to Durand-Ruel in New York had been much friendlier than he had dared expect, although of course there had been hostile elements. "The coming of the French Impressionists," the *New York Daily Tribune* had announced, "has been preceded by much violent language regarding their paintings. Those who have the most to do with such conservative investments as the works of Bouguereau, Cabanel, Meissonier and Gérôme have imparted the information that the paintings of the

SEURAT: A Sunday Afternoon on the Island of La Grande Jatte, 1884-86. 81¼ x 120¼". Art Institute, Chicago (Helen Birch Bartlett Memorial Collection).

CASSATT: *The Morning Toilet*, 1886. 29½ x 24½". *Exhibited at the eighth impressionist show, 1886. Formerly in Degas collection. National Gallery of Art, Washington, D. C. (Chester Dale loan).*

DEGAS: *The Toilet*, 1885-86. Pastel, 29⅛ x 23⅞". *Probably exhibited at the eighth impressionist show, 1886. Metropolitan Museum of Art, New York (H. O. Havemeyer Collection).*

SIGNAC: *Gas meters at Clichy, d. 1886. Present owner unknown.*

Impressionists partake of the character of a 'crazy quilt,' being only distinguished by such eccentricities as blue grass, violently green skies and water with the coloring of a rainbow. In short it has been said that the paintings of this school are utterly and absolutely worthless."[12] Yet the general public had refused to follow the arguments of those "connoisseurs," partly because of Mary Cassatt's unceasing attempts to interest her countrymen in impressionist art (Sargent had also tried to win admirers for Monet), but even more because Durand-Ruel's name was already known in America as that of the defender of and dealer for the Barbizon school. This reputation had led the American public to the very realistic conclusion—a conclusion which the French had failed to draw—that since he had so consistently supported his new friends, their works ought to have some value. Both critics and visitors thus approached his show without prejudice.

Anxious to soften the "shock" which the canvases of Manet, Degas, Renoir, Monet, Sisley, Pissarro, Berthe Morisot, Guillaumin, Signac, Seurat and Caillebotte were likely to produce, Durand-Ruel had not only included paintings by Boudin, Lépine and others in his exhibition but had added to these some more academic works. This precaution, however, proved to be unnecessary, and the *New York Daily Tribune* went so far as to write with regard to the champions of Bouguereau and Cabanel: "We are disposed to blame the gentlemen who purvey pictures for the New York market for leaving the public in ignorance of the artists represented at the exhibition in the American Art Galleries."[12]

PISSARRO: *Old Chelsea Bridge, London, d. 1890. 23¾ x 28¾". Formerly collection Sir William Van Horne, Montreal.*

There were, naturally, some whose comments showed little difference from those in the French papers. *The Sun* spoke of "the lumpy and obnoxious creations of Renoir, the degenerate and debased pupil of so wholesome, honest and well-inspired a man as Gleyre." Its critic also stated that Degas "draws badly," that Pissarro's landscapes are "fantastic and amusing; sometimes he is serious but without intending apparently to be so," that "there is a great deal of bad painting" in Sisley's canvases and that Seurat's "monstrous picture of *The Bathers* . . . is conceived in a coarse, vulgar and commonplace mind, the work of a man seeking distinction by the vulgar qualification and expedient of size."[13] But in general the American reviewers showed an uncommon comprehension and instead of laughing stupidly made an honest effort to understand. From the first they conceded: "It is distinctly felt that the painters have worked with decided intention, that if they have neglected established rules it is because they have outgrown them, and that if they have ignored lesser truths, it has been in order to dwell more strongly on larger."[14]

The general tenor of the press comments, reflecting the reaction of the visitors, was that American artists could learn many technical lessons from the pictures and that this exhibition offered, from the early works by Manet to the large canvas by Seurat, a unique opportunity to study the "uncompromising strength of the impressionistic school." While characterizing this school as "communism incarnate, with

the red flag and the Phrygian cap of lawless violence boldly displayed," the critic of *Art Age,* for instance, readily admitted that there was a great knowledge of art and an even greater knowledge of life in Degas' work, that Renoir could sound a vigorous and virile note and that the landscapes of Monet, Sisley and Pissarro were full of a heavenly calm and wholly lovely.[15] *The Critic* even proclaimed: "New York has never seen a more interesting exhibition than this."[14]

Two weeks after the opening, which had taken place on April 10, the *Tribune* announced that seven or eight pictures had been sold. So lively was the interest in the show that it was decided to have it run for another month. Owing to other commitments of the American Art Galleries, it was taken late in May to the National Academy of Design, which practically amounted to an official blessing. Before Durand-Ruel finally returned to France, the American Art Association itself bought a number of canvases and arranged for him to return in the fall with a new exhibition. Durand-Ruel thus had every reason to be confident of the future and to consider his American venture as the long awaited turn of the tide.[16]

Except for good reasons to be hopeful, Durand-Ruel did not have much to show when he returned to his painters in Paris. His expenses had been heavy, and he was not yet in a position to meet their requests for money. Moreover, his success had unleashed again the jealousy of his opponents. There was some talk of their buying directly from the impressionists and forcing them to break with Durand-Ruel, so as to seize the American market which he had now opened. Meanwhile the dealers in New York, who had taken his failure for granted and were aroused by the unexpected results of his exhibition, were busy in Washington obtaining new customs regulations and thus succeeded in delaying his second show. The difficulties were far from over, but Durand-Ruel remained confident and told his painters not to be discouraged. Yet Pissarro, Monet and Renoir felt uncertain whether he would be able to hold out until a definite financial success. All they gained was the reassuring conviction: "If we are not saved by Durand-Ruel, someone will take us up, since our work is sure to sell in the end."[17] For the moment, however, they were again more or less abandoned to their own devices.

During Durand-Ruel's absence, Monet, without funds from his dealer, had sold several canvases through Georges Petit at very satisfactory prices (he charged dealers up to 1,200 francs for his paintings). He had also participated together with Renoir in an exhibition organized by a new association, *Les Vingt,* in Brussels, a group destined to unite the very active vanguard elements in Belgium with those in other countries.[18] Success had somehow changed Monet's attitude, and he now showed himself more exacting in his dealings with Durand-Ruel, sometimes almost rude in his directness. He reproached the dealer for sending his paintings to America or leaving them as security with his creditors so that he was left with no stock to show to the French public. Pissarro also voiced dissatisfaction with Durand-Ruel's handling of his work and would have liked to conclude a contract with some other dealer if he had only been able to find one sufficiently interested in his art to support him.

Guillaumin and Gauguin meanwhile decided to show in the fall of 1886 with Seurat and Signac at the *Salon des Indépendants,* but Gauguin eventually had a violent discussion with the "little green chemists who pile up tiny dots,"[19] as he called them, and he abstained. Renoir joined Monet and exhibited with him at Petit's *Exposition Internationale.* Durand-Ruel, who went to see his latest pictures there, did not like them, nor did he like the new divisionist paintings which Pissarro showed him. It must have been particularly confusing for him to see the end of impressionism openly proclaimed in their works and to feel the end of Monet's friendship at the very moment when the long expected victory seemed so near.

MONET: *Etretat, d. 1886. 32 x 25¾". Metropolitan Museum of Art, New York (Lillie P. Bliss Bequest).*

As if to emphasize the final breakup of the group, Seurat's friend Félix Fénéon published a pamphlet entitled *Les Impressionnistes en 1886,* in which he drew up categories underlining the differences which divided the various painters. His entire admiration being centered on Seurat, he made no secret of his conviction that impressionism had been supplanted by Seurat's new style. He showed clearly that whatever joined Seurat and Signac to their predecessors was too indefinite a link for the young painters to be regarded as impressionists, even though they had participated in the eighth exhibition of the group. It was at this moment that the term "neo-impressionism" first appeared. As Signac later explained, this name was adopted not to curry favor (since the impressionists had still not won their own battle) but to pay homage to the efforts of the older generation and to emphasize that while procedures varied, the ends were the same: light and color.[20]

At the time when Pissarro, Seurat and Signac broke with the old group, Zola did the same, although for different motives and in a different way. In 1886 he published a new novel in his *Rougon-Macquart* series, *L'Oeuvre,* the hero of which was a painter. It was common knowledge among his readers that this was a *roman à clef,* and Zola's own notes are evidence that the portrait of his hero was based partly on Manet and partly on Cézanne, the two painters whom he had known most intimately. *L'Oeuvre* abounds in biographical details, describing the early struggles of the group, the *Salon des Refusés* and the first attempts of *plein air* painting, but the hero, symbolizing an impressionist, is characterized as a painful mixture of genius and madness. The struggle between his great dreams and his insufficient creative power ends in utter failure, in suicide. While the public merely saw in this novel Zola's disguised disapproval of impressionism, and while the painters themselves discovered in it the final evidence of Zola's lack of understanding, Cézanne was deeply hurt. Although the general reader identified Zola's hero with Manet rather than with Cézanne, who was almost completely unknown, Cézanne himself, reading between the lines, found there a moving echo of his own youth, which had been inseparable from that of Zola, but also the betrayal of his hopes.[21] What he might have sensed already in his conversations with Zola, whom he had visited almost every year in Médan, he now saw irrevocably expressed in this novel: Zola's pity for those who had not achieved success, a pity more unbearable than contempt. Zola not only had failed to grasp the true meaning of the effort to which Cézanne and his comrades had devoted all their strength, he had lost all feeling of solidarity. From the secure castle he had built himself in Médan, he passed judgment upon his friends, embracing all the bourgeois prejudices against which they had once fought together. The letter which Cézanne wrote Zola to thank him for sending a copy of *L'Oeuvre* was melancholy and sad; it was in fact a letter of farewell, and the two friends were never to meet again.[22]

Of Zola's painter friends only Monet was outspoken enough to inform him frankly of his reactions, although Guillemet too voiced some objections. "You were kind enough to send me *L'Oeuvre,*" Monet wrote. "I am much obliged to you. I have always had great pleasure in reading your books, and this one interested me doubly because it raises questions of art for which we have been fighting for such a long time. I have read it, and I remain troubled, disturbed, I must admit. You took care, intentionally, that not one of your characters should resemble any of us, but in spite of that, I am afraid that the press and the public, our enemies, may use the name of Manet, or at least our names, to prove us to be failures, something which is not in your mind, I refuse to believe it. Excuse me for telling you this. It is not a criticism; I have read *L'Oeuvre* with very great pleasure, discovering old memories on each page. You know, besides, my fanatical admiration for your talent. It has nothing to do with that, but I have been

struggling fairly long and I am afraid that in the moment of succeeding, our enemies may make use of your book to deal us a knockout blow."[23] Like Cézanne, Monet, Pissarro and Renoir now avoided Zola.

The break of Cézanne's thirty-year-old friendship with Zola came in the very year in which the painter was at last enjoying some peace. In April 1886 he had married in Aix Hortense Fiquet, with the consent of his parents. Six months later Cézanne's father died at the age of eighty-eight, leaving a sizeable fortune to his son which relieved him of worry. But Cézanne did not change his way of life and continued in Aix the modest existence he had led before. The world around him seemed to shrink; its center was his father's house, Le Jas de Bouffan, where he lived with his aging mother while his wife and son stayed mainly in Paris. There were few old friends left except Pissarro, Renoir, Chocquet and *père* Tanguy, and he did not hear from them often. Besides he did not approve of Pissarro's new conceptions and stated with regret, "If he had continued to paint as he was doing in 1870, he would have been the strongest of us."[24] In his self-imposed isolation nothing could divert Cézanne from the sole aim of his life: the work which absorbed all his thoughts and which, as he had once said to Zola, was "in spite of all the alternatives the only refuge where one finds true contentment in oneself."[25]

Gauguin too had finally made up his mind and decided that what he needed was seclusion. Like Cézanne he was going to develop his gifts and progress in loneliness. He spent the year 1886 far from Paris in lower Brittany, but he chose to live in Pont-Aven, a well-known resort of artists. There he took quarters in the Auberge Gloanec, favored by the pupils of Cormon and Julian, two popular studios in Paris. Too self-centered to be truly sociable, he kept away from the gay hordes, not seeking any company. The young painter Emile Bernard, who paid him a visit at Schuffenecker's suggestion, was not too well received but managed to see some of his paintings and noted that "small brushstrokes weave the color and remind me of Pissarro; there is not much style."[26]

Now almost forty, Gauguin formed a strange contrast with the other boarders at Gloanec's in his appearance as well as in the grimness with which he applied himself to his work, not to speak of this work itself, which seemed revolutionary and brazen to the students from the various academies. A young English painter who saw him there, though he hardly ever spoke to him, later described Gauguin as tall, dark-haired and swarthy of skin, heavy of eyelid and with handsome features, all combined with a powerful figure. He dressed like a Breton fisherman in a blue jersey and wore a beret jauntily on the side of his head. His general appearance, gait and so forth, was rather that of a well-to-to Biscayan skipper of a coastal schooner. In manner he was self-contained and confident, silent and almost dour, though he could unbend and be quite charming when he wished.[27]

His strange behavior could not fail to intrigue the others. Eventually he admitted two painters to intimacy, Charles Laval and a young Frenchman of means who discreetly paid Gauguin's bills.[28] It was through these that the others, who could not approach him directly, learned of his ideas, of his frequently expressed admiration for Degas and Pissarro, of the technical questions which preoccupied him and of his search for a means to preserve the intensity of colors. No longer did he work exclusively out-of-doors as Pissarro had taught him, but endeavored now to match his visual with his visionary qualities. He might say of a painting which he had started in his studio, "I'll finish it outside." A panel of an autumn landscape painted for the dining room of the inn appeared to the others as very extreme in its crude exaggeration. But though they were startled at first, the boldness of his approach left a deep impression on them and created quite a following for Gauguin, who began to be looked to for guidance.

When they returned to Paris at the end of the summer, the pupils of Cormon communicated their new experiences to their fellow students, who had already grieved their teacher, a member of the Institute, by their lively interest in Seurat's theories. Cormon had even temporarily closed his classes in protest at their revolutionary experiments, in which Emile Bernard had taken a leading part.[29] One of his pupils, Vincent van Gogh, thereupon had decided not to return to Cormon's but to work on his own.

Vincent—as he called himself and as he signed his canvases, because nobody in France could pronounce his name properly—had come to Paris in the spring of 1886 to live with his brother Theo and to acquaint himself with all the new art movements. Then thirty-three, Vincent had discovered his real vocation only a few years before, after a hectic existence filled with disappointment and failures in spite or because of the extreme eagerness with which he had approached the professions of art dealer, teacher, preacher and missionary in a mining district. When he finally decided to become an artist he set to work with such a burning ardor that he frightened many of those who approached him. While working at his parents' home in Holland and later at the Academy in Antwerp he felt a growing desire to see the paintings by the impressionists of which Theo spoke so often in letters. He also began to be preoccupied by the problems of simultaneous contrast and complementaries, which formed the basis of Seurat's theories. It soon became obvious that no teacher, but only Paris, could offer the solution for all the theoretical and practical questions which assailed his zealous mind. Thus one fine day he arrived, and Theo took it upon himself to introduce his brother to the painters with whom he had dealings.

Theo van Gogh's little gallery was on the boulevard Montmartre, a branch of Boussod & Valadon's main establishment. There he was allowed to try to build up a business with the works of the impressionists, while his employers looked on skeptically and preferred to deal in the more saleable masters of the Salon. Theo van Gogh was a shy and retiring man, one of the few who had the intelligence to understand the new tendencies, to distinguish unknown or ill-appreciated talents and to transmit his knowledge and enthusiasm to those he met. He handled the works of Monet, Pissarro, Degas and was soon to take up those of Seurat, Signac, Gauguin and Toulouse-Lautrec, whom Vincent had met at the Atelier Cormon. Theo introduced his brother to Pissarro who later said he had felt very soon that Vincent "would either go mad or leave the impressionists far behind."[30]

Van Gogh's work had hitherto been very dark, with scarcely any color, and he was at first bewildered by the rich coloring and the light which he discovered in impressionist pictures. But when Pissarro explained to him the theory and technique of his own paintings, van Gogh began to experiment and immediately took to the new ideas with the greatest enthusiasm. He completely changed his palette and his execution, even adopting for a while the neo-impressionist dot, although he used it without systematic divisionism. He went to work in Asnières together with Signac or Emile Bernard; he paid frequent visits to Guillaumin, who lived on the Ile St. Louis in the former studio of Daubigny; he studied the masterpieces of the Louvre and particularly the paintings of Delacroix; he saw more or less frequently Toulouse-Lautrec, who had also been for a while under the influence of the impressionists; he had frantic discussions with almost every one of his new acquaintances, trying to absorb as much as he could and to reconcile with his own temperament the continuous flow of new impressions. There can be no doubt that he studied assiduously the paintings at the eighth impressionist exhibition, that he visited the Salon and later the *Salon des Indépendants,* where Seurat again showed his *Grande Jatte.* Theo or his painter friends also took him to Durand-Ruel's, to Portier's, to *père* Martin's and especially to the little place of *père* Tanguy.

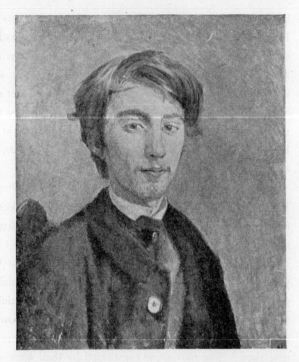

VAN GOGH: *Portrait of* père *Tanguy, Paris, 1886-88. 25 x 20⅛". Collection Edward G. Robinson, Hollywood.*

TOULOUSE-LAUTREC: *Portrait of Emile Bernard, 1886. 21¾ x 18⅛". Formerly collection A. Vollard, Paris.*

Van Gogh and *père* Tanguy quickly became fast friends, much to the distress of Mme Tanguy, who saw her husband supply the young man with canvas and paints (he used much of both) in return for unsaleable paintings. Cézanne, who is said to have once met van Gogh at Tanguy's, is supposed to have seen in these paintings only the work of a madman.[31] But old Tanguy was enthusiastic and from then on divided his admiration equally between Cézanne and van Gogh. The latter painted two portraits of him, sitting against a background decorated with Japanese prints, for—together with impressionism and neo-impressionism—Japanese prints had become one of the great discoveries which van Gogh made in Paris.

When Gauguin returned to Paris in the fall of 1886 he met van Gogh, and a strange friendship soon united the two, in spite of the cold purposefulness of the one and the boiling enthusiasm of the other. All they had in common was the belligerent character of their convictions. Gauguin began to show the superiority and certitude of one who has finally found his way and who has become used to being listened to; van Gogh was animated with all the ardor and humility of the faithful who witnesses wonders and who feels growing in himself the fierce pride of new beliefs. To all the conflicting influences which had been showered on van Gogh, to the kindness and patience of Pissarro, the cold systematization and a certain uncommunicativeness of Seurat, the lively proselytizing of Signac, Gauguin added a new element: a crude outspokenness, an occasional independence from nature, a vague tendency to use exaggeration as a means to go beyond impressionism.

In order to follow this new course Gauguin avoided Pissarro and abruptly turned to Degas. He spoke of leaving France and of seeking in the tropics new motifs as well as more colorful sensations; he

began to plan a trip which would carry him and his friend Laval to Panama and thence to Martinique. He railed against Seurat and Signac. Pissarro, who had already witnessed many sterile fights among the old guard impressionists, now saw the younger generation continue in the same spirit of intolerance. He hardly concealed his pain when he wrote his oldest son in November: "The hostility of the romantic impressionists is more and more marked. They meet regularly, Degas himself comes to the café, Gauguin has become intimate with Degas once more, and goes to see him all the time—isn't this seesaw of interests strange? Forgotten are the difficulties of last year at the seashore, forgotten the sarcasms the Master hurled at the sectarian [Gauguin]. . . . I was naive, I defended him to the limit, and I argued with everybody. It is all so human and so sad."[32]

Monet at the same time had a discussion with Durand-Ruel and returned an advance, saying that henceforth he would only deal on a cash basis with him. He also refused to sell more than half of his recent pictures to him, explaining that he preferred keeping the others since Durand-Ruel sent all his stock to America.[33]

Personal antagonism was no longer concealed; it took the form of bitter quarrels. Thus ended the year of 1886, which had seen the completion and exhibition of Seurat's painting-manifesto, *La Grande Jatte,* van Gogh's arrival in France, the publication of Zola's *L'Oeuvre,* Gauguin's first dreams of faraway tropics, Durand-Ruel's initial success in America and the eighth exhibition of the impressionist group, which was also to be the last. Not even an attempt was made to organize the painters for a new show. The movement constituted by their common efforts had ceased to exist. Henceforth each would go his own way. Pissarro, who had been the only one represented at every exhibition, who had always adopted a conciliatory attitude, had now lost all contact with those who had been his comrades for twenty-five years. But while he suffered from his isolation, he found relief in the conviction that he at least had kept in step with new ideas. And he also knew that—whatever the future might hold in store—he had contributed to the formation of men like Cézanne, Gauguin and van Gogh.

It was van Gogh who summed up the situation when he referred bluntly to the "disastrous squabbles" of the impressionist group, "each member getting at the other's throat with a passion worthy of a nobler and better aim."[34] Yet, in spite of this discouraging situation, neither van Gogh nor the others of his generation could withhold their admiration from this group of painters who, together and as equals, had advanced a new conception of art and of nature, of color and of light. While Ingres and Delacroix had been more or less isolated exponents of their tendencies, out-distancing their followers, while the naturalist movement had been centered around one man, Courbet, impressionism had come into being through the simultaneous efforts of a number of artists, who in continual give-and-take had elaborated a style of their own to express their vision. It was with their achievement in mind that Vincent wrote in 1888: "More and more it seems to me that the pictures which must be painted to make present-day painting completely itself . . . are beyond the power of one isolated individual. They will therefore probably be created by groups of men combining together to execute an idea held in common."[35]

When van Gogh expressed this belief, the first group of this kind in the history of modern art had lost its unity of purpose and already belonged to the past.

NOTES

1. Pissarro to his son, [March 1886]; see Camille Pissarro, Letters to his Son Lucien, New York, 1943, p. 73-74.

2. Gauguin to Schuffenecker, [late 1889]; unpublished document found among Schuffenecker's papers.

3. The catalogue lists 310 works by the following artists (with the number of works exhibited in parentheses): Benassit, Besnard, J. L. Brown, Boudin (23), Cassatt (3), Caillebotte (10), Degas (23), Desboutin, Duez, Dumaresq, Fantin, Flameng, Fleury-Chenu, Forain, Guillaumin (7), Huguet, Laugée, J. P. Laurens, Lépine, Lerolle, Manet (17), Mélin, Monet (50), Montenard, Morisot (9), Pissarro (42), Renoir (38), Roll, Serret, Seurat (2 paintings and 12 "studies," probably drawings), Signac (6), Sisley (14). One painting each by Manet and Degas were lent both by Mr. E. Davis and by Mr. A. J. Cassatt; the latter lent also three paintings each by Monet and Mary Cassatt. Mr. H. O. Havemeyer lent one painting by Pissarro and one by Monet. On the catalogue see also the general bibliography.

4. For a condensed catalogue see L. Venturi: Les Archives de l'Impressionnisme, Paris-New York, 1939, v. II, p. 269-271.

5. See G. Moore: Impressions and Opinions, New York, 1891, p. 318.

6. See Moore: Confessions of a Young Man, London, 1888, p. 28-29.

7. P. Signac: Le Néo-impressionnisme, documents, Paris, 1934. (Introduction to the catalogue of an exhibition "Seurat et ses amis," repr. in Gazette des Beaux-Arts.)

8. See J. K. Huysmans: Certains, Paris, 1889, p. 26.

9. See E. Verhaeren: Sensations, Paris, 1927, p. 196.

10. See Moore: Modern Painting, London-New York, 1898, p. 89.

11. T. de Wyzewa, article in La Revue Indépendante, Nov.-Dec. 1886; quoted by J. Rewald: Seurat, New York. 1943. For other criticisms see ibid., p. 29-32.

12. Unsigned article in The New York Daily Tribune, April 11, 1886.

13. Unsigned article in The Sun, April 11, 1886.

14. Unsigned article in The Critic, April 17, 1886.

15. Unsigned article in Art Age, April 1886.

16. See Durand-Ruel: Mémoires, in Venturi, op. cit., v. II, p. 216-217.

17. Pissarro to his son [July 1886]; see Pissarro, op. cit., p. 77.

18. On the group Les Vingt see M. O. Maus: Trente années de lutte pour l'art, Brussels, 1926.

19. See Gauguin's letter to his wife, quoted by J. Dorsenne: La vie sentimentale de Paul Gauguin, Paris, 1927, p. 87.

20. See Signac, op. cit.

21. On Zola's L'oeuvre and Cézanne's reaction see Rewald: Cézanne, sa vie, son oeuvre, son amitié pour Zola, Paris, 1939, p. 299-329.

22. See Cézanne's letter to Zola, April 4, 1886; Cézanne, Letters, London, 1941, p. 183.

23. Monet to Zola, April 5, 1886; see Rewald: Cézanne, etc., p. 319-320.

24. Cézanne to the painter L. Le Bail, ibid., p. 283.

25. Cézanne to Zola, May 20, 1881; see Cézanne, Letters, p. 156.

26. E. Bernard, quoted by Rewald: Gauguin, London, 1938, p. 12.

27. See A. S. Hartrick: A Painter's Pilgrimage Through Fifty Years, Cambridge, 1939, p. 31-32. On Gauguin in Pont-Aven see also C. Chassé: Gauguin et le groupe de Pont-Aven, Paris, 1921, although this study deals mostly with Gauguin's later sojourns in Brittany.

28. This Frenchman has been identified only by his initial, P. See Hartrick, op. cit., p. 30.

29. On the Atelier Cormon see Hartrick, op. cit.

30. See M. Osborn: Der bunte Spiegel, 1890-1933, New York, 1945, p. 37. Pissarro added that he had no idea at that time that both these presentiments would come true.

31. See E. Bernard: Julien Tanguy, Mercure de France, Dec. 16, 1908.

32. Pissarro to his son [Nov. 1886]; see Pissarro, op. cit., p. 81-82.

33. See Monet's letters to Durand-Ruel, Jan. 12-Dec. 29, 1886; Venturi, op. cit., v. I, p. 305-323.

34. Vincent van Gogh to Bernard [July 1888]; see Vincent van Gogh, Letters to Emile Bernard, New York, 1938, p. 57.

35. Vincent van Gogh to Bernard [June 1888]; ibid., p. 34.

THE YEARS AFTER 1886

The events of the years following 1886 added emphasis to the fact that the impressionist movement had finally broken up, the movement which had taken root back in the studio of Gleyre, in the *Salon des Refusés,* in Fontainebleau forest and in the inn of Mother Anthony, in the *brasseries* and on the terrace of the Café Guerbois. The concepts taking form at these sources had found their first free expression in works painted in the late 'sixties, had been completely realized in the early 'seventies and had appeared in all their disconcerting novelty at the exhibition of 1874. When the eighth exhibition closed its doors in 1886, the "impressionist period" had lasted a little less than twenty years. This period had been a decisive phase in the development of the various painters connected with the movement, but scarcely any of them seemed to regret its end.

After 1886, when the impressionists strove to renew their art independently of each other, at the same time beginning to enjoy the hard-earned rewards of modest success, a new generation carried on the fight for new ideas. This generation, like its forerunner, was anxious to escape the tyranny of academicism and turned toward the impressionists just as these once had asked the painters of Barbizon for advice. Knowingly or not, the impressionists thus guided the younger artists, who found inspiration in their example and in their art. Yet, like some of the men of Barbizon, who had failed to recognize their true successors, they sometimes failed to see in the efforts of the younger painters the continuation of their own conquests.

The history of the years after 1886 is thus the parallel history of two generations: the older one, still in the prime of its vigor and confident in its strength, and the younger, which first had to acquire the independence necessary to unfold its own potentialities. While audacity and initiative often remained with the newcomers, knowledge and experience were the prerogative of the old-timers.

So as to gain experience and independence, after he had absorbed all that impressionism could offer, Gauguin left in the spring of 1887 with Charles Laval for Martinique, attracted by the unknown.[1] At the same time Pissarro, Signac and Seurat exhibited with *Les Vingt* in Brussels, where they were laughed at once more but where their works left a deep impression on many young artists. A little later, in Paris, Berthe Morisot, Sisley, Renoir, Monet and Pissarro participated in the *Exposition Internationale* at Petit's, together with Whistler, Raffaëlli and others. Chocquet, de Bellio and Murer did not hide their disapproval of Pissarro's new canvases, while Pissarro showed little sympathy for the work of his former comrades, which he considered incoherent. "Seurat, Signac, Fénéon, all our young friends like only my

RENOIR: *Bathers, 1884-87. 45¼ x 67". Exhibited at Petit's in 1887. Collection Carroll S. Tyson, Philadel-phia.*

works and Mme Morisot's a little," he wrote his son Lucien, adding: "Naturally they are motivated by our common struggle. But Seurat, who is colder, more logical and more moderate, does not hesitate for a moment to declare that we have the right position, and that the impressionists are even more retarded than before."[2]

Renoir exhibited at Petit's his large composition of *Bathers,* the result of several years of research. Huysmans proclaimed his dislike, Astruc did not approve either, and Pissarro explained to his son: "I do understand what he is trying to do, it is proper not to want to stand still, but he chose to concentrate on the line, his figures are all separate entities, detached from one another without regard for color."[3] Vincent van Gogh, however, admired Renoir's "pure clean line," and so did the general public; Renoir this time achieved noticeable success. "I think," he wrote to Durand-Ruel, "I have advanced a step in public approval, a small step. . . . The public seems to be getting accustomed to my art. Perhaps I am mistaken, but this is being said on all sides. Why at this particular time and not at the others?"[4]

Monet informed Durand-Ruel that the success obtained at Petit's had had its repercussions, that Boussod & Valadon had bought works of his as well as of Renoir, Degas and Sisley and had sold them without difficulty. In Paris there was definitely a demand for impressionists, and there were now several dealers competing for the patronage of collectors. Durand-Ruel learned of this while in New York, where his second exhibition did not produce the expected results. Monet insisted that he would have done better

to stay in Paris and take advantage of the new situation. But Durand-Ruel was unwilling to abandon the American market and decided in 1888 to open a branch in New York. In Paris meanwhile he ran into further complications when Monet refused to join a group exhibition of Renoir, Sisley and Pissarro. Monet finally abandoned Durand-Ruel altogether and signed a contract with Theo van Gogh for Boussod & Valadon. Thereafter, if Durand-Ruel wanted any recent paintings by Monet, he had to buy from these dealers. Boussod & Valadon later went so far as to consider sending Theo van Gogh with a collection of pictures to New York, but nothing came of it.

Early in 1888 Gauguin suddenly returned to France, after illness had driven him and Laval from Martinique, where he thought he had found an ideal background for his work. He arrived in Paris completely penniless. Theo van Gogh organized a small exhibition of Gauguin's new paintings, which had no success whatever. Finally Gauguin returned to Pont-Aven in Brittany, where he barely managed to exist; he was still suffering from dysentery and sometimes was so poor that he could not paint for lack of canvas and colors. But he had hit upon a new concept and tried relentlessly to formulate it. "Don't copy too much from nature," he advised Schuffenecker. "Art is an abstraction; derive it from nature by indulging in dreams in the presence of nature, and think more of creation than of the result."[5] It was now that he began to speak increasingly of *synthesis*, which became his main preoccupation. He tried to achieve synthesis by insisting on the essential and sacrificing color and execution to style.

Van Gogh meanwhile had left Paris and gone to southern France in February 1888. Attracted by Provence, where he hoped to find the color schemes of Delacroix, the incisive outlines of Japanese prints and the landscapes he had seen in the canvases of Cézanne at Tanguy's, van Gogh found stimulating views in and around Arles and feverishly set to work. It was not long after his arrival that he informed his brother: "What I learned in Paris is leaving me and I am returning to the ideas I had . . . before I knew the impressionists. And I should not be surprised if the impressionists soon find fault with my way of working, for it has been fertilized by the ideas of Delacroix rather than by theirs. Because, instead of trying to reproduce exactly what I have before my eyes, I use color more arbitrarily so as to express myself forcibly."[6] Vincent also emphasized that he was "trying now to exaggerate the essential and to leave the obvious vague."[7]

In Brittany, Gauguin's work was guided by similar conceptions. When he painted a portrait of himself for Vincent, he explained that it was "so abstract as to be absolutely incomprehensible. At first glance, a gangster's head . . . from this point of view personifying a discredited impressionist painter. . . . The drawing is quite special; the eyes, mouth and nose are like flowers in Persian rugs, hence representing the symbolic side. The color is rather remote from nature. . . ."[8] In this symbolic portrait van Gogh discovered all the unhappiness of his friend. He persuaded Gauguin to join him in the south, where they might set up for themselves and for others a studio in the tradition of medieval workshops, an idea which he had already discussed in Paris with Guillaumin, Pissarro, Seurat and Theo. At Vincent's request Theo promised to send a monthly remittance to Gauguin in exchange for pictures, thus offering him the same kind of help which Durand-Ruel had offered the impressionists.

At the end of October 1888 Gauguin arrived at Arles but cared little for life in the small Provençal town to which van Gogh had become deeply attached. Their divergent temperaments and opinions soon caused van Gogh and Gauguin to quarrel violently. Late in December they traveled together to nearby Montpellier in order to visit the collection of works by Courbet, Delacroix and others which had been

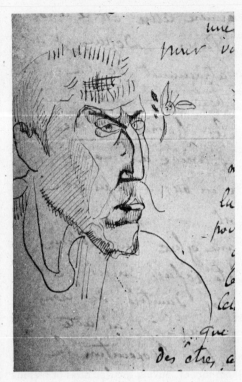

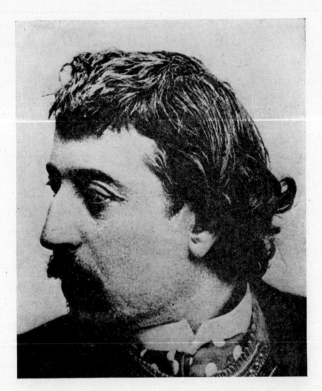

GAUGUIN: *Sketch after a Self Portrait painted for Vincent van Gogh, 1888. Collection C. Roger-Marx, Paris.*

Photograph of Paul Gauguin, probably taken in Brittany around 1888.

bequeathed to the Musée Fabre by Bruyas, who once had refused to buy paintings by Monet which Bazille submitted to him. When Vincent reported to his brother their discussions in front of these pictures, he wrote: "Our arguments are terribly *electric*, we come out of them sometimes with our heads as exhausted as an electric battery after it is discharged."[9] A few days later van Gogh suffered a nervous breakdown and in a fit of insanity attempted to kill Gauguin, later mutilating himself. Vincent was taken to the hospital; Gauguin summoned Theo and returned to Paris.

For Pissarro the year 1888 had again been difficult. Durand-Ruel, preoccupied with his affairs in America, had not been of much help, but the painter had been able to transact some business with Theo van Gogh; his prices too began to pick up. However, Pissarro was losing faith in his new style and became impatient with the slow execution it demanded. Although he vehemently defended Seurat and his conceptions in a discussion with Renoir, he confessed in a letter to Fénéon that the divisionist technique "inhibits me and hinders the development of spontaneity of sensation."[10] Indeed, he soon recognized that he had been deluding himself in following the young innovators. It did not matter any more whether their theory was good in *itself,* since his paintings no longer fully satisfied him, and he openly admitted his error. In a letter to Henri van de Velde (who was closely connected with the group *Les Vingt*), he later explained: "I believe that it is my duty to write you frankly and tell you how I now regard the attempt I made to be a systematic divisionist, following our friend Seurat. Having tried this theory for four

years and having now abandoned it, not without painful and obstinate struggles to regain what I had lost and not to lose what I had learned, I can no longer consider myself one of the neo-impressionists who abandon movement and life for a diametrically opposed esthetic which, perhaps, is the right thing for the man with the right temperament but is not right for me, anxious as I am to avoid all narrow, so-called scientific theories. Having found after many attempts (I speak for myself), having found that it was impossible to be true to my sensations and consequently to render life and movement, impossible to be faithful to the so random and so admirable effects of nature, impossible to give an individual character to my drawing, I had to give up."[11] Pissarro subsequently repainted some of his divisionist canvases and destroyed others.

Monet spent part of the year 1888 in Antibes, painting a series of landscapes which immediately met with enthusiasm. In 1889 he organized, together with Rodin, a great retrospective exhibition at Petit's, including works done between 1864 and 1889. Commenting on his efforts, Monet told the American painter Lilla Cabot Perry that he "wished he had been born blind and then had suddenly gained his sight so that he could have begun to paint in this way without knowing what the objects were that he saw before him."[12] When Mrs. Perry brought one of Monet's landscapes to Boston, only John La Farge appreciated it.

Having broken with Boussod & Valadon, Monet again dealt with Durand-Ruel. However, he refused to bind himself, kept other dealers bidding for his works and reserved the right to raise his prices accordingly. His clever salesmanship partly accounts for the fact that he was the first to command high prices, but he remained for his friends a generous comrade, lending them money, buying their pictures or helping to sell them. Yet he declined to participate in an exhibition of the impressionists which Durand-Ruel wanted to organize. Monet considered the plan to re-establish the old group both unnecessary and bad; his opposition did away with the last chance of a revival attempted by Durand-Ruel.

Now that he began to be well known, Monet conceived the noble idea of organizing a subscription in order to offer Manet's *Olympia* to the French nation. Part of the year 1889 was taken up with these efforts, of which Zola disapproved because he thought that Manet should enter the Louvre in his own right. Most of Manet's friends, however, supported the plan, and Monet was able to raise about 20,000 francs with which to purchase the painting from Manet's widow. Among those who contributed were Dr. de Bellio, Bracquemond, Burty, Caillebotte, Carolus-Duran, Degas, Durand-Ruel, Duret, Fantin, Guillemet, Lautrec, Mallarmé, Murer, Pissarro, Antonin Proust, Puvis de Chavannes, Raffaëlli, Renoir, Rodin and Rouart.[13] Neither Chocquet nor Cézanne seem to have participated.

Renoir had been in the south early in 1888 and had paid a visit to Cézanne at the Jas de Bouffan, occasionally working at his side. Renoir traveled quite a lot, but toward the end of the year he suddenly began to suffer from severe neuralgia: part of his head was paralyzed, and he had to undergo electrical treatment. Moreover, like Pissarro, Renoir was dissatisfied with his recent work. When the vanguard-critic Roger Marx prepared the Fine Arts section of an International Fair to be held in Paris, Renoir informed him: "If you see M. Chocquet, I should appreciate it very much if you would not listen when he talks to you about me. When I have the pleasure of seeing you, I shall explain—what is very simple—that I find everything I have done bad and that it would be for me the most painful thing possible to see it exhibited."[14] Soon, however, the linear dryness was to disappear from Renoir's work and he was to unfold again the richness of his palette and the vivacity of his brushstroke. In 1890 he exhibited once

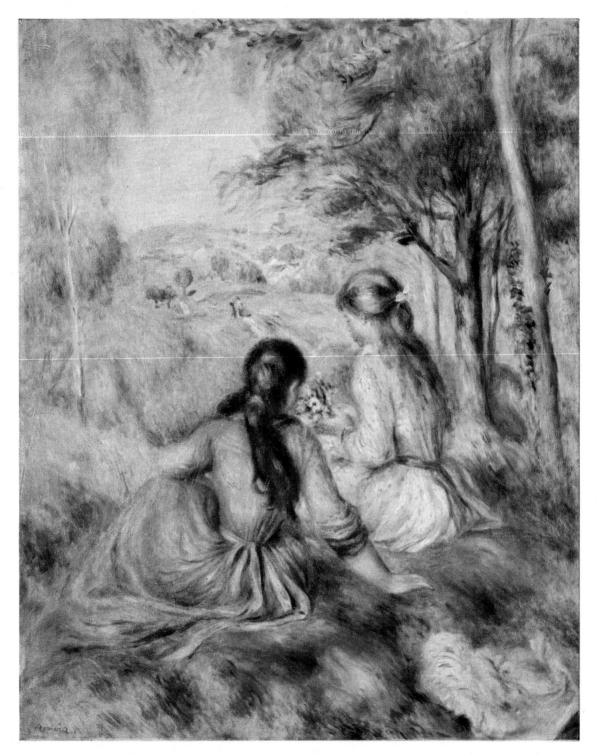

RENOIR: In the Meadow, c. 1895. 32 x 25¾". Collection Mr. and Mrs. Sam A. Lewisohn, New York.

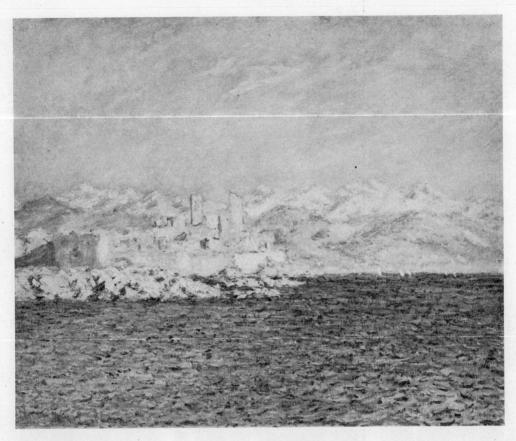

MONET: *Old Fort at Antibes, d. 1888. 26 x 32". Museum of Fine Arts, Boston.*

more at the Salon, after an absence of seven years; he never showed there afterward. A large exhibition of his work put on by Durand-Ruel in 1892 constituted a definite triumph for the artist.

While Chocquet had been hindered by the painter himself from pleading for Renoir in 1889, he succeeded in having one of Cézanne's paintings admitted to the Fair by refusing to lend a piece of antique furniture for which he had been asked unless a work by his friend was accepted. Monet was represented by three canvases at the same exhibition, and Theo van Gogh managed to sell one of his paintings to an American for the unheard-of price of 9,000 francs.

Gauguin, who had returned to the Auberge Gloanec in Pont-Aven, was not admitted to the International Fair and thereupon arranged an exhibition of his own with the steadily growing group of friends gathered around him in Brittany.[15] It was held at the Café Volpi, on the Champ de Mars, during the Fair, and was announced as an "Exhibition of Painting of the Impressionist and Synthetist Group." The inclusion of the word "impressionist" was rather misleading; the exhibition was clearly dominated by the synthetic and symbolic work of Gauguin's recent period. Whereas this show had little success, Gauguin's paintings aroused much anger and also much interest in Brussels, where he exhibited in the same year with *Les Vingt.*

The group of *Les Vingt* had become increasingly active. In 1888 Toulouse-Lautrec had participated

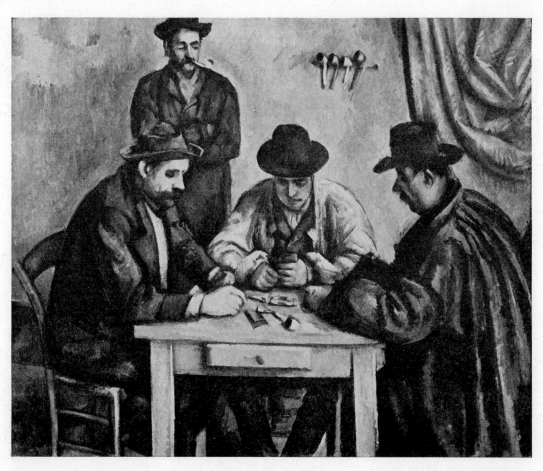

CÉZANNE: *The Card Players, 1890-92. 25⅝ x 32½". Collection Stephen C. Clark, New York.*

in its exhibition, while Degas had declined an invitation—he did so again in 1889. That same year Cézanne accepted, explaining his usual reserve about exhibitions on the basis that he "had resolved to work in silence until the day when I should feel myself able to defend in theory the results of my attempts." Informed that Sisley and van Gogh were also to show, he wrote: "In view of the pleasure of finding myself in such good company I do not hesitate to modify my resolve."[16] Among other paintings Cézanne sent to Brussels his *Maison du pendu,* which he asked Chocquet to lend.

Cézanne had not exhibited in Paris since 1877. Only at Tanguy's could his canvases be seen, though few knew this; nevertheless, an increasing number of young painters went there to study his work. Tanguy's small place began to be a center for artists and critics. There trade in ideas was more active than in paintings, although some, like Signac, purchased canvases by Cézanne for a few hundred francs.

An American critic whom some painters took to Tanguy's shop saw there "violent or thrilling van Goghs, dusky, heavy Cézannes . . . , daring early Sisleys . . . , all lovingly preserved, and lovingly brought out by the old man." And the author added: *"Le père* Tanguy is a short, thick-set, elderly man, with a grizzled beard and large beaming dark blue eyes. He had a curious way of first looking down at his picture with all the fond love of a mother, and then looking up at you over his glasses, as if begging you

CÉZANNE: *Still Life, 1885-90. 26⅛ x 32½". Collection Maurice Wertheim, New York.*

to admire his beloved children. . . . I could not help feeling, apart from all opinions of my own, that a movement in art which can inspire such devotion must have a deeper final import than the mere ravings of a coterie."[17]

Among those who frequented Tanguy's shop were many former pupils of the Académie Julian and others, who had worked with Gauguin in Brittany or were attracted by his theories, such as Emile Bernard, Maurice Denis, Pierre Bonnard and Edouard Vuillard. To them Cézanne appeared something of a myth; many did not know whether he was living or dead and knew nothing of him except what that simple soul, Tanguy, had to tell. This mystery conferred even more fascination upon his art, in which the younger generation discovered the same preoccupation with structure that had become essential for Seurat, van Gogh and Gauguin. They recognized in him the only one of the old impressionists who had abandoned impressionism while retaining its technique, in order to explore spatial relations and reduce forms to their fundamental character.

Maurice Denis later recalled that what they admired most in Cézanne's canvases was the equilibrium, the simplicity, austerity and grandeur. His paintings seemed just as refined as, yet more robust than the strongest works of the impressionists. Denis and his friends had found that impressionism had "a syn-

GAUGUIN: *Portrait of Mlle Marie Henry (in the background Cézanne's* Still Life *owned by Gauguin, repr. p 346), d. 1890. 24¼ x 20¼". Art Institute, Chicago (J. Winterbotham Collection).*

CÉZANNE: *Mme Cézanne in the Greenhouse, c. 1890. 28¾ x 36⅜". Collection Stephen C. Clark, New York.*

thetic tendency, since its aim was to translate a sensation, to objectify a state of mind; but its means were analytical, since color in impressionism was merely the result of an endless number of contrasts. . . ."[18] Cézanne, however, by revealing structure beneath richly nuanced surfaces, went consciously beyond the appearances which satisfied a Monet. To the young painters his work offered a solution to the problem of "preserving sensibility's essential role while substituting conscious reflection for empiricism."[18] They even discovered a link with their own symbolist efforts in his words to the effect that the sun could not be reproduced but had to be *represented* through something else—through color. Cézanne's combination of style and sensibility, the harmony which he achieved between nature and style seemed to them the logical, the sole means to overcome impressionism—and even symbolism—leading them on a new path. To these young painters, avid for theories and experience, Cézanne thus appeared simultaneously as "the final outcome of the classic tradition and the product of the great crisis of liberty and light which has rejuvenated modern art. He is the Poussin of impressionism."[18] And Cézanne himself said that his aim was to "vivify Poussin in contact with nature."

Gauguin untiringly proclaimed his admiration for Cézanne and kept with him one of Cézanne's still lifes, a relic of his collection with which he refused to part; (he placed it in the background of a portrait of his hostess painted in Brittany). Cézanne's and Gauguin's followers formed an important nucleus at the *Salon des Indépendants,* which now every year constituted a decisive event and attracted all those who worked in disregard of official rules. Van Gogh exhibited there; so did Lautrec. In 1886 the works of the *douanier* Rousseau had appeared there for the first time and excited great hilarity. When a friend dragged Pissarro before Rousseau's paintings to make him laugh, Pissarro caused surprise by admiring— in spite of the naiveté of the drawing—the qualities of the painting, the exactness of the values and the richness of the colors. Subsequently Pissarro warmly praised the *douanier's* work to his acquaintances.[19]

It was Pissarro's sympathetic attitude to all sincere efforts which prompted Theo van Gogh to ask him (he had just organized an exhibition of Pissarro's work early in 1890) whether he could help his brother. After his first attack Vincent had remained for one year at the Saint-Rémy Asylum near Arles, where he had been able to work between repeated spells of madness, hoping against hope that he might overcome his affliction. Tired of his uninspiring surroundings and confident that attacks would no longer be so frequent, he had asked Theo to find him a place near Paris where he might live and work. At Theo's request Pissarro was ready to take Vincent into his house at Eragny, but Madame Pissarro was afraid of the effect of an unbalanced man on her children. Pissarro thereupon recommended his old friend, Dr. Gachet at Auvers, who declared himself willing to take care of Vincent. The latter came to Auvers in May 1890; he killed himself there in July of the same year, unable to believe any longer in the possibility of cure. After the suicide of his brother Theo van Gogh fell seriously ill; he was taken to Holland and died in January 1891. He was replaced at the gallery by Maurice Joyant, a school friend of Lautrec's, to whom M. Boussod, the owner, complained that Theo van Gogh had "accumulated appalling things by modern painters which had brought the firm to discredit." Indeed, Theo had left a stock of works by Degas, Gauguin, Pissarro, Guillaumin, Redon, Lautrec, Monet and others. According to M. Boussod only Monet's canvases were saleable, especially in America.[20]

In March 1891 Seurat helped arrange once more the *Salon des Indépendants,* which was to contain a memorial show for van Gogh. He inspected the entries and supervised the hanging, hardly noticing a sore throat. A sudden fever sent him to bed. He died on March 29, 1891, at the age of thirty-one.

CÉZANNE: Sainte-Victoire seen from the Bibémus Quarry near Aix, c. 1898. 26¼ x 32½″. The Etta Cone Collection, Baltimore.

MONET: *Haystack, d. 1893. 24⅛ x 32½". Present owner unknown.*

A few days after Seurat's death, Gauguin again left France, sailing—this time alone—for Tahiti, hoping to live there "on ecstasy, calmness and art." Renoir was greatly puzzled by Gauguin's perpetual longing for exotic subjects; "one can paint so well in Batignolles," was his comment. Pissarro, likewise, was not convinced by Gauguin's theory that "the young would find salvation by replenishing themselves at remote and savage sources."[21] But Degas showed increasing interest in Gauguin's effort and bought several canvases at the auction sale organized by Gauguin to raise the money for his trip. At the request of Mallarmé, Mirbeau wrote an enthusiastic article to support the sale, which netted almost 10,000 francs for thirty paintings. Anxious to know what Monet thought of his evolution "toward complication of the idea in simplification of the form," Gauguin had shown great satisfaction when told by Mirbeau that Monet had liked one of his recent paintings, *Jacob Wrestling with the Angel*.[22] But Monet himself was less charitable and did not hesitate to confess later that he had never taken Gauguin seriously.[23]

Monet's own efforts had just diverged in a new direction which became apparent when he exhibited in 1891 at Durand-Ruel's a series of fifteen paintings representing *Haystacks* at various hours of the day. He explained that in the beginning he had imagined that two canvases, one for grey weather and one for sunshine, would be sufficient to render his subject under different lights. But while painting these *Haystacks* he discovered that the effect of light changed continually, and he decided to retain a whole series of effects on a series of canvases, working on these in succession, each canvas being devoted to one specific effect. He thus strove to attain what he called *instantaneity* and insisted on the importance

of stopping work on a canvas when the effect changed and continuing work on the next canvas, "so as to get a true impression of a certain aspect of nature and not a composite picture."[24] His series of *Haystacks* was followed by similar series of *Poplars,* of the façade of *Rouen Cathedral,* of views of London and *Waterlilies* in his garden pool at Giverny. In his attempt to observe methodically and with almost scientific exactness the uninterrupted changes of light, Monet lost the spontaneity of his perception. He was now disgusted with "easy things that come in a flash," but it had been precisely in those "easy things" that he had manifested his genius to seize in the first impression the luminous splendors of nature. The stubbornness with which he now pursued his race with light—he himself used the word *stubbornness* in this connection—was contrary to his training and to his gifts. While his canvases present an often brilliant solution of this problem, the problem itself remained a mere experiment and imposed severe limitations. His eyes, straining to observe minute transformations, were apt to lose the perception of the whole. Carrying to the extreme his disregard for the actual subject, Monet abandoned form completely and sought to retain in a uniform tissue of subtle nuances the single miracle of light. At the very moment when he imagined he had attained the apogee of impressionism, he turned away from its true spirit and lost the freshness and strength of the initial impression.

Monet's "series" met with tremendous success. All his haystack pictures were sold within three days after the opening at prices ranging between 3,000 and 4,000 francs. But the acclaim of his admirers, led by Monet's friend Clemenceau, was soon to be opposed by severe criticism. A German historian stated that the painter's efforts to test the fertility of his method on a large scale and in different directions had led only to trivialities. He accused Monet of having reduced the impressionist principle to absurdity.[25] As to Monet's former comrades, they witnessed with a certain sadness how his career as an impressionist was ending in technical prowess. Admiring his talent and having tacitly considered him the leader of their group, they were now forced to remember Degas' contention that Monet's art "was that of a skillful but not profound decorator."[26]

Even Guillaumin objected to Monet's "total lack of construction" while marvelling at his ability to attack the problem. Guillaumin in 1891 had won 100,000 francs in a city lottery, and this unexpected fortune had at last enabled him to quit his administrative job in Paris and devote himself entirely to painting. But, having lost contact with his former friends, particularly Pissarro and Monet, he failed to dominate his sensations and scattered his strength in attempts to be forceful in color while he remained weak in construction lacking the breadth of vision and poetic delicacy which saved Monet from banality.

Degas, too, lost contact with his colleagues. He seems not to have attended the "impressionist dinners" held monthly between 1890 and 1894 at the Café Riche. The critic Gustave Geffroy—a particular friend of Monet who introduced him at the dinners—tells of having met there Pissarro, Sisley, Renoir, Caillebotte, Dr. de Bellio, Duret, Mirbeau and occasionally Mallarmé, but does not mention Degas. Avoiding new acquaintances and contenting himself with a few intimate friends like the Rouarts, the sculptor Bartholomé and Suzanne Valadon (whom he had met through the latter), Degas led a hermit's life in the center of Paris, steadily complaining about failing eyesight. He did not even feel the urge any more to show his works and after 1886 appeared only once before the public with a series of landscape pastels, exhibited at Durand-Ruel's in 1892. These very delicate sketches were supposedly executed in his studio and were not really typical of his work at that time. In his incomparably more important pastels of dancers and nudes, he was gradually reducing the emphasis on line in order to seek the pictorial. Resort-

Monet: *Poplar Trees on the Epte near Giverny, 1891. 39½ x 25½".* Wildenstein Galleries, New York.

Monet: *Rouen Cathedral, Morning, 1894. 42 x 29".* Museum of Fine Arts, Boston.

ing to ever more vibrant color effects, he found in his pastels a means to unite line and color. While every pastel stroke became a color accent, its function in the whole was often not different from that of the impressionist brushstroke. His pastels became multicolored fireworks where all precision of form disappears in favor of a texture that glitters with hatching.

Degas now devoted as much time to modeling as to drawings and pastels, striving as a sculptor to give form to the instantaneous, seeking mass in movement. When age dimmed his eyesight to the point where he had to give up brush and pencil entirely, he devoted himself exclusively to modeling. In kneading clay or wax he did with his fingers what he could no longer do with his eyes.[27] As his self-imposed loneliness became more and more complete, the semi-darkness he lived in made him increasingly irritable. Yet his solitude seems also to have made him conscious of the fact that he had antagonized many of his colleagues, offending them by the sharpness of his tongue and by his uncompromising attitude. After a lifelong effort to hide from others a character made up of timidity and violence, modesty and pride, doubt and dogmatism, he made a confession in a letter to his old friend Evariste de Valernes. "I would like to beg your pardon," he wrote, "for something which frequently recurs in your conversation and even more frequently in your thoughts, namely that I was *harsh* to you or seemed to be so during our long friendship. I was mainly harsh against myself. You will probably remember this, for you yourself were astonished and reproached me for my lack of self-confidence. I was, or seemed to be, harsh against all the world because brutality became a habit of mind, which can be explained by my doubts and my bad temper. I felt so insufficiently equipped, so unprepared, so weak, and at the same time it seemed to me that my *calculs* on art were so correct. I quarreled with all the world and with myself. If I have hurt your high and noble spirit, or perhaps your heart, under the excuse of this accursed art, I beg your pardon."[28]

Yet, in spite of his awareness of his faults, Degas remained the same. Paul Valéry, who met him at the Rouarts', later remembered that he was "a great wrangler and formidable arguer, especially excitable on the subject of politics and of drawing. He would never give in, quickly reached the point of shouting, uttered the harshest words, broke off abruptly. . . . But one sometimes wondered if he did not like being intractable and being generally considered as such."[29] Berthe Morisot seems to have been amazed and, moreover, hurt when she heard Degas explain to Mallarmé: "Art is deceit. An artist is only an artist at certain hours through an effort of will; objects possess the same appearance for everyone; the study of nature is a convention. Isn't Manet the proof? For, although he boasted of servilely copying nature, he was the worst painter in the world, never making a brushstroke without the masters in mind. . . ."[30]

Degas continued to be less severe toward his followers, but the true inheritor of his spirit as well as of his draftsmanship was not to be found among them. He was Henri de Toulouse-Lautrec, who, after early attempts in an impressionist vein, had achieved a style of his own which showed a close yet free relation to Degas', similar to the connection that once existed between Degas and Ingres. Lautrec professed an immense admiration for Degas, for his composition as well as for his sober execution. This admiration was nourished particularly by a friendship with the musician Desiré Dihau and his sister, whom Degas had painted so frequently. In turn, Lautrec did their portraits, always wondering uneasily whether they could stand the comparison with those by Degas. Once after a gay night Lautrec took a group of friends at dawn to Mlle Dihau's, who only hesitatingly admitted them, still in evening attire, to her modest flat. Lautrec led the others before Degas' paintings and ordered them to bend their knees in admiration for the revered master.[31]

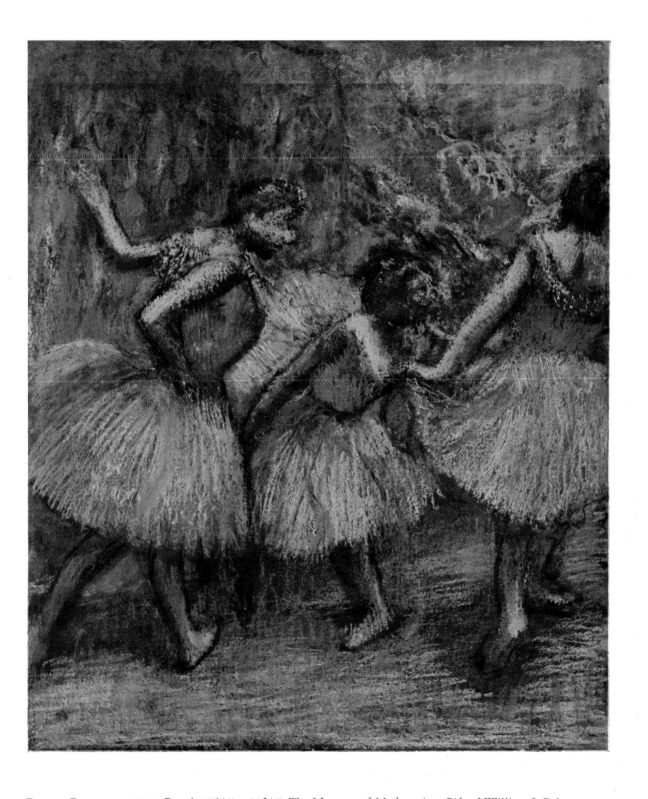

DEGAS: Dancers. c. 1899. Pastel, 37¼″ x 31¾″. The Museum of Modern Art. Gift of William S. Paley.

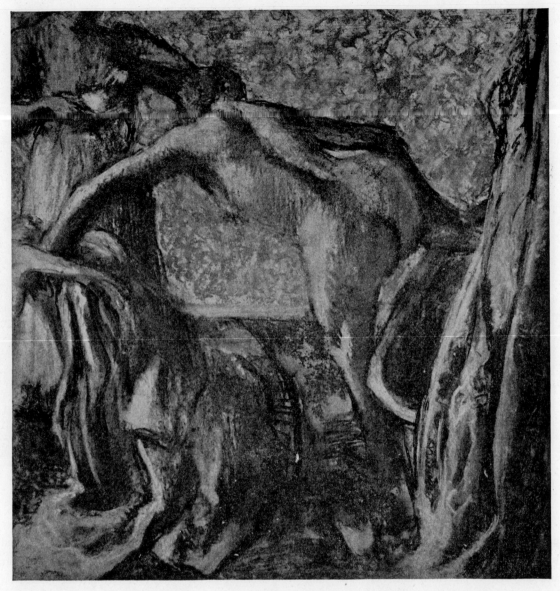

DEGAS: *After the Bath, c. 1905. Pastel, 34⅝ x 30⅝". Durand-Ruel Galleries, New York.*

It is doubtful whether Degas showed particular appreciation for Lautrec's works, in spite of the fact that he recognized his craftsmanship. He was highly suspicious of the new generation and—although he himself sometimes liked to be eccentric—he could not have had much liking for the kind of eccentricities which rendered Lautrec famous all over Montmartre. Stubborn in his convictions, yet inconsistent in his preferences, Degas, for instance, hated people who advertised themselves but was indulgent toward Gauguin, whom he seems to have helped repeatedly. Of his impressionist friends, Degas appears to have remained cordial only with Pissarro, apparently respecting the modesty with which Pissarro pursued his efforts.

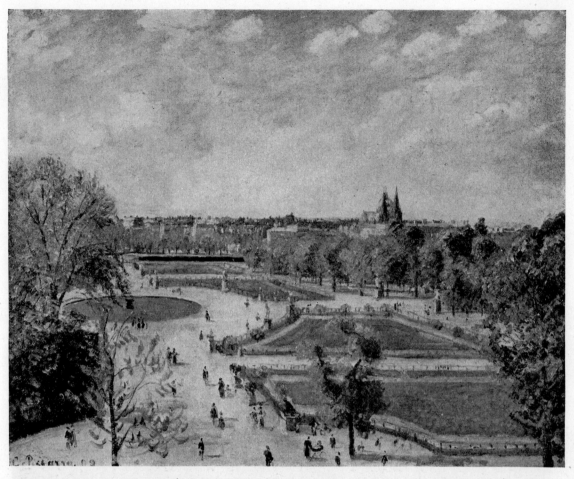

PISSARRO: *View of the Tuileries Gardens in Paris, d. 1899. 29⅜ x 37". Private collection, New York.*

Pissarro had not changed much with the years. He occupied his position as dean of the former group without any ostentation, his just criticism tempered by indulgence, his radical convictions balanced by profound kindness. A chronic infection of one of his eyes began to cause him considerable discomfort and anxiety. It prevented him more and more from working in the open; he therefore concentrated on painting from behind closed windows. When the view from his studio in Eragny failed to reveal anything new, he began to travel, paid frequent visits to his son Lucien, who lived permanently in London, painted from hotel rooms in Rouen and later in Paris. He returned to his impressionist conceptions, abandoned to follow Seurat; his work regained its original freshness, while a greater lightness and purity of color remained as a result of his divisionist experiments. Now over sixty, he devoted himself to his art with such enthusiasm, optimism and youthfulness that he inspired veneration in all those who met him. Although his paintings did not appeal to such a wide public as those of Monet, he slowly achieved recognition. An important retrospective exhibition held at Durand-Ruel's in 1892 contributed definitely to establishing his reputation. But when Mirbeau insisted that the Director of Fine Arts purchase one of Pissarro's canvases for the State, he met with a refusal.

420

PISSARRO: *Rue de l'Epicerie at Rouen, d. 1898. 32½ x 26⅛". Collection F. Moch, Paris.*

Indeed, when Caillebotte died in 1893, leaving his collection of sixty-five paintings to the State, the Government received his gift with the greatest embarrassment. The prospect of seeing impressionist pictures in a museum aroused an uproar of protest from politicians, academicians and critics, equaling and surpassing even the insults heaped upon the painters at the occasion of their first group exhibitions. Gérôme and some of his colleagues even threatened to resign from the *Ecole des Beaux-Arts*. Gérôme summed up the position of the Institute in these words: "I do not know these gentlemen, and of this bequest I know only the title. . . . Does it not contain paintings by M. Monet, by M. Pissarro and others? For the Government to accept such filth, there would have to be great moral slackening. . . ."[32]

The State actually did not dare to accept the bequest as a whole. Despite Caillebotte's provision that his collection should enter the Luxembourg Museum undivided, Renoir, as executor of the will, was forced to yield unless the bequest were to be rejected. Of sixteen canvases by Monet, only eight were admitted; of eighteen by Pissarro, only seven; of eight by Renoir, six; of nine by Sisley, six; of three by Manet, two; of four by Cézanne, two; only Degas saw all seven of his works accepted.[33]

Berthe Morisot—not represented in the Caillebotte collection—had held a very successful exhibition in 1892 at Boussod & Valadon's, an exhibition possibly planned by Theo van Gogh before his death. In 1894, when Duret sold his collection, she saw one of her paintings acquired by the State as a result of Mallarmé's insistence. Her work more than that of any of her colleagues had remained faithful to the initial conceptions of impressionism. Even the severe Seurat had not escaped the charm and freshness of her paintings and watercolors, the directness with which she expressed her delicate vision. But it was Renoir who was most fond of her. Since the late 'eighties he had been seeing her frequently and had painted portraits of her as well as of her young daughter. He considered her the last truly feminine artist since Fragonard and admired the "virginity" of her talent. She died in 1895 in the midst of the debates aroused by Caillebotte's bequest.

In the discussions and protests which raged around the Caillebotte donation, Cézanne's name was hardly ever pronounced, apparently because his case was judged so insignificant as not even to warrant mention. When, after the death of *père* Tanguy, an auction sale was held of his belongings in 1894, six paintings by Cézanne brought bids varying between 45 and 215 francs. At about the same time Pissarro spoke of Cézanne to a young dealer, Ambroise Vollard, who had recently established himself in the rue Lafitte, where most of the Paris galleries were then located. Vollard did not have a very sure taste in art and at the beginning showed little discrimination. Well aware of his lack of judgment, he gladly accepted the advice of others. He had the great good fortune to receive suggestions from Pissarro and occasionally from Degas, and he was intelligent enough to follow them. Vollard thus yielded to Pissarro's insistence and went in search of Paul Cézanne, who sent no less than one hundred and fifty paintings, more than Vollard could show at one time.[34] Vollard's exhibition opened in the fall of 1895. After having been absent from Paris exhibitions for almost twenty years, Cézanne's works came as a great surprise. While the public was outraged and the critics judged his efforts with their customary ignorance and brutality, vanguard artists and Cézanne's former comrades greeted him as a master. Commenting on the exhibition, Pissarro wrote his son: "My enthusiasm was nothing compared to Renoir's. Degas himself is seduced by the charm of this refined savage, Monet, all of us. . . . Are we mistaken? I don't think so. The only ones who are not subject to the charm of Cézanne are precisely those artists or collectors who have shown by their errors that their sensibilities are defective. . . . As Renoir said so well, these paintings

RENOIR: *Portrait of Paul Durand-Ruel, 1910. 25⅝ x 21¼". Private collection, Paris.*

CÉZANNE: *Portrait of Ambroise Vollard, 1899. 40¼ x 32½". Formerly Vollard collection, Paris.*

have I do not know what quality like the things of Pompeii, so crude and so admirable! . . . Degas and Monet have bought some marvellous Cézannes, I exchanged a poor sketch of Louveciennes for an admirable small canvas of bathers and one of his self portraits."[35]

Gauguin missed Cézanne's show by a few months. He had returned from Tahiti in 1893, had held an exhibition at Durand-Ruel's and had again gone to Brittany. His Tahitian paintings had aroused considerable interest, especially among his young followers and their symbolist poet friends. They were attracted by unexpected and novel qualities in his art, by his excessive originality. His powerful, harsh pictures impressed them particularly by the boldness of conception, the naked brutality of forms, the radical simplification of drawing, the brilliance of the pure bright colors used to express states of mind rather than reality, by the ornamental character of his composition and the willful flatness of planes. But of his former colleagues only Degas liked his work; Monet and Renoir found it simply bad. Gauguin had a discussion with Pissarro, who was much opposed to his mystical tendencies and who also accused him almost openly of pillaging the savages of Oceania and adopting a style that did not belong to him as a civilized man.[36] But Gauguin had no ear for these remonstrances. When reproached by an interviewer for the lack of verisimilitude in his color scheme, he pointed to the fact that Delacroix had once been charged with painting a purple horse and defended the artist's right to use color arbitrarily if the harmony of his picture required it. Gauguin explained that his work was the fruit of calculation and meditation (avoiding the word "observation") and emphasized: "I obtain by arrangements of lines and colors, using as pretext some subject borrowed from human life or nature, symphonies, harmonies that represent

nothing absolutely *real* in the vulgar sense of the word; they express no idea directly but they should make one think as music does, without the aid of ideas or images, simply by the mysterious relationships existing between our brains and such arrangements of colors and lines."[37]

Gauguin asserted with disdain that the "impressionists studied color exclusively in terms of decorative effect but without freedom, for they kept the shackles of representation. . . . They look for what is near the eye, and not at the mysterious heart of thought. . . . They are the official painters of tomorrow."[38] In spite of his complete break with the impressionists, however, Gauguin did not forget that it was to them and particularly to Pissarro that he owed his initiation. After he had left once more—this time finally —for Tahiti, early in 1895, he wrote in his notebook: "If we observe the totality of Pissarro's work, we find there, despite fluctuations, not only an extreme artistic will, never belied, but what is more, an essentially intuitive, pure-bred art. . . . He looked at everybody, you say! Why not? Everyone looked at him, too, but denied him. He was one of my masters and I do not deny him."[39]

In 1896 Vollard wrote to Gauguin in Tahiti, possibly on the advice of Degas, and eventually made a contract with him according to which he bought Gauguin's entire output.[40] Vollard thus became the sole depositor in Paris of the works both of Cézanne and of Gauguin. In the world of art Vollard's gallery took the place of *père* Tanguy's shop. But Vollard possessed neither the verve of the good old color merchant nor the benevolent wisdom of Theo van Gogh. Under the mask of an often exaggerated indifference he concealed a shrewd business sense combined with a prudence incapable of enthusiasm. Meanwhile, Durand-Ruel's establishment gained steadily in importance. In 1894 the dealer had finally been able to pay all his debts and now became more active than ever before, not only in Paris and New York but also in many European countries where exhibitions of impressionists were organized. While these met with increasing success in Germany, the English public remained aloof.[41]

Whereas the fame of Monet and Renoir quickly spread abroad, Cézanne only now began his struggle for recognition. When, in 1896, one year after Cézanne's first exhibition at Vollard's, Zola wrote another article on art, he called him with unconscious cruelty an "abortive genius." And he expressed a strange regret at having once fought for the principles of the impressionists, explaining that it was their audacity rather than their ideas which he had defended.[42] But when, in 1897, Zola courageously took up the desperate cause of Captain Dreyfus, Monet and Pissarro overcame their resentment and immediately supported him, repeatedly expressing their admiration for his action.[43] Degas, on the contrary, joined the militarists, turned anti-Semitic and henceforth avoided Pissarro, while Cézanne, prisoner of his bigoted environment in Aix, also failed to rally behind Zola in his fight for justice.

Sisley during all those years stayed completely in the background, living and working in retirement in Moret. Having severed relations with Durand-Ruel, he eventually made a contract with Georges Petit, making him the sole agent for his work. He exhibited again at the Salon. He tried to infuse his work with passion, although his character was more that of a subtle poet and dreamer; he was at his best when he abandoned himself to the delicacy of his perceptions. Asked who were the contemporary painters he liked best, he named Delacroix, Corot, Millet, Rousseau and Courbet, without including any of his former comrades.[44] Yet when, suffering from cancer of the throat, he felt that his end was near, he sent for Monet, who hurried to his side. Little known, poor, full of resignation, Sisley died on January 29, 1899. Within one year after his death his paintings began to command fabulous prices.[45]

GAUGUIN: Hina Tefatu *(The Moon and the Earth), d. 1893. 44¼ x 24". Formerly in the collection of Edgar Degas. Museum of Modern Art, New York (Lillie P. Bliss Collection).*

Cézanne's prices began to pick up slowly at about the same time. This became apparent at the sale of Chocquet's collection in 1899, after the death of both Chocquet and his widow. Urged on by Monet, Durand-Ruel bought some of the Cézanne paintings owned by Chocquet, while Vollard acquired for Cézanne a large watercolor of flowers by Delacroix which Cézanne had always admired among his friend's treasures. In the same year Monet himself bought a canvas by Cézanne at an auction, and the high bid he put in caused a sensation at the Hôtel Drouot.

Cézanne's solitary life in Aix was frequently interrupted at this time by visits, mostly from young artists of Gauguin's entourage who came to ask for advice. "I think the young painters much more intelligent than the others," he wrote with unconcealed satisfaction to his son, "the old ones see in me only a dangerous rival."[46] From 1899 on he consented to show at the *Salon des Indépendants,* but his ambition was still to be accepted at the official Salon and even to be nominated to the *Légion d'Honneur*. It was apparently less a thirst for honors which prompted this desire than the wish to be at last considered "seriously" as a painter, especially since the townfolk of Aix continued to see in him merely a rich man's son who had abandoned himself to a harmless fancy. Yet intervention on his behalf by Mirbeau failed to make Cézanne's dream come true, while Renoir was decorated in 1900. Degas, Monet and Pissarro, however, remained averse to anything connected with officialdom.

The steadily growing number of his followers from the younger generation compensated Cézanne, partly at least, for his failure to win official recognition. It made him sense the coming of a new era in art. He was deeply touched when Maurice Denis, who had never met him, exhibited in 1901 a large canvas, *Hommage à Cézanne,* at the Salon; it showed several artists, among them Redon, Vuillard, Bonnard and Denis himself (with Vollard in the background) gathered around a still life by Cézanne—the still life once owned by Gauguin. This composition, bought by André Gide, was conceived in the same spirit that had prompted Fantin to paint his *Hommage à Delacroix,* and Cézanne himself now frequently spoke of painting an *Hommage à Delacroix* in which he proposed to unite Pissarro, Monet, Victor Chocquet and himself. He read again with delight Baudelaire's art criticism, admired his appreciation of Delacroix as well as the sureness of his judgment. He also frequently returned to the writings of Stendhal and the Goncourt brothers and to Balzac's novel, *Le chef-d'oeuvre inconnu.*

The young artists who came to visit Cézanne in Aix found a tall old man of almost exaggerated politeness, though he sometimes changed abruptly from cordiality to haughtiness. Interested in nothing but art, he liked to talk about painting but could show some irritation if pressed by questioners to formulate theories. He would take his visitors with him to the hills around Aix where he worked, insisting that "one says more and perhaps better things about painting when facing the motif than when discussing purely speculative theories—in which, as often as not, one loses oneself."[47] And he repeated again and again: "All things, particularly in art, are theory developed and applied in contact with nature."[48] He frequently complained about his difficulty—growing with age—of realizing his sensations, recognizing at the same time that the problems to be solved appeared ever clearer to him.

Gauguin's "pupil" Emile Bernard, who had published a eulogy of Cézanne as early as 1892, paid him a first visit in 1904 and through conversation as well as later through letters induced Cézanne to formulate his conceptions. Cézanne told him to "see in nature the cylinder, the sphere, the cone, putting everything in proper perspective so that each side of an object or a plane is directed toward a central point."[49] But when Bernard prepared another article on Cézanne, the old artist advised him to paint rather than to

CÉZANNE: *Sainte-Victoire seen from the Lauves, 1904-06. 29¼ x 37". Philadelphia Museum of Art.*

write, explaining: "Painters must devote themselves entirely to the study of nature and try to produce pictures which are an instruction. Talks on art are almost useless. The work which goes to bring progress in one's own subject is sufficient compensation for the incomprehension of imbeciles. Literature expresses itself by abstractions whereas painting, by means of drawing and color, gives concrete shape to sensations and perceptions. One cannot be too scrupulous or too sincere or too submissive to nature; but one is more or less master of one's model, and above all, of the means of expression." And he insisted: "Get to the heart of what is before you and continue to express yourself as logically as possible."[50]

"I try to render perspective solely by means of color," Cézanne told a German collector who paid him a visit in Aix; "the main thing in a picture is to achieve distance. By that one recognizes a painter's talent." Using one of his landscapes as an example, he followed with his finger the limits of the various planes and showed exactly how far he had succeeded in suggesting depth and where the solution had not yet been found—there color would still be color without having become the expression of distance.[51]

While he warned his friends to avoid the influence of Gauguin, van Gogh and the neo-impression-

ists, Cézanne liked to speak of his former comrades, praising Renoir and especially Monet, evoking with particular tenderness the "humble and colossal" Pissarro. When he was invited by a group of Aix artists to exhibit with them in 1902 and again in 1906, Cézanne—now over sixty and acclaimed by the new generation as their undisputed leader—piously affixed to his name: *pupil of Pissarro*. Pissarro never learned of this tribute, just as he never learned that Gauguin, in spite of his sarcasm and longing for independence, had remained conscious of his debt of gratitude.

Gauguin died lonely and embittered on one of the Marquesas Islands in May 1903; the news of his death had hardly reached Paris when Pissarro died peacefully, after a short illness, in November of the same year. He bequeathed six drawings by Seurat to the Luxembourg Museum. Whistler, too, died in 1903. One year before Zola had succumbed to an accidental poisoning, and in 1901 Lautrec had gone, his health completely ruined through excessive drinking. (In that same year, 1901, Vollard held his first exhibition of the works of a young Spaniard, Pablo Picasso, whose paintings strongly reflected the influence of Lautrec.) In 1904 Fantin died.

Deeply affected by the death of both Zola and Pissarro, Cézanne often spoke of his approaching end and swore that he would "die painting." For once fate granted his wish. On October 15, 1906, a thunderstorm surprised him while he was painting on a hill. He remained outside for several hours and was brought home unconscious in a laundry cart. The next day he went into his garden to work and returned dying. He passed away on October 22, 1906. (In the same year the Metropolitan Museum of New York acquired Renoir's *Portrait of Mme Charpentier and her Children*.)

Of the old-guard impressionists now only three remained; Monet, vigorous, hard-working, conscious of his world-wide reputation, surrounded by numerous admirers, among whom were many American artists and collectors; Degas, threatened by total blindness; and Renoir, increasingly crippled by rheumatism, yet joyful, painting in spite of extreme physical difficulties. Suffering continually, plagued by insomnia, his fingers helplessly cramped, he eventually worked with brushes attached to his wrist and considered that he had no right to complain since things might have been worse. Manifesting a particular preference for red, from the pinkish red of flesh to the purplish red of roses,[52] he delighted to retain the fluidity of living forms in a large array of red nuances, modeling volumes with subtle strokes, an expression of his immense knowledge as well as of his ingenuity and eternal freshness.

When the American painter, Walter Pach, questioned him in 1908 concerning his method, Renoir replied: "I arrange my subject as I want it, then I go ahead and paint it, like a child. I want a red to be sonorous, to sound like a bell; if it doesn't turn out that way, I put more reds or other colors till I get it. I am no cleverer than that. I have no rules and no methods; anyone can look at my materials or watch how I paint—he will see that I have no secrets. I look at a nude; there are myriads of tiny tints. I must find the ones that will make the flesh on my canvas live and quiver. Nowadays they want to explain everything. But if they could explain a picture it wouldn't be art. Shall I tell you what I think are the two qualities of art? It must be indescribable and it must be inimitable. . . . The work of art must seize upon you, wrap you up in itself, carry you away. It is the means by which the artist conveys his passion; it is the current which he puts forth which sweeps you along in his passion."[53]

This passion was never to leave Renoir, it even seemed to increase with age. In 1912 he had to submit to a serious operation which failed to benefit him. In December of that year Durand-Ruel, with whom Renoir maintained throughout the most cordial relations, found him in Cagnes, where he was living per-

RENOIR: Portrait of Mme Tilla Durieux, d. 1914. 36½ x 29″. Collection Stephen C. Clark, New York.

RENOIR: *Seated Bather, 1914. 34 x 27½". Art Institute, Chicago (Mr. and Mrs. L. L. Coburn Memorial Collection).*

manently, "in the same sad condition, but always amazing in his strength of character. He can neither walk nor even raise himself from his chair. Two people have to carry him everywhere. What torment! And along with this the same good humor and the same happiness when he is able to paint."[54]

Like Cézanne, Renoir achieved in his last years the synthesis of his lifelong experience. Impressionism lay far behind him; he retained merely the glistening texture of it, yet the shimmering surface of pigment he used now not to render atmospheric effects but to build with brilliant and strong colors an image of life in almost supernatural intensity. The study of nature no longer was his unique goal. "How hard it is," he explained to a young painter, "to find exactly the point at which imitation of nature must cease in a picture. The painting must not smell of the model and yet one must be conscious of nature."[55]

In attaining the balance between observation and vision, the aging Renoir created a new style, crowning his work by a series of masterpieces, exalted in color, subtle in rhythm, forceful in volumes and rich in invention, progressing from canvas to canvas with fertile imagination and happy rendition. His modesty made him wonder frequently during his last years whether his work was worthy of the great French tradition to which he felt himself more and more attached, considering his own efforts as a continuation of the eighteenth century. When a canvas of his was placed in the National Gallery in London in 1917, some hundred English artists and amateurs seized the opportunity of sending Renoir a testimonial of their admiration. "From the moment your picture was hung among the famous works of the old masters," they wrote, "we had the joy of recognizing that one of our contemporaries had taken at once his place among the great masters of the European tradition."[56] Nothing could have pleased Renoir more, for he never tired of proclaiming that "though one should take care not to remain imprisoned in the forms we have inherited, one should neither, from love of progress, imagine that one can detach oneself completely from past centuries."[57] And he emphasized: "Nature brings one to isolation. I want to stay in the ranks."[53]

Absorbed in his work, living only during those hours which he could give to his art, he pitied Degas, who by this time was entirely isolated from the outer world, unable to work, unable to enjoy the rich collection of paintings and drawings gathered through many years (in which Ingres shared honors with Delacroix, Cézanne and Gauguin) and who wandered aimlessly through the streets of Paris while the battles of the first World War raged not far from the city. When Durand-Ruel informed Renoir of Degas' death in September 1917, his answer was: "It is indeed the best for him. . . . Every imaginable kind of death would be better than to live as he was living."[58] Renoir was spared a similar fate; for in spite of two decades of physical suffering he was able to work until the very end. He died on December 3, 1919.

Two years later, early in 1922, Paul Durand-Ruel passed away at the age of ninety. He had lived long enough to see glory come to his painters, glory of a magnitude never dreamt of by the artists themselves nor by the dealer who more than half a century before had with unerring instinct supported their seemingly hopeless cause.

On June 19, 1926, Mary Cassatt died at her Château Beaufresne near Beauvais. Like Degas she had been afflicted during the latter part of her life with partial blindness which, after 1912, increased until it became almost complete toward the end. A few months later, in December 1926, Claude Monet was buried in the small cemetery of Giverny, at the close of his eighty-seventh year. Guillaumin died at the same age in June 1927.

With the death of Monet—less than twenty years ago—there disappeared the last master of that

unique and astonishing pleiad which had constituted the impressionist group. He died, like Ingres, at a time when the ideas which he personified had long ceased to belong to actuality. The first of the impressionist painters to achieve success, the only one of them to see it turn into a real triumph, he lived to witness his isolation and must have felt some bitterness that the vision which it had taken so many years to impose was most violently attacked by the younger generations.[59] Yet it was not the new art movements which preoccupied him during his last years but the past with which history will forever identify his name. In a letter written shortly before his death, he tried to sum up his contribution: "I have always had a horror of theories, . . . I have only the merit of having painted directly from nature, trying to convey my impressions in the presence of the most fugitive effects, and I am distressed at having been the cause of the name given to a group of which the majority was not at all impressionist."[60]

This regret expressed by Monet in the evening of his life seems strange. Might he not have felt some pride in having provided, though involuntarily, a name for a movement that had added one of the most glorious chapters to the history of art? Forty years had passed since the group of Monet's friends had definitely dissolved, but impressionism was not dead because the men who had promoted it had ceased to be impressionists. Even though it was no longer a battle-cry, it remained a living inspiration to those who came afterwards. Its achievements had become the common heritage of mankind on which to base new conquests. It was true, though, that the younger generation had ended by discarding most of the impressionist principles, that fauvists, cubists, expressionists, futurists, dadaists, surrealists had opened entirely new horizons. But their efforts had been fertilized by Cézanne, Gauguin, van Gogh and Seurat, all of whom had gone through impressionist experiences. While the direct influence of impressionism on contemporary art may sometimes seem negligible, while of the great living masters only Bonnard has continued to developed a style of his own in a truly impressionist spirit, it was the art of Monet and his companions which broke down countless prejudices and opened the road for steadily increasing boldness of technique, of color and abstraction.

The impressionists lived to see their conceptions partly adopted by officialdom, diluted, polished, adapted to petty standards, and this evolution has not yet stopped. But uninspired followers can merely obscure the luster of an achievement, they cannot tarnish the sources from which they draw. Ingres' pupils once succeeded in vulgarizing their master's principles, yet they have not been able to kill classicism, and the present generation has even returned to some of the ideas preached by the man who in his day seemed to personify the obstacle to progress. Impressionism, which contributed its generous share to freeing the world of art from the despotism of misunderstood tradition, may now take its place among the great traditions. And like all traditions it will be rejected at times, only to be rediscovered later; it will remain for periods unexplored or become a vital factor in new efforts. It will be admired as much as it will be opposed, but it will never be ignored.

Impressionism will thus live on as one of the most important phases of the history of modern art, a phase superseded in the eighteen-eighties by another, the representatives of which were partly identical with those of impressionism. It was precisely one of these, Gauguin, who formulated the problems which assailed the artists anxious to advance beyond impressionism: "It was necessary to throw oneself heart and soul into the struggle, to fight against all schools, all without exception, not by disparaging them but by something different, by outraging not only officialdom, but even the impressionists, the neo-impressionists, the old and the new public . . . to take up the strongest abstraction, do all that had been forbidden and

431

rebuild more or less successfully, without fear of exaggeration, even with exaggeration. To learn afresh, then, though you know, learn again. To overcome all fears, no matter what ridicule might be the result. Before his easel, the painter is not the slave either of the past or the present, either of nature or his neighbor. He is himself, still himself, always himself."[61]

This struggle was to lead to unexpected results. Begun by Cézanne, Seurat, Gauguin, van Gogh, Toulouse-Lautrec, it was to be continued by new men, Picasso, Matisse and countless others, who carried on from where the others had left off. Once again history furnished striking proof that it engraves its dates not on tombs but on milestones; the one which bears the date 1886 is the symbol both of an end and of a beginning. From the dissolution of the movement created by Monet and his friends it points into the post-impressionist period, the story of which still remains to be written.

NOTES

1. It seems interesting to note in this connection that there was at that period a strong movement in France for the development of her colonies, a movement which may have influenced Gauguin to some degree. The far-off places of which he dreamt were *all* French colonies: Madagascar, Martinique, French Indo-China and Tahiti. Degas had advised Gauguin to go to New Orleans but the latter did not accept his suggestion.

2. Pissarro to his son, May 15, 1887; see Camille Pissarro, Letters to his son Lucien, New York, 1943, p. 110.

3. Pissarro to his son, May 14, 1887, *ibid.*, p. 107-108.

4. Renoir to Durand-Ruel, May 12, 1887; see L. Venturi: Les Archives de l'Impressionnisme, Paris-New York, 1939, v. I, p. 138.

5. Gauguin to Schuffenecker, August 1888; see C. Roger-Marx: Lettres inédites de Vincent van Gogh et de Paul Gauguin, *Europe*, Feb. 15, 1939.

6. Vincent to Theo van Gogh, Aug. 1888; see: Further Letters of Vincent van Gogh to his Brother, London-New York, 1929, p. 139 (No. 520).

7. Vincent to Theo van Gogh, May 1888, *ibid.*, p. 66 (No. 490). For photographs of Vincent's "motifs" see *L'Amour de L'Art*, Oct. 1936; Catalogue of van Gogh Exhibition, Exposition Internationale, Paris, 1937 and *Art News*, April 1-14, 1942.

8. Gauguin to Schuffenecker, Oct. 8, 1888; see Roger-Marx, *op cit.* This letter is accompanied by the sketch reproduced p. 407.

9. Vincent to Theo van Gogh, Dec. 1888, *op. cit.*, p. 258 (No. 564).

10. Pissarro to Fénéon, Feb. 1, 1889; see J. Rewald: Georges Seurat, New York, 1943, p. 79, note 134.

11. Pissarro to H. van de Velde, March 27, 1896, *ibid.*, p. 68.

12. See L. Cabot Perry: Reminiscences of Claude Monet from 1889 to 1909, *The American Magazine of Art*, March 1927.

13. See G. Geffroy: Claude Monet, sa vie, son oeuvre, Paris, 1922, v. I, ch. XXXIII.

14. Renoir to Roger Marx, July 10, 1888; see C. Roger-Marx: Renoir, Paris, 1937, p. 68.

15. On Gauguin's group see C. Chassé: Gauguin et le groupe de Pont-Aven, Paris, 1921; M. Denis: Théories, 1890-1910, Paris, 1912; E. Bernard: Notes sur l'Ecole dite de "Pont-Aven," *Mercure de France*, Dec. 1903 and A. Armstrong Wallis: The Symbolist Painters of 1890, *Marsyas*, v. I, No. 1.

16. Cézanne to Maus, Nov. 27, 1889; see Cézanne, Letters, London, 1941, p. 190.

17. C. Waern: Some Notes on French Impressionism, *Atlantic Monthly*, April, 1892.

18. M. Denis: Cézanne, *L'Occident*, Sept. 1907, repr. *in* Théories, *op. cit.*

19. Information courtesy M. L. R. Pissarro; see also A. Basler: La Peinture . . . Religion nouvelle, Paris, 1926, p. 62.

20. See M. Joyant: Henri de Toulouse-Lautrec, Paris, 1926, v. 1, p. 118-119. The services Theo van Gogh might

have rendered to the impressionists and post-impressionists, had he lived longer, cannot be estimated. His role has not yet found proper recognition. On him see T. van Gogh: Lettres à son frère Vincent, Amsterdam, 1932; V. van Gogh: Letters and Further Letters to his Brother, London 1927-29; also Paul Gauguin: Letters to A. Vollard and A. Fontainas, San Francisco, 1943, p. 6 ff, as well as Pissarro's Letters to his Son Lucien.

21. See Pissarro's letters to his son, Nov. 23, 1893 and April 20, 1891, op. cit., p. 221 and 163-164.

22. See Mirbeau's letter to Monet, Feb. 1891, Cahier d'Aujourd'hui, No. 9, 1922; also Pissarro's letter to his son, May 13, 1891, op. cit., p. 170. The painting is now in the National Gallery of Scotland, Edinburgh.

23. See L. Vauxcelles: Un après-midi chez Claude Monet, L'Art et les Artistes, Dec. 1905.

24. See L. Cabot Perry, op. cit.; also Duc de Trévise: Le pèlerinage de Giverny, Revue de l'art ancien et moderne, Jan.-Feb. 1927 and Monet's letter to Geffroy, Oct. 7, 1890, Geffroy, op. cit., v. II, ch. X.

25. See W. Weisbach: Impressionismus—Ein Problem der Malerei in der Antike und Neuzeit, Berlin, 1910-11, v. II, p. 141.

26. See Pissarro's letters to his son, July 8 and 10, 1888, op. cit., p. 127.

27. See J. Rewald: Degas, Works in Sculpture, A Complete Catalogue, New York, 1944.

28. Degas to de Valernes, Oct. 26, [1890]; see: Lettres de Degas, Paris, 1931, p. 181.

29. See P. Valéry: Degas, Dance, Dessin, Paris, 1938, p. 12.

30. From Berthe Morisot's notebook; see M. Angoulvent: Berthe Morisot, Paris, 1933, p. 76.

31. Information courtesy Professor Paul J. Sachs, to whom this incident was told by Mlle Dihau; see also G. Mack: Toulouse-Lautrec, New York, 1938, p. 59-62.

32. Gérôme quoted by A. Leroy: Histoire de la peinture française, 1800-1933, Paris, 1934, p. 165-168. On the Caillebotte bequest see also H. Bataille: Enquête, Journal des Artistes, 1894; O. Mirbeau: Le Legs Caillebotte et l'Etat, Le Journal, Dec. 24, 1894; Geffroy, op. cit., v. II, ch. VI; Vollard: Renoir, ch. XIV; G. Mack: Paul Cézanne, New York, 1935, p. 331-337, and particularly A. Tabarant: Le peintre Caillebotte et sa collection, Bulletin de la vie artistique, Aug. 1, 1921.

33. For a discussion of the number of accepted works see Mack: Paul Cézanne, and Renoir's statement, quoted by Leroy, op. cit., p. 167.

34. See A. Vollard: Cézanne, ch. V and Rewald: Cézanne,

sa vie, son oeuvre, son amitié pour Zola, Paris, 1939, p. 370-372.

35. Pissarro to his son, Nov. 21, 1895, op. cit., p. 275-276.

36. See Pissarro's letter to his son, Nov. 23, 1893, op. cit., p. 221.

37. Gauguin quoted by E. Tardieu: La peinture et les peintres, M. Paul Gauguin, Echo de Paris, May 13, 1895.

38. Gauguin: Diverses Choses [1902-1903], quoted by J. de Rotonchamp: Paul Gauguin, Paris, 1925, p. 243.

39. Gauguin: Racontars d'un rapin, Sept. 1902, ibid., p. 237.

40. See: Paul Gauguin, Letters to A. Vollard and A. Fontainas, San Francisco, 1943.

41. See Rewald: Depressionist Days of the Impressionists, Art News, Feb. 15-28, 1945.

42. On Zola's article see Rewald: Cézanne etc., p. 354-362.

43. Ibid., p. 363-365.

44. See Tavernier, article on Sisley in L'Art Français, March 18, 1893.

45. In 1900 Camondo paid 43,000 francs for Sisley's Flood in Marly, repr. p. 313.

46. Cézanne to his son, Oct. 15, 1906; see Cézanne, Letters, p. 273.

47. Cézanne to Camoin, Jan. 28, 1902, ibid., p. 218.

48. Cézanne to Camoin, Feb. 22, 1903, ibid., p. 228.

49. Cézanne to Bernard, April 15, 1904, ibid., p. 234.

50. Cézanne to Bernard, May 26, 1904, ibid., p. 236-237.

51. See Rewald: Cézanne etc., p. 282 and p. 394.

52. According to Renoir's paint dealer Moisse the painter's orders did not vary during his last twenty-five years. His palette was composed of: white lead, antimony yellow, yellow ochre, raw umber, superfine carmine, Venetian red, French vermilion, madder lake, emerald green, cobalt blue and ivory black. Renoir never used cadmium yellow but quantities of Naples yellow.—Monet's palette consisted of white lead, cadmium yellow (light, dark and lemon), ultramarine lemon yellow, vermilion, cobalt violet (light), superfine ultramarine, emerald green. (See Tabarant: Couleurs, Bulletin de la vie artistique, July 15, 1923.) On Monet's palette see also R. Gimpel: At Giverny with Claude Monet, Art in America, June 1927. Pissarro's palette was composed, according to the private notes of Louis Le Bail, of the six rainbow colors: white lead, light chrome yellow, Veronese green, ultramarine or cobalt blue, dark madder lake and vermilion.

53. See W. Pach: Renoir, Scribner's Magazine, 1912, repr. in Queer Thing, Painting, New York, 1938.

54. Letter by Paul Durand-Ruel, Dec. 1912; see Venturi: Archives, v. I, p. 107.

55. See A. André: Renoir, Paris, 1928, p. 42.
56. See C. Bell: Since Cézanne, London, 1922, p. 73.
57. See Renoirs: Letter to Mottez, published as introduction to: Le livre d'art de Cennino Cennini, Paris, n.d. [1911].
58. Renoir to Durand-Ruel, Sept. 30, 1917; see Venturi: Archives, v. I, p. 212-213.
59. "Techniques vary," Monet told his friend Geffroy, "art stays the same: it is a transposition of nature at once forceful and sensitive. But the new movements, in the full tide of reaction against what they call 'the inconsistency of the impressionist image,' deny all that in order to construct their doctrines and preach the solidity of unified volumes." See Geffroy, op. cit., v. II, ch. XXXIII.
60. Monet to Charteris, June 21, 1926; see E. Charteris; John Sargent, London, 1927, p. 131.
61. Gauguin: Racontars d'un rapin, Sept. 1902, quoted by de Rotonchamp, op. cit., p. 241.

SOURCES OF ILLUSTRATIONS

Owners: 12, 13, 17, 18, 24, 25 right, 27 left, 27 right, 28, 29, 34, 35, 42, 43, 48 left, 50, 58, 66, 69, 73, 74, 75, 84, 85, 89 bottom, 91, 92, 94, 95, 97, 98 right, 101, 109, 110, 112, 113, 114, 116, 117, 119, 123, 129, 130, 137, 143, 144, 145, 146, 153, 155, 157, 158, 159, 160, 171, 177, 180, 182, 183, 185, 186, 187, 188, 189, 192, 195, 197, 199, 200, 202, 203, 204, 205, 206, 207 right, 209, 213, 218, 220, 229, 231, 232, 233, 235, 238, 241, 243, 245, 246, 247, 248, 251, 255, 257, 264 top, 265 bottom, 270, 273, 274 top, 278, 279 top, 284, 285, 287, 288, 291 right, 294 right, 296, 301 left, 304 right, 308, 309, 311, 313, 316, 317, 318, 319 left, 321, 326, 329, 340, 342, 345 left, 347, 349, 350 top, 353 right, 357, 359, 362, 363, 371, 376, 378, 379, 381, 382, 383, 386, 388 right, 390, 391, 393, 395, 397, 401 right, 405, 407 left, 409, 411, 412, 419, 425, 427.

Bernheim-Jeune Galleries, Paris: 120, 127, 139, 141, 261, 346, 384.

Bignou Galleries, New York: 88 top, 96, 99, 140, 194, 208, 234, 240, 275 top, 332, 421, 423 right.

Braun et Cie, Paris: 351, 394.

Carstairs Gallery, New York: 274 bottom.

Durand-Ruel Galleries, New York: 37, 39, 45, 49, 51, 52, 53, 67, 71 right, 86, 88 bottom, 89 top, 103, 105, 128, 132 top, 133, 135, 136, 161, 191, 214, 215, 221, 237, 239, 264 bottom, 267, 272, 275 bottom, 277 top, 280, 282, 283, 292, 295 right, 297, 304 left, 305 right, 307, 331 right, 333, 343, 345 right, 350 bottom, 361, 365, 367, 389 left, 415, 420, 423 left, 429.

Giraudon, Paris: 163, 249, 265 top, 305 left, 322.

Knoedler Galleries, New York: 71 left, 90, 147, 181, 286.

Rosenberg Galleries, New York: 260, 279 bottom, 290 left, 312, 368.

J. D. Schiff, New York: 76.

J. Seligmann and Co., New York: 150.

Professor Venturi: 54, 55, 87, 142.

Vizzavona, Paris: 125, 151, 179 right, 211, 323.

Wildenstein Galleries, New York: 138 top, 162, 210, 215, 242, 298, 310, 324, 331 left, 401 left.

Galerie Zak, Paris: 375.

Photo-Archives, Fogg Museum of Art, Cambridge, Mass.: 167, 262.

Photo-Archives, Art Institute, Chicago: 266.

Metropolitan Museum of Art, New York: 236.

Philadelphia Museum of Art: 228.

Museum of Modern Art, New York: 48 right, 410, 413.

The following illustrations were made after reproductions in books, periodicals, catalogues, etc.: 11, 21, 25 left, 41, 46, 47, 56, 61, 63, 65, 79, 81, 82, 83, 93, 98 left, 100, 104, 106, 107, 108, 115, 138 bottom, 165, 173, 190, 193, 198, 201, 221, 244, 259, 268, 271, 276, 277 bottom, 281, 290 right, 291 left, 294 left, 295 left, 301 right, 314, 315, 328, 330, 369, 374, 380, 388 left, 389 right.

The following plates were lent by:

Art News, Inc., New York: 132 bottom, 212 and color plates opp. 298, 312, 378.

Baltimore Museum of Art: 16.

Durand-Ruel Galleries, New York: 31, 263, 319 right, 320, 335, 337, 353 left, 360, 373.

University of California Press, Berkeley and Los Angeles: color plate opp. 414.

Wildenstein Galleries, New York: 175, 207 left, 225, 227, 293, 338, 339, 417.

LIST OF PARTICIPANTS IN THE VARIOUS GROUP SHOWS

	1874	1876	1877	1879	1880	1881	1882	1886
Astruc	■							
Attendu	■							
Béliard	■	■						
Beneau		■						
Boudin	■							
Bracquemond, F.	■			■	■			■
Bracquemond, Mme				■	■			■
Brandon	■							
Bureau	■							
Caillebotte		■	■	■	■		■	
Cals	■	■	■	■				
Cassatt				■	■	■		■
Cézanne	■		■					
Colin	■							
Cordey			■					
Degas	■	■	■	■	■	■		■
Desboutin		■						
Desbras	■							
Forain				■	■	■		■
François		■	■					
Gauguin					■	■	■	■
Guillaumin	■		■		■	■	■	■
Lamy			■					
Latouche	■							
Lebourg				■	■			
Legros		■						
Lepic	■	■						
Lépine	■							
Levert	■	■	■		■			
Maureau			■					
Meyer	■							
Millet, J. B.		■						
de Molins	■							
Monet	■	■	■	■			■	
Morisot	■	■	■		■	■	■	■
Mulot-Durivage	■							
de Nittis	■							
Ottin, A.	■							
Ottin, L. A.	■	■						
Piette			■	■				
Pissarro, C.	■	■	■	■	■	■	■	■
Pissarro, L.								■
Raffaëlli					■	■		
Redon					■			■
Renoir	■	■	■				■	
Robert	■							
Rouart	■	■	■	■	■	■		■
Schuffenecker								■
Seurat								■
Signac								■
Sisley	■	■	■				■	
Somm				■				
Tillot		■	■		■	■		■
Vidal					■	■		
Vignon					■	■	■	■
Zandomeneghi				■	■	■		■

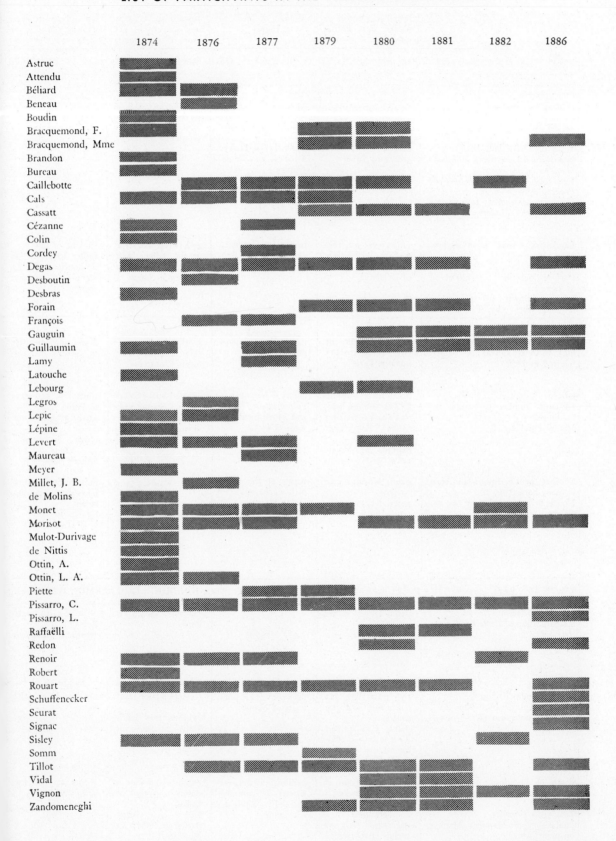

YEAR	CONTEMPORARY EVENTS	MANET * Paris Jan. 25, 1832	DEGAS * Paris July 19, 1834	PISSARRO * St. Thomas July 10, 1830	CÉZANNE * Aix Jan. 6, 1839
1855		pupil of Couture at *Ecole des Beaux-Arts*	student of law visits Ingres	toward end of year arrives in Paris from Virgin Islands	at college in Aix; friendship with Zola
	PARIS WORLD'S FAIR WITH LARGE REPRESENTATION OF INGRES, DELACROIX, ROUSSEAU— COURBET				
1856-1857	Baudelaire writes eulogy of Delacroix Whistler arrives in Paris Duranty prepares new review, *Le Réalisme,* published 1856-57 death of Chassériau, 1856 Bracquemond discovers Hokusai's *Mangwa* Delacroix elected to *Institut de France,* 1857 Flaubert prosecuted for alleged immorality of *Madame Bovary*	leaves Couture's studio in 1856	abandons study of law enters *Ecole des Beaux-Arts;* works under Lamothe travels in Italy; Florence, Rome, Naples	pays visit to Corot works briefly at *Ecole des Beaux-Arts;* later at *Académie Suisse*	
1858-1859	Baudelaire writes Salon review, 1859 Seurat born Dec. 2, 1859 Darwin publishes: *Origin of Species* Bonvin exhibits in his studio rejected works by Fantin and Whistler	rejected at the Salon, 1859, in spite of intervention of Delacroix	paints in Florence, *Portrait of the Bellelli Family* 1859	exhibits landscape at the Salon, 1859 meets Monet at *Académie Suisse*	student of law father acquires "Jas de Bouffan" (1859) wants to become painter
1860	large exhibition of modern paintings includes canvas by Millet, rejected in 1859	rents a studio in the Batignolles quarter, Paris	paints *Young Spartans Exercising*	works in countryside around Paris; meets Chintreuil	father opposes artistic career
1861	start of American Civil War Delacroix finishes decoration for St.-Sulpice Maillol born Dec. 8	great success at the Salon; obtains honorable mention; meets Baudelaire, Duranty, etc. exhibits at Martinet's	paints *Semiramis Founding a Town* and other historical subjects	rejected at the Salon meets Cézanne and Guillaumin at *Académie Suisse*	quits law and goes to Paris; meets Pissarro at *Académie Suisse* returns discouraged to Aix; enters father's bank
1862	Courbet opens a studio: Jan.-April Debussy born Aug. 22 Nobel uses nitro-glycerin as explosive	paints *Musique aux Tuileries* meets Degas praised in article by Baudelaire	paints at the races in Longchamps meets Manet		quits father's bank takes up painting again returns to Paris
	SALON DES REFUSÉS— INCLUDING WORKS BY MANET, PISSARRO, JONGKIND, GUILLAUMIN, WHISTLER,				
1863	death of Delacroix reorganization of *Ecole des Beaux-Arts*	public laughs at his works marries Suzanne Leenhoff		his son, Lucien, is born	Visits Salon with Zola works at *Académie Suisse*
1864	Gleyre's studio is closed Toulouse-Lautrec born Nov. 24 Geneva Convention (Red Cross)	two paintings at Salon meet with no success paints *Combat of Kearsarge and Alabama;* also *Races at Longchamps*	does several portraits of Manet	receives advice from Corot exhibits two landscapes at Salon as "pupil of Corot"	rejected at the Salon
1865	death of Proudhon; posthumous publication of his *Principe de l'art* etc. Zola visits Courbet publication of Mendel's Memoir on plant hybridity	*Olympia* at Salon is violently attacked Baudelaire encourages him during August spends two weeks in Spain; meets Duret in Madrid	exhibits pastel at Salon; is complimented by Puvis de Chavannes	exhibits landscape at Salon as "pupil of Corot" said to have visited Renoir and Sisley at Marlotte	works at the *Académie suisse*

MONET	RENOIR	SISLEY	BAZILLE	MORISOT	GAUGUIN
* Paris Feb. 14, 1840	* Limoges Feb. 25, 1840	* Paris Oct. 30, 1839 or 40	* Montpellier Dec. 6, 1841	* Bourges Jan. 14, 1841	* Paris June 7, 1848
lives with parents in Le Havre	lives in Paris since age of four				

EXHIBITS IN HIS OWN *PAVILLON DU RÉALISME*

MONET	RENOIR	SISLEY	BAZILLE	MORISOT	GAUGUIN
			goes to school in Montpellier	lives in Paris	returns from Peru with widowed mother lives in Orléans
draws caricatures in Le Havre	apprentice porcelain painter takes evening courses in drawing	sent to England by his parents (both British) to learn the language and prepare himself for commercial career		studies painting with Guichard (pupil of Ingres and Delacroix) admires a drawing by Ingres at her music teacher's, Stamaty	goes to school in Orléans
meets Boudin in 1858 goes to Paris, May, 1859; frequents *Brasserie des Martyrs* meets Pissarro	paints on porcelain; paints stores, fans, etc.—decides to become artist but has to earn his tuition			copies at the Louvre with her sister Edma; there meets Fantin admires Rousseau, Daubigny, Millet, but above all Corot	enters the Petit Seminaire in Orléans
works at *Académie Suisse* drafted in African regiment in Algiers			studies medicine in Montpellier	wishes to paint out-of-doors, against advice of Guichard	
soldier in Algiers			continues medical studies in Montpellier	is introduced to Corot; works with Corot in Ville d'Avray, becomes his pupil Corot lends her paintings which she copies	
discharged from the Army; works with Jongkind and Boudin in Le Havre; returns to Paris in Nov.; enters studio of Gleyre	enters *Ecole des Beaux-Arts* (studio of Gleyre)	enters *Ecole des Beaux-Arts* (studio of Gleyre)	comes to Paris for study of medicine and painting; enters studio of Gleyre	paints under guidance of Corot's pupil Oudinot	

MEET AT THE STUDIO OF GLEYRE

FANTIN, CÉZANNE

MONET	RENOIR	SISLEY	BAZILLE	MORISOT	GAUGUIN
works in Fontainebleau forest watches Delacroix at work in his studio	meets Fantin; visits the Louvre frequently with him	protests change of *Ecole des Beaux-Arts* statutes	together with Monet watches Delacroix at work in his studio	works in Pontoise; meets Daubigny and Daumier	

LEAVE GLEYRE'S STUDIO — WORK TOGETHER IN CHAILLY

MONET	RENOIR	SISLEY	BAZILLE	MORISOT	GAUGUIN
works in Honfleur with Bazille, Boudin, Jongkind sends works to Bruyas	meets Diaz in forest; exhibits painting at Salon, destroys it later.		fails in medical examination; quits medicine for art accompanies Monet to Honfleur	exhibits two landscapes at the Salon	
lives with Bazille in Paris obtains success at the Salon paints *Déjeuner sur l'herbe* in Fontainebleau forest works with Courbet at Trouville	exhibits two paintings at the Salon works in Marlotte (Fontainebleau forest)	works with Renoir in Marlotte (Fontainebleau forest)	poses for Monet's *Déjeuner sur l'herbe* paints Monet after his accident shares his studio with Monet Pissarro, Cézanne and Courbet come to his studio	exhibits two paintings at the Salon between 1864 and 1874 frequently spends summers in Normandy	leaves school becomes apprentice pilot at sea, making first voyage in this capacity on board the *Luzitano*, plying between Le Havre and Rio de Janeiro

YEAR	CONTEMPORARY EVENTS	MANET	DEGAS	PISSARRO	CÉZANNE
1866	Corot and Daubigny members of Salon jury Zola writes *Mon Salon,* dedicated to Cézanne Goncourt brothers publish *Manette Salomon*	rejected at the Salon meets Zola, Cézanne, Monet Zola predicts that his place is in the Louvre	exhibits race scene at the Salon	has disagreement with Corot exhibits at Salon (no longer as "pupil of Corot"); is praised by Zola establishes himself at Pontoise	is complimented by Manet on his still lifes rejected at the Salon in spite of intervention of Daubigny writes letter of protest to Director of Fine Arts
1867	PARIS WORLD'S FAIR WITH SPECIAL PAVILIONS CONSTRUCTED BY COURBET AND MANET				
	Mexican Revolution death of Baudelaire and Ingres Bonnard born Oct. 20 Siemens brothers introduce dynamo Lister introduces antiseptic surgery opening of Suez Canal Marx publishes *Das Kapital*	one-man show at Fair meets with little success is impressed with *View of Paris* by Berthe Morisot paints *Execution of Emperor Maximilien* (barred from exhibition) his portrait by Fantin exhibited at Salon	exhibits two portraits at the Salon, commended by Castagnary	rejected at the Salon	rejected at the Salon a painting exhibited in Marseilles has to be withdrawn so as not to be torn to pieces by the crowd
1868	Zola writes another Salon review, praises Manet and Pissarro	exhibits *Portrait of Zola* at the Salon works at Boulogne; makes short trip to England paints portrait of Duret, contributor with Zola to anti-imperial *Tribune* meets Berthe Morisot, who poses for *Balcony*	exhibits *Mlle Fiocre* at the Salon	two views of Pontoise accepted at Salon with the help of Daubigny at about this time obliged to accept commercial jobs with Guillaumin	rejected at the Salon
1869	Manet and his friends gather at Café Guerbois, Batignolles death of Berlioz Clemenceau returns to France from United States Matisse born Dec. 31	exhibits *Balcony* and *Déjeuner sur l'herbe* at Salon spends summer at Boulogne Eva Gonzalès becomes his pupil and poses for her portrait	*Portrait of Mme G.* accepted, one painting rejected at the Salon travels in Italy paints portrait of Berthe Morisot's sister Yves	one painting accepted at the Salon; settles in Louveciennes with his family	rejected at the Salon meets Hortense Fiquet in Paris
1870	FRANCO-PRUSSIAN WAR DECLARED JULY 18 — PROCLAMATION OF THE THIRD REPUBLIC SEPT. 4 —				
	Manet, Millet, Courbet, Daumier are unsuccessful candidates for Salon jury Daubigny and Corot resign from jury Duret writes Salon review	exhibits two paintings at the Salon unsuccessful candidate for jury is central figure of Fantin's *Atelier aux Batignolles* staff officer in National Guard under Meissonier	exhibits *Portrait of Mme Camus* at the Salon works on the coast enlists in infantry (his right eye is discovered to be almost blind); meets Rouart	exhibits two landscapes at the Salon; flees from Louveciennes to Brittany; later goes with family to England, there marries Julie Vellay, mother of his children	works in Aix, later in near-by L'Estaque avoids draft lives with Hortense Fiquet is joined for a while by Zola
1871	Courbet president of *Commune* Art Commission; is involved in destruction of Vendôme Column Duret travels to United States and Japan	joins family near Bordeaux during *Commune* sells over twenty paintings to Durand-Ruel (Nov.-Dec.)	stays with friends Valpinçon during *Commune* paints dancers	sells two paintings to Durand-Ruel in London where he meets Monet rejected by Royal Academy loses all his work left at Louveciennes returns to France in June	returns to Paris after end of *Commune*

MONET	RENOIR	SISLEY	BAZILLE	MORISOT	GAUGUIN
obtains great success at Salon with *Camille;* is introduced to Manet paints views of Paris; Latouche shows his canvases lives in Ville d'Avray; later works at Ste.-Adresse and Le Havre	works at Inn of Mother Anthony in Marlotte rejected at the Salon in spite of intervention of Corot and Daubigny paints Paris views with Monet lives with Bazille	exhibits two paintings at the Salon	one painting accepted at the Salon and one rejected paints *Réunion de Famille* shares studio with Renoir	exhibits two paintings at the Salon	plying between Le Havre and Rio de Janeiro
Femmes au jardin rejected at the Salon; stays with family in Ste.-Adresse while Camille gives birth to Jean Monet	rejected at the Salon works at Chantilly paints *Lise* in Fontainebleau forest	rejected at the Salon works in Honfleur	*Réunion de Famille* rejected at the Salon, later destroyed discusses plans for organizing an exhibition of works by his friends buys Monet's *Women in the Garden*	view of Paris, exhibited at Salon, impresses Manet spends summer in Brittany	seaman
one painting refused and one accepted (with Daubigny's help) at Salon spends several weeks with Renoir and Bazille; works in Etretat, exhibits in Le Havre, lives in Fécamp attempts suicide (?) finds patron in Le Havre	*Lise* accepted at the Salon, praised by Bürger paints portraits of Sisley and Bazille; his Bazille portrait greatly pleases Manet	one painting accepted at the Salon; is painted with his wife by Renoir	second version of *Réunion de Famille* and still life accepted at the Salon shares his studio in turn with Renoir, Monet and Sisley meets Manet frequently at the studio of Stevens	one painting accepted at the Salon; introduced by Fantin to Manet poses for Manet's *Balcony*	Feb., enlists in the Navy, engaged as seaman at Le Havre and embarks on the cruiser *Jérôme Napoléon*
rejected at the Salon works in Bougival (with Renoir), later in Etretat and Le Havre his paintings are seized by creditors; cannot work for want of paints	one painting accepted at the Salon lives at Ville d'Avray with Lise helps Monet; works with him at Bougival (*La Grenouillère*); too poor to buy paints	rejected at the Salon	one painting accepted at the Salon and one rejected receives compliments from Puvis de Chavannes pays visit to Corot	sends nothing to Salon her sister and steady companion, Edma, marries and gives up painting offers Manet a painting done in Lorient	seaman

ARMISTICE JAN. 28, 1871 — THE *COMMUNE*, MARCH 18 — MAY 28, 1871

MONET	RENOIR	SISLEY	BAZILLE	MORISOT	GAUGUIN
rejected at the Salon marries Camille in June works in Trouville and Le Havre until autumn leaves for England	exhibits two paintings at the Salon lives with Bazille drafted, sent to Bordeaux, later to Tarbes (Pyrenees) with regiment of cuirassiers	exhibits two Paris landscapes at the Salon	one painting accepted and one rejected at the Salon paints group of friends in his studio; shares studio with Renoir enlists in Zouave regiment, Aug. 10 killed at Beaune-la-Rolande Nov. 28	two paintings accepted at the Salon remains in Paris during siege	serves on the cruiser *Jérôme Napoléon* during the war
introduced by Daubigny to Durand-Ruel in London meets Pissarro rejected by Royal Academy goes to Holland (possibly with Daubigny) returns to France towards end of year	during *Commune* in Paris, later in Louveciennes and Bougival	leaves Paris goes to England		on advice of Puvis de Chavannes leaves Paris during *Commune;* goes to St.-Germain	in April leaves naval service recommended by his godfather Arosa (a patron of Pissarro), enters employ of Bertin, stock broker, rue Lafitte, Paris

YEAR	CONTEMPORARY EVENTS	MANET	DEGAS	PISSARRO	CÉZANNE
1872	France makes tremendous effort to pay reparations; government loans over-subscribed; heavy taxes, business boom artists protest publicly against nomination of salon jury by new Aministration of Fine Arts Desboutin settles in Paris Dr. Gachet buys house in Auvers	exhibits *Combat of Kearsarge and Alabama* at the Salon travels in Holland: admires Jongkind and especially Hals Durand-Ruel pays 40,000 francs for 29 paintings, prices varying between 400 and 3,000 francs	is introduced to Durand-Ruel apparently sends nothing to the Salon works at Paris Opera (subjects: orchestra, ballet classes) in autumn accompanies brother to New Orleans	apparently sends nothing to the Salon settles in Pontoise where Cézanne, Guillaumin, etc., join him	Hortense Fiquet gives birth to a son christened Paul Cézanne joins Pissarro in Pontoise and works at his side
1873	crash, followed by a six year depression Duret returns from trip to United States, Japan, China, Mongolia, Java, India	*Bon Bock* (bought by Faure) obtains great success at the Salon spends summer in Berc-sur-mer sells 5 paintings to Faure at prices varying between 2,500 and 6,000 francs	paints uncle's cotton exchange office in New Orleans and portraits of cousin returns to France in spring; plans trip to Rouen Opera house destroyed by fire; company moves to temporary quarters where Degas continues work Short trip to Italy in December	Duret prefers his work to that of Monet and Sisley his canvasses obtain comparatively high prices at auctions works in Pontoise, especially Hermitage quarter, also in nearby Osny and Auvers-sur-Oise	moves to Auvers-sur-Oise near Pontoise; works in Dr. Gachet's house paints *Modern Olympia* and numerous landscapes through Pissarro meets *père* Tanguy (1873-74)
1874	first group exhibition at Nadar's, 35 Boulevard des Capucines, April 15-May 15; thirty participants death of Millet	two paintings rejected, one canvas and one watercolor accepted at the Salon Mallarmé protests rejections Manet refuses to participate in group exhibition despite insistence of Degas and Monet in August joins Monet in Argenteuil goes to Venice illustrates Mallarmé's translation of Poe's *Raven*	visited by E. de Goncourt who admires his work insists on inviting as many artists as possible to group show	opposes Duret's advice to exhibit at the Salon insists that Cézanne and Guillaumin show with the group	on insistence of Pissarro is admitted to group show Pissarro does his portrait
			FIRST GROUP EXHIBITION		
			exhibits 10 works notices Mary Cassatt's painting at the Salon sells *Examen de Danse* to Faure for 5,000 francs	exhibits 5 paintings joins his friend Piette in Montfoucault, Brittany, during the winter	exhibits two landscapes and *Modern Olympia* which are greeted by laughter returns to Aix, later comes back to Paris
1875	auction sale at Hôtel Drouot, March 24; average price 144 francs death of Corot, Carpeaux, Bizet	canvas painted in Argenteuil causes scandal at the Salon recommends his friends' auction sale to critic A. Wolff visits Hoschedé at Montgeron; paints portrait of Carolus-Duran		works in Pontoise continues to encourage Cézanne spends autumn again in Montfoucault	canvas of his bought by Chocquet at Tanguy's through Renoir meets Chocquet paints portrait of Chocquet lives in Paris, quai d'Anjou; neighbor of Guillaumin in whose company he sometimes works
1876	second group exhibition, 11 rue Le Peletier, April; nineteen participants Duranty publishes *La Nouvelle Peinture* death of Diaz Bell invents telephone	two paintings rejected at the Salon; invites public to see them in his studio paints portrait of Mallarmé Eva Gonzalès, for the first time, exhibits at the Salon as "pupil of Manet"			rejected at the Salon; declines to join the group works in L'Estaque has disagreement with Monet
			SECOND		
			exhibits 24 works at about this time gives up greater part of his fortune to help brother; from then on occasionally obliged to sell some works	exhibits 12 paintings works in Pontoise, also in Montfoucault and Melleraye (Mayenne)	

MONET	RENOIR	SISLEY	MORISOT	GAUGUIN	SEURAT *Paris Dec. 2, 1859
returns from Holland; with Boudin visits Courbet, imprisoned for participation in *Commune* apparently sends nothing to the Salon; works in Le Havre after second trip to Holland settles in Argenteuil Daubigny buys one of his Dutch landscapes	rejected at the Salon introduced by Degas to Duret lives in Paris; paints Pont Neuf and other urban subjects pays frequent visits to Monet in Argenteuil	introduced to Durand-Ruel apparently sends nothing to the Salon works in Argenteuil	exhibits at the Salon after sojourn in St. Jean de Luz makes short trip to Spain: Toledo, Madrid, Escurial; impressed by works of Goya and Velasquez	successful bank agent	
works in Argenteuil; at about this time constructs studio on a boat and frequently paints on the Seine takes up Bazille's plan for a group exhibition	introduced to Durand-Ruel whose first acquisitions enable him to take large studio, 35 rue St.-Georges, Paris two paintings rejected at the Salon	works in Louveciennes, Marly, Bougival, Pontoise	one pastel accepted at the Salon	successful bank agent in Nov. marries Danish Mette-Sophie Gad; begins to draw shortly after his marriage	
apparently invites Boudin to participate in group show; Manet declines his invitation	takes active part in organization of group; votes against too strict rules; member of hanging committee	works in Marly, Bougival, Louveciennes	against Manet's protest agrees to join the group and never to send anything again to the Salon	continues to draw and paint increasingly after the birth of his first child, Emil	
OF PAINTERS DUBBED "IMPRESSIONISTS"					
exhibits 12 works among which *Impression—Sunrise* Manet and Renoir join him in Argenteuil meets Caillebotte	exhibits 7 works stays with Monet in Argenteuil friendship with Caillebotte (1874-75)	exhibits 5 landscapes goes to England with Faure; works in and around Hampton Court, later returns to France	exhibits 9 works spends part of summer in Fécamp with Manet family in December marries Manet's brother Eugène		
ORGANIZE AUCTION SALE IN MARCH				continues to draw and paint in his free time	works in Municipal Art School; does mostly sketches after plaster casts
auction prices vary between 165 and 325 francs works in Argenteuil in great financial difficulties	10 of his works obtain less than 100 francs apiece commissioned by Chocquet to paint portrait of Mme Chocquet takes Chocquet to Tanguy's	auction prices vary between 50 and 300 francs works in Bougival, Marly, St.-Germain, Louveciennes	obtains better prices at auction than Monet, Renoir and Sisley works in England		
through Cézanne meets Chocquet in January		paints flood in Bougival		exhibits landscape at the Salon at about this time begins to buy Impressionist pictures, investing 15,000 francs in a collection of Manet, Cézanne, Pissarro, Renoir, Monet, Sisley, Guillaumin, Jongkind, Daumier, etc.	works in Municipal Art School
GROUP EXHIBITION					
exhibits 18 paintings in great financial difficulties; leaves Argenteuil visits Hoschedé begins *Gare St.-Lazare* series in Paris	exhibits 15 paintings rents house Rue Cortot, Montmartre paints *Balançoire, Moulin de la Galette*	exhibits 8 landscapes works in Louveciennes and Moret near Fontainebleau Forest	participates in group show at about this time spends summers in Maurecourt near Paris		

YEAR	CONTEMPORARY EVENTS	MANET	DEGAS	PISSARRO	CÉZANNE
1877	third group exhibition, 6 rue Le Peletier, April; eighteen participants Rivière edits *L'Impressionniste* second auction sale at Hôtel Drouot, May 28; average price 169 francs death of Courbet the painters begin to gather at the Café de la Nouvelle-Athènes Edison invents phonograph	one painting accepted, one rejected at the Salon begins portrait of A. Wolff	exhibits 22 paintings, drawings, as well as a number of monotypes	works with Cézanne in Pontoise **THIRD** exhibits 22 landscapes participates in second sale; bids vary between 50 and 260 francs	works with Pissarro in Pontoise; also in Auvers and Issy near Paris exhibits 16 works, mostly still lifes and landscapes
1878	World's Fair in Paris Duret publishes *Les Impressionnistes* death of Daubigny Zola buys house in Médan after immense success of *L'Assommoire* low prices at Faure and Hoschedé sales affect painters adversely harvest poor both in this and the following year	rejected at the World's Fair; plans own show but decides against it April: obtains low prices at Faure sale (average less than 600 francs); even lower prices at Hoschedé sale (June) helps Monet financially		works in Pontoise; deeply discouraged paints portrait of Guillaumin's friend Murer who helps him financially	works in Aix and L'Estaque has difficulties with his father Zola helps him financially rejected at the Salon; is ready to show with the group but no exhibition is organized
1879	fourth group show, 28 Ave. de l'Opera; April 10—May 11; nets 439 francs benefit for each of 15 participants Charpentier founds *La Vie Moderne* to which Renoir contributes drawings and which organizes one-man shows death of Daumier and Couture Edison's electric bulb Art Institute, Chicago, founded	two paintings accepted at the Salon exhibits *Execution of Maximilien* with little success in New York paints portrait of G. Moore at the Nouvelle-Athènes begins portrait of Clemenceau	announces 25 works in catalogue, exhibits less than a dozen; invites Mary Cassatt to exhibit with the group plans publication of print portfolios with Pissarro, Cassatt, Bracquemond, etc.	**FOURTH GROUP** exhibits 38 works; works in Pontoise is interested in Degas' print publication to be called *Le jour et la nuit*	rejected at the Salon in spite of intervention of Guillemet works in L'Estaque, later in Melun; pays visit to Zola in Médan in Paris from summer until end of year
1880	fifth group show, 10 rue des Pyramides; April 1-30; 18 participants Zola publishes new art criticisms death of Duranty, Flaubert, Offenbach business begins to recover from 1873 crash; stock market feverish with speculation	*Execution of Maximilien* exhibited in Boston (Jan.); show in Chicago canceled April: one-man show at *La Vie Moderne* exhibits portrait of A. Proust at the Salon; jury considers medal spends summer in Bellevue; onset of fatal illness	travels in Spain exhibits 8 paintings and pastels, several drawings and etchings and *Portrait of Duranty* does etchings with Pissarro and Mary Cassatt	invites Gauguin to show with the group **FIFTH GROUP** exhibits 11 paintings and series of etchings in various states, done for Degas' publication does etchings with Degas and Mary Cassatt works in Pontoise	sojourn in Melun probably again rejected at the Salon lives from April to end of year in Paris; visits Zola in Médan
1881	sixth group show, 35 Blvd. des Capucines; April 2—May 1; 13 participants State abandons control of Salon; creation of "Société des Artistes Français" Durand-Ruel again buys impressionist works Clemenceau founds *La Justice* with G. Geffroy as art critic Picasso born October 25	two paintings accepted at the Salon; awarded second class medal spends summer in Versailles Nov.: Proust becomes Fine Arts Minister in Gambetta government; proposes Manet for Legion of Honor seriously ill in Dec.	exhibits dressed wax statuette of *Dancer* and 7 works, apparently mostly pastels	**SIXTH GROUP** exhibits 11 landscapes works in Pontoise with Cézanne and Gauguin	probably again rejected at the Salon in Paris Jan. to April; from May to October with Pissarro (and Gauguin) in Pontoise visits Zola in Médan; returns to Aix in Nov.

MONET	RENOIR	SISLEY	MORISOT	GAUGUIN	SEURAT
continues *Gare St.-Lazare* series		works in Sèvres, St.-Cloud, St.-Mammès on the Loing canal	exhibits 19 works	at about this time meets Pissarro, probably through Arosa	does copies after Holbein, Poussin, Ingres, Raphael, etc.; reads and admires de Goncourts' novels

GROUP EXHIBITION

MONET	RENOIR	SISLEY	MORISOT	GAUGUIN	SEURAT
exhibits 30 paintings / offers paintings to Chocquet for 40-50 francs	exhibits 22 works participates in second sale; bids vary between 47 and 285 francs	exhibits 17 landscapes participates in second sale; bids vary between 105 and 165 francs	participates in group show		
settles in Vétheuil; receives financial help from Manet but finishes year again without money / in March, a second son Michel, is born / Monet's works average 184 francs at Hoschedé sale	exhibits at the Salon	works in Sèvres through Duret sells several pictures decides to follow Renoir's example and to exhibit again at the Salon			enters Ecole des Beaux-Arts, class of Ingres' pupil Lehmann / studies at about this time Chevreul's *Principles of Harmony and Contrast of Colors* and Ch. Blanc's *Grammar of Painting and Engraving* as well as other theoretical treatises

EXHIBITION

MONET	RENOIR	SISLEY	MORISOT	GAUGUIN	SEURAT
exhibits 29 paintings works in Vétheuil-Lavacourt on the Seine, frequently painting on his boat / inspired by Renoir's example decides to exhibit again at the Salon / Camille dies in the fall	obtains great success at the Salon with *Portrait of Mme Charpentier and her Children* June: one-man show at *La Vie Moderne* works in Chatou and Berneval (Normandy)	rejected at the Salon lives in Veneux-Nadon; works also in Sèvres and Suresnes is helped by Charpentier	expecting a child, she does not exhibit with the group	apparently works with Pissarro in Pontoise during his holidays	shares studio with his friend Aman-Jean leaves Paris in Nov. for Brest
1 painting accepted, 1 rejected at the Salon; protests bad placement one-man show at *La Vie Moderne* which impresses young Signac accuses impressionist group of "opening doors to the first-come dauber" works in Vétheuil-Lavacourt	2 canvases accepted at the Salon; protests with Monet against bad placement during summer works in Berneval	works in Suresnes, Louveciennes, Moret		invited by Pissarro to exhibit with the group	military service in Brest returns to Paris in Nov.

EXHIBITION

MONET	RENOIR	SISLEY	MORISOT	GAUGUIN	SEURAT
			exhibits 15 paintings and watercolors spends summer in Bougival spends winter 1881-82 in Nice	exhibits 7 paintings (several done in Pontoise) and a marble bust	

EXHIBITION

MONET	RENOIR	SISLEY	MORISOT	GAUGUIN	SEURAT
never again sends anything to the Salon works in Vétheuil, Fécamp, Petites Dalles; lives in Poissy near St.-Germain with Mme Hoschedé	exhibits 2 portraits of Mlle S. at the Salon short trip to Algiers works in Chatou; meets his future wife, Alice Charigat works in Wargemont travels to Venice, Rome, Naples, Capri; impressed by Raphael and Pompeiian frescoes	works on the Isle of Wight	exhibits 7 paintings and pastels spends summer in her house in Bougival	exhibits 8 paintings and 2 sculptures; a nude study of his is highly praised by J. K. Huysmans spends summer holidays with Pissarro and Cézanne in Pontoise	devotes his time mostly to drawing and study of color theories takes detailed notes on a series of paintings by Delacroix

YEAR	CONTEMPORARY EVENTS	MANET	DEGAS	PISSARRO	CÉZANNE
1882	Durand-Ruel takes active part in organization of seventh group show, 251 rue St.-Honoré; March; 8 participants new bank crash causes great losses bankruptcy of associate imperils Durand-Ruel's position; his rival, G. Petit, founds "Exposition Internationale" death of D. G. Rossetti	exhibits *Bar aux Folies - Bergère* at the Salon nominated *Chevalier de la Légion d'Honneur* in July increasingly ill; spends summer in Rueil	short trip to Spain; in autumn short sojourn in Veyrier near Geneva	works in Pontoise SEVENTH exhibits 36 paintings and gouaches	works in L'Estaque with Renoir admitted at the Salon as "pupil of Guillemet" Feb.-Sept. in Paris; visits Zola in Médan is caricatured in a novel by Duranty, published posthumously works at the Jas de Bouffan near Aix makes his last will
1883	Durand-Ruel organizes series of one-man shows exhib. of Japanese prints at Petit's Rodin does portrait bust of Victor Hugo Huysmans publishes *L'art moderne* death of Wagner Pasteur vaccinates against anthrax business begins to recover; France enters long period of economic calm	bed-ridden amputation of left leg fails to save him dies April 30		one-man show in May moves to Osny near Pontoise works with Gauguin at Osny; later at Petites Dalles on Channel coast and in Rouen where Gauguin joins him again	works mostly around Aix probably again rejected at the Salon; in L'Estaque from May to Nov.; sees Monticelli often in Dec. meets Renoir and Monet in the south
1884	Jan.: "Société des Vingt" founded in Brussels "Société des Artistes Indépendants" founded in Paris; proposes to organize exhibitions without jury and rewards Durand-Ruel has mounting debts	large memorial show organized at the Ecole des Beaux-Arts	spends summer at Ménil-Hubert near Gace (Orne) with his friends Valpinçon; there works on bust of Hortense Valpinçon short sojourn in Dieppe	moves from Osny to Eragny near Gisors (Eure) works in Eragny and nearby Bazincourt	rejected at the Salon in spite of intervention of Guillemet works mostly around Aix
1885	the *Douanier* Rousseau retires from Paris Customs (c. 1885) to devote himself to painting death of Victor Hugo		in August short trip to Le Havre, Mont St. Michel and Dieppe (where he meets the English painter Sickert and Gauguin)	at about this time meets Théo van Gogh at Boussod & Valadon Gallery at Guillaumin's meets Signac who introduces him to Seurat; influenced by their theories works at Eragny, Bazincourt, Gisors	probably again rejected at the Salon works in L'Estaque and Aix has mysterious love affair visits Renoir during June and July in La Roche-Guyon; visits Zola in Médan works in Gardanne near Aix
1886	eighth and last group show, 1 rue Laffitte; May 15—June 15; 17 participants van Gogh arrives in Paris; meets E. Bernard and Lautrec at Cormon Studio Durand-Ruel obtains first success in America Fénéon publishes *Les Impressionnistes en 1886* Zola publishes *L'Oeuvre* Rousseau exhibits at second "Salon des Indépendants" death of Monticelli and Liszt unveiling of the Statue of Liberty, gift of France to the United States		during January in Naples exhibits 5 works and series of 10 pastels of nudes has difficulties with Faure concerning paintings promised since 1874 shown by Durand-Ruel in New York	insists that Signac and Seurat show with the group EIGHTH GROUP exhibits 20 paintings, pastels, gouaches and etchings meets Vincent van Gogh through his brother Théo works in Eragny shown by Durand-Ruel in New York	probably again rejected at the Salon works in Gardanne in April marries Hortense Fiquet in Aix deeply hurt by Zola's *L'Oeuvre*; breaks with him inherits fortune after death of his father, Oct.

MONET	RENOIR	SISLEY	MORISOT	GAUGUIN	SEURAT
	Jan.: does portrait of Wagner in Palermo		works in Nice sojourn in Florence	takes active part in organization of group show	devotes his time mostly to drawing and study of color theories

GROUP EXHIBITION

MONET	RENOIR	SISLEY	MORISOT	GAUGUIN	SEURAT
exhibits 35 paintings works in Varengeville, Pourville, Petites Dalles, Dieppe, Poissy	exhibits 25 works with group exhibits portrait at the Salon meets Cézanne in L'Estaque, there stricken with pneumonia; returns to Algiers	exhibits 27 landscapes works in Veneux-Nadon; settles in Sept. in Moret	exhibits 9 paintings and pastels spends summer in Bougival	exhibits 12 paintings and pastels as well as bust of his son Clovis	
March: one-man show in May settles with Mme Hoschedé in Giverny works in nearby Vernon, in Le Havre and Etretat in Dec. short trip with Renoir to Côte d'Azur	exhibits 1 portrait at Salon one-man show in April; works in Paris; Suzanne Valadon poses for *Dance* paintings during fall in Guernsey in Dec. short trip with Monet to Côte d'Azur	one-man show in June works in Moret and near-by Les Sablons and St.-Mammès in autumn settles in St.-Mammès	moves to a house she built with her husband, rue de Villejuste, Paris spends summer in Bougival	works with Pissarro in Osny leaves bank definitely; joins Pissarro in Rouen with his wife and their 5 children	exhibits large portrait drawing of Aman-Jean at the Salon; the rest of his entries rejected by the jury studies particularly the work of Delacroix paints *La Baignade*
from January to March works in Bordighera; during April in Menton in Etretat during Aug., later in Giverny	works in Paris and La Rochelle searches for a new style; feels dislike for impressionism	works in St.-Mammès, Les Sablons and La Celle	spends summer in Bougival	lives in Rouen, later goes with family to Copenhagen; there tries without success to represent commercial firms an exhibition of his is closed by order of the Academy (1884-85)	*Baignade* rejected at the Salon with Signac and Redon participates in founding "Société des Indépendants," in the first Salon of which he shows *La Baignade*; plans *La Grande Jatte*
works in Giverny participates in "Exposition Internationale" at Petit's Oct.-Dec. in Etretat	works in Wargemont in La Roche-Guyon with Cézanne, later in Essoyes, home of his wife overcomes doubts, shows satisfaction with new work	works in St.-Mammès, Les Sablons, Moret and in Fontainebleau Forest	spends early summer in Bougival, later works in Holland	June: returns from Denmark where he leaves his family except for Clovis who falls ill in Paris job as bill-poster; sojourn in hospital goes to Brittany where he meets and quarrels with Degas	works during summer in Grandcamp through Signac introduced to Guillaumin and Pissarro continues work on *La Grande Jatte*
trip to Haarlem refuses to join group probably on account of Seurat participates in "Exposition Internationale" at Petit's and "Les Vingt" exhibition in Brussels shown by Durand-Ruel in New York sells to Petit at relatively high prices Sept. to Nov. in Belle-Isle; there meets Geffroy disagreement with Durand-Ruel	refuses to join group probably on account of Seurat participates in "Exposition Internationale" at Petit's and "Les Vingt" exhibition in Brussels shown by Durand-Ruel in New York works in La Roche-Guyon maintains cordial relations with Durand-Ruel	works in Moret and Les Sablons refuses to join group shown by Durand-Ruel in New York	with her husband takes active part in organization of group show	lives in Gloanec pension in Pont-Aven; there meets E. Bernard	on insistence of Pissarro is admitted to group show with Signac

EXHIBITION

MONET	RENOIR	SISLEY	MORISOT	GAUGUIN	SEURAT
			exhibits 14 works; in June on the Isle of Jersey shown by Durand-Ruel in New York Renoir, Degas, Monet, Mallarmé begin to gather frequently at her house	exhibits 19 paintings done in Rouen, Denmark and Brittany meets van Gogh in Paris during autumn dreams of going to the tropics	exhibits 6 paintings and 3 drawings; his *Grande Jatte* causes scandal, his efforts are supported by Fénéon; shown by Durand-Ruel in New York exhibits *Grande Jatte* again at second "Salon des Indépendants"

BIBLIOGRAPHY

This bibliography is meant as a *guide*. While most scholarly and more or less complete bibliographies devote equal space to the important and the unimportant, the good and the bad, an attempt has been made here to limit the list to the principal publications and at the same time to indicate to the reader what to expect from them.

The section devoted to studies on impressionism in general is arranged chronologically so that the reader may follow in the accompanying comments the development of the appreciation of impressionism as well as the progress of research.

The sections devoted to individual artists (Bazille, Cassatt, Cézanne, Degas, Gauguin, Manet, Monet, Morisot, Pissarro, Renoir and Sisley) are, for greater convenience, classified as follows: *Oeuvre Catalogues; The Artist's Own Writings; Witness Accounts; Biographies; Studies of Styles; Reproductions.* Since some publications must be listed under more than one heading, all items are numbered and the numbers repeated wherever this seems called for.

The comments deal mostly with the reliability of the various publications, special emphasis being put on firsthand material. They also mention bibliographies, indexes, choice of illustrations and so on; offer an appreciation of the quality of reproductions, etc.

Of articles published in periodicals, only those are mentioned which contain important contributions, new documents, etc. Among books, however, even those which seem comparatively unimportant are listed if they have reached a large public or enjoy an undeserved reputation.

Since no attempt at completeness has been made, not all the publications consulted or quoted by the author are given in the bibliography. The reader will find ample references to further publications in the notes following each chapter.

GENERAL

LEROY, L: L'exposition des Impressionnistes, *Charivari,* April 25, 1874. Quoted extensively p. 256-261. This article, in which the painters were called "impressionists" for the first time, stands here for the innumerable attacks published in French papers on the occasion of the various group exhibitions.

DURANTY, E.: La nouvelle peinture. A propos du groupe d'artistes qui expose dans les Galeries Durand-Ruel. Paris, 1876. Quoted extensively and discussed p. 300-302. The first publication devoted to the impressionist group, although the word "impressionist" is carefully avoided. A new edition has been published with notes by M. Guérin, Paris, 1945.

RIVIÈRE, G. (editor): *L'Impressionniste, journal d'art.* Five issues published in the spring of 1877 (April 6-28) on the occasion of the third group exhibition. Published with the special support and occasional collaboration of Renoir. For excerpts see L. Venturi: Les Archives de l'Impressionnisme, Paris-New York, 1939, v. II, p. 305-329.

RIVIÈRE, G.: Les intransigeants et les impressionnistes— Souvenir du Salon libre de 1877. *L'Artiste,* Nov. 1, 1877. At the request of the editor, this article does not mention Cézanne and Pissarro.

DURET, T.: Les Peintres impressionnistes, Paris, 1878. Reprinted in the same author's: Critique d'avant-garde, Paris, 1885 and in his: Peintres impressionnistes, Paris, 1923. Combines a short general study with biographical notes on Monet, Sisley, Pissarro, Renoir and Berthe Morisot. The first authoritative attempt to explain impressionism and to single out its leaders. See p. 332.

CLEMENT, C. E. and HUTTON, L.: Artists of the Nineteenth Century and their works. A handbook. Boston-New York, 1879. This book lists no modern painter with the exception of Manet; it is useful, however, for the study of those artists who were famous at the time when the impressionists first appeared before the public.

MARTELLI, D.: Gli Impressionisti. Lettura data al circolo filologico di Livorno. Florence, 1880. Lecture given by a friend of Degas.

BURTY, PH.: Grave Imprudence, Paris, 1880. A novel; the love story of a painter who shares certain traits with Renoir, Monet and Manet. The author relates the early phases of impressionism, describes the gatherings at the cafés and introduces a critic in whom he portrays himself. For excerpts see L. Venturi: Les Archives de l'Impressionnisme, Paris-New York, 1939, v. II, p. 293.

ZOLA, E.: Le naturalisme au Salon, *Voltaire,* June 18, 19, 22, 1880. See p. 344.

DURANTY, E.: Le pays des arts, published posthumously, Paris, 1881. Four novels of which "Le peintre Louis Martin" offers the author's opinions on art, recollections of the *Salon des Refusés,* Manet, Degas, Fantin-Latour, as well as a scurrilous description of Cézanne, designated as Maillobert. (On the latter see J. Rewald: Cézanne, sa vie, son oeuvre, son amitié pour Zola, Paris, 1939, p. 261-263.)

WEDMORE, F.: The Impressionists, *Fortnightly Review,* Jan. 1883. Exhibition review.

HUYSMANS, J. K.: L'art moderne, Paris, 1883. Reprints of the author's Salon review of 1879 and of articles on the impressionist exhibitions of 1880, 1881 and 1882. At first rather hostile to the group, sharing the prejudices of his friend Zola, Huysmans eventually became a convinced supporter because—as he thought—the painters had overcome their "errors," whereas actually it was he himself who gradually achieved a fuller understanding of their aims.

DURET, T.: Critique d'avant-garde, Paris, 1885. Reprints of a Salon review of 1870, of the 1878 pamphlet on the impressionists, and of studies on Monet, Renoir, Manet, Japanese prints, etc., written mostly as forewords to exhibition catalogues.

FÉNÉON, F.: Les impressionnistes en 1886, Paris, 1886. Review of the last group exhibition with special emphasis on Seurat and a discussion of the various tendencies of the impressionists and their followers.

NATIONAL ACADEMY OF DESIGN: Special Exhibition "Works in Oil and Pastel by the Impressionists of Paris," New York, 1886. Catalogue of the historic exhibition organized by Durand-Ruel with excerpts from writings by Duret, Pellet, Georget, Burty, Mirbeau, Geffroy, and from articles published in *Le Temps* and *The Evening Standard*. See also p. 403, note 3.

SABBRIN, C.: Science and Philosophy in Art, Philadelphia, 1886. Review of the impressionist exhibition in New York, spring 1886; chiefly concerned with Monet, whose paintings are analyzed in detail and defined as "the latest art expression of scientific and philosophic thought."

ZOLA, E.: L'Oeuvre, Paris, 1886. A novel filled with autobiographical details, the hero of which is a painter for whose character Zola borrowed many traits from his friends Manet and Cézanne. On this book and Zola's notes for it see J. Rewald: Cézanne, sa vie, son oeuvre, son amitié pour Zola, Paris, 1939, ch. XIX and XX.

MOORE, G.: Confessions of a Young Man, London, 1888. This and the other writings by the same author offer occasional glimpses of the impressionists, among whom he knew especially Manet and Degas. Moore's Confessions contain a caricatured report of the last group exhibition of 1886. On his reliability see D. Cooper: George Moore and Modern Art, *Horizon*, Feb. 1945.

MOORE, G.: Impressions and Opinions, London-New York, 1891. Contains an important chapter on Degas.

L'ART DANS LES DEUX MONDES, periodical published by Durand-Ruel, Nov. 1890 to May 1891. The various issues contain important articles by Wyzewa on Renoir, Berthe Morisot, Seurat; by Geffroy on Degas; by Lecomte on Sisley; by Mirbeau on Pissarro and Monet, etc.

WYZEWA ET PERREAU: Les grands peintres de la France. Paris, 1891.

HAMERTON, P. S.: The Present State of the Fine Arts in France. IV. Impressionism. *The Portfolio*, 1891. Though the author approached some of the painters and asked them for explanations as well as illustrations, his study reflects the common prejudices of the period, reproaching the impressionists for their "neglect of details, their lack of drawing, their indifference to the charm of composition."

WAERN, C.: Notes on French Impressionists, *Atlantic Monthly*, April 1892. A sympathetic essay concluding with a lively description of a visit to Tanguy's shop.

LECOMTE, G.: L'art impressionniste d'après la collection privée de M. Durand-Ruel, Paris, 1892. Written at the time when the impressionists began very slowly to achieve recognition, this book combines short sketches on the artists with more or less lyrical descriptions of some of their most important works; it contains almost no biographical data and constitutes mainly a glowing appraisal of impressionism. Illustrated with etchings after works by Degas, Monet, Manet, Renoir, Pissarro, etc.

AURIER, C. A.: Oeuvres posthumes, Paris, 1893.

GEFFROY, G.: L'impressionnisme, *Revue Encyclopédique*, Dec. 15, 1893.

MOORE, G.: Modern Painting, London-New York, 1893. Contains a study on "Monet, Sisley, Pissarro, and the Decadence," some words on Monet and Berthe Morisot as well as some curious and erroneous remarks on Renoir and an amusing discussion concerning Degas.

GEFFROY, G.: Histoire de l'Impressionnisme—La vie artistique, IIIe série, Paris, 1894. A study on the evolution of impressionism followed by chapters devoted to the individual artists. This first "History of Impressionism," like Lecomte's book, was written mainly in defense of the painters, at a time when it was still important to convince readers of their honest intentions and scrupulous efforts. Although the author knew most of the impressionists intimately, he avoids personalities, concentrating instead on the common element of their research and the logic with which they developed the heritage of the past. This book is interesting as a historic document, but the reader is unlikely to find much information not available in more recent publications.

GARLAND, H.: Crumbling Idols, Chicago-Cambridge, 1894. A short chapter on impressionism presents what is probably the first all-out defense of the movement to be written in English. The author compares the painters to "skilled musicians; the actual working out of the melody is rapid, but it has taken vast study and practice."

NITTIS, J. DE: Notes et Souvenirs, Paris, 1895. Not very interesting; contains some notes concerning Manet, Degas (simply designated as D.), both of whom the author knew well, as well as on Caillebotte, Duranty and the author's participation in the first group exhibition.

MICHEL, A.: Notes sur l'art moderne, Paris, 1896.

MUTHER, R.: The History of Modern Painting, London, 1896, 3 v. The chapter on impressionism in v.2, based on a very incomplete knowledge of facts, now seems totally antiquated.

ZOLA, E.: Peinture, *Figaro*, May 2, 1896. Zola's last article of art criticism which expresses his disappointment with the impressionist movement. Quoted extensively *in* J. Rewald: Cézanne, sa vie, son oeuvre, son amitié pour Zola, Paris, 1939, p. 354-361.

SÉAILLES, G.: L'Impressionnisme; Almanach du Bibliophile pour l'année 1898, Paris, 1898.

BRICON, E: L'art impressionniste au Musée du Luxembourg, *La Nouvelle Revue*, Sept. 15, 1898. A sympathetic study on the Caillebotte bequest, particularly concerned with Manet, Monet, Degas and Renoir. See also p. 433, note 32.

SIGNAC, P.: D'Eugène Delacroix au Néo-impressionnisme, Paris, 1899. An attempt to sum up the development of art since Delacroix as a logical and inescapable evolution toward neo-impressionism, written by the chief promoter of this movement.

THIÉBAULT-SISSON: Une Histoire de l'Impressionnisme, *Le Temps*, April 17, 1899.

BRIDGMANN, F. A.: Enquête sur l'Impressionnisme, *La Revue Impressionniste*, Marseille-Paris, 1900.

GENERAL

GEFFROY, G.: La peinture en France de 1850 à 1900, Paris, n.d. [1900].

MELLÉRIO, A.: L'exposition de 1900 et l'Impressionnisme, Paris, 1900.

LECOMTE, G.: Catalogue de la Collection E. Blot, Paris, May 1900.

MACCOLL, D. S.: Nineteenth Century Art, Glasgow, 1902.

MAUCLAIR, C.: Les précurseurs de l'impressionnisme, La Nouvelle Revue, 1902. An article devoted mostly to Monticelli whose friendship with Cézanne, however, is ignored.

MEIER-GRAEFE, J.: Manet und sein Kreis, Berlin, 1902. The first book on the subject by an author whose numerous and enthusiastic writings on impressionism did much to spread its fame in Germany and abroad. This small illustrated book contains chapters on Manet, Monet, Pissarro, Cézanne and Renoir.

LAFORGUE, J.: Mélanges posthumes, Paris, 1903 (Oeuvres complètes, v. III). Contains a chapter on impressionism, a "physiologic esthetic explanation of the impressionist formula," written in connection with an impressionist exhibition in Berlin, 1883. See also Dufour, M.: Une philosophie de l'impressionnisme, étude sur l'esthétique de Jules Laforgue, Paris, 1904.

MAUCLAIR, C.: The French Impressionists, London, 1903. The first study on the subject translated into English, it has unquestionably contributed much to the appreciation of impressionism, yet its author was not, precisely, ordained to be the champion of the movement. As art critic of the *Mercure de France* he had published many articles of a pretentious character, launching insolent attacks on all the great contemporary painters. He saw in neo-impressionism a *trifling technique*, referred to Gauguin's art as *colonial*, spoke of the *gangsterism* of Lautrec, poured out his scorn for Cézanne and treated Pissarro with contempt. At the same time he admired Böcklin, Hodler, Carrière, etc. But when the painters were finally rewarded with recognition—and when most of those he slandered had died, Mauclair did not scruple to add his voice to the general expressions of admiration. It must be admitted, however, that he remained at least faithful to his opinions concerning Cézanne and has never ceased to consider him a poor provincial artist stricken with incompetence and ambition.

Under the Vichy government, Mauclair, once more a turncoat, wrote a book on the Jews in art, denouncing Pissarro among others. After the liberation of France, he was condemned to "national unworthiness."

Mauclair's book offers short chapters on the historic background and the theories of the movement, followed by studies on Manet, Monet, Degas, Renoir and a chapter entitled: "The minor impressionists, Pissarro, Sisley, Cézanne, Morisot, Cassatt, Caillebotte, Lebourg, Boudin." There follow studies on modern illustrators (where Raffaelli is preferred to Lautrec), on neo-impressionism (comprising not only Seurat and Signac but also Denis, Vuillard, Bonnard, Gauguin, etc.) and a final chapter on the merits and "faults" of impressionism.

The original French text was published as: L'impressionnisme, son histoire, son esthétique, ses maîtres, Paris, 1904, ill.

MEIER-GRAEFE, J.: Der moderne Impressionismus, Berlin, n.d. [1903-04]. Devoted to Lautrec, Gauguin, Japanese prints and neo-impressionism.

DEWHURST, W.: Impressionist Painting, its Genesis and Development, London, 1904. A well-intentioned book by a painter who knew and admired Monet and corresponded with Pissarro. Neither historian nor writer, the author is extremely unreliable as far as facts and dates are concerned and shows no sense for the succession of events. Although himself an artist, he has almost no technical information to offer. Following Mauclair closely in his judgments, he puts Cézanne on the same level as Boudin and Jongkind. Apparently unable to distinguish between initiators and followers, Dewhurst includes in his book many artists who have little or nothing to do with impressionism. Excellent halftone illustrations in black and white and in colors.

MEIER-GRAEFE, J.: Entwicklungsgeschichte der modernen Kunst, 3 v., Stuttgart, 1904. Second enlarged edition: München, 1927. English translation: The Development of Modern Art, Being a Contribution to a new System of Aesthetics, 2 v., New York, 1908. The first broadly conceived general history that assigns a dominating place to the individual impressionists. Richly ill., index.

BURNE-JONES, PH.: The Experiment of "Impressionism," *Nineteenth Century & After*, March 1905. A diatribe against impressionism by an exponent of the Pre-Raphaelite movement.

NICHOLSON, A.: The Luminists, *Nineteenth Century & After*, April 1905. A moderate defense of impressionism against Burne-Jones' attack.

LANOÉ, G.: Historie de l'école française du paysage, depuis Chintreuil jusqu'à 1900. Nantes, 1905.

DURET, T.: Histoire des peintres impressionnistes, Paris, 1906. The author's pamphlet of 1878, considerably expanded. This is not a history of the movement but a collection of chapters devoted to Pissarro, Monet, Sisley, Renoir, Morisot, Cézanne, Guillaumin. Though this book —long the standard work on the subject—contains biographical information and personal recollections, it seems today somewhat disappointing in view of the fact that the author, an intimate friend of the painters since before 1870, was the one person from whom a complete eye-witness account might have been expected. Duret fails to give vivid portraits of the painters and makes little or no use of the numerous letters he received from them. According to Tabarant (Autour de Manet, *L'Art vivant,* Aug. 15, 1928) who first published many of the documents in Duret's possession, Duret had no sense for information and did not know how to evaluate properly either irrefutable facts or original documents. Insufficient bibliography, no index, illustrated.

An English edition, augmented with a chapter on Manet, has been published under the title: Manet and the French Impressionists, Philadelphia-London, 1910. 40

halftone ill. and original etchings. No bibl., no index.

FONTAINAS, A.: Histoire de la peinture française au XIXe siècle, Paris, 1906. An excellent study of the impressionists and their predecessors is followed by an informative chapter on the official art of the same period. New expanded edition (1801-1920), Paris, 1922.

MOORE, G.: Reminiscences of the Impressionist Painters, Dublin, 1906. Reprint of a lecture using much of the material published in the author's Confessions with additional recollections on Renoir, Pissarro, Cézanne and Cassatt. Later incorporated in: Vale, London, 1914.

MEIER-GRAEFE, J.: Impressionisten, Munich-Leipzig, 1907. Chapters on Guys, Manet, van Gogh, Pissarro and Cézanne; ill., no index.

PICA, V.: Gl'impressionisti Francesi, Bergamo, 1908. An important study accompanied by numerous and well chosen illustrations.

HAMANN, R.: Der Impressionismus in Leben und Kunst, Marburg, 1908. A philosophical rather than historical treatise of impressionism in painting, sculpture, music, poetry and abstract thought, with emphasis on the literary expressions. The author sees in neo-impressionism the most characteristic achievement of the impressionist movement. No ill., no index.

MEIER-GRAEFE, J.: Ueber Impressionismus, Die Kunst für Alle, Jan. 1, 1910.

HUNEKER, J.: Promenades of an Impressionist, New York, 1910. Chapters on Cézanne, Degas, Monet, Renoir, Manet, Gauguin and others. No ill., no index.

WEISBACH, W.: Impressionismus—Ein Problem der Malerei in der Antike und Neuzeit, 2 v. Berlin, 1910-11. The second volume contains a selective study of East Asian art and of French impressionism with a few small color plates of little known works and numerous black and white reproductions.

DEWHURST, W.: What is Impressionism? Contemporary Review, 1911. Traces briefly "the extraordinary analogies which exist between Ruskin's theories and impressionism."

PHILLIPS, D. C.: What is Impressionism? Art and Progress, Sept. 1912.

DENIS, M.: Théories, 1890-1910, Du Symbolisme et de Gauguin vers un nouvel ordre classique, Paris, 1912. Reprints of a number of articles, among them some on Gauguin and Cézanne, both of whom the author had known. An important document on the conceptions of the post-impressionist generation among the leaders of which Denis, for some time, occupied a prominent place.

RAPHAEL, M.: Von Monet zu Picasso, Munich-Leipzig, 1913. Contains a long essay on the creative mind in general and a very readable chapter on impressionism concerned mostly with Monet and Rodin. Impressionism is defined as "reaction rather than action" in its submission to immediate perceptions. 30 ill., no bibl. or index.

BORGMEYER, C. L.: The Master Impressionists, Chicago, 1913. This, the first important book published in America on the impressionists, with no less than 234 often well chosen illustrations, is today completely antiquated. The author's critical appreciations lack interest and his factual information is full of errors; the illustrations are arranged with no system whatsoever. They comprise not only works by the real impressionists but also by Carolus-Duran, Bastien Lepage, de Nittis, Raffaelli, numerous epigones and even Matisse.

WRIGHT, W. H.: Modern Painting, its Tendency and Meaning, London-New York, 1915. One of the first attempts in English to approach impressionism in a scholarly manner, and to show both that it was not a break with the past and that it was not based on science, as has been so often contended. No bibl.; index, ill.

GRAUTOFF, O.: Die Auflösung der Einzelform durch den Impressionismus, Der Cicerone, 1919.

BLANCHE, J. E.: Propos de Peintre; de David à Degas. Paris, 1919. Contains three important chapters of recollections on Manet, Renoir, Degas. No ill., no index.

FÉNÉON, F., (editor): L'Art Moderne, Paris, 1919. 2 vol. with 173 good but undated ill. after works by Cézanne, Manet, Renoir, etc., from the Bernheim-Jeune collection. Interesting quotations from various authors.

MAUCLAIR, C.: L'art indépendant français sous la IIIe République, Paris, 1919. Studies on painting, literature and music between 1890 and the first World War.

LANDSBERGER, F.: Impressionismus und Expressionismus, Leipzig, 1919. A brief juxtaposition of the two styles with emphasis on the latter.

DERI, M.: Die Malerei im XIX. Jahrhundert, Berlin, 1919. 2 vol. (text and ill.) A treatise of development based, in the author's words, on psychology. The chapters on impressionism and neo-impressionism suffer from a lack of discrimination between initiators and followers. No bibl., short index. For a condensed study of impressionism see the same author's: Die neue Malerei, Leipzig, 1921.

LETELLIER, A.: Des Classiques aux Impressionnistes, Paris, 1920. Written in defense of official art, this book makes a poor attempt to "crush" impressionism with a hodgepodge of quotations and a garrulous pseudo-erudition.

FAURE, E.: Histoire de l'art—L'art moderne, Paris, 1921. Excellent English translation by Walter Pach, New York, 1924. Deals only briefly with impressionism but devotes penetrating studies both to Cézanne and to Renoir. Ill., index and a summary historical chart.

DENIS, M.: Nouvelles Théories sur l'art moderne, sur l'art sacré, 1914-1921, Paris, 1922. Contains chapters on impressionism, Cézanne and Renoir.

FONTAINAS, VAUXCELLES and GEORGE: Historie générale de l'art français de la révolution à nos jours, Paris, 1922, v.I. Good chapters on impressionism in general and on the individual painters. Richly ill. No index, no bibl.

LES MAÎTRES DE L'IMPRESSIONNISME ET LEUR TEMPS—Exposition d'art français, Brussels, summer 1922. A catalogue with biographical notes and excerpts from various writings.

MAUCLAIR, C.: Les maîtres de l'impressionnisme, leur histoire, leur esthétique, leur oeuvre. Paris, 1923. Reprint of the 1904 edition.

HILDEBRANDT, H.: Die Kunst des 19. und 20. Jahrhunderts, Potsdam, 1924. This book, dealing on an equal basis with

the best and the worst, devotes only little space to impressionism, and this in a wholly unsatisfactory way.

LAMANDÉ, A.: L'impressionnisme dans l'art et la littérature (lecture), Monaco, 1925.

MAUS, M. O.: Trente années de luttes pour l'art, Bruxelles, 1926. The detailed history of the group *Les Vingt* and of the *Libre Esthétique* movement in Belgium.

GOODRICH, L.: The impressionists fifty years ago, *The Arts*, Jan. 1927. An extremely well documented study.

WALDMANN, E.: Die Kunst des Realismus und des Impressionismus im 19. Jahrhundert, Berlin, 1927. The text does not contain anything new; the good illustrations show mostly well known works. Short index.

MATHER, F. J.: Modern Painting, New York, 1927. An excellent chapter on "Landscape Painting before Impressionism" is followed by a study on impressionism which, unfortunately, is marred by some errors, and in which Monet is credited with divisionism. This is the only book in English which devotes a whole chapter to a detailed analysis of the important problem of the "Official Art in the Nineteenth Century." Mediocre ill., short index.

BELL, C.: Landmarks in Nineteenth Century Painting, New York, 1927. A chapter on impressionism opposes the approach of the plein-artists to that of Degas. Ill., no index.

FOCILLON, H.: La peinture aux XIXe et XXe siècles, Paris, 1928. Contains a short chapter on impressionism with paragraphs devoted to the individual painters.

PACH, W.: The Masters of Modern Art, New York, 1929. The chapter: "From the Revolution to Renoir" sums up the evolution of French art since David. A few ill., list of principal books.

GUIFFREY, J. (editor): La peinture au Musée du Louvre, Paris, 1929.—tome I, section III, Jamot, P.: XIXe siècle. Catalogue of the most important works from the Camondo, May, Dihau, Moreau-Nélaton and other collections, combining biographical notes with analyses of the various paintings. This catalogue does not list the important collections which later entered the Louvre, such as those of Caillebotte, Koechlin and Personnaz.

BLANCHE, J. E.: Les arts plastiques—La IIIe République, de 1870 à nos jours. Paris, 1931. In a chapter on impressionism the author gives some personal recollections on the period in general as well as on some of the painters.

REY, R.: La peinture française à la fin du XIXe siècle—La renaissance du sentiment classique, Paris, 1931. Important studies on Renoir, Cézanne, Gauguin and Seurat, of which the last mentioned is particularly rich in new material.

WILENSKI, R. H.: French Painting, Boston, 1931. A general history from the XIVth to the XXth century. The chapter on Impressionism offers a condensation of the material presented in the author's later work: Modern French Painting, 1940.

POULAIN, G.: Pre-Impressionism, *Formes*, Nov. 1931.

JAMOT, P.: French Painting II, *Burlington Magazine*, special issue, Jan. 1932, published on the occasion of a large exhibition of French art in London.

ROTHENSTEIN, J.: Nineteenth Century Painting—A Study in Conflict. London, 1932.

COGNIAT, R.: Le Salon entre 1880 et 1900. Catalogue of an exhibition organized by *Beaux-Arts* and *Gazette des Beaux-Arts*, (Paris, April-May 1934), containing biographical notices and reproductions of works by the most prominent official painters of the period, that is, of some of the most outspoken foes of impressionism.

ROTHSCHILD, E. F.: The Meaning of Unintelligibility in Modern Art, Chicago, 1934. Defines impressionism as "the subjectification of the objective."

LES ORIGINES DE L'IMPRESSIONNISME, special issue, *Les Beaux-Arts* (Bruxelles), June-Sept. 1935.

VENTURI, L.: L'impressionismo, *L'Arte*, March 1935. An important study of the development and particular character of the impressionist approach to nature.

VENTURI, L.: Impressionism, *Art in America*, July, 1936.

KATZ, L.: Understanding Modern Art, (Chicago) 1936. Ch. XXV-XXVIII, vol. I, feature a rather confused explanation of impressionism; dates not dependable.

VOLLARD, A.: Recollections of a picture dealer, Boston, 1936. Slightly expanded French edition: Souvenirs d'un marchand de tableaux, Paris, 1937. Though he was in a position to add considerably to our knowledge of most of the impressionists whom he had known more or less intimately since around 1895, the author has contented himself mainly with gossip which makes good reading but offers practically no important information. Ill., index.

SCHAPIRO, M.: Nature of Abstract Art, *Marxist Quarterly*, Jan.-March 1937. An interesting discussion of the relationship between art and historical conditions. The author sees in the unconventionalized, unregulated vision of early impressionism an implicit criticism of symbolic social and domestic formalities.

COGNIAT, R.: La naissance de l'impressionnisme. Catalogue of an exhibition organized in Paris (May 1937) by *Beaux-Arts* and *Gazette des Beaux-Arts*.

FRANCASTEL, P.: L'impressionnisme—Les origines de la peinture moderne, de Monet à Gauguin, Paris, 1937. The author pretends that there may be observed a sudden break in the works of Monet, Pissarro, Sisley and Renoir about 1875. Consequently he places the beginning of impressionism at this period, connecting it with the scientific discoveries of Helmholz and Chevreul. Overemphasizing the role of science, the author also greatly exaggerates the importance of Duranty's writings; moreover he confounds impressionism and divisionism. 12 insufficient ill.

LAVER, T.: French Painting and the Nineteenth Century, London, 1937. Short text, not free of errors, followed by notes on individual painters. Excellent choice of good black and white illustrations, some fair color plates.

UHDE, W.: The Impressionists, New York, 1937. A Phaidon picture book with excellent black and white illustrations and some color plates. Two thirds of the reproductions represent works of Manet and the rest is unequally divided among the impressionists. Even more confusing is

the fact that the illustrations are not arranged chronologically.

KLEIN, J.: Modern Masters, New York, 1938. A short and popular presentation of modern art from Manet to Gauguin with adequate black and white illustrations but extremely poor color plates.

BOWIE, T. R.: Relationships between French Literature and Painting in the XIX Century. Catalogue of an exhibition, Columbus Gallery of Fine Arts, April-May, 1938.

HUYGHE, R.: L'impressionnisme et la pensée de son temps, *Prométhée*, Feb. 1939.

LHOTE, A.: Traité du paysage, Paris, 1939. Ill.

VENTURI, L.: Les Archives de l'Impressionnisme, Paris-New York, 1939. Two volumes indispensable for the study of impressionism. They feature 213 letters by Renoir, 411 by Monet, 86 by Pissarro, 16 by Sisley, 31 by Mary Cassatt, 27 by Degas and a number of letters by other artists, all written to Durand-Ruel, chiefly after 1881, as well as some letters to Octave Maus; also a few letters by and the memoirs of Paul Durand-Ruel. (Most letters written to Durand-Ruel before 1881 are lost and even for the later period these archives are not absolutely complete since some documents have found their way into private collections.)

Vol. II contains condensed catalogues of the eight impressionist exhibitions. An appendix offers excerpts, complete reprints or short reports of writings on impressionism published between 1863 and 1880; these are limited to serious studies only and do not comprise any of the violent attacks directed against the artists. Authors quoted extensively are Zola, Astruc, Silvestre, Burty, Pothey, Rivière, Edmond Renoir.

Venturi's long introduction traces the story of the Durand-Ruel Galleries and follows the development of Monet, Pissarro, Sisley and Renoir. It lists the first collectors of impressionist paintings, analyzes the comments of contemporary critics and rounds out the information provided by the documents. Few ill., no bibl., index.

RICHARDSON, E. P.: The Way of Western Art, 1776-1914, Cambridge, 1939. A short chapter on "Objective Realism and Impressionism" treats these movements on an international basis. Few ill., index.

SLOCOMB, G.: Rebels of Art—Manet to Matisse, New York, 1939. More biographical than critical, this book deals with the "wild men" of impressionism in an oversimplified fashion. It is by no means exact in data given and relies sometimes too heavily on anecdotes dear to Vollard and others. Ill., index, no bibl.

WILENSKI, R. H.: Modern French Painters, London-New York, 1940. An interesting but completely unreliable book. The author, who lists "my knowledge" as his principal source of information, depended on others for the research work and fitted their findings with the utmost freedom into the general pattern of his work. The results are extremely frequent inaccuracies, oversimplifications and unwarranted conclusions which suit the author's purpose and make for smooth reading but which make the book unusable as a reference work. No references for quotations are given and, for reasons unknown, numerous quotations are left in French. Summary and insufficient bibliography. Excellent and well chosen illustrations; exhaustive index. Unfortunately no serious review has as yet exposed the shortcomings of this book of which a second edition with some color plates appeared in 1945.

CHENEY, S.: The Story of Modern Art, New York, 1941. A popular book repeating popular errors, confounding impressionist and neo-impressionist doctrines. For a correction of these errors see J. C. Webster (below). Ill., uncritical bibl., index.

NEUMEYER, A.: One Step before Impressionism, *The Pacific Art Review*. Spring 1941.

VENTURI, L.: The Aesthetic Idea of Impressionism, *The Journal of Aesthetics*, Spring 1941.

VENTURI, L.: Art Criticism Now, Baltimore, 1941. Contains a chapter on "The Problems of Impressionism and Post-Impressionism."

ROCHEBLAVE, S.: French Painting, XIXth Century, New York, 1941. A Hyperion picture book with badly selected illustrations and particularly poor color plates. Inadequate text and insufficient bibl.

SCHEYER, E.: Far Eastern Art and French Impressionism, *The Art Quarterly*, VI, No. 2, Spring 1943.

PISSARRO, C.: Letters to his son Lucien, edited with the assistance of Lucien Pissarro by John Rewald. New York, 1943. Several hundred letters written between 1883 and 1903 with detailed accounts of the last impressionist exhibition and useful information on Pissarro and his friends, 100 ill., index.

VENTURI, L.: Qu'est-ce que l'impressionnisme, *Labyrinthe*, August 15, 1944.

CAIRNS, H. and WALKER, J. (editors): Masterpieces of Painting from the National Gallery of Art, Washington, New York, 1944. Some good color plates with comments.

JEWELL, E. A.: French Impressionists and their Contemporaries, represented in American collections, New York, 1944. A Hyperion picture book assembled without any plan or order. Poor color plates. The short biographical notes and the bibliography by Aimée Crane are often inaccurate. See the detailed review by Rewald, *Magazine of Art*, March 1945.

WEBSTER, J. C.: The Technique of Impressionism—a reappraisal, *College Art Journal*, Nov. 1944. This article offers a welcome refutation of some often repeated errors concerning optical mixture, etc.

DORIVAL, B.: Les étapes de la peinture française contemporaine, 2 vol. No copies of this book, published recently in France, are available as yet in this country.

VENTURI, L.: Painting and Painters: How to Look at a Picture, from Giotto to Chagall, New York, 1945. In the chapter "Vitalizing Nature" the author points out that "what impressionists painted and interpreted was not reality but the appearance of reality."

GOLDWATER, R. and TREVES, M. (editors): Artists on Art, from the XIV to the XX Century, New York, 1945. Contains some excerpts from writings and utterances by Manet, Degas; Sisley, Monet, Pissarro, Cézanne, etc.

BAZILLE-CASSATT

BAZILLE

Oeuvre Catalogues

A list of Bazille's paintings, 44 in number, as well as drawings, lost works, etc., is contained in (1). This list (which is not complete) does not give dimensions. No ill.

The Artist's Own Writings

A great number of letters by Bazille to his family are quoted in (1). A few excerpts in English are to be found in (5).

Biographies

(1) POULAIN, G.: Bazille et ses amis. Paris, 1932. This book is of prime importance not only for the study of Bazille but for the beginnings of impressionism. It is based on letters written by Bazille to his family as well as received by Bazille from Monet and Renoir. The importance of these documents cannot be over-estimated. Unfortunately, they have not been edited with sufficient care. Several letters seem inaccurately dated, many have not been copied completely—but even more disturbing is the fact that they have been either badly deciphered or else rewritten, for some of these same documents, quoted in an article by the same author (5), present noticeable variations in syntax and expression. For list of works see above. No index, no bibl., no ill.

Studies of Style

(2) SCHEYER, E.: Jean Frédéric Bazille—The Beginning of Impressionism. *The Art Quarterly*, Spring 1942. The first serious study—based on Poulain's documents (1) and several unpublished works in American and European collections. Ill.

(3) CHARENSOL, J.: Frédéric Bazille et les débuts de l'impressionnisme. *L'Amour de l'Art*, Jan. 1927.

(4) FOCILLON, H.: La Peinture aux XIXe et XXe siècles, Paris, 1928, p. 211-212.

Reproductions

(5) POULAIN, G.: Un languedocien, Frédéric Bazille. *La Renaissance*, April 1927. French and English text, reproductions of Bazille's major paintings. See also (2).

CASSATT

Oeuvre Catalogues

A catalogue of Cassatt's graphic work, compiled by Adelyn D. Breeskin, was announced by the Hyperion Press, New York, in 1942 but never published, although it has long since been completed. Mrs. Breeskin is now preparing a complete catalogue of the artist's paintings.

The Artist's Own Writings

31 letters to Durand-Ruel are reproduced by L. Venturi: Les Archives de l'Impressionnisme, Paris-New York, 1939, vol. 2. Letters to Mrs. Havemeyer are quoted in (1), a letter to Avery is quoted in (10), letters to Weitenkampf are quoted in (11); a letter to a friend is quoted in Rewald's forthcoming biography of Cézanne. Mrs. Breeskin is now assembling the letters of Cassatt.

Witness Accounts

(1) HAVEMEYER, L. W.: Mary Cassatt, *The Pennsylvania Museum Bulletin*, May 1927.

(2) WATSON, F.: Mary Cassatt, New York, 1932. Important recollections, accompanied by 20 halftone reproductions of paintings, pastels and prints, chronologically arranged. Bibl.

(3) WATSON, F.: Philadelphia Pays Tribute to Mary Cassatt, *The Arts*, June 1927.

(4) BIDDLE, G.: Some memories of Mary Cassatt, *The Arts*, Aug. 1926.

Biographies

(5) SEGARD, A.: Mary Cassatt, un peintre des enfants et des mères, Paris, 1913. Although the author interviewed the artist, he offers very little precise information (and this often is relegated to footnotes); his book consists mostly of lyrical commentaries and descriptions of paintings. 38 good ill., arranged chronologically. Appendix with list of exhibitions, private collections and bibl., no index.

(6) ANONYMOUS: Mary Cassatt, Painter and Engraver, *Index of Twentieth Century Artists*, Oct. 1934. Features a short biography, list of exhibitions, reproductions and bibl.

Studies of Style

(7) CARY, E. L.: The Art of Mary Cassatt, *The Scrip*, Oct. 1905.

(8) MELLERIO, A.: Mary Cassatt, *L'Art et les Artistes*, Nov. 1910. Contains list of exhibitions and bibl.

(9) WALTON, W.: Miss Mary Cassatt, *Scribner's Magazine*, March 1896.

(10) MARY CASSATT, CATALOG OF A COMPREHENSIVE EXHIBITION, Baltimore Museum of Art, 1941. Unsigned introduction (by A. D. Breeskin); ill., chronological chart, bibl.

(11) JOHNSON, U. E.: The Graphic Art of Mary Cassatt, *American Artist*, Nov. 1945.

(12) GRAFLY, D.: In retrospect—Mary Cassatt, *American Magazine of Art*, June 1927.

(13) ANONYMOUS: Mary Cassatt's Achievement, *The Craftsman*, March 1911.

Reproductions

(14) VALERIO, E.: Mary Cassatt, Paris, 1930. 32 photogravures after paintings, pastels, drawings and prints with no indication of dates, measurements or owners.

(15) BREUNING, M.: Mary Cassatt, New York, 1944. 46 ill. not assembled in chronological order, poor color plates, short bibl. (Hyperion)

See also (2) and (5).

CÉZANNE

Oeuvre Catalogues

(1) VENTURI, L.: Cézanne, son art—son oeuvre, Paris, 1936. 2 vol. (text and plates) with 1619 ill. after Cézanne's paintings, watercolors, drawings and prints (plus 15 photographs); also a list of still unpublished works. The descriptive catalogue is preceded by an excellent and authoritative study of Cézanne's evolution. An exhaustive bibliography lists 561 publications. The index unfortunately is limited to present owners. A new, revised and augmented edition is now being planned. This book is indispensable for the study of Cézanne.

For a chronology of Cézanne's work see (29).
See also the catalogue raisonné for the Cézanne exhibition, Paris, Orangerie, 1936, compiled by C. Sterling.

The Artist's Own Writings

(2) PAUL CÉZANNE: Letters, edited by J. Rewald, London, 1941. More than 200 letters; ill., index. Original French edition: Paul Cézanne, Correspondance, Paris, 1937.
See also (6).

Witness Accounts

(3) VOLLARD, A.: Paul Cézanne, Paris, 1914, 1919, 1924, 1938 (English translation: Paul Cézanne, His Life and Art, New York, 1926). The first biography of Cézanne, written by his dealer, it is mostly anecdotal and now antiquated except for the part that relates the author's personal experiences with Cézanne, whom he knew during the last ten years of the painter's life. Some details on the years 1860-70 were communicated by Guillemet, who knew Cézanne intimately during that period, but the author neither quotes him directly nor acknowledges his collaboration. Appendix I features excerpts from contemporary criticisms. Ill., index.

(4) GASQUET, J.: Cézanne, Paris, 1921. The author, a poet of distinction, was the son of a school friend of Cézanne's and knew the painter during his last years. He succumbs frequently to the tendency of reporting Cézanne's utterances in a style of his own which—beautiful as it may be—does not always appear truthful. In three chapters of more or less imaginary conversations with Cézanne on the "motif," in the Louvre and at the artist's studio he apparently quotes freely, partly from memory or notes, partly from letters written to him by Cézanne which have since been lost. In spite of its shortcomings this book provides the most lively account of Cézanne offered by a contemporary. Richly ill., no index.

(5) BERNARD, E.: Souvenirs sur Paul Cézanne, Paris, 1921, 1925, 1926. The author, a painter who had already published an article on Cézanne in 1892, met the artist in 1904 and subsequently corresponded with him. His recollections are somewhat tinted by his efforts to justify his own art through utterances by Cézanne. On Cézanne's opinion concerning Bernard, see his letters to his son in (2). Ill., no index.

(6) LARGUIER, L.: Le dimanche avec Paul Cézanne, Paris, 1925. A charming account of the author's frequent visits to Cézanne while he did his military service in Aix, 1901-02. Augmented by some utterances of Cézanne's, as transcribed by his son. See also (8).

(7) JALOUX, E.: Fumées dans la campagne, Paris, 1918; also: Souvenirs sur Paul Cézanne, L'Amour de l'Art, 1920.

(8) CAMOIN, C.: Souvenirs sur Paul Cézanne, L'Amour de l'Art, Jan. 1921; later incorporated in (6). The author, a painter, who did his military service in Aix at the same time as Larguier, enjoyed the particular friendship of Cézanne, whom he approached—unlike Bernard—with a wholly unselfish admiration.

(9) LAFARGUE, M.: Souvenirs sur Cézanne, L'Amour de l'Art, Jan. 1921.

(10) OSTHAUS, K.: Article in Das Feuer, 1920; condensed translation in Marianne, Feb. 22, 1939. Account of a visit paid to Cézanne in 1906.

(11) GEFFROY, G.: Claude Monet, sa vie, son temps, son oeuvre, Paris, 1922, v. II, ch. XIII and XIV.
See also (22).

Emile Zola has used some of Cézanne's traits for his characterization of the painter Claude Lantier in: L'Oeuvre; see (13).

Biographies

(12) MACK, G.: Paul Cézanne, New York, 1935. The best biography in English, excellently written, with a chronological outline, condensed bibl., 48 ill. and an exhaustive index.

(13) REWALD, J.: Paul Cézanne, sa vie, son oeuvre, son amitié pour Zola, Paris, 1939 (second much expanded edition of the same author's: Cézanne et Zola, Paris, 1936). The most complete biography of Cézanne with special emphasis on his thirty year friendship with Zola, based on numerous new

CÉZANNE

documents, letters, interviews, etc. An English edition is now in preparation under the title: Cézanne. Ill., extensive bibl., index.

(14) RIVIÈRE, G.: Le Maître Paul Cézanne, Paris, 1923. The author, a life-long friend of Renoir and father-in-law of Cézanne's only son, has little new information to offer. Ill., no index. (See also the same author's: Cézanne, Paris, 1936; poor ill., no index.)

(15) COQUIOT, G.: Paul Cézanne, Paris, 1919. Containing no firsthand material, this rambling book has become completely obsolete through more recent publications.

(16) HUYGHE, R. and REWALD, J.: Cézanne, special issue of L'Amour de l'Art, May 1936. Offers a chronological chart and a study of Cézanne's evolution by Huyghe, as well as an iconography of Cézanne; richly ill.

(17) GRABER, H.: Paul Cézanne nach eigenen und fremden Zeugnissen, Basle, 1942. This book presents a more or less clumsy translation of material first published in (1) and (3), but especially in (2) and (13), without indicating any source or even acknowledging the fact that the documents were not actually gathered by the author. There is not a single new document in the entire book nor in the similar publications by the same author. R. Goldwater in his review (The Art Bulletin, June 1945) has justly censured Graber's "methods" as piracy.

Studies of Style

(18) FRY, R.: Cézanne, A Study of His Development, New York, 1927. The first good study of Cézanne's evolution. 54 ill., no index.

(19) LORAN, E.: Cézanne's Composition, Analysis of His Form with Diagrams and Photographs of His Motifs, Berkeley and Los Angeles, 1943. Richly ill., index. This book aims at establishing a few general principles of drawing and composition that can be applied to creative work, by presenting concrete examples that reveal the "organization of space" in Cézanne's work.

(20) BARNES, A. C. and MAZIA, V. DE: The Art of Cézanne, New York, 1939. With 71 ill. and an analysis of these. Index.

(21) NOVOTNY, F.: Cézanne und das Ende der wissenschaftlichen Perspektive, Vienna, 1938. 56 ill., index. An extremely thorough investigation of Cézanne's space organization, with a list of all the artist's "motifs" that have, so far, been identified.

(22) DENIS, M.: Théories, 1890-1910, Paris, 1912. Chapter on Cézanne.

(23) HUYGHE, R.: Cézanne, Paris, 1936. Ill.

(24) FAURE, E.: Cézanne, Paris, 1926. 59 ill., no index. (See also the same author's: Cézanne, New York, 1913. No ill., no index.)

(24a) REY, R.: La renaissance du sentiment classique, Paris, 1931. Important chapter on Cézanne.

(25) MEIER-GRAEFE, J.: Cézanne, London-New York, 1927. 40 ill., no index. (See also 38)

(26) ORS, E. D': Paul Cézanne, Paris, 1930, London, 1936. Richly ill.

(27) PFISTER, K.: Cézanne, Gestalt, Werk, Mythos, Potsdam, 1927. Richly ill.

(28) RAPHAEL, M.: Von Monet zu Picasso, Munich-Leipzig, 1913.

(29) BURGER, F.: Cézanne und Hodler, Munich, 1913. Ill.

(30) REWALD, J.: A propos du catalogue raisonné de l'oeuvre de Paul Cézanne et de la chronologie de cette oeuvre, La Renaissance, March-April, 1937.

(31) LA RENAISSANCE, special issue: Cézanne, May-June, 1936. Ill.

(32) BAZIN, G.: Cézanne devant l'impressionnisme, Labyrinthe, Feb. 15, 1945.

(33) BERNARD, E.: L'erreur de Cézanne, Mercure de France, May 1, 1926.

See also (1), (38) and (42).

Reproductions

(34) NOVOTNY, F.: Cézanne, New York, 1937. This Phaidon book presents an excellent choice of 126 good black and white, and color plates, chronologically arranged.

(35) CHAPPUIS, A.: Dessins de Paul Cézanne, Paris, 1938. 48 well-reproduced drawings among which several are not illustrated in (1), and 4 color plates.

(36) RAYNAL, M.: Cézanne, Paris, 1936. 119 good though small ill., 4 color plates.

(37) RAYNAL, M.: Cézanne, Paris, 1939. Album of 8 good color plates.

(38) MEIER-GRAEFE, J.: Cézanne und sein Kreis, Munich, 1922. Richly ill.

(39) JEWELL, E. A.: Paul Cézanne, New York, 1944. A carelessly edited Hyperion book with especially poor color plates. 48 ill. in no chronological order.

(40) RECUEIL IMPORTANT DES OEUVRES DE PAUL CÉZANNE, Japan, [n.d.]. v. I, Landscapes; v. II, Portraits and Nudes; v. III, Still lifes. Each vol. contains 20 poor color plates with short comments in Japanese.

(41) MEIER-GRAEFE, J.: Cézanne und seine Ahnen, Munich, 1910.—Cézannes Aquarelle, Munich, 1920. Two excellent albums of the Marées Gesellschaft.

(42) VENTURI, L.: Paul Cézanne—Water Colours, London, 1943. 32 good halftone ill.

(43) GASQUET, J.: Cézanne, Paris, 1926. An Album d'art Druet with rather poor black and white ill.

(44) MIRBEAU, DURET, WERTH, ETC.: Cézanne, Paris, 1914. 49 good ill. in black and white and color.

(45) KLINGSOR, T. L.: Cézanne, Paris, 1923. 40 plates.

See also (1), (4), (18), (19), (20), (24), (25), (26), (27) and p. 325, note 37.

DEGAS

Oeuvre Catalogues

A complete catalogue is being prepared by P. A. Lemoisne. In the meantime the following illustrated catalogues may be consulted:

(1) Catalogues des tableaux, pastels et dessins par Edgar ░░░░░░ ░░ ░░░░░░░░░░ ░░ ░░░ ░░░░░ ░░░░░ ░░ ░░░░ aura lieu à Paris, Galeries Georges Petit, May 6-8, 1918 (336 ill.); Dec. 11-13, 1918 (421 ill.); April 7-9, 1919 (637 ill.); July 2-4, 1919 (755 ill.). Four sales of paintings, watercolors, pastels, drawings and monotypes.

See also: Catalogue of the "Succession de M. René de Gas" [Degas' brother], Paris, Nov. 10, 1927, and catalogue of the "Collection de Mlle J. Fèvre" [Degas' niece], Paris, June 12, 1934.

(2) Catalogue of the Degas Exhibition, Paris, Galeries Georges Petit, April-May 1924, compiled by M. Guérin; ill.

(3) Catalogue of the exhibition: "Degas, Portraitiste, Sculpteur," Paris, Orangerie, 1931. Introductions by Jamot and Vitry; ill.

(4) Catalogue of the Degas Exhibition, Philadelphia, Pennsylvania Museum of Art, 1936, compiled by H. P. McIlhenny, introductions by P. J. Sachs and A. Mongan; ill.

(5) Catalogue of the Degas Exhibition, Paris, Orangerie, March-April 1937, compiled by J. Bouchot-Saupique and M. Delaroche-Vernet, introduction by Jamot; ill., extensive bibl.

(6) DELTEIL, L.: Edgar Degas. Le peintre-graveur illustré, v. IX, Paris, 1919. A catalogue of Degas' 66 prints.

(7) REWALD, J.: Degas, Works in Sculpture, A Complete Catalogue, New York, 1944. 141 ill. after bronzes, wax models, plaster casts and drawings; bibl.

The Artist's Own Writings

(8) Lettres de Degas, recueillies et annotées par M. Guérin, Paris, 1931. 193 letters (1872-1910), 17 ill., chiefly after excellent photographs of the artist, no index. A new and more complete edition is now being prepared by M. Guérin; it will contain among others the few letters to Durand-Ruel published by L. Venturi: Les Archives de l'Impressionnisme, Paris-New York, 1939. 9 recently discovered letters will be published separately by M. Guérin. An English edition is now being prepared in London.

(9) LEMOISNE, P. A.: Les Carnets de Degas au cabinet des Estampes, Gazette des Beaux-Arts, April 1921. Extremely interesting excerpts from Degas' notebooks, some of which have been quoted in the present book.

(10) DURANTY, E.: La nouvelle peinture, Paris, 1876. The letter by an unnamed artist, quoted by Duranty, was supposedly written by Degas.

Witness Accounts

(11) MICHEL, A.: Degas et son modèle, Mercure de France, Feb. 1 and 16, 1919. Two excellent articles by a model of Degas' which give a vivid description of the aging artist at work, of his studio, etc.

(12) Souvenirs de M. Ernest Rouart (p. 160-173) and Souvenirs de Berthe Morisot, notés par elle sur un ░░░░░░ (p. 146-148) published in (29).

(13) ROUART, E.: Degas, Le Point, Feb. 1937.

(14) JEANNIOT, G.: Souvenirs sur Degas, La Revue Universelle, Oct. 15, Nov. 1, 1933. Important study.

(15) SICKERT, W.: Degas, Burlington Magazine, Nov. 1917. Repr. in Emmons, R.: The Life and Opinions of Walter Richard Sickert, London, 1941.

(16) MOORE, G.: Memories of Degas, Burlington Magazine, Jan., Feb. 1918. See also the same author's: Impressions and Opinions, New York, 1891 (chapter on Degas) and his: Modern Painting, London, 1893.

(17) MOREAU-NÉLATON, E.: Deux heures avec Degas. L'Amour de l'Art, July 1931. Interesting notes taken after an interview in 1907, concerning chiefly Degas' meeting with Ingres.

(18) VOLLARD, A.: Degas, Paris, 1924, 1938. English translation: Degas, An Intimate Portrait, New York, 1927. A series of unrelated and often poor anecdotes which—at times—offer a better insight into Vollard than into Degas. The most disappointing among the author's books of recollections, it is of little help to the student. Poor ill., no index.

(18a) THIÉBAULT-SISSON: Article on Degas, Le Temps, May 18, 1918.

(19) BLANCHE, J. E.: Propos de peintre. De David a Degas, Paris, 1919.

(20) CHARLES, F.: Les mots de Degas, La Renaissance, April 1918.

(21) CHIALIVA, J.: Comment Degas a changé sa technique du dessin, Bulletin de la Société de l'Histoire de l'art français, 1932.

For Caillebotte's letter on Degas see p. 348 of the present book.

See also (22), (29) and (30).

Octave Mirbeau has used some of Degas' traits for the artist in his novel: Le Calvaire. English edition: The Calvary, New York, 1922.

Biographies

(22) LAFOND, P.: Degas, Paris, 1918-1919. 2 v. A study of Degas' life and art written by a friend of the artist. Richly ill. The black and white, and color plates in the second volume are superior to those in the first, but all are assembled without order. No. bibl., no index.

(23) MANSON, J. B.: The Life and Work of Edgar Degas, London, 1927. This conscientious biography is the best work in English on the artist. 81 good black

and white plates, chronologically arranged, some color plates, no bibl., no index.

(24) RIVIÈRE, G.: Mr. Degas, Bourgeois de Paris, Paris, 1935. Although the author knew Degas, he has nothing new to offer and sees the artist mostly through the eyes of Renoir who was a lifelong friend of Rivière. 71 mediocre ill., no bibl., no index.

(25) MEIER-GRAEFE, J.: Degas, Munich, 1920; English translation, London, 1923, 1927. 103 excellent plates, chronol. arranged. No. bibl., no index.

(26) COQUIOT, G.: Degas, Paris, 1924. More verbiage than information, accompanied by an insufficient list of Degas' "principal" works, assembled without any dates. Mediocre ill., no index, no bibl.

(27) GRABER, H.: Edgar Degas, Eigene Zeugnisse—Fremde Schilderungen—Anekdoten, Basle, 1940. On this author's "methods" see Cézanne Bibliography (17).
See also (28).

Studies of Style

(28) JAMOT, P.: Degas, Paris, 1924. An excellent study of Degas' evolution. 88 good halftone plates, chronologically arranged and accompanied by detailed commentaries. Also a list of exhibitions in which Degas participated, with titles of the works shown. Short bibl., no index.

(29) VALÉRY, P.: Degas, Danse, Dessin, Paris, 1938. Subtle considerations on art in general and on Degas in particular, whom the author knew and on whom he gives some reminiscences. To these are added those of E. Rouart and Berthe Morisot, see (12).

(30) LEMOISNE, P. A.: Degas, Paris, n.d. [1912]. 48 plates, chronologically arranged, accompanied by a running commentary which occasionally contains information supplied by Degas, whom the author knew. Short bibl., no index.

(31) HERTZ, H.: Degas, Paris, 1920. Mediocre ill.

(32) ROUART, D.: Degas à la recherche de sa technique, Paris, 1945. Richly ill., notes, bibl.

(33) LIEBERMANN, M.: Degas, Berlin, 1899, 1912. Short essay.

(34) HUYSMANS, J. K.: L'Art moderne, Paris, 1883, 1902. See also the same author's: Certains, Paris, 1889.

(35) GEFFROY, G.: Degas, L'Art dans les deux Mondes, Dec. 20, 1890.

(36) MAUCLAIR, C.: Edgar Degas, La revue de l'art ancien et moderne, Nov. 10, 1903.

(37) GUÉRIN, M.: Remarques sur des portraits de famille peints par Degas, Gazette des Beaux-Arts, June 1928.

(38) MITCHELL, E.: 'La fille de Jephté' par Degas, génèse et évolution, Gazette des Beaux-Arts, Oct. 1937.

(39) WALKER, J.: Degas et les maîtres anciens, Gazette des Beaux-Arts, 1933. Includes a list of works copied by Degas.

Reproductions

(40) Degas, vingt dessins, 1861-1896. 20 superb color reproductions executed according to a new process invented by Manzi, friend of Degas. The artist himself supervised the printing and autographed each album.

(41) RIVIÈRE, H.: Les dessins de Degas, Paris, 1922-23. A large album of excellent reproductions in black and white and in color printed by Demotte.

(42) ANDRÉ, A.: Degas, Paris, 1935. 30 excellent plates in black and white after drawings and pastels.

(43) DEGAS, Paris, 1914, 1918. 98 reproductions in black and white after paintings, pastels, drawings and prints. Before printing these, Vollard submitted the photographs to Degas who signed them. The plates are mediocre.

(44) DEGAS, special issue of L'Amour de l'Art, July 1931, with essays on Degas' paintings and sculptures. Richly ill., several interesting photographs of and by Degas.

(45) GRAPPE, G.: Degas, Paris, n.d. [1936].

(46) GUÉRIN, M., and Lemoisne, P. A.: Dix-neuf portraits de Degas par lui-même, Paris, 1931.

(47) FOSCA, F.: Degas, Paris, 1927. 24 mediocre plates (Album d'art Druet).

(48) MAUCLAIR, C.: Degas, Paris, 1937, New York, 1941, 1945. Fair black and white ill., poor color plates. (Hyperion).

(49) JAMOT, P.: Manet, Paris-London, 1939. Portfolio of 10 excellent color plates.
See also (19), (20), (22), (25), (27), (32), (37), (38), (39).

GAUGUIN

Gauguin's impressionist period has not yet received proper attention. His works have neither been assembled in any special publication nor have they been studied critically. The same holds true for his paintings done in Martinique (1887), where he continued to paint in a style closely related to that which he had adopted under Pissarro's influence. Most of Gauguin's biographers have devoted serious attention to his evolution only beginning with the year 1888, when the artist first expressed his theories of *Synthesism*.

There is no catalogue of Gauguin's work (except for his graphic output). The letters which Gauguin wrote before 1888 contain few remarks on his art. This is the case especially for his correspondence with his wife published by J. Dorsenne: La vie sentimentale de Paul Gauguin, Paris, 1927. In his numerous writings Gauguin touches only occasionally upon the question of impressionism, as in his *Diverses Choses* and *Racontars d'un rapin*, both quoted at length by J. de Rotonchamp [see below]. Gauguin's more important writings, *Avant et Après* and *Noa-Noa*, as well as his extensive correspondence with G. D. de Monfreid are concerned almost exclusively with his life in Tahiti and on the island of Dominique.

Short witness accounts of Gauguin's early years as an artist may be found *in*: Further Letters of Vincent van Gogh to his Brother, London-New York, 1929; *in* Camille Pissarro, Letters to his Son Lucien, New York, 1943, and *in*: A Painter's Pilgrimage Through Fifty Years (Cambridge, 1939) by A. S. Hartrick who saw Gauguin in Pont-Aven during the summer of 1886. Some references to this sojourn of Gauguin's in Pont-Aven are to be found *in* C. Chassé: Gauguin et le groupe de Pont-Aven, Paris, 1921, although this book deals chiefly with Gauguin's later and more significant sojourns in Brittany.

The most authoritative biographies of Gauguin are by J. de Rotonchamp (pseudonym for Brouillon): Paul Gauguin, Weimar and Paris, 1906, new edition Paris, 1925, and by C. Morice: Paul Gauguin, Paris, 1920, both of whom knew the painter (although not during his impressionist period) and had access to many of his letters, manuscripts, etc. The best biographies in English are by R. Burnett: The Life of Paul Gauguin, London, 1936, and by Pola Gauguin: My Father, Paul Gauguin, New York (and Stockholm) 1937. The title of this last publication, however, is somewhat misleading since it is in no way what one might expect from a book by a son on his father. The author knew Gauguin only as a child and what he learned from his mother was more or less biased. He therefore had to rely almost completely on the material gathered by Rotonchamp and Morice as well as on Gauguin's letters to de Monfreid. Pola Gauguin's conscientious text is accompanied by a great many illustrations of early and little known works. For further reproductions (unfortunately not chronologically arranged) see J. Rewald: Gauguin, London-New York, 1938, which also contains an extensive bibliography.

MANET

Oeuvre Catalogues

(1) JAMOT, WILDENSTEIN, BATAILLE: Manet, 2 v., Paris, 1932. The catalogue lists 546 paintings and pastels (no watercolors or drawings) including a number of doubtful works and fakes, designated as such. Detailed notes give all desirable information on every work. A long introduction by P. Jamot examines the evolution of Manet's style. It is followed by a genealogy of the artist's family, by an iconography of Manet, by descriptions of Manet quoted from the writings of A. Proust, Bazire, Zola, Mallarmé, Moore, de Nittis, etc. An extremely detailed chronological chart with numerous direct quotations from documents is particularly valuable. Excellent index. The 487 illustrations unfortunately are not chronologically arranged and make it extremely difficult to follow Manet's development. Extensive bibl.

(2) TABARANT, A.: Manet, Histoire catalographique, Paris, 1931. A valuable attempt to unite oeuvre catalogue and biography. Unfortunately, this book, published before (1), is not illustrated. Extensive bibl.

(3) GUÉRIN, M.: L'oeuvre gravé de Manet, Paris, 1944. A new and more complete edition of Moreau-Nélaton's catalogue published in 1906, the introduction to which is here reprinted. A chronologically arranged record of Manet's important output of etchings, lithographs, etc. 182 good ill., including paintings or sketches related to prints. Short bibl.

The Artist's Own Writings

(4) E. MANET: Lettres de Jeunesse, Paris, 1929. A number of letters written by Manet at the age of 17 while sailing as apprentice between Rio de Janeiro and Le Havre.

(5) DURET, T.: Quelques Lettres de Manet et de Sisley, *Revue Blanche,* March 15, 1899.

(6) TABARANT, A.: Une correspondance inédite d'Edouard Manet—Lettres du siège de Paris, Paris, 1935.

(7) GUIFFREY, J.: Lettres illustrées de Edouard Manet, Paris, 1929. Excellent facsimiles of 22 letters written around 1880 and more interesting for their charming watercolor illustrations than for their text. A new edition was published in New York: Manet, Letters with Aquarelles, 1944.

Most of Manet's important letters to his family and to his friends are quoted extensively in (15); others are to be found in (1), (2) and also (3).

Witness Accounts

(8) ZOLA, E.: Edouard Manet, étude biographique et critique, Paris, 1867.

(9) PROUST, A.: Edouard Manet, Souvenirs, publiés par A. Barthelemy, Paris, 1913. The author, who met Manet at college and again at Couture's and who later turned to politics, presents his recollections in a more or less coherent way. He is not always reliable, errs in dates, follows the artist's career only intermittently and, above all, does not fully understand Manet's art (he even takes time out to write on Meissonier and other "masters"). Yet his book offers occasionally useful information.

(10) JEANNIOT: article on Manet in *La Grande Revue,* Jan. 1882.

(11) GOETSCHY, G.: Edouard Manet, *La Vie Moderne,* May 12, 1883. (10) and (11) offer accounts of visits to the artist's studio; the former was published during Manet's lifetime.

(12) BLANCHE, J. E.: Essays et portraits, Paris, 1912. Notes on Manet later reprinted *in*: Propos de peintre, de David à Degas, Paris, 1919.

(13) NITTIS, J. DE: Notes et souvenirs, Paris, 1895. The few notes of interest have been quoted in (15); some also appear in the present book.

(14) MOORE, G.: Confessions of a Young Man, London, 1888. See also the same author's: Modern Painting, London-New York, 1898. On Moore's friendship with Manet see D. Cooper: George Moore and Modern Art, *Horizon,* Feb. 1945.

See also (17) and (18).

MANET-MONET

Biographies

(15) MOREAU-NÉLATON, E.: Manet raconté par lui-même, 2 v., Paris, 1926. An extremely careful and excellent presentation of all data concerning Manet with abundant quotations from letters and other documents. The author's careful exploration of source material practically renders all previously published biographies obsolete. Profusely ill., with excellent photogravures. In appendix a catalogue and photographs of the Manet exhibition, Paris, 1884. Extensive index, no bibl.

(16) JEDLICKA, G.: Manet, Erlenbach-Zürich, 1941. An attempt to unite a biographical account with a critical artistic study, this book offers a painstaking and careful investigation of Manet's life and of his development which presupposes, however, a thorough acquaintance with the artist's world. Those who look for precise data and documents may be disappointed. Occasionally the author seems not to be critical enough in his use of source material, such as information offered by Proust, etc. But this does not detract from the great merit of his book as an extremely detailed portrait of Manet. Profusely ill. with excellent halftones, no bibl., index.

(17) DURET, T.: Histoire de Edouard Manet et de son oeuvre, Paris, 1902, 1906; English edition: Manet and the French Impressionists, Philadelphia-London, 1910. A biography based on the author's long friendship with Manet.

(18) BAZIRE, E.: Manet, Paris, 1884. The first book on Manet, published the year after his death. It is of value as a testimony of admiration but suffers from considerable incompleteness.

(19) COLIN, P.: Edouard Manet, Paris, 1932. 96 fair plates, bibl., no index.

(19a) COURTHION, P. and CAILLER, P. (editors): Manet raconté par lui-même et par ses amis, Vésenaz-Geneva, 1945. Excerpts from Manet's letters and from writings by Zola, Baudelaire, Mallarmé, Proust, etc. No new material. Ill., short bibl., no index.

(20) GRABER, H.: Edouard Manet, nach eigenen und fremden Zeugnissen, Basle, 1941. On this author's "methods" see Cézanne bibl. (17).

A. Tabarant is preparing a new biography of Manet which promises to be the most complete work on the artist.

Studies of Style

(21) ROSENTHAL, L.: Manet graveur et lithographe, Paris, 1925.

(22) HOURTICQ: Manet, Paris, n.d. [1912]. 48 ill. chronologically arranged, accompanied by a running commentary. No bibl., no index.

P. Jamot has published a series of articles on Manet

listed in the bibl. of (1). See also his introduction to (1).

See also note 27, p. 168 in the present book.

Reproductions

(23) REY, R.: Choix de soixante-quatre dessins de Edouard Manet, Paris-New York, 1932. 64 good ill. of drawings.

(24) MANET, ALBUM OF THE MARÉES GESELLSCHAFT, Munich, 1928, with 15 superb color plates.

(25) TABARANT, A.: Manet, Paris-London, 1939. Portfolio with 8 excellent color plates.

(26) REY, R.: Manet, Paris-London, 1938. A Hyperion book. The plates are arranged without order; the captions were written without consultation of (1), which is not even listed in the bibl. Fair ill., some color plates.

(27) BLANCHE, J. E.: Manet, Paris-New York, 1925. 40 good but small ill.

(28) FELS, F.: Edouard Manet, Paris, n.d. [1928?]. An Album d'art Druet with 24 mediocre plates.

(29) MORTIMER, R.: Manet's "Un bar aux Folies-Bergère." London, n.d. [1944]. Excellent photographs of details.

(30) MANET, special issue of *L'Amour de l'Art,* 1932. Very interesting ill.

(31) MANET, special issue of *L'Art Vivant,* June, 1932. See also (1), (3), (7), (15), (16), (19) and (20).

MONET

Oeuvre Catalogues

None.

The Artist's Own Writings

(1) VENTURI, L.: Les Archives de l'Impressionnisme, Paris-New York, 1939, 2 v. Contains 411 letters to Durand-Ruel (1876-1926) and 6 to O. Maus.

(2) For letters to Boudin see G. Cahen: Eugène Boudin, sa vie et son oeuvre, Paris, 1900.

(3) For letters to Bazille see G. Poulain: Bazille et ses amis, Paris, 1932.

(4) Some letters to Zola are quoted in J. Rewald: Cézanne, sa vie, son oeuvre, son amitié pour Zola, Paris, 1939, as well as in the present volume.

(5) Several letters to Duret are published in T. Duret: Manet and the French Impressionists, Philadelphia-London, 1910.

(6) For letters to Manet see A. Tabarant: Autour de Manet, *L'Art Vivant,* May 4, 1928.

(7) For letters to Chocquet see J. Joets: Les impressionnistes et Chocquet, *L'Amour de l'Art,* April, 1935.

(8) A letter to Houssaye was published by R. Chavance: Claude Monet, *Le Figaro Illustré,* Dec. 16, 1926.

(9) A letter to Charteris is reproduced in Charteris: John Sargent, London, 1927.

Letters to Geffroy are quoted in (22), Letters to Charpentier in (23).

Monet also expressed his opinions in a number of interviews:

(10) THIÉBAULT-SISSON: Claude Monet, An Interview, *Le Temps,* Nov. 27, 1900 (translated and reprinted i.. glish by Durand-Ruel, New York).

(11) TABOUR: x, E.: Claude Monet, *La Vie Moderne,* June 12, 1880.

(12) GUILLEMOT, M.: Claude Monet, *Revue Illustré,* March 15, 1898.

(13) VAUXCELLES, L.: Un après-midi chez Claude Monet, *L'Art et les Artistes,* Dec. 1905.

(14) PACH, W.: Interview of Monet, published in *Scribner's Magazine,* 1908, repr. *in* Queer Thing, Painting, New York, 1938.

(15) TRÉVISE, DUC DE: Le pèlerinage de Giverny, *Revue de l'art ancien et moderne,* Jan., Feb. 1927.

(16) GIMPEL, R.: At Giverny with Claude Monet, *Art in America,* June 1927.

(17) MARX, R.: Les 'Nymphéas' de M. Claude Monet, repr. *in* Maîtres d'hier et d'aujourd'hui, Paris, 1914.
See also (18) and (37).

Witness Accounts

(18) ELDER, M.: Chez Claude Monet à Giverny, Paris, 1924. A series of interviews pertaining mostly to the painter's youth and to his last years, the period of his *Waterlilies.* Ill.

(19) CLEMENCEAU, G.: Claude Monet, Les Nymphéas, Paris, 1928. Though written by one of Monet's closest friends, this book contains little firsthand information, offering instead a panegyric of his last works. Excellent English translation by George Boas, New York, 1930.

(20) PERRY, L. C.: Reminiscences of Claude Monet from 1889 to 1909, *The American Magazine of Art,* March 1927.

(21) KOECHLIN, R.: Claude Monet, *Art et Décoration,* Feb. 1927.
See also (10)—(17), (22), (24) and (31).
Marcel Proust has used some of Monet's traits for his characterization of the painter Elstir in: A la recherche du temps perdu; see M. E. Chernowitz: Proust and Painting, New York, 1945.

Biographies

(22) GEFFROY, G.: Claude Monet, sa vie, son temps, son oeuvre, Paris, 1922 (an expensive one-volume and a cheap two-volume edition). The author, one of the painter's most intimate friends, had access to Monet's private papers. His rambling book contains a great wealth of documents, letters addressed to Monet by his painter friends, generous quotations from early press clippings and narrations of various episodes which Monet confided to his biographer whose publication appeared while he was still alive. Unfortunately the book is edited without great care; the author apparently neglected doing any research of his own or even classifying the material obtained from Monet, nor does he seem to have consulted the latter in order to clarify many obscure points. His book therefore is not as authoritative as it ought to be and various flagrant errors indicate that Monet may not himself have read the text before it went to press. Extensive bibl., index. The de luxe edition has excellent illustrations.

(23) FELS, M. DE: La vie de Claude Monet, Paris, 1929. To date the best and most discriminating biography of Monet, intelligently conceived, and presenting the documents most effectively. Contains a list of Monet's principal works in France and abroad, but without giving the dates for these works. Short bibl., no index.

(24) DURET, T.: Manet and the French Impressionists, Philadelphia-London, 1910. A chapter on Monet based chiefly on the author's long association with the painter.

(25) GWYNN, S.: Claude Monet and His Garden, London, 1934. Contains nothing new, relies heavily on (22). Index, 23 ill., among which are many photographs of Monet's garden in Giverny.

(26) LATHOM, X.: Claude Monet, London, 1931, New York, 1932. A rather poor and uncritical account of Monet's life, not free of errors. 24 good plates, assembled without any order.

(27) MAUCLAIR, C.: Claude Monet, Paris, 1924, London, 1927. Chiefly lyrical comments, contains no firsthand information. 40 undated ill. not chronologically arranged, short bibl. A new edition has appeared recently in France.

(28) GRABER, H.: Pissarro—Sisley—Monet, nach eigenen und fremden Zeugnissen, Basle, 1943. Material from various French publications translated into German without any indication of sources. On this author's "methods" see Cézanne bibl. (17).

Studies of Style

(29) RÉGAMEY, R.: La formation de Claude Monet, *Gazette des Beaux-Arts,* Feb. 1927.

(30) MIRBEAU, O.: Claude Monet, *L'Art dans les deux Mondes,* March 7, 1891.

(31) BLANCHE, J.-E.: Propos de peintre—De Gauguin à la Revue nègre, Paris, 1928. The chapter on Monet also contains some reminiscences of him.

(32) ALEXANDRE, A.: Claude Monet, Paris, 1921. With 48 good ill., chiefly of little known works.

(33) SABBRIN, C.: Science and Philosophy in Art, Philadelphia, 1886.
See also Venturi's introduction to (1).

Reproductions

(34) FRANCASTEL, P.: Monet, Sisley, Pissarro, Paris, 1939. Portfolio with some excellent color plates.

(35) WERTH, L.: Claude Monet, Paris, 1928. 67 good

halftone plates after paintings and drawings, dated and chronologically arranged; also some photographs of Monet.

(36) CETTO, A. M.: Claude Monet, Basle, 1943. Portfolio of 8 excellent color plates.

(37) FELS, F.: Claude Monet, Paris, 1927. 24 plates (Album d'art Druet).

(38) FELS, F.: Claude Monet, Paris, 1925. 28 small and poor ill. The introduction quotes some utterances of Monet's.

(39) WILDENSTEIN, D.: Claude Monet. Catalogue of a loan exhibition, New York, April-May 1945. 49 good ill. Table of chronology incomplete and not free of errors.

See also (18), (26), (27), (32).

MORISOT

Oeuvre Catalogues

A list of 663 paintings, pastels, watercolors and drawings, and of their owners, is featured in (6). The works are dated, but dimensions are not always given.

The Artist's Own Writings

Several letters are quoted in (5) and in (6).

(1) Notes on Degas are reproduced in Valéry, P.: Degas, Danse, Dessin, Paris, 1938.

(2) Some letters concerning Manet are quoted in Moreau-Nélaton, E.: Manet raconté par lui-même, Paris, 1926. (Most books on Manet refer to Berthe Morisot; her biographer, however (6), neglects studying her relationship with Manet.)

Witness Accounts

(3) VALÉRY, P.: Tante Berthe, La Renaissance, June 1926. The author married one of Morisot's nieces, Jenny Gobillard, daughter of the painter's sister Yves. Ill. See also (1).

(4) MALLARMÉ, S.: Preface to the catalogue of the memorial exhibition at the Durand-Ruel Galleries, Paris, March 1896.

Biographies

(5) FOURREAU, A.: Berthe Morisot, Paris-London, 1925. A serious and well-documented study based on documents and information provided by Morisot's family, (her brother, Tiburce, and her daughter, Mme Ernest Rouart). 40 ill.

(6) ANGOULVENT, M.: Berthe Morisot, Paris, 1933. Although somewhat amateurishly written, this book is valuable for its documents, its catalogue of Morisot's work, its bibl. and its good ill., chronologically arranged. No index.

(7) MARX, R.: Maîtres d'hier et d'aujourd'hui, Paris, 1914. Chapter on Morisot.

See also (10).

Studies of Style

(8) WYZEWA, T. DE: Mme Berthe Morisot, l'Art dans les deux Mondes, March 28, 1891.

(9) ROUART, L.: Berthe Morisot, Art et Decoration, May 1908.

(10) DURET, T.: Manet and the French Impressionists, Philadelphia, 1910. Chapter on Morisot.

Reproductions

See (3), (5), (6) and (9).

PISSARRO

Oeuvre Catalogues

(1) PISSARRO, L. R. AND VENTURI, L.: Camille Pissarro, son art, son oeuvre, Paris, 1939. 2 vol. One volume of text, listing 1664 paintings, gouaches, détrempes and paintings on porcelain as well as pastels (no watercolors or drawings), is accompanied by a volume of plates with 1632 excellent illustrations. This book is absolutely indispensable for the study of Pissarro's work. The catalogue has been most carefully prepared by the artist's son, Ludovic-Rodo, and is preceded by an important critical study of Pissarro's art by Venturi. Many of the catalogue notices are accompanied by quotations from letters and other documents concerning the specific work. An extensive bibliography, chronologically arranged, lists over 500 publications. The index of collectors, unfortunately, is limited to owners at the time of publication.

(2) DELTEIL, L.: Pissarro, Sisley, Renoir. Le peintre-graveur illustré, v. XVII. Paris, 1923. Pissarro's very important graphic work comprises 194 etchings, aquatints and lithographs, some of which are reproduced here in various states. Richly ill. See also Hind, A. M.: Camille Pissarros graphische Arbeiten und Lucien Pissarros Holzschnitte nach seines Vaters Zeichnungen, Die graphischen Künste, 1908.

The Artists's Own Writings

(3) Camille Pissarro, Letters to his Son Lucien, edited with the assistance of Lucien Pissarro by John Rewald. New York, 1943. Complete transcription of, or excerpts from, 477 letters written to the artist's oldest son between 1883 and 1903. A great wealth of firsthand material with comments on Pissarro's impressionist friends and on art in general. Profusely ill., index. An edition of the original French text is now being prepared in Paris.

(4) VENTURI, L.: Les Archives de l'Impressionnisme, Paris-New York, 1939. 2 vol. The second volume features 86 letters written to Durand-Ruel between 1881 and 1903, as well as 16 letters to O. Maus.

(5) LECOMTE, G. AND KUNSTLER, C.: Un fondateur de l'impressionnisme, *Revue de l'art ancien et moderne,* 1930. Two articles with quotations from letters to Mirbeau and Lucien Pissarro. For letters to Mirbeau see also (10).

(6) For letters to Monet see Geffroy, G.: Claude Monet, sa vie, son oeuvre, Paris, 1922, vol. II.

(7) For letters to Zola and Huysmans see Rewald, J.: Cézanne, sa vie, son oeuvre, son amitié pour Zola, Paris, 1939.

(8) For letters to Fénéon and Verhaeren see Rewald, J.: Georges Seurat, New York, 1943.

(9) For letters to Dewhurst see Dewhurst, W.: Impressionist Painting, London-New York, 1904.
For letters to Murer and Duret see (14).
See also (1).

Witness Accounts

(10) LECOMTE, G.: Camille Pissarro, Paris, 1922. The first chapter gives an excellent description of Pissarro's physical appearance and of his character. The last chapter features long excerpts from letters to Mirbeau. Although the author knew Pissarro intimately over a period of 20 years he offers very little biographical data or information about the painter's artistic conceptions. Good ill., no bibl., no index.

(11) DURET, T.: Manet and the French Impressionists, Philadelphia-London, 1910. Chapter on Pissarro.

(12) VILLEHERVÉ, R. DE LA: Choses du Havre, les dernières semaines du peintre Camille Pissarro, *Havre-Eclair,* Sept. 25, 1904.

(13) MOORE, G.: Reminiscences of the Impressionist Painters, Dublin, 1906. See also the same author's: Modern Painting, London-New York, 1893, chapter "Monet, Sisley, Pissarro, and the Decadence."
For the recollections of the painter Louis Le Bail see p. 356, 358, of the present book.
Some recollections are contained in C. Kunstler's book on the artist's son Paulémile, Paris, 1928.

Biographies

(14) TABARANT, A.: Pissarro, Paris, 1924; New York, 1925. An excellent and well documented study based mainly on the private papers of Eugène Murer as well as on information apparently supplied by the artist's family. Quotations from letters to Murer and Duret. 40 good plates, no index.

(15) GRABER, H.: Camille Pissarro, Alfred Sisley, Claude Monet, nach eigenen und fremden Zeugnissen, Basle, 1943. On this author's "methods" see Cézanne bibliography (17).

Studies of Style

(16) MIRBEAU, O.: Camille Pissarro, *L'Art dans les Deux Mondes,* Jan. 10, 1891.

(17) REWALD, J.: Camille Pissarro, His Work and Influence, *Burlington Magazine,* June 1938.

(18) STEPHENS, H. G.: Camille Pissarro, Impressionist, *Brush and Pencil,* March 1904. Also contains some recollections of the artist.
See also Venturi's introductions to (1) and (4).

Reproductions

(19) KUNSTLER, C.: Camille Pissarro, Paris, 1930. 32 good though small illustrations, chronologically arranged, preceded by a short biographical and critical text.

(20) REWALD, J.: Camille Pissarro au Musée du Louvre, Paris-Brussels, 1939. 10 good color plates accompanied by brief comments.

(21) FRANCASTEL, P.: Monet, Sisley, Pissarro, Paris, 1939. A few excellent color plates.
See also (1), (2), (3), (10) and (14).

RENOIR

Oeuvre Catalogues

A complete catalogue of Renoir's paintings is being prepared by L. Venturi. In the meantime the following illustrated catalogues may be consulted:

(1) ANDRÉ, A. AND ELDER, M.: L'atelier de Renoir, Paris, 1931. Two volumes, profusely illustrated, reproducing in chronological order all the works found in Renoir's studio after the painter's death.

(2) Catalogue of the Renoir exhibition, Paris, Orangerie, 1933. Compiled by C. Sterling. Ill.

(3) Catalogue of the Renoir exhibition, New York, Metropolitan Museum of Art, 1937. Introduction by H. B. Wehle. Ill.

(4) Catalogue of the Renoir Centennial exhibition, New York, 1941 (Duveen Brothers). Ill.

(5) Catalogue of the sale of the Maurice Gangnat collection, Paris, 1925. With 160 illustrations, mostly of later works. Introductions by R. de Flers and E. Faure.

(6) DELTEIL, L.: Pissarro, Sisley, Renoir. Le peintre-graveur illustré, vol. XVII. Listing of Renoir's 55 etchings, lithographs, etc., profusely ill.

The Artist's own Writings

(7) VENTURI, L.: Les Archives de l'Impressionnisme, Paris, New York, 1939. 2 v. 212 letters to Durand-Ruel, written between 1881 and 1919 are featured in v. I. Among these letters is Renoir's "Manifesto on the importance of irregularity in the arts" (partly translated *in* Goldwater, R., and Treves, M.: Artists on Art, New York, 1945). Vol. II of the Archives contains 9 letters to O. Maus.

(8) An important letter to Mottez has been published as introduction to a translation of Le Livre d'Art de Cennino Cennini, Paris, 1911.

RENOIR

(9) G. POULAIN: Bazillet et ses amis, Paris, 1932, contains excerpts from Renoir's important letters to Bazille, written in the '60s.

(10) G. Geffroy: Claude Monet, sa vie, son oeuvre, Paris, 1924. Some letters to Monet appear in v. II.

(11) FLORISOONE, M.: Renoir et la famille Charpentier, L'Amour de l'Art, Feb. 1938. Letters to Charpentier and Duret.

(12) A letter to Manet is quoted in Moreau-Nélaton, E.: Manet raconté par lui-même, Paris, 1926.

(13) J. JOETS: Les Impressionnistes et Chocquet, L'Amour de l'Art, April 1935, reproduces letters to Chocquet.

(14) 5 letters to A. André are published in Bulletin des Expositions, Nov., Dec. 1932, Galerie d'art, Braun et Cie, Paris.

(15) A letter concerning Renoir's portrait of Wagner is included in L'Amateur d'Autographes, Paris, 1913; see also Lockspeiser, E.: The Renoir Portraits of Wagner, Music and Letters, Jan. 1937.

(16) A letter to Durand-Ruel has appeared in Catalogue d'Autographes No. 61 of Marc Loliée, Paris, 1936. Letters to Roger Marx, Eugène and Julie Manet and A. André are quoted in (31).
 See also (19), (20), (21) and (27).

Witness Accounts

(17) RENOIR, E.: Article on his brother in La Vie Moderne, June 19, 1879; repr. in (7). On Edmond Renoir's recollections see also Rewald, J.: Auguste Renoir and his Brother, Gazette des Beaux-Arts, March 1943.

(18) RIVIÈRE, G.: Renoir et ses amis, Paris, 1921. Written by a lifelong friend of the painter, this book offers the best, most detailed and most vivid record of Renoir and his entourage. By far the most rewarding book on the subject. Richly ill., no bibl., no index.

(19) VOLLARD, A.: Renoir, Paris, 1918 (profusely ill.), 1920, 1938. English edition: Renoir, An Intimate Record, New York, 1925. The best of Vollard's books, based on an acquaintance with Renoir of over 20 years. The painter's friends, however, claim that Renoir, a dry joker, enjoyed surprising his biographer with misleading or paradoxical statements and that many of the conversations recorded by Vollard do not give the painter's real views. See G. B. (Besson): Renoir, par Ambroise Vollard, Les Cahiers d'Aujourd'hui, July 1921.

(20) PACH, W.: Interview with Renoir, Scribner's Magazine, 1912, repr. in the same author's: Queer Thing, Painting, New York, 1938. Condensation of a series of interviews, 1908-1912. An important text, approved by Renoir.

(21) ANDRÉ, A.: Renoir, Paris, 1923, 1928. A valuable record of numerous conversations with the artist, whom the author knew intimately during his last

years. The 116 good halftone plates of the second edition are chronologically arranged, but the dates are not always correct.

(22) BESSON, G.: Auguste Renoir, Paris, 1929. Some recollections of Renoir, 32 fair ill. chronologically arranged. See also the same authors: Arrivée de Matisse à Nice—Matisse et quelques contemporains, Le Point, July 1939, and: Renoir à Cagnes, Les Cahiers d'Aujourd'hui, Nov. 1920.

(23) ALEXANDRE, A.: Renoir sans phrases, Les Arts, No. 183, 1920. Recollections with some new photographs.

(24) MONCADE, C. L. DE: Le peintre Renoir et le Salon d'Automne. La Liberté, Oct. 15, 1904. An interview.

(25) BLANCHE, J. E.: Propos de peintre, de David à Degas, Paris, 1919. Ch. "De Cézanne à Renoir."

(26) OSTHAUS, K. E.: Erinnerungen an Renoir, Das Feuer, Feb. 1920. Information on Renoir as a sculptor.

(27) BÉRARD, M.: Renoir à Wargemont, Souvenirs, Paris, 1939. A very brief introduction, accompanied by 35 good illustrations of works done by Renoir in Wargemont; also facsimile of a letter by Renoir.

(28) MIRBEAU, O.: Renoir, Paris, 1913. Mirbeau's introduction is followed by 58 interesting excerpts from writings by A. Wolff, Burty, Castagnary, Huysmans, Geffroy, Mellério, Signac, Fontainas, Denis, Pach, Maus, Bonnard, etc. 40 good ill., chronologically arranged.

(29) ANONYMOUS: L'éternel Jury, Les Cahiers d'Aujourd'hui, 1921. 2 letters on the painter by Mme F., sister of Renoir's friend Jules Lecoeur.

Biographies

(30) DURET, T.: Renoir, New York, 1937. A biography based on the author's long friendship with Renoir. 60 fair to poor halftone ill., 8 mediocre color plates.

(31) COQUIOT, G.: Renoir, Paris, 1925. Another disappointing book by this author who likes to speak about himself as much as about his subject. 32 ill. and an inadequate attempt at cataloguing Renoir's work. No bibl., no index.

(32) ROGER-MARX, C.: Renoir, Paris, 1933, Mediocre ill., short bibl., no index.

(33) GRABER, H.: Auguste Renoir nach eigenen und fremden Zeugnissen, Basle, 1943. On this author's "methods" see Cézanne Bibliography (17).
 See also (18) and (19).

Studies of Style

(34) BARNES, A. C. AND MAZIA, V. DE: The Art of Renoir, New York, 1935. An approach to art based on a method which "promises results of the same verifiable objectivity of those of science." 158 good ill., chronologically arranged and accompanied by detailed analyses. Extensive index, no bibl.

(35) Jamot, P.: Renoir, *Gazette des Beaux-Arts,* Nov., Dec. 1923.

(36) Meier-Graefe, J.: Renoir, Munich, 1911, Leipzig, 1929 (richly ill.), French edition, Paris, 1912. A study based on the author's acquaintance with Renoir. The illustrations are not always correctly dated.

(37) Faure, E.: Renoir, *Revue Hebdomadaire,* 1920.

(38) Wyzewa, T. de: Pierre-Auguste Renoir, *L'Art dans les deux Mondes,* Dec. 6, 1890. On Renoir's classical period.

(39) Fontainas, A.: The Encounter of Ingres and Renoir, *Formes,* March 1931.

(40) George, W.: L'oeuvre sculpté de Renoir, *L'Amour de l'Art,* Nov. 1924, ill.

(41) Bazin, G.: Renoir's Sanguine Drawings, *Formes,* May 1930.

(42) Labasque, F.: La pureté de Renoir, *Esprit,* Dec. 1, 1933.

(43) Fosca, F.: Les dessins de Renoir, *Art et Décoration,* Oct. 1921.

(44) Fosca, F.: Renoir, Paris, 1923, London, 1924. Accompanied by 40 mediocre plates, undated and ar-arranged without order.

See also Venturi's introduction to (7) as well as (32) and (45).

Reproductions

(45) Florisoone, M.: Renoir, Paris, London, 1938. 120 fair black and white ill., 8 poor color plates, not chronologically arranged. Bibl. (Hyperion).

(46) Régnier, H. de: Renoir, peintre du nu, Paris, 1923. 40 fair plates, some in color. The brief foreword contains some recollections of the painter.

(47) Meier-Graefe, J.—Hausenstein, W.: Renoir, Munich, 1920, 1929. 2 Marées Gesellschaft Portfolios, each with 20 superb plates after drawings, pastels and watercolors.

(48) René-Jean: Portfolio with 10 mediocre plates after watercolors, sanguines and pastels, Geneva-Paris, 1921.

(49) Bazin, G.: Renoir, Paris-London, 1939. Portfolio with 8 excellent color plates.

(50) Lhote, A.: Peintures de Renoir, Paris, 1944. Portfolio with 12 good but not too well chosen color plates.

(51) Bell, C.: Renoir, Les parapluies, London, n.d. [1945]. Interesting photographs of details.

(52) Frost, R.: Pierre-Auguste Renoir, New York, 1944. A Hyperion book with fair black and white but poor color illustrations, not chronologically arranged.

(53) Stein, L.: A. Renoir, Paris, n.d. [1928?]. An Album d'art Druet with 24 poor plates.

(54) *L'Amour de l'Art,* special issue, Renoir Feb. 1921.

(55) *L'Art Vivant,* special issue, Renoir, July 1933.

See also (1), (2), (3), (4), (5), (6), (18), (19), (21), (22), (27), (28), (30), (34) and (36).

SISLEY

Oeuvre Catalogues

No catalogue for paintings.

(1) Delteil, L.: Pissarro, Sisley, Renoir. Le peintre-graveur illustré, v. XVII, Paris, 1923. Catalogue of the few prints by Sisley.

The Artist's Own Writings

(2) A letter to the artist's friend, Tavernier, containing an explanation of Sisley's approach to nature, was published by the latter in an article in *L'Art Français,* March 18, 1893. It is partly translated in Goldwater, R., and Treves, M.: Artists on Art, New York, 1945. For a complete German translation see *Kunst und Künstler,* March 1908.

(3) Venturi, L.: Les Archives de l'Impressionnisme, Paris-New York, 1939. Vol. 2 features 16 letters to Durand-Ruel (1887-1891) and 5 letters to O. Maus (1887-1897).

(4) Letters to Duret were published by the latter in *La Revue Blanche,* March 15, 1899. For an English translation see (7).

(5) Huyghe, R.: Some unpublished letters of Sisley, *Formes,* Nov. 1931. Letters to Charpentier, Mirbeau and Tavernier.

(6) Letters to Duret, Monet and Dr. Viau were published in: Bulletin des Expositions, II, Galerie d'art Braun et Cie, Paris, Jan. 30—Feb. 18, 1933.

Biographies

(7) Duret, T.: Manet and the French Impressionists, Philadelphia, 1910. The chapter on Sisley offers a condensed biography of him. There exists no complete biography of the artist. For other biographical details see Venturi's introduction to (3).

(8) Watson, F.: Sisley's Struggle for Recognition, *The Arts,* Feb.—March, 1921.

(9) Graber, H.: Camille Pissarro, Alfred Sisley, Claude Monet, nach eigenen und fremden Zeugnissen, Basle, 1943. On this author's "methods" see Cézanne bibliography (17).

Studies of Style

See Venturi's introduction to (3).

Reproductions

(10) Geffroy, G.: Sisley, Paris [n.d.] 60 good halftone plates, assembled without order. The author knew Sisley but his text consists chiefly of lyrical comments.

(11) Francastel, P.: Monet, Sisley, Pissarro, Paris, 1939. A few excellent color plates.

(12) Heilmaier, H.: Alfred Sisley, *Die Kunst für Alle,* 1930-31.

See also (7) and (8).

INDEX

rejected at the Salon, 338, 354 (note 34)

Durand-Ruel again buys his paintings, 355

death 424

rejected at the Salon, 338, 354 (note

Portraits by Renoir, *ill*. 114, 160, 296; *Portrait* by Bazille, *ill*. 158

mentioned, 67, 79, 93, 134, 149, 150, 156, 162, 163, 179, 183, 199, 219, 225, 226, 230, 238, 244, 250, 252, 263, 295, 299, 302, 306, 313, 314, 323, 327, 331, 332, 333, 336, 337, 339, 341, 346, 348, 351, 352, 356, 363, 364, 365, 368, 369, 372, 377, 389, 394, 395, 396, 404, 405, 406, 410, 416, 422

Boats at Anchor in Argenteuil, ill. 286

Bridge near Paris, ill. 274

Canal St. Martin, ill. 200

Charing Cross Bridge, 212; *ill.* 214

Chestnut Trees in St. Cloud, ill. 161

Early Snow in Louveciennes, ill. opp. 180

Flood at Port-Marly, ill. 313

Fontainebleau Forest, ill. 89

House of Mme Du Barry in Marly, ill. 265

Landscape near Louveciennes, ill. 265

Louveciennes, ill. 240

Louveciennes, Autumn, 256; *ill.* 255

Louveciennes, Winter, ill. 241

Montmartre, ill. 206

Petite Place at Argenteuil, 273

Road at Louveciennes, ill. 321

Village Street in Marlotte, ill. 115.

Société anonyme des artistes peintres, sculpteurs, graveurs, etc., 254, 263.

Société des Artistes Indépendants, 380, 381, 385 (note 38), 390, 396, 400, 414, 426.

Spain, 44, 111, 200, 227, 322.

Stevens, A., 164, 169, 183, 184, 225, 227, 250, 366, 392.

Synthetism, 406, 409.

Tahiti, 415, 423, 424.

Tanguy, *père,* 248, 249, 269 (note 14), 290, 291, 333, 351, 399, 400, 401, 406, 410, 422, 424; *Portrait* by *van Gogh, ill.* 401.

Tiepolo, 359.

Tillot, 294, 313, 337, 341, 348, 352, 389.

Tintoretto, 65, 66.

Tissot, 65, 176, 208; *Portrait* by Degas, *ill.* 155.

Titian, 65.

Toulmouche, 60, 61, 81.

Toulouse-Lautrec, 400, 408, 409, 414, 418, 419, 428, 432; *Portrait of Emile Bernard, ill.* 401.

Tribune, (newspaper), 165, 210.

Trouville, 113, 147; *ill.* 116, 209.

Troyon, 15, 35, 37, 38, 41, 53, 56, 78, 95, 220, 250, 336.

Turner, 213, 224 (note 59).

Valabrègue, 121, 150, **178**; *Portraits* by Cézanne, *ill.* 120, opp. 210.

Valadon, 370, 416; painted by Renoir, *ill.* 371.

Valernes, E. de, 24, 418.

Valéry, 418.

Valpinçon, 13, 219, 372; *Portraits* by Degas, 218, 264.

Van Gogh, see Gogh, van

Van de Velde, H., 407.

Velasquez, 44, 46, 65, 92, 111, 134.

Venice, 286, 359; *ill.* 359.

Verhaeren, 392.

Vermeer, 65.

Veronese, 65, 66, 359.

Versailles, 219, 358.

Vétheuil, 334, 337; *ill.* 339.

Vidal, 341, 352.

Vie Moderne, La, 337, 339, 344, 354 (note 32), 381.

Vignon, 341, 352, 364, 365.

Ville d'Avray, 66, 131, 148, 149, 189, 210.

Villiers de l'Isle-Adam, 327.

Vingt, Les, 396, 403 (note 18), 404, 407, 409.

Viollet-le-Duc, 21.

Vollard, 401, 422, 424, 426, 428; *Portrait* by Cézanne, *ill.* 423.

Vuillard, 411, 426.

Wagner, 101, 359; *Tannhäuser,* 101; *Parsifal,* 359.

Wargemont, 372.

Watteau, 65.

Wheelwright, 83.

WHISTLER,

rejected in 1859, 28; *ill.* 28

exhibits at Bonvin's, 29

copyist, 65

at the *Salon des Refusés,* 70, 72; *ill.* 73

with Courbet in Trouville, 112, 113; *ill.* 116

against Courbet, 147, 148

and Japan, 176

mentioned, 16, 23, 59, 62, 68, 78, 101, 111, 150, 225, 301, 313, 356, 404, 428.

At the Piano, ill. 28

Courbet at Trouville, ill. 116

Self Portrait, ill. 27

White Girl, 70, 77, 113, 148, 168 (note 43); *ill.* 73.

Wolff, A., 288, 293, 295, 314, 366.

Zandomeneghi, 327, 338, 341, 342, 348, 352, 389.

ZOLA,

friendship with Cézanne, 54, 122, 123, 126

at the *Salon des Refusés,* 77

editor of *L'Evénement,* 115, 123, 124

and Manet, 123, 124

art critic, 123, 124, 150, 163

on Monet, 124

Mon Salon, 126

on Pissarro, 126, 163

and naturalism, 131

at the Café Guerbois, 169, 172, 174, 225

letters from Monet, 291, 292

helps Cézanne, 334

in Médan, 334

publishes article on Naturalism at the Salon, 344

publishes *L'Oeuvre,* 398

break with Cézanne, 398

last article on art, 424

defends Dreyfus, 424

death, 428

Portrait by Manet, *ill.* 171; *Portrait* by Fantin, *ill.* 175

mentioned, 56, 134, 139, 158, 165, 170, 178, 182, 196, 198, 200, 204, 208, 210, 213, 219, 221, 243, 271, 300, 303, 324, 327, 352, 366, 372, 399, 402, 408.

Sixteen thousand and three hundred copies of this book have been printed in April, 1946, for the Trustees of the Museum of Modern Art by The Gallery Press, New York. The color inserts have been printed by William E. Rudge's Sons, New York.